THE HUMANITIES
THROUGH THE ARTS

THE HUMANITIES THROUGH THE ARTS

Eighth Edition

F. David Martin
Professor of Philosophy Emeritus
Bucknell University

Lee A. Jacobus
Professor of English Emeritus
University of Connecticut

Mc Graw Hill

Connect
Learn
Succeed™

Published by McGraw-Hill, an imprint of The McGraw-Hill Companies, Inc., 1221 Avenue of the Americas, New York, NY 10020. Copyright © 2011, 2008, 2004, 1997, 1991, 1983, 1978, 1975. All rights reserved. No part of this publication may be reproduced or distributed in any form or by any means, or stored in a database or retrieval system, without the prior written consent of The McGraw-Hill Companies, Inc., including, but not limited to, in any network or other electronic storage or transmission, or broadcast for distance learning.

This book is printed on acid-free paper.

2 3 4 5 6 7 8 9 10 DOC/DOC 1 5 4 3 2 1 0

ISBN: 978-0-07-337663-9
MHID: 0-07-337663-9

Vice President, Editorial: *Michael Ryan*
Publisher: *Christopher Freitag*
Sponsoring Editor: *Betty Chen*
Managing Editor: *Briana Porco*
Marketing Manager: *Pamela Cooper*
Production Editor: *Holly Paulsen*
Manuscript Editor: *Judith Brown*
Design Manager: *Margarite Reynolds*
Text Designer: *tani hasegawa*
Cover Designer: *Margarite Reynolds*
Photo Research Manager: *Brian Pecko*
Production Supervisor: *Louis Swaim*
Composition: *10/12 New Aster by MPS Limited, A Macmillan Company*
Printing: *70# Sterling Ultraweb Dull, R. R. Donnelley*

On the cover: Jacques Herzog, Pierre Meuron, Ai Weiwei, Beijing National Stadium ("Bird's Nest"), Beijing, China. 2003–2008. Photo © Xiaoyang Liu/Corbis.

Credits: The credits section for this book begins on page C-1 and is considered an extension of the copyright page.

Library of Congress Cataloging-in-Publication Data has been applied for.

The Internet addresses listed in the text were accurate at the time of publication. The inclusion of a Web site does not indicate an endorsement by the authors or McGraw-Hill, and McGraw-Hill does not guarantee the accuracy of the information presented at these sites.

www.mhhe.com

ABOUT THE AUTHORS

F. David Martin (PhD, University of Chicago) taught at the University of Chicago and then at Bucknell University until his retirement in 1983. He was a Fulbright Research Scholar in Florence and Rome from 1957 through 1959, and he has received seven other major research grants during his career as well as the Christian Lindback Award for Distinguished Teaching. Dr. Martin recently taught in the University of Pittsburgh's Semester at Sea and is currently a consultant for Time-Warner for the development of CD-ROMs in the arts and the humanities. In addition to more than 100 articles in professional journals, Dr. Martin is the author of *Art and the Religious Experience* (Associated University Presses, 1972), *Sculpture and the Enlivened Space* (The University Press of Kentucky, 1981), and *Facing Death: Theme and Variations* (Associated University Presses, 2006). Although he has taught all fields of philosophy, Dr. Martin's main teaching interests have centered on the "why" questions of the arts and the humanities. Married with four children, ten grandchildren, and fifteen greatchildren, Dr. Martin lives on the Susquehanna River in Lewisburg, Pennsylvania. His hobbies are the arts, nature, golf, and the world—especially Italy.

Lee A. Jacobus (PhD, Claremont Graduate University) is Professor of English Emeritus at the University of Connecticut (Storrs). His undergraduate and master's degrees are from Brown University. He held a Danforth Teacher's Grant while earning his doctorate. Dr. Jacobus has taught at Western Connecticut State University, Columbia University, and Brown University as well as the University of Connecticut. His specialties are Milton, Shakespeare, Joyce, and Modern Irish Literature. His publications include *Shakespeare and the Dialectic of Certainty* (St. Martin's, 1992); *Sudden Apprehension: Aspects of Knowledge in Paradise Lost* (Mouton, 1976); *John Cleveland: A Critical Study* (G. K. Hall, 1975); *Humanities: The Evolution of Values* (McGraw-Hill, 1985); *Writing as Thinking* (Macmillan, 1989); *Substance, Style and Strategy* (Oxford University Press, 1999); *Literature: An Introduction to Critical Reading* (Prentice-Hall, 1996; Compact ed. 2002); and several edited volumes: *Aesthetics and the Arts* (McGraw-Hill, 1968); *A World of Ideas* (Bedford/St. Martin's, 8th ed. 2010); *The Bedford Introduction to Drama* (Bedford/St. Martin's, 6th ed. 2009; Compact ed. 2009); *The Longman Anthology of American Drama* (Longman, 1982); and *Teaching*

Literature (Prentice-Hall, 1996). Dr. Jacobus was founder and co-editor of the scholarly journal *Lit: Literature Interpretation Theory.* He has held grants for photographic work in the northeast quadrant of Connecticut, and his photographs are in permanent collections, magazines, and books. In addition, he has published short fiction, poetry, numerous essays, and scholarly articles, and he had three plays produced in off-Broadway theaters. He is married to choreographer and dancer Joanna Jacobus.

We dedicate this study to
teachers and students of the humanities.

BRIEF CONTENTS

CONTENTS

PREFACE

The Humanities through The Arts, eighth edition, continues to explore the humanities with an emphasis on the arts. Examining the relationship of the humanities to values, objects, and events important to people is central to this book. We also make a distinction between the role of artists and that of other humanists: Artists reveal values, while other humanists examine or reflect on values. The goal of this text is to study how values are revealed in the arts, all while keeping in mind the important question, "What is Art?" We aim to provide a text that helps students understand, interpret, and experience the arts in ways that are meaningful, enjoyable, and relevant to everyday life. Participation in the arts helps us realize that "Our knowledge," as Isaac Singer put it, "is a little island in a great ocean of the non-knowable." It is one of the indispensable means to the good life.

CONTINUING STRENGTHS OF THE BOOK

Genre-Based Approach

Our genre-based approach focuses on each of the individual arts, offering students the opportunity to engage works of art in the depth that they demand. Subject matter, form, and content in each of the arts supply the framework for analysis. Painting and photography focus our eyes on the visual appearance of things. Sculpture reveals the textures, densities, and shapes of things. Architecture sharpens our perception of spatial relationships, both inside and out. Literature, drama, film, and video make us more aware of the human condition, among other ideas. Our understanding of feelings is deepened by music. Our sensitivity to movement, especially of the human body, is enhanced by dance. The reader's processes of criticism and analysis are thus given full rein, with attention to perception of and response to the specific works we discuss. For the historical context, we have included a simplified **Timeline** on the inside covers, locating historically the artists and works referred to in the text.

Organization

This edition is organized into three parts to offer instructors flexibility in the classroom:

Part 1, "Fundamentals," includes the first three introductory chapters. In Chapter 1 we distinguish the humanities from the sciences, and the arts from the other humanities. In Chapter 2 we raise one of the most important questions, "What is Art?" In Chapter 3 we describe some of the ways of responding to art, and discuss the vital role of criticism in art appreciation and evaluation. Part 1 is the foundation of the text.

Part 2, "The Arts," includes chapters on each of the basic arts. We have structured this section so that individual chapters, such as "Painting," "Sculpture," and "Architecture," may be used in any order. This is true as well of chapters on "Literature," "Drama," "Music," "Dance," "Film," "Television and Video Art," and "Photography." Instructors may reorder or even omit some chapters if necessary.

Part 3, "Interrelationships," begins in Chapter 14 with the question "Is It Art or Something Like It?" We study briefly what art forms may be "art-like"—illustration, folk, popular, propaganda, kitsch, and decoration. We revisit that most important and pervasive question, "What is Art?" And now we can also study systematically the avant-garde, the exciting developments that are exploding at the edges of traditional art. In Chapter 15 we examine "The Interrelationships among the Arts." We study, for example, how film interprets a novel by E. M. Forster, the ways in which music and literature intersect in a Mozart opera, how a Van Gogh painting inspires poetry and song, and how poetry inspires a Bernini sculpture. In Chapter 16, "The Interrelationships of the Humanities," we address the way the arts impact the other humanities, particularly history, philosophy, and theology.

Perception Keys

This unique feature helps readers sharpen their responses to art. Concentrating usually on specific works of art, the **Perception Keys** include questions and suggestions designed to elicit more sensitive perception. They are also designed to open discussion, not to demand answers. In some cases, our own responses and analyses follow the keys, and are offered not as *the* way to perceive a given work of art, but rather as one *possible* way. We try to avoid dogmatic answers and explanations; our primary interest is exciting our readers to perceive the splendid singularity of the work of art. In Chapter 16 we use **Conception Keys.** Similar in format to the Perception Keys, they focus on conceptual problems and explore the distinctions between perceiving and conceiving.

Vivid Illustration Program

We have taken great care to encourage participation with the works of art by providing a strong image program. The 200-plus images have been

carefully chosen and reproduced in full color when possible, resulting in a beautifully illustrated text.

KEY CHANGES IN THE EIGHTH EDITION

- **New Experiencing feature.** The Experiencing boxes expand on the Perception Keys, a hallmark of the text, to give students a more in-depth look at a particular work or concept in each chapter. Analysis of the work starts by answering a few preliminary questions to make it more accessible to students. Follow-up questions ask students to think more critically about the work and guide them to their own interpretation.

- **Updated illustration program with important and more current works of art.** Twenty percent of the images in this edition have been updated. New discussions of these important works appear in the chapters on dance, television and video art, and photography.

- **New discussion of the media of painting in Chapter 4.** In an effort to clarify the various media of painting, a new section discusses tempera, fresco, oil, watercolor, acrylic, and ink and mixed media. The discussion of Impressionism has been expanded to include more important works and a more detailed analysis of the question of style.

- **New play in Chapter 8, "Drama."** Anton Chekhov's *The Swan Song* is an example of meta-drama and an introduction to the significance of a life in the theatre. It is one of Chekhov's most endearing and moving short plays.

- **Additions and changes in Chapter 9, "Music."** New content on blues, popular music, and rock has been added. The musical analysis of Beethoven's *Eroica* symphony concentrates on the dynamic first movement. For students interested in further study, the detailed analysis of the other movements is online.

- **New analysis of Orson Welles' *Citizen Kane* in Chapter 10.** This new section provides insight into a film classic that has been described as the greatest film of the twentieth century.

- **Revised placement of Chapters 14 and 15.** "Is It Art or Something Like It?" now precedes "The Interrelationships of the Arts" to make a more logical transition from art as a concept to the intersections between the arts. Chapter 14 has been revised to help students distinguish between works of art that reveal significant values with works that may only appear to do so. This is another opportunity to ask the question, "What is Art?"

- **Refinement of design to take advantage of color reproductions.** This edition continues a pattern of design refinement aimed at making the book more captivating and exciting to use.

SUPPLEMENTS

Telecourse

The eighth edition continues to be closely coordinated with the telecourse **Humanities through The Arts,** based on our text. Produced by KOCE-TV and Coast Learning Systems, consisting of thirty half-hour programs and hosted by Maya Angelou, the telecourse is distributed through Coast Telecourses. *Telecourse Student Guide to accompany: The Humanities through The Arts*, eighth edition (New York: The McGraw-Hill Companies, 2011), written by Richard T. Searles, has been revised by Rosemary Canfield Reisman for Coast Learning Systems. This study guide continues to help students master material in the text and videos, providing lesson overviews, objectives, assignments, additional readings, review quizzes, and suggestions for further study. The listing of websites has been updated and expanded to lead computer users to the exploding resources of the Internet in all areas of the arts.

Online Learning Center

Instructor Resources An Instructor's Online Learning Center (OLC) at www .mhhe.com/hta8 includes a number of resources to assist instructors with planning and teaching their courses: an instructor's manual, which offers learning objectives, chapter outlines, possible discussion and lecture topics, and more; a test bank with multiple-choice and essay questions; and a chapter-by-chapter PowerPoint presentation.

Student Resources The student content for the Online Learning Center of this new edition of *The Humanities through The Arts* enriches the learning experience. Students can watch videos on various art techniques and access interactive designs to strengthen their understanding of visual art, dance, music, sculpture, literature, theater, architecture, and film. They will also be able to use the guided Research in Action tool to enhance their understanding of time periods, genres, and artists. We hope that this online availability will spark their own creativity. All of this information is available at www.mhhe.com/hta8 when you click on the MyHumanitiesStudio link. Additional resources, including quizzes, links to relevant websites, and a chapter-by-chapter glossary are available on the OLC to help students review and test their knowledge of the material covered in the book.

ACKNOWLEDGMENTS

This book is indebted to more people than we can truly credit. We are deeply grateful to the following for their help:

David Avalos, *California State University San Marcos*
Bruce Bellingham, *University of Connecticut*
Eugene Bender, *Richard J. Daley College*

Michael Berberich, *Galveston College*
Barbara Brickman, *Howard Community College*
Peggy Brown, *Collin County Community College*
Lance Brunner, *University of Kentucky*
Alexandra Burns, *Bay Path College*
Bill Burrows, *Lane Community College*
Glen Bush, *Heartland Community College*
Sara Cardona, *Richland College*
Brandon Cesmat, *California State University San Marcos*
Selma Jean Cohen, *editor of* Dance Perspectives
Karen Conn, *Valencia Community College*
Harrison Davis, *Brigham Young University*
Jim Doan, *Nova University*
Jill Domoney, *Johnson County Community College*
Gerald Eager, *Bucknell University*
Jane Ferencz, *University of Wisconsin–Whitewater*
Roberta Ferrell, *SUNY Empire State*
Michael Flanagan, *University of Wisconsin–Whitewater*
Andy Friedlander, *Skagit Valley College*
Harry Garvin, *Bucknell University*
Susan K. de Ghizee, *University of Denver*
Michael Gos, *Lee College*
Lee Hartman, *Howard Community College*
Jeffrey T. Hopper, *Harding University*
James Housefield, *Texas State University–San Marcos*
Stephen Husarik, *University of Arkansas–Fort Smith*
Joanna Jacobus, *choreographer*
Lee Jones, *Georgia Perimeter College–Lawrenceville*
Deborah Jowitt, *Village Voice*
Nadene A. Keene, *Indiana University–Kokomo*
Marsha Keller, *Oklahoma City University*
Paul Kessel, *Mohave Community College*
Edward Kies, *College of DuPage*
Gordon Lee, *Lee College*
Marceau Myers, *North Texas State University*
Martha Myers, *Connecticut College*
L. Timothy Myers, *Butler Community College*
William E. Parker, *University of Connecticut*
Seamus Pender, *Franklin Pierce College*
Susan Shmeling, *Vincennes University*
C. Edward Spann, *Dallas Baptist University*
Mark Stewart, *San Joaquin Delta College*
Robert Streeter, *University of Chicago*
Peter Surace, *Cuyahoga Community College*
Robert Tynes, *University of North Carolina at Asheville*
Walter Wehner, *University of North Carolina at Greensboro*
Keith West, *Butler Community College*

We especially want to thank our editorial team for this edition: Susan Gouijnstook, Briana Porco, and Betty Chen, as well as our former editors: Lisa Pinto, Lisa Moore, Kristen Mellitt, Alison Meersshaert, Cheryl Mehalik, Kaye Pace, Peter Labella, Allison McNamara, Nancy Blaine, Cynthia Ward,

and Caroline Ryan. We would also like to thank our production team: production editor, Holly Paulsen; manuscript editor, Judith Brown; designer, Margarite Reynolds; production supervisor, Louis Swaim; and photo researcher, Brian Pecko. Without their expertise, this book could never have been put together so beautifully.

Finally, we thank Associated University Presses for permission to paraphrase and quote from *Art and the Religious Experience* (1972) and the University Press of Kentucky for permission to quote from *Sculpture and Enlivened Space* (1981) both by F. David Martin.

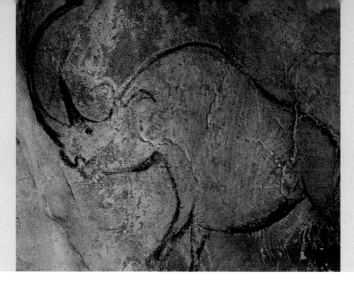

Chapter 1

THE HUMANITIES: AN INTRODUCTION

THE HUMANITIES: A STUDY OF VALUES

In the medieval period, the word *humanities* distinguished that which pertained to humans from that which pertained to God. Mathematics, the sciences, the arts, and philosophy were humanities: They had to do with humans. Theology and related studies were the subjects of divinity: They had to do with God. This distinction does not have the importance it once did. Today we think of the humanities as those broad areas of human creativity and study that are distinct from mathematics and the "hard" *sciences,* mainly because in the humanities, strictly objective or scientific standards are not usually dominant.

The current separation between the humanities and the sciences reveals itself in a number of contemporary controversies. For example, the cloning of animals has been greeted by many people as a curiosity and a possible benefit for domestic animal farmers. Genetically altered wheat, soybeans, and other cereals have been heralded by many scientists as a breakthrough that will produce disease-resistant crops and therefore permit us to continue to increase the world food supply. On the other hand, some people resist such modifications and purchase food identified as not being genetically altered. Scientific research into the human genome has identified certain genes for inherited diseases, such as breast cancer or Alzheimer's disease,

that could be modified to protect individuals or their offspring. Genetic research also suggests that in a few years individuals will be able to "design" their children's intelligence, their body shape, their height, their general appearance, and their physical ability.

Scientists provide the tools for these choices. Their values are centered in science in that they value the nature of their research and their capacity to make it work in a positive way. However, the impact on humanity of such a series of dramatic changes to life brings to the fore values that clash with one another. For example, is it a positive social value for couples to decide the sex of their offspring rather than following nature's own direction? In this case, who should decide if "designing" one's offspring is a positive value, the scientist or the humanist?

Even more profound is the question of cloning a human being. Once a sheep was cloned successfully, it was clear that this science would lead directly to the possibility of a cloned human being. Some proponents of cloning support the process because we could clone a child who dies in infancy or clone a genius who has given great gifts to the world. For these people, cloning is a positive value. For others, the very thought of cloning a person is repugnant on the basis of religious belief. For still others, the idea of human cloning is objectionable because it echoes the creation of an unnatural monster, and for them it is a negative value. Because this is a worldwide problem, local laws will have limited effect on establishing a clear position on the value of cloning of all sorts. The question of how we decide on such a controversial issue is at the heart of the humanities, and some observers have pointed to Mary Wollstonecraft Shelley's famous novel, *Frankenstein, Or the Modern Prometheus,* which in some ways enacts the conflict among these values.

These examples demonstrate that the discoveries of scientists often have tremendous impact on the values of society. Yet some scientists have declared that they merely make the discoveries and that others—presumably politicians—must decide how the discoveries are to be used. It is this last statement that brings us closest to the importance of the humanities. If many scientists believe they cannot judge how their discoveries are to be used, then we must try to understand why they give that responsibility to others. This is not to say that scientists uniformly turn such decisions over to others, for many of them are humanists as well as scientists. But the fact remains that many governments have made use of great scientific achievements without pausing to ask the "achievers" if they approved of the way their discoveries were being used. The questions are, Who decides how to use such discoveries? On what grounds should their judgments be based?

Studying the behavior of neutrinos or string theory will not help us get closer to the answer. Such study is not related to the nature of humankind but to the nature of nature. What we need is a study that will get us closer to ourselves. It should be a study that explores the reaches of human feeling in relation to ***values***—not only our own individual feelings and values but also the feelings and values of others. We need a study that will increase our sensitivity to ourselves, others, and the values in our world. To be sensitive is to perceive with insight. To be sensitive is also to feel and believe that things make a difference. Furthermore, it involves an awareness of those aspects

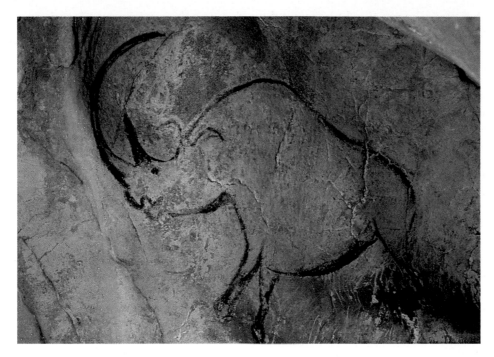

FIGURE 1-1
Cave painting from Chauvet
Caves, France.

Only recently discovered, the
Chauvet Caves have yielded
some of the most astonishing
examples of prehistoric art the
world has seen. This rhinoceros
may have lived as many as
35,000 years ago, while the
painting itself seems as modern
as a contemporary work.

of values that cannot be measured by objective standards. To be sensitive is
to respect the humanities, because, among other reasons, they help develop
our sensitivity to values, to what is important to us as individuals.

There are numerous ways to approach the humanities. The way we have
chosen here is the way of the arts. One of the contentions of this book is
that values are clarified in enduring ways in the arts. Human beings have
had the impulse to express their values since the earliest times. Ancient
tools recovered from the most recent Ice Age, for example, have features
designed to express an affection for beauty as well as to provide utility.

The concept of progress in the arts is problematic. Who is to say whether
the cave paintings (Figure 1-1) of 30,000 years ago that were discovered
in present-day France are less excellent than the work of Picasso (see Fig-
ure 1-4)? Cave paintings were probably not made as works of art to be con-
templated. To get to them in the caves is almost always difficult, and they
are very difficult to see. They seem to have been made for some practical
purpose, such as improving the prospects for the hunt. Yet the work reveals
something about the power, grace, and beauty of this kind of animal. These
cave paintings function now as works of art. From the beginning, our spe-
cies instinctively had an interest in making revealing forms.

Among the numerous ways to approach the humanities, we have chosen
the way of the arts because, as we shall try to elucidate, the arts clarify or
reveal values. As we deepen our understanding of the arts, we necessarily
deepen our understanding of values. We will study our experience with
works of art as well as the values others associate with them, and in this
process we will also educate ourselves about our own values.

Because a value is something that matters, engagement with art—the illumination of values—enriches the quality of our lives significantly. Moreover, the *subject matter* of art—what it is about—is not limited to the beautiful and the pleasant, the bright sides of life. Art may also include and help us understand the dark sides—the ugly, the painful, and the tragic. And when it does and when we get it, we are better able to come to grips with those dark sides of life.

Art brings us into direct communication with others. As Carlos Fuentes wrote in *The Buried Mirror,* "People and their cultures perish in isolation, but they are born or reborn in contact with other men and women of another culture, another creed, another race. If we do not recognize our humanity in others, we shall not recognize it in ourselves." Art reveals the essence of our existence.

TASTE

Taste is an exercise in the choice of values. People who have already made up their minds about what art they like or do not like defend their choices as an expression of their taste. Some opera buffs think Italian opera is uniformly superior to opera in English, French, or German. Others claim that any opera Mozart wrote is wonderful, but all others are impossible. All of us have various kinds of limitations about the arts. Some cannot stand opera at all. Some cannot look at a painting or sculpture of a nude figure without smirking. Some think any painting is magnificent as long as it has a sunset or a dramatic sea or a battle, or as long as it is abstract and goes well with the couch. Some people will read any book that deals with horse racing, or has a scientific angle, or discusses their current hobby.

The taste of the mass public shifts constantly. Movies, for example, survive or fail on the basis of the number of people they appeal to. A film is good if it makes money. Consequently, film producers make every effort to cash in on current popular tastes, often by making sequels until the public's taste changes—for example, the *Batman* series (1989, 1992, 1995, 1997, 2005, 2008).

One point our study of the humanities emphasizes is that commercial success is not the most important guide to excellence in the arts. The long-term success of works of art depends on their ability to interpret human experience at a level of complexity that warrants examination and reexamination. Many commercially successful works give us what we think we want rather than what we really need with reference to insight and understanding. By satisfying us in an immediate and superficial way, commercial art can dull us to the possibilities of more complex and more deeply satisfying art.

Everyone has limitations as a perceiver of art. Sometimes we defend ourselves against stretching our limitations by assuming that we have developed our taste and that any effort to change it is bad form. An old saying— "Matters of taste are not disputable"—can be credited with making many of us feel righteous about our own taste. What the saying means is that there is no accounting for what people like in the arts, for beauty is in the

eye of the beholder. Thus, there is no use in trying to educate anyone about the arts. Obviously we disagree. We believe that all of us can and should be educated about the arts and should learn to respond to as wide a variety of the arts as possible: from jazz to string quartets, from Charlie Chaplin to Steven Spielberg, from Lewis Carroll to T. S. Eliot, from folk art to Picasso. Most of us defend our taste because anyone who challenges it challenges our deep feelings. Anyone who tries to change our responses to art is really trying to get inside our minds. If we fail to understand its purpose, this kind of persuasion naturally arouses resistance.

The study of the arts can involve a multitude of factual information. The dates of Beethoven's birth and death and the dates of his important compositions, as well as their key signatures and opus numbers, can be verified. We can investigate the history of jazz and the claim of Jelly Roll Morton to have been its "inventor." We can decide who was or was not part of the Realistic school of painting in mid-nineteenth-century France. We can make lists of the Impressionist painters in late nineteenth-century France and those they influenced. Oceans of facts attach to every art. But our interest is not in facts alone.

For us, the study of the arts penetrates beyond facts to the values that evoke our feelings—the way a succession of Eric Clapton's guitar chords when he plays the blues can be electrifying or the way song lyrics can give us a chill. In other words, we want to go beyond the facts *about* a work of art and get to the values revealed in the work. How many times have we all found ourselves liking something that, months or years before, we could not stand? And how often do we find ourselves now disliking what we previously judged a masterpiece? Generally, we can say the work of art remains the same. It is we who change. We learn to recognize the values illuminated in such works as well as to understand the ways in which this is accomplished. Such development is the meaning of "education" in the sense in which we have been using the term.

RESPONSES TO ART

Our responses to art usually involve processes so complex that they can never be fully tracked down or analyzed. At first, they can only be hinted at when we talk about them. However, further education in the arts permits us to observe more closely and thereby respond more intensely to the content of the work. This is true, we believe, even with "easy" art, such as exceptionally beautiful works—for example, the Raphael (see Figure 14-10), Giorgione (see Figure 2-17), Cézanne (see Figure 2-4), and O'Keeffe (see Figure 4-12). Such gorgeous works generally are responded to with immediate satisfaction. What more needs to be done? If art were only of the beautiful, text-books such as this would never find many users. But we think more needs to be done, even with the beautiful. We will begin, however, with three works that obviously are not beautiful.

The Mexican painter David Alfaro Siqueiros's *Echo of a Scream* (Figure 1-2) is a highly emotional painting—in the sense that the work seems to demand a strong emotional response. What we see is the huge head of a baby crying

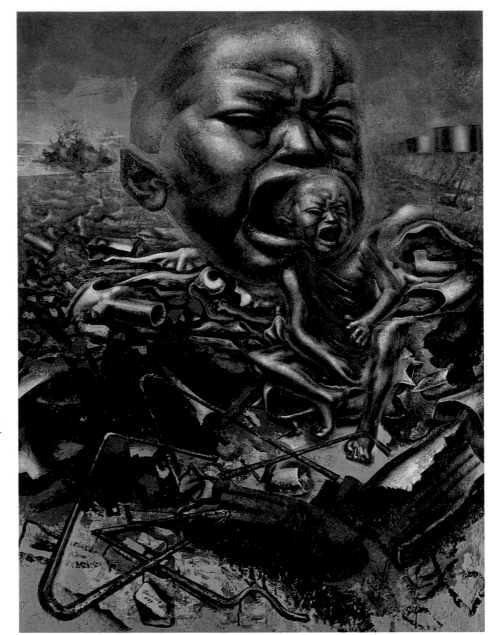

FIGURE 1-2
David Alfaro Siqueiros,
Mexican, 1896–1974, *Echo of a
Scream*. 1937. Enamel on wood,
48 × 36 inches (121.9 × 91.4 cm).
Gift of Edward M. M. Warburg.
Museum of Modern Art,
New York.

Siqueiros, a famous Mexican
muralist, fought during the
Mexican Revolution and
possessed a powerful political
sensibility, much of which
found its way into his art. He
painted some of his works
in prison, held there for his
political convictions. In the
1930s he centered his attention
on the Spanish Civil War,
represented here.

and, then, as if issuing from its own mouth, the baby himself. What kinds of
emotions do you find stirring in yourself as you look at this painting? What
kinds of emotions do you feel are expressed in the painting? Your own emo-
tional responses—such as shock, pity for the child, irritation at a destructive,
mechanical society, or any other nameable emotion—do not sum up the paint-
ing. However, they are an important starting point, since Siqueiros paints in
such a way as to evoke emotion, and our understanding of the painting in-
creases as we examine the means by which this evocation is achieved.

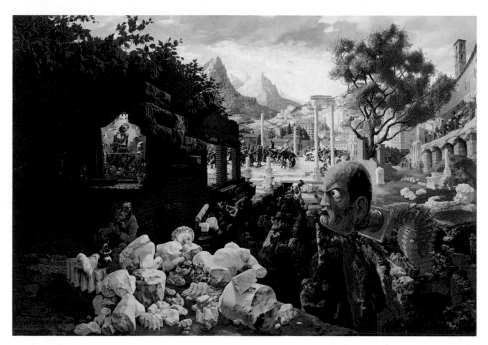

FIGURE 1-3

Peter Blume, 1906–1992, *The Eternal City*. 1934–1937. Dated on painting 1937. Oil on composition board, 34 × 47⅞ inches. Museum of Modern Art, New York. Mrs. Simon Guggenheim Fund.

Born in Russia, Blume came to America when he was six. His paintings are marked by a strong interest in what is now known as magic realism, interleaving time and place and the dead and the living in an emotional space that confronts the viewer as a challenge. He condemned the tyrant dictators of the first half of the twentieth century.

Art © Estate of Peter Blume/Licensed by VAGA, New York, NY

PERCEPTION KEY *Echo of a Scream*

1. Identify the mechanical objects in the painting.
2. What is the condition of these objects? What is their relationship to the baby?
3. What are those strange round forms in the upper right corner?
4. How might your response differ if the angular lines were smoothed out?
5. What is the significance of the red cloth around the baby?
6. Why are the natural shapes in the painting, such as the forehead of the baby, distorted? Is awareness of such distortions crucial to a response to the painting?
7. What effect does the repetition of the baby's head have on you?

Study another work, very close in temperament to Siqueiros's painting: *The Eternal City* by the American painter Peter Blume (Figure 1-3). After attending carefully to the kinds of responses awakened by *The Eternal City*, take note of some background information about the painting that you may not know. The year of this painting is the same as that of *Echo of a Scream*: 1937. *The Eternal City* is a name reserved for only one city in the world—Rome. In 1937 the world was on the verge of world war: Fascists were in power in Italy and the Nazis in Germany. In the center of the painting is the Roman Forum, close to where Julius Caesar, the alleged tyrant, was murdered by Brutus. But here we see fascist Blackshirts, the modern tyrants, beating people. In a niche at the left is a figure of Christ, and beneath him (hard to see) is a crippled beggar woman. Near her are ruins of Roman statuary. The enlarged and distorted head, wriggling out like a jack-in-the-box, is that of Mussolini, the man who invented fascism and

the Blackshirts. Study the painting closely again. Has your response to the painting changed?

PERCEPTION KEY Siqueiros and Blume

1. What common ingredients do you find in the Blume and Siqueiros paintings?
2. Is your reaction to the Blume similar to or distinct from your reaction to the Siqueiros?
3. Is the effect of the distortions similar or different?
4. How are colors used in each painting? Are the colors those of the natural world, or do they suggest an artificial environment? Are they distorted for effect?
5. With reference to the objects and events represented in each painting, do you think the paintings are comparable? If so, in what ways?
6. With the Blume, are there any natural objects in the painting that suggest the vitality of the Eternal City?

Before going on to the next painting, which is quite different in character, we should pause to make some observations about what we have done, however briefly, with the Blume. With added knowledge about its cultural and political implications—what we shall call the background of the painting—your responses to *The Eternal City* may have changed. Ideally, they should have become more focused, intense, and certain. Why? The painting is surely the same physical object you looked at originally. Nothing has changed in that object. Therefore, something has changed because something has been added to you, information that the general viewer of the painting in 1937 would have had and would have responded to more emotionally than viewers do now. Consider how a Fascist, on the one hand, or an Italian humanist and lover of Roman culture, on the other hand, would have reacted to this painting in 1937.

A full experience of this painting is not one thing or one system of things but an innumerable variety of things. Moreover, "knowledge about" a work of art can lead to "knowledge of" the work of art, which implies a richer experience. This is important as a basic principle, since it means that we can be educated about what is in a work of art, such as its shapes, objects, and **structure,** as well as what is external to a work, such as its political references. It means we can learn to respond more completely. It also means that artists such as Blume sometimes produce works that demand background information if we are to appreciate them fully. This is particularly true of art that refers to historical circumstances and personages. Sometimes we may find ourselves unable to respond successfully to a work of art because we lack the background knowledge the artist presupposes.

Picasso's *Guernica* (Figure 1-4), one of the most famous paintings of the twentieth century, is also dated 1937. Its title comes from the name of an old Spanish town that was bombed during the Spanish Civil War—the first aerial bombing of noncombatant civilians in modern warfare. Examine this painting carefully.

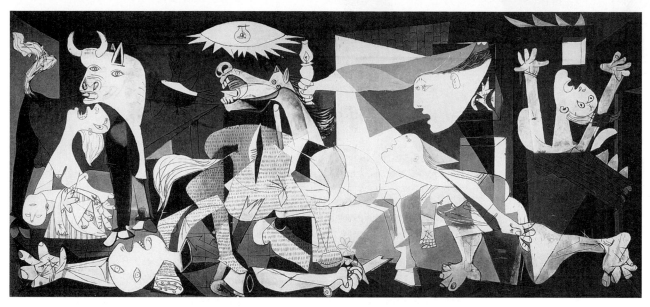

FIGURE 1-4

Pablo Picasso, *Guernica*. 1937. Oil on canvas, 11 feet 6 inches × 25 feet 8 inches.

Ordinarily, Picasso was not a political painter. During World War II he was a citizen of Spain, a neutral country. But the Spanish Civil War excited him to create one of the world's greatest modern paintings, a record of the German bombing of the small Spanish town, Guernica. When a Nazi officer saw the painting he said to Picasso, "Did you do this?" Picasso answered scornfully, "No, you did."

PERCEPTION KEY *Guernica*

1. Distortion is powerfully evident in this painting. How does its function differ from that of the distortion in Blume's or Siqueiros's paintings?
2. Describe the objects in the painting. What is their relationship to one another?
3. Why the prominence of the lightbulb?
4. There are large vertical rectangles on the left and right sides and a very large triangle in the center. Do these shapes provide a visual order to what would otherwise be sheer chaos? If so, how? As you think about this, compare one of many studies Picasso made for *Guernica* (Figure 1-5). Does the painting possess a stronger form than the study? If so, in what ways?
5. Because of reading habits in the West, we tend initially to focus on the left side of most paintings and then move to the right, especially when the work is very large. Is this the case with your perception of *Guernica*? In the organization or form of *Guernica* is there a countermovement that, once our vision has reached the right side, pulls us back to the left? If so, what shapes in the painting cause this countermovement? How do these left–right and right–left movements affect the balance of the painting? Note that the actual painting is over twenty-five feet wide.
6. The bull seems to be totally indifferent to the carnage. Do you think the bull may be a symbol? For example, could the bull represent the spirit of the Spanish people? Could the bull represent General Franco, the man who ordered the bombing? Or could the bull represent both? To answer these questions adequately, do you need further background information, or can you defend your answers by referring to what is in the painting, or do you need to use both?
7. The bombing of Guernica occurred during the day. Why did Picasso portray it as happening at night?
8. Which are more visually dominant, human beings or animals? If you were not told, would you know that this painting was a representation of an air raid?
9. Is the subject matter—what the work is about—of this painting war? Death? Suffering? Fascism? Or a combination?

9

The next painting (Figure 1-6), featured in "Experiencing: The *Mona
Lisa*," is by Leonardo da Vinci, arguably one of the greatest painters of
the Italian Renaissance. Da Vinci is a household name in part because of
this painting. Despite the lack of a political or historically relevant subject
matter, the *Mona Lisa,* with its tense pose and enigmatic expression, has
become possibly the most famous work of art in the West.

Structure and Artistic Form

The responses you have when you look at the *Mona Lisa* are probably differ-
ent from those you have when viewing the other paintings in this chapter,
but why? You might reply that the *Mona Lisa* is hypnotizing, a carefully
structured painting depending on a subtle but basic geometric form, the
triangle. Such structures, while operating subconsciously, are obvious on
analysis. Like all structural elements of the artistic form of a painting, they
affect us deeply even when we are not aware of them. We have the capac-
ity to respond to pure form even in paintings in which objects and events
are portrayed. Thus, responding to *The Eternal City* will involve respond-
ing not just to an interpretation of fascism taking hold in Italy but also
to the **sensuous** surface of the painting. This is certainly true of *Echo of
a Scream;* if you look again at that painting, you will see not only that its
sensuous surface is interesting intrinsically but also that it deepens our
response to what is represented. Because we often respond to artistic form
without being conscious that it is affecting us, it is of first importance that
the painter makes the structure interesting. Consider the contrast between
the simplicity of the structure of the *Mona Lisa* and the urgent complexity
of the structures of the Siqueiros and the Blume.

EXPERIENCING The *Mona Lisa*

1. Leonardo Da Vinci's *Mona Lisa* is one of the most famous paintings in the history of art. What, in your opinion, makes this painting noteworthy?
2. Because this painting is so familiar, it has sometimes been treated as if it were a cliché. In several cases, it has been treated with satirical scorn. Why would any artist want to make fun of this painting? Is it a cliché, or are you able to look at it as if for the first time?
3. Unlike the works of Siqueiros, Blume, and Picasso, this painting has no obvious connections to historical circumstances that might intrude on your responses to its formal qualities. How does a lack of context affect your understanding of the painting?
4. It has been pointed out that the landscape on the left and the landscape on the right are totally different. If that judgment is correct, why do you think Leonardo made such a decision? What moods do the landscapes suggest?
5. The woman portrayed may be Lisa Gherardini del Giocondo, the wife of a local businessman, and the painting has long been known in Italy as *La Gioconda*. Is it necessary to your sense of participation that we know who the sitter is, or that we know that Leonardo kept this painting with him throughout his life and took it wherever he went?

Experiencing a painting as frequently reproduced as *Mona Lisa*, which is visited by millions of people every year at the Louvre in Paris, takes most of us some special effort. Unless we study the painting as if it were new to us, we will simply see it as an icon of high culture rather than as a painting with a formal power and a lasting value. Because it is used in advertisements, on mouse pads, playing cards, jigsaw puzzles, and a host of other banal locations, we might see this as a cliché, an overworked image.

However, we are also fortunate in that we see the painting as itself, apart from any social or historical events, and in a location that is almost magical or mythical. The landscape may be unreal, fantastic, and suggestive of a world of mystical opportunity. Certainly it emphasizes mystery. Whoever this woman is, she is concentrating in an unusual fashion on the viewer, whether we imagine it is we or it is Leonardo whom she contemplates. A study of her expression reminds us that for generations the "Gioconda smile" has teased authors and critics with its mystery. Is she making an erotic suggestion in that smile, or is it a smile of self-satisfaction? Or is it a smile of tolerance, suggesting that she is just waiting for this sitting to be done? Her expression has been the most intriguing of virtually any portrait subject in any museum in the world. It is no surprise, then, that Leonardo kept this for himself, although we must wonder whether or not he was commissioned for the painting and that for some reason did not want to deliver it.

The arresting quality of the painting is in part, to be sure, because of the enigmatic expression on her face, but the form of the painting is also arresting. Leonardo

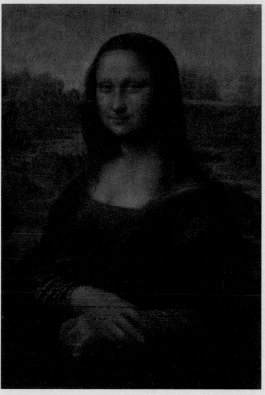

FIGURE 1-6
Leonardo da Vinci, *Mona Lisa* c. 1503–1506. Oil on panel, 30 1/4 × 21 inches. Musee du Louvre, Paris.

Leonardo's most personal picture has sometimes been hailed as a psychologically powerful painting because of the power of Mona Lisa's gaze, which virtually rivets the viewer to the spot. It is now protected under glass, and while it always has a crowd of viewers around it, its small size proportional to its reputation has sometimes disappointed viewers because it is so hard to see. And in a crowd it is impossible to contemplate.

(continued)

has posed her so that her head is the top of an isosceles triangle in which her face glows in contrast with her dark clothing. Her hands, expressive and radiant, create a strong diagonal leading to the base of the triangle. Her shoulders are turned at a significant angle so that her pose is not really comfortable, not easy to maintain for a long time—should you try to adopt the pose yourself you would see. However, her position is visually arresting because it imparts a tension to the entire painting that contributes to our response to it as a powerful object.

The most savage satirical treatment of this painting is the Dadaist Marcel Duchamp's *L.H.O.O.Q.*, (Figure 14-14). By parodying this work, Duchamp thumbed his nose at high culture in 1919, after World War I, and after the *Mona Lisa* had assumed its role as an epitome of high art. His work was an expression of disgust at the middle and upper classes that had gone so enthusiastically into a war of attrition that had brought Europe to the verge of self-destruction.

The composition of any painting can be analyzed because any painting has to be organized: Parts have to be interrelated. Moreover, it is important to think carefully about the composition of individual paintings. This is particularly true of paintings one does not respond to immediately—of "difficult" or apparently uninteresting paintings. Often the analysis of structure can help us gain access to such paintings so that they become genuinely exciting.

PERCEPTION KEY *The Eternal City*

1. Sketch the basic shapes of the painting.
2. Do these shapes relate to one another in such a way as to help reveal the obscenity of fascism? If so, how?

Artistic form is a composition or structure that makes something—a subject matter—more meaningful. The Siqueiros, Blume, and Picasso reveal something about the horrors of war and fascism. But what does the *Mona Lisa* reveal? Perhaps just the form and structure? For us, structures or forms that do not give us insight are not artistic forms. Some will argue the point. This major question will be pursued throughout the text.

Perception

We are not likely to respond sensitively to a work of art that we do not perceive properly. What is less obvious is what we referred to previously—the fact that we can often give our attention to a work of art and still not really perceive very much. The reason for this should be clear from our previous discussion. Frequently, we need to know something about the background of a work of art that would aid our perception. Anyone who did not know something about the history of Rome, or who Christ was, or what fascism was, or what Mussolini meant to the world would have a difficult time making sense of *The Eternal City*. But it is also true that anyone who could

not perceive Blume's composition might have a completely superficial response to the painting. Such a person could indeed know all about the background and understand the symbolic statements made by the painting, but that is only part of the painting. From seeing what da Vinci can do with form, structure, pose, and expression, you can understand that the formal qualities of a painting are neither accidental nor unimportant. In Blume's painting, the form focuses attention and organizes our perceptions by establishing the relationships between the parts.

Composition is basic to all the arts. To perceive any work of art adequately, we must perceive its structure. Examine the following poem—"l(a"—by e. e. cummings. It is unusual in its form and its effects.

l(a

le
af
fa

ll

s)
one
l

iness

At first this poem looks like a strange kind of code, like an Egyptian hieroglyph. But it is not a code—it is more like a Japanese haiku, a poem that sets a scene or paints a picture and then waits for us to get it. And to "get it" requires sensitive perception.

PERCEPTION KEY "l(a"

1. Study the poem carefully until you begin to make out the words. What are they?
2. One part of the poem refers to an emotion; the other describes an event. What is the relationship between them?
3. Is the shape of the poem important to the meaning of the poem?
4. Why are the words of the poem difficult to perceive? Is that difficulty important to the poem?
5. Does the poem evoke an image or images?
6. With the emphasis on letters in the poem, is the use of the lowercase for the poet's name fitting?
7. Once you have perceived the words and imagery of the poem, does your response change? Compare your analysis of the poem with ours, which follows.

In this poem a word is interrupted by parentheses: "l one l iness"—a feeling we have all experienced. Because of its isolating, biting power, we ordinarily do not like this feeling. Then, inside the parentheses, there is a phrase, "a leaf falls," the description of an event. In poetry such a description is usually called an image. In this poem the image illustrates the idea

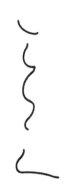

FIGURE 1-7
Diagram of e. e. cummings'
"l(a."

or theme of loneliness, melding the specific with the abstract. But how is this melding accomplished? First of all, notice the devices that symbolize or represent oneness, an emblem of loneliness. The poem begins with the letter "l," which in the typeface used in the original poem looks like the number "one." Even the parenthesis separating the "a" from the "l" helps accent the isolation of the "l." Then there is the "le," which is the singular article in French. The idea of one is doubled by repetition in the "ll" figure. Then cummings brazenly writes "one" and follows it by "l" and then the ultimate "iness." Furthermore, in the original edition the poem is number one of the collection. Also notice how these representations of oneness are wedded to the image: "a leaf falls."

As you look at the poem, your eye follows a downward path that swirls in a pattern similar to the diagram in Figure 1-7. This is merely following the parentheses and consonants. As you follow the vowels as well, you see curves that become spirals, and the image is indeed much like that of a leaf actually falling. This accounts for the long, thin look of the poem. Now, go back to the poem and reread it. Has your response changed? If so, how?

Of course, most poems do not work in quite this way. Most poems do not rely on the way they look on the page, although this is one of the most important strategies cummings uses. But what most poets are concerned with is the way the images or verbal pictures fit into the totality of the poem, how they make us experience the whole poem more intensely. In cummings' poem the single, falling, dying leaf—one out of so many—is perfect for helping us understand loneliness from a dying person's point of view. People are like leaves in that they are countless when they are alive and together. But like leaves, they die singly. And when one person separates himself or herself from the community of friends, that person is as alone as the separate leaf.

ABSTRACT IDEAS AND CONCRETE IMAGES

"l(a" presents an abstract idea fused with a concrete image or word picture. It is concrete because what is described is a physical event—a falling leaf. Loneliness, on the other hand, is abstract. Take an abstract idea: love, hate, indecision, arrogance, jealousy, ambition, justice, civil rights, prejudice, revenge, revolution, coyness, insanity, or any other. Then link it with some physical object or event that you think expresses the abstract idea. "Expresses" here means simply making us see the object as portraying—and thus helping us understand—the abstract idea. Of course, you need not follow cummings' style of splitting words and using parentheses. You may use any way of lining up the letters and words that you think is interesting.

In *Paradise Lost,* John Milton describes hell as a place with "Rocks, Caves, Lakes, Fens, Bogs, Dens, and shades of death." Now, neither you nor the poet has ever seen "shades of death," although the idea is in Psalm 23, "the valley of the shadow of death." Milton gets away with it because he has linked the abstract idea of shades of death to so many concrete images

in this single line. He is giving us images that suggest the mood of hell just as much as they describe the landscape, and we realize that he gives us so many topographic details in order to get us ready for the last detail—the abstract idea of shades of death.

There is much more to be said about poetry, of course, but on a preliminary level poetry worked in much the same way in the seventeenth-century England of Milton as it does in contemporary America. The same principles are at work: Described objects or events are used as a means of bringing abstract ideas to life. The descriptions take on a wider and deeper significance—wider in the sense that the descriptions are connected with the larger scope of abstract ideas, deeper in the sense that because of these descriptions the abstract ideas become vividly focused and more meaningful. Thus, cummings' poem gives us insight—a penetrating understanding—into what we all must face: the isolating loneliness of our death.

The following poem is highly complex: the memory of an older culture (simplicity, in this poem) and the consideration of a newer culture (complexity). It is an African poem by the contemporary Nigerian poet Gabriel Okara; and knowing that it is African, we can begin to appreciate the extreme complexity of Okara's feelings about the clash of the old and new cultures. He symbolizes the clash in terms of music, and he opposes two musical instruments: the drum and the piano. They stand respectively for the African and the European cultures. But even beyond the musical images that abound in this poem, look closely at the images of nature, the pictures of the panther and leopard, and see how Okara imagines them.

PIANO AND DRUMS

When at break of day at a riverside
I hear jungle drums telegraphing
the mystic rhythm, urgent, raw
like bleeding flesh, speaking of
primal youth and the beginning,
I see the panther ready to pounce,
the leopard snarling about to leap
and the hunters crouch with spears poised;
And my blood ripples, turns torrent,
topples the years and at once I'm
in my mother's lap a suckling;
at once I'm walking simple
paths with no innovations,
rugged, fashioned with the naked
warmth of hurrying feet and groping hearts
in green leaves and wild flowers pulsing.
Then I hear a wailing piano
solo speaking of complex ways
in tear-furrowed concerto;
of far-away lands
and new horizons with
coaxing diminuendo, counterpoint,
crescendo. But lost in the labyrinth

of its complexities, it ends in the middle
of a phrase at a daggerpoint.
And I lost in the morning mist
of an age at a riverside keep
wandering in the mystic rhythm
of jungle drums and the concerto.

PERCEPTION KEY "Piano and Drums"

1. What are the most important physical objects in the poem? What cultural significance do they have?
2. Why do you think Okara chose the drum and the piano to help reveal the clash between the two cultures? Where are his allegiances?

Such a poem speaks directly to legions of the current generation of Africans. But consider some points in light of what we have said earlier. In order to perceive the kind of emotional struggle that Okara talks about—the subject matter of the poem—we need to know something about Africa and the struggle African nations have in modernizing themselves along the lines of more technologically advanced nations. We also need to know something of the history of Africa and the fact that European nations, such as Britain in the case of Nigeria, once controlled much of Africa. Knowing these things, we know then that there is no thought of the "I" of the poem accepting the "complex ways" of the new culture without qualification. The "I" does not think of the culture of the piano as manifestly superior to the culture of the drum. That is why the labyrinth of complexities ends at a "daggerpoint." The new culture is a mixed blessing.

We have argued that the perception of a work of art is aided by background information and that sensitive perception must be aware of form, at least implicitly. But we believe there is much more to sensitive perception. Somehow the form of a work of art is an artistic form that clarifies or reveals values, and our response is intensified by our awareness of those revealed values. But how does artistic form do this? And how does this awareness come to us? In the next chapter we shall consider these questions, and in doing so, we will also raise that most important question: What is a work of art? Once we have examined each of the arts, it will be clear, we hope, that the principles developed in these opening chapters are equally applicable to all the arts.

Participate and analyze and participate again with Edward Hopper's *Early Sunday Morning* (Figure 1-8).

PERCEPTION KEY *Early Sunday Morning*

1. What is the subject matter of this painting?
2. Back up your judgment with reference to as many relevant details as possible before reading further.

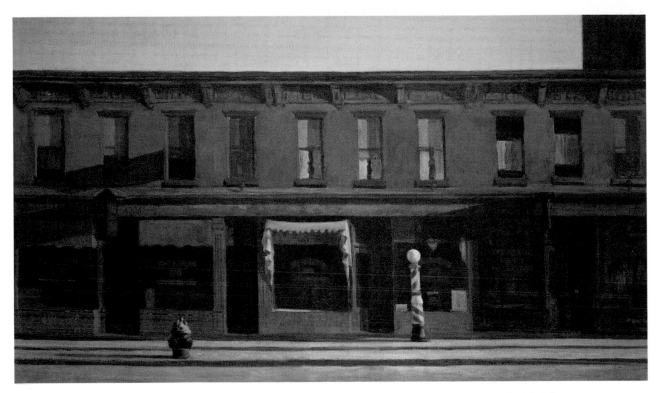

FIGURE 1-8
Edward Hopper, *Early Sunday Morning*. 1930. Oil on canvas, 35 × 60 inches.

When the Whitney Museum of American Art purchased *Early Sunday Morning* in 1930, it was their most expensive acquisition. Hopper's work, centered in New York's Greenwich Village, revealed the character of city life. His colors—vibrant, intense—and the early morning light—strong and unyielding—created indelible images of the city during the Great Depression.

On one level the subject matter is a city street scene. But on a more basic level, we think, the subject matter is loneliness. Packed human habitation is portrayed, but no human being is in sight (incidentally but noteworthy, a human figure originally placed behind one of the windows was painted out). We seem to be at the scene alone on New York's Seventh Avenue. We seem to be strangely located across the street at about the level of the second-story windows. Loneliness is usually accompanied by anxiety. And anxiety is expressed by the silent windows, especially the ominous dark storefronts, the mysterious translucent lighting, and the strange dark rectangle (what is it?) on the upper right. The street and buildings, despite their rectilinear format, seem to lean slightly downhill to the left, pushed by the shadows, especially the unexplainable weird flaglike one wrapping over the second window on the left of the second story. Even the bright barber pole is tilted to the left, the tilt accentuated by the uprightness of the door and window frames in the background and the wonderfully painted toadlike fire hydrant. These subtle oddities of the scene accent our "iness"—our separateness.

SUMMARY

Unlike scientists, humanists generally do not use strictly objective standards. The arts reveal values; other humanities study values. Artistic form refers to the structure or organization of a work of art. Values are clarified or revealed

by a work of art. Judging from the most ancient efforts to make things, we can assert that the arts represent one of the most basic of human activities. They satisfy a need to explore and express the values that link us together. By observing our responses to a work of art and examining the means by which the artist evokes those responses, we can deepen our understanding of art. Our approach to the humanities is through the arts, and our taste in art connects with our deep feelings. Yet our taste is continually improved by experience and education. Background information about a work of art and increased sensitivity to its artistic form intensify our responses.

Chapter 2

WHAT IS A WORK OF ART?

No definition for a *work of art* seems completely adequate, and none is universally accepted. We shall not propose a definition here, therefore, but rather attempt to clarify some criteria or distinctions that can help us identify works of art. Since the term "work of art" implies the concept of making in two of its words—"work" and "art" (short for "artifice")—a work of art is usually said to be something made by a person. Hence sunsets, beautiful trees, "found" natural objects such as grained driftwood, "paintings" by insects or songs by birds, and a host of other natural phenomena are not considered works of art, despite their beauty. You may not wish to accept the proposal that a work of art must be of human origin, but if you do accept it, consider the construction shown in Figure 2-1, Jim Dine's *Shovel*.

Shovel is part of a valuable collection and was first shown at an art gallery in New York City. Furthermore, Dine is considered an important American artist. However, he did not make the shovel himself. Like most shovels, the one in his construction, although designed by a person, was mass-produced. Dine mounted the shovel in front of a beautifully painted panel (obviously not evident in the photograph) and presented this construction for serious consideration. The construction is described as "mixed media," meaning it consists of several materials: paint, wood, a cord, and metal. Is *Shovel* a work of art?

We can hardly discredit the construction as a work of art simply because Dine did not make the shovel; after all, we often accept objects manufactured to specification by factories as genuine works of sculpture (see the

Calder construction, Figure 5-10). **Collages** by Picasso and Braque, which include objects such as paper and nails mounted on a panel, are generally accepted as works of art. Museums have even accepted objects such as a signed urinal by Marcel Duchamp, one of the **Dadaist** artists of the early twentieth century, which in many ways anticipated the works of Dine, Warhol, and others in the **Pop Art** movement of the 1950s and 1960s.

IDENTIFYING ART CONCEPTUALLY

Three more or less accepted criteria for determining whether something is a work of art are that (1) the object or event is made by an artist, (2) the object or event is intended to be a work of art by its maker, and (3) recognized experts agree that it is a work of art. Unfortunately, one cannot always determine whether a work meets these criteria only by perceiving it. In many cases, for instance, we may confront an object such as *Shovel* and not know whether Dine constructed the shovel, thus not satisfying the first criterion that the object be made by an artist; or whether Dine intended it to be a work of art; or whether experts agree that it is a work of art. In fact, Dine did not make this particular shovel, but because this fact cannot be established by perception, one has to be told.

FIGURE 2-1
Jim Dine, *Shovel*. 1962. Mixed media.

Using off-the-shelf products, Dine makes a statement about the possibilities of art.

> PERCEPTION KEY Identifying a Work of Art
>
> 1. Why not simply identify a work of art as what an artist makes?
> 2. If Dine actually made the shovel, would *Shovel* then unquestionably be a work of art?
> 3. Suppose Dine made the shovel, and it was absolutely perfect in the sense that it could not be readily distinguished from a mass-produced shovel. Would that kind of perfection make the piece more a work of art or less a work of art? Suppose Dine did not make the shovel but did make the panel and the box. Then would it seem easier to identify *Shovel* as a work of art?
> 4. Find people who hold opposing views about whether *Shovel* is a work of art. Ask them to argue the point in detail, being particularly careful not to argue simply from personal opinion. Ask them to point out what it is about the object itself that qualifies it for or disqualifies it from being identified as a work of art.

Identifying art conceptually seems to the authors as not very useful. Because someone intends to make a work of art tells us little. It is the *made* rather than the *making* that counts. The third criterion—the judgment of experts—is obviously important but surely debatable.

IDENTIFYING ART PERCEPTUALLY

Perception, what we can observe, and **conception,** what we know or think we know, are closely related. We often recognize an object because it conforms to our conception of it. For example, in architecture

we recognize churches and office buildings as distinct because of our conception of what churches and office buildings are supposed to look like. The ways of identifying a work of art mentioned above depend on the conceptions of the artist and experts on art and not enough on our perceptions of the work itself. Objects and events have qualities that can be perceived without the help of artists or experts, although these specialists are often helpful. If we wish to consider the artistic qualities of objects or events, we can easily do so. Yet to do so implies an attitude or an approach.

We suggest an approach here that is simple and flexible and that depends largely on perception. The distinctions of this approach will not lead us necessarily to a definition of art, but they will offer us a way to examine objects and events with reference to whether they possess artistically perceivable qualities. And, in some cases at least, it should bring us to reasonable grounds for distinguishing certain objects or events as art. We will consider four basic terms related primarily to the perceptual nature of a work of art:

Artistic form: the organization of a medium that results in clarifying some subject matter.

Participation: sustained attention and loss of self-awareness.

Content: the interpretation of subject matter.

Subject matter: some value expressed in the work of art.

Understanding any one of these terms requires an understanding of the others. Thus we will follow—please trust us—what may appear to be an illogical order: artistic form; participation; participation and artistic form; content; subject matter; subject matter and artistic form; and, finally, participation, artistic form, and content.

ARTISTIC FORM

All objects and events have form. They are bounded by limits of time and space, and they have parts with distinguishable relationships to one another. Form is the interrelationships of part to part and part to whole. To say that some object or event has form means it has some degree of perceptible unity. To say that something has ***artistic form,*** however, usually implies a strong degree of perceptible unity. It is artistic form that distinguishes a work of art from objects or events that are not works of art.

Artistic form implies that the parts we perceive—for example, line, color, texture, shape, and space in a painting—have been unified for the most profound effect possible. That effect is revelatory. Artistic form reveals, clarifies, enlightens, gives fresh meaning to something valuable in life, some subject matter. A form that lacks a significant degree of unity is unlikely to accomplish this. Our daily experiences usually are characterized more by disunity than by unity. Consider, for instance, the order

of your experiences during a typical day or even a segment of that day. Compare that order with the order most novelists give to the experiences of their characters. One impulse for reading novels is to experience the tight unity that artistic form usually imposes, a unity almost none of us comes close to achieving in our daily lives. Much the same is true of music. Noises and random tones in everyday experience lack the order that most composers impose.

Since strong, perceptible unity appears so infrequently in nature, we tend to value the perceptible unity of artistic form. Works of art differ in the power of their unity. If that power is weak, then the question arises: Is this a work of art? Consider Mondrian's *Broadway Boogie Woogie* (Figure 4-10) with reference to its artistic form. If its parts were not carefully proportioned in the overall structure of the painting, the tight balance that produces a strong unity would be lost. Mondrian was so concerned with this balance that he often measured the areas of lines and rectangles in his works to be sure they had a clear, almost mathematical, relationship to the totality. Of course, disunity or playing against expectations of unity can also be artistically useful at times. Some artists realize how strong the impulse toward unity is in those who have perceived many works of art. For some people, the contemporary attitude toward the loose organization of formal elements is something of a norm, and the highly unified work of art is thought of as old-fashioned. However, it seems that the effects achieved by a lesser degree of unity succeed only because we recognize them as departures from our well-known, highly organized forms.

Artistic form, we have suggested, is likely to involve a high degree of perceptible unity. But how do we determine what is a high degree? And if we cannot be clear about this, how can this distinction be of much help in distinguishing works of art from things that are not works of art? A very strong unity does not *necessarily* identify a work of art. That formal unity must give us insight into something important. Nevertheless, a very strong unity is usually a sign that the work may be art.

Consider the news photograph—taken on one of the main streets of Saigon in February 1968 by Eddie Adams, an Associated Press photographer—showing Brig. Gen. Nguyen Ngoc Loan, then South Vietnam's national police chief, killing a Vietcong captive (Figure 2-2). Adams stated that his picture was an accident, that his hand moved the camera reflexively as he saw the general raise the revolver. The lens of the camera was set in such a way that the background was thrown out of focus. The blurring of the background helped bring out the drama of the foreground scene. Does this photograph have a high degree of perceptible unity? Certainly the experience of the photographer is evident. Not many amateur photographers would have had enough skill to catch such a fleeting event with such stark clarity. If an amateur had accomplished this, we would be inclined to believe that it was more luck than skill. Adams's skill in catching the scene is even more evident, and he risked his life to get it. But do we admire this work the way we admire Siqueiros's *Echo of a Scream* (Figure 1-2)? Do we experience these two works in the same basic way?

FIGURE 2-2
Eddie Adams, *Execution in Saigon.* 1968. Silver halide.

Adams captured General Loan's execution of a Vietcong captive. He said later, "The general killed the Vietcong; I killed the general with my camera. Still photographs are the most powerful weapon in the world."

Compare a painting of a somewhat similar subject matter—Goya's *May 3, 1808* (Figure 2-3). Goya chose the most terrible moment, that split second before the crash of the guns. There is no doubt that the executions will go on. The desolate mountain pushing down from the left blocks escape, while from the right the firing squad relentlessly hunches forward. The soldiers' thick legs—planted wide apart and parallel—support like sturdy pillars the blind, pressing wall formed by their backs. These are men of a military machine. Their rifles, flashing in the bleak light of the ghastly lantern, thrust out as if they belonged to their bodies. It is unimaginable that any of these men would defy the command of their superiors. In the dead of night, the doomed are backed up against the mountain like animals ready for slaughter. One man flings up his arms in a gesture of utter despair—or is it defiance? The uncertainty increases the intensity of our attention. Most of the rest of the men bury their faces, while a few, with eyes staring out of their sockets, glance out at what they cannot help seeing—the sprawling dead smeared in blood.

With the photograph of the execution in Vietnam, despite its immediate and powerful attraction, it takes only a glance or two to grasp what is presented. Undivided attention, perhaps, is necessary to become aware of the significance of the event, but not sustained attention. In fact, to take careful notice of all the details—such as the patterns on the prisoner's shirt—does not add to our awareness of the significance of the photograph. If anything, our awareness will be sharper and more productive if we avoid such detailed examination.

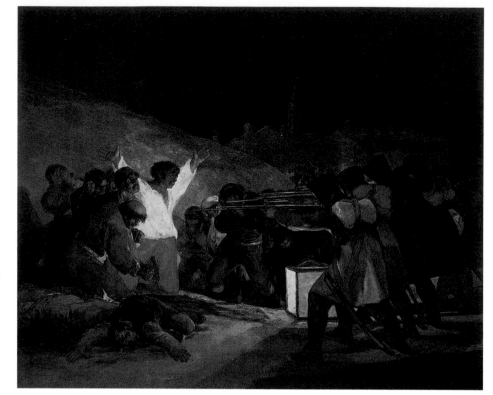

FIGURE 2-3

Francisco Goya, *May 3, 1808*. 1814–1815. Oil on canvas, 8 feet 9 inches × 13 feet 4 inches. The Prado, Madrid.

Goya's painting of Napoleonic soldiers executing Spanish guerrillas the day after the Madrid insurrection portrays the faces of the victims, but not of the killers.

Is such the case with the Goya? We believe not. Indeed, without sustained attention to the details of this work, most of what is revealed would be missed. For example, block out everything but the dark shadow at the bottom right. Note how differently that shadow appears when it is isolated. We must see the details individually and collectively, as they work together. Unless we are aware of their collaboration, we are not going to grasp fully the total form.

Close examination of the Adams photograph reveals several efforts to increase the unity and thus the power of the print. For example, the flak jacket of General Loan has been darkened so as to remove distracting details. The buildings in the background have been "dodged out" (held back in printing so that they are not fully visible). The shadows of trees on the road have been softened so as to lead the eye inexorably to the hand that holds the gun. The space around the head of the victim is also dodged out so that it appears that something like a halo surrounds the head. All this is done in the act of printing, enhancing the formal unity.

Yet we are suggesting that the Goya has a much higher degree of perceptible unity than Adams's photograph, that perhaps only the Goya has artistic form. We base these conclusions on what is given for us to perceive: the fact that the part-to-part and the part-to-whole relationships are much stronger in the Goya. Now, of course, you may disagree. No judgment about such matters is indisputable. Indeed, that is part of the fun of talking about whether something is or is not a work of art—we can learn how to perceive from one another.

PERCEPTION KEY Goya and Adams

1. Is the painting different from Adams's photograph in the way the details work together? Be specific.
2. Could any detail in the painting be changed or removed without weakening the unity of the total design? What about the photograph?
3. Does the photograph or the painting more powerfully reveal human barbarity?
4. Are there details in the photograph that distract your attention?
5. Do the buildings in the background of the photograph add to or subtract from the power of what is being portrayed? Compare the effect of the looming architecture in the painting.
6. Do the shadows on the street add anything to the significance of the photograph? Compare the shadows on the ground in the painting.
7. Does it make any significant difference that the Vietcong prisoner's shirt is checkered? Compare the white shirt on the gesturing man in the painting.
8. Is the expression on the soldier's face, along the left edge of the photograph, appropriate to the situation? Compare the facial expressions in the painting.
9. Can these works be fairly compared when one is in black and white and the other is in full color?
10. What are some basic differences between viewing a photograph of a real man being killed and a painting of such an event?

PARTICIPATION

Both the photograph and the Goya tend to grasp our attention. Initially for most of us, probably, the photograph has more pulling power than the painting, especially as the two works are illustrated here. In its setting in the Prado in Madrid, however, the great size of the Goya and its powerful lighting and color draw the eye like a magnet. But the term "participate" is more accurately descriptive of what we are likely to be doing in our experience of the painting. With the Goya, we need not only give but also sustain our undivided attention. If that happens, we lose our self-consciousness, our sense of being separate, of standing apart from the painting. We participate. And only by means of participation can we come close to a full awareness of what the painting is about.

Works of art are created, exhibited, and preserved for us to perceive with not only undivided but also sustained attention. Artists, critics, and philosophers of art (aestheticians) generally are in agreement about this. Thus, if a work requires our participation in order to understand and appreciate it fully, we have an indication that the work is art. Therefore—unless our analyses have been incorrect, and you should satisfy yourself about this—the Goya would seem to be a work of art. Conversely, the photograph is not as obviously a work of art as the painting, and this is the case despite the fascinating impact of the photograph. Yet these are highly tentative judgments. We are far from being clear about why the Goya requires our participation and the photograph may not. Until we are clear about these "whys," the grounds for these judgments remain shaky.

Goya's painting tends to draw us on until, ideally, we become aware of all the details and their interrelationships. For example, the long dark shadow at the bottom right underlines the line of the firing squad, and the line of the firing squad helps bring out the shadow. Moreover, this shadow is the darkest and most opaque part of the painting. It has a forbidding, blind, fateful quality that, in turn, reinforces the ominous appearance of the firing squad. The dark shadow on the street just below the forearm of General Loan seems less powerful. The photograph has fewer meaningful details. Thus our attempts to keep our attention on the photograph tend to be forced—which is to say that they will fail. Sustained attention or participation cannot be achieved by acts of will. The splendid singularity of what we are attending to must fascinate and control us to the point that we no longer need to will our attention. We can make up our minds to give our undivided attention to something. But if that something lacks the pulling power that grasps our attention, we cannot participate with it.

The ultimate test for recognizing a work of art, then, is how it works in us, what it does to us. ***Participative experiences*** of works of art are communions—experiences so full and fruitful that they enrich our lives. Such experiences are life-enhancing not just because of the great satisfaction they may give us at the moment but also because they make more or less permanent contributions to our future lives. Does da Vinci's *Mona Lisa* (Figure 1-6) heighten your perception of a painting's underlying structure, the power of simplicity of form, and the importance of a figure's pose? Does cummings' "l(a" (Figure 1-7) heighten your perception of falling leaves and deepen your understanding of the loneliness of death? Do you see shovels differently, perhaps, after experiencing *Shovel* by Dine (Figure 2-1)? If not, presumably they are not works of art. But this assumes that we have really participated with these works, that we have allowed them to work fully in our experience, so that if the meaning or content were present, it had a chance to reveal itself to our awareness. Of the four basic distinctions—subject matter, artistic form, content, and participation—the most fundamental is participation. We must not only understand what it means to participate but also be able to participate. Otherwise, the other basic distinctions, even if they make good theoretical sense, will not be of much practical help in making art more important in our lives. The central importance of participation requires further elaboration.

Participation involves undivided and sustained attention. However, spectator attention dominates most of our experiences. Spectator attention is more commonsensical, and it works much more efficiently than participative attention in most situations. We would not get very far changing a tire if we only participated with the tire. We would not be able to use the scientific method if we failed to distinguish between ourselves and our data. Practical success on every level requires problem solving. This requires distinguishing the means from the end and then manipulating the means to achieve the end. In so doing, we are aware of ourselves as subjects distinct from the objects involved in our situation. In turn, the habit of spectator attention gets deeply ingrained in all of us because of the demands of survival. That is

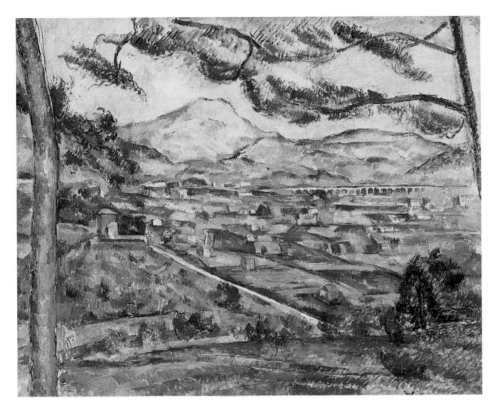

FIGURE 2-4
Paul Cézanne, *Mont Sainte-Victoire*. 1886–1887. Oil on canvas, 23½ × 28½ inches. **The Phillips Collection, Washington, D.C.**

Cézanne painted Mont **Sainte-**Victoire in Aix, France, through-out his life. Local legend **is that** the mountain was home to a god and therefore a holy **place.**

why, especially after we have left the innocence of childhood, participative attention is so rarely achieved. A child who has not yet had to solve problems, alternatively, is dominated by participative attention. In this sense, to learn how to experience works of art properly requires a return to the receptive attitudes of childhood. As children, we did not always try to dominate things but, rather, let them reveal themselves to us. Watch young children at play. Sometimes they will just push things around, but often they will let things dominate them. Then, if they are looking at flowers, for example, they will begin to follow the curves and textures with their hands, be entranced with the smell, perhaps even the taste—so absorbed that they seem to listen, as if the flowers could speak.

As participators, we do not think of the work of art with reference to categories applicable to objects—such as what kind of thing it is. We grasp the work of art directly. When, for example, we participate with Cézanne's *Mont Sainte-Victoire* (Figure 2-4), we are not making geographical or geological observations. We are not thinking of the mountain as an object. For if we did, Mont Sainte-Victoire pales into a mere instance of the appropriate scientific categories. We might judge that the mountain is a certain type. But in that process, the vivid impact of Cézanne's mountain would dim down as the focus of our attention shifted beyond in the direction of generality. This is the natural thing to do with mountains if you are a geologist. It is also the natural thing to do with this amateur photograph of the mountain (Figure 2-5).

FIGURE 2-5
John Rewald, a Cézanne expert, but amateur photographer, renders Mont Sainte-Victoire from a different angle. Note how differently Cézanne interprets the form of the mountain.

When we are participators, our thoughts are dominated so much by something that we are unaware of our separation from that something. Thus the artistic form initiates and controls thought and feeling. When we are spectators, our thoughts dominate something, and we are aware of our separation from that something. We set the object into our framework. We see the Cézanne—name it, identify its maker, classify its style, recall its background information—but this approach will not lead us into the Cézanne as a work of art. Of course, such knowledge can be very helpful. But that knowledge is most helpful when it is under the control of the work of art working in our experience. This happens when the artistic form not only suggests that knowledge but also keeps it within the boundaries of the painting. Otherwise the painting will fade away. Its splendid specificity will be sacrificed for some generality. Its content or meaning will be missed.

These are strong claims, and they may not be convincing. In any case, before concluding our search for what a work of art is, let us seek further clarification of our other basic distinctions—artistic form, content, and subject matter. Even if you disagree with the conclusions, clarification helps understanding. And understanding helps appreciation.

PARTICIPATION AND ARTISTIC FORM

The participative experience—the undivided and sustained attention to an object or event that makes us lose our sense of separation from that object or event—is induced by strong or artistic form. Participation is not likely to

develop with weak form because weak form tends to allow our attention to wander. Therefore, one indication of a strong form is the fact that participation occurs. Another indication of artistic form is the way it clearly identifies a whole or totality. In the case of the visual arts, a whole is a visual field limited by boundaries that separate that field from its surroundings.

Both Adams's photograph and Goya's painting have visual fields with boundaries. No matter what wall these two pictures are placed on, the Goya will probably stand out more distinctly and sharply from its background. This is partly because the Goya is in vibrant color and on a large scale—eight feet nine inches by thirteen feet four inches—whereas the Adams photograph is normally exhibited as an eight by ten-inch print. However carefully such a photograph is printed, it will probably include some random details. No detail in the Goya, though, fails to play a part in the total structure. To take one further instance, notice how the lines of the soldiers' sabers and their straps reinforce the ruthless forward push of the firing squad. The photograph, however, has a relatively weak form because a large number of details fail to cooperate with other details. For example, running down the right side of General Loan's body is a very erratic line. This line fails to tie in with anything else in the photograph. If this line were smoother, it would connect more closely with the lines formed by the Vietcong prisoner's body. The connection between killer and killed would be more vividly established. But as it is, and after several viewings, our eyes tend to wander off the photograph. The unity of its form is so slack that the edges of the photograph seem to blur into their surroundings. That is another way of saying that the form of the photograph fails to establish a clear-cut whole or identity.

Artistic form normally is a prerequisite if our attention is to be grasped and held. Artistic form makes our participation possible. Some philosophers of art, such as Clive Bell and Roger Fry, even go so far as to claim that the presence of artistic form—what they call "significant form"—is all that is necessary to identify a work of art. And by significant form, in the case of painting, they mean the interrelationships of elements: line to line, line to color, color to color, color to shape, shape to shape, shape to texture, and so on. The elements make up the artistic medium, the "stuff" the form organizes. According to Bell and Fry, any reference of these elements and their interrelationships to actual objects or events should be basically irrelevant in our awareness.

According to the proponents of significant form, if we take explicit notice of the executions as an important part of Goya's painting, then we are not perceiving properly. We are experiencing the painting not as a work of art but rather as an illustration telling a story, thus reducing a painting that is a work of art to the level of commercial communications. When the lines, colors, and the like pull together tightly, independently of any objects or events they may represent, there is a significant form. That is what we should perceive when we are perceiving a work of art, not a portrayal of some object or event. Anything that has significant form is a work of art. If you ignore the objects and events represented in the Goya, significant form is evident. All the details depend on one another and jell, creating a strong structure. Therefore, the Goya is a work of art. If you ignore the objects and events represented in the Adams photograph, significant form is not evident. The

organization of the parts is too loose, creating a weak structure. Therefore, the photograph, according to Bell and Fry, would not be a work of art. "To appreciate a work of art," according to Bell, "we need bring with us nothing from life, no knowledge of its ideas and affairs, no familiarity with its emotions."

Does this theory of how to identify a work of art satisfy you? Do you find that in ignoring the representation of objects and events in the Goya, much of what is important in that painting is left out? For example, does the line of the firing squad carry a forbidding quality partly because you recognize that this is a line of men in the process of killing other men? In turn, does the close relationship of that line with the line of the long shadow at the bottom right depend to some degree upon that forbidding quality? If you think so, then it follows that the artistic form of this work legitimately and relevantly refers to objects and events. Somehow artistic form, at least in some cases, has a significance that goes beyond just the design formed by elements such as lines and colors. Artistic form somehow goes beyond itself, referring to objects and events from the world beyond the form. Artistic form informs us about things outside itself. These things—as revealed by the artistic form—we shall call the "content" of a work of art. But how does the artistic form do this?

CONTENT

Let us begin to try to answer the question posed in the previous section by examining more closely the meanings of the Adams photograph and the Goya painting. Both basically, although oversimply, are about the same abstract idea—barbarity. In the case of the photograph, we have an example of this barbarity. Since it is very close to any knowledgeable American's interests, this instance is likely to set off a lengthy chain of thoughts and feelings. These thoughts and feelings, furthermore, seem to lie "beyond" the photograph. Suppose a debate developed over the meaning of this photograph. The photograph itself would play an important role primarily as a starting point. From there on, the photograph would probably be ignored except for dramatizing points. For example, one person might argue, "Remember that this occurred during the Tet offensive and innocent civilians were being killed by the Vietcong. Look again at the street and think of the consequences if the terrorists had not been eliminated." Another person might argue, "General Loan was one of the highest officials in South Vietnam's government, and he was taking the law into his own hands like a Nazi." What would be very strange in such a debate would be a discussion of every detail or even many of the details in the photograph.

In a debate about the meaning of the Goya, however, every detail and its interrelationships with other details become relevant. The meaning of the painting seems to lie "within" the painting. And yet, paradoxically, this meaning, as in the case of the Adams photograph, involves ideas and feelings that lie beyond the painting. How can this be? Let us first consider some background information. On May 2, 1808, guerrilla warfare had flared

up all over Spain against the occupying forces of the French. By the following day, Napoleon's men were completely back in control in Madrid and the surrounding area. Many of the guerrillas were executed. And, according to tradition, Goya portrayed the execution of forty-three of these guerrillas on May 3 near the hill of Principe Pio just outside Madrid. This background information is important if we are to understand and appreciate the painting fully. Yet notice how differently this information works in our experience of the painting compared with the way background information works in our experience of the Adams photograph.

The execution in Adams's photograph was of a man who had just murdered one of General Loan's best friends and had then knifed to death his wife and six children. The general was part of the Vietnamese army fighting with the assistance of the United States, and this photograph was widely disseminated with a caption describing the victim as a suspected terrorist. What shocked Americans who saw the photograph was the summary justice that Loan meted out. It was not until much later that the details of the victim's crimes were published. A century from now, the photograph may be largely ignored except by historians of the Vietnam War. If you are dubious about this, consider how quickly most of us pass over photographs of similar scenes from World War I and even World War II. The value of the Adams photograph seems to be very closely tied to its historical moment.

With the Goya, the background information, although very helpful, is not as essential. Test this for yourself. Would your interest in Adams's photograph last very long if you completely lacked background information? In the case of the Goya, the background information helps us understand the where, when, and why of the scene. But even without this information, the painting probably would still grasp and hold the attention of most of us because it would still have significant meaning. We would still have a powerful image of barbarity, and the artistic form would hold us on that image. In the Prado Museum in Madrid, Goya's painting continually draws and holds the attention of innumerable viewers, many of whom know little or nothing about the rebellion of 1808. Adams's photograph is also a powerful image, of course—and probably initially more powerful than the Goya—but the form of the photograph is not strong enough to hold most of us on that image for very long.

With the Goya, the abstract idea (barbarity) and the concrete image (the firing squad in the process of killing) are tied tightly together because the form of the painting is tight. We see the barbarity in the lines, colors, masses, shapes, groupings, and lights and shadows of the painting itself. The details of the painting keep referring to other details and to the totality. They keep holding our attention. Thus the ideas and feelings that the details and their organization awaken within us keep merging with the form. We are prevented from separating the meaning or content of the painting from its form because the form is so fascinating. The form constantly intrudes, however unobtrusively. It will not let us ignore it. We see the firing squad killing, and this evokes the idea of barbarity and the feeling of horror. But the lines, colors, mass, shapes, and shadowings of that firing squad form a pattern that keeps exciting and guiding our eyes. And then the pattern leads

us to the pattern formed by the victims. Ideas of fatefulness and feelings of pathos are evoked, but they, too, are fused with the form. The form of the Goya is like a powerful magnet that allows nothing within its range to escape its pull. Artistic form fuses or embodies its meaning with itself.

In addition to participation and artistic form, then, we have come upon another basic distinction—**content.** Unless a work has content—meaning that is fused or embodied with its form—we shall say that the work is not art. Content is the meaning of artistic form. If we are correct (for our view is by no means universally accepted), artistic form always informs—has meaning, or content. And that content, as we experience it when we participate, is always ingrained in the artistic form. We do not perceive an artistic form and then a content. We perceive them as inseparable. Of course, we can separate them analytically. But when we do so, we are not having a participative experience. Moreover, when the form is weak—that is, less than artistic—we experience the form and its meaning separately. We see the form of the Adams photograph, and it evokes powerful thoughts and feelings. But the form is not strong enough to keep its meaning fused with itself. The photograph lacks content, not because it lacks meaning but because the meaning is not merged with the form. Idea and image break apart.

> ## PERCEPTION KEY Goya and Adams Revisited
>
> We have argued that the painting by Goya is a work of art and the photograph by Adams is not. Even if the three basic distinctions we have made so far—artistic form, participation, and content—are useful, we may have misapplied them. Bring out every possible argument against the view that the painting is a work of art and the photograph is not.

SUBJECT MATTER

The content is the meaning of a work of art. The content is embedded in the artistic form. But what does the content interpret? We shall call it subject matter. Content is the interpretation—by means of an artistic form—of some subject matter. Thus **subject matter** is the fourth basic distinction that helps identify a work of art. Since every work of art must have a content, every work of art must have a subject matter, and this may be any aspect of experience that is of some human interest. Anything related to a human interest is a value. Some values are positive, such as pleasure and health. Other values are negative, such as pain and ill health. They are values because they are related to human interests. Negative values are the subject matter of both Adams's photograph and Goya's painting. But the photograph, unlike the painting, has no content. The less than artistic form of the photograph simply *presents* its subject matter. The form does not transform the subject matter, does not enrich its significance. In comparison, the artistic form of the painting enriches or interprets its subject matter, says something significant about it. In the photograph, the subject matter is

directly given. But the subject matter of the painting is not just there in the painting. It has been transformed by the form. What is directly given in the painting is the content.

The meaning, or content, of a work of art is what is revealed about a subject matter. But in that revelation you must infer or imagine the subject matter. If someone had taken a news photograph of the May 3 executions, that would be a record of Goya's subject matter. The content of the Goya is its interpretation of the barbarity of those executions. Adams's photograph lacks content because it merely shows us an example of this barbarity. That is not to disparage the photograph, for its purpose was news, not art. A similar kind of photograph—that is, one lacking artistic form—of the May 3 executions would also lack content. Now, of course, you may disagree with these conclusions for very good reasons. You may find more transformation of the subject matter in Adams's photograph than in Goya's painting. For example, you may believe that transforming the visual experience in black and white distances it from reality and intensifies content. In any case, such disagreement can help the perception of both parties, provided the debate itself is focused. It is hoped that the basic distinctions we are making—subject matter, artistic form, content, and participation—will aid that focusing.

SUBJECT MATTER AND ARTISTIC FORM

Whereas a subject matter is a value—something of importance—that we may perceive before any artistic interpretation, the content is the significantly interpreted subject matter as revealed by the artistic form. Thus the subject matter is never directly presented in a work of art, for the subject matter has been transformed by the form. Artistic form transforms and, in turn, informs about life. The conscious intentions of the artist may include magical, religious, political, economic, and other purposes; the conscious intentions may not include the purpose of clarifying values. Yet underlying the artist's activity—going back to cavework (Figure 1-1)—is always the creation of a form that illuminates something from life, some subject matter. Content is the subject matter detached by means of the form from its accidental or insignificant aspects. Artistic form makes the significance of a subject matter more manifest. Artistic form is the means whereby values are threshed from the husks of irrelevancies. A form that only entertains or distracts or shocks is not artistic (we will come back to this issue in detail in Chapter 14). Whereas nonartistic form merely presents a subject matter, artistic form makes that subject matter clearer, vivid, and understandable.

Artistic form draws from the chaotic state of life, which, as Van Gogh describes it, is like "a sketch that didn't come off"—a distillation. In our interpretation, Adams's photograph is like "a sketch that didn't come off," because it has numerous meaningless details. Goya's form eliminates meaningless detail. A work of art creates an illusion that illuminates reality. Thus such paradoxical declarations as Delacroix's are explained: "Those things

which are most real are the illusions I create in my paintings." Or Edward Weston's "The photographer who is an artist reveals the essence of what lies before the lens with such clear insight that the beholder may find the recreated image more real and comprehensible than the actual object." Camus: "If the world were clear, art would not exist." Artistic form is an economy that produces a lucidity that enables us better to understand and, in turn, manage our lives. Hence the informing of a work of art reveals a subject matter with value dimensions that go beyond the artist's idiosyncrasies and perversities. Whether or not Goya had idiosyncrasies and perversities, he did justice to his subject matter: He revealed it. The art of a period is the revelation of the collective soul of its time.

Values in everyday situations are often confused and obscured. In art, values are clarified. Art helps us perceive what we have missed. Anyone who has participated with cummings' "l(a" will see autumn leaves with heightened sensitivity and will understand the isolation of loneliness and death more poignantly. In clarifying values, art gives us an understanding that supplements the truths of science. Dostoevsky may teach us as much about ourselves as Freud. All of us require something that fascinates us for a time, something out of the routine of the practical and the theoretical. Participation with works of art is especially useful in this respect, for art transforms the routine. If a work of art "works" successfully in us, it is more than a momentary delight, for it deepens our understanding of what matters most.

PARTICIPATION, ARTISTIC FORM, AND CONTENT

Participation is the necessary condition that makes possible our insightful perception of artistic form and content. Unless we participate with the Goya, we will fail to see the power of its artistic form. We will fail to see how the details work together to form a totality. We will also fail to grasp the content fully, for artistic form and content are inseparable. Thus we will have failed to gain insight into the subject matter. We will have collected just one more instance of barbarity. The Goya will have basically the same effect upon us as Adams's photograph except that it may be less important to us because it happened long ago. But if, on the contrary, we have participated with the Goya, we probably will never see such things as executions in quite the same way again. The insight that we have gained will tend to refocus our vision so that we will see similar subject matters with heightened awareness.

Look, for example, at the photograph by Kevin Carter (Figure 2-6), which was published in the *New York Times* on March 26, 1993, and which won the Pulitzer Prize for photography in 1994. The form isolates two dramatic figures. The closest is a starving Sudanese child making her way to a feeding center. The other is a plump vulture waiting for the child to die. This powerful photograph raised a hue and cry, and the *New York Times* published a commentary explaining that Carter chased away the vulture and took the child to the feeding center. Carter committed suicide in July 1994.

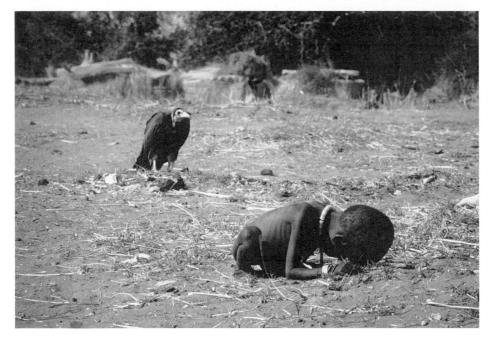

FIGURE 2-6
Kevin Carter, *Vulture and Child in Sudan*. 1993. Silver halide.

Carter saved this child, but became so depressed by the terrible tragedies he had recorded in Sudan and South Africa that he committed suicide shortly after taking this photograph.

PERCEPTION KEY Adams, Carter, and Goya

1. Does our discussion of the Adams photograph refocus your vision of Carter's photograph?
2. To what extent does Carter's photograph have artistic form? Are there as many meaningless details in the Carter as in the Adams?
3. Why are your answers to these questions fundamentally important in determining whether Adams's photograph or Carter's photograph or Goya's painting or all of them are works of art?
4. Describe your experience regarding your participation with either Adams's or Carter's photograph or Goya's painting. Can you measure the intensity of your participation with each of them? Which work do you reflect upon most when you relax and are not thinking directly on the subject of art?
5. The intensity of your reactions to the Adams and Carter photographs may well be stronger than the intensity of your experience with the Goya. If so, should that back up the assertion that the photographs are works of art?

Artistic Form: Examples

Let us examine artistic form in a series of examples taken from the work of the late Roy Lichtenstein, in which the subject matter, compared with *May 3, 1808,* is not so obviously important. With such examples, a purely formal analysis should seem less artificial. In the late 1950s and early 1960s, Lichtenstein became interested in comic strips as subject matter. The story goes that his two young boys asked him to paint a Donald Duck "straight," without the encumbrances of art. But much more was involved. Born in 1923,

Lichtenstein grew up before the invention of television. By the 1930s, the comic strip had become one of the most important of the mass media. Adventure, romance, sentimentality, and terror found expression in the stories of Tarzan, Flash Gordon, Superman, Wonder Woman, Steve Roper, Winnie Winkle, Mickey Mouse, Donald Duck, Batman and Robin, and the like. Even today, despite the competition of the soap operas on television, the comic strip remains an important mass medium.

The purpose of the comic strip for its producers is strictly commercial. And because of the large market, a premium has always been put on making the processes of production as inexpensive as possible. And so generations of mostly unknown commercial artists, going well back into the nineteenth century, developed ways of quick, cheap color printing. They developed a technique that could turn out cartoons like the products of an assembly line. Moreover, because their market included a large number of children, they developed ways of producing images that were immediately understandable and of striking impact. As the tradition evolved, it provided a common vocabulary: Both the technique and its product became increasingly standardized. The printed images became increasingly impersonal. Wonder Woman, Bugs Bunny, Donald Duck, and Batman all seemed to come from the same hand or, rather, the same machine.

Lichtenstein reports that he was attracted to the comic strip by its stark simplicity—the blatant primary colors, the ungainly black lines that encircle the shapes, the balloons that isolate the spoken words or the thoughts of the characters. He was struck by the apparent inconsistency between the strong emotions of the stories and the highly impersonal, mechanical style in which they were expressed. Despite the crudity of the comic strip, Lichtenstein saw power in the directness of the medium. Somehow the cartoons mirrored something about our selves. Lichtenstein set out to clarify what that something was. At first people laughed, as was to be expected. He was called the "worst artist in America." Today he is considered one of our best.

The accompanying examples (Figures 2-7 through 2-16) pair the original cartoon with Lichtenstein's transformation.[1] Both the comic strips and the transformations originally were in color, and Lichtenstein's paintings are much larger than the comic strips. For the purpose of analysis, however, our reproductions are presented in black and white, with the sizes equalized. The absence of color and the reduction of size all but destroy the power of Lichtenstein's work, but these changes will help us compare the structures. They will also help us concentrate upon what is usually the most obvious element of two-dimensional visual structure—line. The five pairs of examples have been scrambled so that either the comic strip or Lichtenstein's painting of it may be on the left or the right.

[1]These examples were suggested to us by an article on Lichtenstein's balloons. Albert Boime,"Roy Lichtenstein and the Comic Strip," *Art Journal*, vol. 28, no. 2 (Winter 1968–69): 155–159.

FIGURE 2-7
Pair 1a

FIGURE 2-8
Pair 1b

The exploration of popular forms of graphic art gave Pop artists of the 1960s a source of inspiration that appealed to a wide audience.

PERCEPTION KEY Comic Strips and Lichtenstein's
Transformations (Figures 2-7 through 2-16)

Decide which are the comic strips and which are Lichtenstein's transformations. Defend your decisions with reference to the strength of organization. Presumably Lichtenstein's works will possess much stronger structures than those of the commercial artists. Be as specific and detailed as possible. For example, compare the lines and shapes as they work together—more or less—in each example. Take plenty of time, for the perception of artistic form is something that must "work" in you. Such perception never comes instantaneously. Compare your judgments with those of others, and only then study our analysis.

Compare your analysis of Pair 1 with ours (Figures 2-7 and 2-8). Example *a* of Pair 1, we think, has a much stronger structure than *b*. The organization of the parts of *a* is much more tightly unified. The circles formed by the peephole and its cover in *a* have a graceful, rhythmic unity lacking in *b*. Note how in *a* the contour lines, formed by the overlapping of the cover on the right side, have a long sweeping effect. These lines look as if they had been drawn by a human hand. In *b* the analogous contours, as well as the circles to which the contours belong, look as if they had been drawn with the aid of

37

FIGURE 2-9
Pair 2a

FIGURE 2-10
Pair 2b

a compass. In *a* the circular border of the cover is broken at the right edge and by the balloon above, helping to soften the hard definiteness not only of this circle but also of the contours it forms with the circle of the peephole. In *a*, also, the man's fingers and most of his face are shadowed. These contrasts help give variety and irregularity to the peephole circle, which blends in smoothly with its surroundings compared to the abrupt insularity of the peephole in *b*. Notice, too, that in *b* a white outline goes almost completely around the cover, whereas in *a* this is avoided. Moreover, the balloon in *a* overlies a significant portion of the cover. In *b* the balloon is isolated and leaves the cover almost alone.

In *a* the line outlining the balloon as it overlies the cover repeats the contours of the overlapping cover and its peephole. Rhythm depends upon repetition, and repetition unifies. But repetition that is absolutely regular is monotonous. Try tapping a pencil with a strong beat followed by a weak beat, and continue to repeat this rhythm as exactly as you can. Against your will, and unconsciously, you may desire some variations in stress. You will do this because absolute repetition becomes boring. In *a* the repetitions of the contour formed by the peephole and its cover, as well as other repetitions, have variations. The repetitions unify, whereas the variations excite interest. There are more repetitions in *b*; but, lacking variations except of the most obvious kind, these repetitions are monotonous. For example, the size of the peephole and cover appear exactly alike. In *a*, though, sometimes the peephole appears larger and sometimes the cover. This subtle variation depends on the area on which your eyes focus. And this, in turn, is controlled by the lines and shapes in dynamic interrelationship. In *b* this kind of moving control is missing.

In *a* no part remains isolated. Thus, the balloon as it extends over the breadth of the painting helps bind the lower parts together. At the same time, the shape and contours of the balloon help accent the shape and contours of the other details. Even the shape of the man's mouth is duplicated

FIGURE 2-11
Pair 3a

Pop artist Roy Lichtenstein treats anonymous comic strip panels as if they were early sketches that need development to make them visually stronger.

FIGURE 2-12
Pair 3b

FIGURE 2-13
Pair 4a

FIGURE 2-14
Pair 4b

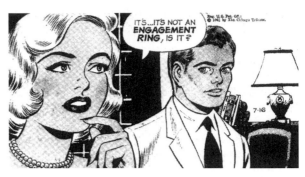

FIGURE 2-16
Pair 5b

FIGURE 2-15
Pair 5a

partially by the shape of the balloon. Conversely, the balloon in *b* is more isolated from the other details. It just hangs there. Yet notice how the tail of the balloon in *a*, just below the exclamation point, repeats the curve of the latch of the cover and also how the curve of the tail is caught up in the sweep of the curves of the peephole and cover. In *a* the latch of the cover unobtrusively helps orbit the cover around the peephole. In *b* the latch of the cover is awkwardly large, and this helps block any sense of dynamic inter-relationship between the peephole and its cover. Whereas the cover seems light and graceful in *a* and only the top of a finger is needed to turn it back, in *b* a much heavier finger is necessary. Similarly, the lines of face and hand in *a* lightly integrate, whereas in *b* they are heavy and fail to work together very well. Compare, for example, the eye in *a* with the eye in *b*. Finally, there are meaningless details in *b*—the bright knob on the cover, for instance. Such details are eliminated in *a*. Even the shape and size of the lettering in *a* belong to the whole in a way completely lacking in *b*.

Now turn to Pair 2 (Figures 2-9 and 2-10). Limit your analysis to the de-sign functioning of the lettering in the balloons of Pair 2.

> **PERCEPTION KEY** Comic Strips and Lichtenstein's
> Transformation, Pair 2
>
> 1. Does the shape of the lettering in *a* play an important part in the formal organi-zation? Explain.
> 2. Does the shape of the lettering in *b* play an important part in the formal organi-zation? Explain.

Compare your analysis of Pair 2 with ours. We think it is only in *b* that the shape of the lettering plays an important part in the formal organiza-tion. Conversely, the shape of the lettering is distracting in *a*. In *b* the bulky

balloons are eliminated and only two important words are used—"torpedo" and "LOS!" The three letters of "LOS" stand out very vividly. A regular shape among so many irregular shapes, the balloon's simple shape helps the letters stand out. Also, "LOS" is larger, darker, and more centrally located than "torpedo." Notice how no word or lettering stands out vividly in *a*. Moreover, as Albert Boime points out in his study of Lichtenstein, the shapes of the letters in "LOS" are clues to the structure of the panel:

> The "L" is mirrored in the angle formed by the captain's hand and the vertical contour of his head and in that of the periscope. The "O" is repeated in the tubing of the periscope handle and in smaller details throughout the work. The oblique "S" recurs in the highlight of the captain's hat just left of the balloon, in the contours of the hat itself, in the shadow that falls along the left side of the captain's face, in the lines around his nose and in the curvilinear tubing of the periscope. Thus the dialogue enclosed within the balloon is visually exploited in the interests of compositional structure.[2]

Now analyze Pair 3 (Figures 2-11 and 2-12), Pair 4 (Figures 2-13 and 2-14), and Pair 5 (Figures 2-15 and 2-16).

PERCEPTION KEY Comic Strips and Lichtenstein's
Transformations, Pairs 3, 4, and 5

1. Decide once again which are the comic strips and which the transformations.
2. If you have changed any of your decisions or your reasons, how do you account for these changes?

Don't be surprised if you have changed some of your decisions; perhaps your reasoning has been expanded. Other people's analyses, even when you disagree with them, will usually suggest new ways of perceiving things. In the case of good criticism, this is almost always true. The correct identifications follow, and they should help you test your perceptive abilities.

Pair 1a Lichtenstein, *I Can See the Whole Room . . . and There's Nobody in It!* 1961.

Pair 1b Panel from William Overgard's comic strip *Steve Roper*.

Pair 2a Anonymous comic book panel.

Pair 2b Lichtenstein, *Torpedo . . . Los!* 1963. Magna on canvas.

Pair 3a Anonymous comic book panel.

Pair 3b Lichtenstein, *Image Duplicator.* 1963. Magna on canvas.

Pair 4a Anonymous comic book panel.

[2]Boime, "Roy Lichtenstein and the Comic Strip."

Pair 4b Lichtenstein, *Hopeless.* 1963. Magna on canvas.

Pair 5a Lichtenstein, *The Engagement Ring.* 1961.

Pair 5b Panel from Martin Branner's comic strip *Winnie Winkle.*

If you have been mistaken, do not be discouraged. Learning how to perceive sensitively takes time. Furthermore, it is not possible to decide beyond all doubt, as with the proof that $2 + 2 = 4$, whether Lichtenstein is a creator of artistic form and the comic-strip makers are not. We think it is highly probable that this is the case. And it should be noted that the comic-strip makers generally look upon Lichtenstein's work as "strongly decorative and backward looking."

PERCEPTION KEY *I Can See the Whole Room . . . and There's Nobody in It!* (Figure 2–7)

Lichtenstein's painting (Figure 2-7) recently sold for $1.9 million. Do you consider this strong evidence that this painting is a work of art? Or is it conceivable that the art world (dealers, collectors, and critics) has been taken? If Figure 2-7 is worth $1.9 million, then how much do you think the comic strip panel, Figure 2-8, should sell for? Do you think collectors will be willing to pay a million dollars for it? If not, why not?

The examination of these examples makes it fairly evident, we believe, that Lichtenstein was a master at composing forms. But are these paintings works of art? Do these forms inform? Do they have content? If so, what are their subject matters? What is the subject matter of *Torpedo . . . Los!*? The aggressiveness of submarine commanders? Or, rather, the energy, passion, directness, and mechanical nature of comic strips? Or could the subject matter include both these questions? Perhaps there is no interpreted subject matter. Perhaps the event in the submarine is just an excuse for composing a form. Or perhaps this form is best understood and appreciated not as informing but, rather, as simply interesting and attractive. We will examine these issues in detail in Chapter 14. As you think about these questions, remember you are judging from photographs lacking color and usually greatly reduced in size.

Subject Matter and Content

While the male nude was a common subject in Western art well into the **Renaissance,** images of the female body have since predominated. The variety of treatment of the female nude is bewildering, ranging from the sexy *Playboy* centerfold cliché to the radical reordering of Duchamp's *Nude Descending a Staircase.* A number of well-known female nude studies follow (Figures 2-17 through 2-25). Consider, as you look at them, how the form of the painting interprets the female body. Does it reveal it in such a way that you have

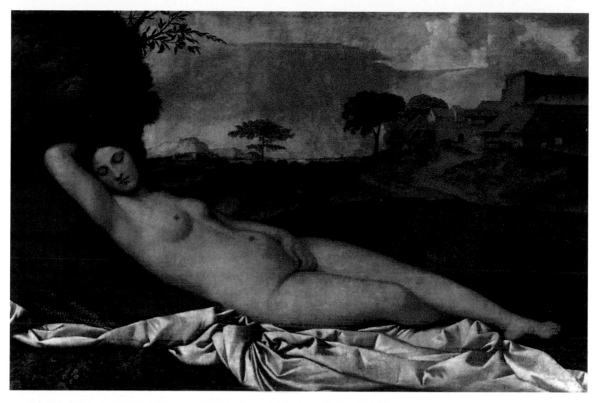

FIGURE 2-17
Giorgione, *Sleeping Venus*. 1508–1510. Oil on canvas, 43 × 69 inches. Gemaldegalerie, Dresden.

Giorgione established a Renaissance ideal in his painting of the goddess Venus asleep in the Italian countryside.

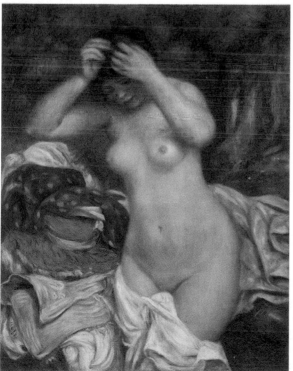

FIGURE 2-18
Pierre-Auguste Renoir, *Bather Arranging Her Hair*. 1893. Oil on canvas, 36⅜ × 29⅛ inches. National Gallery of Art, Washington, D.C., Chester Dale Collection.

Renoir's impressionist interpretation of the nude provides a late-nineteenth-century idealization of a real-life figure who is not a goddess.

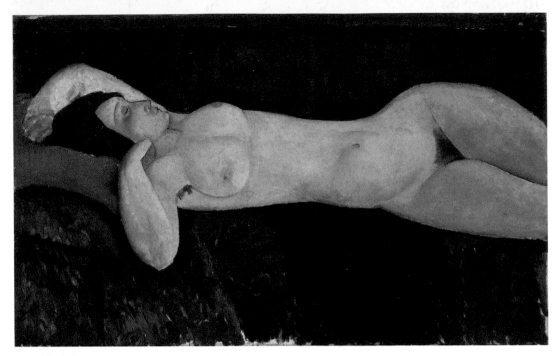

FIGURE 2-19
Amedeo Modigliani, Italian, 1884–1920, *Reclining Nude*. Circa 1919. Oil on canvas, 28½ × 45⅞ inches (72.4 × 116.5 cm). Mrs. Simon Guggenheim Fund. Museum of Modern Art, New York.

Modigliani's characteristic distortion of the figure implies yet another idealization for the early twentieth century.

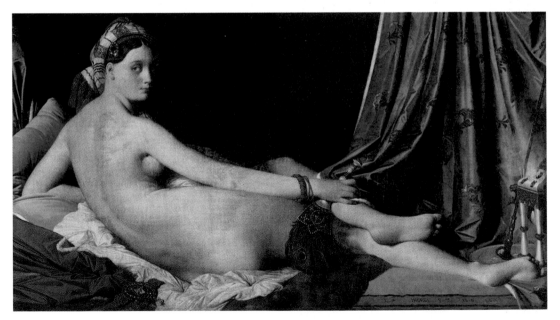

FIGURE 2-20
Jean-August-Dominique Ingres, *Large Odalisque*. 1814. Oil on canvas, 35 × 64 inches. Louvre Paris.

Ingres' *Odalisque* is a frank portrait of a prostitute idealized by the addition of three extra vertebrae, achieving a lengthened torso similar to Modigliani's.

FIGURE 2-21
Tom Wesselmann, 1931–2004, study for *Great American Nude*. 1975. Watercolor and pencil, 19½ × 54 inches. Private collection.

Wesselmann's study leaves the face blank and emphasizes the telephone as a suggestion of this nude's availability in the modern world.

FIGURE 2-22
Marcel Duchamp, *Nude Descending a Staircase*, No. 2. 1912. Oil on canvas, 58 × 35 inches. Philadelphia Museum of Art. Louise and Walter Arensberg Collection.

This painting created a riot in 1912 and made Duchamp famous as a chief proponent of the distortions of Cubism and modern art at that time.

FIGURE 2-23
Suzanne Valadon, *Reclining Nude*. 1928. Oil on canvas, 23⅝ × 30¹¹⁄₁₆ inches. Photo: Metropolitan Museum of Art, New York. Robert Lehman Collection, 1975.

Valadon interprets the nude simply, directly. To what extent is the figure idealized?

FIGURE 2-24
Alice Neel, *Margaret Evans Pregnant*. 1978. Oil on canvas, 57¾ × 38 inches. Collection, John McEnroe Gallery.

Neel's *Margaret Evans Pregnant* is one of a series of consciously anti-idealized nude portraits of pregnant women.

FIGURE 2-25
Pablo Picasso, *Nude under a Pine Tree*. 1959. Oil on canvas, 72 × 96 inches. Art Institute of Chicago. Bequest of Grant J. Pick.

Picasso painted *Nude under a Pine Tree* in a period in which he experimented with profound distortions and reorganizations of spatial forms in figures such as this.

an increased understanding of and sensitivity to the female body? In other words, does it have content? Also ask yourself whether the content is different in the two paintings by women compared with the seven by men.

Most of these paintings are highly valued—some as masterpieces—because they are powerful interpretations of their subject matter, not just presentations of the human body as in *Playboy*. Notice how different the interpretations are. Any important subject matter has many different facets. That is why shovels and soup cans have limited utility as subject matter. They have very few facets to offer for interpretation. The female nude, however, is almost limitless. The next artist interprets something about the female nude that had never been interpreted before, because the female nude seems to be inexhaustible as a subject matter, more so perhaps than the male nude.

More precisely, these paintings all have somewhat different subject matters. All are about the nude, except possibly the Duchamp, but the painting by Giorgione is about the nude as idealized, as a goddess, as Venus. Now there is a great deal that all of us could say in trying to describe Giorgione's interpretation. We see not just a nude but an idealization that presents the nude as Venus, the goddess who the Romans felt best expressed the ideal

of woman. She represents a form of beautiful perfection that humans can only strive toward. A description of the subject matter can help us perceive the content if we have missed it. In understanding what the form worked on—that is, the subject matter—our perceptive apparatus is better prepared to perceive the **form-content,** the work of art's structure and meaning.

The subject matter of Renoir's painting is the nude more as an earth mother. In the Modigliani, the subject matter is the sensual nude. In the Duchamp, it is a mechanized dissection of the female form in action. In the Wesselmann, it is the nude as exploited. In the Ingres, it is the nude as prostitute. In all nine paintings the subject matter is the female nude—but qualified in relation to what the artistic form focuses upon and makes lucid.

The two paintings by Suzanne Valadon and Alice Neel treat the female nude somewhat differently from the others, which were painted by men. Neel's painting emphasizes an aspect of femaleness that the men usually ignore—pregnancy. Her painting does not show the alluring female but the female who is beyond allure. Valadon's nude is more traditional, but a comparison with Renoir and Giorgione should demonstrate that she is far from their ideal.

PERCEPTION KEY Nine Female Nudes

1. Which of these nudes is most clearly idealized? What visual qualities contribute to that idealization?
2. Which of these nudes seem to be aware of being seen? How does their awareness affect your interpretation of the form of the nude?
3. *Nude Descending a Staircase* caused a great uproar when it was exhibited in New York in 1917. Do you feel it is still a controversial painting? How does it interpret the female nude in comparison with the other paintings in this group? Could the nude be male? Why not? Suppose the title were *Male Descending* or *Body Descending.* Isn't the sense of human movement the essential subject matter?
4. If you were not told that Suzanne Valadon and Alice Neel painted Figures 2-23 and 2-24, would you have known they were painted by women? What are the principal differences of treatment of the nude figure on the part of all these painters? Does their work surprise you?
5. Comment on the variety of these artists' treatment of the subject matter of the female nude. Which of them seems to you to most reveal positive values regarding the subject matter? Which seem to reveal negative values?

EXPERIENCING Interpretations of the Female Nude

1. Is there an obvious difference between the representation of the female nude by male painters and by female painters?
2. Does distortion of the human figure help distance the viewer from the subject?
3. To what extent does the represented figure become a potential sexual object?

Some suggestions for analysis:

First, working backwards, we can see that the question of the figure's being a sexual object is to a large extent parodied by Tom Wesselmann's Study for *Great American Nude* (Figure 2-21). The style and approach to painting is couched in careful design including familiar objects—the telephone, the rose, the perfume bottle, the sofa cushions, the partial portrait—all of which imply the boudoir and the commodification of women

and sex. The figure's face is totally anonymous, implying that this is not a painting of a woman, but of the idea of the modern American woman, with her nipple carefully exposed to accommodate advertising's breast fetish as a means of selling goods.

Even Ingres' *Large Odalisque,* (Figure 2-20), a painting whose subject is supposedly a high-class prostitute, is less a sexual object than Wesselmann's. For one thing, her body is less revealed than Wesselmann's, and her face, with its remarkable gaze obviously examining the person who observes her, suggests she is in command of herself and is not to be taken lightly. The objects in the painting are sumptuous and sensuous—rich fabrics, a gold-handled peacock feather duster, silks behind her, a jeweled belt on the divan and a jeweled headpiece, and in the lower right, a rack of what may be pipes to increase the pleasure of the evening.

Then, the question of the distortion of the subject is powerfully handled by Duchamp's *Nude Descending a Staircase, No. 2* (Figure 2-22). This painting created a near riot in 1912 because it seemed to be a contemptuous portrait of the nude at a time when the nude aesthetic was still academic in style. Duchamp was taunting the audience for art, while also finding a modern technological representation of the nude on canvas that mimed the cinema of his time. On the other hand, the more modern nude by Picasso (Figure 2-25) essentially deconstructs the human figure, moving its parts in ways that are impossible in life unless the figure were dissected on a morgue table. The question is whether Picasso simply wants us to look at the human figure from a completely new perspective, or if he is making a comment about women.

Finally, we may partly answer the question of whether women paint nude females differently by looking at Suzanne Valadon's (Figure 2-23) and Alice Neel's (Figure 2-24) paintings. Neel represents Margaret Evans in a manner emphasizing her womanness, not her sexual desirability. Hers is the only pregnant female figure—emphasizing the power of women to create life. Valadon's nude makes an effort to cover herself while looking at the viewer. She is relaxed yet apprehensive. There is no attempt at commodification of either of these figures, which means we must look at them very differently from the rest of the paintings represented here.

Further Thoughts on Artistic Form

Artistic form is an organized structure, a design, but it is also a window opening on and focusing our world, helping us to perceive and understand what is important. This is the function of artistic form. The artist uses form as a means to understanding some subject matter, and in this process, the subject matter exerts its own imperative. A subject matter has, as Edmund Husserl puts it, a "structure of determination" that to some significant degree is independent of the artist. Even when the ideas of the artist are the subject matter, they challenge and resist, forcing the artist to discover their significance by discarding irrelevancies.

Subject matter is friendly, for it assists interpretation, but subject matter is also hostile, for it resists interpretation. Otherwise there would be no fundamental stimulus or challenge to the creativity of the artist. Only subject matter with interesting latent or uninterpreted values can challenge the artist, and the artist discovers these values through form. If the maker of a work takes the line of least resistance by ignoring the challenge of the subject matter—pushing the subject matter around for entertaining or escapist effects instead of trying to uncover its significance—the maker functions as a decorator rather than an artist.

Whereas decorative form merely pleases, artistic form informs about subject matter with value dimensions that go beyond the artist's idiosyncrasies and perversities. Artistic subject matter is embedded in values that are a product of social forces that to an overwhelming extent are produced independently of the artist. By revealing those values, the artist helps us understand ourselves and our world, provided we participate, or "think from."

Thinking from is a flowing experience. One thought or image or sensation merges into another, and we don't know where we are going for certain, except that what we are thinking from is moving and controlling the flow, and clock time is irrelevant. Instead of objects being fixed points of reference, from which our "thinking at" proceeds in a succession of stops, there is no stopping when we think from, because each thing unfolds in a duration in which beginning, middle, and end meld.

Thinking from is often interrupted—someone moves in front of the painting, the telephone call breaks the reading of the poem, someone goes into a coughing fit at the concert—but as long as we keep coming back to thinking from as dominant over thinking at, we have something of the wonder of participation.

SUMMARY

A work of art is a form-content. An artistic form is a form-content. An artistic form is more than just an organization of the elements of an artistic medium, such as the lines and colors of painting. The artistic form interprets or clarifies some subject matter. The subject matter, strictly speaking, is not in a work of art. When participating with a work of art, one can only imagine the subject matter, not perceive it. The subject matter is only suggested by the work of art. The interpretation of the subject matter is the content, or meaning, of the work of art. Content is embodied in the form. The content, unlike the subject matter, is in the work of art, fused with the form. We can separate content from form only by analysis. The ultimate justification of any analysis is whether it enriches our participation with that work, whether it helps that work "work" in us. Good analysis or criticism does just that. But, conversely, any analysis not based on participation is unlikely to be very helpful. Participation is the way—the only way—of getting into direct contact with the form-content. And so any analysis that is not based upon a participative experience inevitably misses the work of art. Participation and good analysis, although necessarily occurring at different times, end up hand in hand.

In this chapter, we have elaborated one set of guidelines. Other sets are possible, of course. We have discussed one other set very briefly: that a work of art is significant form. If you can conceive of other sets of guidelines, make them explicit and try them out. The ultimate test is clear: Which set helps you most in appreciating works of art? We think the set we have proposed meets that test better than other proposals. But this is a large question indeed, and your decision should be delayed. In any event, we will now investigate the principles of criticism. These principles should help show us how to apply our set of guidelines to specific examples. Then we will be properly prepared to examine the extraordinary uniqueness of the various arts.

Chapter 3

BEING A CRITIC
OF THE ARTS

In this chapter, we are concerned with establishing the goals of responsible *criticism.* The act of responsible criticism aims for the fullest under-standing and the fullest participation possible. Being a responsible critic demands being at the height of awareness while examining a work of art in detail, establishing its context, and clarifying its achievement. It is not to be confused with popular journalism, which often sidetracks the critic into being flashy, negative, and cute. The critic aims at a full understanding of a work of art.

YOU ARE ALREADY AN ART CRITIC

Almost everyone operates as an art critic much of the time. Choosing a film or changing the television channel to look for something better implies a critical act. When turning a radio dial looking for good music, we become critics of music. The same is true when we stop to admire a building or a sculpture. What qualifies us to make such critical judgments? What training underlies our constant criticism of such arts as film, music, archi-tecture, and sculpture? Experience is one factor. We have gone to movies, listened to music on the radio, and watched television since before we can remember. We can count on a lifetime of seeing architecture, of respond-ing to the industrial design of automobiles and furniture, of seeing public

sculpture. This is no inconsiderable background, and it helps us make critical judgments without hesitation.

But even though all this is true, we realize something further. Everyone has limitations as a critic. When left to our own devices, we grow up with little specific critical training, even in a society rich in art, and find ourselves capable of going only so far. If we do nothing to increase our critical skills, they may not grow. By learning some principles about criticism and how to put them to work, we can develop our capacities as critics and, in turn, our ability to understand and enjoy.

PARTICIPATION AND THE CRITIC

One reason many of us resist our roles as critics is that we value so highly the participative experience. Criticism interferes with that participative delight. For example, most of us lose ourselves in a good film and never think about the film in an objective way. It "ruins" the experience to stop and be critical, because the act of criticism is quite different from the act of participative enjoyment. And if we were to choose which act is the most important, then, of course, we would have to stand firm behind enjoyment. Art is, above all, enjoyable. Yet the kinds of enjoyment it affords are sometimes complex and subtle. Good critics make the complexities and subtleties more understandable both to themselves and to others. In other words, by reflecting upon our participative experiences, we help deepen our next participation. Thus the critical act is—at its best—an act that is very much related to the act of participatory enjoyment. The reason is simple: A fine critical sense helps us develop the perceptions essential to understanding what's "going on" in a work of art.

Seeing a film twice, for instance, is often interesting. At first our personalities may melt away, and we become involved and lost in the experience. Competent and clever filmmakers can cause us to do this quickly and efficiently—the first time. But if the filmmaker is only competent and clever, as opposed to being creative, then the second time we see the film, its flaws are likely to be obvious and we are likely to have a less complete participatory experience. However, when we see a truly great film, the second experience is likely to be more exciting than the first. If we have become good critics and reflected wisely on our first experience, we will find that the second experience of any great work of art is likely to be more intense and our participation deeper. For one thing, our understanding of the artistic form and content is likely to be considerably more refined in our second experience and in all subsequent experiences.

Only those works of art that are successful on most or all levels can be as interesting the second time. This presumes, however, a reliable perception of the work. For example, the first experience of most works of art will not be satisfying—perhaps it will not produce the participative experience at all—if we fail to perceive the artistic form to a significant extent. Consequently, it is possible that the first experience of a difficult poem, for instance, will be less than enjoyable. If, however, we have gained helpful

information from the first experience and thus have made ourselves more sensitive to the poem, the second experience will be more satisfying.

One of the first critical questions we should ask concerns whether we actually have had a participative experience. Has the work of art taken us out of ourselves? If it is a good work of art, we should find ourselves lost in the delight of experiencing it. However, as we have been suggesting all along, if we are not so carried away by a given work, the reason may not be because it is not successful. It may be because we do not perceive all or most of what there is to perceive. We may not get it well enough for it to transport us into participation. Consequently, we have to be critical of ourselves some of the time in order to be sure we have laid the groundwork essential to participation. When we are sure that we have done as much as we can to prepare ourselves, then we are in a better position to decide whether the deficiency is in the work or in us. In the final analysis, we must have the participative experience if we are to fully comprehend a work of art.

KINDS OF CRITICISM

With our basic critical purpose clearly in mind—that is, to learn, by reflecting on works of art, how to participate with them more intensely and enjoyably—let us now analyze the practice of criticism more closely. If, as we have argued in Chapter 2, a work of art is essentially a form-content, then good criticism will sharpen our perception of the form of a work of art and thus increase our understanding of its content.

CONCEPTION KEY Kinds of Criticism

Seek out at least three examples of criticism from any available place, including, if you like, Chapters 1 and 2 of this book. Film or book reviews in newspapers or magazines or discussions of art in books may be used. Analyze these examples with reference to the following questions:

1. Does the criticism focus mainly on the form or the content?
2. Can you find any examples in which the criticism is entirely about the form?
3. Can you find any examples in which the criticism is entirely about the content?
4. Can you find any examples in which the focus is on neither the form nor the content but on evaluating the work as good or bad or better or worse than some other work?
5. Can you find any examples in which there is no evaluation?
6. Which kinds of criticism do you find most helpful—those bearing on form, content, or evaluation? Why?
7. Do you find any examples in which it is not clear whether the emphasis is on form, content, or evaluation?

This Conception Key points to three basic kinds of criticism: descriptive, which focuses on form; interpretive, which focuses on content; and evaluative, which focuses on the relative merits of a work. (Historical criticism is a fourth type, which we will cover in Chapter 16.)

FIGURE 3-1
Leonardo da Vinci, *Last Supper*. Circa 1495–1498. Oil and tempera on plaster, 15 feet 1⅛ inches × 28 feet 10½ inches. Refectory of Santa Maria delle Grazie, Milan.

Leonardo's painting was one of many on this subject, but his is the first to represent recognizably human figures with understandable facial expressions. This is the dramatic moment when Jesus tells his disciples that one of them will betray him.

Descriptive Criticism

Descriptive criticism concentrates on the form of a work of art, describing, sometimes exhaustively, the important characteristics of that form in order to improve our understanding of the part-to-part and part-to-whole inter-relationships. At first glance this kind of criticism may seem unnecessary. After all, the form is all there, completely given—all we have to do is observe. But most of us know all too well that we can spend time attending to a work we are very much interested in and yet not perceive all there is to perceive. We miss things, oftentimes things that are right there for us to observe. For example, were you immediately aware of the visual form of e. e. cummings' "l(a" (Figure 1-7)—the spiraling downward curve? Or, in Goya's *May 3, 1808* (Figure 2-3), were you immediately aware of the way the line of the long dark shadow at the bottom right underlines the line of the firing squad?

Good descriptive critics call our attention to what we otherwise might miss in an artistic form. And even more important, they help us learn how to do their work when they are not around. We can, if we carefully attend to descriptive criticism, develop and enhance our own powers of observation. That is worth thinking about. None of us can afford to have a professional critic with us at all times in order to help us perceive the art around us more fully. Descriptive criticism, more than any other type, is most likely to improve our participation with a work of art, for such criticism turns us directly to the work itself.

Study Leonardo da Vinci's *Last Supper* (Figure 3-1), damaged by repeated restorations that were usually badly done. Leonardo unfortunately experimented with dry fresco, which usually, as in this case, deteriorates rapidly. Still, even in its present condition, it can be overwhelming.

FIGURE 3-2
The *Last Supper* is geometrically arranged with the single-point vanishing perspective centered on the head of Jesus. The basic organizing form for the figures in the painting is the triangle. Leonardo aimed at geometric perfection.

PERCEPTION KEY *Last Supper*

Descriptively criticize the *Last Supper* (Figure 3-1). Point out every facet of form that seems important. Look for shapes that relate to each other, including groupings of figures. Do any shapes stand out as unique—for example, the shapes of Christ and Judas? Describe the color relationships. Describe the symmetry, if any. Describe how the lines tend to meet in the landscape behind Christ's head. The descriptions of Goya's *May 3, 1808* (Figure 2-3) might be a helpful guide.

Leonardo planned the fresco so that the perspectival vanishing point would reside in the head of Jesus, the central figure in the painting (Figure 3-2). He also used the concept of the trinity, in the number 3, as he grouped each of the disciples in threes, two groups on each side of the painting. Were you to diagram them, you would see they form the basis of triangles. The three windows in the back wall also contribute to the idea of three. The figure of Jesus is itself a perfect isosceles triangle, while the red and blue garment centers the eye. In some paintings, this kind of architectonic organization might be much too static, but because Leonardo gathers the figures in dramatic poses, with facial expressions that reveal apparent emotions, the viewer is distracted from the formal organization while being subliminally affected by its perfection. It seems that perfection—appropriate to his subject matter—was what Leonardo aimed

55

at in creating the underlying structure of the fresco. Judas, the disciple who will betray Jesus, is the fourth figure from the left, his face in shadow, pulling back in shock.

Detail, Regional, and Structural Relationships

The totality of any work of art is a continuum of parts. A small part we shall call a **detail,** a large part a **region.** Significant relationships between or among details or regions we shall call **detail** or **regional relationships,** respectively. Significant relationships between or among details or regions to the totality we shall call **structural relationships.** For example, the triangular figure of Christ, with red and blue garments, in the center of *The Last Supper* (Figure 3-1) is a dominant settling force for the eye, but it contrasts immediately with the other triangular arrangements of the apostles. This is a detail relationship. So, too, the white rectangular table cloth beneath all the figures establishes a powerful element as a visual base. In turn, that white rectangle contrasts with the receding white wall to the right of the composition. Each of the figures in the painting, with their complimentary colors of red, blue, and ochre, compete with the dominant darkness of the upper left segment of the painting. Seeing the many color garments and their natural triangular grouping is a matter of regional relationship. However, seeing the competition of triangular and rectangular shapes implies a structural relationship.

> ## PERCEPTION KEY Detail, Regional, or Structural Dominance
>
> Whether detail, regional, or structural relationships dominate—or are equal—often varies widely from work to work. Compare Mondrian's *Composition with Yellow, Blue and Red* (Figure 1-6), Picasso's *Guernica* (Figure 1-4), and Pollock's *Autumn Rhythm* (Figure 3-3). In which painting or paintings, if any, do detail relationships dominate? Regional relationships? Structural relationships?

Detail relationships dominate *Autumn Rhythm* (Figure 3-2), so much that at first sight, perhaps, no structure is apparent. The loops, splashes, skeins, and blots of color were dripped or thrown on the canvas, which was laid out flat on the floor during execution. Yet there is not as much chaotic chance as one might suppose. Most of Pollock's actions were controlled accidents, the result of his awareness, developed through long trial-and-error experience, of how the motion of his hand and body along with the weight and fluidity of the paint would determine the shape and textures of the drips and splashes as he moved around the borders of the canvas. Somehow the endless details finally add up to a self-contained sparkling totality holding the rhythms of autumn. Picasso's *Guernica,* alternatively, is more or less balanced with respect to detail, region, and structure. The detail relationships are organized into three major regions:

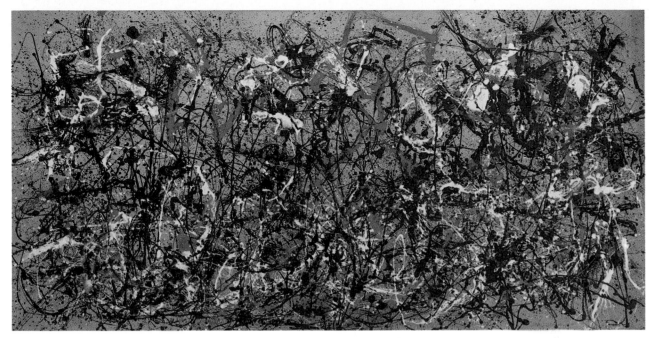

FIGURE 3-3

Jackson Pollock, *Autumn Rhythm*. 1950. Oil on canvas, 8 feet 9 inches × 17 feet 3 inches. Photo: Metropolitan Museum of Art. George A. Hearn Fund, 1957.

Pollock's *Autumn Rhythm*, one of the best examples of his drip technique, is often connected with the improvisations of the jazz music he listened to as he painted.

the great triangle—with the apex at the candle and two sides sloping down to the lower corners—and the two large rectangles, vertically oriented, running down along the left and right borders. Moreover, these regions are hierarchically ordered. The triangular region takes precedence in both size and interest, and the left rectangle, mainly because of the fascination of the impassive bull (what is he doing here?), dominates the right rectangle, even though both are about the same size. Despite the complexity of the detail relationships in *Guernica,* we gradually perceive the power of a very strong, clear structure.

Interpretive Criticism

Interpretive criticism explicates the content of a work of art. It helps us understand how form transforms subject matter into content: what has been revealed about some subject matter and how that has been accomplished. The content of any work of art will become clearer when the structure is perceived in relationship to the details and regions. The examples on the next page (Figures 3-4 and 3-5) demonstrate that the same principle holds for architecture as holds for painting. The subject matter of a building—or at least an important component of it—is usually the practical function the building serves. We have no difficulty telling which of these buildings was meant to serve as a bank and which was meant to serve as a church.

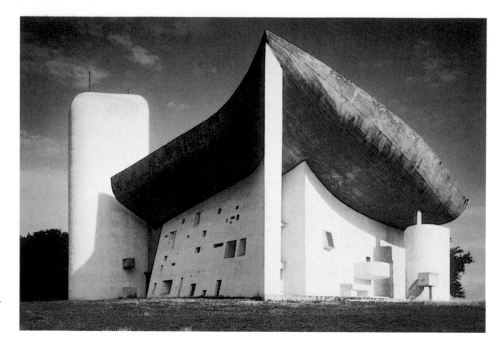

FIGURE 3-4
Le Corbusier, Notre Dame-du-Haut, Ronchamps, France. 1950–1955.

The chapel is built on a hill where a pilgrimage chapel was destroyed during the second world war. Le Corbusier used soaring lines to lift the viewer's eyes to the heavens and the surrounding horizon, visible on all four sides.

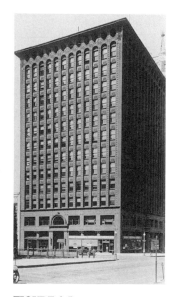

FIGURE 3-5
Louis Henry Sullivan, Guaranty (Prudential) Building, Buffalo, New York. 1894.

Sullivan's building, among the first high-rise structures, was made possible by the use of mass-produced steel girders supporting the weight of each floor.

PERCEPTION KEY Sullivan and Le Corbusier

1. Which of these structures suggests solidity? Which suggests flight and motion? What have these things got to do with the function of each building?
2. Which of these buildings places more emphasis on details?
3. Which building possesses the more varied detail?
4. The entrance to the bank is off-center. Would it have been better to have it centralized? There is no centralized entrance to the church. Good or bad?
5. Explain the content of each building.

Form–Content The interpretive critic's job is to find out as much about an artistic form as possible in order to explain its meaning. This is a particularly useful task for the critic—which is to say, for us in particular—since the forms of numerous works of art seem important but are not immediately understandable. When we look at the examples of the bank and the church, we ought to realize that the significance of these buildings is expressed by means of the *form-content*. It is true that without knowing the functions of these buildings we could appreciate them as structures without special functions, but knowing about their functions deepens our appreciation. Thus, the lofty arc of Le Corbusier's roof soars heavenward more mightily when we recognize the building as a church. The form takes us up toward heaven, at least in the sense that it moves our eyes upward. For a Christian church, such a reference is perfect. The bank, however, looks like a pile of square coins or banknotes. Certainly the form "amasses" something, an appropriate suggestion for a bank. We will not belabor these examples, since

it should be fun for you to do this kind of critical job yourself. Observe how much more you get out of these examples of architecture when you consider each form in relation to its meaning—that is, the form as form-content. Furthermore, such analyses should convince you that interpretive criticism operates in a vacuum unless it is based on descriptive criticism. Unless we perceive the form with sensitivity—and this means that we have the basis for good descriptive criticism—we simply cannot understand the content. In turn, any interpretive criticism will be useless.

Participate with a poem by William Butler Yeats:

THE LAKE ISLE OF INNISFREE

I will arise and go now, and go to Innisfree,
 And a small cabin build there, of clay and wattles made;
Nine bean rows will I have there, a hive for the honey bee,
 And live alone in the bee-loud glade.

And I shall have some peace there, for peace comes dropping slow,
 Dropping from the veils of the morning to where the cricket sings;
There midnight's all a glimmer, and noon a purple glow,
 And evening full of the linnet's wings.

I will arise and go now, for always night and day
 I hear lake water lapping with low sounds by the shore;
While I stand on the roadway, or on the pavements gray,
 I hear it in the deep heart's core.

> **PERCEPTION KEY** Yeats's Poem
>
> 1. Offer a brief description of the poem, concentrating on the nature of the rhyme-words, the contrasting imagery, the rhythms of the lines.
> 2. What does the poet say he intends to do? Do you think he will actually do it?
> 3. What does the poet mean by "the deep heart's core"?
> 4. To what extent do you sympathize with the poet's desires?

"The Lake Isle of Innisfree" is a lyric written from the first person, "I." Its three stanzas of four lines each rhyme in simple fashion with full vowel sounds, and as a result, the poem lends itself to being sung, as indeed it has often been set to music. The poet portrays himself as a simple person preferring the simple life. The critic will notice the basic formal qualities of the poem: rhyme, steady meter, the quatrain stanza structure. But the critic will also move further to talk about the imagery in the poem: the image of the simply built cabin, the small garden with bean rows, the bee hive, the sounds of the linnet's wings and the lake water lapping the shore, the look of noon's purple glow. The interpretive critic will address the entire project of the poet, who is standing "on the roadway, or on the pavements gray," longing to return to the distant country and the simple life. The poet "hears" the lake waters "in the deep heart's core," which is to say that the simple life is absolutely basic to the poet. The last three words actually repeat the same

idea. The heart is always at the core of a person, and it is always deep in that core. Such emphasis helps produce in the reader a sense of completion and significance.

Yeats later commented on this poem and said it was the first poem of his career to have a real sense of music. He also said that the imagery came to him when he was stepping off a curb near the British Museum in the heart of London and heard the sound of splashing water. The sounds immediately brought to mind the imagery of the island, which is in the west of Ireland.

It is important that we grasp the relative nature of explanations about the content of works of art. Even descriptive critics, who try to tell us about what is really there, will perceive things in a way that is relative to their own perspective. An amusing story in Cervantes' *Don Quixote* illustrates the point. Sancho Panza had two cousins who were expert wine tasters. However, on occasion, they disagreed. One found the wine excellent except for an iron taste; the other found the wine excellent except for a leather taste. When the barrel of wine was emptied, an iron key with a leather thong was found. As N. J. Berrill points out in *Man's Emerging Mind,*

> The statement you often hear that seeing is believing is one of the most misleading ones a man has ever made, for you are more likely to see what you believe than believe what you see. To see anything as it really exists is about as hard an exercise of mind and eyes as it is possible to perform.[1]

Two descriptive critics can often "see" quite different things in an artistic form. This is not only to be expected but is also desirable; it is one of the reasons great works of art keep us intrigued for centuries. But even though they may see quite different aspects when they look independently at a work of art, when they get together and talk it over, the critics will usually come to some kind of agreement about the aspects each of them sees. The work being described, after all, has verifiable, objective qualities each of us can perceive and talk about. But it has subjective qualities as well, in the sense that the qualities are observed only by "subjects."

In the case of interpretive criticism, the subjectivity and, in turn, the relativity of explanations are more obvious than in the case of descriptive criticism. The content is "there" in the form, and yet, unlike the form, it is not there in a directly perceivable way. It must be interpreted.

Interpretive critics, more than descriptive critics, must be familiar with the subject matter. Interpretive critics often make the subject matter more explicit for us at the first stage of their criticism, bringing us closer to the work. Perhaps the best way initially to get at Picasso's *Guernica* (Figure 1-4) is to discover its subject matter. Is it about a fire in a building or something else? If we are not clear about this, perception of the painting is obscured. But after the subject matter has been elucidated, good interpretive critics go much further: exploring and discovering meanings about the subject matter as revealed by the form. Now they are concerned with helping us

[1]N. J. Berrill, *Man's Emerging Mind* (New York: Dodd, Mead, 1955), p. 147.

grasp the content directly, in all of its complexities and subtleties. This final stage of interpretive criticism is, undoubtedly, the most demanding of all criticism.

Evaluative Criticism

To evaluate a work of art is to judge its merits. At first glance, this seems to suggest that *evaluative criticism* is prescriptive criticism, which prescribes what is good as if it were a medicine and tells us that this work is superior to that work.

PERCEPTION KEY Evaluative Criticism

1. Suppose you are a judge of an exhibition of painting and Figures 2-17 through 2-25 in Chapter 2 have been placed into competition. You are to award first, second, and third prizes. What would your decisions be? Why?
2. Suppose, further, that you are asked to judge which is the best work of art from the following selection: cummings' "l(a" (page 13), Cézanne's *Mont Sainte-Victoire* (Figure 2-4), and Le Corbusier's church (Figure 3-4). What would your decision be? Why?

It may be that this kind of evaluative criticism makes you uncomfortable. If so, we think your reaction is based on good instincts. In the first place, each work of art is such an individual thing that a relative merit ranking of several of them seems arbitrary. This is especially the case when the works are in different media and have different subject matters, as in the second question of the Perception Key. In the second place, it is not clear how such judging helps us in our basic critical purpose—to learn from our reflections about works of art how to participate with these works more intensely and enjoyably.

Nevertheless, evaluative criticism of some kind is generally necessary. As authors, we have been making such judgments continually in this book—in the selections for illustrations, for example. You make such judgments when, as you enter a museum, you decide to spend your time with this painting rather than that. Obviously, directors of museums must also make evaluative criticisms, because usually they cannot display every work owned by the museum. If a Van Gogh is on sale—and one of his paintings was bought recently for $82.5 million—someone has to decide its worth. Evaluative criticism, then, is always functioning, at least implicitly. Even when we are participating with a work, we are implicitly evaluating its worth. Our participation implies its worth. If it were worthless to us, we would not even attempt participation.

The problem, then, is how to use evaluative criticism as constructively as possible. How can we use such criticism to help our participation with works of art? Whether Giorgione's painting (Figure 2-17) or Modigliani's (Figure 2-19) deserves first prize seems trivial. But if almost all critics agree that Shakespeare's poetry is far superior to Edward Guest's, and if we have

been thinking Guest's poetry is better, we would probably be wise to do some reevaluating. Or if we hear a music critic whom we respect state that the music of the Beatles is worth listening to—and up to this time we have dismissed it—then we should indeed make an effort to listen. Perhaps the basic importance of evaluative criticism lies in its commendation of works that we might otherwise dismiss. This may lead us to delightful experiences. Such criticism may also make us more skeptical about our own judgments. If we think that the poetry of Edward Guest and the paintings of Norman Rockwell (see Figure 14-6) are among the very best, it may be helpful for us to know that other informed people think otherwise.

Evaluative criticism presupposes three fundamental standards: perfection, insight, and inexhaustibility. When the evaluation centers on the form, it usually values a form highly only if the detail and regional relationships are tightly organized. If they fail to cohere with the structure, the result is distracting and thus inhibits participation. An artistic form in which everything works together may be called perfect. A work may have perfect organization, however, and still be evaluated as poor unless it satisfies the standard of insight. If the form fails to inform us about some subject matter—if it just pleases or interests or excites us but doesn't make some significant difference in our lives—then, for us, that form is not artistic. Such a form may be valued below artistic form because the participation it evokes, if it evokes any at all, is not lastingly significant. Incidentally, a work lacking representation of objects and events may possess artistic form. Abstract art has a definite subject matter—the sensuous. Who is to say that the Pollock (Figure 3-3) is a lesser work of art because it informs only about the sensuous? The sensuous is with us all the time, and to be sensitive to it is exceptionally life-enhancing. Finally, works of art may differ greatly in the breadth and depth of their content. The subject matter of Pollock's *Autumn Rhythm* (Figure 3-3)—the sensuous—is not as broad as the subject of Cézanne's *Mont Sainte-Victoire* (Figure 2-4). Yet it does not follow necessarily that the Cézanne is a superior work. However, the depth of penetration into the subject matter is far deeper in the Cézanne, we believe, than in the photograph of the mountain (Figure 2-5). The stronger the content—that is, the richer the insight on the subject matter—the more intense our participation, because we have more to keep us involved in the work. Such works resist monotony, no matter how often we return to them. Such works apparently are inexhaustible, and evaluative critics usually will rate only those kinds of works as masterpieces. Notice how unimportant it is how you ultimately rank these works. But notice, also, how evaluation is inescapable.

One of the most popular and controversial art shows of recent times was *Sensation: Young British Artists,* originally viewed at the Royal Academy of Art in London in 1997. Three hundred thousand viewers went to see art that was described as shocking by a number of commentators. The show moved on to Hamburg, Germany, where it was a signal success, and then on to the Brooklyn Museum in New York in 1999, where it faced intense

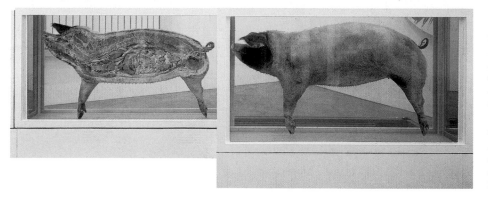

FIGURE 3-6
Damien Hirst, *This Little Piggy Went to Market, This Little Piggy Stayed at Home*. 1996. Steel, glass, pig, and formaldehyde solution. Two tanks: each tank 120 × 210 × 60 cm.

This is an example of shock art, pigs suspended in formaldehyde. Hirst's work, similar in spirit to this, has sold for millions of dollars.

negative criticism from churchmen and politicians. The museum put up a sign restricting the show to those over seventeen (the British Academy restricted it to those over eighteen).

Rudolph Giuliani, mayor of New York at the time, did not see the show but was horrified by complaints from William Donahue, president of the Catholic League, and cut off funding to the museum. He later restored it, but not until protesters accused him of censorship. Some of the complaints were aimed at Damien Hirst's animals preserved in formaldehyde, such as his two pigs in Figure 3-6. They are real pigs, and one of them is sliced in half lengthwise. But the most shocking work of art was by Chris Ofili, a young black painter whose *Holy Virgin Mary* (Figure 3-7) alarmed religious New Yorkers because elephant dung was part of the mixed media that went into the painting.

PERCEPTION KEY The *Sensation* Show

1. Musician and artist David Bowie said *Sensation* was the most important show since the 1917 New York Armory show in which Duchamp's *Nude Descending a Staircase* (Figure 2-22) created a scandal, protest, and intense controversy. Most art that was once shocking seems tame a few years later. To what extent do any of these works of art still have shock value?
2. Should politicians like the mayor of New York punish major museums for showing art that the politicians feel is offensive? Does such an act constitute a legitimate form of evaluative art criticism? Does it constitute art criticism if, like ex-mayor Giuliani, the politician has not seen and experienced the art? Would you agree that punishing museums for shows constitutes a form of censorship?
3. The *Sensation* show was described as **shock art.** Damien Hirst's use of real pigs in formaldehyde produced a shock in most audiences. Why would it have been shocking? To what extent is shock an important value in art? Would you agree with those who said Hirst's work was not art at all? What would be the basis for such a position?

(continued)

FIGURE 3-7
Chris Ofili, *Holy Virgin Mary.*
1996. Mixed media, 96 × 72
inches. Victoria-Miro Gallery,
London.

This is another example of
shock art, by Ofili, a British
artist noted for works referenc-
ing his African heritage. Audi-
ences were alarmed when they
discovered one of the media
was elephant dung, a substance
common in African art, but
not easily accepted by Western
audiences.

4. Would Chris Ofili's painting be shocking if people were unaware that he painted
some of it with elephant dung? Would people be less alarmed if they knew that
in Africa such a practice in art is relatively common? Does any of this matter in
making a judgment about the painting's success as a work of art? What matters
most for you in evaluating this painting?
5. Government officials in totalitarian states invariably censor the arts. They typi-
cally approve only of realistic, idealized portraits of the "happy life" under their
rule. What do you make of an American elected official condemning modern art,
punishing a public museum, and urging everyone to boycott the show?

The Polish Rider (Figure 3-8), featured in "Experiencing: *The Polish Rider,*"
until recently was attributed to Rembrandt. But in 1982 a group of five
scholars, members of the Rembrandt Research Project, "disattributed" the
painting. Studying subtleties such as brushwork, color transitions, trans-
parency, shadowing, and structuring, they concluded that Willem Drost,
a student of Rembrandt, was probably the artist. In the Frick Museum in
New York City, *The Polish Rider* no longer draws crowds. Another work,
presumably by Rembrandt had been expected to sell for at least $15 million.
It too was disattributed and was sold for *only* $800,000!

EXPERIENCING *The Polish Rider*

1. Does knowing *The Polish Rider* was probably painted by Willem Drost instead of Rembrandt van Rijn diminish your participation with the painting? Does the fact that it was painted by a student negatively affect your evaluation of the painting?
2. Should a work of art be evaluated completely without reference to its creator?
3. How should our critical judgment of the painting be affected by knowing it was once valued at millions of dollars and is now worth vastly less?

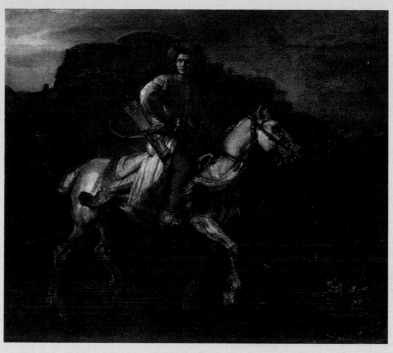

One of the authors, as a young adult, saw this painting in the Frick Museum and listened to a discussion of its merits when it was thought to be by Rembrandt. Today the painting is neglected partly because its value is thought to be less, not because it is less excellent than it was. Questions about monetary value for works of art have been intensely debated in the last three or four centuries because the modern age has produced individuals who can, like Charles Kane in the film *Citizen Kane*, amass huge collections at great expense and then, like Henry Clay Frick, create great museums when they die. Art critics do not feel a painting is better because it is worth more money. Evaluative judgments are made on the basis of observation and sometimes by comparing works of art.

One school of thought holds that paintings are to be evaluated wholly on their own merit without reference to the artist who created it. *The Polish Rider,* for instance, would still be held in great esteem if it had not been assumed to be by Rembrandt. But another school of thought holds that a painting is best evaluated when seen in the context of other paintings by the same artists, or even in the context of other paintings with similar style and subject matter.

Because in modern times artworks have sometimes been investment opportunities for wealthy people, the question of value has become a financial question even more than an aesthetic question. The result is that some works of art have been grossly overvalued by art critics who are swayed by the dollar value, not the artistic value. We believe art must be valued for its capacity to provide us with insight and to promote our participation, not for its likelihood to be worth a fortune.

4. Which school of thought do you belong to: those who evaluate a painting all by itself, or those who consider the reputation of the artist?

(continued)

5. Prices for art soared enormously beginning in the 1980s. Many artists less renowned than Rembrandt have commanded high prices. Gustave Klimt's portrait, *Adele Block-Bauer I* (Figure 3-9) was sold in 2006 for $135 million. What would seem to make this painting so valuable in terms of money? Do you feel its artistic value is great or slight?

FIGURE 3-9
Gustave Klimt, *Adele Bloch-Bauer I.* 1907. Oil and gold on canvas, 54 x 54 inches. Private collection.

This is one of two portraits Klimt did of the wife of a wealthy sugar industrialist, Adele Bloch-Bauer, the only person Klimt painted more than once. The painting took three years to complete. After World War II, it was restored to the Bloch-Bauer estate following a lengthy legal battle.

SUMMARY

Being a responsible critic demands being at the height of awareness while examining a work of art in detail, establishing its subject matter, and clarifying its achievement. There are three main types of criticism: Descriptive criticism focuses on form, interpretive criticism focuses on content, and evaluative criticism focuses on the relative merits of a work.

Good critics can help us understand works of art while also giving us the means or techniques that will help us become good critics ourselves. They can teach us about what kinds of questions to ask. Each of the following chapters on the individual arts is designed to do just that—to give some help about what kinds of questions a serious viewer should ask in order to come to a clearer perception and deeper understanding of any specific work. With the arts, unlike many other areas of human concern, the questions are often more important than the answers. The real lover of the arts will often not be the person with all the answers, but rather the one who asks the best questions. This is not because the answers are worthless but because the questions, when properly applied, lead us to a new awareness, a more exalted consciousness of what works of art have to offer. Then when we get to the last chapter, this preparation will lead to better understanding of how the arts are related to other branches of the humanities.

Chapter 4

PAINTING

YOUR VISUAL POWERS

Because painting is the preeminent visual artistic medium, we need to think about our own daily patterns of visual perception. In a busy world, we tend to pick and choose what we pay close attention to. Were we to be as intent in examining visual detail in everyday life as we are when we stand before a great painting, we would never get very far in our travels. Even if we are unusually sensitive to light, color, shape, and patterns, we cannot live our lives at the same pitch we expect from ourselves when we experience the intensity of a Goya or a Van Gogh painting. However, sensitive though we may be, daily life tends to make demands on our attention such that we block out much of the visual world in which we live and work. We often fail to observe the world around us with care. Test your visual powers for yourself by answering the questions in the Perception Key.

PERCEPTION KEY Your Visual Powers

1. What are the eye colors of your family members? Your best friends?
2. Draw the front of your house from memory. Do you account for all the windows and doors?
3. Take some green paint and some red paint, a brush, and paper. If these are not available, take anything that is at hand, such as cutouts from a magazine, crayons,

(continued)

or colored objects. Place the colors or objects together in a way that emphasizes the green. Spend enough time to study the greenness of the green. Reverse the experiment and emphasize the redness of the red.

4. With this book open, describe its cover in as much detail as you can. How does your description compare with those of your classmates?
5. Study closely a material like marble or glass or a structure like a mountain. How difficult is it for you to make yourself aware of the marbleness of the marble or the glassness of the glass or the mountainness of the mountain? How does such examination of objects alter your perception of them?
6. In Chapter 3 of this book, you saw Pollock's *Autumn Rhythm* (Figure 3-3). Without referring back to it, what do you recall as its major or dominant color? Go back and see if you are right.

If you found the results from the Perception Key surprising, or if you find it difficult to work with colors such as green and red, or if you find your memory for colors is not exceptional, you are experiencing what most people do.

Like the great majority of us, you have probably been educated away from sensitivity to the qualities of things and things as things. We have been taught how to manage and control things by thinking at them, as taught by the scientific method. This does not mean that such education is bad. Without this education, the business of the world would come to a halt. But if not supplemented, this training may blind us like some terrible disease of the eye. For help we must go to the artists, especially the painter and the sculptor—those who are most sensitive to the visual appearances of things. With their aid, our vision can be made whole again, as when we were children. Their works accomplish this, in the first place, by making things and their qualities much clearer than they usually appear. The artist purges from our sight the films of familiarity. Second, painting, with its "all-at-onceness," more than any other art, gives us the time to allow our vision to focus.

THE MEDIA OF PAINTING

Throughout this book we will be talking about the basic materials and **media** in each of the arts, because a clear understanding of their properties will aid us in understanding what artists do and how they work. The most prominent media in Western painting—and most painting in the rest of the world—are tempera, fresco, oil, watercolor, and acrylic. In early paintings, the **pigment**—the actual color—required a **binder** such as egg yolk, glue, or casein to keep it in solution and permit it to be applied to canvas, wood, plaster, and other substances.

Tempera

Tempera is pigment bound by egg yolk and applied to a carefully prepared surface like the wood panels of Cimabue's thirteenth-century *Madonna and Child Enthroned with Angels* (Figure 4-1). The colors of tempera sometimes look slightly flat and are difficult to change as the artist works, but the

FIGURE 4-1
Cimabue, *Madonna and Child Enthroned with Angels*. Circa 1285–1290. Tempera and gold on wood, 12 feet 7¾ inches × 7 feet 4 inches. Uffizi, Florence.

Cimabue's painting is typical of Italian altar pieces in the thirteenth century. The use of tempera and gold leaf creates a radiance appropriate to a religious scene.

FIGURE 4-2
Giotto, *Madonna Enthroned.*
Circa 1310. Tempera and gold
on wood, 10 feet 8³⁄₁₆ inches ×
6 feet 8⅜ inches. Uffizi,
Florence.

Giotto, credited with creating
a realistic portrayal of figures
from nature in religious art,
lavishes his *Madonna Enthroned*
with extraordinary detail per-
mitted by the use of tempera
and gold leaf. Giotto was one of
Florence's greatest painters.

marvelous precision of detail and the subtlety of linear shaping are extraor-
dinary. The purity of colors, notably in the lighter range, can be wondrous,
as with the tinted white of the inner dress of Giotto's *Madonna Enthroned*
(Figure 4-2). In the fourteenth century, Giotto achieves an astonishing level
of detail in the gold ornamentation below and around the Madonna. At the
same time, his control of the medium of tempera permitted him to repre-
sent figures with a high degree of individuality and realism, representing a
profound change in the history of art.

Fresco

Because many churches and other buildings required paintings directly
on plaster walls, artists perfected the use of *fresco,* pigment dissolved
in lime water applied to wet plaster as it is drying. In the case of wet
fresco, the color penetrates to about one-eighth of an inch and is bound

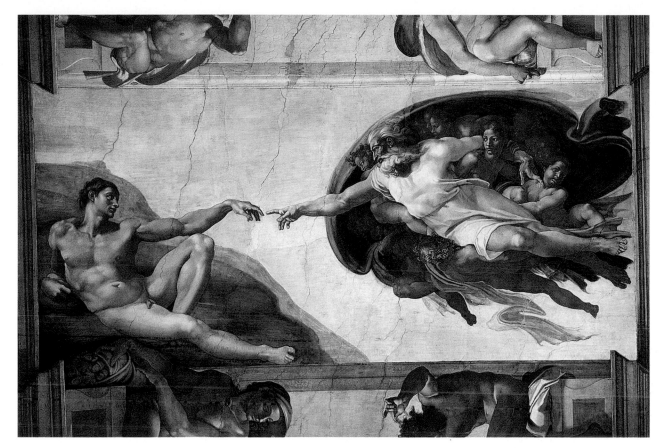

FIGURE 4-3
Michelangelo, *Creation of Adam*, detail. Circa 1508–1512. Fresco.

Michelangelo's world famous frescos in the Sistine Chapel have recently been cleaned to reveal intense, brilliant colors. This detail from the ceiling reveals the long-lasting nature of fresco painting. The period 1508–1512 marks the High Renaissance in Italy.

into the plaster. There is little room for error because the plaster dries relatively quickly, and the artist must understand how the colors will look when embedded in plaster and no longer wet. One advantage of this medium is that it will last as long as the wall itself. One of the greatest examples of the use of fresco is Michelangelo's Sistine Chapel, on the ceiling of which is the famous *Creation of Adam* (Figure 4-3).

Oil

Oil painting uses a mixture of pigment, linseed oil, varnish, and turpentine to produce either a thin or thick consistency, depending on the artist's desired effect. In the fifteenth century, oil painting dominated because of its flexibility, the richness of its colors, and the extraordinary durability and long-lasting qualities. Because oil paint dries slowly and because it can be put on in thin layers, it offers the artist remarkable control over the final product. No medium in painting offers a more flexible blending of colors or subtle portrayal of light and textures, as in Parmigianino's *The Madonna with the Long Neck* (Figure 4-4). Oil paint can be messy, and it takes sometimes months or years to dry completely, but it has been the dominant medium in easel painting since the Renaissance.

71

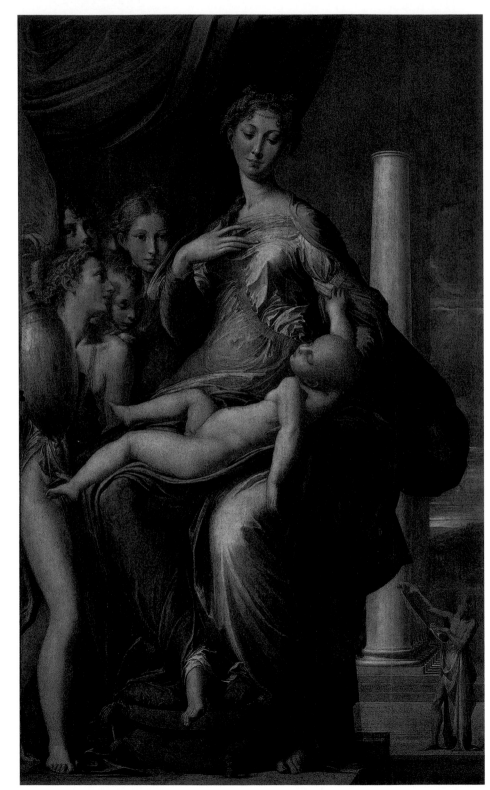

FIGURE 4-4

Parmigianino, *The Madonna with the Long Neck*. Circa 1535. Oil on panel, 85 × 52 inches. Uffizi, Florence.

Humanistic values dominate the painting, with recognizably distinct faces, young people substituting for angels, and physical distortions designed to unsettle a conservative audience. This style of oil painting, with unresolved figures and unanswered questions, is called Mannerism—painting with an attitude.

FIGURE 4-5
Winslow Homer, *Hound and Hunter*. 1892. Oil on canvas, 28¼ × 48⅛ inches. National Gallery of Art, Washington, D.C. Gift of Stephen C. Clark.

The two versions of Winslow Homer's *Hound and Hunter*, here and in Figure 4-6, help clarify the differences between the media of oil and watercolor. The permanence of oil painting is implied here because the sketch—the preparation for the painting—is not in oil, but in watercolor, which permits Homer to work fast and get the general effect he wants in the final product.

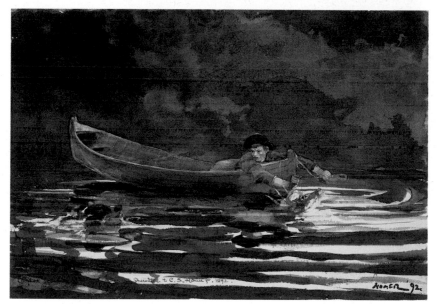

FIGURE 4-6
Winslow Homer, *Sketch for "Hound and Hunter."* 1892. Watercolor, 13¹⁵⁄₁₆ × 20 inches. National Gallery of Art, Washington, D.C. Gift of Ruth K. Henschel in memory of her husband, Charles R. Henschel.

Watercolor

The pigments of **watercolor** are bound in a water-soluble adhesive, such as gum-arabic, a gummy plant substance. Usually, watercolor is slightly translucent so that the whiteness of the paper shows through. Unlike artists working with tempera or oil painting, watercolorists work quickly, often with broad strokes and in broad washes. The color resources of the medium are limited in range, but often striking in effect. Unlike tempera, watercolor usually does not lend itself to precise detail. Compare, for example, Winslow Homer's *Hound and Hunter* (Figure 4-5) in the medium of oils with his watercolor *Sketch for Hound and Hunter* (Figure 4-6). Each version has its particular qualities, and you may find yourself responding more to one than the other.

FIGURE 4-7
Helen Frankenthaler, *The Bay*.
1963. Acrylic on canvas, 6 feet
8⅞ inches × 6 feet 9⅞ inches.
Detroit Institute of Arts, Detroit.

The painting reveals the fluid
qualities of acrylics, essentially
sensuous color permitted to
radiate through a range of
tones. Its size, almost seven feet
square, intensifies our reaction
to the shapes the colors take,
which Frankenthaler controls in
a characteristic fashion.

Acrylic

A modern synthetic medium, **acrylic** is fundamentally a form of plastic
resin that dries very quickly and is flexible for the artist to apply and use.
One advantage of acrylic paints is that they do not fade, darken, or yellow as
they age. They can support luminous colors and look sometimes very close
to oil paints in their final effect. Many modern painters use this medium.
Helen Frankenthaler's *The Bay* (Figure 4-7) is a large abstract painting whose
colors are somewhat flat, but suggest a range of intensities similar to what
we see in watercolor details.

Other Media and Mixed Media

The dominant medium for Chinese and many Asian artists has been ink,
as in Fan K'uan's *Travelers amid Mountains and Streams* (Figure 4-8). Mod-
ern painters often employ **mixed media,** using duco and aluminum paint,
house paint, oils, even grit and sand. Jackson Pollock's *Autumn Rhythm*

FIGURE 4-8
Fan K'uan, *Travelers amid Mountains and Streams*.
Eleventh century. Ink and color on silk, 81¼ ×
40¾ inches. From the collection of the Chinese National
Palace Museum, Taipei, Republic of China.

Travelers amid Mountains and Streams shows the re-
sources of ink and color on silk, typical of the great Chi-
nese nature paintings that place humans in an expanse
of grandeur that seems designed to establish the hierar-
chy of the values of nature and the values of humankind.
The media K'uan uses permit considerable detail and a
rendering of atmosphere.

(Figure 3-3) is a good example. Andy Warhol used acrylic and silk-screen ink in his famous *Marilyn Monroe* series. Some basic kinds of **prints** (the graphic arts) are woodcut, engraving, linocut, etching, drypoint, lithography, and aquatint.

PERCEPTION KEY The Media of Painting

1. Compare the detail of tempera in Giotto's *Madonna Enthroned* with the radiance of color in Parmigianino's oil painting *The Madonna with the Long Neck*. What differences do you see in the quality of detail in each painting and in the quality of the color?
2. Contrast the two versions of Winslow Homer's *Hound and Hunter*. What are the most perceptible differences between the two? To what extent do you think the differences are caused by the different media, oil paint in one version, watercolor in the other? Which version pleases you more? Which version do you feel is more appropriate for the subject matter?
3. Compare the traditional fresco of Michelangelo's *Creation of Adam* with Leonardo's experimental fresco of the *Last Supper* (Figure 3-1). To what extent does Michelangelo's use of the medium help you imagine what Leonardo's fresco would have looked like if he had used Michelangelo's technique?

ELEMENTS OF PAINTING

The **elements** are the basic building blocks of a medium. For painting they are line, color, texture, and composition.[1] Before we discuss the elements of painting, consider the issues raised by the Perception Key associated with Botticelli's painting, *Venus and Mars* (Figure 4-9).

PERCEPTION KEY *Venus and Mars*

This painting is about the struggle between the sexes, a scene after adulterous lovemaking by two mythical gods.
1. Would you know this was a power struggle if you knew nothing about the myth?
2. Mars is reduced to a snoring lump of flesh. Venus is dreamy but alert. What is the point?
3. In what way do the four little satyrs play a part in the subject matter? In the formal design? If they were taken out, would there be a significant artistic loss?
4. The lines of Venus are far more convoluted than the lines of Mars. What does this difference suggest?
5. In the power struggle between the sexes, which one appears the stronger?
6. Is there any other painting (or paintings) illustrated in the book with a more linear design?

[1]Light, shape, volume, and space are often referred to as elements, but strictly speaking, they are compounds.

Line

Line is a continuous marking made by a moving point on a surface. Line outlines shapes and can contour areas within those outlines. Sometimes contour or internal lines dominate the outlines, as with the robe of Cimabue's *Madonna* (Figure 4-1). *Closed line* most characteristically is hard and sharp, as in Mondrian's *Broadway Boogie Woogie* (Figure 4-10) and Lichtenstein's *Torpedo . . . Los!* (Figure 2-10). In the Cimabue and in Botticelli's *Venus and Mars*, the line is also closed but somewhat softer. *Open line* most characteristically is soft and blurry, as in Frankenthaler's *The Bay* (Figure 4-7) and Renoir's *Bather Arranging Her Hair* (Figure 2-18).

FIGURE 4-9
Botticelli, *Venus and Mars*. 1483. Egg tempera and oil on poplar, 27.2 × 68.3 inches.

Botticelli's painting combines media to achieve a heightened detail and radiance. In ancient myth, Venus, the goddess of love, and Mars, the god of war, are often in conflict. Botticelli portrays them here with love clearly having conquered war. The satyrs, fertility figures in myth, are playful children celebrating a victory.

PERCEPTION KEY Goya, Frankenthaler, and Cézanne

1. Goya used both closed and open line in his *May 3, 1808* (Figure 2-3). Locate these lines. Why did Goya use both kinds?
2. Does Frankenthaler use both closed and open lines in *The Bay* (Figure 4-7)? Locate these lines.
3. Identify outlines in Cézanne's *Mont Sainte-Victoire* (Figure 2-4). There seem to be no outlines drawn around the small bushes in the foreground. Yet we see these bushes as separate objects. How can this be? Discuss.

Line can suggest movement. Up-and-down movement may be indicated by the vertical, as in Mondrian's *Broadway Boogie Woogie*. Lateral movement may be indicated by the horizontal and tends to stress stability, as in the same Mondrian. Depending on the context, however, vertical and horizontal lines may appear static, as in Wesselmann's study for *Great American Nude* (Figure 2-21) and Lichtenstein's *Torpedo . . . Los!* (Figure 2-10). Generally, diagonal lines, as in Cézanne's *Mont Sainte-Victoire* (Figure 2-4), express more tension and movement than verticals and horizontals. Curving lines usually appear softer and more flowing, as in Giorgione's *Sleeping Venus* (Figure 2-17) and Modigliani's *Reclining Nude* (Figure 2-19).

FIGURE 4-10
Piet Mondrian, Dutch, 1872–1944, *Broadway Boogie Woogie*, 1942–1943. Oil on canvas, 50 × 50 inches (127 × 127 cm). Given anonymously. Museum of Modern Art, New York.

Mondrian moved from Europe to New York to avoid World War II. He loved jazz, was a good dancer, and in this work tried to project in three primary colors the jazz rhythms he heard on Broadway.

An ***axis line*** is an imaginary line that helps determine the basic visual directions of a painting. In Goya's *May 3, 1808* (Figure 2-3), for example, two powerful axis lines move toward and intersect at the white shirt of the man about to be shot: The lines of the rifles appear to converge and go on, and the line of those to be executed moving out of the ravine seems to be inexorably continuing. Axis lines are invisible vectors of visual force. Every visual field is dynamic, a field of forces directing our vision, some visible and some invisible but controlled by the visible. Only when the invisible lines are basic to the structuring of the image, as in the Goya, are they axis lines.

Since line is usually the main determinant of shapes, and shapes are usually the main determinant of detail, regional, and structural relationships, line is usually fundamental in the overall composition—Mark Rothko's *Earth Greens* (Figure 4-11) is an exception. The term "linear design" is often used to describe this organizing function.

Cézanne's small bushes are formed by small juxtaposed greenish-blue planes that vary slightly in their tinting. These planes are hatched by brushstrokes that slightly vary the textures. And from the center of the planes to

FIGURE 4-11
Mark Rothko, *Earth Greens*,
1955. Oil on canvas, 90¼ ×
73½ inches. Museum Ludwig,
Koln.

At seven and a half feet high
and six feet wide, *Earth Greens*,
has a huge physical impact on
the viewer. Many of Rothko's
similar works were commis-
sioned for public spaces such as
restaurants, but they ended up
in sanctuaries because of their
calming, spiritual effect on the
viewer.

the perimeters there is usually a shading from light to dark. Thus emerges
a strong sense of volume with density. We see those small bushes as some-
how distinct objects, and yet we see no separating outlines. Colors and
textures meet and create impressions of line. As with axis lines, the visible
suggests the invisible—we project the outlines.

On occasion, this kind of projection may occur when we think we see
outlines of trees and other objects in the natural world. We see a tree, know
it is a distinct object, and assume, of course, that it has distinct edges or out-
lines. But it may be that sometimes we imagine lines while seeing only col-
ors, shadows, and textures. Cézanne has clarified the way we sometimes see

things in the natural world. That is one reason why his paintings may strike us as so fresh and true. What Cézanne has revealed is the way we sometimes see and our ignorance about how it occurs. What we are suggesting is controversial, and you may not be seeing it that way. Try to get to a museum that has a late Cézanne landscape (after 1890), and test our analysis. But above all, participate. You may come out with a wonderful new lens in your eyes.

In the Asian tradition, the expressive power of line is achieved generally in a very different way from the Western tradition. The stroke—made by flexible brushes of varying sizes and hairs—is intended to communicate the spirit and feelings of the artist, directly and spontaneously. The sensitivity of the inked brush—especially on silk—is extraordinary. The ink offers a wide range of nuances: texture, shine, depth, pallor, thickness, and wetness. The silk has an immediate absorbent quality; the lightest touch of the brush and the slightest drop of ink registers at once, indelibly. The brush functions like a seismograph of the painter's mind.

> PERCEPTION KEY Fan K'uan
>
> Examine with a magnifying glass the brushstrokes in *Travelers amid Mountains and Streams* (Figure 4-8).
> 1. What different kinds of brushstrokes can you identify?
> 2. Why such a variety?

On the higher ranges of the mountain, broad, translucent strokes were made with wide brushes. Tiny brushes were used for dottings representing vegetation. The sheared rocks in the lower left foreground were produced by chopping brushstrokes, the so-called ax-cut. The vegetation, especially the leaves of trees in the lower half, was produced by pointed strokes using brushes somewhat larger than those used for the dottings in the upper half. The tree trunks are smoothly brushed. The lines of the waterfall are exquisite, absolutely unchangeable. The water of the pool bounces with very light foam, line disappearing. Tiny but continuing brushstrokes barely outline the two travelers. In the Western tradition, the brushstroke usually is not as emphasized. For the most part, until the late nineteenth century, the brushstroke is smoothed over. Then we have extraordinary examples of brushwork such as Van Gogh's *The Starry Night* (see Figure 15-4), which helps express frenetic disturbance.

Color

Color is composed of three distinct qualities: hue, saturation, and value. **Hue** is simply the name of a color. Red, yellow, and blue are the ***primary colors.*** Their mixtures produce the ***secondary colors:*** green, orange, and purple. Further mixing produces six more, the ***tertiary colors.*** Thus the spectrum of the color wheel shows twelve hues. **Saturation** refers to the purity, vividness, or intensity of a hue. When we speak of the "redness of red," we mean its highest

saturation. *Value,* or shading, refers to the lightness or darkness of a hue, the mixture in the hue of white or black. A high value of a color is obtained by mixing in white, and a low value is obtained by mixing in black. The highest value of red shows red at its lightest; the lowest value of red shows red at its darkest. *Complementary colors* are opposite each other on the color wheel—for example, red and green, orange and blue. When two complements are equally mixed, a neutral gray appears. An addition of a complement to a hue will lower its saturation. A red will look less red—will have less intensity—by even a small addition of green. And an addition of either white or black will change both the value and the saturation of the hue.

Texture

Texture is the surface "feel" of something. When the brushstrokes have been smoothed out, the surface is seen as smooth, as in Wesselmann's *Great American Nude* (Figure 2-21) or Modigliani's *Reclining Nude* (Figure 2-19). When the brushstrokes have been left rough, the surface is seen as rough, as in Van Gogh's *The Starry Night* (see Figure 15-4) and Pollock's *Autumn Rhythm* (Figure 3-3). In these two examples, the textures are real, for if—heaven forbid!—you were to run your fingers over these paintings, you would feel them as rough. Yet the surface of paintings that would be smooth to touch can render simulated textures that are rough.

Distinctive brushstrokes produce distinctive textures. Compare, for example, the soft hatchings of Valadon's *Reclining Nude* (Figure 2-23) with the grainy effect of most of the brushstrokes in Fan K'uan's painting (Figure 4-8). Sometimes the textural effect can be so dominant that the specific substance behind the textures is disguised, as in the background behind the head and shoulders of Renoir's *Bather Arranging Her Hair* (Figure 2-18).

PERCEPTION KEY Texture

1. In what ways are the renditions of textures an important part in the portrayal of the nine nudes (Figures 2-17 to 2-25)?
2. Suppose the ultra-smooth surfaces of Wesselmann's nude had been used by Neel. How would this have significantly changed the content of her picture?
3. In Pollock's *Autumn Rhythm*, the impasto (the protruding paint) lies noticeably on top of a smoothly textured brownish background. Suppose there were no impasto. Would this have made a significant difference? If so, why?

Neel's nude would be greatly altered, we believe, if she had used textures such as Wesselmann's. A tender, vulnerable, motherly appearance would become harsh, confident, and brazen. With the Pollock, the title brings autumn to mind; and, in turn, the laying on and drippings of heavy paint suggest vivid chaotic swirling rhythms of rain and wind-blown debris.

The medium of a painting may have much to do with textural effects. Tempera usually has a dry feel. Watercolor naturally lends itself to a fluid

feel. Because they can be built up in heavy layers, oil and acrylic are useful for depicting rough textures, but of course they can be made smooth. Fresco usually has a grainy crystalline texture.

Composition

In painting or any other art, **composition** refers to the ordering of relationships: among details, among regions, among details and regions, and among these and the total structure. Deliberately or more usually instinctively, artists use organizing principles to create forms that inform. Techniques are the ways artists go about applying the principles of composition.

Principles Among the basic principles of traditional painting are balance, gradation, movement and rhythm, proportion, variety, and unity. We will be discussing most of these principles in terms of the other arts as well, especially when offering descriptive criticism. The discussion that follows, however, is restricted to painting.

- *Balance* refers to the equilibrium of opposing visual forces. Leonardo's *Last Supper* is an example of symmetrical balance. Details and regions are arranged on either side of a central axis. Goya's *May 3, 1808* (Figure 2-3) is an example of asymmetrical balance, for there is no central axis.
- *Gradation* refers to a continuum of changes in the details and regions, such as the gradual variations in shape, color value, and shadowing in Siqueiros's *Echo of a Scream* (Figure 1-2).
- *Movement and rhythm* refers to the way a painting controls the movement and pace of our vision. For example, the pulsing rhythm of Mondrian's *Broadway Boogie Woogie* (Figure 4-10) is particularly interesting. Note how the reds have a loud beat compared to the softer beat of the blues. Visual rhythm depends on the repetition, however varied, of details as well as regions.
- *Proportion* refers to the emphasis achieved by the scaling of sizes of shapes—for example, the way the large Madonna in the Cimabue (Figure 4-1) contrasts with the tiny prophets.
- *Unity* refers to the togetherness, despite contrasts, of details and regions to the whole, as in Picasso's *Guernica* (Figure 1-4).
- *Variety* refers to the contrasts of details and regions—for example, the color and shape oppositions in O'Keeffe's *Ghost Ranch Cliffs* (Figure 4-12).

PERCEPTION KEY Principles of Composition

After defining each principle briefly, we listed an example. Go through the color photographs of paintings in the book, and select another example for each principle.

FIGURE 4-12
Georgia O'Keeffe, *Ghost Ranch Cliffs*. 1940–1942. Oil on canvas, 16 × 36 inches. Private collection.

O'Keeffe found the American West to be a refreshing environment after living for years in New York. *Ghost Ranch* is the name of her home in Abiquiu, New Mexico, where she painted landscapes such as this.

Techniques Techniques are the way painters go about applying the principles of composition. Most techniques, as with principles, usually are used instinctively. It is unlikely that a painter, except perhaps a beginner, refers to a color wheel or brings to mind explicitly a principle of composition. But for many of us, an awareness of some of the techniques can make us more sensitive to how a painting is formed. Unless we participate with the artistic form, we miss the content. Probably the most important and interesting techniques of painting have to do with the handling of space and shapes.

Space and Shapes Perhaps the best way to understand *space* is to think of it as a hollow volume available for occupation by *shapes.* Then that space can be described by referring to the distribution and relationships of those shapes in that space; for example, space can be described as crowded or open.

Shapes in painting are areas with distinguishable boundaries, created by colors, textures, and usually—and especially—lines. A painting is a two-dimensional surface with breadth and height. But three-dimensional simulation, even in the flattest of paintings, is almost always present, even in Mondrian's *Broadway Boogie Woogie* (Figure 4-10). Colors when juxtaposed invariably move forward or backward visually. And when shapes suggest mass—three-dimensional solids—depth is inevitably seen.

The illusion of depth—*perspective*—can be made by various techniques, including

- Overlapping of shapes (Wesselmann, Figure 2-21)
- Making distant shapes smaller, darker, and less detailed (Siqueiros, Figure 1-2)
- Placing distant shapes higher (Goya, Figure 2-3)

83

- Moving from higher to lower saturation (Pollock, Figure 3-3)
- Moving from lighter to heavier textures (Cézanne, Figure 2-4)
- Shading from light to dark (Giorgione, Figure 2-17)
- Using less saturated and cooler hues in the distance (Rothko, Figure 4-11)
- Slanting lines inward—*linear perspective*—illustrated by the phenomenon of standing on railroad tracks and watching the two rails apparently meet in the distance.

PERCEPTION KEY Composition

Choose four paintings not discussed so far and answer the following questions:
1. In which does color dominate line, or line dominate color?
2. Which painting has the most balanced space?
3. Which painting is most symmetrical? Which most asymmetrical?
4. Which pleases your eye more: symmetry or asymmetry?
5. In which painting is the sense of depth perspective the strongest? How does the artist achieve this depth?
6. Which painting most controls the movement of your eye along set paths?
7. In which painting is proportion most important?
8. Which painting pleases you the most? Explain how its composition pleases you.

THE CLARITY OF PAINTING

Examine again the photograph of Mont Sainte-Victoire (Figure 2-5). The photograph was taken many years after Cézanne was there, but, aside from a few more buildings and older trees, the scene of the photograph shows essentially what Cézanne saw. Compare the painting with the photograph. The painting does not reproduce the visible; rather it makes it more visible.

PERCEPTION KEY Mont Sainte-Victoire

1. Why did Cézanne put the two trees in the foreground at the left and right edges? Why did he have them cut off by the frame? Why did he portray the trees as if trembling?
2. In the photograph, there is an abrupt gap between the foreground and the middle distance. In the painting, this gap is filled in. Why?
3. In the painting, the viaduct has been moved over to the left. Why?
4. In the painting, the lines of the viaduct appear to move toward the left. Why?
5. Furthermore, the lines of the viaduct lead (with the help of an axis line) to a meeting point with the long road that runs (also with the help of an axis line) toward the left side of the mountain. The fields and buildings within that triangle all seem drawn toward that unseen apex. Why did Cézanne organize this middle ground more geometrically than the foreground or the mountain? And why is the apex of the triangle the unifying area for that region?
6. Why is the peak of the mountain in the painting given a slightly concave shape?
7. In the painting, the ridge of the mountain above the viaduct is brought into much closer proximity to the peak of the mountain. Why?
8. In the painting, the lines, ridges, and shapes of the mountain are much more tightly organized than in the photograph. How is this accomplished?

The subject matter of Cézanne's painting is surely the mountain. Suppose the title of the painting were *Trees*. This would strike us as strange because when we read the title of a representational painting, we usually expect it to tell us what the painting is about—that is, its subject matter. And although the trees in Cézanne's painting are important, they obviously are not as important as the mountain. A title such as *Viaduct* would also be misleading.

The questions in the Perception Key have already hinted at some of the ways that the form reveals the essence of the mountain. But this occurs in so many ways that a complete description is very difficult. Each aspect of the composition helps bring forth the energy of Mont Sainte-Victoire, which seems to roll down the valley and then shake the foreground trees. Everything is dominated and unified around the mountain. The rolls of its ridges are like waves of the sea, but far more durable, as we sense the impenetrable solidity of the masses underneath.

The small color shapes are something like pieces in a mosaic. These units move toward one another in receding space, and yet their intersections are rigid, as if their impact froze their movement. Almost all the colors reflect light, like the facets of a crystal, so that a solid color or one-piece effect rarely appears. And the color tones of the painting, variously modulated, are repeated endlessly. For example, the color tones of the mountain are repeated in the viaduct and the fields and buildings of the middle ground and the trees of the foreground. Cézanne's colors animate everything, mainly because the colors seem to be always moving out of the depth of everything rather than being laid on flat like house paint. The vibrating colors, in turn, rhythmically charge into one another and then settle down, reaching an equilibrium in which everything except the limbs of the foreground trees seems to come to rest.

Cézanne's form distorts reality in order to reveal reality. He makes Mont Sainte-Victoire far clearer in his painting than you will ever see it in nature or even in the best of photographs. Once you have participated with this and similar paintings, you will find that you may begin to see mountains like Mont Sainte-Victoire with a more meaningful vision.

THE "ALL-AT-ONENESS" OF PAINTING

In addition to revealing the visually perceptible more clearly, paintings give us time for our vision to focus, hold, and participate. Of course, there are times when we can hold on a scene in nature. We are resting with no pressing worries and with time on our hands, and the sunset is so striking that we fix our attention on its redness. But then darkness descends and the mosquitoes begin to bite. In front of a painting, however, we find that things stand still, like the red in Siqueiros' *Echo of a Scream* (Figure 1-2). Here the red is peculiarly impervious and reliable, infallibly fixed and settled in its place. It can be surveyed and brought out again and again; it can be visualized with closed eyes and checked with open eyes. There is no hurry, for all of the painting is present, and, under normal conditions, it is going to stay present; it is not changing in any significant perceptual sense.

Moreover, we can hold on any detail or region or the totality as long as we like and follow any order of details or regions at our own pace. No region of a painting strictly presupposes another region temporally. The sequence is subject to no absolute constraint. Whereas there is only one route in listening to music, for example, there is a freedom of routes in seeing paintings. With *Mont Sainte-Victoire*, for example, we may focus on the foreground trees, then on the middle ground, and finally on the mountain. The next time around, we may reverse the order. "Paths are made," as the painter Paul Klee observed, "for the eye of the beholder which moves along from patch to patch like an animal grazing." There is a "rapt resting" on any part, an unhurried series, one after the other, of "nows," each of which has its own temporal spread.

Paintings make it possible for us to stop in the present and enjoy at our leisure the sensations provided by the show of the visible. That is the second reason paintings can help make our vision whole. They not only clarify our world but also may free us from worrying about the future and the past, because paintings are a framed context in which everything stands still. There is the "here-now" and relatively speaking nothing but the "here-now." Our vision, for once, has time to let the qualities of things and the things themselves unfold.

ABSTRACT PAINTING

Abstract, or **nonrepresentational, painting** may be difficult to appreciate if we are confused about its subject matter. Since no objects or events are depicted, abstract painting might seem to have no subject matter: pictures of nothing. But this is surely not the case. The subject matter is the sensuous. The sensuous is composed of visual qualities—line, color, texture, space, shape, light, shadow, volume, and mass. Any qualities that stimulate our vision are **sensa.** In representational painting, sensa are used to portray objects and events. In abstract painting, sensa are freed. They are depicted for their own sake. Abstract painting reveals sensa, liberating us from our habits of always identifying these qualities with specific objects and events. They make it easy for us to focus on sensa themselves, even though we are not artists. Then the radiant and vivid values of the sensuous are enjoyed for their own sake, satisfying a fundamental need. Abstractions can help fulfill this need to behold and treasure the images of the sensuous. Instead of our controlling the sensa, transforming them into signs that represent objects or events, the sensa control us, transforming us into participators.

Moreover, because references to objects and events are eliminated, there is a peculiar relief from the future and the past. Abstract painting, more than any other art, gives us an intensified sense of here-now, or **presentational immediacy.** When we perceive representational paintings such as *Mont Sainte-Victoire*, we may think about our chances of getting to southern France some time in the future. Or when we perceive *May 3, 1808*, we may think about similar massacres. These suggestions bring the future and past into our participation, causing the here-now to be somewhat compromised. But with abstract painting—because there is no portrayal of objects or events that suggest the past or the future—the sense of presentational immediacy is more intense.

FIGURE 4-13
Rembrandt van Rijn, *Self Portrait*. 1659. Oil on canvas, 33¼ × 26 inches. Andrew W. Mellon Collection. National Gallery of Art, Washington, D.C.

Rembrandt was remarkable for his repeated self-portraits. This one shows him at age 53 at the height of his powers as an artist. His forceful expression is arresting and assertive although at the same time tentative. He seems to emerge from a darkness.

Although sensa appear everywhere we look, in paintings, sensa shine forth. This is especially true with abstract paintings, because there is nothing to attend to but the sensa. What you see is what you see. In nature the light usually appears as external to the colors and surface of sensa. The light plays on the colors and surface. In paintings the light usually appears immanent in the colors and surface, seems to come—in part at least—through them, even in the flat polished colors of a Mondrian. When a light source is represented or suggested, as in Rembrandt's *Self Portrait* (Figure 4-13), the light often seems to

be absorbed into the colors and surfaces. There is a depth of luminosity about the sensa of paintings that rivals nature. Generally the colors of nature are more brilliant than the colors of painting; but usually in nature the sensa are either so glittering that our squints miss their inner luminosity or so changing that we lack the time to participate and penetrate. To ignore the allure of the sensa in a painting, and, in turn, in nature, is to miss one of the chief glories life provides. It is especially the abstract painter—the shepherd of sensa— who is most likely to call us back to our senses.

Study the Mondrian (Figure 4-10) or the Rothko (Figure 4-11). Then reflect on how you experienced a series of durations—"spots of time"—that are ordered by the relationships between the regions of sensa. Compare your experience with listening to music.

PERCEPTION KEY Rothko and Music

1. Can the varieties of pulsing color tones in the Rothko be compared with the tones of music? Do the colors suggest musical tonalities? If you have access to a musical instrument, play the tones that you find suggested by the painting.
2. If you have the opportunity to see any "color field" painting by Rothko, similar to *Earth Greens,* focus for a minute or so on just one color. Then focus on an adjoining color. Do you find the second color taking on a different hue? Is there a kind of visual pulsing occurring?
3. The tones of music come to us successively, and they usually interpenetrate. For example, as we hear the tone C, we also hear the preceding G, and we anticipate the coming E. Do the tones of the music interpenetrate more than the sensa of the Rothko? Do you see a succession of colors when you look at the Rothko, or do you see a color field with an "all-at-onceness"?
4. Is the process of listening to musical tones quite different from the process of seeing abstract paintings? If so, in what way?

In our view, the sensa of abstract paintings (and the same is largely true of representational paintings) are divided from one another in a different way from the more fluid progressions of music. Whereas when we listen to music the tones interpenetrate, when we see an abstract painting the sensa are more juxtaposed. Whereas the process of perceiving music is continuous, the process of perceiving abstract painting is discontinuous. Whereas music is perceived as motion, abstract painting is perceived as motionlessness. We are fascinated by the vibrant novelty and the primeval power of the red of an abstract painting for its own sake, cut off from explicit consciousness of past and future. But then, sooner or later, we notice the connection of the red to the blue, and then we are fascinated by the blue. Or then, sooner or later, we are fascinated by the interaction or contrast between the red and the blue. Our eyes travel over the canvas step-by-step, free to pause at any step as long as our eyes desire. With music, this pausing is impossible. If we hold on a tone or passage, the oncoming tones sweep by us and are lost. Music is always in part elsewhere—gone or coming—and we are swept up in the flow of process. The processes of hearing music and seeing abstract paintings are at opposite poles. Yet, as suggested by question 2 of the Perception Key, the differences are not absolute.

Abstract painting reveals sensa in their primitive but powerful state of innocence. This makes possible an extraordinary intensity of vision, renewing the spontaneity of our perception and enhancing the tone of our physical existence. We clothe our visual sensations in positive feelings, living in these sensations instead of using them as means to ends. And such sensuous activity—sight, for once minus anxiety and eyestrain—is sheer delight. Abstract painting offers us a complete rest from practical concerns. Abstract painting is, as Matisse in 1908 was beginning to see,

> an art of balance, of purity and serenity devoid of troubling or depressing subject matter, an art which might be for every mental worker, be he businessman or writer, like an appeasing influence, like a mental soother, something like a good armchair in which to rest from physical fatigue.[2]

PERCEPTION KEY Rothko and O'Keeffe

1. Rothko's *Earth Greens* (Figure 4-11) is, we think, an exceptional example of time-lessness and the sensuous. O'Keeffe's *Ghost Ranch Cliffs* (Figure 4-12) also emphasizes the sensuous, especially the rich yellows and greens. What makes one presumably more timeless?
2. Examine the sensa in the O'Keeffe. Does the fact that the painting represents real things distract you from enjoying the sensa? How crucial are the sensa to your full appreciation of the painting?
3. What difference do you perceive in Rothko's and O'Keeffe's treatment of sensa?
4. Look at the Rothko upside down. Is the form weakened or strengthened? Does it make a difference? If so, what?

The underlying blue rectangle of *Earth Greens* is cool and recessive with a pronounced vertical emphasis, accented by the way the bands of blue gradually expand upward. However, the green and rusty-red rectangles, smaller but more prominent because they stretch over most of the blue, have a horizontal "lying down" emphasis that quiets the upward thrust. The vertical and the horizontal—the simplest, most universal, and potentially the most tightly "relatable" of all axes, but in everyday experience usually cut by diagonals and oblique curves or strewn about chaotically—are brought together in perfect peace. This fulfilling harmony is enhanced by the way the lines, with one exception, of all these rectangles are soft and slightly irregular, avoiding the stiffness of straight lines that isolate. Only the outside boundary line of the blue rectangle is strictly straight, and this serves to separate the three rectangles from the outside world.

Within the firm frontal symmetry of the color field of this painting, the green rectangle is the most secure and weighty. It comes the closest to the stability of a square; the upper part occupies the actual center of the picture, which, along with the lower blue border, provides an anchorage; and the location of

[2]Matisse, "Notes of a Painter," *La Grande Revue*, December 25, 1908.

the rectangle in the lower section of the painting suggests weight because in our world heavy objects seek and possess low places. But even more important, this green, like so many earth colors, is a peculiarly quiet and immobile color. Wassily Kandinsky, one of the earliest abstract painters, finds green generally an "earthly, self-satisfied repose." It is "the most restful color in existence, moves in no direction, has no corresponding appeal, such as joy, sorrow, or passion, demands nothing." Rothko's green, furthermore, has the texture of earth, thickening its appearance. Although there are slight variations in brightness and saturation in the green, their movement is congealed in a stable pattern. The green rectangle does not look as though it wanted to move to a more suitable place.

The rusty-red rectangle, on the other hand, is much less secure and weighty. Whereas the blue rectangle recedes and the green rectangle stays put, the rusty-red rectangle moves toward us, locking the green in depth between itself and the blue. Similarly, whereas the blue is cold and the rusty-red warm, the temperature of the green mediates between them. Unlike the blue and green rectangles, the rusty-red seems light and floating, radiating vital energy. Not only is the rusty-red rectangle the smallest, but also its winding, swelling shadows and the dynamism of its blurred, obliquely oriented brushstrokes produce an impression of self-contained movement that sustains this lovely shape like a cloud above the earthy green below. This effect is enhanced by the blue, which serves as a kind of firmament for this sensuous world, for blue is the closest to darkness, and this blue, especially the middle band, seems lit up as if by starlight. Yet, despite its amorphous inner activity, the rusty-red rectangle keeps its place, also serenely harmonizing with its neighbors. Delicately, a pervasive violet tinge touches everything. And everything seems locked together forever, an image of eternity. When *Earth Greens* is turned upside down, the green rectangle weighs heavily down on the red—breaking the harmonious stability.

REPRESENTATIONAL PAINTING

In the participative experience with ***representational paintings,*** the sense of here-now, so overwhelming in the participative experience with abstractions, is somewhat weakened. Representational paintings situate the sensuous in objects and events. A representational painting, just like an abstraction, is "all there" and "holds still." But past and future are more relevant than in our experience of abstract paintings because we are seeing representations of objects and events. Inevitably, we are at least vaguely aware of place and date; and, in turn, a sense of past and future is a part of that awareness. Our experience is a little more ordinary than it is when we feel the extraordinary isolation from objects and events that occurs in the perception of abstract paintings. Representational paintings always bring in some suggestion of "once upon a time." Moreover, we are kept a little closer to the experience of every day, because images that refer to objects and events usually lack something of the strangeness of the sensuous alone.

Representational painting furnishes the world of the sensuous with objects and events. The horizon is sketched out more closely and clearly, and the spaces of the sensuous are filled, more or less, with things. But even when these furnishings (subject matter) are the same, the interpretation (content) of every painting is always different.

FIGURE 4-14
Claude Monet, *Impression,
Sunrise*. 1873. Oil on canvas,
19 × 24 inches. Musée
Marmottan Monet, Paris.

This painting gave the name to
the French Impressionists and
remains one of the most identi-
fiable paintings of the age. Com-
pared with paintings by Ingres
or Giorgione, this seems to be
a sketch, but that is the point.
It is an impression of the way
the brilliant light plays on the
waters at sunrise.

COMPARISON OF FIVE IMPRESSIONIST PAINTINGS

From time to time, painters have grouped themselves into "schools" in
which like-minded artists sometimes worked and exhibited together. The
Barbizon school in France in the 1840s, a group of six or seven painters,
attempted to paint outdoors so that their landscapes would have a natural
feel in terms of color and light, unlike the studio landscapes that were popu-
lar at the time. Probably the most famous school of art of all time is the
Impressionist school, which flourished between 1870 and 1905, especially
in France. The impressionists' approach to painting was dominated by a
concentration on the impression light made on the surfaces of things.

> PERCEPTION KEY Comparison of Five Impressionist Paintings
>
> 1. In which of the following paintings is color most dominant over line? In which
> is line most dominant over color? How important does line seem to be for the
> impressionist painter?
> 2. In terms of composition, which paintings seem to rely on diagonal lines or diago-
> nal groups of objects or images?
> 3. Comment on the impressionist reliance on balance as seen in these paintings. In
> which painting is symmetry most effectively used? In which is asymmetry most effec-
> tive? How is your response to the paintings affected by symmetry or asymmetry?
> 4. If you were to purchase one of these paintings, which would it be? Why?

Claude Monet's *Impression: Sunrise* (Figure 4-14) was shown at the first
show of the impressionist painters in 1874, and it lent its name to the entire

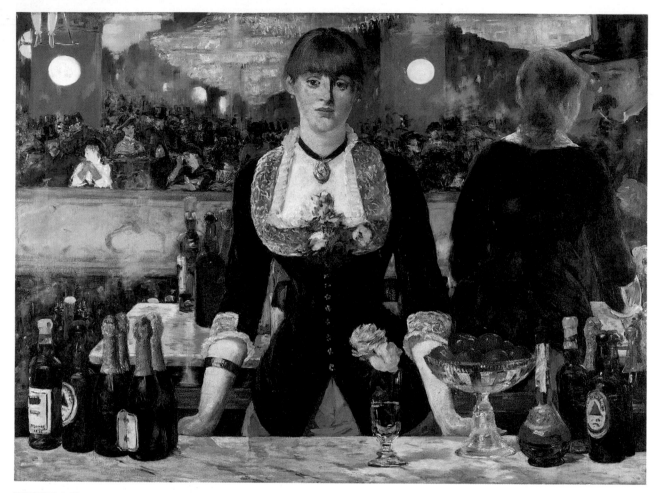

FIGURE 4-15

Edouard Manet, *A Bar at the Folies-Bergère*. 1881–1882. Oil on canvas, 37¾ × 51¼ inches. Courtauld Institute Galleries, London.

Typical of impressionist paintings, this one has for its subject matter ordinary everyday events. Viewers may also surmise a narrative embedded in the painting, given the character in the mirror, not to mention the feet of the trapeze artist in the upper left.

group. Unfortunately, this painting has been stolen and not yet recovered. However, Monet's many impressionist paintings grace museums around the world. The scene in *Sunrise* has a spontaneous, sketchy effect, the sunlight breaking on glimmering water. Boats and ships lack mass and definition. The solidity of things is subordinated to shimmering surfaces. We sense that only a moment has been caught. Monet and the impressionists painted, not so much objects they saw, but the light that played on and around them.

Edouard Manet was considered the leader of the impressionist group. His striking painting *A Bar at the Folies-Bergère* (Figure 4-15) is more three-dimensional than Monet's, but the emphasis on color and light is similar. In this painting the impressionists' preference for everyday scenes with ordinary people and objects is present. Details abound in this painting—some mysterious, such as the legs of the trapeze artist in the upper left corner.

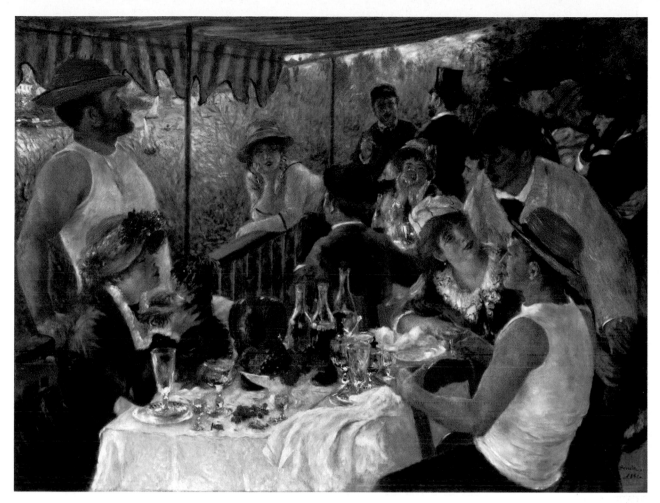

FIGURE 4-16
Pierre-Auguste Renoir, *Luncheon of the Boating Party*. 1881. Oil on canvas, 51 × 68 inches. The Phillips Collection, Washington, D.C.

Renoir, one of the greatest of the impressionists, portrays ordinary Parisians in *Luncheon of the Boating Party*. Earlier painters would have seen this as unfit for exhibition because its subject is not heroic or mythic. The impressionists celebrated the ordinary.

Pierre-Auguste Renoir's joyful painting (Figure 4-16) also represents an ordinary scene of people dining on a warm afternoon, all blissfully unaware of the painter. The scene, like many impressionist scenes, could have been captured by a camera. The perspective is what we would expect in a photograph, while the cut-off elements of people and things are familiar from our experience with snapshots. The use of light tones and reds balances the darker greens and grays in the background. Again, color dominates in this painting.

Mary Cassatt's *The Boating Party* (Figure 4-17) gives us the impression of a close-up view with much of the boat and sail cut off. Cassatt's sense of design is expressed in her use of intense colors, the lime-yellow boat in contrast with the deep blues of the water and the boatman's sash. Cassatt was a close associate of Edgar Degas, whose enthusiasm for the camera was notable, especially evident in his skillful photographs.

Edgar Degas became famous for his studies of young ballerinas, and Figure 4-18, *The Dancing Class*, is the first of his paintings of this subject

FIGURE 4-17
Mary Cassatt, *The Boating Party*.
1893–1894. Oil on canvas,
35½ × 46⅛ inches. National
Gallery of Art, Washington, D.C.

Cassatt presents a view of a
mother and child, one of her
most frequent subjects. Here,
however, she gives much more
intensity to the dominant colors
of water, sail, boat, and the cos-
tume of the man doing the row-
ing than she does to the mother
and child.

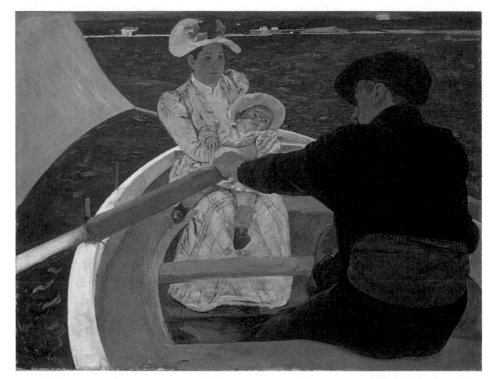

FIGURE 4-18
Edgar Degas, *The Dancing Class*.
1871–1872. Oil on wood, 7¾
× 10⅝ inches. Metropolitan
Museum of Art.

The Dancing Class is one of a
sequence of paintings of ballet
dancers, usually at practice.
Degas was an enthusiastic pho-
tographer, and his technique in
this study reveals his reliance on
the way the camera "sees."

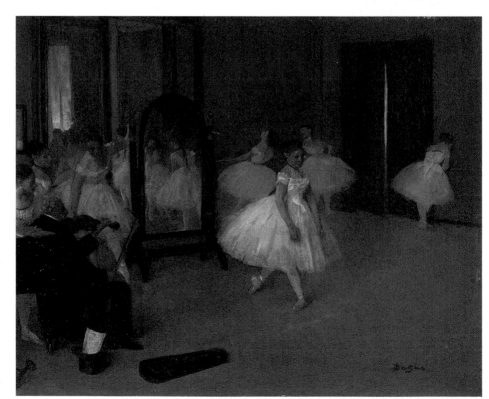

matter. The scene seems very much what we might have witnessed had we been there. The musician has paused, the ballerina in the center foreground seems balanced, the other students either watch or ignore her, and we have the impression of an instant of calm and suspension. The tonal range of the painting is limited, but Degas works carefully to balance the dark tones with one another and to use the light tones to guide us into the work.

DETERMINING THE SUBJECT MATTER OF A PAINTING

Study Frankenthaler's *The Bay* (Figure 4-7).

> **PERCEPTION KEY** Frankenthaler
>
> 1. Is this painting abstract or representational? Take plenty of time before you decide, but disregard the title.
> 2. Do you see a bay when you ignore the title? Do you see a bay when you take the title into consideration?
> 3. If you do, in fact, see a bay when taking notice of the title, does this make the painting representational?
> 4. If you do not see a bay, what do you see?
> 5. There is a tiny slash of red slightly down and to the left of center. Is there a suggestion, perhaps, of a mouth below a huge nose? What do you make of this?
> 6. What about *The Nose* for the title? Or *Red Lips*? Or *Tiny Eye*? Or *Africa*? Or *Abstraction*? Are any of these a better title than *The Bay*?

The third question is tricky. We suggest the following principle as a basis for answering such questions. If a work only shows (presents) but does not interpret (reveal) the objects and events that the title sometimes indicates, this is not enough to make it representational. These objects and events must be interpreted if the work is to be usefully classified as representational. Our view is that a bay in Frankenthaler's painting is interpreted, that our perception of the spreading, merging earthy stains, soft as water, intensifies our awareness of the rhythms of surges and backwater eddies. If this judgment is correct, the work is representational. Alternatively, your view may be that recognition of a bay in the painting only helps intensify your perception of the sensuous—the swirling rhythm of colors. If this judgment is correct, the work is abstract. *The Bay* seems to lie on a vague borderline between representational and abstract painting.

Sometimes, as we have seen with Frankenthaler's *The Bay*, it is extremely difficult to distinguish between abstract and representational painting. Whether the recognition of objects and events in a painting intensifies perception of the sensuous may vary with the differences in temperament and background of the participators. Nevertheless, the distinction between abstract and representational painting is useful because it brings up this important fact: Whereas in abstract painting objects and events are not a part of the content, in representational paintings they are. Even when the distinction is difficult to make, as with *The Bay*, focusing on the issue of abstraction and representation can help clarify what is most important in any particular painting.

FIGURE 4-19
Hokusai, *Dawn at Isawa in Kai Province.* 1833. Color wood-block print, 12 × 16 inches.

This is part of *Thirty-six Views of Mount Fuji.* This view was added to the original collection when it was expanded to forty-six views. The composition shows human activity in the foreground, a landscape in the middle ground, and the dominant Mount Fujiyama in the top background. Because it is a woodcut the colors are flatter and less supple than they would be in an oil painting.

INTERPRETATION OF MOUNTAINS

Mountains have been a favorite subject of painters from many traditions and over many centuries. We have spoken frequently of Cézanne's many paintings of Mont Sainte-Victoire and commented on the Chinese tradition that emphasizes the height of mountains. The following Perception Key asks you to consider Cézanne's and Fan K'uan's paintings, which we discussed earlier, along with Hokusai's *Dawn at Isawa in Kai Province* (Figure 4-19) and Asher Durand's *Kindred Spirits* (Figure 4-20). Each of these paintings demonstrates the range of possibilities that are afforded any painter who is deeply moved by the size, grace, and awesomeness of mountains and nature.

FIGURE 4-20
Asher Durand, *Kindred Spirits*.
1849. Oil on canvas, 44 × 36
inches. Private collection.

Durand's *Kindred Spirits* por-
trays William Cullen Bryant, an
important American poet, and
Thomas Cole, one of the Hud-
son River School painters. Cole
was Durand's mentor and was
in turn inspired by the panthe-
ism of Bryant. The figures are
dwarfed by the grandeur of the
Adirondacks.

PERCEPTION KEY Four Mountain Paintings

1. Compare the Cézanne (Figure 2-4) with the Hokusai (Figure 4-19). Which one
 reveals its mountain as more powerful, dynamic, solid?
2. Compare the Fan K'uan (Figure 4-8) with the Durand (Figure 4-20). Which one
 is more sublime? romantic?

(continued)

3. Which of the four paintings best illustrates these lines from Robinson Jeffers's *Wise Men in Their Bad Hours:*

> The mountains are dead stone, the people
> Admire or hate their stature, their insolent quietness.
> The mountains are not softened nor troubled.

4. In which one of the four is the sense of the power of the human being revealed perhaps as at least equal to the power of nature?
5. In the nineteenth century, especially in the painting traditions of the United States, mountains were a favorite subject matter. Why is it that in contemporary times mountains are no longer a prevalent subject matter?

FRAMES

Photographs of paintings, as in this book, usually do not include their frames, the exceptions being Figures 4-1, 4-2, 4-8, and 14-10. In general, it seems obvious that a "good" or appropriate frame should harmonize and enhance rather than dominate the picture. For example, the frame of the Cimabue (Figure 4-1) delicately picks up the colors and lines of the Madonna's throne. Furthermore, an appropriate frame usually should separate the picture from its surroundings, as again with the Cimabue. Sometimes the artist doesn't bother with a frame. And sometimes owners have the frame removed or remade to their taste, often at variance with the intent of the artist.

SOME PAINTING STYLES OF THE PAST HUNDRED YEARS

Painting, whether abstract or representational, sets forth the visually perceptible in such a way that it works in our experience with heightened intensity. Every *style* of painting finds facets of the visually perceptible that had previously been missed. For example, the painting of the past hundred years has given us, among many other styles, Impressionism, revealing the play of sunlight on color, as in the Monet, Manet, Renoir, Cassatt, and Degas (Figures 4-14 to 4-18); Post-Impressionism, using the surface techniques of Impressionism but drawing out the solidity of things, as in the Cézanne (Figure 2-4); *Expressionism,* portraying strong emotion, as in the Blume (Figure 1-3); Cubism, showing the three-dimensional qualities of things as splayed out in a tightly closed two-dimensional space—without significant perspective or cast shadow—through geometrical crystallization, a technique partially exhibited in Picasso's *Guernica* (Figure 1-4); Dada, poking fun at the absurdity of everything, as in Picabia's *The Blessed Virgin* (see Figure 14-12); *Surrealism,* expressing the subconscious, as perhaps in Siqueiros (Figure 1-2); Suprematism or Constructivism, portraying sensa in movement with—as in Expressionism—the expression of powerful emotion or energy, exemplified in the Pollock (Figure 3-3); *Pop Art,*

EXPERIENCING **Frames**

1. What importance does the frame have for our enjoyment of a painting?
2. Giotto's frame (Figure 4-2) is plainer than Cimabue's (Figure 4-1). But would a more decorative frame be appropriate for the Giotto?
3. Howard Hodgkin is famous for painting directly on the frames of his works. Examine his *Dinner in Palazzo Albrizzi* (Figure 4-21). How effective is his use of the frame? Is there any question about whether it is part of the painting?

Sometimes a frame overwhelms a painting, as in Raphael's Madonna (Figure 14-10), and sometimes paintings have no frames, as in almost all of Mondrian's paintings. The consensus seems to be that a frame is valuable when it complements the painting, either by establishing its preciousness—as in the ordinary gold frame—or by establishing its shape and purpose, as in the case of the Giotto and Cimabue frames. Neither is very ornate, both are sufficient and useful. Clearly, the fact that almost all the paintings illustrated in this book lack frames tells us something about the frame's ultimate worth. Yet, all museums include frames in most of the paintings represented here. Frames stabilize the canvas, establish the period and value of a painting, and set it off from the wall. They also "finish" the painting—almost like the final chord of a great symphony or the closing of the final curtain on a play. They say, "the end."

In the case of Howard Hodgkin, the paintings for which he is best known are all marked by the existence of a frame, sometimes a large and heavy frame, but Hodgkin inevitably paints brightly over the frame, in some cases giving the impression that the painting does not end at its borders, but could continue.

Dinner in Palazzo Albrizzi is a brilliantly colored painting seemingly representing the vegetables and seafood that are popular in Venice, where the palazzo—which has been owned by the same family for 500 years, and which hosts gala high-society dinners—sits on the canal. Brushstrokes in bright red, and in darker red, are clearly visible on the frame, which is itself clearly identifiable as a frame, not part of the canvas. Hodgkin seems to be saying that no frame could contain his painting—its astonishing energy, as expressed in brilliant colors and striking shapes and visual rhythms, seems uncontainable. Here we can say the frame is functional, that it shares center stage with the painting.

FIGURE 4-21
Howard Hodgkin, *Dinner in Palazzo Albrizzi*. 1964–1988. Oil on wood, 46¼ × 46¼ inches. Modern Art Museum of Fort Worth, Fort Worth, Texas.

This is typical of Hodgkin's work in that he includes a frame upon which he ordinarily paints freely. His abstract paintings are notable for their intense and characteristic colors. While appearing instantaneous and improvisatory, his brushstrokes are often the product of months of careful work.

the revelation of mass-produced products, as in the Dine (Figure 2-1). And today and tomorrow, new dimensions are and will be portrayed. In Chapter 14, we will study some examples of *avant-garde* painting. Never in the history of painting have there been such rapid change and vitality. Never in history has there been so much help available for those of us who, in varying degrees, are blind to the fullness of the visually perceptible. If we take advantage of this help, the rewards are priceless.

SUMMARY

Painting is the art that has most to do with revealing the sensuous and the visual appearance of objects and events. Painting shows the visually perceptible more clearly. Because a painting is usually presented to us as an entirety, with an all-at-onceness, it gives time for our vision to focus, hold, and participate. This makes possible a vision that is both extraordinarily intense and restful. Sensa are the qualities of objects or events that stimulate our sense organs. Sensa can be disassociated or abstracted from the objects or events in which they are usually joined. Sensa and the sensuous (the color field composed by the sensa) are the primary subject matter of abstract painting. Objects and events are the primary subject matter of representational painting.

Chapter 5

SCULPTURE

SCULPTURE AND TOUCH

Sculpture, along with painting and architecture, is usually, but not very usefully, classified as one of the visual arts. Such classification suggests that the eye is the chief sense organ involved in our participation with sculpture. Yet observe participants at an exhibition of both paintings and sculptures. Usually at least a few will touch or try to touch some of the sculptures despite the "Do Not Touch" signs. Some kinds of sculpture invite us to explore and caress them with our hands and even, if they are not too large or heavy, to pick them up. Constantin Brancusi noticed this and created a *Sculpture for the Blind*. Within a box with an opening at the top large enough to allow passage of the hand, he placed three-dimensional shapes of varying sizes and textures, rhythmically organized. Sculpture draws the eye to the fingers.

PERCEPTION KEY Experiment with Touch

Using scissors, cut out four approximately six-inch cardboard squares. Shape them with curves or angles into abstract patterns (structures that do not represent objects), and put one into a bag. Ask a friend to feel that sample in the bag without looking at it. Then ask your friend (1) to draw the pattern with pencil on paper. Continue the same procedure with the other three samples. Have your friend make four samples for you, and follow the same procedures yourself. Analyze your results. How closely did the drawings match the samples? What is the significance of this experiment?

SCULPTURE AND DENSITY

Sculpture engages our senses differently than painting. This is because sculpture occupies space as a three-dimensional **mass,** whereas painting is essentially a two-dimensional surface that can only represent ("re-present") three-dimensionality. Of course, painting can suggest density—for example, *Mont Sainte-Victoire* (Figure 2-4)—but sculpture is dense. Henry Moore, one of the most influential modern sculptors, states that the sculptor "gets the solid shape, as it were, inside his head—he thinks of it, whatever its size, as if he were holding it completely enclosed in the hollow of his hand." The sculptor, Moore continues, "mentally visualizes a complex form *from all round itself;* he knows while he looks at one side what the other side is like; he identifies himself with its center of gravity, its mass, its weight; he realizes its volume, as the space that the shape displaces in the air."[1] Apparently we can only fully apprehend sculpture by senses that are alive not only to visual and **tactile** (touchable) surfaces but also to the weight and volume lying behind those surfaces.

SENSORY INTERCONNECTIONS

It is surely an oversimplification to distinguish the various arts on the basis of which sense organ is activated—for example, to claim that painting is experienced solely by sight and sculpture solely by touch. Our nervous systems are far more complicated than that. Generally no clear separation is made in experience between the faculties of sight and touch. The sensa of touch, for instance, are normally joined with other sensa—visual, aural, oral, and olfactory. Even if only one kind of sensum initiates a perception, a chain reaction triggers other sensations, either by sensory motor connections or by memory associations. We are constantly grasping and handling things as well as seeing, hearing, tasting, and smelling them. And so when we see a thing, we have a pretty good idea of what its surface would feel like, how it would sound if struck, how it would taste, and how it would smell if we approached. And if we grasp or handle a thing in the dark, we have some idea of what its shape looks like.

As we approach a stone wall, we see various shapes. And these shapes recall certain information. We know something about how the surface of these stones would feel and that it would hurt if we walked into them. We do not know about the surface, volume, and mass of those stones by sight alone but by sight associated with manual experience. Both painting and sculpture involve sight and touch. But touch is much more involved in our participation with sculpture. If we can clarify such differences as these, our understanding of sculpture will be deeper and, in turn, our participation more rewarding.

[1]Henry Moore, "Notes on Sculpture," in *Sculpture and Drawings 1921–1948,* 4th rev. ed., ed. David Sylvester (New York: George Wittenborn, 1957), p. xxxiii ff.

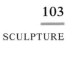

FIGURE 5-1

Jean Arp, *Growth*. 1938. Marble, 39½ inches high. Philadelphia Museum of Art. Gift of Curt Valentin.

Shown here in marble, *Growth* was also cast in bronze. Arp showed his work with the Surrealists, who often included chance in abstract pieces that suggest organic natural forms.

SCULPTURE AND PAINTING COMPARED

Compare Rothko's *Earth Greens* (Figure 4-11) with Arp's *Growth* (Figure 5-1). Both works are abstract, we suggest, for neither has objects or events as its primary subject matter. Arp's sculpture has something to do with growth, of course, as confirmed by the title. But is it human, animal, or vegetable

growth? Male or female? Clear-cut answers do not seem possible. Specificity of reference, just as in the Rothko, is missing. And yet, if you agree that the subject matter of the Rothko is the sensuous, would you say the same for the Arp? To affirm this may bother you, for Arp's marble is dense material. This substantiality of the marble is very much a part of its appearance as sculpture. Conversely, *Earth Greens* as a painting—that is, as a work of art rather than as a physical canvas of such and such a weight—does not appear as a material thing. The weight of the canvas is irrelevant to our participation with *Earth Greens* as a work of art. That weight becomes relevant if we are hanging *Earth Greens* on a wall, but that is a procedure antecedent to our participation with it as a painting.

Rothko has abstracted sensa, especially colors, from objects or things, whereas Arp has brought out the substantiality of a thing—the density of the marble. Earth and grass and sky are not "in" Rothko's painting. Conversely, Arp has made the marble relevant to his sculpture. This kind of difference, incidentally, is perhaps the underlying reason the term "abstract painting" is used more frequently than the term "abstract sculpture." There is an awkwardness about describing as abstract something as material as most sculpture. Picasso once remarked, "There is no abstract art. You must always start with something. There is no danger then anyway because the idea of the object will have left an indelible mark." This may be an overstatement with respect to painting, but the point rings true with sculpture. Still, the distinction between abstract and representational sculpture is worth making, just as with painting, for being clear about the subject matter of a work of art is essential to all sensitive participation. It is the key to understanding the content, for the content is the subject matter interpreted by means of the form.

PERCEPTION KEY Rothko and Arp

1. Would you like to touch either of these works?
2. Would you expect either the Rothko or the Arp to feel hot or cold to your touch?
3. Which work seems to require the more careful placement of lighting? Why?
4. Which of the two works appears to be the more unchangeable in your perception?
5. Why do the authors claim that *Earth Greens* is more abstract than *Growth*? Can you think of other reasons—for example, the shapes in the two works?

Most sculpture, whether abstract or representational, returns us to the voluminosity (bulk), density (mass), and tactile quality of things. Thus sculpture has touch or tactile appeal. Even if we do not actually handle a work of sculpture, we can and often do imagine how it would feel with reference to its surface, volume, and weight. Sculpture brings us back into touch with things by allowing the thickness of things to permeate its surface. Most sculptures make us feel them as resistant, as substantial. Hence the primary subject matter of most abstract sculpture is the density of sensa. Sculpture is more than skin deep. Abstract painting can only represent density, whereas sculpture, whether abstract or representational, presents density. Abstract

painters generally emphasize the surfaces of sensa, as in *Earth Greens*. Their interest is in the vast ranges of color qualities, lines, and the play of light that bring out textural nuances. Abstract sculptors, on the other hand, generally restrict themselves to a minimal range of color, line, and textural qualities and emphasize light not only to play on these qualities but also to bring out the inherence of these qualities in things. Whereas abstract painters are shepherds of surface sensa, abstract sculptors are shepherds of depth sensa.

SCULPTURE AND SPACE

A painting is usually set off by a frame, the painting space being imaginary, separate and distinct from real space. Between the painting and us space is transparent. With sculpture, the space between is translucent. Thus to be explicitly aware of our place in real space and the space between us and a painting is an impediment in perceiving that painting. Conversely, to be explicitly aware of our place in real space and the space between us and a sculpture is in most cases an aid in perceiving. The space from the material body of a work of art to the participant we call "the between." Usually this space is intangible, but sometimes it is tangible in the sense that it strongly forces itself into our perceptions and explicitly influences our awareness. In the former case the between is empty, insensible, only a means to the work of art; in the latter case the between is full of forces, sensory, an essential part of the perceptible structure of the sculpture. With sculpture, even if we do not actually touch the material body, we can still sense the solidity of the material body permeating and animating the surrounding space. Shadows cast by a sculpture, for example, slant into the space between us and the material body of the sculpture, charging the between with energy; whereas shadows cast by the things represented in a painting stay within the painting. The convexities of a sculpture are actively outgoing into the between, and the between invades the concavities; whereas the convexities and concavities of a painting stay within the frame. The lines of the material body of a sculpture may create vectors into the between, whereas the lines of a painting do not impinge into the between. Sculpture creates an "impacting between."

Since the between is energized by the material body of a sculpture, the between is not only a perceptible part of that sculpture but is felt as pushing into us. Vision is fundamental in this perception of impact, of course, not because our eyes directly feel very much impact but because sight records the solidity and the texture of the material as well as the effects of the mass of the sculpture into the between. Such sight is likely to evoke tactual memories. We recall the density and the feel of such solids and textures and the outward advance of such masses. These evocations are an essential part of our perception of impact, however indirect, and they occur with our experience of painting as well as with sculpture. With sculpture, however, in our view there is *also* a direct or physical impact. The space between us and any three-dimensional thing that we are perceiving comes forth into our perception, by literally pushing into our bodies. Sculpture (leaving aside events such as sticks and stones and fists striking us) channels the ordinary impact of the things in

FIGURE 5-2

Stele of Maety, Gatekeeper of the Royal Treasury, from Thebes. Dynasty XI, reign of Mentuhotep II (ca. 2040–2020 B.C.). Limestone, 24¼ inches high. Metropolitan Museum of Art, New York.

The *Stele of Maety* is typical of the sunken-relief funeral sculpture of ancient Egypt.

everyday perception into more concentrated and stronger currents. Sculpture transforms real space, making the between more perceptible and impacting. To put it awkwardly but succinctly, sculpture is a "more real world." It makes real space more physical, whereas painting makes real space less physical. Both sculpture and painting are "in" our world, but only sculpture is "of" our world, in the sense of belonging to our world as spatially present.

SUNKEN-RELIEF SCULPTURE

The *Stele of Maety* (Figure 5-2) is incised in limestone, representing the gatekeeper of the Royal Treasury celebrating at his own funeral service. The emblems incised beside him indicate measures of wealth for which he was responsible. Compare this **sunken-relief sculpture** with Jackson Pollock's *Autumn Rhythm* (Figure 3-3). While their subject matters are very different, their surfaces are curiously similar. The stele does not project into space, as do most sculptures, but actually projects inward, into the surface of the stone. Pollock's painting, although considered essentially flat, is built up slightly and, in some spots, projects up to half an inch into space.

The light helps clarify the tactile qualities of the stele by revealing the sharp edges of the limestone. The density of the stone is evident. We virtually sense the weight of the object. Pollock's work lacks significant tactile

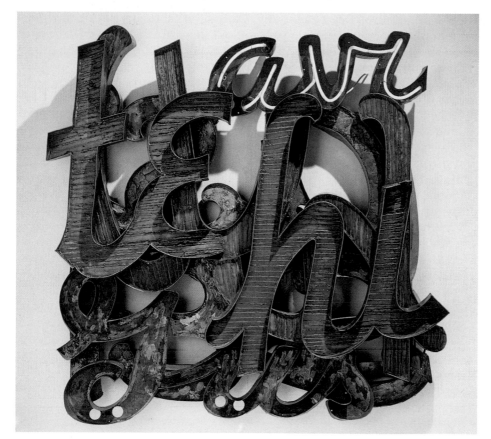

FIGURE 5-3

Chryssa, *Times Square Sky*. 1962. Neon, aluminum, steel, 60 × 60 × 9½ inches. Collection, Walker Art Center, Minneapolis. Gift of the T. B. Walker Foundation, 1964.

Chryssa's *Times Square Sky*, a multimedia low-relief sculpture, emulates the neon excitement of the displays in Times Square, New York.

appeal despite the projection of its thick, heavy paint. And while the stele makes us aware of its material texture and substance—perhaps even revealing essential qualities of the limestone—the painting remains an essentially two-dimensional image whose impact is much less tactile than visual.

LOW-RELIEF SCULPTURE

Low-relief sculpture projects relatively slightly from its background plane, and so its depth dimension is very limited. Medium- and high-relief sculpture project farther from their backgrounds, their depth dimensions expanded. Sculpture in the round is freed from any background plane, and so its depth dimension is unrestricted. *Times Square Sky* (Figure 5-3) is, we think, most usefully classified as sculpture of the low-relief species. The materiality of the steel, the neon tubing, and especially the aluminum is brought out very powerfully by their juxtaposition. Unfortunately, this is difficult to perceive from a photograph. Because of its three-dimensionality, sculpture generally suffers even more than painting from being seen only in a photograph. Chryssa Vardea was born in Greece, and when she came to America, she was fascinated by the garishness of Times Square. She worked extensively with

neon lighting. In *Times Square Sky,* Chryssa is especially sensitive to aluminum, the neon light helping to bring out the special sheen of that metal, which flashes forth in smooth and rough textures through subtle shadows.

Yet *Times Square Sky,* as the title suggests, is representational. The subject matter is about a specific place, and the content of *Times Square Sky*—by means of its form—is an interpretation of that subject matter. Times Square is walled around by manufactured products, such as aluminum and steel, animated especially at night by a chaos of flashing neon signs. Letters and words—often as free of syntax as in the sculpture—clutter that noisy space and merge with the bombarding sensa. The feel of that fascinating square is Chryssa's subject matter, just as it is in Mondrian's *Broadway Boogie Woogie* (Figure 4-10). Both works reveal something of the rhythm, bounce, color, and chaos of Times Square, but *Times Square Sky* interprets more of its physical character. Whereas Mondrian abstracts from the physicality of Broadway, Chryssa gives us a heightened sense of the way Broadway feels as our bodies are assaulted by buses, cars, crowds, noises, and smells. Those attacks—tactile, visual, aural, and olfactory—can have a metallic, mechanical, impersonal, and threatening character, and something of those menacing qualities is revealed in *Times Square Sky.* The physicality of that effect is, we suggest, what distinguishes this work as sculpture rather than painting. And yet the line here cannot be too sharply drawn. For if the neon tubing and aluminum were flattened down on the steel somewhat, or if Pollock had laid on his paints an inch or so thicker, would these works then be sculpture or painting?

Relief sculpture, except sunken relief, allows its materials to stand out from a background plane, as in *Times Square Sky.* Thus relief sculpture in at least one way reveals its materials simply by showing us—directly—their surface and something of their depth. By moving to a side of *Times Square Sky,* we can see that the steel, neon tubing, and aluminum are of such and such thickness. However, this three-dimensionality in relief sculpture, this movement out into space, is not allowed to lose its ties to its background plane. Hence relief sculpture, like painting, is usually best viewed from a basically frontal position. You cannot walk around a relief sculpture and see its back side as sculpture any more than you can walk around a painting and see its back side as painting. That is why both relief sculptures and paintings are usually best placed on walls or in niches.

HIGH-RELIEF SCULPTURE

The ***high-relief sculpture*** from a thirteenth-century temple in Orissa (Figure 5-4) was carved during a period of intense temple-building in that part of India. The tenderness of the two figures is emphasized by the roundness of the bodies as well as by the rhythms of the lines of the figures and the overarching swoop of the vegetation above them. This temple carving was made in a very rough stone, which emphasizes the bulk and mass of the man and woman, despite their association with religious practice. Almost a thousand years of weathering have increased its sense of texture. The happy expression on the faces is consistent with the great erotic religious sculpture of this period.

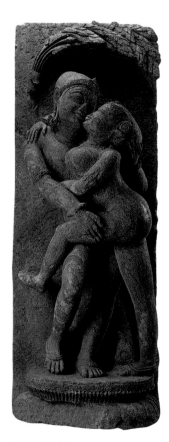

FIGURE 5-4

Mithuna Couple. Twelfth to thirteenth century. Orissa, India. Stone, 83 inches high. Metropolitan Museum of Art, New York.

Stone, high-relief sculpture like this, found on Indian temples built in the thirteenth and fourteenth centuries, represents figures combining the divine spirit with the erotic.

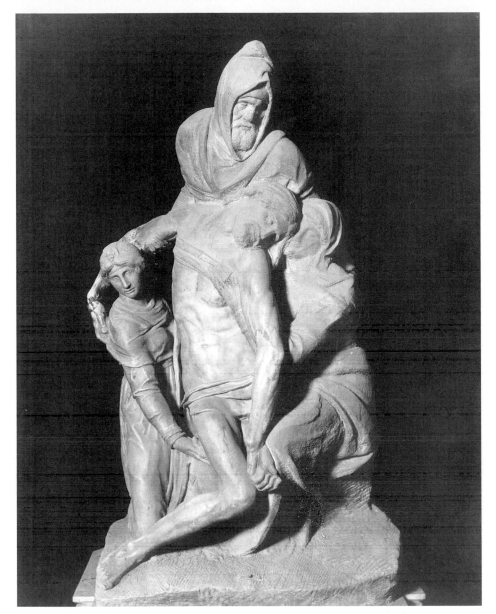

FIGURE 5-5
Michelangelo Buonarroti, *Pietà*.
Circa 1550–1555. Marble,
7 feet 8 inches high. Opera del
Duomo, Florence.

One of Michelangelo's last un-
finished pieces represents Jesus
being taken down from the
cross. The portrayal of emotion
in the faces of Joseph of Ari-
mathea and Mary, next to Jesus,
is subtle but haunting. The *Pietà*
was a favorite subject of Renais-
sance artists.

SCULPTURE IN THE ROUND

Michelangelo's *Pietà* (Figure 5-5), one of his last sculptures, ca. 1550–1555,
is unfinished. According to Vasari and Condivi, historians of the time,
Michelangelo originally wanted to be buried at the foot of this sculpture,
which was to be placed in Santa Maria Maggiore in Rome. Hence he por-
trayed his own features in the head of Joseph of Arimathea, the figure
hovering above. Apparently he was making good progress when a series
of accidents occurred, some involuntary and some probably voluntary. In

carving the left leg of Christ, a vein in the marble broke, and the leg was completely destroyed. There are also breaks above the left elbow of Christ, in his chest on the left, and on the fingers of the hand of the Virgin. The story goes that, in despair, Michelangelo did some of this damage himself. In any case, he gave up on it as a monument for his tomb and sold it in 1561, deciding that he preferred burial in Florence.

PERCEPTION KEY *Pietà*

1. Of the four figures in this statue—Joseph, Christ, the Virgin to the right, and Mary Magdalene to the left—one seems to be not only somewhat stylistically out of harmony with the other three but of less artistic quality. Historians and critics generally agree that this figure was not done or at least not completed by Michelangelo but rather by a second-rate sculptor, presumably Tiberio Calcagni. Which figure is this? What are your reasons for choosing it?
2. Michelangelo, perhaps more than any other sculptor, was obsessed with marble. He spent months searching the hills of Carrara near Pisa for marble blocks from which he could help sculptural shapes emerge. Something of his love for marble, perhaps, is revealed in this *Pietà*. Do you perceive this?
3. Is this sculpture in the round? The figures are freed from a base as background, and the viewer can walk around the work. But is this *Pietà* in the round in the same way as Arp's *Growth* (Figure 5-1)?

The answer to the first question is the Magdalene. Her figure and pose, relative to the others, are artificial and stiff. Her robe—compare it with the Virgin's—fails to integrate with the body beneath. For no accountable reason, she is both aloof and much smaller, and the rhythms of her figure fail to harmonize with the others. Finally, the marbleness of the marble fails to come out with the Magdalene.

In the other figures—and this is the key to the second question—Michelangelo barely allows his shapes, except for the polished surfaces of the body of Christ, to emerge from the marble block. The features of the Virgin's face, for example, are very roughly carved. It is as if she were still partially a prisoner in the stone. The Virgin is a marble Virgin; the Magdalene is a Magdalene and marble. Or, to put it another way, Michelangelo saw the Virgin in the marble and helped her image out without allowing it to betray its origin. Calcagni, or whoever did the Magdalene, saw the image of Magdalene and then fitted the marble to the image. Thus the claim that the face of the Virgin was unfinished is mistaken. It is hard to conceive, for us at least, how more chiseling or any polishing could have avoided weakening the expression of tender sorrow. The face of the Magdalene is more finished in a realistic sense, of course, but the forms of art reveal rather than reproduce reality. In the case of the body of Christ—compared with the rest of the statue except the Magdalene—the more finished chiseling and the high polish were appropriate because they help reveal the bodily suffering.

Since there is no background plane from which the figures emerge, the *Pietà* is usually described as **sculpture in the round.** Yet when compared with Arp's *Growth* (Figure 5-1), it is obvious that the *Pietà* is not so clearly in the round. There is no "pull" around to the rough-hewn back side, except,

perhaps, our need to escape from the intensity of the awesome pity. And when we do walk behind the *Pietà*, we find the back side unintegrated with the sides and front and of little interest. Michelangelo intended this essentially three-sided pyramid, as with practically all of his sculptures, to be placed in a niche so that it could be seen principally from the front. In this sense, the *Pietà* is a transition piece between high-relief sculpture, such as the *Mithuna Couple,* and unqualified sculpture in the round, such as *Growth*.

SCULPTURE AND ARCHITECTURE COMPARED

Architecture is the art of separating inner from outer space so that the inner space can be used for practical purposes. Sculpture does not provide a practically usable inner space. What about the Sphinx and the Pyramid at Memphis? They are the densest and most substantial of all works. They attract us visually and tactilely. But since there is no usable space within the Sphinx, it is sculpture. Within the Pyramid, however, space was provided for the burial of the dead. There is a separation of inner from outer space for the functional use of the inner space. Yet the use of this inner space is so limited that the living often have a difficult time finding it. The inner space is functional only in a restricted sense—is this Pyramid then sculpture or architecture? We shall delay our answer until the next chapter. The difficulty of the question points up an important factor to keep in mind. The distinctions between the arts that we have been and will be making are helpful in order to talk about them intelligibly, but the arts resist neat pigeonholing, and attempts at that are futile.

SENSORY SPACE

The space around a sculpture is sensory rather than empty. Despite its invisibility, sensory space—like the wind—is felt. Sculptures such as Arp's *Growth* (Figure 5-1) are surrounded by radiating vectors, something like the axis lines of painting. But with sculpture, our bodies as well as our eyes are directed. *Growth* is like a magnet drawing us in and around. With relief sculptures, except for very high relief such as the *Mithuna Couple* (Figure 5-4), our bodies tend to get stabilized in one favored position. The framework of front and sides meeting at sharp angles, as in *Times Square Sky* (Figure 5-3), limits our movements to 180 degrees at most. Although we are likely to move around within this limited range for a while, our movements gradually slow down, as they do when we finally get settled in a comfortable chair. We are not Cyclops with just one eye, and so we see something of the three-dimensionality of things even when restricted to one position. But even low-relief sculpture encourages some movement of the body, because we sense that different perspectives, however slight, may bring out something we have not directly perceived, especially something more of the three-dimensionality of the materials.

When one of the authors participated with Arp's *Growth,* he had this response:

> I find a warm and friendly presence. I find myself reaching toward the statue rather than keeping my distance. (If a chair were available I would not use it.)

Whereas generally my perceptual relationship to a painting requires my getting to and settling in the privileged position, as when finding the best seat in the theater, my perceptual relationship to the Arp is much more mobile and flexible. The smooth rounded shapes with their swelling volumes move gently out into space, turn my body around the figure, and control the rhythm of my walking. My perception of the Arp seems to take much more time than my perception of a painting, but in fact that is not necessarily so.

The Arp seems not only three-dimensional but four-dimensional, because it brings in the element of time so discernibly—a cumulative drama. In addition to making equal demands upon my contemplation, at the same time, each aspect is also incomplete, enticing me on to the next for fulfillment. As I move, volumes and masses change, and on their surfaces points become lines, lines become curves, and curves become shapes. As each new aspect unrolls, there is a shearing of textures, especially at the lateral borders. The marble flows. The leading border uncovers a new aspect, and the textures of the old aspect change. The light flames. The trailing border wipes out the old aspect. The curving surface continuously reveals the emergence of volumes and masses in front, behind, and in depth. What is hidden behind the surfaces is still indirectly perceived, for the textures indicate a mass behind them. As I move, what I have perceived and what I will perceive stand in defined positions with what I am presently perceiving. My moving body links the aspects. A continuous metamorphosis evolves, as I remember the aspects that were and anticipate the aspects to come, the leaping and plunging lights glancing off the surface helping to blend the changing volumes, shapes, and masses. The remembered and anticipatory images resonate in the present perception. My perception of the Arp is alive with motion. The sounds in the museum room are caught, more or less, in the rhythm of that motion. As I return to my starting point, I find it richer, as home seems after a journey.

Sculpture and the Human Body

Sculptures generally are more or less a center—the place of most importance that organizes the places around it—of actual three-dimensional space: "more" in the case of sculpture in the round, "less" in the case of low relief. That is why sculpture in the round is more typically sculpture than is the other species. Other things being equal, sculpture in the round, because of its three-dimensional centeredness, brings out the voluminosity and density of things more certainly than does any other kind of sculpture. First of all, we can see and perhaps touch all sides. But, more important, our sense of density has something to do with our awareness of our bodies as three-dimensional centers thrusting out into our surrounding environment. Philosopher-critic Gaston Bachelard remarks that

> immensity is within ourselves. It is attached to a sort of expansion of being which life curbs and caution arrests, but which starts again when we are alone. As soon as we become motionless, we are elsewhere; we are dreaming in a world that is immense. Indeed, immensity is the movement of a motionless man.[2]

[2]From Gaston Bachelard, *The Poetics of Space*. Translation © 1964 by the Orion Press, Inc. Reprinted by permission of Grossman Publishers.

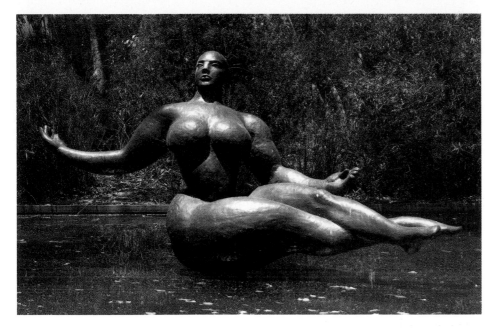

FIGURE 5-6
Gaston Lachaise, *Floating Fig-*
ure. 1927. Bronze (cast in 1935),
51¾ × 96 × 22 inches (131.4 ×
243.9 × 55.9 cm), weight 840 lbs
(381.81 kg). Museum of Modern
Art, New York. Given anony-
mously in memory of the artist.

This massive sculpture appears
to be "floating" in a reflective
pool. New York's Museum
of Modern Art elevates it
on a plinth in its sculpture
garden. The National Gallery
of Australia places its *Floating*
Figure in a reflecting Pool.

Lachaise's *Floating Figure* (Figure 5-6), with its ballooning buoyancy
emerging with lonely but powerful internal animation from a graceful el-
lipse, expresses not only this feeling but also something of the instinctual
longing we have to become one with the world about us. Sculpture in
the round, even when it does not portray the human body, often gives
us something of an objective image of our internal bodily awareness as
related to its surrounding space. Furthermore, when the human body is
portrayed in the round, we have the most vivid material image of our in-
ternal feelings.

PERCEPTION KEY Exercise in Drawing and Modeling

1. Take a pencil and paper. Close your eyes. Now draw the shape of a human being
 but leave off the arms.
2. Take some clay or putty elastic enough to mold easily. Close your eyes. Now model
 your material into the shape of a human being, again leaving off the arms.
3. Analyze your two efforts. Which was easier to do? Which produced the more
 realistic result? Was your drawing process guided by any factor other than your
 memory images of the human body? What about your modeling process? Did
 any significant factors other than your memory images come into play? Was the
 feel of the clay or putty important in your shaping? Did the awareness of your
 internal bodily sensations contribute to the shaping? Did you exaggerate any of
 the functional parts of the body where movement originates, such as the neck
 muscles, shoulder bones, knees, or ankles? Could these exaggerations, if they
 occurred, have been a consequence of your inner bodily sensations?

SCULPTURE IN THE ROUND AND THE HUMAN BODY

No object is more important to us than our bodies, which are always with us. Yet when something is continually present to us, we find great difficulty in focusing our attention upon it. Thus we usually are only vaguely aware of air except when it is deficient in some way. Similarly, we usually are only vaguely aware of our bodies except when we feel pain or pleasure. Nevertheless, our bodies are part of our most intimate selves—we are our bodies—and, since most of us are narcissists to some degree, most of us have a deep-down driving need to find a satisfactory material counterpoint for the mental images of our bodies. If that is the case, we are likely to be lovers of sculpture in the round. All sculpture always evokes our outward sensations and sometimes our inward sensations. Sculpture in the round often evokes our inward sensations, for such sculpture often is anthropomorphic in some respect. And sculpture in the round that has the human body as its subject matter not only often evokes our inward sensations but also interprets them—as in the *Aphrodite* (Figure 5-7), Michelangelo's *David* (Figure 5-8), or Rodin's *Danaïde* (Figure 5-9).

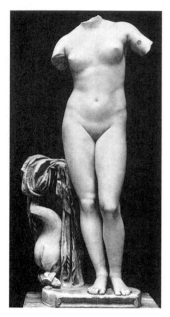

FIGURE 5-7
Aphrodite. First century B.C. Marble, slightly under life size. Found at Cyrene. Museo Nazionale delle Terme, Rome.

A Roman copy of a Greek original, this is an example of the idealization of human form interpreted by ancient sculptors.

PERCEPTION KEY *Aphrodite* and *Venus*

The marble *Aphrodite* (Figure 5-7), slightly under life size, is a Roman copy of a Greek original of the first century B.C. It is extraordinary both for the delicacy of its carving—for most Roman copies of Greek works crudely deaden their liveliness—and the translucency of its marble, which seems to reflect light from below its surface. Compare this work with Giorgione's *Venus* (Figure 2-17).

1. In both these works, graceful lassitude and sexuality have something to do with their subject matter. Yet they are interpreted, we think, quite differently. What do you think?
2. If the head and arms of the *Venus* were obliterated, would this injure the work more than in the *Aphrodite*? If so, why? Some critics claim that the *Aphrodite* is not very seriously injured as an artistic object by the destruction of her head and arms. Yet how can this be? Suppose the *Aphrodite* were to come off her pedestal and walk. Would you not find this monstrous? Yet many people treasure her as one of the most beautiful of all female sculptures. How is this to be explained?

Rodin, one of the greatest sculptors of the human body, wrote that

instead of imagining the different parts of the body as surfaces more or less flat, I represented them as projections of interior volumes. I forced myself to express in each swelling of the torso or of the limbs the efflorescence of a muscle or a bone which lay beneath the skin. And so the truth of my figures, instead of being merely superficial, seems to blossom forth from within to the outside, like life itself.[3]

Aphrodite, David, and *Danaïde* present **objective correlatives**—images that are objective in the sense that they are "out there" and yet correlate or are

[3]Auguste Rodin, *Art,* trans. Romilly Fedden (Boston: Small, 1912), p. 65.

similar to subjective awareness. All three clarify internal bodily sensations as well as outward appearance. These are large claims and highly speculative. You may disagree, of course, but we hope they will stimulate your thinking.

When we participate with sculpture such as the *Aphrodite*, we find something of our bodily selves confronting us. If we demanded all of our bodily selves, we would be both disappointed and stupid. Art is always a transformation of reality, never a duplication. Thus the absence of head and arms in the *Aphrodite* does not shock us as it would if we were confronting a real woman. Nor does their absence ruin our perception of its beauty. Even before the damage, the work was only a partial image of a female. Now the *Aphrodite* is even more partial. But, even so, she is in that partiality exceptionally substantial. The *Aphrodite* is substantial because the female shape, texture, grace, sensuality, sexuality, and beauty are interpreted by a form and thus clarified.

The human body is supremely beautiful. To begin with, there is its sensuous charm. There may be other things in the world as sensuously attractive—for example, the full glory of autumn leaves—but the human body also possesses a sexuality that greatly enhances its sensuousness. Moreover, in the human body, mind is incarnate. Feeling, thought, purposefulness—spirit—have taken shape. Thus the absent head of the *Aphrodite* is not really so absent after all. There is a dignity of spirit that permeates her body. It is the manifestation of Aphrodite's composed spirit in the shaping of her body that, in the final analysis, explains why we are not repulsed by the absence of the head and arms.

Compare Michelangelo's *David* (Figure 5-8) and *Pietà* (Figure 5-5) with the *Aphrodite*.

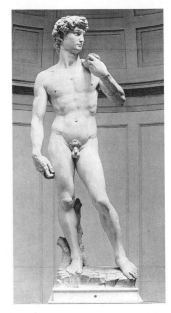

FIGURE 5-8
Michelangelo Buonarroti, *David*. 1501–1504. Marble, 13 feet high. Accademia, Florence.

The heroic-size *David* stood as Florence's warning to powers that might consider attacking the city-state. It represents Michelangelo's idealization of the human form and remains a Renaissance ideal.

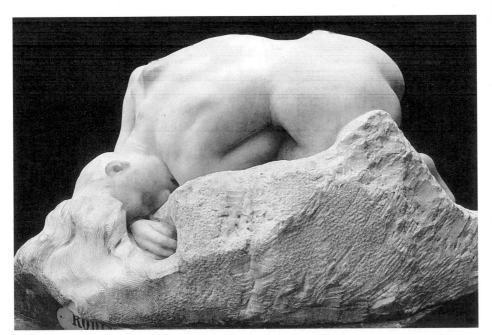

FIGURE 5-9
Auguste Rodin, *Danaïde*. 1885. Marble, approximately 14 × 28 × 22 inches. Musée Rodin, Paris.

Danaïde is from a Greek myth in which the fifty daughters of Danaos were ordered to kill their fifty husbands, sons of Argos, on their wedding night. All complied but the one Rodin portrays here in sensuous carving.

115

EXPERIENCING Sculpture and Physical Size

1. The sculptor Henry Moore claims that "sculpture is more affected by actual size considerations than painting. A painting is isolated by a frame from its surroundings (unless it serves just a decorative purpose) and so retains more easily its own imaginary scale." He makes the further claim that the actual physical size of sculpture has an emotional meaning. "We relate everything to our own size, and our emotional response to size is controlled by the fact that men on the average are between five and six feet high."[4] Now look at *Five Swords,* by Alexander Calder (Figure 5-10), and compare it to *David* and the *Danaïde.* Does the fact that *Five Swords* is much larger than *David,* which in turn is larger in size than the *Danaïde,* make any significant difference with respect to your tactile sensations?

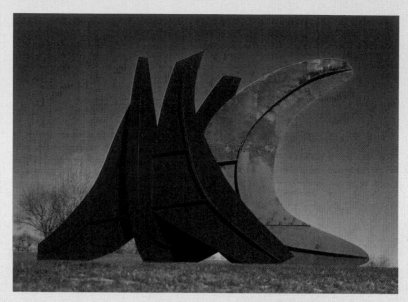

FIGURE 5-10
Alexander Calder, *Five Swords.* 1976. Sheet metal, bolts, paint, 213 × 264 × 348 inches.

Calder's sculpture implies by its form that the swords have been turned into plowshares, which may be seen as a monument to the end of the Vietnam War, America's longest modern war.

Size in sculpture can be significant for many reasons. Michelangelo intentionally made *David* large as a political statement in Florence. The great Renaissance sculptor Donatello had created an earlier *David* that was slightly smaller than a life-size boy, partly as a way of emphasizing the fact that the small warrior defeated the large warrior. But Michelangelo's heroic-size figure was a warning to other Italian city-states that Florence was not easy pickings at a time when regional wars were common.

Rodin's *Danaïde* is much smaller than the *David,* but its expressiveness, as Rodin suggests, is considerable despite its size. This sculpture, unlike Calder's and Michelangelo's, is not intended as an outdoor monument. Rather, it is an intimate piece designed to be close to the viewer, even close enough to tempt the viewer to touch and sense its tactile repertoire, from smooth to rough.

Five Swords is a gigantic structure, not in marble, but in steel panels painted a brilliant color. Calder's work needs to have space around it, which is one reason why it is located in a huge parklike setting. We are arrested by the sensa of this piece, and its hugeness when we are near it is an important part of the sensa. Calder's ideas about size are naturally influenced by his own practice as a sculptor of monumental works, some of which dominate huge public spaces in major cities. Unfortunately, photographs in this book can only suggest the differences in size, but if you spend time with sculpture in its own setting, consider how much the size of the work affects your capacity to participate with it.

2. Find and photograph a sculpture whose size seems to contribute importantly to its impact. In your photograph, try to provide a visual clue that would help a viewer see whether the object is huge or tiny.
3. To what extent does your respect for size affect your response to the sculpture?

[4]Moore, "Notes on Sculpture," p. xxxiv.

Developments in sculpture are emerging and changing so rapidly that no attempt can be made here even to begin to classify them adequately. But adding to the traditional species (relief sculpture and sculpture in the round), at least five new species have taken hold: space, protest against technology, accommodation with technology, machine, and earth sculpture. In most contemporary sculpture, however diverse, there is one fairly pervasive characteristic: ***truth to materials,*** more of a reaffirmation than an innovation.

TRUTH TO MATERIALS

In the flamboyant eighteenth-century *Baroque* and in some of the *Romanticism* of the later nineteenth century, respect for materials tended to be ignored. Karl Knappe referred to a "crisis" in the early twentieth century that "concerns . . . the artistic media":

> An image cannot be created without regard for the laws of nature, and each kind of material has natural laws of its own. Every block of stone, every piece of wood is subject to its own rules. Every medium has, so to speak, its own tempo; the tempo of a pencil or a piece of charcoal is quite different from the tempo of a woodcut. The habit of mind which creates, for instance, a pen drawing cannot simply be applied mechanically to the making of a woodcut; to do this would be to deny the validity of the spiritual as well as the technical tempo.[5]

PERCEPTION KEY Truth to Materials

1. Examine the examples of twentieth-century sculpture in the book. Assuming that these examples are fairly representative, do you find a pervasive tendency to truth to materials? Do you find exceptions, and, if so, how might these be explained?
2. Henry Moore has stated that "Every material has its own individual qualities. It is only when the sculptor works direct, when there is an active relationship with his material, that the material can take its part in the shaping of an idea. Stone, for example, is hard and concentrated and should not be falsified to look like soft flesh—it should not be forced beyond its constructive build to a point of weakness. It should keep its hard tense stoniness."[6] Does *Recumbent Figure* (Figure 5-11) illustrate Moore's point? If so, point out as specifically as possible how this is done.

The *Maternity Group Figure* (Figure 5-12), from Nigeria, is notable for its respect for materials. The wood is grooved, ridged, and carved in ways that make its woodiness all the more apparent. Societies in which technology has not been dominant live closer to nature than we do, and so their feeling for natural things, such as stone and wood, feathers and bone, is usually reverent.

[5]Karl Knappe, quoted in Kurt Herberts, *The Complete Book of Artists' Techniques* (London: Thames and Hudson, 1958), p. 16. Published in the United States by Frederick A. Praeger.
[6]Quoted by Herbert Read, *Henry Moore, Sculptor* (London: A. Zwemmer, 1934), p. 29.

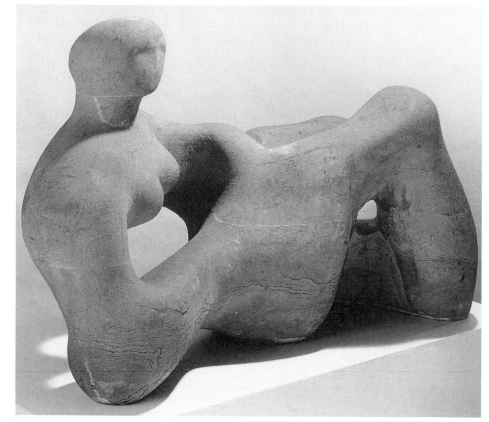

FIGURE 5-11
Henry Moore, *Recumbent Figure*. 1938. Green Hornton stone, 54 inches long.

Recumbent Figure is one of an enormous number of similar sculptures by Moore in both stone and bronze. This stone piece distorts the figure in ways reminiscent of Picasso's paintings of the same period.

As technology has gained more and more ascendancy, reverence toward natural things has receded. In highly industrialized societies, people tend to revere artificial things, and the pollution of our environment is one result. Another result is the flooding of the commercial market with imitations of primitive sculpture, which are easily identified because of the lack of truth to the materials (test this for yourself). Even contemporary sculptors have lost some of their innocence toward things simply because they live in a technological age. Many sculptors still possess something of the natural way of feeling things, and so they find inspiration in primitive sculpture. Despite its abstract subject matter, Barbara Hepworth's *Pelagos* (Figure 5-13), with its reverence to wood, has a close spiritual affinity to the *Maternity Group Figure*. Truth to materials sculpture is an implicit protest against technological ascendancy.

SPACE SCULPTURE

Space sculpture emphasizes spatial relationships and tends to deemphasize the density of materials. Space sculpture, however, never completely loses its ties to the materiality of its materials. Otherwise, tactile qualities would be largely missing also, and then it would be doubtful if such work could usefully be classified as sculpture. Naum Gabo, one of the fathers of space sculpture, often uses translucent materials, as in *Spiral Theme*

(Figure 5-14). Although the planes of plastic divide space with multidirectional movement, no visual barriers develop. Each plane varies in translucency as our angle of vision varies, and in seeing through each, we see them all—allowing for free-flowing transitions between the space without and the space within. In turn, the tactile attraction of the plastic, especially its smooth surface and rapid fluidity, is enhanced. As Gabo has written,

> Volume still remains one of the fundamental attributes of sculpture, and we still use it in our sculptures. . . . We are not at all intending to dematerialize a sculptural work. . . . On the contrary, adding Space perception to the perception of Masses, emphasizing it and forming it, we enrich the expression of Mass, making it more essential through the contact between them whereby Mass retains its solidity and Space its extension.[7]

PERCEPTION KEY Recumbent Figure, Pelagos, and Brussels Construction

1. Compare Moore's *Recumbent Figure* (Figure 5-11), Hepworth's *Pelagos* (Figure 5-13), and Rivera's *Brussels Construction* (Figure 5-15). Is there in these works, as Gabo claims for his, an equal emphasis on mass and space? If not, in which ones does mass dominate space? Vice versa?
2. Moore has written that "The first hole made through a piece of stone [or most three-dimensional materials] is a revelation. The hole connects one side to the other, making it immediately more three-dimensional. A hole can itself have as

(continued)

[7]Quoted by Herbert Read and Leslie Martin in *Gabo: Constructions, Sculpture, Drawings, Engravings* (Cambridge, Mass: Harvard University Press, 1957), p. 168.

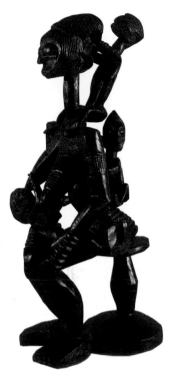

FIGURE 5-12
Maternity Group Figure. Afo peoples, Nigeria. Nineteenth century. Wood, 27¾ inches high. Horniman Museum & Gardens, London.

This figure is one of the African spiritual pieces that inspired modern European painters in the early twentieth century.

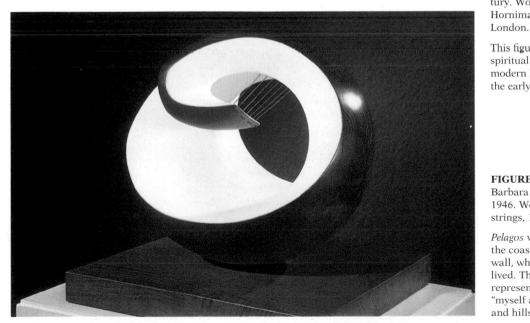

FIGURE 5-13
Barbara Hepworth, *Pelagos.* 1946. Wood with color and strings, 16 inches in diameter.

Pelagos was inspired by a bay on the coastline of St. Ives in Cornwall, where Barbara Hepworth lived. The strings, she said, represent the tension between "myself and the sea, the wind and hills."

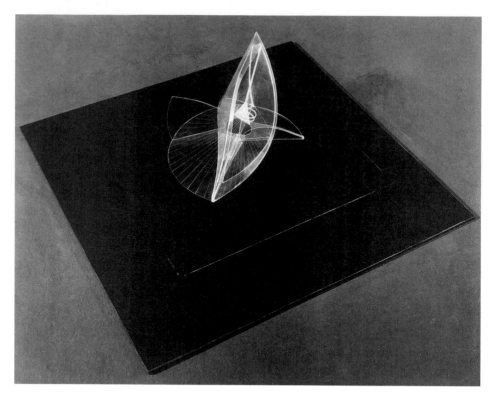

FIGURE 5-14
Naum Gabo, *Spiral Theme*. 1941.
Construction in plastic, 5½ ×
13¼ × 9⅜ inches (14 × 33.6 ×
23.7 cm), on base 24 inches
(61 cm) square. Museum of
Modern Art, New York. Advisory
Committee Fund.

Gabo's construction in plas-
tic was heralded by the critic
Herbert Read as "the highest
point ever reached by the aes-
thetic intuition of man," but
Gabo himself was at a loss for
why the sculpture produced so
much public admiration.

much shape-meaning as a solid mass."[8] Is Moore's claim equally applicable to the
Hepworth and the Rivera?

3. How many holes are there in *Pelagos*? What is the function of the strings? Why did
Hepworth color the inside white? Hepworth said, "The colour in the concavities
plunged me into the depth of water, caves or shadows . . . the strings were the ten-
sion I felt between myself and the sea, the wind, and the hills." Are her comments
helpful in responding to the work?

4. *Brussels Construction* is mounted on a flat disk turned by a low-revolution motor. Is
it useful to refer to holes in this sculpture? The three-dimensional curve of *Brussels
Construction* proceeds in a long, smooth, continuous flow. Does this have anything
to do with the changing diameter of the chromium-plated stainless steel? Suppose
the material absorbed rather than reflected light. Would this change the structure
significantly? Do you think this sculpture should be displayed under diffused light
or in dim illumination with one or more spotlights? Is there any reference to human
life in the simplicity and elegant vitality of this work? Or is the subject matter just
about stainless steel and space? Or is the subject matter about something else?
Do you agree that this work is an example of space sculpture? And what about
Pelagos? Note that there is no assemblage of pieces in the case of *Brussels Construc-
tion*, whereas, because of the addition of strings, there is some assemblage in *Pelagos*.
Would you classify Figures 5-11, 5-13, 5-14, and 5-15 as space sculptures?

[8]Moore, "Notes on Sculpture," p. xxxiv.

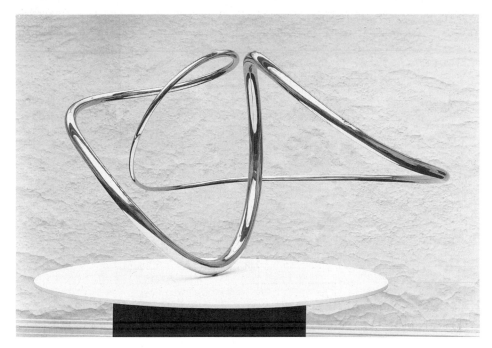

FIGURE 5-15
Jose de Rivera, *Brussels Construction*. 1958. Stainless steel. Art Institute of Chicago. Gift of Mr. and Mrs. R. Howard Goldsmith.

Brussels Construction was done for the Brussels World's Fair. Rivera, a Louisianan, said his work "represents nothing but itself."

It seems to us that *Pelagos* and *Recumbent Figure* are not space sculptures because, although they open up space within, the density of their materials dominates space. *Brussels Construction,* in contrast, is space sculpture because the spatial relationships are at least as interesting as the stainless steel. The fact that *Pelagos* was assembled in part and *Brussels Construction* was not is not conclusive. Assemblage is the technique generally used in space sculpture, but what we are perceiving and should be judging is the product, not the producing process. Of course, the producing process affects what is produced, and that is why it can be helpful to know about the producing process. That is why we went into some detail about the differences between modeling, carving, and assemblage. But the basis of a sound judgment about a work of art is that work as it is given to us in perception. Any kind of background information is relevant provided it aids that perception. But if we permit the producing process rather than the work of art itself to be the basis of our judgment, we are led away from, rather than into, the work. This destroys the usefulness of criticism.

PROTEST AGAINST TECHNOLOGY

Explicit social protest is part of the subject matter of the works we will discuss by Trova, Segal, and Giacometti, although perhaps only in *Study: Falling Man (Wheel Man)* (Figure 5-16) is that protest unequivocally directed at technology. Flaccid, faceless, and sexless, this anonymous robot has "grown"

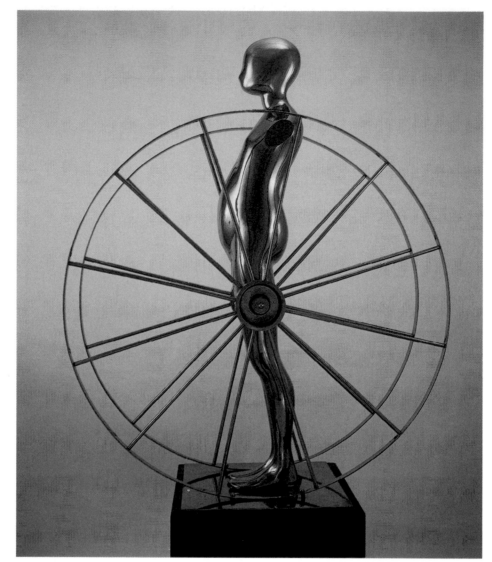

FIGURE 5-16
Ernest Trova, *Study: Falling Man (Wheel Man)*. 1965. Silicon bronze, 60 × 48 × 20¹³⁄₁₆ inches. Collection, Walker Art Center, Minneapolis. Gift of the T. B. Walker Foundation, 1965.

Trova's sculpture portrays man as part of a machine, implying that in the machine age humans are becoming less and less human. Consider the unidealized human figure in comparison with the Greek ideal.

spoked wheels instead of arms. Attached below the hips, these mechanisms produce a sense of eerie instability, a feeling that this antiseptically cleansed automaton with the slack, protruding abdomen may tip over from the slightest push. In this inhuman mechanical purity, no free will is left to resist. Human value, as articulated in Aldous Huxley's *Brave New World*, has been reduced to human power, functions performed in the world of goods and services. Since another individual can also perform these functions, the given person has no special worth. His or her value is a unit that can easily be replaced by another.

The Bus Driver (Figure 5-17) is an example of environmental sculpture. Grimly set behind a wheel and coin box taken from an old bus, the

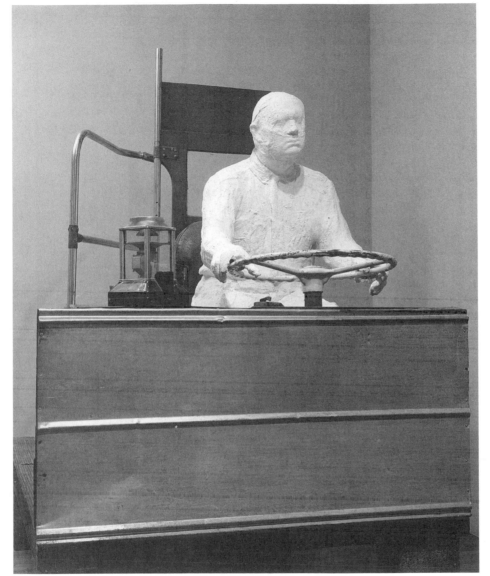

driver is a plaster cast made in sections over a living, well-greased human model. Despite the "real" environment and model, the stark white figure with its rough and generalized features is both real and strangely unreal. In the air around him, we sense the hubbub of the streets, the smell of fumes, the ceaseless comings and goings of unknown customers. Yet, despite all these suggestions of a crowded, nervous atmosphere, there is a heartrending loneliness about this driver. Worn down day after day by the same grind, Segal's man, like Trova's, has been flattened into an x—a quantity.

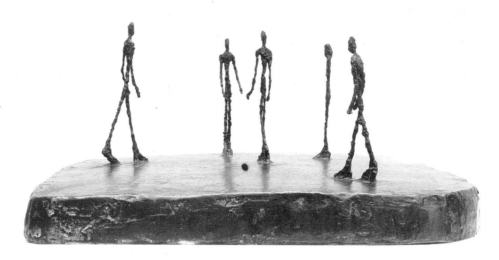

FIGURE 5-18
Alberto Giacometti, Swiss, 1901–1965, *City Square (La Place)*. 1948. Bronze, 8½ × 25⅜ × 17¼ inches (21.6 × 64.5 × 43.8 cm). Museum of Modern Art, New York. Purchase.

This is one of a series of sculptures that became emblematic of the alienation of modern life in the decade following the end of World War II.

In Giacometti's emaciated figures (Figure 5-18), the huge, solidly implanted feet suggest nostalgia for the earth; the soaring upward of the elongated bodies suggests aspiration for the heavens. The surrounding environment has eaten away at the flesh, leaving lumpy, irregular surfaces with dark hollows that bore into the bone. Each figure is without bodily or mental contact with anyone, as despairingly isolated as *The Bus Driver*. They stand in or walk through an utterly alienated space, but, unlike *Falling Man*, they seem to know it. And whereas the habitat of *Falling Man* is the clean, air-conditioned factory or office of *Brave New World*, Giacometti's people, even when in neat galleries, always seem to be in the grubby streets of our decaying cities. The cancer of the city has left only the armatures of bodies stained with pollution and scarred with sickness. There is no center in this city square or any particular exit, nor can we imagine any communication among these citizens. Their very grouping in the square gives them, paradoxically, an even greater feeling of isolation. Each Giacometti figure separates a spot of space from the common place. The disease and utter distress of these vulnerable creatures demand our respectful distance, as if they were lepers to whom help must come, if at all, from some public agency. To blame technology entirely for the dehumanization of society interpreted in these sculptures is an oversimplification, of course. But this kind of work does bring out something of the horror of technology when it is misused.

ACCOMMODATION WITH TECHNOLOGY

Many contemporary sculptors see in technology blessings for humankind. It is true that sculpture can be accomplished with the most primitive tools (that, incidentally, is one of the basic reasons sculpture in primitive cultures usually not only precedes painting but also usually dominates both qualitatively and quantitatively). Nevertheless, sculpture in our day, far more than

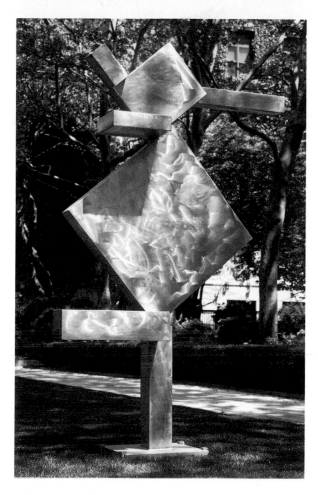

FIGURE 5-19
David Smith, American, 1906–1965, *Cubi X*. 1963. Stainless steel, 10 feet 1⅜ inches × 6 feet 6¾ inches × 2 feet (308.3 × 199.9 × 61 cm), including steel base 2⅞ × 25 × 23 inches (7.3 × 63.4 × 58.3 cm). Museum of Modern Art, New York. Robert O. Lord Fund.

Cubi X, is Smith's cubistic experiment representing a human figure in planes of polished steel, akin to the cubistic paintings of Picasso and others. Smith produced a wide collection of *Cubi* sculptures.

painting, can take advantage of some of the most sophisticated advances of technology, surpassed in this respect only by architecture. Many sculptors today interpret the positive rather than the negative aspects of technology. This respect for technology is expressed by truth to its materials and the showing forth of its methodology.

David Smith's *Cubi X* (Figure 5-19), like Chryssa's *Times Square Sky* (Figure 5-3), illustrates truth to technological materials. But unlike Chryssa, Smith usually accomplishes this by wedding these materials to nature. The stainless steel cylinders of *Cubi X* support a juggling act of hollow rectangular and square cubes that barely touch one another as they cantilever out into space. Delicate buffing modulates the bright planes of steel, giving the illusion of several atmospheric depths and reflecting light like rippling water. Smith writes,

> I like outdoor sculpture and the most practical thing for outdoor sculpture is
> stainless steel, and I make them and I polish them in such a way that on a dull
> day, they take on the dull blue, or the color of the sky in late afternoon sun, the

glow, golden like the rays, the colors of nature. And in a particular sense, I have used atmosphere in a reflective way on the surfaces. They are colored by the sky and the surroundings, the green or blue of water. Some are down by the water and some are by the mountains. They reflect the colors. They are designed for outdoors.[9]

But Smith's steel is not just a mirror, for in the reflections the fluid surfaces and tensile strength of the steel emerge in a structure that, as Smith puts it, "can face the sun and hold its own."

MACHINE SCULPTURE

Some avant-garde sculptors are interested in revealing the machine and its powers. For example, George Rickey's *Two Lines—Temporal I* (Figure 5-20) is kinetic, or moving, sculpture; but the motion of **machine sculpture,** unlike this work, is primarily a result of mechanical rather than natural forces. Sculptors in this tradition, going back to the ideas and work of László Moholy-Nagy after World War I, welcome the machine and its sculptural possibilities. Rivera hides his machine under *Brussels Construction* (Figure 5-15), but many machine sculptors expose their machines. They are interested not only in the power of the machine but also in the mechanisms that make that power possible. Rickey, the literary prophet of machine sculpture, writes that "A machine is not a projection of anything. The crank-shaft exists in its own right; it is the image. . . . The concreteness of machines is heartening."[10]

FIGURE 5-20
George Rickey, *Two Lines—Temporal I.* 1964. Two stainless steel mobile blades on a stainless steel base, overall height 35 feet 4⅝ inches (10.79 m); blades 31 feet ¾ inches (946.8 cm) and 31 feet 1¼ inches (948.5 cm) long; base 8 feet 11¼ inches (247 cm) high; weight 498 lbs (not including extra weights). Museum of Modern Art, New York. Mrs. Simon Guggenheim Fund.

Two Lines–Temporal I is characteristic of Rickey's kinetic sculpture. Originally a painter, he devised the bearings that were needed to insure the proper movement of the arms of his sculpture. The arms move very slowly.

Art © Estate of George Rickey/Licensed by VAGA, New York, NY.

> **PERCEPTION KEY** *Two Lines—Temporal I* and *Homage to New York*
>
> 1. Although depending upon air current for its motion, Rickey's *Two Lines—Temporal I* is basically a machine—two 35-foot stainless steel blades balanced on knife-edge fulcrums. Does its subject matter include more than just machinery? As you reflect about this, can you imagine perhaps more appropriate places than the Museum of Modern Art for this work?
> 2. Is Jean Tinguely's *Homage to New York* (Figure 5-21) an image of a machine? Or does its subject matter include more than just machinery?

A good case can be made, we believe, for placing *Two Lines—Temporal I* in a grove of tall trees. Despite its mechanical character, this work belongs in nature. Otherwise, the lyrical poetry of its gentle swaying tends to be reduced to a metronome. But even in its location in New York, it is much

[9]David Smith in Cleve Gray, ed., *David Smith* (New York: Holt, Rinehart and Winston, 1968), p. 123.

[10]George Rickey, *Art and Artist* (Berkeley: University of California Press, 1956), p. 172.

FIGURE 5-21
Jean Tinguely, *Homage to New York*. 1960. Mixed media. Exhibited at the Museum of Modern Art, New York.

Homage to New York was exhibited in the sculpture garden of the Museum of Modern Art in New York, where it operated for some twenty-seven minutes until it destroyed itself. This was a late Dadaist experiment.

more than just an image of machinery. *Two Lines—Temporal I* suggests something of the skeletal structure and vertical stretch of the buildings in New York City as we see them rising to the sky as well as something of the sway of the skyscrapers against the sky.

Jean Tinguely is dedicated to humanizing the machine. His *Homage to New York* (Figure 5-21), exhibited at the Museum of Modern Art in 1960,

is a better example than *Two Lines—Temporal I* of the image of the machine in its own right. The mechanical parts, collected from junk heaps and dismembered from their original machines, stood out sharply, and yet they were linked by their spatial locations, shapes, and textures, and sometimes by nervelike wires. Only the old player piano was intact. As the piano played, it was accompanied by howls and other weird sounds in irregular patterns that seemed to be issuing from the wheels, gears, and rods, as if they were painfully communicating with one another in some form of mechanical speech. Some of the machinery that runs New York City was exposed as vulnerable, pathetic, and comic, but Tinguely humanized this machinery as he exposed it. Even death was suggested, for *Homage to New York* was self-destructing: The piano was electronically wired for burning, and, in turn, the whole structure collapsed.

EARTH SCULPTURE

Another avant-garde sculpture—***earth sculpture***—goes so far as to make the earth itself the medium, the site, and the subject matter. The proper spatial selection becomes absolutely essential, for the earth usually must be taken where it is found. Structures are traced in plains, meadows, sand, snow, and the like, in order to help make us stop and perceive and enjoy the "form site"—the earth transformed to be more meaningful. Usually nature rapidly breaks up the form and returns the site to its less ordered state. Accordingly, many earth sculptors have a special need for the photographer to preserve their art.

Robert Smithson was a pioneer in earthwork sculpture. One of his best-known works is *Spiral Jetty* (Figure 5-22), a 1,500-foot-long coil 15 feet wide that spirals out from a spot on the Great Salt Lake. It is constructed of "mud, precipitated salt crystals, rocks, water," and colorful algae, all of which is now submerged in the lake. At times it reemerges when the water level is low. Because the sculpture is usually hidden, it exists for most viewers only in photographs. This mode of existence offers some interesting problems for those who question the authenticity of such works.

PERCEPTION KEY *Spiral Jetty*

1. Does the fact that the sculpture is usually submerged and invisible disqualify it as a work of art? How important is it for such a work to be photographed artistically?
2. Would you like to see a work of this kind in a lake near you?
3. What would be the best vantage point to observe and participate with *Spiral Jetty*?
4. How does Smithson's use of the spiral connect this sculpture with its natural surroundings?

FIGURE 5-22
Robert Smithson, *Spiral Jetty*.
1970. Rock, salt crystals, earth,
algae; coil length 1,500 feet.
Great Salt Lake, Utah (now
submerged).

Reaching 1,500 feet into the
Great Salt Lake is one of the
first and most influential of
large earth sculptures. Utah of-
ficials stopped a recent move to
drill for oil nearby.

SCULPTURE IN PUBLIC PLACES

Sculpture has traditionally shared its location with major buildings, some-
times acting as decoration on the building, as in many churches, or acting
as a center point of interest, as in the original placement of Michelangelo's
David, which was positioned carefully in front of the Palazzo Vecchio, the
central building of the Florentine government. It stood as a warning not to
underestimate the Florentines. Many small towns throughout the world have
public sculpture that commemorates wars or other important events.

One of the most popularly successful of contemporary public sculp-
tures has been Maya Ying Lin's *Vietnam Veterans Memorial* (Figure 5-23)
in Washington, D.C. Because the Vietnam War was both terribly unpopular
and a major defeat, there were fears that any memorial might stir public
antagonism. However, the result has been quite the opposite. The piece is a
sloping black granite wall, V-shaped, which descends ten feet below grade.
On the wall are engraved more than 58,000 names of dead Americans. Visi-
tors walk along its length, absorbing the seemingly endless list of names.
The impact of the memorial grows in part because the list of names grows
with each step down the slope. Visitors respond to the memorial by touch-
ing the names, sometimes taking rubbings away with them, sometimes sim-
ply weeping.

Maya Lin's *Vietnam Veterans Memorial* was a controversial public sculp-
ture when it was first unveiled, but has become a most popular attraction

FIGURE 5-23
Maya Ying Lin, *Vietnam Veterans Memorial.* 1982. Black granite, V-shaped, 493 feet long, 10 feet high at center. Washington, D.C.

Lin designed the memorial when she was an undergraduate. One angle of the wall points to the Washington Monument, the other to the Lincoln Memorial. Its V-shape below the ground was intended to suggest a wound in the earth. Incised on it are the names of 58,256 fallen American warriors.

both in its place in Washington, D.C., and as a replica tours around the country. Judy Chicago's *The Dinner Party* (Figure 5-24), in the midst of a powerful wave of feminist activity in the late 1970s, was celebrated by feminists and denounced by opponents of the movement. Although it is not public sculpture in the sense that it is on view outdoors, it once toured the country and attracted huge crowds. It is now in the permanent collection of the Brooklyn Museum of Art. The sculpture includes place settings for thirty-nine mythic and historical women such as Ishtar, Hatshepsut, Sacagawea, Mary Wollstonecraft, Sojourner Truth, Emily Dickinson, and Virginia Woolf. Each place setting has embroidery, napkins, place settings, and a plate with a butterfly design that alludes to female genitalia—one reason for protest against the work. Judy Chicago oversaw the project, but it is the work of many women working in crafts traditionally associated with women, such as sewing and embroidery.

Study (with imagination) Serra's *Sequence* (Figure 5-25), four huge torqued Car-Ten steel plates installed in the garden of the Museum of Modern Art in summer 2007. We are—as never before—immersed in sculptural space. At both ends we have the chance of entering through one of two openings—one leads into a containment center of settled space, the other pulls us into a seemingly endless curvilinear corridor between two brutal, looming steel walls. Yet strangely, if we wait, we see on the steel intriguing textures and beautiful orange-rust patterns sculpted by time. Still we may feel compressed, confused, perhaps even a touch fearful. To go back is not

FIGURE 5-24
Judy Chicago, *The Dinner Party*. 1979. Mixed media, each side 48 feet. Elizabeth A. Sackler Center, Brooklyn Museum of Art.

The Dinner Party consists of thirty-nine place settings for important women of myth and history. The work was produced by a collective of women sewing, embroidering, and weaving to complement the elaborately designed plates.

necessarily an appealing option, for the spaces are narrow, and where are we anyhow? Normal spatial perception is undermined. The walls appear to close both behind and over us. They seem to sway, and so does the floor. At last we come to the center, overcome with wonder.

PERCEPTION KEY Public Sculpture

1. Public sculpture such as that by Maya Lin, Richard Serra, and Judy Chicago usually produces tremendous controversy when it is not representative, such as a conventional statue of a man on a horse, a hero holding a rifle and flag, or person of local fame. What do you think causes these more abstract works to attract controversy? Do you react negatively or positively to any of these three works?
2. Should artists who plan public sculpture meant to be viewed by a wide-ranging audience aim at pleasing that audience? Should that be their primary mission, or should they simply make the best work they are capable of?
3. Which of the three, *Vietnam Veterans Memorial, Sequence 2006,* or *The Dinner Party,* seems least like a work of art to you? Try to convince someone who disagrees with you that it is not a work of art.
4. Choose a public sculpture that is in your community, photograph it, and establish its credentials, as best you can, for making a claim to being an important work of art.
5. If we label Chicago's *The Dinner Party* a feminist work, is it then to be treated as political sculpture? Do you think Lin's *Vietnam Veterans Memorial* is a less political or more political sculpture than Chicago's work? Could Serra's *Sequence* be considered a political work? Would labeling these works as political render them any less important as works of art?

FIGURE 5-25
Richard Serra, *Sequence,* 2006. Cor-Ten steel, 12 feet 9 inches × 40 feet 8⅜ inches × 65 feet 2³⁄₁₆ inches.

People walk around and in, this gigantic work, in which the walls are torqued in such a way as to lean toward the viewer. Critic Ronald Paulson calls Serra the greatest modern sculptor, perhaps the greatest sculptor.

SUMMARY

Sculpture is perceived differently from painting, engaging more acutely our sense of touch and the feeling of our bodies. Whereas painting is more about the visual appearance of things, sculpture is more about things as three-dimensional masses. Whereas painting only represents voluminosity and density, sculpture presents these qualities. Sculpture in the round, especially, brings out the three-dimensionality of objects. No object is more important to us than our bodies, and its "strange thickness" is always with us. When the human body is the subject matter, sculpture more than any other art reveals a material counterpoint for our mental images of our bodies. Traditional sculpture is made by either modeling or carving. Many contemporary sculptures, however, are made by assembling preformed pieces of material. New sculptural techniques and materials have opened developments in avant-garde sculpture that defy classification. Nonetheless, contemporary sculptors, generally, have emphasized truth to materials, respect for the medium that is organized by their forms. Space, protest against technology, accommodation with technology, machine, and earth sculpture are five of the most important new species. Public sculpture is flourishing.

Chapter 6

ARCHITECTURE

Buildings constantly assault us. Our only temporary escape is to the increasingly less accessible wilderness. We can close the novel, shut off the music, refuse to go to a play or dance, sleep through a movie, shut our eyes to a painting or a sculpture. But we cannot escape from buildings for very long, even in the wilderness. Fortunately, however, sometimes buildings are works of art—that is, architecture. They draw us to them rather than push us away or make us ignore them. They make our living space more livable. Architecture is the shaping of buildings and space.

CENTERED SPACE

Painters do not command real three-dimensional space: They feign it. Sculptors can mold out into space, but generally they do not enfold an enclosed or inner space for our movement. The holes in the sculpture by Henry Moore (Figure 5-11), for example, are to be walked around, not into, whereas our passage through the inner spaces of architecture is one of the conditions under which its solids and voids have their effect. In a sense, architecture is a great hollowed-out sculpture that we perceive by moving about both outside and inside. Space is the material of the architect, the primeval cutter,[1] who carves apart an inner space from an outer

[1]This meaning is suggested by the Greek *architectón*.

FIGURE 6-1
Gian Lorenzo Bernini, the Piazza before St. Peter's, Rome. 1656–1667.

Bernini created a space large enough to permit thousands to see the pope offer his blessings. The Egyptian obelisk centers the space, and the two fountains on a design by Maderno give it balance. The colonnades on each side create a sense of awe.

space in such a way that both spaces become more fully perceptible and interesting.

Inner and outer space come together on the earth to form a centered and illuminated context or clearing. ***Centered space*** is the arrangement of things around some paramount thing—the place at which the other things seem to converge. Sometimes this center is a natural site, such as a great mountain, river, canyon, or forest. Sometimes the center is a natural site enhanced by a human-made structure.

Centered space is centripetal, insisting upon drawing us in. There is an in-rush that is difficult to escape, that overwhelms and makes us acquiescent. We perceive space not as a receptacle containing things but rather as a context energized by the positioned interrelationships of things. Centered space has a pulling power that, even in our most harassed moments, we can hardly help feeling. In such places as the piazza before St. Peter's (Figure 6-1), we walk slowly and speak softly. We find ourselves in the presence of a power beyond our control. We feel the sublimity of space, but, at the same time, the centeredness beckons and welcomes us.

SPACE AND ARCHITECTURE

Architecture—as opposed to mere engineering—is the creative conservation of space. Architects perceive the centers of space in nature and build to preserve these centers and make them more vital. Architects are confronted

by centered spaces that desire to be made, through them, into works. These spaces of nature are not offspring of architects alone but appearances that step up to them, so to speak, and demand protection. If an architect succeeds in carrying through these appeals, the power of the natural space streams forth and the work rises. Architects are the shepherds of space. In turn, the paths around their shelters lead us away from our ordinary preoccupations demanding the use of space. We come to rest. Instead of our using up space, space takes possession of us with a ten-fingered grasp. We have a place to dwell.

The architect typically shelters inner space from outer space in such a way that we can use the inner space for practical purposes at the same time we perceive both spaces and their relationships as more interesting, thus evoking participation. The partitioning of space renders invisible air visible. Inside the building, space is filled with stresses and pressures. Outside the building, space becomes organized and focused. Inner space is anchored to the earth. Outer space converges upon inner space. Sunlight, rain, snow, mist, and night fall gracefully upon the cover protecting the inner space as if drawn by a channeled and purposeful gravity, as if these events of the outside belonged to the inside as much as the earth from which the building rises. Inner and outer space are formed over the earth by the architect to create a centered and illuminated clearing.

Centered space is the positioned interrelationships of things organized *around* some paramount thing as the place to which the other things appear to belong. If we are near such buildings, we tend to be drawn to them—unless practical urgencies have desensitized our senses either momentarily or habitually—for centered space has an overpowering dynamism that captures our attention and orients our bodies. Centered space propels us out of the ordinary modes of experiencing in which spatial relations are perceived mainly as a means to get somewhere. With centered space, we are encouraged to perceive space not abstractly as a receptacle containing things, but rather as a receptacle within which we are drawn by the power of the positioned interrelationships of things.

Architecture generally creates a strengthened hierarchy in the positioned interrelationships of earth and sky and what is in between. Architecture enhances the centered clearings of nature, accentuating a context in which all our senses can be in harmony with their surroundings. And even when architecture is not present, our memories of architecture, especially of great buildings, teach us how to order the sensations of our natural environment. Aristotle said, "Art completes nature." Every natural environment, unless it has been ruined by man, lends itself to centering and ordering, even if no architecture is there. The architectural model teaches us how to be more sensitive to the potential centering and ordering of nature. As a result of such intensified sensitivity, we have a context—a special place—within which the sounds, smells, temperatures, breezes, volumes, masses, colors, lines, textures, and constant changes of nature can be ordered into something more than a blooming, buzzing confusion. That special place might be sublimely open, as with the spectacle of an ocean, or cozily closed, as

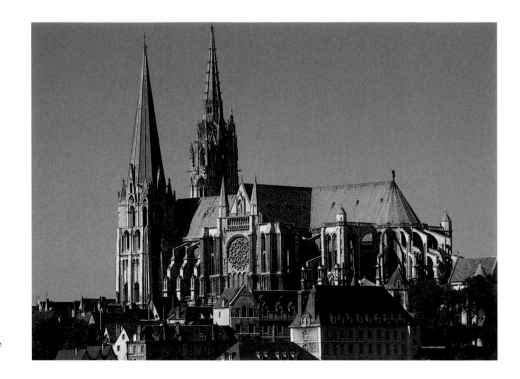

FIGURE 6-2
Chartres Cathedral, Paris.

The cathedral, built starting in 1140 and continuing into the fifteenth century, dominates the cityscape of modern Paris. Chartres is considered the greatest of the Gothic cathedrals.

with a bordered brook. In either case, nature is consecrated, and we belong and dwell.

CHARTRES

On a hot summer day many years ago, following the path of Henry Adams, who wrote *Mont-Saint-Michel and Chartres,* one of the authors was attempting to drive from Mont-Saint-Michel to Chartres in time to catch the setting sun through the western rose window of Chartres Cathedral. The following is an account of this experience:

> In my rushing anxiety—I had to be in Paris the following day and I had never been to Chartres before—I became oblivious of space except as providing landmarks for my time-clocked progress. Thus I have no significant memories of the towns and countrysides I hurried through. Late that afternoon the two spires of Chartres [Figures 6-2 and 6-3], like two strangely woven strands of rope let down from the heavens, gradually came into focus. The blue dome of the sky also became visible for the first time, centering as I approached more and more firmly around the axis of those spires. "In lovely blueness blooms the steeple with metal roof" (Hölderlin). The surrounding fields and then the town, coming out now in all their specificity, grew into tighter unity with the church and sky. I recalled a passage from Aeschylus: "The pure sky desires to penetrate the earth, and the earth is filled with love so that she longs for blissful unity with the sky. The rain falling from the sky impregnates the earth, so that she gives birth to plants and

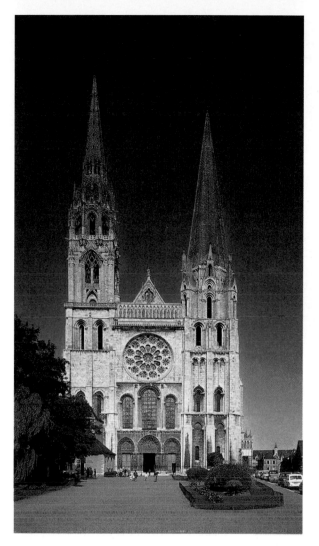

FIGURE 6-3
Chartres Cathedral. The West
Front. 1194–1260.

The towers are asymmetrical,
having been constructed three
centuries apart.

grain for beasts and men." No one rushed in or out or around the church. The
space around seemed alive and dense with slow currents all ultimately being
pulled to and through the central portal.[2] Inside, the space, although spacious
far beyond the scale of practical human needs, seemed strangely compressed,
full of forces thrusting and counterthrusting in dynamic interrelations. Slowly,
in the cool silence inlaid with stone, I was drawn down the long nave, follow-
ing the stately rhythms of the bays and piers. But my eyes also followed the vast

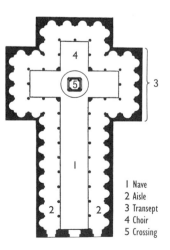

1 Nave
2 Aisle
3 Transept
4 Choir
5 Crossing

[2]Chartres, like most Gothic churches, is shaped roughly like a recumbent Latin cross:
The front (Figure 6-3)—with its large circular window shaped like a rose and the three ver-
tical windows, or lancets, beneath—faces west. The apse, or eastern end, of the building
contains the high altar. The nave is the central and largest aisle leading from the central
portal to the high altar. But before the altar is reached, the transept crosses the nave. Both
the northern and southern facades of the transept of Chartres contain, like the western fa-
cade, glorious rose windows. (Drawing after R. Sturgis)

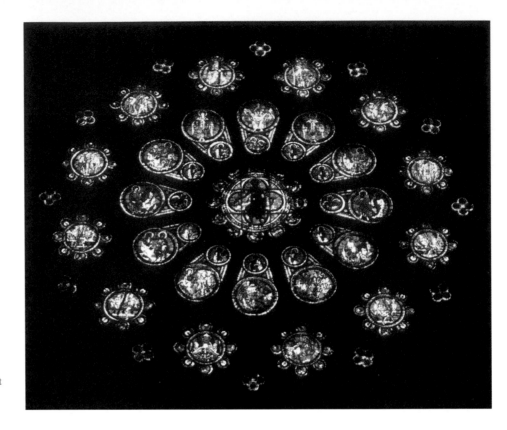

FIGURE 6-4
Chartres Cathedral. The great west rose window.

The window casts a powerful light within the cathedral in the later afternoon. Rose windows were designed to cast a "dim, religious light," as the poet John Milton said.

vertical stretches far up into the shifting shadows of the vaultings. It was as if I were being borne aloft. Yet I continued down the narrowing tunnel of the nave, but more and more slowly as the pull of the space above held back the pull of the space below. At the crossing of the *transept,* the flaming colors, especially the reds, of the northern and southern roses transfixed my slowing pace, and then I turned back at last to the western rose [Figure 6-4] and the three lancets beneath—a delirium of color, dominantly blue, was pouring through. Earthbound on the crossing, the blaze of the Without was merging with the Within. Radiant space took complete possession of my senses. In the protective grace of this sheltering space, even the outer space which I had dismissed in the traffic of my driving seemed to converge around the center of this crossing. Instead of being alongside things—the church, the town, the fields, the sky, the sun—I was with them, at one with them. This housing of holiness made me feel at home in this strange land.

PERCEPTION KEY Chartres

The two towers of Chartres Cathedral (Figure 6-3) are asymmetrical, both in height and detail. The one on the left was completed in the sixteenth century, about 300 years after the tower on the right.

1. Which tower do you like better? Why?

2. The details of the left tower are much more elaborate than those of the right tower. Do you think these details are overly elaborate, given the relative plainness of the facade?
3. Why do you think the architects of the sixteenth century turned away from making the towers more identical?
4. Would the facade be more or less effective if the towers were twins?
5. Do you think that historical knowledge is likely to make a difference in how one answers the above questions? If so, how?

LIVING SPACE

Living space is the feeling of the comfortable positioning of things in the environment, promoting both liberty of movement and paths as directives. Taking possession of space is our first gesture as infants, and sensitivity to the position of other things is a prerequisite of life. Space infiltrates through all our senses, and our sensations of everything influence our perception of space. A breeze broadens the spaciousness of a room that opens on a garden. A sound tells us something about the surfaces and shape of that room. A cozy temperature brings the furniture and walls into more intimate relationships. The smell of books gives that space a personality. Each of our senses helps record the positioning of things, expressed in such terms as "up-down," "left-right," and "near-far." These recordings require a reference system with a center. With abstract space, as when we estimate distances visually, the center is the zero point located between the eyes. With living space, since all the senses are involved, the whole body is a center. Furthermore, when we relate to a place of special value, such as the home, a "configurational center" is formed, a place that is a gathering point around which a field of interest is structured. If we oversimplify, we can say that for the ancient Romans, it was the city of Rome to which they most naturally belonged—Rome constituted their configurational center. For medieval people, it was the church and castle, for Babbitt the office, for Sartre the café, and for de Gaulle the nation. But, for most people at almost any time, although undoubtedly more so in contemporary times, there are more than a couple of centers. Often these are more or less confused and changing. In living space, nevertheless, places, principal directions, and distances arrange themselves around configurational centers.

PERCEPTION KEY Buildings

1. Select a house in your community that strikes you as ugly. Why?
2. Select a house in your community that strikes you as beautiful. Why?
3. Do the same for an apartment house, a school building, an office building, a gas station, a supermarket, a city street, a bridge.
4. Do you have any buildings that provide a centered space?

A building that lacks artistic qualities, even if it encloses a convenient void, encourages us to ignore it. Normally we will be blind to such a building

and its space as long as it serves its practical purposes. If the roof leaks or a wall breaks down, however, we will only see the building as a damaged instrument. A well-designed building, on the other hand, brings us into living space by centering space. Such a building clarifies earlier impressions of the scene that had been obscure and confused. The potentialities of power in the positioned interrelationships of things are captured and channeled. Our feeling for interesting, enlivened space is awakened. We become aware of the power and embrace of space. Such a building strikes a bargain between what it lets us do and what it makes us do. In the piazza before St. Peter's, we are free to wander this way or that, but always within the draw of the powerful facade of the church and the reach of its embracing wings.

FOUR NECESSITIES OF ARCHITECTURE

The architect's professional life is perhaps more difficult than that of any other artist. Architecture is a peculiarly public art because buildings generally have a social function, and many buildings require public funds. More than other artists, architects must consider the public. If they do not, few of their plans are likely to materialize. Thus architects must be psychologists, sociologists, economists, businesspeople, politicians, and courtiers. They must also be engineers, for they must be able to design structurally stable buildings. And then they need luck. Even as famous an architect as Frank Lloyd Wright could not prevent the destruction, for economic reasons, of one of his masterpieces—the Imperial Hotel in Tokyo.

Architects have to take into account four basic and closely interrelated necessities: technical requirements, function, spatial relationships, and revelatory requirements. To succeed, their structures must adjust themselves to these necessities. As for what time will do to their creations, they can only hope and prepare with foresight. Wright's hotel withstood earthquakes, but ultimately every building is peculiarly susceptible to economic demands and the whims of future taste.

Technical Requirements of Architecture

Of the four necessities, the technical requirements of a building are the most obvious. Buildings must stand and withstand. Architects must know the materials and their potentialities, how to put the materials together, and how the materials will work on a particular site. Stilt construction, for instance, will not withstand earthquakes—and so architects are engineers. But they are something more as well—artists. In solving their technical problems, they must also make their forms revelatory. Their buildings must illuminate something significant that we would otherwise fail to perceive.

Consider, for example, the relationship between the engineering requirements and artistic qualities of the Parthenon, 447–432 B.C. (Figure 6-5). The engineering was superb, but unfortunately the building was almost destroyed

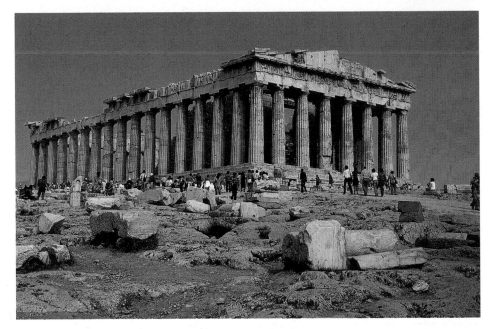

FIGURE 6-5
The Parthenon, Athens. 447–432
B.C.E.

The Parthenon was dedicated
to Athena, the patron of Athens.
In order to give its proportions
a sense of perfection, a number
of imperfections were built
into the columns to accommo-
date the way people must look
up to the building.

in 1687, when it was being used as an ammunition dump by the Turks and
was hit by a shell from a Venetian gun. Basically the technique used was
post-and-lintel (or beam) construction. Set on a base, or stylobate, columns
(verticals: the posts) support the entablature (horizontals: the lintel), which,
in turn, supports the ***pediment*** (the triangular structure) and roof.

PERCEPTION KEY Parthenon and Chartres

Study the schematic drawing for the Doric order (Figure 6-6), the order followed in
the Parthenon, and Figure 6-5.

1. What is the visual effect of the narrow vertical grooves or flutes carved into the
 marble columns of the Parthenon?
2. The columns bulge or swell slightly, a characteristic called ***entasis.*** Can you per-
 ceive the bulge in the photograph of the Parthenon?
3. Why are the columns wider at the base than at the top?
4. Why is there a capital between the top of the shaft and the architrave (the lintels
 that span the voids from column to column and compose the lowest member of
 the entablature)?
5. The capital is made up of three parts: the circular grooves at the bottom (the
 necking); the bulging cushionlike molding (the echinus); and the square block
 (the abacus). Why the division of the capital into these three parts?
6. The columns at the corners are a couple of inches thicker than the other columns.
 Why?
7. The corner and adjacent columns are slighly closer together than the other col-
 umns. Is the difference perceptible in the photograph? All the columns except
 those in the center of each side slant slightly inward. Why?

(continued)

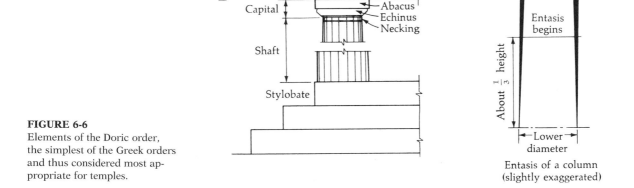

FIGURE 6-6
Elements of the Doric order, the simplest of the Greek orders and thus considered most appropriate for temples.

> 8. Subtle refinements such as those mentioned above abound throughout the Parthenon. Few if any of them are necessary from a technical standpoint, nor were these refinements accidental. They are found repeatedly in other Greek temples of the time. Presumably, then, they are a result of a need to make the form of the temple mean something, to have it be a form-content. Presumably, as well, the Parthenon can still reveal something of the values of the ancient Greeks. What values? Compare those with the values revealed by Chartres. For example, which building seems to reveal a society that places more trust in God? And what kind of God? And in what way are the subtle refinements of the Parthenon relevant to these questions?

Functional Requirements of Architecture

Architects must not only make their buildings stand but also usually stand them in such a way that they reveal their function or use. One contemporary school of architects even goes so far as to claim that form must follow function. If the form succeeds in this, that is all the form should do. In any case, a form that disguises the function of a building seems to irritate almost everyone.

If form follows function in the sense that the form stands "for" the function of its building, then conventional forms or structures are often sufficient. No one is likely to mistake Chartres Cathedral for an office building.

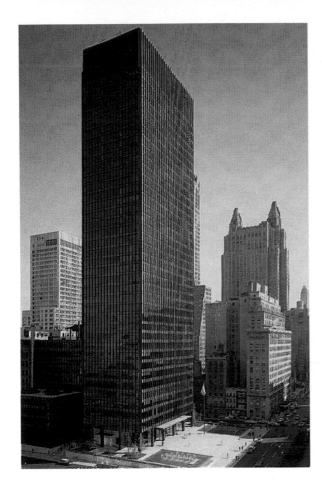

FIGURE 6-7
Ludwig Mies van der Rohe and
Philip Johnson, architects, the
Seagram Building, New York
City. 1954–1958.

An example of the International
style popular in midcentury, the
building was designed so the
structure of the building would
be visible.

We have seen the conventional structures of too many churches and of-
fice buildings to be mistaken about this. Nor are we likely to mistake the
Seagram Building (Figure 6-7) for a church. We recognize the functions of
these buildings because they are in the conventional shapes that such build-
ings so often possess.

PERCEPTION KEY Form, Function, Content, and Space

Study Figures 6-7 and 3-4, Le Corbusier's Notre Dame-du-Haut.

1. What is the basic function of each of these buildings?
2. How do you know what the functions are? How have the respective forms re-
 vealed the functions of their buildings? And does it seem appropriate to use the
 term "reveal" for Figures 6-7 and 3-4? We would argue that both works are archi-
 tecture because the form of the building in Figure 3-4 is revelatory of the subject
 matter—of the tension, anguish, striving, and ultimate concern of religious faith;
 whereas in Figure 6-7 the form of the building is revelatory of the stripped-down,
 uniform efficiency of an American business corporation. Consider every possible
 relevant argument against this view.

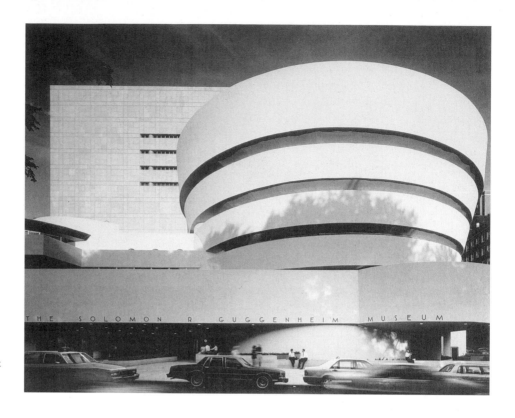

FIGURE 6-8
Frank Lloyd Wright, Solomon Guggenheim Museum, New York City. 1957–1959.

This was the last great commission for Wright, whose cast concrete design was instantly controversial.

Study one of Frank Lloyd Wright's last and most famous works, the Solomon R. Guggenheim Museum in New York City (Figures 6-8 and 6-9), constructed in 1957–1959 but designed in 1943. Wright wrote,

> Here for the first time architecture appears plastic, one floor flowing into another (more like sculpture) instead of the usual superimposition of stratified layers cutting and butting into each other by way of post-and-beam construction. The whole building, cast in concrete, is more like an egg shell—in form a great simplicity—rather than like a crisscross structure. The light concrete flesh is rendered strong enough everywhere to do its work by embedded filaments of steel either separate or in mesh. The structural calculations are thus those of cantilever and continuity rather than the post and beam. The net result of such construction is a greater repose, the atmosphere of the quiet unbroken wave: no meeting of the eye with abrupt changes of form.[3]

The term ***cantilever*** refers to a structural principle in architecture in which one end of a horizontal form is fixed—usually in a wall—while the other end juts out over space. Steel beam construction makes such forms possible; many modern buildings, like the Guggenheim Museum, have forms extending fluidly into space.

[3]Reprinted from *The Solomon R. Guggenheim Museum*, copyright 1960, by permission of the publishers, The Solomon R. Guggenheim Foundation and Horizon Press, New York, p. 16ff.

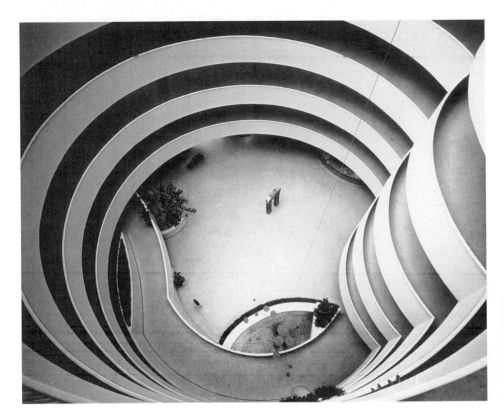

FIGURE 6-9
Solomon Guggenheim Museum interior.

The floor spirals continuously upward with art hung on the walls. A large transparent skylight is shaped similarly to cathedral rose windows.

PERCEPTION KEY Guggenheim Museum

1. Does the exterior of this building harmonize with the interior?
2. Does the form reveal the building as an art museum?
3. Elevators take us to the top of the building, and then we can participate with the exhibited works of art by walking down the spiraling ramp. This enables us to see each work from many perspectives. Does this seem to you to be an interesting, efficient, and comfortable way of exhibiting works of art?
4. The front of the museum faces Fifth Avenue. The surrounding buildings are tall rectangular structures evenly lined up along the sidewalks. If possible, visit the site. Did Wright succeed in bringing his museum into a harmonious spatial relationship with these other buildings? Or was his purpose perhaps to make his museum stand out in sharp contrast, like a plant among inorganic shapes? But if so, does the museum fit successfully into the spatial context—"the power and embrace of the positioned interrelationships of things"?
5. Originally the museum was to have been situated in Central Park. Do you think a park site would have been better than its present site? Why?

Spatial Requirements of Architecture

Wright solved his technical problems (such as cantilevering) and his functional problems (efficient and commodious exhibition of works of art) with considerable success. Moreover, the building reveals itself as a museum.

What else could it be? Yet perhaps Wright was not completely successful in relating the museum to the surrounding buildings in a spatially satisfactory way. This, in turn, detracts from some of the "rightness" of the building. In any case, the technical, functional, and spatial necessities are obviously interdependent. If a building is going to be artistically meaningful—that is to say, if it is to be architecture—it must satisfy all four necessities to some extent: technical requirements, functional fitness, spatial relationships, and content. Otherwise, its form will fail to be a form-content. There is, of course, the question of the degree of success in satisfying each of the four necessities. Despite the apparent problem of its siting, Wright's museum is so successful otherwise that it would be strange indeed to describe it as just a building, something less than architecture.

Revelatory Requirements of Architecture

The function or use of a building is an essential part of the subject matter of that building, what the architect interprets or gives insight into by means of its form. The function of the Seagram Building (Figure 6-7) is to house offices. The form of that building reveals that function. But does this function exhaust the subject matter of this building? Is only function revealed? Would we, perhaps, be closer to the truth by claiming that involved with this office function are values closely associated with, but nevertheless distinguishable from, this function? That somehow other values, besides functional ones, are interpreted in architecture? That values of the architect's society somehow impose themselves, and the architect must be sensitive to them? We think that even if architects criticize or react against the values of their time, they must take account of them. Otherwise, their buildings would stand for little more than projections of their personal idiosyncrasies.

We are claiming that the essential values of contemporary society are a part of all artists' subject matter, part of what they must interpret in their work, and this—because of the public character of architecture—is especially so with architects. The way architects (and artists generally) are influenced by the values of their society has been given many explanations. According to art historian Walter Abell, the state of mind of a society influences architects directly. Historical and social circumstances generate psychosocial tensions and latent imagery in the minds of the members of a culture. Architects, among the most sensitive members of a society, release this tension by condensing this imagery in their art. The psyche of the artist, explained by Abell by means of psychoanalytic theory and social psychology, creates the basic forms of art; but this psyche is controlled by the state of mind of the artist's society, which, in turn, is controlled by the historical and social circumstances of which it is a part.

> Art is a symbolical projection of collective psychic tensions. . . . Within the organism of a culture, the artist functions as a kind of preconsciousness, providing a zone of infiltration through which the obscure stirrings of collective intuition

can emerge into collective consciousness. The artist is the personal transformer within whose sensitivity a collective psychic charge, latent in society, condenses into a cultural image. He is in short the dreamer . . . of the collective dream.[4]

Whereas Abell stresses the unconscious tensions of the social state of mind that influence the architect's creative process, Erwin Panofsky, another art historian, stresses the artist's mental habits, conscious as well as unconscious, that act as principles to guide the architect. For example,

> We can observe [between about 1130 and 1270] . . . a connection between Gothic art and Scholasticism which is more concrete than a mere "parallelism" and yet more general than those individual (and very important) "influences" which are inevitably exerted on painters, sculptors, or architects by erudite advisors. In contrast to a mere parallelism, the connection which I have in mind is a genuine cause-and-effect relation; but in contrast to an individual influence, this cause-and-effect relation comes about by diffusion rather than by direct impact. It comes about by the spreading of what may be called, for want of a better term, a mental habit—reducing this overworked cliché to its precise Scholastic sense as a "principle that regulates the act." Such mental habits are at work in all and every civilization.[5]

Whatever the explanation of the architect's relationship to society—and Abell's and Panofsky's are two of the best[6]—the forms of architecture reflect and interpret some of the fundamental values of the society of the architect. Yet, even as these forms are settling, society changes. Thus, while keeping the past immanent in the present, architecture takes on more and more the aura of the past, especially if the originating values are no longer viable or easily understandable. Anything that now exists but has a past may refer to, or function as, a sign of the past, but the forms of architecture interpret the past. Not only do the forms of architecture preserve the past more carefully than do most things, for most architects build buildings to last, but these structures also enlighten that past. They inform about the values of the artists' society. Architects did the forming, of course, but from beginning to end that forming, insofar as it succeeded artistically, brought forth something of their society's values. Thus architectural forms are weighted with the past—a past, furthermore, that is more public than private. The past is preserved in the forms as part of the content of architecture.

Every stone of the Parthenon, in the way it was cut and fitted, reveals something about the values of the Age of Pericles, the fifth century B.C.—for

[4]Walter Abell, *The Collective Dream in Art* (Cambridge, Mass.: Harvard University Press, 1957), p. 328.

[5]Erwin Panofsky, *Gothic Architecture and Scholasticism*, 2nd Wimmer Lecture, 1948, St. Vincent College (Latrobe, Penn.: Archabbey Press, 1951), p. 20ff; (New York: New American Library, 1957), p. 44.

[6]For an evaluation of these and other explanations, see F. David Martin, "The Sociological Imperative of Stylistic Development," *Bucknell Review*, vol. 11, no. 4 (December 1963): 54–80.

example, the emphasis on moderation and harmony, the importance of mathematical measurement and yet its subordination to the eminence of humans and their rationality, as well as the immanence rather than the transcendence of the sacred.

Chartres Cathedral also is an exceptional example of the preservation of the past. Chartres reveals three principal value areas of that medieval region: the special importance of Mary, to whom the cathedral is dedicated; the doctrines of the cathedral school, one of the most important centers of learning in Europe in the twelfth and thirteenth centuries; and the value preferences of the main patrons—the royal family, the lesser nobility, and the local guilds. The windows of the 175 surviving panels and the sculpture, including more than 2,000 carved figures, were a bible in glass and stone for the illiterate, but they were also a visual encyclopedia for the literate. From these structures the iconographer—the decipherer of the meaning of icons or symbols—can trace almost every fundamental value of the society that created Chartres Cathedral: the conception of human history from Adam and Eve to the Last Judgment; the story of Christ from his ancestors to his Ascension; church history; ancient lore and contemporary history; the latest scientific knowledge; the curriculum of the cathedral school as divided into the trivium (grammar, logic, and rhetoric) and the quadrivium (arithmetic, geometry, astronomy, and music); the hierarchy of the nobility and the guilds; the code of chivalry and manners; and the hopes and fears of the time. Furthermore, the participator also becomes aware of a society that believed God to be transcendent but the Virgin to be both transcendent and immanent, not just a heavenly queen but also a mother. Chartres is Mary's home. For, as Henry Adams insisted, "You had better stop here, once for all, unless you are willing to feel that Chartres was made what it was, not by the artist, but by the Virgin."

Even if we disagree with Adams, we understand, at least to some extent, Mary's special position within the context of awe aroused by God as "wholly other." The architecture of Chartres does many things, but, above all, its structures preserve that awe. Something of the society of the Chartres that was comes into our present awareness with overwhelming impact. And then we can understand something about the feelings of such medieval men as Abbot Haimon of Normandy, who, after visiting Chartres, wrote to his brother monks in Tutbury, England,

> Who has ever heard tell, in times past, that powerful princes of the world, that men brought up in honor and wealth, that nobles, men and women, have bent their proud and haughty necks to the harness of carts, and that, like beasts of burden, they have dragged to the abode of Christ these wagons, loaded with wines, grains, oil, stone, wood, and all that is necessary for the wants of life, or for the construction of the church . . . ? When they have reached the church, they arrange the wagons about it like a spiritual camp, and during the whole night they celebrate the watch by hymns and canticles. On each wagon they light tapers and lamps; they place there the infirm and sick, and bring them the precious relics of the saints for their relief.

To participate with a work of public architecture fully, we must have as complete an understanding as possible of its subject matter—the function of the building and the relevant values of the society that subsidized the building. The more we know about the region of Chartres in medieval times, the more we will appreciate its cathedral. The more we understand our own time, the more we will appreciate the Seagram Building. Similarly, the more we understand about the engineering problems involved in a work of architecture, including especially the potentialities of its materials, the better our appreciation. And, of course, the more we know about the stylistic history of architectural details and structures and their possibilities, the deeper will be our appreciation. That tradition is a long and complex one, but you can learn its essentials in any good book on the history of architecture.

Let us return again to architecture and space, for what most clearly distinguishes architecture from painting and sculpture is the way it works in space. Works of architecture separate an inside space from an outside space. They make that inside space available for human use. And in interpreting their subject matter (functions and the values of their society), architects make space "space." They bring out the power and embrace of the positioned interrelationships of things. Architecture in this respect can be divided into four main types—the earth-rooted, the sky-oriented, the earth-resting, and the earth-dominating.

EARTH-ROOTED ARCHITECTURE

The earth is the securing agency that grounds the place of our existence, our center. In many primitive cultures, it is believed that people are born from the earth. And in many languages, people are the "Earth-born." In countless myths, Mother Earth is the bearer of humans from birth to death. Of all things, the expansive earth, with its mineral resources and vegetative fecundity, most suggests or is symbolic of security. Moreover, since the solidity of the earth encloses its depth in darkness, the earth is also suggestive of mystery and death.

No other thing exposes its surface more pervasively and yet hides its depth dimension more completely. The earth is always closure in the midst of disclosure. If we dig below the surface, there is always a further depth in darkness that continues to escape our penetration. Thus the Earth Mother has a mysterious, nocturnal, even funerary aspect—she is also often a goddess of death. But, as the theologian Mircea Eliade points out, "even in respect of these negative aspects, one thing that must never be lost sight of, is that when the Earth

becomes a goddess of Death, it is simply because she is felt to be the universal womb, the inexhaustible source of all creation."[7] Nothing in nature is more suggestive or symbolic of security and mystery than the earth. ***Earth-rooted architecture*** accentuates this natural symbolism more than any other art.

Site

Architecture that is earth-rooted discloses the earth by drawing our attention to the site of the building, its submission to gravity, its raw materials, and its centrality in outer and inner space. Sites whose surrounding environment can be seen from great distances are especially favorable for helping a building to bring out the earth. The site of the Parthenon (Figure 6-5), for example, is surely superior in this respect to the site of Chartres (Figures 6-2 and 6-3), because the acropolis is a natural center that dominates a widespread concave space. Thus the Parthenon emphasizes by continuity both the sheer heavy stoniness of the limestone cliffs of the acropolis and the gleaming whites of Athens. In contrast, it sets off the deep blue of the Mediterranean sky and sea and the grayish greens of the encompassing mountains that open out toward the weaving blue of the sea like the bent rims of a colossal flower. All these elements of the earth would be present without the Parthenon, of course, but the Parthenon, whose columns from a distance push up like stamens of a flower, centers these elements more tightly so that their interrelationships add to the vividness of each. Together they form the ground from which the Parthenon slowly and majestically rises.

Gravity

The Parthenon is also exceptional in the way it manifests a gentle surrender to gravity. The horizontal rectangularity of the entablature follows evenly along the plain of the acropolis with the steady beat of its supporting columns and quiets their upward thrust. Gravity is accepted and accentuated in this serene stability—the hold of the earth is secure.

The site of Mont-Saint-Michel (Figure 6-10) can also be seen from great distances, especially from the sea; and the church, straining far up from the great rock cliffs, organizes a vast scene of sand, sea, shallow hills, and sky. But the spiny, lonely verticality of the church overwhelms the pull of the earth. We are lured to the sky, to the world of light and open vastness, whereas the Parthenon draws us back into the womb of the earth. Mont-Saint-Michel discloses the earth, for both the earth and a world to be opened up require centering and thus each other, but the defiance of gravity weakens the securing sense of place. Mont-Saint-Michel rapidly moves us around its walls, when the tides permit, with a dizzying effect, whereas the Parthenon moves us around slowly and securely so that our orientation is never in doubt. The significance of the earth is felt much more deeply at the Parthenon than at Mont-Saint-Michel.

[7]Mircea Eliade, *Myths, Dreams and Mysteries,* trans. Philip Mairet (New York: Harper, 1961), p. 188.

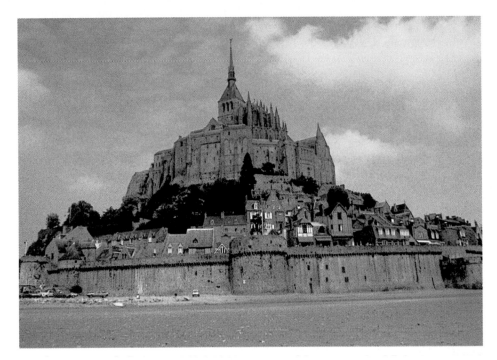

FIGURE 6-10
Mont-Saint-Michel, Normandy, France. Ninth century.

The church itself was begun in the ninth century and continued to the twentieth century. Because it is on a fortified island it can be seen from a great distance.

Rockefeller Center (Figure 6-11) in New York City is an exceptional example of an architecture that allows for only a minimal submission to gravity. The surrounding buildings, unless we are high up in one nearby, block out the lower sections of the Center. If we are able to see the lower sections by getting in close, we are blocked from a clear and comprehensive view of the upper sections. The relationships between the lower and upper sections are, therefore, somewhat disconnected, and there is a sense of these tapering towers not only scraping but also being suspended from the sky. The Seagram Building (Figure 6-7), not far away, carries this feeling even further by the placement of the shaftlike box on stilts. Apparently weightless, the Seagram Building mitigates but does not annihilate our feeling of the earth, for despite its elegant soaring, we are aware of its base. Even at night, when the sides of this structure become dark curtains pierced by hundreds of square lights, we feel these lights, as opposed to the light of the stars, as somehow grounded. In setting up a world, architecture always sets forth the earth, and vice versa.

Raw Materials

When the medium of architecture is made up totally or in large part of unfinished materials furnished by nature, especially when they are from the site, these materials tend to stand forth and help reveal the earthiness of the earth. In this respect, stone, wood, and clay in a raw or relatively raw state are much more effective than steel, concrete, and glass. If the Parthenon had been made in concrete rather than in native Pentelic marble—the

FIGURE 6-11
Raymond Hood, Rocke-
feller Center, New York City.
1931–1940.

Hood executed the project in
Art Deco style. At the time it
was the largest private building
project of modern times.

quarries can still be seen in the distance—the building would not grow out
of the soil so organically, and some of the feeling of the earth would be
dissipated. Also, if the paint that originally covered much of the Parthenon
had remained, the effect would be considerably less earthy than at present.
Note, however, that the dominant colors were terra-cotta reds, colors of the
earth. Wright's Kaufmann house (Figure 6-12) is an excellent example of
the combined use of manufactured and raw materials that helps set forth
the earth. The concrete and glass bring out by contrast the textures of stone
and wood taken from the site, while the lacelike flow of the falling water is
made even more graceful by its reflection in the smooth clear flow of con-
crete and glass. Like a wide-spreading plant, drawing the sunlight and rain
to its good earth, this home seems to breathe within its homeland.

PERCEPTION KEY Architecture and Materials

In his *Praise of Architecture*, the Italian architect Gio Ponti writes, "Beautiful materials
do not exist. Only the right material exists. . . . Rough plaster in the right place is
the beautiful material for that place. . . . To replace it with a noble material would
be vulgar."
1. Do you agree with Ponti?
2. If you agree, refer to examples that corroborate Ponti's point.
3. If you disagree, refer to examples that do not corroborate.

FIGURE 6-12
Frank Lloyd Wright, Edgar J. Kaufmann House, known as Fallingwater. 1937–1939.

Fifty miles southeast of Pittsburgh, it was described by *Time* magazine as Wright's "most beautiful job."

Centrality

A building that is strongly centered, in both its outer and its inner space, helps disclose the earth. Perhaps no building is more centered in its site than the Parthenon, but the weak centering of its inner space slackens somewhat the significance of the earth. Unlike Chartres, there is no strong pull into the Parthenon, and, when we get inside, the inner space, as we reconstruct it, is divided in such a way that no certain center can be felt. There is no place to come to an unequivocal standstill as at Chartres. Even Versailles (Figure 6-13), despite its seemingly never-ending partitions of inner space, brings us eventually to somewhat of a center at the bed in Louis XIV's bedroom. Yet this centering is made possible primarily by the view from the room that focuses both the pivotal position of the room in the building and the placement of the room on a straight-line axis to Paris in the far distance. Conversely, the inner space of Chartres, most of which from the crossing can be taken in with a sweep of the eyes, achieves centrality without this kind of dependence upon outside orientation. Buildings such as the Parthenon and Versailles, which divide the inner space with solid partitions, invariably are weaker in inner centrality than buildings without such divisions. The

FIGURE 6-13
Louis le Vau and Jules
Hardouin-Mansart, Palace of
Versailles, France. 1661–1687.

France was governed from
this palace from 1682 until the
French Revolution of 1789.
Its immensity was designed to
house the entire Royal Court in
a place several miles from Paris,
the official capital of France.

endless boxes within boxes of the Seagram Building (Figure 6-7) negate any possibility of significant inner centering, adding to the unearthiness of this cage of steel and glass.

Buildings sometimes draw us to a privileged position in their inner space, the position that gives us the best perception of that space. Then we are likely to feel the security of inner centeredness. This feeling is further enhanced when the expanses of inner space are more or less equidistant from the privileged position. *Greek-cross* buildings, in which the floor plan resembles a cross whose arms are equal in length, are likely to center us in inner space more strongly than *Latin-cross* buildings, such as Chartres. If Bramante's and Michelangelo's Greek-cross plan for St. Peter's had been carried out, the centrality of the inner space would have been greatly enhanced. It does not follow, however, that all centrally planned buildings that open up all or almost all of the inner space will be strongly centered internally. San Vitale (Figures 6-14 and 6-15) in Ravenna, for example, is basically an octagon, but the enfolded interior spaces are not clearly outlined and differentiated. There is a floating and welling of space working out and up through the arcaded niches into the outer layers of the ambulatory and gallery that fade into semidarkness. The dazzling colors of the varied marble slabs and the mosaics lining the piers and walls add to our sense of spatial uncertainty. We can easily discover the center of San Vitale if we so desire, but there is no directed movement to it because the indeterminacy of the surrounding spaces makes the feeling of the center insecure and insignificant. The unanchored restlessness of the interior of San Vitale belies its solid weighty exterior.

Buildings in the round, other things being equal, are the most internally centered of all. In the Pantheon (Figure 6-16), almost all the inner space can be seen with a turn of the head, and the grand and clear *symmetry* of the enclosing shell draws us to the center of the circle, the privileged position, beneath the eye of the dome opening to a bit of the sky. Few buildings

154



FIGURE 6-14
San Vitale, Ravenna, Italy.
526–547.

An example of Byzantine
architecture, San Vitale was
based on the octagon shape
because the number eight is
Christ's number.

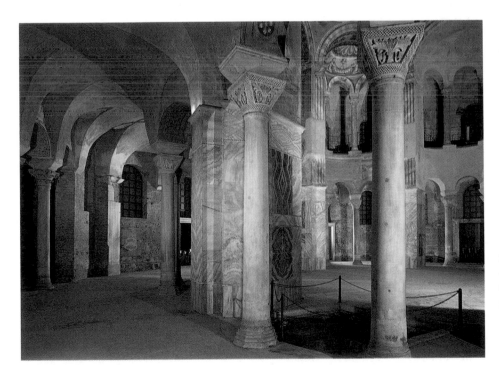

FIGURE 6-15
San Vitale interior.

While the center of the church
rises as high as the dome and
admits a considerable amount
of light, the columns that sup-
port much of the weight are just
inside the doorway.

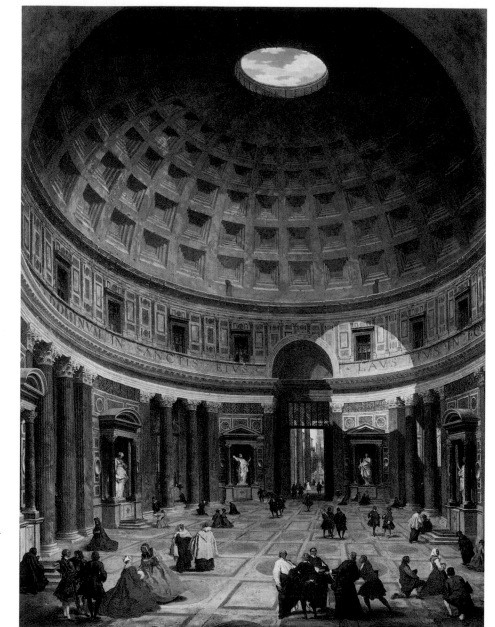

FIGURE 6-16
Giovanni Paolo Panini,
Interior of the Pantheon,
Rome. Circa 1734. Oil on
canvas, 50 ½ × 39 inches.

The Pantheon dates from the
second century. It is notable for
being one of the only Roman
buildings still in use and still
intact as it originally was. The
interior space is overwhelm-
ing in part because it contrasts
dramatically with a very plain
exterior.

root us more firmly in the earth. The massive dome with its stony blunt-
ness seems to be drawn down by the funneled and dimly spreading light
falling through the eye. This is a dome of destiny pressing tightly down. We
are driven earthward in this crushing ambience. Even on the outside, the
Pantheon seems to be forcing down (Figure 6-17). In the circular interior
of Wright's Guggenheim Museum (Figure 6-9), not all of the inner space
can be seen from the privileged position, but the smoothly curving ramp

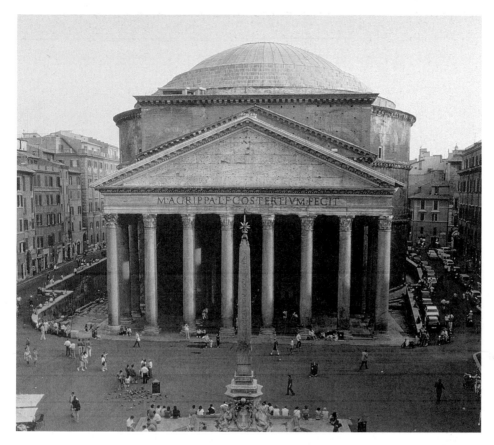

FIGURE 6-17
The Pantheon exterior. 117–125.

The Greek facade, eight Egyptian marble Corinthian pillars, hides the drumlike structure of the building, which was used as a Christian church starting in the seventh century.

that comes down like a whirlpool makes us feel the earth beneath as our only support. Whereas in buildings such as Mont-Saint-Michel and Chartres, mass seems to be overcome, the weight lightened, and the downward motion thwarted, in buildings such as the Pantheon and the Guggenheim Museum, mass comes out heavily and down.

The importance of a center, usually within a circle, as a privileged and even sacred position in relation to the earth, is common among the spatial arrangements of ancient cultures—for example, Stonehenge on the Salisbury Plain of England (Figure 6-18). And the first city of Rome, according to Plutarch, was laid out by the Etruscans around a circular trench, or *mundus,* over which was placed a great capstone. Around the *mundus,* the Etruscans outlined a large circle for the walls that would enclose the city. Following a carefully prescribed ritual, a deep furrow was plowed along the circle, and the plow was lifted from the ground wherever a gate was to appear. This circular plan was subdivided by two main cross streets: the *cardo,* running north and south in imitation of the axis of the earth, and the *decumanus,* running east and west, dividing the city into four equal parts. These streets crossed at the site of the *mundus,* believed to be the entrance to the underworld, and the capstone was removed three times each year to allow the spirits passage

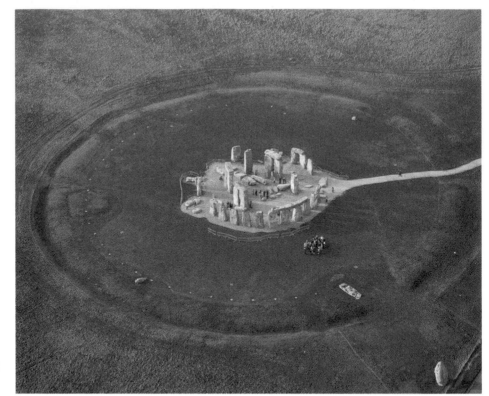

between the world of the living and the world of the dead. Although such beliefs and customs have long been dead in Western civilization, we can still feel the power of the earth in circular city plans and buildings.

SKY-ORIENTED ARCHITECTURE

Architecture that is ***sky-oriented*** suggests or is symbolic of a world as the generating agency that enables us to project our possibilities and realize some of them. A horizon, always a necessary part of a world, is symbolic of the limitations placed upon our possibilities and realizations. The light and heat of the sun are more symbolic than anything else in nature of generative power. Dante declared, "There is no visible thing in the world more worthy to serve as symbol of God than the Sun; which illuminates with visible life itself first and then all the celestial and mundane bodies." The energy of the moving sun brightens the sky that, in turn, opens up for us a spacious context or world within which we attempt to realize our possibilities. In total darkness we may be able to orient ourselves to the earth, but in order to move with direction, as do the blind, we must imagine space as open in some way, as a world enlightened with light even if our imaginations must provide that light. Total darkness, at least until we can envision a world, is terrifying. That is why, as the Preacher of Ecclesiastes proclaims, "The light is sweet, and a pleasant

thing it is for the eyes to behold the sun." "The light of the living" is a common Hebrew phrase, and in Greek "to behold light" is synonymous with "to live." The light of the sky reveals space—the positioned interrelationships of things. The dome of the sky, with its limits provided by the horizon, embraces a world within which we find ourselves. But a world is above all the context for activity. A world stirs our imaginations to possibilities. A world, with its suggestion of expectation, turns our faces to the future, just as the smile of the sun lures our eyes. Architecture organizes a world, usually more tightly than nature, by centering that world on the earth by means of a building. By accentuating the natural symbolism of sunlight, sky, and horizon, sky-oriented architecture opens up a world that is symbolic of our projections into the future.

Such architecture discloses a world by drawing our attention to the sky bounded by a horizon. It accomplishes this by means of making a building appear high and centered within the sky, defying gravity, and tightly integrating the light of outer with inner space. Negatively, architecture that accents a world de-emphasizes the features that accent the earth. Thus the manufactured materials, such as the steel and glass of the Seagram Building (Figure 6-7), help separate this building from the earth. Positively, architects can accent a world by turning their structures toward the sky in such a way that the horizon of the sky forms a spacious context. Architecture is an art of bounding as well as opening.

PERCEPTION KEY Sky-Oriented Architecture

1. Identify the most sky-oriented building in your local community. Photograph that building from an angle or angles that support your choice.

Stained glass, usually framed within a wall, is activated by penetrating light. Outside, the great rose window of Chartres (Figure 6-4) is only of sculptural interest. Inside, on a sunny day, the cascade of flashing colors, especially blues, is overwhelming. No photograph can capture the sublimity. There is a "strangeness." Our sight is wired to see light falling on objects rather than shining through them.

2. Try to find in your local community any buildings with powerful stained glass. Do you think stained glass is generally sky-oriented?
3. Do you think stained glass should be classified as an independent art distinct from painting?

Barcelona's Antonio Gaudí created one of the most striking of modern buildings in his Sagrada Familia (Figures 6-19 to 6-21). Gaudí never lived to see the erection of the four towers that dominate the façade. The interior space is not yet covered with a roof, and this emphasizes the sky-orientation of the building. One's eye is lifted upward by almost every part of the building. Under construction for over a hundred years, it may be at least another hundred years before the church is completed. Work proceeds slowly, guided more or less by Gaudí's general designs. Gaudí developed details and structures based on organic forms of nature through irregular sweeping lines, shapes, and volumes. Geometric designs are subordinated. Textures vary greatly, often with strong contrasts between smooth and rough; and sometimes, especially in the

FIGURE 6-19
Antonio Gaudí, Sagrada
Familia (Church of the Holy
Family, interior), Barcelona.
1883–present.

Gaudí famously relied on
organic forms to create an
idiosyncratic style.

FIGURE 6-20
Sagrada Familia, interior detail.

Gaudí merged traditional
cathedral details with flowing
modern forms.

FIGURE 6-21
Sagrada Familia, exterior detail.

Organic forms are clearly visible on the exterior along with figures typically found on the exteriors of Gothic churches.

towers, brilliantly colored pieces of glass and ceramics are embedded, sparkling in the sunlight. The effect is both sculptural—dense volumes activating the surrounding space—and organic, as if a forest of plants were stretching into the sky searching for sunlight. The earth, despite its necessity, is superseded. This is a building for heaven.

> **PERCEPTION KEY** Sagrada Familia
>
> 1. Compare Sagrada Familia with Chartres (Figures 6-2 and 6-3). How do their sky-orientations differ? How are they similar? Compare Sagrada Familia with any church well known to you. What are the differences?
> 2. Chartres, St. Peter's (Figure 6-1), Sagrada Familia, and Notre Dame-du-Haut (Figure 3-4) are all Catholic churches. Do they each reveal different expressions of religious values?

Axis Mundi

Early civilizations often express a need for a world by centering themselves in relation to the sky by means of an **axis mundi.** Mircea Eliade cites many instances, for example, among the nomadic Australians, whose economy is based on gathering food and hunting small game:

> According to the traditions of an Arunta tribe, the Achipla, in mythical times the divine being Numbakula cosmicized their future territory, created their Ancestor,

and established their institutions. From the trunk of a gum tree Numbakula fashioned the sacred pole *(kauwa-auwa)* and, after anointing it with blood, climbed it and disappeared into the sky. This pole (the *axis mundi*) represents a cosmic axis, for it is around the sacred pole that territory becomes habitable, hence is transformed into a world. The sacred pole consequently plays an important role ritually. During their wanderings the Achipla always carry it with them and choose the direction they are to take by the direction toward which it bends. This allows them, while being continually on the move, to be always in "their world" and, at the same time, in communication with the sky into which Numbakula vanished. For the pole to be broken denotes catastrophe; it is like "the end of the world," reversion to chaos. Spencer and Gillen report that once, when the pole was broken, "the entire clan were in consternation; they wandered about aimlessly for a time, and finally lay down on the ground together and waited for death to overtake them."[8]

Buildings that stretch up far above the land and nearby structures, such as Mont-Saint-Michel (Figure 6-10), Chartres, Rockefeller Center (Figure 6-11), and Sagrada Familia (Figure 6-19), not only direct our eyes to the sky but also act as a center that orders the sunlight in such a way that a world with a horizon comes into view. The sky both opens up and takes on limits. Such buildings reach up like an *axis mundi,* and the sky reaches down to meet them in mutual embrace. And we are blessed with an orienting center, our motion being given direction and limits.

Defiance of Gravity

The more a building appears to defy gravity, the more it is likely to disclose the sky, for this defiance draws our eyes upward. The thrust against gravity is not simply a question of how high the building goes. Many skyscrapers of New York City seem to stop finally, not because they have reached a more or less perfect union with the sky, but because the space used up had exhausted them. They seem to have just enough strength to stand upright but no power to transcend the rudimentary laws of statics. Gravity wins out after all. The up and down frustrate each other, and their conflict dims the world that might have been.

Perhaps Brunelleschi's dome of the Cathedral of Florence (Figure 6-22) is the most powerful structure ever built in seeming to defy gravity and

The stony logic of the press of the **flying buttresses** of Chartres and the arched roof, towers, and spires that carry on their upward thrust seem to overcome the binding of the earth, just as the stone birds on the walls seem about to break their bonds and fly out into the world. The reach up is full of vital force and finally comes to rest comfortably and securely in the bosom of the heavens. Mont-Saint-Michel is even more impressive in this respect, mainly because of the advantages of its site.

[8]Mircea Eliade, *The Sacred and the Profane,* trans. Willard R. Trask (New York: Harcourt, Brace, 1959), p. 32ff.

FIGURE 6-22
Filippo Brunelleschi, dome
of the Cathedral of Florence.
1420–1436.

One of the great architectural
achievements of the
Renaissance, the cathedral
still dominates the landscape
of modern Florence.

achieving height in relation to its site. The eight outside ribs spring up to
the cupola with tremendous energy, in part because they repeat the spring
of the mountains that encircle Florence. The dome, visible from almost
everywhere in and around Florence, appears to be precisely centered in the
Arno Valley, precisely as high as it should be in order to organize its sky.
The world of Florence begins and ends at the still point of this dome of as-
piration. In contrast, Michelangelo's dome of St. Peter's, although grander
in proportions and over fifty feet higher, fails to organize the sky of Rome
as firmly, mainly because the seven hills of Rome do not lend themselves to
centralized organization.

Integration of Light

When the light of outer space suffuses the light of inner space, especially
when the light from the outside seems to dominate or draw the light from
the inside, a world is accented. Inside Chartres, the light through the stained
glass is so majestic that we cannot fail to imagine the light outside that is
generating the transfiguration inside. For a medieval man like Abbot Suger,
the effect was mystical, separating the earth from Heaven:

> When the house of God, many colored as the radiance of precious jewels, called me
> from the cares of the world, then holy meditation led my mind to thoughts of piety,
> exalting my soul from the material to the immaterial, and I seemed to find myself,
> as it were, in some strange part of the universe which was neither wholly of the
> baseness of the earth, nor wholly of the serenity of heaven, but by the grace of God
> I seemed lifted in a mystic manner from this lower toward the upper sphere.

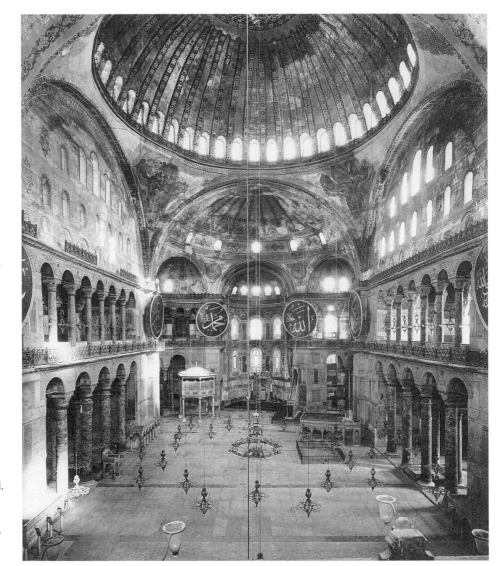

FIGURE 6-23
Hagia Sophia (Church of the Holy Wisdom of God), Istanbul. 532–537; restored 558, 975.

Isadore and Anthemius were nonprofessional architects who used light materials to create a huge well-lighted interior.

For a contemporary person, the stained glass is likely to be felt more as integrating rather than as separating us from a world. Hagia Sophia in Istanbul (Figure 6-23) has no stained glass, and its glass areas are completely dominated by the walls and dome. Yet the subtle placement of the relatively small windows, especially around the perimeter of the dome, seems to draw the light of the inner space up and out. Unlike the Pantheon (Figure 6-16), the great masses of Hagia Sophia seem to rise. The dome floats gently, despite its diameter of 107 feet, and the great enfolded space beneath is absorbed into the even greater open space outside. We imagine a world.

Sky-oriented architecture reveals the generative activity of a world. The energy of the sun is the ultimate source of all life. The light of the sun enables us to see the physical environment and guides our steps accordingly.

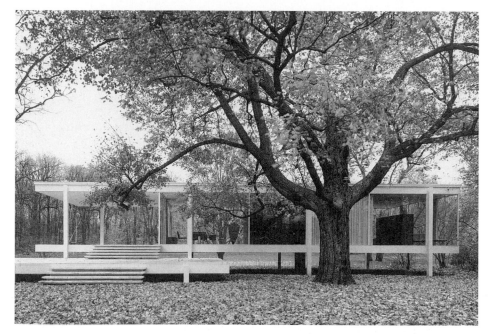

FIGURE 6-24
Ludwig Mies van der Rohe,
Farnsworth Residence, Plano,
Illinois. 1950.

Mies insisted on building with
the interior structure visible
from all angles.

"Arise, shine, for thy light is come" (Isaiah 60:1). The sky with its horizon provides a spacious context for our progress. The world of nature vaguely suggests the potentialities of the future. Architecture, however, tightly centers a world on the earth by means of its structures. This unification gives us orientation and security.

EARTH-RESTING ARCHITECTURE

Most architecture accents neither earth nor sky but rests on the earth, using the earth like a platform with the sky as background. **Earth-resting** buildings relate more or less harmoniously to the earth. Mies van der Rohe's residence for Edith Farnsworth (Figure 6-24) in Plano, Illinois, is an example of a very harmonious relationship. Unlike sky-oriented architecture, the earth-resting type does not strongly organize the sky around itself, as with Chartres (Figure 6-2) or the Cathedral of Florence (Figure 6-22). The sky is involved with earth-resting architecture, of course, but more as backdrop.

With earth-resting architecture—unlike earth-rooted architecture—the earth does not appear as an organic part of the building, as in Wright's Kaufmann house (Figure 6-12). Rather, the earth appears as a stage. Earth-resting buildings, moreover, are usually cubes that avoid cantilevering structures, as in the Kaufmann house, as well as curving lines, as in the Sagrada Familia (Figure 6-19). Earth-rooted architecture seems to "hug to" the earth, as with the Pantheon (Figure 6-17), or to grow out of the earth, as with the Kaufmann house. Earth-resting architecture, on the other hand, seems to "sit on" the earth. Thus, because it does not relate to its environment quite as strongly as earth-rooted and sky-oriented architecture, this

kind of architecture usually tends to draw to itself more isolated attention with reference to its shape, articulation of the elements of its walls, lighting, and so on.

Earth-resting architecture is usually more appropriate than earth-rooted architecture when the site is severely bounded by other buildings. Perhaps this is a basic deficiency of Wright's Guggenheim Museum (Figure 6-8). In any case, it is obvious that if buildings were constructed close to the Kaufmann house—especially earth-resting or sky-oriented buildings—they would destroy much of the glory of Wright's creation.

In villages, towns, and cities with climates that do not require pitched roofs, earth-resting buildings, especially among homes, are in the great majority. Usually they are the easiest and cheapest to build, and they lend themselves easily to coordination with other buildings. Check this claim with your own observations. Are we suggesting that buildings with pitched roofs are not likely to be earth-resting?

EARTH-DOMINATING ARCHITECTURE

Unlike an earth-resting building, an ***earth-dominating*** building does not sit on but "rules over" the earth. There is a sense of power and aggression. And unlike earth-rooted buildings, such as the Pantheon (Figure 6-17) or the Kaufmann house (Figure 6-12), there is no feeling of an organic relationship between the building and the earth.

PERCEPTION KEY Palazzo Farnese

Study the Palazzo Farnese (Figure 6-25) by Antonio da Sangallo and Michelangelo Buonarroti.

1. The façade of this building is 185 feet by 96½ feet. Is there any particular significance to the large size and proportion of these dimensions? Suppose, for example, that the construction had stopped with the second floor. Would the relationship between width and height be as right as it now appears?
2. The *cornice*—the horizontal molding projecting along the top of the building—is very large, and *quoins* (roughly cut stones) sharply accent the ends of the facade. There is a sense of heavy stability. Is this appropriate for a palace?
3. What function and what values, if any, does this building reveal? In other words, what is the subject matter that the form informs about? And how does the form achieve its content?
4. Is the palace earth-resting or earth-dominating?

The Palazzo Farnese expresses authority. It commands the earth and everything around. Michelangelo's third floor, compared with Sangallo's lower floors, is even awesome, as if the power cannot be contained. Only the third floor of this mighty, sharply outlined, indestructible cube expresses movement.

Earth-dominating buildings generally are easily identified. Any work of architecture *solicits* attention. But earth-dominating buildings *demand*

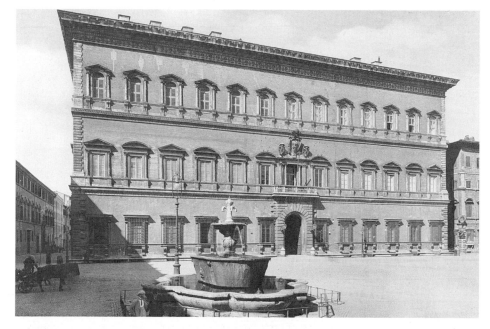

FIGURE 6-25
Antonio da Sangallo and
Michelangelo Buonarroti,
Palazzo Farnese, Rome. 1534.

Explicitly designed as a "power
house," it was the home of the
Farnese family and the most
imposing palazzo of its time.

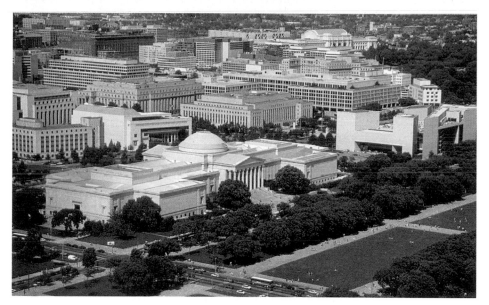

FIGURE 6-26
John Russell Pope, National
Gallery of Art, Washington,
D.C. 1941.

The Mall entrance (West
Wing) is a massive building
using echoes of Greek and
Roman architecture, including
a dome with an oculus like
the Pantheon. The West Wing
contains artifacts up to the
twentieth century.

attention: Take notice! Who would fail to notice the Palazzo Farnese? Usually,
earth-dominating buildings are large and massive, but those features do not
necessarily express earth-dominance. For example, Versailles is huge and
heavy, but its vast horizontal spread has, we think, the effect of earth-resting.
The earth as a platform holds its own with the palace. You can sense this
much better from the ground than from an aerial photograph (Figure 6-13).
Study the West Wing of the National Gallery of Art (Figure 6-26). Do you
think the building is earth-resting or earth-dominating? As you think about

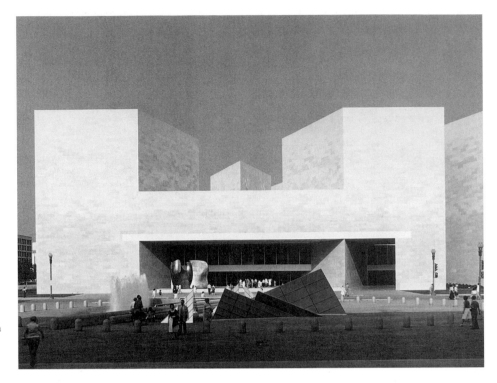

FIGURE 6-27

I. M. Pei, East Wing of the National Gallery of Art, Washington, D.C. 1974–1978.

The East Wing contains modern and contemporary art. Pei's design features powerful geometric forms.

this, compare St. Peter's (Figure 6-1). In the West, St. Peter's is probably the supreme example of earth-dominating architecture.

PERCEPTION KEY The National Gallery and the East Wing

In 1978 the East Wing (Figures 6-27 and 6-28)—designed by I. M. Pei and Partners—was completed, supplementing the old wing, or West Wing, of the National Gallery. If possible, visit both the old and new buildings and study their structures carefully.

1. Does the exterior of the East Wing—a trapezoid divided into two triangular sections—reveal the function of the building as a museum? Compare with the West Wing.
2. Both buildings use Tennessee pink marble from the same quarries. Does either succeed in bringing out the marbleness of this marble?
3. Is the technology that underlies the structure of the East Wing as hidden as in the West Wing?
4. Is there a draw into the entrance of the East Wing, inviting visitors to enter? Compare with the Mall entrance of the West Wing.
5. Do you think that architecturally the East Wing is better or worse than the West Wing? Why?

Beijing's National Stadium (on the cover of this book) was built for the 2008 Summer Olympics. It is the largest steel building in the world. From the beginning it was a sensation with an endearing nickname, the Bird's Nest, given to it by its Swiss architects, Jacques Herzog and Pierre Meuron. They, along with Ai Weiwei, a Chinese artist responsible for echoing Chinese

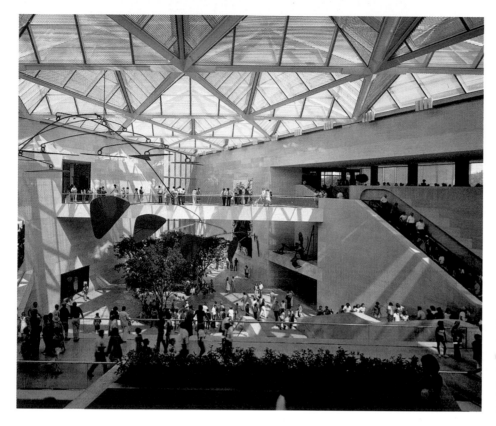

FIGURE 6-28
National Gallery of Art interior.

The interior space of the walk-way connecting the two wings of the museum is lighted by the triangular skylights visible from the exterior.

design elements, made it unlike all other stadiums in the world. It avoids the merely functional and impersonal qualities of stadiums like the new Yankee Stadium in New York City. Instead, the National Stadium is an innovative, daring building, attracting people to a profound and enriching space appropriate for its function as a temple for athletes.

Most stadiums are earth-resting, but the dynamic energy imparted by the National Stadium's fluid cross trusses, most brilliantly visible at night, implies a dominating movement skyward. The nickname, Bird's Nest, points up to where we find most natural birds' nests. Following the Olympics, the plan for the building included creating shopping malls and entertainment centers. As of now only a few large-scale entertainment groups have shown up to use the 80,000-seat facility.

You may find it difficult to locate earth-dominating buildings in your community. Palaces are rare, except in very wealthy communities. Few churches exert anything close to the power of St. Peter's. Indeed, for many religious traditions in the United States, such architectural display might be considered sacrilegious. Public buildings such as courthouses tend to avoid aggressive appearance. They are expected to be traditional and democratic. And buildings of commerce—from banks to malls—are meant to invite.

FIGURE 6-29
Richard Meier, Long Island
Federal Courthouse, Central
Islip, New York. 2000.

A stark white building, it is
one of the largest courthouses
in the nation. It is designed to
accommodate public gatherings
as well as numerous individual
courts.

COMBINATIONS OF TYPES

PERCEPTION KEY The Palazzo Farnese and the
Long Island Federal Courthouse

Compare the Palazzo Farnese (Figure 6-25) with Richard Meier's Courthouse (Figure 6-29). Both buildings are horizontally oriented cubes. Both use the earth as a platform. Neither one uses cantilevering as with the Kaufmann house (Figure 6-12) or curving organic lines as with the Sagrada Familia (Figure 6-19). Both use the sky basically as a backdrop and thus obviously are not sky-oriented. Would you describe the Courthouse as earth-rooted, -resting, or -dominating? Or some combination? As you think about this, note the following features of the Courthouse as contrasted with the Palazzo Farnese: the play of solids and voids and shadows, the deep penetration of visual space into the interiors, the variations in the size of the rectangular divisions, the play of details on top of the roof, the sense of structural lightness, and asymmetry.

It seems to us that the Courthouse might best be described as a combination of the earth-resting and the earth-rooted. The earth-resting features, such as the sky as a backdrop and the platform character of the earth, are fairly obvious. The earth-rootedness is also there, however, because of the powerful effect of the huge rotunda that rises at the entrance like a giant tree anchoring the building into the earth. The Courthouse does not just use the earth but seems to belong to it. Some critics have described the rotunda as a huge ugly nose that defaces a handsome face. What do you think? Meier, incidentally, is the architect of the famous Getty Museum in Los Angeles.

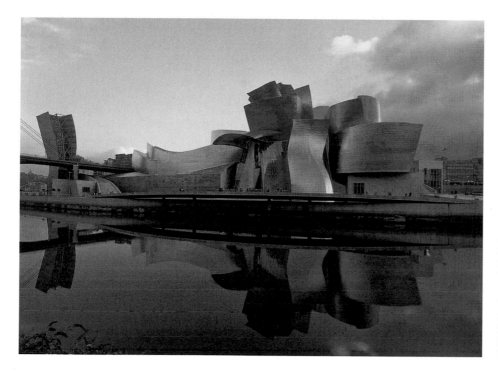

FIGURE 6-30
Frank O. Gehry, Guggenheim
Museum Bilbao, Bilbao, Spain.
1997.

View from across the river. Gehry's titanium-clad free-flowing
forms have been made possible
by the computer and have
become his signature style.

The problem of when to use earth-rooted, -resting, or -dominating, or sky-oriented structures, or some combination is usually resolved by making the function of the building paramount. Churches and large office buildings, especially in crowded cities, lend themselves to sky-orientation. Homes in surburbia lend themselves to earth-orientation, usually resting but sometimes rooted. Homes in crowded urban areas present special problems. Earth-rooted buildings, such as the Kaufmann house, normally require relatively large open spaces, and to some extent the same is true of the earth-dominating. Most urban dwellings therefore are earth-resting. But as our populations have become increasingly dense, sky-oriented apartment buildings have become a common sight.

Guggenheim Museum Bilbao and Sydney Opera House

Frank Gehry's Guggenheim Museum in Bilbao, Spain, 1991–1997 (Figures 6-30 through 6-33), was the culminating architectural sensation of the twentieth century, surpassing in interest even Wright's Guggenheim of 1959. Gehry, like many contemporary architects, often uses the computer to scan models and flesh out the possibilities of his designs. The titanium-swathed structure changes drastically and yet harmoniously from every view: For example, from across the Nervion River that cuts through Bilbao the Guggenheim looks something like a whale (Figure 6-30). The locals say that from the bridge it looks like a colossal artichoke; from the south a

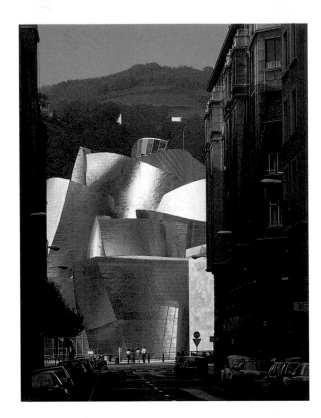

FIGURE 6-31
Guggenheim Museum Bilbao.

This view from the south reveals the play of light in an otherwise dark street.

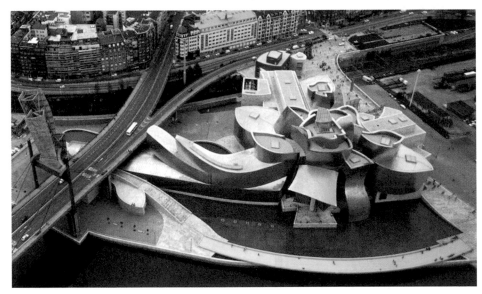

FIGURE 6-32
Aerial view of Guggenheim Museum Bilbao.

The view from the air reveals powerful interrelationships of geometric forms with the almost floral organic forms that flow from rectilinear "stems."

bulging, blooming flower (Figure 6-31). The silvery skin of the south facade reflects colors and lights that subtly harmonize, something like a Rothko abstraction (Figure 4-11). The billowing volumes, mainly cylindrical, spiral upward, as if blown by gently sweeping winds.

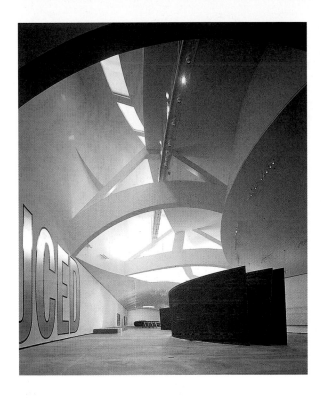

FIGURE 6-33
Guggenheim Museum Bilbao,
interior.

The sculpture is by Richard
Serra.

Inside (Figure 6-33), smooth curves dominate perpendiculars and right angles, propelling visitors leisurely from each gallery or room to another with constantly changing perspectives, orderly without conventional order.

PERCEPTION KEY Guggenheim Museum Bilbao

1. Is the Guggenheim earth-rooted, earth-resting, earth-dominating, or sky-oriented? Could it be a combination? It would be helpful if you could examine more photographs (see, for instance, *Frank O. Gehry: The Complete Works*, by Francesco Dal Co and Kurt W. Forster [New York: Monacelli Press, 1998]).
2. Identify a building in your community that is an example of a combination of types. Photograph that building from the angle or angles that support your choice.

It seems to us that the Guggenheim Bilbao is earth-rooted from the northern perspective (Figure 6-30), the reflection in the river beautifully accenting that orientation. Yet from the southern perspective (Figure 6-31), the building is sky-oriented, its roofs appearing to stretch up the mountain like clouds tinted by the sun. Gehry has accented the natural unity of earth and sky.

Study the photograph of Jørn Utzon's Opera House (Figure 6-34), begun in the late 1950s in the beautiful harbor of Sydney, Australia. Although Utzon did not complete the designs for the final details of the building because of

1. Would you recognize the function of the building if you did not know its name?
2. Which type does this building fulfill, earth-resting, earth-rooted, or sky-oriented?

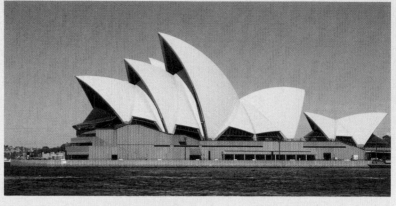

FIGURE 6-34
Jørn Utzon, Opera House, Sydney, Australia. 1973.

This is considered an expressionist modern design. The precast concrete shells house various concert and performance halls.

In the late 1950s this building was a sensation in part because no one could know by looking at it that it was a concert and opera hall. Its swooping "sails" were so novel that people were more amazed at its construction than by its function. Additionally, the fact that the building was floating in a harbor rather than being built on solid earth was all the more mystifying. Today, however, with the innovations of computer-generated plans for buildings like Gehry's Guggenheim in Bilbao (Figures 6-30 through 6-33), we are accustomed to the extraordinary shapes that make these buildings possible. In fact, now we are likely to associate the shape of the Sydney Opera House with a function related to the arts. This tells us that our perception of function in a building is established by tradition and our association with a class of buildings. Therefore, the dogma that was so firmly established years ago—"form follows function"—is capable of distinct revision.

The Sydney Opera House is resting on a reinforced concrete platform rather than being built into the earth; so it certainly cannot be considered earth-rooted. It is also difficult to say that it is earth-resting, because it is resting on water. One can safely say, however, that it appears to be earth-resting. Yet, it is not sufficient to stop there. The "sails," or "wings," are upward thrusting, almost like a church (see Figure 3-4, Notre Dame-du-Haut), so it is certainly appropriate to claim that it is in some ways sky-oriented. If so, then this is an example of a building that satisfies the requirements of two types at the same time.

3. Have you seen other buildings that appear to satisfy two types at the same time?
4. Have you seen another building whose function is not clearly apparent from its form?

disputes over cost overruns and long delays, the architecture is basically his, and the building is considered to be one of the architectural masterpieces of the twentieth century. Check the Internet for different views of the building.

High-Rises and Skyscrapers

Some of the most dramatic examples of the combination of types occur when traditional architecture is fused with contemporary architecture, as happens quite often in Shanghai. With a population of over 18 million and

FIGURE 6-35
High-rise buildings, Shanghai, China.

High-rise buildings in Shanghai emulate and echo traditional Chinese buildings. Even office buildings sometimes reprise the details of ancient pagodas.

rapidly growing, closely crowded around a huge and superb port, Shanghai in recent years has grown over 2,000 high-rises with 2,000 more on the way, both for offices and domestic housing. Many of the buildings visible in Figure 6-35 are fairly representative.

PERCEPTION KEY High-Rises in Shanghai

1. Examine the top structures of the high-rises in Figure 6-35. Are these tops horizontally oriented as with the Seagram Building (Figure 6-7), or are they more vertically oriented as with Rockefeller Center (Figure 6-11)?
2. Are these top structures suggestive of structures normally built on and belonging to the earth, such as temples, pagodas, restaurants, and porches?
3. The Chinese usually use the term "high-rise" rather than "skyscraper." Is this significant? If so, in what way?
4. A Chinese architect in Shanghai commented to one of the authors, "In our big cities we build high for practical purposes, just as in the West. But the culture of China is much more traditional than the culture of the West, especially in its arts. With painting, for example, it often takes an expert to identify a twentieth- or twenty-first-century work from earlier centuries. The painter begins by imitating a style and then evolves a style that never loses its roots. Likewise, the Chinese architect tends to be very sensitive to the styles of the past, and that past is more reverent to the earth than to the sky." Is this comment relevant to the toppings of many of the Shanghai high-rises?

(continued)

FIGURE 6-36
I. M. Pei, Bank of China Tower,
Hong Kong. 1982–1990.

At seventy-two stories high, this
is Hong Kong's tallest building.
One of Pei's challenges was to
satisfy the needs of feng shui,
the proper positioning of the
building and its angles.

5. The high-rises of Shanghai never begin to be as high as Rockefeller Center (Figure 6-11). Does the quote in question 4 perhaps partially explain why? What other reasons can you cite?
6. If there is, as we have been suggesting, a combination of sky-orientation with earth-orientation in many of the Shanghai high-rises, is that earth-orientation rooted, resting, or dominating?

From outside, the buildings of Hong Kong as a conglomerate appear overwhelmingly sky-oriented (Figure 6-36). Most of the skyscrapers appear to penetrate the heavens, aided in their thrust by the uplift of the background mountains. Photographs cannot do justice to this effect. The earthly tops of the Shanghai high-rise type are rare, and the Hong Kong buildings generally are considerably higher than those of Shanghai. "Skyscraper" more than "high-rise" more accurately describes these Hong Kong buildings. Sometimes verticality stretches so powerfully that even the diagonal struts of I. M. Pei's Bank of China Tower (Figure 6-36)—the tallest building in Hong Kong—may appear to stretch imaginatively beyond the top of the roof into vertical straight lines.

FIGURE 6-37
Cityscape in Hong Kong. The crowding of buildings is typical in this small city.

From inside the city, the architectural impressions of Hong Kong are generally another story (Figure 6-37). The skyscrapers usually abut, crowd, mirror, and slant into each other, often from odd angles, blocking a full view, closing and overwhelming the spaces between. Unlike New York City, where the grid of broad straight avenues provides breathing room for the skyscraper, the narrow crooked streets that dominate Hong Kong rarely allow for more than truncated views of the buildings. Except on the waterfront, only small patches of the sky are usually visible. The skyscrapers press down. Gravity is overbearing. Sometimes the atmosphere is claustrophobic. Inside Hong Kong, the skyscrapers are usually more earth-dominating than sky-oriented. In New York City there are a few areas of this kind (see Figure 6-40), but even there, Park Avenue provides an extensive clearing.

The high-rise in Malmö, Sweden (Figure 6-38)—often described as the "Turning Torso"—by the Spanish architect Santiago Calatrava, provides splendid views for most of the 147 apartments. At the core of the building, stairs and elevators provide internal communication. The service rooms—kitchen, bath, and utilities—are grouped around that core, freeing the living-room spaces for the outside world. The tallest building in Scandinavia, the Turning Torso is bound by struts forming triangles, reducing the use of steel by about 20 percent compared to the conventional box structure such as the Seagram Building (Figure 6-7).

PERCEPTION KEY The Turning Torso

1. Is the building sky-oriented?
2. Is it earth-oriented?
3. Is it a combination?

It seems to the authors that the Turning Torso is a combination of sky- and earth-orientation. The horizontal gaps that divide the building disect powerful sweeping vertical edges. The top of the building, unlike the Shanghai examples, has no earthlike structures. Surely this building, especially with its spatial isolation, is sky-oriented. And yet the aptly named Turning Torso seems to be twisting fantastically on the earth as one walks around it. Or from the perspective of our photograph, the building seems to be striding toward the right. Whatever the view, the Turning Torso is horizontally kinetic, totally unlike the static Seagram Building (Figure 6-7). The Turning Torso is an extraordinary example, we think, of a combihation of sky-orientation and earth-domination, unlike the Shanghai examples, which are sky-oriented and earth-resting.

Study the photograph (Figure 6-39) of Norman Foster's recently completed Hearst Tower at Eighth Avenue and Fifty-seventh Street, New York City. Check the Internet for different views. Don't miss this building if you are in New York City, viewing it from different angles. The six lower floors of the original building were gutted except for the four facades. Thus the tower seems to rise from the top of the facades, which strangely appear to provide a platform.

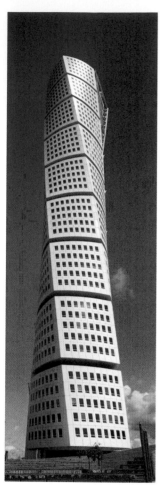

FIGURE 6-38
Santiago Calatrava, "Turning Torso," high-rise, Malmö, Sweden. 1999–2000.

The twisting design derived from one of Calatrava's own sculptures.

PERCEPTION KEY Hearst Tower

1. Does the tower strike you as more or less interesting than the two adjoining skyscrapers? Why?
2. Would you describe the building as earth-rooted, earth-dominating, sky-oriented, or some combination? As you think about this, notice how the great triangular panels of glass reflect the sky (at night, of course, there is the reflection of lights).

We suggest that the tower is most accurately described as sky-oriented. The platform's earth-resting effect is overwhelmed by the great soaring beautiful volumes of triangular glass. The tower overwhelms the earth. Its flat topping doesn't penetrate the sky, like the two fellow skyscrapers, but with its reflecting glass mirrors, it merges with the sky. The tower would seem to be most accurately described as sky-oriented.

URBAN PLANNING

Nowhere has the use of space become more critical in our time than in the city. In conclusion, therefore, the issues we have been discussing about space and architecture take on special relevance with respect to city planning.

The conglomerate architecture visible in Figure 6-40, surrounding a large church on Park Avenue, makes us aware that the setting of many interesting buildings so completely overwhelms them that we hardly know how to respond. An urban planner might decide to unify styles of buildings or to separate buildings so as to permit us to participate with them more individually. The scene of Figure 6-40 suggests that there has been little or no planning. Of

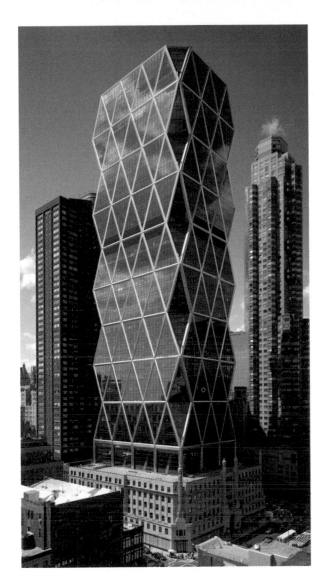

FIGURE 6-39
Norman Foster, Hearst Tower,
New York City. 2006.

The project was to build on top
of a seventy-eight-year-old lime-
stone building whose interior
was essentially gutted to accom-
modate the tower, which rises
sharply and suddenly above the
conventional lower section.

course, some people might argue that such an accidental conglomeration is
part of the charm of urban centers. One might feel, for example, that part of
the pleasure of looking at a church is responding to its contrast with its sur-
roundings. For some people, a special energy is achieved in such a grouping. A
consensus is unlikely. Other people are likely to find the union of old and new
styles—without first arranging some kind of happy marriage—a travesty. The
dome of a church capped by a skyscraper! The church completely subdued
by business! What do you think? These are the kinds of problems, along with
political and social complications, that city planners must address.

Now study the MetLife Building on Park Avenue (Figure 6-41). The height
of certain structures can be limited so that only notable buildings are allowed

FIGURE 6-40
St. Bartholomew's Church on
Park Avenue, New York City.
1902.

Once a dominant building, it
now seems dwarfed by nearby
office buildings. Bertram
Goodhue was the architect,
with the portico done by
McKim, Meade, and White.

FIGURE 6-41
Emery Roth and Sons, MetLife Building,
NewYork City. 1963.

Centered on Park Avenue, and originally
named the Pan-Am Building, this struc-
ture reveals the way urban space can
be transformed by closure. Traffic flows
around and through the building.

to rise to great heights, as in Florence, for example. Only a few sections in
New York City actually have been controlled. On Park Avenue, the buildings
have height restrictions, and in some cases, top stories have been removed

FIGURE 6-42
A typical facade on an anony-
mous building in Greenwich
Village, New York City.

The design is rudimentary
and the buildings rarely more
than four stories high. This
is an earth-centered, humble
structure.

from buildings under construction. In certain areas, the buildings on both
sides of an avenue can create darkness in the middle of the day. The jam of
taxis is only one symptom of the narrowness of the avenues in New York
City. The architecture along this section of Park Avenue has created a space
dominated by dark shadows, making the looming buildings appear threaten-
ing. Now consider the contrast in a building in the Greenwich Village section
of New York City (Figure 6-42), where most of the buildings are about as tall
as this one. Even though the building is by no means as sleek and elegant as
the MetLife Building, it has a human scale and a humble brightness.

PERCEPTION KEY Urban Views

1. Would you prefer to live in a humble building, such as that in Figure 6-42, or in
 one of the buildings that creates the shadows in the vicinity of the MetLife Build-
 ing in Figure 6-41?
2. Do you find the placement of the building in front of the MetLife Building visually
 attractive? If so, why? Do you like the contrast between the pyramidal top and the
 flat top?
3. Suppose St. Bartholomew's Church (Figure 6-40) was no longer being used for
 religious purposes. As a city planner, would you preserve or destroy it? Explain.
4. Do you find the scene around the church visually attractive? Compare this scene
 with the main avenue of Dubai (Figure 6-43), a city audaciously built on the Per-
 sian Gulf in a few recent decades. Dubai's growth was planned and controlled,
 New York's growth was largely unplanned and little controlled. Would you prefer,
 other things being more or less equal, to live in a city with architecture like New
 York or architecture like Dubai? Explain.

FIGURE 6-43
Main road, Dubai.

This nation has been building high-rises and other structures in a pristine environment, making urban planning an absolute necessity.

Suppose spacious parking lots were located around the fringes of the city, rapid public transportation were readily available from those lots into the city, and in the city only public and emergency transportation—most of it underground—were permitted. In place of poisonous fumes, screeching noises, and jammed streets, there could be fresh air, fountains, flowers, sculpture, music, wide-open spaces to walk and talk in and enjoy, benches, and open theaters. Without the danger of being run over, all the diversified characters of a city— theaters, opera, concert halls, museums, shops, offices, restaurants, parks, squares—could take on some spatial unity. Furthermore, we could get to those various places without nervous prostration and the risk of life and limb.

Most cities are planned either sporadically in segments or not at all. Natural features, such as rivers and hills, often distinguish living spaces from working spaces. In older cities, churches often dominate high ground. Human-made divisions, such as aqueducts, railroad tracks and trestles, bridges, and highways, now largely define neighborhoods, sections, and functional spaces. The invasion of the suburban mall has threatened the old downtown business sections in most cities, and, in order to preserve those spaces from blight, imaginative schemes have been developed in some cities. San Antonio, Texas, has created a canal lined with shops and restaurants. Providence, Rhode Island, and Portland, Oregon, closed large areas to automobiles and made them inviting for shoppers, especially those with strollers and children. Many cities have remodeled their inner shopping areas and made plans to keep them lively and attractive. Street music is now common in many downtown areas, such as New York, London, and Paris.

CONCEPTION KEY City Planning

1. Do you think the city ought to be saved? Why not just spread out, without the centralized functions of a city? What advantages does the city alone have? What still gives glamour to such cities as Florence, Venice, Rome, Paris, Vienna, and London?
2. Suppose you are a city planner for New York City, and assume that funds are available to implement your plans. What would you propose? For example, would you destroy all the old buildings? Joseph Hudnut has written, "There is in buildings that have withstood the siege of centuries a magic which is irrespective of form and technical experience . . . the wreckage of distant worlds are radioactive with a long-gathered energy."[9] Do you agree?
3. Would you allow factories within the city limits? How would you handle transportation to and within the city? For instance, would you allow expressways to slice through the city, as in Detroit and Los Angeles? If you banned private cars from the city, what would you do with the streets? Would you concentrate on an effective subway system? Could the streets become a unifier of the city?

SUMMARY

Architecture is the creative conservation of centralized space—the power of the positioned interrelationships of things. The spatial centers of nature organize things around them, and architecture enhances these centers. Architects carve apart an inner space from an outer space in such a way that both spaces become more fully perceptible, and especially the inner space can be used for practical purposes. A work of architecture is a configurational center, a place of special value, a place to dwell. Architects must account for four basic and closely interrelated necessities: technical requirements, function, spatial relationships, and content. To succeed, their forms must adjust to these necessities. Because of the public character of architecture, moreover, the common or shared values of contemporary society usually are in a direct way a part of architects' subject matter. Architecture can be classified into four main types. Earth-rooted architecture brings out with special force the earth and its symbolisms. Such architecture appears organically related to the site, its materials, and gravity. Sky-oriented architecture brings out with special force the sky and its symbolisms. Such architecture discloses a world by drawing our attention to the sky bounded by a horizon. It accomplishes this positively by means of making a building high and centered within the sky, defying gravity, and tightly integrating the light of outer and inner space. Negatively, this kind of architecture deemphasizes the features that accent the earth. Earth-resting architecture accents neither earth nor sky but rests on the earth, using the earth as a platform with the sky as backdrop. Earth-dominating architecture rules over the earth. There is a sense of aggression, and such buildings seem to

[9]Joseph Hudnut, *Architecture and the Spirit of Man* (Cambridge, Mass.: Harvard University Press, 1949), p. 15ff.

say that humanity is the measure of all things. In recent years, more and more combinations of these four types have been built.

If we have been near the truth, architects are the shepherds of space. And if we are sensitively aware of their buildings and their relationships, we help, in our humble way, to preserve their work. Architects can make space a welcoming place. Such places, like a home, give us a center from which we can orient ourselves to the other places around us. And then in a way we can feel at home anywhere.

Chapter 7

LITERATURE

SPOKEN LANGUAGE AND LITERATURE

The basic medium of literature is spoken language. Eons before anyone thought to write it down, literature was spoken and sung aloud. Homer's great epics, *The Iliad* and *The Odyssey*, may date from 800 B.C. or earlier. They were memorized by poets, who sang the epics to the plucking of a harplike instrument while entertaining royalty at feasts. The tradition of memorizing and reciting such immense works actually survived into the twentieth century but seems to have disappeared after the Second World War.

In the Middle Ages, St. Augustine was surprised to see Ambrose reading without making a sound. Before the printing press was invented, monks copied books by hand, and they would speak the words softly to themselves as they wrote. Thus the room would be noisy with the sounds of a dozen or more people reading. Today we are told to read without moving our lips or making a sound, but that may not be the best way to read literature. We invite you to read aloud all the samples of literature that follow.

In the fourteenth century, Geoffrey Chaucer wrote down his *Canterbury Tales* for convenience, more than a century before the invention of the printing press. But he read his tales out loud to an audience of courtly listeners who were much more attuned to hearing a good story than to reading it. Today people interested in literature are usually described as readers, which underscores the dependence we have developed on the printed word for our literary experiences. Yet words "sound" even when read silently, and the sound is an essential part of the sense, or meaning, of the words.

Literature—like music, dance, film, and drama—is a serial art. In order to perceive it, we must be aware of what is happening now, remember what happened before, and anticipate what is to come. This is not so obvious with a short lyric poem or with cummings' "l(a" (page 13) because we are in the presence of something akin to a painting: It seems to be all there in front of us all at once. But one word follows another; one sentence, one line, or one stanza another. There is no way to perceive the all-at-onceness of a literary work as we sometimes perceive a painting, although cummings' poem comes close.

"Do Not Go Gentle into That Good Night," by Dylan Thomas, is an example of harnessing deep emotion in the confines of a rigid form. Thomas wrote the poem while his father was dying. Read it first; then we will consider the issues that go into making it a powerful poem. If possible, listen to a recording of the poem by Thomas himself.

DO NOT GO GENTLE INTO THAT GOOD NIGHT

Do not go gentle into that good night,
Old age should burn and rave at close of day;
Rage, rage against the dying of the light.

Though wise men at their end know dark is right
Because their words had forked no lightning they
Do not go gentle into that good night.

Good men, the last wave by, crying how bright
Their frail deeds might have danced in a green bay,
Rage, rage against the dying of the light.

Wild men who caught and sang the sun in flight,
And learn, too late, they grieved it on its way,
Do not go gentle into that good night.

Grave men, near death, who see with blinding sight
Blind eyes could blaze like meteors and be gay,
Rage, rage against the dying of the light.

And you, my father, there on the sad height,
Curse, bless, me now with your fierce tears, I pray.
Do not go gentle into that good night.
Rage, rage against the dying of the light.

PERCEPTION KEY Dylan Thomas

1. Which of the sounds of the poem are most sensuous for you?
2. What is the subject matter of the poem? What is its content?
3. The poem is built, in part, on a principle of repetition. How effective is this repetition? What is its influence on the emotional effect of the poem?
4. A student—whose father had just died—reported that the clusters of meaning were so intense the words seemed to stand up on the page. Have you ever experienced anything like that?

This poem is an address to the poet's father, telling him not to die without a struggle to hold onto life. The poet uses sounds to underscore his emotional pain, especially the use of one g sound in "gentle" another in "good," and yet another g sound in "age" and "rage." As you examine the opening stanza, you can see the careful use of o sounds in "Do," "go," "good," and "old," which eventually give way to the a sounds in "rage." These are careful poetic devices called **consonance** in the case of g and **assonance** in the cases of the o and a sounds. Excellent poets attempt to soothe or stir a reader with a careful balance of such sounds.

The form of the poem—the villanelle—is one of the most difficult forms for English-language poets to use. First, there must be five three-line stanzas and one final four-line stanza. Line one must repeat in its entirety at lines six, twelve, and eighteen. Line three must repeat at lines nine, fifteen, and nineteen. There can be only two rhyme sounds. The first and third lines of each stanza rhyme with "light" and the second line rhymes with "day."

The miracle in this poem is that the burden of form does not weigh the poem down. If anything, it intensifies and focuses the powerful emotions that are its source. In this case, sound and sense merge brilliantly in a form that emphasizes the skill of the poet. The significance of the poem lies in the blending of sound and meaning because one cannot alter the sounds of this poem without altering its meaning. We can talk easily about the subject matter of the poem. It is the complaint of the poet regarding his father's imminent death. But the content of the poem goes beyond that into the experience of apprehending—both silently and audibly—the poem itself. Before you move on, read the poem aloud to a friend and talk about what the poem means to you both.

Ezra Pound once said, "Great literature is simply language charged with meaning to the utmost possible degree." The ways in which writers intensify their language and "charge" it with meaning are many. First, they need to attend to the basic elements of literature because, like architecture, a work of literature is, in one sense, a construction of separable elements. The details of a scene, a character or event, or a group of symbols can be conceived of as the bricks in the wall of a literary structure. If one of these details is imperfectly perceived, our understanding of the function of that detail—and, in turn, of the total structure—will be incomplete. The **theme** (main idea) of a literary work usually involves a structural decision, comparable to an architectural decision about the kind of space being enclosed. Decisions about the sound of the language, the characters, the events, the setting are comparable to the decisions regarding the materials, size, shape, and landscape of architecture. It is helpful to think of literature as works composed of elements that can be discussed individually in order to gain a more thorough perception of them. And it is equally important to realize that the discussion of these individual elements leads to a fuller understanding of the whole structure. Details are organized into parts, and these, in turn, are organized into structure.

Our structural emphasis in the following pages will be on the narrative—both the episodic narrative, in which all or most of the parts are loosely interrelated, and the organic narrative, in which the parts are tightly interrelated. Once we have explored some of the basic structures of literature, we will examine some of the more important details. In everyday language situations,

what we say is usually what we mean. But in a work of literature, language is rarely that simple. Language has **denotation,** a literal level where words mean what they obviously say, and **connotation,** a subtler level where words mean more than they obviously say. When we are being denotative, we say the rose is sick and mean nothing more than that. But if we are using language connotatively, we might mean any of several things by such a statement. When the poet William Blake says the rose is sick, he is describing a symbolic rose, something very different from a literal rose (see page 209). Blake may mean that the rose is morally sick, spiritually defective, and that in some ways we are like the rose. The image, metaphor, symbol, irony, and diction (word choices) are the main details of literary language that will be examined. All are found in poetry, fiction, drama, and even the essay.

LITERARY STRUCTURES

The Narrative and the Narrator

The **narrative** is a story told to an audience by a teller controlling the order of events and the emphasis those events receive. Most narratives concentrate upon the events. But some narratives have little action: They reveal depth of character through responses to action. Sometimes the **narrator** is a character in the fiction; sometimes the narrator pretends an awareness of an audience other than the reader. However, the author controls the narrator; and the narrator controls the reader. Participate with the following narrative poem by D. H. Lawrence:

PIANO

Softly, in the dusk, a woman is singing to me;
Taking me back down the vista of years, till I see
A child sitting under the piano, in the boom of the tingling strings
And pressing the small, poised feet of a mother who smiles as she sings.

In spite of myself, the insidious mastery of song
Betrays me back, till the heart of me weeps to belong
To the old Sunday evenings at home, with winter outside
And hymns in the cozy parlor, the tinkling piano our guide.

So now it is vain for the singer to burst into clamor
With the great black piano appassionato. The glamor
Of childish days is upon me, my manhood is cast
Down by the flood of remembrance, I weep like a child for the past.

> ## PERCEPTION KEY "Piano"
>
> 1. Which is more fully developed, events or character? Or are they roughly equally important?
> 2. What do we know about the narrator?
> 3. Is the narrator D. H. Lawrence? Does it make a significant difference to your understanding of the poem to know that answer? Why or why not?
> 4. To whom does this poem seem to be addressed?

Lawrence's poem relates events that are interesting mainly because they reveal something about the character of the narrator, especially his double focus as man and as child, with all the ambiguities that the narrator's memory evokes. If your background information includes something about the life of D. H. Lawrence, you probably will identify Lawrence as the narrator. The poem certainly has autobiographical roots: Lawrence's closeness to his mother evokes in our participation a dimension of poignancy. Yet if we did not have this information, not much would be lost. The revelation of the narrator's character is general in the sense that most of us understand and sympathize with the narrator's feelings, no matter whether the narrator is Lawrence.

The following poem is a powerful example of the way in which Sylvia Plath uses the first-person narrator while creating an "I" character who is not herself. The poem is told by someone in an iron lung:

PARALYTIC

It happens. Will it go on?—
My mind a rock,
No fingers to grip, no tongue,
My god the iron lung

That loves me, pumps
My two
Dust bags in and out,
Will not

Let me relapse
While the day outside glares by like ticker tape
The night brings violets,
Tapestries of eyes,

Lights,
The soft anonymous
Talkers: "You all right?"
The starched, inaccessible breast.

Dead egg, I lie
Whole
On a whole world I cannot touch,
At the white, tight

Drum of my sleeping couch
Photographs visit me—
My wife, dead and flat, in 1920 furs,
Mouth full of pearls,

Two girls
As flat as she, who whisper "We're your daughters."
The still waters
Wrap my lips,

Eyes, nose and ears,
A clear
Cellophane I cannot crack.
On my bare back

I smile, a buddha, all
Wants, desire
Falling from me like rings
Hugging their lights.

The claw
Of the magnolia,
Drunk on its own scents,
Asks nothing of life.

PERCEPTION KEY "Paralytic"

1. Analyze the narrative. What are the limitations of telling a story from the point of view of a person who is paralyzed?
2. What is the role of the magnolia claw—a living but not a moving instrument (unlike people's hands)—in the poem?
3. Explore some of the implications of the fact that the narrator of the poem is an imaginary character invented by the poet. Is this information crucial to a full understanding of the poem?
4. Sylvia Plath committed suicide not long after writing this poem. Does that information add intensity to your experience of the poem?

The Episodic Narrative

An **episodic narrative** describes one of the oldest kinds of literature, embodied by **epics** such as Homer's *Odyssey*. We are aware of the overall structure of the story centering on the adventures of Odysseus, but each adventure is almost a complete entity in itself. We develop a clear sense of the character of Odysseus as we follow him in his adventures, but this does not always happen in episodic literature. The adventures sometimes are not only completely disconnected from one another, but the thread that is intended to connect everything—the personality of the **protagonist** (the main character)—also may not be strong enough to keep things together. Sometimes the character may even seem to be a different person from one episode to the next. This is often the case in oral literature, compositions by people who told or sang traditional stories rather than by people who wrote their narratives. In oral literature, the tellers or singers may have gathered adventures from many sources and joined them in one long narrative. The likelihood of disconnectedness in such a situation is quite high. But disconnectedness is sometimes desirable. It may offer several things: compression, speed of pacing, and variety of action that sustains attention. Some of the most famous episodic narratives are novels: Cervantes' *Don Quixote,* Fielding's *Tom Jones,* Defoe's *Moll Flanders,* and Saul Bellow's *The Adventures of Augie March*.

The Organic Narrative

The term *organic* implies a close relationship of all the details in a narrative. Unlike episodic narratives, the **organic narrative** unifies both the events

of the narrative and the nature of the character or characters in it. Everything relates to the center of the narrative in a meaningful way so that there is a consistency to the story that is not broken into separable narratives. An organic narrative can be a narrative poem or a prose narrative of any length, so long as the material in the narrative coheres and produces a sense of unity.

The following short narrative poem, "Song of Wandering Aengus," by William Butler Yeats, illustrates most of the qualities of an organic narrative despite the fact that its narrative concerns what might be thought of as a moment of madness or perhaps hallucination.

THE SONG OF WANDERING AENGUS

I went out to the hazel wood,
Because a fire was in my head,
And cut and peeled a hazel wand,
And hooked a berry to a thread;
And when white moths were on the wing,
And moth-like stars were flickering out,
I dropped the berry in a stream
And caught a little silver trout.

When I had laid it on the floor
I went to blow the fire aflame,
But something rustled on the floor,
And some one called me by my name:
It had become a glimmering girl
With apple blossom in her hair
Who called me by my name and ran
And faded through the brightening air.

Though I am old with wandering
Through hollow lands and hilly lands,
I will find out where she has gone,
And kiss her lips and take her hands;
And walk among long dappled grass,
And pluck till time and times are done
The silver apples of the moon,
The golden apples of the sun.

PERCEPTION KEY William Butler Yeats

1. How do the references to fire in line two of the first two stanzas relate to the overall narrative of the wanderings of Aengus?
2. Examine the modifying words in the poem, such as "moth-like," "glimmering," "brightening," and "dappled." How do these words imply mystery?
3. Underline the uses of repetition in this poem. Repetition is one of Yeats's hallmarks in his early poetry. How does repetition contribute to a sense of coherence in the poem?
4. Can you find any description, action, or figure that is out of place in this poem?
5. Why is the poem called a song?

Aengus is the Irish god of youth and beauty, and Yeats tells us of his lifelong search for what seems to have been a magical girl—almost a mermaid—whom he "caught" on his fishing pole, significantly described as a "wand." The magical qualities of the narrative are intensified by the reference to a "hazel wood," because the hazel tree is the tree of life in Irish mythology. The girl appears with an apple blossom, a symbol of life and fruitfulness, and, like an apparition, "faded through the brightening air." The wanderings over "hollow lands and hilly lands" are endless because Aengus pursues a spiritual being, a mystery like the mystery of the powerful images of "The silver apples of the moon, / The golden apples of the sun." These apples are the fruit of a mystical search that has no end on earth.

Yeats uses words that are connotative, but not denotative—as in "glimmering" and "brightening," which cannot be pinned down and made specific. They suggest shadow lighting and mystery. The constant references to "hazel," "moth," and "berry" tend to make the lines of the first stanza cohere by linking line to line. The first stanza is linked to the second by the repetition of "fire" in each stanza. The second stanza is linked to the last by the repetition of the word "apple." The entire poem coheres through the description of the movement of Aengus, his excursion to go fishing, which ends up catching a mysterious woman who knows his name, but whom he cannot hold for more than a few moments. But he realizes she is divine and he must continue his journey to find her, though it should take him to the moon and the sun.

Most novels and almost all short stories are organically structured. For an example of a fine short story—Boccaccio's *The Pot of Basil*—go to the book's website at www.mhhe.com/hta8e for the complete text and accompanying Perception Key.

The Quest Narrative

The **quest narrative** is simple enough on the surface: A protagonist sets out in search of something valuable that must be found at all cost. Such, in simple terms, is the plot of almost every adventure yarn and adventure film ever written. However, where most such yarns and films content themselves with erecting impossible obstacles that the heroes overcome with courage, imagination, and skill, the quest narrative has other virtues. Herman Melville's *Moby-Dick,* the story of Ahab's determination to find and kill the white whale that took his leg, is also a quest narrative. It achieves unity by focusing on the quest and its object. But at the same time, it explores in great depth the psychology of all those who take part in the adventure. Ahab becomes a monomaniac, a man who obsessively concentrates on one thing. The narrator, Ishmael, is like an Old Testament prophet in that he has lived the experience, has looked into the face of evil, and has come back to tell the story to anyone who will listen, hoping to impart wisdom and sensibility to those who were not there. The novel is centered on the question of good and evil. When the novel begins, those values seem fairly clear and well defined. But as the novel progresses, the question becomes murkier and murkier because

the actions of the novel begin a reversal of values that is often a hallmark of the quest narrative.

Because most humans feel uncertain about their own nature—where they have come from, who they are, where they are going—it is natural that writers from all cultures should invent fictions that string adventures and character development on the thread of the quest for self-understanding. This quest attracts our imaginations and sustains our attention. Then the author can broaden and deepen the meaning of the quest until it engages our concepts of ourselves. As a result, the reader usually identifies with the protagonist.

The quest structure in Ralph Ellison's *Invisible Man* is so deeply rooted in the novel that the protagonist has no name. We know a great deal about him because he narrates the story and tells us about himself. He is black, Southern, and, as a young college student, ambitious. His earliest heroes are George Washington Carver and Booker T. Washington. He craves the dignity and the opportunity he associates with their lives. But things go wrong. He is dismissed unjustly from his college in the South and must leave home to seek his fortune. He imagines himself destined for better things and eagerly pursues his fate, finding a place to live and work up North, beginning to find his identity as a black man. He discovers the sophisticated urban society of New York City, the political incongruities of communism, the complexities of black nationalism, and the subtleties of his relationship with white people, to whom he is an invisible man. Yet he does not hate the whites, and in his own image of himself he remains an invisible man. The novel ends with the protagonist in an underground place he has found and which he has lighted, by tapping the lines of the electric company, with almost 200 electric lightbulbs. Despite this colossal illumination, he still cannot think of himself as visible. He ends his quest without discovering who he is beyond this fundamental fact: He is invisible. Black or white, we can identify in many ways with this quest, for Ellison is showing us that invisibility is in all of us.

PERCEPTION KEY The Quest Narrative

Read a quest narrative. Some suggestions: Ralph Ellison, *Invisible Man;* Mark Twain, *The Adventures of Huckleberry Finn;* Herman Melville, *Moby-Dick;* J. D. Salinger, *The Catcher in the Rye;* Graham Greene, *The Third Man;* Franz Kafka, *The Castle;* Albert Camus, *The Stranger;* and Toni Morrison, *Beloved.* How does the quest help the protagonist get to know himself or herself better? Does the quest help you understand yourself better? Is the quest novel you have read basically episodic or organic in structure?

The quest narrative is central to American culture. Mark Twain's *Huckleberry Finn* is one of the most important examples in American literature. But, whereas *Invisible Man* is an organic quest narrative, because the details of the novel are closely interwoven, *Huckleberry Finn* is an episodic quest narrative. Huck's travels along the great Mississippi River qualify as episodic in the same sense that *Don Quixote,* to which this novel is closely

related, is episodic. Huck is questing for freedom for Jim, but also for freedom from his own father. Like Don Quixote, Huck comes back from his quest richer in the knowledge of who he is. One might say Don Quixote's quest is for the truth about who he is and was, since he is an old man when he begins. But Huck is an adolescent, and so his quest is for knowledge of who he is and can be.

The Lyric

The **lyric,** usually a poem, primarily reveals a limited but deep feeling about some thing or event. The lyric is often associated with the feelings of the poet, although it is not uncommon for poets to create narrators distinct from themselves and to explore hypothetical feelings, as in Plath's "Paralytic."

If we participate, we find ourselves caught up in the emotional situation of the lyric. It is usually revealed to us through a recounting of the circumstances the poet reflects on. T. S. Eliot speaks of an **objective correlative:** an object that correlates with the poet's feeling and helps express that feeling. Eliot has said that poets must find the image, situation, object, event, or person that "shall be the formula for that *particular* emotion" so that readers can comprehend it. This may be too narrow a view of the poet's creative process, because poets can understand and interpret emotions without necessarily undergoing them. Otherwise, it would seem that Shakespeare, for example, and even Eliot would have blown up like overcompressed boilers if they had had to experience directly all the feelings they interpreted in their poems. But, in any case, it seems clear that the lyric has feeling—emotion, passion, or mood—as basic in its subject matter.

The word "lyric" implies a personal statement by an involved writer who feels deeply. In a limited sense, lyrics are poems to be sung to music. Most lyrics before the seventeenth century were set to music—in fact, most medieval and Renaissance lyrics were written to be sung with musical accompaniment. And the writers who composed the words were usually the composers of the music—at least until the seventeenth century, when specialization began to separate those functions.

John Keats (1795–1821), an English poet of the Romantic period, died of tuberculosis. The following **sonnet,**[1] written in 1818, is grounded in his awareness of early death:

> When I have fears that I may cease to be
> Before my pen has glean'd my teeming brain,
> Before high-piled books, in charact'ry,

[1]A sonnet is a poem of fourteen lines typically in **iambic pentameter** with patterned rhyme, as with the Keats. An iamb is a metrical unit, or foot, of two syllables, the first unaccented and the second accented. Pentameter is a line of five metrical feet. Thus ˘ˊˈˊˈˊˈˊˈˊ. *Rhyme* is the regular reoccurrence of corresponding sounds, especially at the end of lines.

Hold like rich garners the full-ripen'd grain;
When I behold, upon the night's starr'd face,
Huge cloudy symbols of a high romance,
And think that I may never live to trace
Their shadows, with the magic hand of chance;
And when I feel, fair creature of an hour!
That I shall never look upon thee more,
Never have relish in the faery power
Of unreflecting love! then on the shore
Of the wide world I stand alone, and think
Till love and fame to nothingness do sink.

PERCEPTION KEY "When I have fears . . ."

1. This poem has no setting (environmental context), yet it establishes an atmosphere of uncertainty and, possibly, of terror. How does Keats create this atmosphere?
2. The poet is dying and knows he is dying—why does he then labor so over the rhyme and meter of this poem? What does the poem do for the dying narrator?

Keats interprets a terrible personal feeling. He realizes he may die before he can write his best poems. The epitaph Keats chose for his headstone just before he died, "Here lies one whose name was writ in water," is one of the most sorrowful lines of all poetry. He was wrong in believing that his poems would not be read by posterity. Moreover, his work is so brilliant that we cannot help wondering what else he might have done. Had Chaucer, Shakespeare, Milton, Proust, or Joyce died at twenty-six, we might not know their names, for their important work was yet to come.

It is not difficult for us to imagine how Keats must have felt. The lyric mode usually relies not on narrative but on our ability to respond to the circumstances described. In this poem, Keats has important resources. One is the fact that since we all will die, we can sympathize with the thought of death cutting a life's work short. The tone Keats establishes in the poem—one of direct speech, honestly said, not overdone or melodramatic—helps him communicate his feelings. It gives the poem an immediacy: one human being telling another something straight from the heart. Keats modulates the tone slightly, slowing things down enough at the end of the poem for us to sense and share the despairing contemplative mood "to nothingness do sink."

A very different treatment of the question of death dominates e. e. cummings' poem, which uses the line breaks to create a dynamic rhythm. Instead of imagining or reflecting upon his own death, he meditates on an instrument of death, the Wild West gunman, Buffalo Bill. Our culture thinks of William Cody as something of a hero, although ecologists remember him as a man who slaughtered thousands of buffalo so their tongues could be shipped to Chicago restaurants and their bodies left to rot. Some of cummings' contempt may be apparent in the tone of the last three lines.

BUFFALO BILL'S DEFUNCT

Buffalo Bill's
defunct
 who used to
 ride a watersmooth-silver
 stallion
and break onetwothreefourfive pigeonsjustlikethat
 Jesus
he was a handsome man
 and what i want to know is
how do you like your blueeyed boy
Mister Death

PERCEPTION KEY "Buffalo Bill's Defunct"

1. Read the poem aloud to a friend. Where do your emphases fall? Underline the emphatic words or syllables before you do the actual reading. Where do you rush the words? How much control do cummings' line breaks have over the way you read?
2. By comparison, read aloud any of the other lyrics in this section. How does the line structure of that poem control the way you read the lines? Where do the emphases fall? Try to characterize the differences between the line structures of the two poems.

Numerous lyric poems are inspired by works of visual or musical art, such as W. H. Auden's "Musée des Beaux Arts," which describes Brueghel's (also spelled Breughel) famous painting of Daedalus and his son Icarus. In the myth, Daedalus and Icarus fashion wings with feathers and wax, and Icarus flies so close to the sun that the wax melts and he falls to the earth. Thus, the myth became a metaphor for overreaching. But what Auden saw is that great events, such as the fall of Icarus, happen in a landscape in which no one notices. Not everyone wishes for or is aware of martyrdom, suffering, or great achievement, even when those events change their world.

MUSÉE DES BEAUX ARTS

About suffering they were never wrong,
The Old Masters: how well they understood
Its human position; how it takes place
While someone else is eating or opening a window or just walking dully along;
How, when the aged are reverently, passionately waiting
For the miraculous birth, there always must be
Children who did not specially want it to happen, skating
On a pond at the edge of the wood:
They never forgot
That even the dreadful martyrdom must run its course
Anyhow in a corner, some untidy spot
Where the dogs go on with their doggy life and the torturer's horse
Scratches its innocent behind on a tree.

In Breughel's *Icarus,* for instance: how everything turns away
Quite leisurely from the disaster; the ploughman may

EXPERIENCING "Musée des Beaux Arts"

1. Auden has structured the poem in two parts. How are they related?
2. Auden wrote this poem in 1938, when the Germans had just invaded Poland, thus beginning World War II. To what extent is this a lyric with political undertones?
3. How important is visual imagery in this poem?

W. H. Auden was profoundly aware of political events in his time, especially those leading up to the world war. He structures this poem in two parts. The first thirteen lines address the fact that suffering is ancient and probably changeless enough that the Old Masters—the great older painters in the Museum of Beaux Arts—portrayed it much as it still is. In other words, the Old Masters provide us with the blueprints, the types of suffering. His first line says it all: "About suffering they were never wrong." He then goes on to tell us that it happens around us even when we are not aware, while we are involved in daily chores, like the people in Brueghel's paintings skating on a pond.

Then the second section of the poem focuses on a single painting in which, according to the Roman poet Ovid, a major disaster occurred: Icarus flew too close to the sun and fell to his death in the sea. Yet, in Brueghel's painting no one notices. The plowman has his work to do, and he keeps his eyes on his plow. Even some viewers of the painting might miss the tiny splash that Icarus leaves. Put together with the references to miracles, martyrdom, and torture, in the first part of the poem, we can appreciate the implication that ordinary people go on their ordinary ways even when the most hideous events occur, as they did in 1938 when Poland was attacked and the German concentration camps were being filled with Jews, Gypsies, homosexuals, priests, and retarded citizens. The first section of the poem consists of generalities and references to general activities. The second section fastens itself to the first by introducing the specifics of the myth of Daedalus and Icarus by referring to the visual image of the plowman in the foreground of the painting, and the death of Icarus in the distant background far from the headland on which the plowman moves.

4. Do you think it necessary to see Brueghel's *Landscape with the Fall of Icarus* in order to understand this poem? Does the specific reference of the poem to a painting make the poem any less poetic?
5. What does Auden do to accommodate readers who have not seen or even heard of Brueghel's painting?

Have heard the splash, the forsaken cry,
But for him it was not an important failure; the sun shone
As it had to on the white legs disappearing into the green
Water; and the expensive delicate ship that must have seen
Something amazing, a boy falling out of the sky,
Had somewhere to get to and sailed calmly on.

Emily Dickinson, like Keats and Auden, meditated on suffering and loss. She lived in her family house for most of her life, never married, and kept most of her personal romantic interests to herself, so that biographers can only speculate on the kind of pain that she seems to be describing in "After Great Pain, a Formal Feeling Comes." Her method is to be indirect and not to specify the issues at the heart of her lyric. She uses metaphors, such as

"A Quartz contentment," which is both specific and yet completely abstract and untranslatable. We have no idea what pain she is talking about—perhaps the loss of a loved one, perhaps the loss of a love—but we know that the pain is so great it can only be addressed from an angle and described as "the Hour of Lead," which seems to resemble something very close to death.

AFTER GREAT PAIN, A FORMAL FEELING COMES

After great pain, a formal feeling comes—
The Nerves sit ceremonious, like Tombs—
The stiff Heart questions was it He, that bore,
And Yesterday, or Centuries before?

The Feet, mechanical, go round—
Of Ground, or Air, or Ought—
A Wooden way
Regardless grown,
A Quartz contentment, like a stone—

This is the Hour of Lead—
Remembered, if outlived,
As Freezing persons, recollect the Snow—
First—Chill—then Stupor—then the letting go—

PERCEPTION KEY "After Great Pain, a Formal Feeling Comes"

1. Read the poem aloud. To what extent do the open vowels and the rich rhymes give a "musical" quality to your reading? Listen to someone else read the poem and ask the same question: How musical is this poem?
2. The imagery and language seem designed to describe or produce an emotional quality in the poet's or the reader's experience. Describe as best you can the emotional content of the poem.
3. Is this poem describing a positive experience or a negative experience?
4. Does the indirectness of the imagery enhance the effect of the poem, or limit it?

The five lyrics that follow are notable for their rich use of *imagery* and *metaphor.* William Blake's "The Tyger" is almost surreal in its intense visual imagery, perhaps in part because Blake was by profession a painter and illustrated this and other poems with brilliant color and imagination. For Blake, the "tyger" represents a dark force in nature, one he attempts to understand. Ben Jonson's "Song to Celia" is a carpe diem poem—a poem designed to seduce a lover on the grounds that we live only a short time and must "make hay while the sun shines." The imagery of the poem competes with the argument for importance. In contrast, "Arms and the Boy," by the World War I poet Wilfred Owen, is also an argument of a sort, but its intense imagery carries the power of the poem, apart from its argument. The imagery of war, bayonets, bullets, and the idea of a "madman's flash" all make a statement about war that contrasts with the heroics displayed in Virgil's epic, from which the poem's title comes. Langston Hughes's "Ballad of the Landlord" is part of a tradition of sung poems. Ballads were sung by common people in the streets. Hughes's use of repetition, "Landlord, landlord," is characteristic

of ballads and songs, as is his use of rhyme. However, Hughes adds a dimension of seriousness to his poem by addressing a social issue that many people understand firsthand. Andrew Marvell's "To His Coy Mistress" is in the carpe diem tradition (seize the day) and is widely known as a poem of seduction. It is also a lyric that attempts to argue a point, that one must do today what one may not be able to do later. Time is one of the central sources of imagery in the poem, and urgency is one of its central messages.

THE TYGER

Tyger! Tyger! burning bright
In the forests of the night,
What immortal hand or eye
Could frame thy fearful symmetry?

In what distant deeps or skies
Burnt the fire of thine eyes?
On what wings dare he aspire?
What the hand dare seize the fire?

And what shoulder, and what art,
Could twist the sinews of thy heart?
And when thy heart began to beat,
What dread hand? and what dread feet?

What the hammer? what the chain?
In what furnace was thy brain?
What the anvil? what dread grasp
Dare its deadly terrors clasp?

When the stars threw down their spears,
And water'd heaven with their tears,
Did he smile his work to see?
Did he who made the Lamb make thee?

Tyger! Tyger! burning bright
In the forests of the night,
What immortal hand or eye
Dare frame thy fearful symmetry?

—William Blake

SONG TO CELIA

Come my *Celia*, let us prove,
While we may, the sports of love;
Time will not be ours, for ever:
He, at length, our good will sever.
Spend not then his guifts in vaine.
Sunnes, that set, may rise againe:
But if once we loose this light,
'Tis, with us, perpetuall night.
Why should we deferre our joyes?
Fame, and rumor are but toyes.

Cannot we delude the eyes
Of a few poore houshold spyes?
Or his easier eares beguile,
So removed by our wile?
'Tis no sinne, loves fruit to steale,
But the sweet theft to reveale:
To be taken, to be seene,
These have crimes accounted beene.

—Ben Jonson

ARMS AND THE BOY[2]

Let the boy try along this bayonet-blade
How cold steel is, and keen with hunger of blood;
Blue with all malice, like a madman's flash;
And thinly drawn with famishing for flesh.

Lend him to stroke these blind, blunt bullet-leads,
Which long to nuzzle in the hearts of lads,
Or give him cartridges whose fine zinc teeth
Are sharp with sharpness of grief and death.

For his teeth seem for laughing round an apple.
There lurk no claws behind his fingers supple;
And God will grow no talons at his heels,
Nor antlers through the thickness of his curls.

—Wilfred Owen

BALLAD OF THE LANDLORD

Landlord, Landlord,
My roof has sprung a leak.
Don't you 'member I told you about it
Way last Week?

Landlord, Landlord.
These steps is broken down.
When you come up yourself
It's a wonder you don't fall down.

Ten bucks you say I owe you?
Ten bucks you say is due?
Well, that's Ten bucks more'n I'll pay you
Till you fix this house up new.

What? You gonna get eviction orders?
You gonna cut off my heat?
You gonna take my furniture and
Throw it on the street?

[2]"Arms and the Boy": a reference to Virgil's *Aeneid*: "Of arms and the man I sing."

Um-huh! You talking high and mighty.
Talk on—till you get through.
You ain't gonna be able to say a word
If I land my fist on you.

Police! Police!
Come and get this man!
He's trying to ruin the government
And overturn the land!
Patrol bell!
Arrest!

Precinct Station.
Iron cell.
Headlines in press.
MAN THREATENS LANDLORD
TENANT HELD NO BAIL
JUDGE GIVES NEGRO 90 DAYS IN COUNTY JAIL.

—Langston Hughes

TO HIS COY MISTRESS

Had we but world enough, and time,
This coyness, Lady, were no crime.
We would sit down, and think which way
To walk, and pass our long love's day.
Thou by the Indian Ganges' side
Shouldst rubies find: I by the tide
Of Humber would complain. I would
Love you ten years before the flood:
And you should, if you please, refuse
Till the conversion of the Jews.
My vegetable love should grow
Vaster than empires, and more slow.
An hundred years should go to praise
Thine eyes, and on thy forehead gaze.
Two hundred to adore each breast:
But thirty thousand to the rest.
An age at least to every part,
And the last age should show your heart:
For, Lady, you deserve this state;
Nor would I love at lower rate.
 But at my back I always hear
Time's wingèd chariot hurrying near:
And yonder all before us lie
Deserts of vast eternity.
Thy beauty shall no more be found;
Nor, in thy marble vault, shall sound
My echoing song: then worms shall try
That long-preserved virginity:
And your quaint honor turn to dust;
And into ashes all my lust.

The grave's a fine and private place,
But none, I think, do there embrace.
 Now, therefore, while the youthful glue
Sits on thy skin like morning dew,
And while thy willing soul transpires
At every pore with instant fires,
Now let us sport us while we may;
And now, like amorous birds of prey,
Rather at once our time devour,
Than languish in his slow-chapped[3] power.
Let us roll all our strength, and all
Our sweetness, up into one ball:
And tear our pleasures with rough strife,
Thorough[4] the iron gates of life.
Thus, though we cannot make our sun
Stand still, yet we will make him run.

—Andrew Marvell

PERCEPTION KEY Varieties of Lyric

1. What feelings (emotions, passions, or moods) does each poem evoke?
2. Which two lyrics seem most different to you? What constitutes their differences? Comment on use of language, rhythm, imagery.
3. Of these five lyrics, which would you most want to set to music? If possible, either sing that lyric yourself (make up your own tune or rely on a tune you know) or listen to someone sing the lyric. What difference in emotional response do you detect in listening to the lyric as it is sung? Comment on the relationship of the music to the words of the lyric.
4. Lyrics are often noted for their appeal to our feelings. Which of these poems appeals to you most powerfully? Compare your choice with the choices of others.
5. Comment on the poems whose imagery seems to you to be most powerful. What senses do these images appeal to? How does the imagery help convey the significance of the poem?
6. Meditate on a traumatic experience. Write a lyric poem that reveals your feelings about that trauma.

LITERARY DETAILS

So far we have been analyzing literature with reference to structure, the overall order. But within every structure are details that need close examination in order to properly perceive the structure.

Language is used in literature in ways that differ from everyday uses. This is not to say that literature is artificial and unrelated to the language

[3]*Chapped:* jawed.
[4]*Thorough:* through.

we speak but, rather, that we sometimes do not see the fullest implications of our speech and rarely take full advantage of the opportunities language affords us. Literature uses language to reveal meanings that are usually absent from daily speech.

Our examination of detail will include image, metaphor, symbol, irony, and diction. They are central to literature of all *genres*.

Image

An image in language asks us to imagine or "picture" what is referred to or being described. An image appeals essentially to our sense of sight, but sound, taste, odor, and touch are sometimes involved. One of the most striking resources of language is its capacity to help us reconstruct in our imaginations the "reality" of perceptions. This resource sometimes is as important in prose as in poetry. Consider, for example, the following passage from Joseph Conrad's *Youth:*

> The boats, fast astern, lay in a deep shadow, and all around I could see the circle of the sea lighted by the fire. A gigantic flame arose forward straight and clear. It flares fierce, with noises like the whirr of wings, with rumbles as of thunder. There were cracks, detonations, and from the cone of flame the sparks flew upwards, as man is born to trouble, to leaky ships, and to ships that burn.

PERCEPTION KEY Conrad's *Youth* and Imagery

1. Which of our senses is most powerfully appealed to in this passage?
2. How does this passage differ from the average, nonliterary description of a burning boat? If possible, read a newspaper description of a burning boat (or perhaps one written by you or one of your friends) that does not try to involve the reader in the occurrence itself. What are the differences between it and Conrad's passage? Compare especially the use of images.

In *Youth,* this scene is fleeting, only an instant in the total structure of the book. But the entire book is composed of such details, helping to engage the reader's participation.

Virginia Woolf, in the following passage from her novel *To the Lighthouse,* has Lily thinking about Mrs. Ramsay's thoughts on her philosopher-husband's mind. In the process, Lily constructs images that reflect the activity of the bees in her garden as well as the activity of Mr. Ramsay's thoughts.

> Nothing happened. Nothing! Nothing! as she leant her head against Mrs. Ramsay's knee. And yet, she knew knowledge and wisdom were stored up in Mrs. Ramsay's heart. How then, she had asked herself, did one know one thing or another thing about people, sealed as they were? Only like a bee, drawn by some sweetness or sharpness in the air intangible to touch or taste, one haunted the dome-shaped hive, ranged the wastes of the air over the countries

of the world alone, and then haunted the hives with their murmurs and their stirrings; the hives, which were people. Mrs. Ramsay rose. Lily rose. Mrs. Ramsay went. For days there hung about her, as after a dream some subtle change is felt in the person one has dreamt of, more vividly than anything she said, the sound of murmuring and, as she sat in the wicker arm-chair in the drawing-room window she wore, to Lily's eyes, an august shape; the shape of a dome.

In this passage, the dome-shaped hive is metaphorically related to the dome-shaped head of Mr. Ramsay, whose thoughts, like bees, "range the wastes of the air over the countries of the world alone." The murmurings and stirrings of the bees that sound in her garden are appropriate to the murmurings and stirrings of the thoughts of the philosopher. The use of the verb "rose" in "Mrs. Ramsay rose. Lily rose" also implies a garden image, just as does the name of Lily, Mrs. Ramsay's friend. Lily is a painter; and when she reflects on this moment, she imagines Mrs. Ramsay as "an august shape; the shape of a dome," which for the reader of the novel underscores Mrs. Ramsay's own intelligence, which Mr. Ramsay usually downplays. These images, like most of Woolf's imagery, intensify the significance of the story, which helps us understand the values of the socially devalued world of Mrs. Ramsay.

Because of its tendency towards the succinct, poetry usually contains stronger images than prose, and poetry usually appeals more to our senses (Conrad's prose being an obvious exception). Listen to the following poem by T. S. Eliot:

I

PRELUDES

The winter evening settles down
With smell of steaks in passageways.
Six o'clock.
The burnt-out ends of smoky days.
And now a gusty shower wraps
The grimy scraps
Of withered leaves about your feet
And newspapers from vacant lots;
The showers beat
On broken blinds and chimney-pots,
And at the corner of the street
A lonely cab-horse steams and stamps.

And then the lighting of the lamps.

PERCEPTION KEY "Preludes"

1. Is there a significant narrative?
2. What senses are imaginatively stimulated?
3. Does the poem appeal to and evoke one particular sense more than the others? If so, which one and why?

Archibald MacLeish, poet and critic, points out in *Poetry and Experience* that not all images in poetry work metaphorically—that is, as a comparison of two things. This may be the case even when the images are placed side by side. Thus in a grave, in John Donne's "The Relic," "a loving couple lies," and there is this marvelous line: "A bracelet of bright hair about the bone. . . ." The image of a bracelet of bright hair is coupled with an image of a bone. The images lie side by side, tied by the *b* sounds. Their coupling is startling because of the immediacy of their contrasting associations: vital life and inevitable death. There is no metaphor here (something is like something else in some significant way), simply two images juxtaposed. We hear or read through the sounds—but never leave them—into their references, through the references to the images they create, through the images to their relationship, and finally to the poignant meaning: Even young girls with golden hair die. We all know that, of course, but now we face it, and feel it, because of the meaning generated by those images lying side by side: life, death, beauty, and sorrow bound together in that unforgettable grave.

PERCEPTION KEY John Donne

1. Suppose the word "blonde" were substituted for "bright." Would the meaning of the line be enhanced or diminished? Why?
2. Suppose the word "white" were placed in front of "bone." Would the meaning of the line be enhanced or diminished? Why?

The imagery in Chinese and Japanese poetry was influential in English and American poetry of the early twentieth century. The following is a poem from China's late T'ang dynasty (618–970). Li Shang-Yin (812?–858) rarely titled his poems, but they are clearly derived from his awareness of the kind of Chinese landscapes that dominate Chinese painting, such as Fan K'uan's *Travelers amid Mountains and Streams* (Figure 4–8).

The East wind sighs, the fine rains come:
Beyond the pool of water-lilies, the noise of faint thunder.
A gold toad gnaws the lock. Open it, burn the incense.
A tiger of jade pulls the rope. Draw from the well and escape.
Chia's daughter peeped through the screen when Han the clerk was young,
The goddess of the river left her pillow for the great Prince of Wei.
Never let your heart open with the spring flowers:
One inch of love is an inch of ashes.

PERCEPTION KEY "The East Wind Sighs"

1. Which are the most interesting images in the poem? Which senses do they appeal to?
2. Is there a narrative implied in the poem?
3. What other poem in this chapter seems closely related to this one?

Metaphor

Metaphor helps writers intensify language. Metaphor is a comparison designed to heighten our perception of the things compared. Poets or writers will usually let us know which of the things compared is the main object of their attention. For example, in the following poem, Shakespeare compares his age to the autumn of the year and himself to a glowing fire that consumes its vitality. The structure of this sonnet is marked by developing one metaphor in each of three quatrains (a group of four rhyming lines) and a couplet that offers a summation of the entire poem.

SONNET 73

That time of year thou mayst in me behold
When yellow leaves, or none, or few, do hang
Upon those boughs which shake against the cold,
Bare ruined choirs, where late the sweet birds sang.
In me thou see'st the twilight of such day
As after sunset fadeth in the west,
Which by and by black night doth take away,
Death's second self, that seals up all in rest.
In me thou see'st the glowing of such fire
That on the ashes of his youth doth lie,
As the death-bed whereon it must expire,
Consumed with that which it was nourished by.
 This thou perceiv'st, which makes thy love more strong,
 To love that well which thou must leave ere long.

PERCEPTION KEY Shakespeare's 73rd Sonnet

1. The first metaphor compares the narrator's age with autumn. How are "yellow leaves, or none" appropriate for comparison with a man's age? What is implied by the comparison? The "bare ruined choirs" are the high place in the church—what place, physically, would they compare with in a man's body?
2. The second metaphor is the "sunset" fading "in the west." What is this compared with in a man's life? Why is the imagery of the second quatrain so effective?
3. The third metaphor is the "glowing" fire. What is the point of this metaphor? What is meant by the fire's consuming "that which it was nourished by"? What is being consumed here?
4. Why does the conclusion of the poem, which contains no metaphors, follow logically from the metaphors developed in the first three quatrains?

The standard definition of the metaphor is that it is a comparison made without any explicit words to tell us a comparison is being made. The *simile* is the kind of comparison that has explicit words: "like," "as," "than," "as if," and a few others. We have no trouble recognizing the simile, and we may get so used to reading similes in literature that we recognize them without any special degree of awareness.

Although there is some difference between a metaphor and a simile, basically both are forms of comparison for effect. Our discussion, then, will

use the general term "metaphor" and use the more specific term "simile" only when necessary. However, symbols, which are also metaphoric, will be treated separately, since their effect is usually much more specialized than that of the nonsymbolic metaphor.

The use of metaphor pervades all cultures. Daily conversation—none too literary—nevertheless is full of metaphoric language used to emphasize our points and give color and feeling to our speech (check this for yourself). The Chinese poet Li Ho (791–817) shows us the power of the metaphor in a poetic tradition very different from that of the West.

THE GRAVE OF LITTLE SU

I ride a coach with lacquered sides,
My love rides a dark piebald horse.
Where shall we bind our hearts as one?
On West Mound, beneath the pines and cypresses.
 (Ballad ascribed to the singing girl Little Su, circa 500 A.D.)

Dew on the secret orchid
No thing to bind the heart to.
Misted flowers I cannot bear to cut.
Grass like a cushion,
The pine like a parasol:
The wind is a skirt,
The waters are tinkling pendants.
A coach with lacquered sides
Waits for someone in the evening.
Cold blue candle-flames
Strain to shine bright.
Beneath West Mound
The wind puffs the rain.

Little Su was important to the narrator, but the portrayal of his feeling for her is oblique—which is, perhaps, why so many metaphors appear in such a short poem. Instead of striking bluntly and immediately, the metaphoric language resounds with nuances, so that we are aware of its cumulative impact only after reading and rereading.

Metaphor pervades poetry, but we do not always realize how extensive the device is in other kinds of literature. Prose fiction, drama, essays, and almost every other form of writing use metaphors. Poetry in general, however, tends to have a higher metaphoric density than other forms of writing, partly because poetry is somewhat distilled and condensed to begin with. Rarely, however, is the density of metaphor quite as thick as in "The Grave of Little Su."

Since literature depends so heavily on metaphor, it is essential that we reflect on its use. One kind of metaphor tends to evoke an image and involves us mainly on a perceptual level—because we perceive in our imaginations something of what we would perceive were we there. This kind we shall call a ***perceptual metaphor.*** Another kind of metaphor tends to evoke ideas, gives us information that is mainly conceptual. This kind of metaphor we shall call a ***conceptual metaphor.*** To tell us the pine is like a parasol is basically

perceptual: Were we there, we would see that the cone shape of the pine resembles that of a parasol. But to tell us the wind is a skirt is to go far beyond perception and simple likeness. The metaphor lures us to reflect upon the suggestion that the wind resembles a skirt, and we begin to think about the ways in which this might be true. Then we are lured further—this is an enticing metaphor—to explore the implications of this truth. If the wind is like a skirt, what then is its significance in the poem? In what ways does this conceptual metaphor help us understand the poet's insights at the grave of Little Su? In what ways does the perceptual metaphor of the pine and parasol help us?

The answer to how the wind is a skirt is by no means simple. Its complexity is one of the precious qualities of this poem. It is also one of the most precious possibilities of strong conceptual metaphors generally, for then one goes beyond the relatively simple perceptual comparison into the more suggestive and significant acts of understanding. We suggest, for instance, that if the wind is like a skirt, it clothes a girl: Little Su. But Little Su is dead, so perhaps it clothes her spirit. The comparison then is between the wind and the spirit. Both are impossible to see, but the relationships between their meanings can be understood and felt.

Symbol

The **symbol** is a further use of metaphor. Being a metaphor, it is a comparison between two things, but unlike most perceptual and conceptual metaphors, only one of the things compared is clearly stated. The symbol is clearly stated, but what it is compared with (sometimes a very broad range of meanings) is only hinted at. For instance, the white whale in Herman Melville's novel *Moby-Dick* is a symbol both in the novel and in the mind of Captain Ahab, who sees the whale as a symbol of all the malevolence and evil in a world committed to evil. But we may not necessarily share Ahab's views. We may believe that the whale is simply a beast and not a symbol at all. Or we may believe that the whale is a symbol for nature, which is constantly being threatened by human misunderstanding. Such a symbol can mean more than one thing. It is the peculiar quality of most symbols that they do not sit still; even their basic meanings keep changing. Symbols often are vague and ambiguous. The context in which they appear usually helps guide us to their meaning. It is said that many symbols are a product of the subconscious, which is always treating things symbolically and always searching for implicit meanings. If this is so, it helps account for the persistence of symbols in even the oldest literature.

Perhaps the most important thing to remember about the symbol is that it implies rather than explicitly states meaning. We sense that we are dealing with a symbol in those linguistic situations in which we believe there is more being said than meets the eye. Most writers are quite open about their symbols, as William Blake was in his poetry. He saw God's handiwork everywhere, but he also saw forces of destruction everywhere. Thus his poetry discovers symbols in almost every situation and/or thing, not just in those situations and things that are usually accepted as meaningful. The

following poem is an example of his technique. At first the poem may seem needlessly confusing, because we do not know how to interpret the symbols. But a second reading begins to clarify their meaning.

THE SICK ROSE

O rose, thou art sick!
 The invisible worm,
That flies in the night,
 In the howling storm,
Has found out thy bed
 Of crimson joy;
And his dark secret love
 Does thy life destroy.

PERCEPTION KEY "The Sick Rose"

1. The rose and the worm stand as opposites in this poem, symbolically antagonistic. In discussion with other readers, explore possible meanings for the rose and the worm.
2. The bed of crimson joy and the dark secret love are also symbols. What are their meanings? Consider them closely in relation to the rose and the worm.
3. What is not a symbol in this poem?

Blake used such symbols because he saw a richness of implication in them that linked him to God. He thus shared in a minor way the creative act with God and helped others understand the world in terms of symbolic meaningfulness. For most other writers, the symbol is used more modestly to expand meaning, encompassing deep ranges of suggestion. The symbol has been compared with a stone dropped into the still waters of a lake: The stone itself is very small, but the effects radiate from its center to the edges of the lake. The symbol is dropped into our imaginations, and it, too, radiates with meaning. But the marvelous thing about the symbol is that it tends to be permanently expansive: Who knows where the meaningfulness of Blake's rose ends?

Prose fiction has made extensive use of the symbol. In Melville's *Moby-Dick,* the white whale is a symbol, but so, too, is Ahab. The quest for Moby-Dick is itself a symbolic quest. The albatross in Samuel Coleridge's "The Ancient Mariner" is a symbol, and so is the Ancient Mariner's stopping one of the wedding guests to make him hear the entire narrative. In these cases, the symbols operate both structurally, in the entire narrative, and in the details.

The problem most readers have with symbols centers on either the question of recognition—is this a symbol?—or the question of what the symbol stands for. Usually an author will use something symbolically in situations that are pretty clearly identified. Blake does not tell us that his rose and worm are symbolic, but we readily realize that the poem says very little worth listening to if we do not begin to go beyond its literal meaning. The fact that worms kill roses is more important to gardeners than it is to readers

of poetry. But that there is a secret evil that travels mysteriously to kill beautiful things is not as important to gardeners as to readers of poetry.

Some less experienced readers tend to see everything as symbolic. This is as serious a problem as being unable to identify a symbol at all. The best rule of thumb is based on experience. Symbols are very much alike from one kind of literature to another. Once you begin to recognize symbols—the several presented here are various enough to offer a good beginning—other symbols and symbolic situations will be clearer and more unmistakable. But the symbol should be compelling. The situation should be clearly symbolic before we dig in to explore what the symbols mean. Not all black objects are symbolic of death; not all predators are symbolic of evil. Moreover, all symbols should be understood in the context in which they appear. Their context in the literature is what usually reveals their meaning.

In those instances in which there is no evident context to guide us, we should interpret symbols with extreme care and tentativeness. Symbolic objects usually have a fairly well understood range of meaning that authors such as Blake depend on. For instance, the rose is often thought of in connection with beauty, romance, love. The worm is often thought of in connection with death, the grave, and—if we include the serpent in the Garden of Eden (Blake had read Milton's *Paradise Lost*)—the worm also suggests evil, sin, and perversion. Most of us know these things. Thus the act of interpreting the symbol is usually an act of bringing this knowledge to the forefront of our minds so we can use it in our interpretations.

Irony

Irony implies contradiction of some kind. It may be a contradiction of expectation or a contradiction of intention. For example, much sarcasm is ironic. Apparent compliments are occasionally digs intended to be wickedly amusing. In literature, irony can be one of the most potent of devices. For example, in Sophocles' play *Oedipus Rex,* the prophecy is that Oedipus will kill his father and marry his mother. What Oedipus does not know is that he has been adopted and taken to another country; so when he learns his fate he determines to leave home in order not to harm his parents. Ironically, he heads to Thebes and challenges his true father, a king, at a crossroads and kills him. He then answers the riddle of the Sphinx, lifting the curse from the land—apparently a good outcome—but is then wed to the wife of the man he has killed. That woman is his mother. These events are part of a pattern of tragic irony, and in narrative literature this is a powerful device.

Sometimes irony is reinforced in drama when the audience knows the truth and the character does not. This is the situation when Hamlet hesitates in killing Claudius because he sees Claudius kneeling and praying. Hamlet thinks Claudius's prayers will get him into heaven, whereas the audience knows that Claudius is professing his guilt and refusing to do penance. Wilfred Owen's "Arms and the Boy" is a tissue of ironies, the chief one being that nature did not equip the boy with "claws," "talons," or "antlers" to go into combat. Yet, the boy is a warrior with weapons "famishing for flesh."

Edwin Arlington Robinson's poem "Richard Cory" is marked by regular meter, simple rhyme, and a basic pattern of four four-line stanzas. There is very little if any imagery in the poem, very little metaphor, and possibly no symbol, unless Richard Cory is the symbol. What gives the poem its force is the use of irony.

RICHARD CORY

Whenever Richard Cory went down town,
We people on the pavement looked at him:
He was a gentleman from sole to crown,
Clean favored, and imperially slim.

And he was always quietly arrayed,
And he was always human when he talked;
But still he fluttered pulses when he said,
"Good-morning," and he glittered when he walked.

And he was rich—yes, richer than a king—
And admirably schooled in every grace:
In fine, we thought that he was everything
To make us wish that we were in his place.

So on we worked, and waited for the light,
And went without the meat, and cursed the bread;
And Richard Cory, one calm summer night,
Went home and put a bullet through his head.

The irony lies in the contrast between the wealthy, accomplished, polished, and admired Richard Cory, and the struggling efforts of those around him to keep up with him. Ultimately, the most powerful irony is that the man everyone idolized did not love himself enough to live. For an admired person to have everything and then "put a bullet through his head" simply does not seem reasonable. And yet, that is what happened.

Diction

Diction refers to the choice of words. But because the entire act of writing involves the choice of words, the term "diction" is usually reserved for literary acts (speech as well as the written word) that use words chosen especially carefully for their impact. The diction of a work of literature will sometimes make that work seem inevitable, as if there were no other way of saying the same thing, as in Hamlet's "To be or not to be." Try saying that in other words.

Sometimes artificially formal diction is best, as it often is in the novels of Henry James; other times conversational diction works best, as in the novels of Ernest Hemingway. Usually, as Joseph Conrad asserts in one of his famous prefaces, there is "the appeal through the senses":

All art, therefore, appeals primarily to the senses, and the artistic aim when expressing itself in written words must also make its appeal through the senses, if its high desire is to reach the secret spring of responsive emotions. It must

strenuously aspire to the plasticity of sculpture, to the colour of painting, and to the magic suggestiveness of music—which is the art of arts. And it is only through complete, unswerving devotion to the perfect blending of form and substance; it is only through an unremitting, never-discouraged care for the shape and ring of sentences that an approach can be made to plasticity, to colour; and the light of magic suggestiveness may be brought to play for an evanescent instant over the commonplace surface of words: of the old, old words, worn thin, defaced by ages of careless usage.[5]

In Robert Herrick's poem, we see an interesting example of the poet calculating the effect of specific words in their context. Most of the words in "Upon Julia's Clothes" are single-syllable words, such as "then." But the few polysyllables—"vibration" with three syllables and the most unusual four-syllable word "liquefaction"—lend an air of intensity and special meaning to themselves by means of their syllabic contrast. There may also be an unusual sense in which those words act out or imitate what they describe.

UPON JULIA'S CLOTHES

Whenas in silks my Julia goes,
Then, then, methinks, how sweetly flows
That liquefaction of her clothes.

Next, when I cast mine eyes, and see
That brave vibration, each way free,
O, how that glittering taketh me!

> ## PERCEPTION KEY "Upon Julia's Clothes"
>
> 1. The implications of the polysyllabic words in this poem may be quite different for different people. Read the poem aloud with a few people. Ask for suggestions about what the polysyllables do for the reader. Does their complexity enhance what is said about Julia? Their sounds? Their rhythms?
> 2. Read the poem to some listeners who are not likely to know it beforehand. Do they notice such words as "liquefaction" and "vibration"? When they talk about the poem, do they observe the use of these words? Compare their observations with those of students who have read the poem in this book.

We have been giving examples of detailed diction. Structural diction produces a sense of linguistic inevitability throughout the work. The careful use of structural diction can sometimes conceal a writer's immediate intention, making it important for us to be explicitly aware of the diction until it has made its point. Jonathan Swift's essay *A Modest Proposal* is a classic example. Swift most decorously suggests that the solution to the poverty-stricken Irish farmer's desperation is the sale of his infant children—for the purpose of serving them up as plump, tender roasts for Christmas dinners in England. The diction is so subtly ironic that it is with some difficulty that

[5]From *The Nigger of the 'Narcissus'* (1897).

many readers finally realize Swift is writing *satire.* By the time we reach the following passage, we should surely understand the irony:

> I have been assured by a very knowing American of my acquaintance in London, that a young healthy child well nursed is at a year old a most delicious, nourishing, and wholesome food, whether stewed, roasted, baked, or boiled; and I make no doubt that it will equally serve in a fricasee or a ragout.

Many kinds of diction are available to the writer, from the casual and conversational to the archaic and the formal. Every literary writer is sensitive, consciously or unconsciously, to the issues of diction, and every piece of writing solves the problem in its own way. When the choice of words seems so exact and right that the slightest tampering diminishes the value of the work, then we have literature of high rank. Then, to paraphrase Robert Frost, "Like a piece of ice on a hot stove the poem rides on its own melting." No writer can tell you exactly how he or she achieves "inevitability," but much of it depends upon sound and rhythm as it relates to sense.

Summary

Our emphasis throughout this chapter has been on literature as the wedding of sound and sense. Literature is not passive; it does not sit on the page. It is engaged actively in the lives of those who give it a chance. A reading aloud of some of the literary samples in this chapter—especially the lyric—illustrates the point.

We have been especially interested in two aspects of literature: its structure and its details. Any artifact is composed of an overall organization that gathers details into some kind of unity. It is the same in literature, and before we can understand how writers reveal the visions they have of their subject matters, we need to be aware of how details are combined into structures. The use of image, metaphor, symbol, and diction, as well as other details, determines in an essential sense the content of a work of literature.

Structural strategies, such as the choice between a narrative or a lyric, will determine to a large extent how details are used. There are many kinds of structures besides the narrative and the lyric, although these two offer convenient polarities that help indicate the nature of literary structure. It would be useful for any student of literature to discover how many kinds of narrative structures—in addition to the already discussed episodic, organic, and quest structures—can be used. And it also would be useful to determine how the different structural strategies tend toward the selection of different subject matters. We have made some suggestions as starters: pointing out the capacity of the narrative for reaching into a vast range of experience, especially for revealing psychological truths, and the capacity of the lyric for revealing feeling.

Chapter 8

DRAMA

We sit in the darkened theater with many strangers. We sense an air of anticipation, an awareness of excitement. People cough, rustle about, then suddenly become still. Slowly the lights on the stage begin to come up, and we see actors moving before us apparently unaware of our presence. They are in rooms or spaces similar to those that we may be in ourselves at the end of the evening. Eventually they begin speaking to one another much the way we might ourselves, sometimes saying things so intimate that we are almost uneasy. They move about the stage, conducting their lives in total disregard for us, only hinting occasionally that we might be there in the same space with them.

At first we feel that despite our being in the same building with the actors, we are in a different world. Then slowly the distance between us and the actors begins to diminish until, in a good play, our participation erases the distance. We thrill with the actors, but we also suffer with them. We witness the illusion of an action that has an emotional impact for us and changes the way we think about our own lives. Great plays such as *Hamlet, Othello, The Misanthrope, Death of a Salesman, A Streetcar Named Desire,* or *Long Day's Journey into Night* can have the power to transform our awareness of ourselves and our circumstances. It is a mystery common to much art: that the illusion of reality can affect the reality of our own lives.

ARISTOTLE AND THE ELEMENTS OF DRAMA

Drama is a collaborative art that represents events and situations, either realistic and/or symbolic, that we witness happening through the actions of actors in a play on a stage in front of a live audience. According to the greatest of dramatic critics, Aristotle (384–322 B.C.), the *elements of drama* are as follows:

> *Plot:* a series of events leading to disaster for the main characters who undergo reversals in fortune and understanding but usually ending with a form of enlightenment—sometimes of the characters, sometimes of the audience, and sometimes of both.

> *Character:* the presentation of a person or persons whose actions and the reason for them are more or less revealed to the audience.

> *Diction:* the language of the drama, which should be appropriate to the action.

> *Thought:* the ideas that underlie the plot of the drama, expressed in terms of dialogue and soliloquy.

> *Spectacle:* the places of the action, the costumes, set designs, and visual elements in the play.

> *Music:* in Greek drama, the dialogue was sometimes sung or chanted by a chorus, and often this music was of considerable emotional importance. In modern drama, music is rarely used in serious plays, but it is of first importance in the modern musical.

Aristotle conceived his theories in the great age of Greek tragedy, and therefore much of what he has to say applies to tragedies by such dramatists as Aeschylus (ca. 525–456 B.C.), especially his trilogy, *Agamemnon, The Libation Bearers,* and *The Eumenides.* Sophocles (ca. 496–406 B.C.) wrote *Oedipus Rex, Antigone,* and *Oedipus at Colonus;* and Euripides (ca. 485–406 B.C.), the last of the greatest Greek tragedians, wrote *Andromache, Medea,* and *The Trojan Women.* All of these plays are still performed around the world, along with comedies by Aristophanes (ca. 448–385 B.C.), the greatest of Greek writers of comedies. His plays include *Lysistrata, The Birds, The Wasps,* and *The Frogs.* These plays often have a satirical and political purpose and set a standard for much drama to come.

Plot involves rising action, climax, falling action, **denouement.** For Aristotle, the tragic hero quests for truth. The moment of truth—the climax—is called **recognition.** When the fortune of the protagonist turns from good to bad, the **reversal** follows. The strongest effect of tragedy occurs when recognition and reversal happen at the same time, as in Sophocles' *Oedipus Rex* (Figure 8-1).

The protagonist or leading character in the most powerful tragedies fails not only because of fate, which is a powerful force in Greek thought, but because of a **flaw in character** (hamartia), a disregard of human limitations. The protagonist in the best tragedies ironically brings his misfortune upon himself. In *Oedipus Rex,* for example, the impetuous behavior of Oedipus

FIGURE 8-1
Oedipus Rex.

In the Tyrone Guthrie Theatre production, 1973, the shepherd tells Oedipus the truth about his birth and how he was prophesied to kill his father and marry his mother.

works well for him until he decides to leave "home." Then his rash actions bring on disaster. Sophocles shows us that something of what happens to Oedipus could happen to us. We pity Oedipus and fear for him. Tragedy, Aristotle tells us, arouses pity and fear and by doing so produces in us a **_catharsis,_** a purging of those feelings, wiping out some of the horror. The drama helps us understand the complexities of human nature and the power of our inescapable destinies.

PERCEPTION KEY Shakespeare and Arthur Miller

1. Read, or better, see one of Shakespeare's great tragedies: *Hamlet, Macbeth, Othello,* or *King Lear.* Compare one of these tragedies with Arthur Miller's *Death of a Salesman.* Do both playwrights rely on a flaw in the character of the protagonist?
2. Does it matter that Shakespeare's protagonists are kings or nobles, while Miller's is an ordinary salesman? Is there a difference in the pity and fear we experience in each work?

Dialogue and Soliloquy

The primary dramatic interchanges are achieved by dialogue, the exchange of conversation among the characters. In older plays, the individual speech

of a character might be relatively long, and then it is answered by another character in the same way. In more modern plays, the dialogue is often extremely short. Sometimes a few minutes of dialogue will contain a succession of speeches only five or six words in length. The following is an example of a brief dialogue between Algernon and his manservant, Lane, from Oscar Wilde's *The Importance of Being Earnest.*

> Algernon: A glass of sherry, Lane.
> Lane: Yes, sir.
> Algernon: Tomorrow, Lane, I'm going Bunburying.
> Lane: Yes, sir.
> Algernon: I shall probably not be back till Monday. You can put up my dress clothes, my smoking jacket, and all the Bunbury suits—
> Lane: Yes, sir. *(Handing sherry.)*
> Algernon: I hope tomorrow will be a fine day, Lane.
> Lane: It never is, sir.
> Algernon: Lane, you're a perfect pessimist.
> Lane: I do my best to give satisfaction, sir.

In this passage, Algernon plans to visit an imaginary friend, Bunbury, an invention designed to help him avoid dinners and meetings that he cannot stand. The dialogue throughout the play is quick and witty, and the play is generally regarded as one of the most amusing comedies. As in most plays, the dialogue moves the action forward by telling us about the importance of the situations in which the actors speak. This tiny example is interesting because, while amusing, the dialogue is shallow. We know very little if anything about the characters speaking the lines.

The ***soliloquy,*** on the other hand, is designed to give us insight into the character who speaks the lines. Usually the character is totally alone onstage and speaking apparently to himself. In the best of soliloquies, we are given to understand that the character is not speaking to the audience—the term "aside" is used to describe such speeches. The character is alone, and therefore we can trust to the sincerity of the speech and the truths that it reveals. Hamlet's soliloquies in Shakespeare's play are among the most famous in literature. Here, Hamlet speaks at a moment in the play when the tension is greatest:

> Hamlet: To be, or not to be, that is the question:
> Whether 'tis nobler in the mind to suffer
> The slings and arrows of outrageous fortune,
> Or to take arms against a sea of troubles,
> And by opposing end them. To die, to sleep—
> No more—and by a sleep to say we end
> The heart-ache and the thousand natural shocks
> That flesh is heir to. [3.1.57–64]

There is nothing superficial about this speech, nor the many lines that come after it. Hamlet considers suicide and, once having renounced it, considers what he must do. The many soliloquies in *Hamlet* offer us insight into

Hamlet's character, showing us an interiority, or psychological existence, that is rich and deep. In the Greek tragedies, some of the function of the modern soliloquy was taken by the Chorus, a group of citizens who frequently commented in philosophic fashion on the action of the drama.

> ## PERCEPTION KEY Soliloquy
>
> A soliloquy occurs when a character alone onstage reveals his or her thoughts. Study the use of the soliloquy in Shakespeare's *Hamlet* (3.3.73–96, 4.4.32–66) and in Tennessee Williams's *The Glass Menagerie* (Tom's opening speech; Tom's long speech in scene 5; and his opening speech in scene 6). What do these soliloquies accomplish? Is their purpose different in these two plays? Are soliloquies helpful in all drama? What are their strengths and weaknesses?

IMITATION AND REALISM

Generally, drama is a form of narrative that exhibits events at the moment of their occurring, vividly, with immediate impact. No other art comes closer to life; hence drama, more than any other art, led Aristotle to his theory of drama as the imitation of nature—or life in general. In his *Poetics,* Aristotle claimed that **tragedy** is the imitation (mimesis) of human action. From other comments, we can assume he meant to include comedy and other forms of drama. Just what Aristotle meant by "imitation" is open to different interpretations. For instance, certain kinds of drama imitate an action by allusion. The musical dramas *Godspell, Jesus Christ Superstar,* and *Your Arms Too Short to Box with God* all allude to the story of Christ. They do not, however, aim at representing the gospels with accuracy. Historical plays, such as Shakespeare's *Henry V,* strive for enough accuracy to resemble reasonably what had happened. Plays on the assassinations of Lincoln, John F. Kennedy, and Malcolm X all depend on historical accuracy to some extent. Numerous one-person dramas such as Hal Holbrook's imitation of Mark Twain and Julie Harris's imitation of Emily Dickinson are part of a long tradition of representing the famous.

Anna Deavere Smith (Figure 8-2), in two extraordinary one-woman performances—*Fires in the Mirror: Crown Heights, Brooklyn, and Other Identities* and *Twilight: Los Angeles, 1992*—takes the roles of dozens of ordinary people, male and female, of various ages and races, and convinces her audiences that she speaks with the characters' voices. Her focus is on racial and religious violence in Brooklyn—the death of a black youth and the killing of a Jewish rabbinical student in the ensuing riots. The Los Angeles riots of 1992 were sparked by the failure to convict the policemen who beat Rodney King and then were further inflamed by the sight on television of Reginald Denney being hauled by rioters from his truck and beaten. These events generated intense emotional reponses from the entire nation. Smith interprets those events from a variety of realistic points of view.

However, no matter how realistically events are portrayed onstage, they cannot duplicate the actions we experience in our ordinary lives outside the

FIGURE 8-2
Anna Deavere Smith in *Twilight:
Los Angeles 1992.*

Here, she takes on one of her
many roles in her drama about
the race riots in Los Angeles.
Smith's is a performance piece
that can probably only be acted
by her.

theater. Audiences are necessarily called upon to exercise what Coleridge
called the "willing suspension of disbelief"; that is, we must agree to imagine
that the events onstage are actually occurring in ancient Greece, or Denmark,
even though we are simultaneously aware that we are seated in a theater in
our own hometown in the twenty-first century.

The history of drama is filled with amusing anecdotes about the extent to
which a drama has been realistic enough to cause an audience to mistake
drama for real life. For instance, when Arthur Miller's *Death of a Salesman*
(1949) played to early audiences that included salesmen at a New York con-
vention, stories circulated that several salesmen in the audience leaped up
in anguish to help the hero, Willy Loman, by offering good business advice
to help him hold onto his territory. These are breakdowns of a distinction
that we ought to maintain with all art, and they help explain why realism has
limits. Our awareness of the distinction between life and art is sometimes de-
scribed as "aesthetic distance." Maintaining that distance implies, paradoxi-
cally, the possibility of truly participating with the drama, since it implies the
loss of the self-conscious self that participation demands. When spectators
leap onstage to right the wrongs of drama, they show that there has been no
loss of self. Indeed, because they see themselves as capable of changing the
action, they are projecting their own egos into—rather than participating
with—the actors in the dramatic action unfolding before them.

There is one realistic restraint that allows for little compromise—the ca-
pacity of an average audience for sustained concentration. Most plays run
for approximately two hours, with intermissions as concessions to the need
for mental and physical relaxation. Thus a drama must unfold rapidly and be

interesting at all times. Perhaps a novel may occasionally make us nod. We can take a break. But if a drama does, we leave. Furthermore, the drama must be comprehensible, independent of extended explanations, and this independence must be accomplished mainly through the conduct and speech of the actors. Dramatists must leave the significance of what is happening largely to inference, whereas novelists, for example, have many leisurely ways of reflecting about the significance of the action. Nevertheless, conventions such as the soliloquy allow for reflection and explanation within the drama.

An Alternative Theory of Tragedy

We lack space to study the many alternative theories that attempt to explain tragedy. But—even as oversimplified—the theory of G. W. F. Hegel, the nineteenth-century German philosopher, requires attention, for his explanation of tragedy is quite different from Aristotle's. Hegel argues that it is not the tragic flaw of a protagonist that leads to the tragic. Rather, all of us inhabit a world where one's good intentions inevitably collide with the good intentions of someone else. Our world being finite, we cannot avoid these collisions. Thus the tragic is our fate. Even if Oedipus possessed no tragic flaw, his "good" inevitably would have collided with the "good" of his parents and others. Tragedy, according to Hegel, reveals our sorrows and the sufferings as inevitable.

PERCEPTION KEY Hegel

1. Hegel, if our interpretation is accurate, apparently presumes that all human beings have good intentions. But what about Iago in *Othello*? Or Hitler or Stalin?
2. Examine Miller's *Death of a Salesman*. Is Hegel's explanation of that tragedy more illuminating than Aristotle's?
3. Hegel presumably would have argued that the tragic end of Shakespeare's *Romeo and Juliet* is due not to tragic flaws, but rather to the collision of good intentions. Romeo and Juliet had no tragic flaws—they simply were caught in a web of fate from which there was no escape. Which explanation is more illuminating—the Aristotelian or the Hegelian? What about a combination of the two?

Archetypal Patterns

Certain structural principles tend to govern the shape of dramatic narrative, just as they do the narrative of fiction. The discussion of episodic and organic structures in the previous chapter has relevance for drama as well. However, drama originated from ancient rituals and sometimes maintains a reference to those rites. For example, the ritual of sacrifice—which implies that the individual must be sacrificed for the commonweal of society—seems to find its way into a great many dramas, both old and new. Such a pattern is *archetypal*—a basic psychological pattern that people apparently react to on a more or less subconscious level. These patterns, **archetypes,** are deep in the *myths* that have permeated history. We feel their importance even if we do not recognize them consciously.

Archetypal drama aims at symbolic or mythic interpretations of experience. For instance, one's search for personal identity, for self-evaluation, since it seems to be a pattern repeated in all ages, can serve as a primary archetypal structure for drama. This particular archetype is the driving force in Sophocles' *Oedipus Rex*, Shakespeare's *Hamlet*, August Wilson's *The Piano Lesson*, Arthur Miller's *Death of a Salesman*, and many more plays—notably, but by no means exclusively, in tragedies. (As we shall see, **comedy** also often uses this archetype.) One reason this archetype is so powerful is that it involves large risks. Many of us are content to watch other people discover their identities, while we are satisfied to remain undiscovered. There is fear of finding that we may not be the delightful, humane, and wonderful people we want others to think we are.

The power of the archetype derives, in part, from our recognition of a pattern that has been repeated by the human race throughout history. The psychologist Carl Jung, whose work spurred critical awareness of archetypal patterns in all the arts, believed that the greatest power of the archetype lies in its capacity to reveal through art the "imprinting" of human experience. Maud Bodkin, a critic who developed Jung's views, explains the archetype this way:

> The special emotional significance going beyond any definite meaning conveyed attributes to the stirring in the reader's mind, within or beneath his conscious response, of unconscious forces which he terms "primordial images" or archetypes. These archetypes he describes as "psychic residua of numberless experiences of the same type," experiences which have happened not to the individual but to his ancestors, and of which the results are inherited in the structure of the brain.[1]

The quest narrative (Chapter 7) is an example of an archetypal structure, one that recurs in drama frequently. For instance, Hamlet is seeking the truth about his father's death (Aristotle's recognition), but in doing so, he is also trying to discover his own identity as it relates to his mother. Sophocles' *Oedipus* is the story of a man who kills his father, marries his mother, and suffers a plague on his lands. He discovers the truth (recognition again), and doom follows (Aristotle's reversal). He blinds himself and is ostracized. Freud thought the play so archetypal that he saw in it a profound human psychological pattern, which he called the "Oedipus complex": the desire of a child to get rid of the same-sex parent and to have a sexual union with the parent of the opposite sex. Not all archetypal patterns are so shocking, but most reveal an aspect of basic human desires. Drama—because of its immediacy and compression of presentation—is, perhaps, the most powerful means of expression for such archetypes.

Some of the more important archetypes include those of an older man, usually a king in ancient times, who is betrayed by a younger man, his trusted lieutenant, with regard to a woman. This is the theme of Lady Gregory's *Grania*. The loss of innocence, a variation on the Garden of Eden theme, is another favorite, as in August Strindberg's *Miss Julie* and Henrik Ibsen's *Ghosts* and *The Wild Duck*. Tom Stoppard's *Arcadia* combines two archetypes: loss of innocence and the quest for knowledge. However, no

[1]Maud Bodkin, *Archetypal Patterns in Poetry* (New York: Oxford University Press, 1934), p. 1.

archetype seems to rival the quest for self-identity. That quest is so common that it is even parodied, as in Wilde's *The Importance of Being Earnest*.

The four seasons set temporal dimensions for the development of archetypes because the seasons are intertwined with patterns of growth and decay. The origins of drama, which are obscure beyond recall, may have been linked with rituals associated with the planting of seed, the reaping of crops, and the entire complex issue of fertility and death. In *Anatomy of Criticism*, Northrop Frye associates comedy with spring, romance with summer, tragedy with autumn, irony and satire with winter. His associations suggest that some archetypal drama may be rooted in connections between human destiny and the rhythms of nature. Such origins may account for part of the power that archetypal drama has for our imaginations, for the influences that derive from such origins presumably are deeply pervasive in all of us. These influences may also help explain why tragedy usually involves the death of a hero—although, sometimes, as in the case of Oedipus, death is withheld—and why comedy frequently ends with one or more marriages, as in Shakespeare's *As You Like It, Much Ado about Nothing,* and *A Midsummer Night's Dream,* with their suggestions of fertility. Such drama seems to thrive on seasonal patterns and on the capacity to excite in us a recognition of events that on the surface may not seem important but that underneath have profound meaning.

CONCEPTION KEY Archetypes

1. You may wish to supplement the comments above by reading the third chapter of Northrop Frye's *Anatomy of Criticism* or the *Hamlet* chapter in Francis Fergusson's *The Idea of a Theater.*
2. Whether or not you do additional reading, consider the recurrent patterns you have observed in dramas—include television dramas or television adaptations of drama. Can you find any of the patterns we have described? Do you see other patterns showing up? Do the patterns you have observed seem basic to human experience? For example, do you associate gaiety with spring, love with summer, death with fall, and bitterness with winter? What season seems most appropriate for marriage?

GENRES OF DRAMA: TRAGEDY

Carefully structured plots are basic for Aristotle, especially for tragedies. The action must be probable or plausible, but not necessarily historically accurate. Although noble protagonists are essential for great tragedies, Aristotle allows for tragedies with ordinary protagonists. In these, plot is much more the center of interest than character. Then we have what may be called action dramas, never, according to Aristotle, as powerful as character dramas, other things being equal. Action dramas prevail on the popular stage and television. But when we turn to the great tragedies that most define the genre, we think immediately of great characters: Oedipus, Agamemnon, Prometheus, Hamlet, Macbeth, King Lear.

Modern drama tends to avoid traditional tragic structures because modern concepts of morality, sin, guilt, fate, and death have been greatly altered.

FIGURE 8-3
Theater at Epidaurus, Greece,
ca. 350 B.C.

The theater, which has a capac-
ity of more than 10,000 patrons,
was used for early Greek
tragedy and is still used for
performances.

Modern psychology explains character in ways the ancients either would
not have understood or would have disputed. It has been said that there is
no modern tragedy because there can be no character noble enough to en-
gage our heartfelt sympathy. Moreover, the acceptance of chance as a force
equal to fate in our lives has also reduced the power of tragedy in modern
times. Even myth—which some modern playwrights like Eugene O'Neill still
use—has a diminished vitality in modern tragedy. It may be that the return
of a strong integrating myth—a world vision that sees the actions of human-
ity as tied into a large scheme of cosmic or sacred events—is a prerequisite
for producing a drama that we can recognize as truly tragic, at least in the
traditional sense. This may be an overstatement. What do you think?

The Tragic Stage

Our vision of tragedy focuses on two great ages—ancient Greece and
Renaissance England. These two historical periods share certain basic ideas:
for instance, that there is a "divine providence that shapes our ends," as
Hamlet says, and that fate is immutable, as the Greek tragedies tell us. Both
periods were marked by considerable prosperity and public power, and both
ages were deeply aware that sudden reversals in prosperity could change ev-
erything. In addition, both ages had somewhat similar ideas about the way a
stage should be constructed. The relatively temperate climate of Greece per-
mitted an open amphitheater, with seating on three sides of the stage. The
Greek architects often had the seats carved out of hillside rock, and their at-
tention to acoustics was so remarkable that even today in some of the surviv-
ing Greek theaters, as at Epidaurus (Figure 8-3), a whisper on the stage can

be heard in the farthest rows. The Elizabethan stages were roofed wooden structures jutting into open space enclosed by stalls in which the well-to-do sat (the not-so-well-to-do stood around the stage), providing for sight lines from three sides. Each kind of theater was similar to a modified theater-in-the-round, such as is used occasionally today. A glance at Figures 8-3, 8-4, and 8-5 shows that the Greek and Elizabethan theaters were very different from the standard theater of our time—the **proscenium** theater.

The proscenium acts as a transparent "frame" separating the action taking place on the stage from the audience. The Greek and Elizabethan stages are not so explicitly framed, thus involving the audience more directly spatially and, in turn, perhaps, emotionally. With the Greek theater, the area where the action took place was a circle, called the "orchestra." The absence of a separate stage put the actors on the same level as those seated at the lowest level of the audience.

Shakespeare's Romeo and Juliet

For a contemporary audience, *Romeo and Juliet* is probably easier to participate with than most Greek tragedies because, among other reasons, its tragic hero and heroine, although aristocratic, are not a king and a queen. Their youth and innocence add to their remarkable appeal. The play presents the archetypal story of lovers whose fate—mainly because of the hatred their families bear each other—is sealed from the first. The archetype of lovers who are not permitted to love enacts a basic struggle among forces that lie so deep in our psyches that we need a drama such as this to help reveal

FIGURE 8-4
Modern rendering of DeWitt's 1596 drawing of the interior of an Elizabethan theater in London.

This is typical of those in which Shakespeare's plays were performed.

FIGURE 8-5
The auditorium and proscenium of the Royal Opera House, Covent Garden, London.

The proscenium arch is typical of theaters from the eighteenth century to the present. It has been compared with the fourth wall of the drama within.

them. It is the struggle between light and dark, between the world in which we live on the surface of the earth with its light and openness and the world of darkness, the underworld of the Greeks and the Romans, and the hell of the Christians. Young lovers represent life, the promise of fertility, and the continuity of the human race. Most of us who are no longer in the bloom of youth were once such people, and we can both sympathize with and understand their situation. Few subject matters could be more potentially tragic than that of young lovers whose promise is plucked by death.

The play begins with some ominous observations by Montague, Romeo's father. He points out that when Romeo, through love of a girl named Rosaline (who does not appear in the play), comes home just before dawn, he locks "fair daylight out," making for himself an "artificial night." In other words, Montague tells us that Romeo stays up all night, comes home, pulls down the shades, and converts day into night. These observations seem innocent enough unless one is already familiar with the plot; then it seems a clear and tragic irony: that Romeo, by making his day a night, is already foreshadowing his fate. After Juliet has been introduced, her nurse wafts her offstage with an odd bit of advice aimed at persuading her of the wisdom of marrying Count Paris, the man her mother has chosen. "Go, girl, seek happy nights to happy days." At first glance, the advice seems innocent. But with knowledge of the entire play, it is prophetic, for it echoes the day/night imagery Montague has applied to Romeo. Shakespeare's details invariably tie in closely with the structure. Everything becomes relevant.

Much of the play takes place at night, and the film version by Franco Zeffirelli was particularly impressive for exploiting the spectacle, one of Aristotle's basic elements of tragedy. Spectacle includes all the visual and sounding features of a production, which, in their richness or starkness, can intensify the drama. Zeffirelli skillfully exploited the dramatic use of lighting, costuming, and music.

PERCEPTION KEY Drama and Music

1. Is music in a film production likely to be a more important element than in a stage production? Why or why not?
2. If you are able to see Zeffirelli's film of *Romeo and Juliet,* judge the effectiveness of the music.

When Romeo first speaks with Juliet, not only is it night but they are in Capulet's orchard: symbolically a place of fruitfulness and fulfillment. Romeo sees her and imagines her, not as chaste Diana of the moon, but as his own luminary sun: "But soft! What light through yonder window breaks? / It is the East, and Juliet is the sun!" He sees her as his "bright angel." When she, unaware he is listening below, asks, "O Romeo, Romeo! Wherefore art thou Romeo? / Deny thy father and refuse thy name," she is touching on profound concerns. She is, without fully realizing it, asking the impossible: that he not be himself. The denial of identity often brings great pain, as witness Oedipus, who at first refused to believe he was his father's child. When Juliet

asks innocently, "What's in a name? That which we call a rose / By any other name would smell as sweet," she is asking that he ignore his heritage. The mythic implications of this are serious and, in this play, fatal. Denying one's identity is rather like Romeo's later attempt to deny day its sovereignty.

When they finally speak, Juliet explains ironically that she has "night's cloak to hide me" and that the "mask of night is upon my face." We know, as she speaks, that eternal night will be on that face, and all too soon. Their marriage, which occurs offstage as Act Two ends, is also performed at night in Friar Lawrence's cell, with his hoping that the heavens will smile upon "this holy act." But he is none too sure. And before Act Three is well under way, the reversals begin. Mercutio, Romeo's friend, is slain because of Romeo's intervention. Then Romeo slays Tybalt, Juliet's cousin, and finds himself doomed to exile from both Verona and Juliet. Grieving for the dead Tybalt and the banished Romeo, Juliet misleads her father into thinking the only cure for her condition is a quick marriage to Paris, and Romeo comes to spend their one night of love together before he leaves Verona. Naturally they want the night to last and last—again an irony we are prepared for—and when daylight springs, Romeo and Juliet have a playful argument over whether it is the nightingale or the lark that sings. Juliet wants him to stay, so she defends the nightingale; he knows he must go, so he points to the lark and the coming light. Then both, finally, admit the truth. His line is "More light and light—more dark and dark our woes."

Another strange archetypal pattern, part of the complexity of the subject matter, has begun here: the union of sex and death as if they were aspects of the same thing. In Shakespeare's time, death was a metaphor for making love, and often when a singer of a love song protested that he was dying, he expected everyone to understand that he was talking about the sexual act. In *Romeo and Juliet*, sex and death go together, both literally and symbolically. The first most profound sense of this appears in Juliet's pretending death in order to avoid marrying Paris. She takes a potion from Friar Lawrence—who is himself afraid of a second marriage because of possible bigamy charges—and appears, despite all efforts of investigation, quite dead.

When Romeo hears that she has been placed in the Capulet tomb, he determines to join her in death as he was only briefly able to do in life. The message Friar Lawrence had sent by way of another friar explaining the counterfeit death did not get through to Romeo. And it did not get through because genuine death, in the form of plague, had closed the roads to Friar John. When Romeo descends underground into the tomb, he must ultimately fight Paris, although he does not wish to. After killing Paris, Romeo sees the immobile Juliet. He fills his cup (a female symbol) with poison and drinks. When Juliet awakes from her potion and sees both Paris and Romeo dead, she can get no satisfactory answer for these happenings from Friar Lawrence. His fear is so great that he runs off as the authorities bear down on the tomb. This leaves Juliet to give Romeo one last kiss on his still warm lips, then plunge his dagger (a male symbol) into her heart and die (Figure 8-6).

Earlier, when Capulet thought his daughter was dead, he exclaimed to Paris, "O son, the night before thy wedding day / Hath Death lain with thy wife. There she lies, / Flower as she was, deflowered by him. / Death is my

FIGURE 8-6
Romeo and Juliet in the tomb.
Worcester Foothills Theater
production, 2003, directed by
Edward Isser.

Juliet awakes to find Romeo's
body after he has drunk poison.
She will seize his dagger and
follow him to the grave.

son-in-law, Death is my heir." At the end of the play, both Juliet and his real
son-in-law, Romeo, are indeed married in death. The linkage of death and
sex is ironically enacted in their final moments, which include the awful
misunderstandings that the audience beholds in sorrow, that make Romeo
and Juliet take their own lives for love of each other. And among the last
lines is one that helps clarify one of the main themes: "A glooming peace
this morning with it brings. / The sun for sorrow will not show his head."
Theatergoers have mourned these deaths for generations, and the promise
that these two families will now finally try to get along together in a peaceful
manner does not seem strong enough to brighten the ending of the play.

PERCEPTION KEY Tragedy

1. While participating with *Romeo and Juliet,* did you experience pity and fear for the
 protagonists? Catharsis (the purging of those emotions)?
2. Our discussion of the play did not treat the question of the tragic flaw (hamartia): the weakness of character that brings disaster to the main characters. One of
 Romeo's flaws may be rashness—the rashness that led him to kill Tybalt and thus
 be banished. But he may have other flaws as well. What might they be? What are
 Juliet's tragic flaws, if any?

(continued)

3. In scenes such as that in which Romeo views the apparently dead Juliet, the film version focuses narrowly on the two and brings us close in. On the stage, the surrounding space cannot be completely abolished (even with highly concentrated lighting), and we cannot be brought as close in. In this respect, does this flexibility give film a distinct advantage over the stage play? Discuss.

4. You may not have been able to see *Romeo and Juliet,* but perhaps other tragedies are available. Try to see any of the tragedies by Aeschylus, Sophocles, or Shakespeare; Ibsen's *Ghosts;* John Millington Synge's *Riders to the Sea;* Eugene O'Neill's *Long Day's Journey into Night;* Tennessee Williams's *The Glass Menagerie;* or Miller's *Death of a Salesman.* Analyze the issues of tragedy we have raised. For example, decide whether the play is archetypal. Are there tragic flaws? Are there reversals and recognitions of the sort Aristotle analyzed? Did the recognition and reversal occur simultaneously? Are the characters important enough—if not noble enough—to excite your compassion for their sorrow and suffering?

5. If you were to write a tragedy, what kind of tragic protagonist would you choose? What kind of plot? Imagine a drama based on the love of an Israeli girl and a Palestinian boy? Would something like the plot of *Romeo and Juliet* be helpful in writing the play? Would Aristotle favor this? Why or why not?

COMEDY: OLD AND NEW

Ancient Western comedies were performed at a time associated with wine making, thus linking the genre with the wine god Bacchus and his relative Comus—from whom the word "comedy" comes. Comedy, like tragedy, achieved institutional status in ancient Greece. Some of the earliest comedies, along with satyr plays, were frankly phallic in nature, and many of the plays of Aristophanes, the master of **Old Comedy,** were raucous and coarse. Plutarch was offended by plays such as *The Clouds, The Frogs, The Wasps,* and especially *Lysistrata,* the world's best-known phallic play, concerning a situation in which the women of a community withhold sex until the men agree not to wage any more war. At one point in the play, the humor centers on the men walking around with enormous erections under their togas. Obviously Old Comedy is old in name only, since it is still present in the routines of nightclub comedians and the bawdy entertainment halls of the world.

In contrast, the **New Comedy** of Menander, with titles such as *The Flatterer, The Lady from Andros, The Suspicious Man,* and *The Grouch,* his only surviving complete play, concentrated on the more common situations in the everyday life of the Athenian. It also avoided the brutal attacks on individuals, such as Socrates, which characterize much Old Comedy. Historians credit Menander with developing the comedy of manners, the kind of drama that satirizes the manners of a society as the basic part of its subject matter.

Old Comedy is associated with our modern farce, burlesque, and the broad humor and make-believe violence of slapstick. New Comedy tends to be suave and subtle. Concentrating on manners, New Comedy developed **type characters,** for they helped focus upon the foibles of social behavior. Type characters, such as the gruff and difficult man who turns out to have a heart of gold, the good cop, the bad cop, the ingenue, the finicky

person, or the sloppy person—all these work well in comedies. Such characters can become **stereotypes**—with almost totally predictable behavior patterns—although the best dramatists usually make them complex enough so that they are not completely predictable.

Comedy makes us laugh. If a man slips on a banana peel and very awkwardly regains his balance, we laugh. But if he breaks his leg, we do not laugh. The humorous has something to do with gracelessness, behavior that is not under our control but that does not have tragic consequences. When we behave in an antisocial way—for example, with sloppy table manners—we are liable to be laughed at. We do not enjoy that, so we may mend our ways. Comedy satirizes and criticizes antisocial behavior, as Henri Bergson brilliantly analyzed in *Laughter*. Whereas Old Comedy often indulges in wild exaggeration, New Comedy is usually subtler. Comedy, more than any other art, is the arena of oddball activity.

There is, however, another important dimension to comedy. The comic vision celebrates life and fecundity. Typically in comedy, all ends well; conflicts are resolved; and, as often in Shakespeare's comedies, the play concludes with feasting, revelry, and a satisfying distribution of brides to the appropriate suitors. We are encouraged to imagine that they will live happily ever after.

PERCEPTION KEY Type Characters

1. Neil Simon, who has written some of the most popular modern comedies, relies extensively on type characters. In *The Odd Couple*, Felix Unger, a finicky opera-loving neatnik, lives with Oscar Madison, a slob whose life revolves around sports. What is inherently funny about linking two characters like them?
2. Type characters exist in all drama. What types are Romeo, Juliet, the Nurse, and Friar Lawrence? How close do they stay to their types?
3. To what extent is Hamlet a type character? Is it possible that the character of Hamlet actually created the dark-hued melancholiac as a type that did not exist before Shakespeare created him?
4. What type characters do you remember from your experiences with drama? What are the strengths of such characters? What are their limitations?

Both Old and New Comedy, despite, or perhaps because of, the humor, can have serious meaning. Comedy is a powerful reformer of society, which is one reason dictators are so quick to censor the comic dramatist. We love to be laughed with but hate to be laughed at. No one likes to be seen as ridiculous. When comedy reveals aspects of ourselves that are laughable, we try to change.

Comedy, like tragedy, may use archetypal patterns. For example, there is the pattern pointing toward marriage and the new life made possible by the hoped-for fruitfulness of such a union. The forces of society, personified often by a parent or controlling older person, are usually pitted against the younger characters who wish to be married. Thus one of the most powerful archetypal patterns of comedy is a variant of the generation gap. The "parent" can be any older person who blocks the younger people, usually by virtue of controlling their inheritance or their wealth. When the older

person wishes to stop a marriage, he or she becomes the blocking character. This character, for reasons that are usually social or simply mercenary, does everything possible to stop the young people from getting together.

Naturally, the blocking character fails. But the younger characters do not merely win their own struggle. They usually go on to demonstrate the superiority of their views over those of the blocking character. For example, they may demonstrate that true love is a better reason for marrying than is merging two neighboring estates. One common pattern is for two lovers to decide to marry regardless of their social classes. The male, for instance, may be a soldier or a student but not belong to the upper class to which the female belongs. But often at the last minute, through means such as a birthmark (as in *The Marriage of Figaro*) or the admission of another character who knew all along, the lower-class character will be shown to be a member of the upper class in disguise. Often the character himself will not know the truth until the last minute in the drama. This is a variant of Aristotle's recognition in tragedy, although it does not have the unhappy consequences. In all of this, New Comedy is usually in tacit agreement with the ostensible standards of the society it entertains. It only stretches the social standards and is thus evolutionary rather than revolutionary.

Blocking characters are often eccentrics, like Archie Bunker, whose behavior is marked by an extreme commitment to a limited perspective. They may be misers, for example, whose entire lives are devoted to mercenary goals, although they may not be able to enjoy the money they heap up; or malcontents, forever looking on the dark side of humanity; or hypochondriacs, whose every move is dictated by their imaginary illnesses. Such characters are so rigid that their behavior is a form of vice. The effort of the younger characters is often to reform the older characters, educating them away from their entrenched and narrow values toward accepting the idealism and hopefulness of the young people who, after all, are in line to inherit the world that the older people are reluctant to turn over. Few generations give way without a struggle, and this archetypal struggle on the comic stage may serve to give hope to the young when they most need it, as well as possibly to help educate the old so as to make the real struggle less terrible.

PERCEPTION KEY Old and New Comedy

Studying comedy in the abstract is difficult. It is best for you to test what has been discussed above by comparing our descriptions and interpretations with your own observations. If you have a chance to see some live comedy onstage, use that experience, but if that is impossible, watch some television comedy.

1. Is there criticism of society? If so, is it savage or gentle?
2. Are there blocking characters? Do they function somewhat in the ways described above? Are there any new twists?
3. Do you find examples of the generation gap? Are they similar to the archetypal pattern of the blocking character opposing the marriage of younger people? Do you observe any modern variations of this archetype?

4. See or read at least two comedies. How many type or stereotype characters can you identify? Is there an example of the dumb blonde? The braggart tough guy? The big lover? The poor but honest fellow? The dumb cop? The absentminded professor? Do types or stereotypes dominate? Which do you find more humorous? Why?

TRAGICOMEDY: THE MIXED GENRE

On the walls beside many stages, especially the ancient, we find two masks: the tragic mask with a downturned mouth and the comic mask with an upturned mouth. If there were a third mask, it would probably have an expression of bewilderment, as if someone had just asked a totally unanswerable question. Mixing the genres of tragedy and comedy in a drama may give such a feeling. Modern audiences are often left with many unanswered questions when they leave the theater. They are not always given resolutions that wrap things up neatly. Instead, **tragicomedy** tends, more than either tragedy or comedy, to reveal the **ambiguities** of the world. It does not usually end with the finality of death or the promise of a new beginning. It usually ends somewhere in between.

The reason tragicomedy has taken some time to become established as a genre may have had something to do with the fact that Aristotle did not provide an analysis—an extraordinary example of a philosopher having great influence on the arts. Thus for a long time, tragicomedy was thought of as a mixing of two pure genres and consequently inferior in kind. The mixing of tragedy and comedy is surely justified, if for no other reason than the mixture works so well, as proved by most of the marvelous plays of Chekhov. This mixed genre is a way of making drama truer to life. As playwright Sean O'Casey commented to a college student, "As for the blending 'Comedy with Tragedy,' it's no new practice—hundreds have done it, including Shakespeare. . . . And, indeed, Life is always doing it, doing it, doing it. Even when one lies dead, laughter is often heard in the next room. There's no tragedy that isn't tinged with humour, no comedy that hasn't its share of tragedy—if one has eyes to see, ears to hear." Much of our best modern drama is mixed in genre so that, as O'Casey points out, it is rare to find a comedy that has no sadness to it, or a tragedy that is unrelieved by laughter.

A PLAY FOR STUDY: *THE SWAN SONG*

Anton Chekhov (1860–1904) is one of the giants of modern drama. His major plays for the Moscow Art Theater, *The Cherry Orchard*, *Three Sisters*, *Ivanov*, and *Uncle Vanya*, are all part of the international repertory of modern theatrical mainstays. *The Swan Song* (1889), his earliest produced play, can be thought of as meta-drama, drama about the theater itself. Svietlovidoff is an old actor in perhaps his last play—"swan song" is shorthand for one's last performance or last appearance. In his late age he is

FIGURE 8-7
Paul Rainville as Ivanitch
and Douglas Campbell as
Svietlovidoff in Chekhov's
The Swan Song. The National
Arts Centre's English Theatre
(Canada) production, 2003.

reduced to ridiculous roles, while Ivanitch is reduced to being a prompter, calling out the lines that aged actors, like Svietlovidoff, forget. Both are sad characters, but Chekhov reveals their true nature as they talk and as they recall some of the great poetry and great speeches that animate theater and theater life (Figure 8-7). They enact a few lines from *King Lear,* then from *Hamlet* and *Othello,* all spoken with great authority and with the conviction of their characters, revealing to themselves that they still possess genius. Chekhov enlarges their sense of themselves while praising the nature of drama through the representation of some of its greatest moments.

THE SWAN SONG Anton Chekhov, tr. Marian Fell

Characters
VASILI SVIETLOVIDOFF, a comedian, 68 years old
NIKITA IVANITCH, **a prompter, an old man**

The scene is laid on the stage of a country theatre, at night, after the play. To the right a row of rough, un-painted doors leading into the dressing-rooms. To the left and in the background the stage is encumbered with all sorts of rubbish. In the middle of the stage is an overturned stool.

SVIETLOVIDOFF. [*With a candle in his hand, comes out of a dressing-room and laughs*] Well, well, this is funny! Here's a good joke! I fell asleep in my dressing-room when the play was over, and there I was calmly snoring after everybody else had left the theatre. Ah! I'm a foolish old man, a poor old dodderer! I have been drinking again, and so I fell asleep in there, sitting up. That was clever! Good for you, old boy! [*Calls*] Yegorka! Petrushka! Where the devil are you? Petrushka! The scoundrels must be asleep, and

an earthquake wouldn't wake them now! Yegorka! [*Picks up the stool, sits down, and puts the candle on the floor*] Not a sound! Only echos answer me. I gave Yegorka and Petrushka each a tip to-day, and now they have disappeared without leaving a trace behind them. The rascals have gone off and have probably locked up the theatre [*Turns his head about*] I'm drunk! Ugh! The play to-night was for my benefit, and it is disgusting to think how much beer and wine I have poured down my throat in honour of the occasion. Gracious! My body is burning all over, and I feel as if I had twenty tongues in my mouth.

It is horrid! Idiotic! This poor old sinner is drunk again, and doesn't even know what he has been celebrating! Ugh! My head is splitting, I am shivering all over, and I feel as dark and cold inside as a cellar! Even if I don't mind ruining my health, I ought at least to remember my age, old idiot that I am! Yes, my old age! It's no use! I can play the fool, and brag, and pretend to be young, but my life is really over now, I kiss my hand to the sixty-eight years that have gone by; I'll never see them again! I have drained the bottle, only a few little drops are left at the bottom, nothing but the dregs. Yes, yes, that's the case, Vasili, old boy. The time has come for you to rehearse the part of a mummy, whether you like it or not. Death is on its way to you. [*Stares ahead of him*] It is strange, though, that I have been on the stage now for forty-five years, and this is the first time I have seen a theatre at night, after the lights have been put out. The first time. [*Walks up to the foot-lights*] How dark it is! I can't see a thing. Oh, yes, I can just make out the prompter's box, and his desk; the rest is in pitch darkness, a black, bottomless pit, like a grave, in which death itself might be hiding. . . . Brr. . . . How cold it is! The wind blows out of the empty theatre as though out of a stone flue. What a place for ghosts! The shivers are running up and down my back. [*Calls*] Yegorka! Petrushka! Where are you both? What on earth makes me think of such gruesome things here? I must give up drinking; I'm an old man, I shan't live much longer. At sixty-eight people go to church and prepare for death, but here I am—heavens! A profane old drunkard in this fool's dress—I'm simply not fit to look at. I must go and change it at once. . . . This is a dreadful place, I should die of fright sitting here all night. [*Goes toward his dressing-room; at the same time NIKITA IVANITCH in a long white coat comes out of the dressing-room at the farthest end of the stage. SVIETLOVIDOFF sees IVANITCH—shrieks with terror and steps back*]

Who are you? What? What do you want? [*Stamps his foot*] Who are you?

IVANITCH. It is I, sir.

SVIETLOVIDOFF. Who are you?

IVANITCH [*Comes slowly toward him*] It is I, sir, the prompter, Nikita Ivanitch. It is I, master, it is I!

SVIETLOVIDOFF. [*Sinks helplessly onto the stool, breathes heavily and trembles violently*] Heavens! Who are you? It is you . . . you Nikitushka? What . . . what are you doing here?

IVANITCH. I spend my nights here in the dressing-rooms. Only please be good enough not to tell Alexi Fomitch, sir. I have nowhere else to spend the night; indeed, I haven't.

SVIETLOVIDOFF. Ah! It is you, Nikitushka, is it? Just think, the audience called me out sixteen times; they brought me three wreathes and lots of other things, too; they were all wild with enthusiasm, and yet not a soul came when it was all over to wake the poor, drunken old man and take him home. And I am an old man, Nikitushka! I am sixty-eight years old, and I am ill. I haven't the heart left to go on. [*Falls on IVANITCH'S neck and weeps*] Don't go away, Nikitushka; I am old and helpless, and I feel it is time for me to die. Oh, it is dreadful, dreadful!

IVANITCH. [*Tenderly and respectfully*] Dear master! it is time for you to go home, sir!

SVIETLOVIDOFF. I won't go home; I have no home—none! none!—none!

IVANITCH. Oh, dear! Have you forgotten where you live?

SVIETLOVIDOFF. I won't go there. I won't! I am all alone there. I have nobody, Nikitushka! No wife—no children. I am like the wind blowing across the lonely fields. I shall die, and no one will remember me. It is awful to be alone—no one to cheer me, no one to caress me, no one to help me to bed when I am drunk. Whom do I belong to? Who needs me? Who loves me? Not a soul, Nikitushka.

IVANITCH. [*Weeping*] Your audience loves you, master.
SVIETLOVIDOFF. My audience has gone home. They are all asleep, and have forgotten their old clown. No, nobody needs me, nobody loves me; I have no wife, no children.

IVANITCH. Oh, dear! Oh, dear! Don't be so unhappy about it.

SVIETLOVIDOFF. But I am a man, I am still alive. Warm, red blood is tingling in my veins, the blood of noble ancestors. I am an aristocrat, Nikitushka; I served in the army, in the artillery, before I fell as low as this, and what a fine young chap I was! Handsome, daring, eager! Where has it all gone? What has become of those old days? There's the pit that has swallowed them all! I remember it all now. Forty-five years of my life lie buried there, and what a life, Nikitushka! I can see it as clearly as I see your face: the ecstasy of youth, faith, passion, the love of women—women, Nikitushka!

IVANITCH. It is time you went to sleep, sir.

SVIETLOVIDOFF. When I first went on the stage, in the first glow of passionate youth, I remember a woman loved me for my acting. She was beautiful, graceful as a poplar, young, innocent, pure, and radiant as a summer dawn. Her smile could charm away the darkest night. I remember, I stood before her once, as I am now standing before you. She had never seemed so lovely to me as she did then, and she spoke to me so with her eyes—such a look! I shall never forget it, no, not even in the grave; so tender, so soft, so deep, so bright and young! Enraptured, intoxicated, I fell on my knees before her, I begged for my happiness, and she said: "Give up the stage!" Give up the stage! Do you understand? She could love an actor, but marry him—never! I was acting that day, I remember—I had a foolish, clown's part, and as I acted, I felt my eyes being opened; I saw that the worship of the art I had held so sacred was a delusion and an empty dream; that I was a slave, a fool, the plaything of the idleness of strangers. I understood my audience at last, and since that day I have not believed in their applause, or in their wreathes, or in their enthusiasm. Yes, Nikitushka! The people applaud me, they buy my photograph, but I am a stranger to them. They don't know me, I am as the dirt beneath their feet. They are willing enough to meet me . . . but allow a daughter or a sister to marry me, an outcast, never! I have no faith in them, [sinks onto the stool] no faith in them.

IVANITCH. Oh, sir! you look dreadfully pale, you frighten me to death! Come, go home, have mercy on me!

234

SVIETLOVIDOFF. I saw through it all that day, and the knowledge was dearly bought. Nikitushka! After that . . . when that girl . . . well, I began to wander aimlessly about, living from day to day without looking ahead. I took the parts of buffoons and low comedians, letting my mind go to wreck. Ah! but I was a great artist once, till little by little I threw away my talents, played the motley fool, lost my looks, lost the power of expressing myself, and became in the end a Merry Andrew instead of a man. I have been swallowed up in that great black pit. I never felt it before, but to-night, when I woke up, I looked back, and there behind me lay sixty-eight years. I have just found out what it is to be old! It is all over . . . [sobs] . . . all over.

IVANITCH. There, there, dear master! Be quiet . . . gracious! [Calls] Petrushka! Yegorka!

SVIETLOVIDOFF. But what a genius I was! You cannot imagine what power I had, what eloquence; how graceful I was, how tender; how many strings [beats his breast] quivered in this breast! It chokes me to think of it! Listen now, wait, let me catch my breath, there; now listen to this:

"The shade of bloody Ivan now returning
Fans through my lips rebellion to a flame,
I am the dead Dimitri! In the burning
Boris shall perish on the throne I claim.
Enough! The heir of Czars shall not be seen
Kneeling to yonder haughty Polish Queen!"[1]

Is that bad, eh? [Quickly] Wait, now, here's something from King Lear. The sky is black, see? Rain is pouring down, thunder roars, lightning—zzz zzz zzz—splits the whole sky, and then, listen:

"Blow winds, and crack your cheeks! rage! blow!
You cataracts and hurricanoes spout
Till you have drench'd our steeples, drown'd
 the cocks!
You sulphurous thought-executing fires
Vaunt-couriers of oak-cleaving thunderbolts
Singe my white head! And thou, all shaking
 thunder,
Strike flat the thick rotundity o' the world!
Crack nature's moulds, all germons spill at once
That make ungrateful man!"[2]

[1] From *Boris Godunoff*, by Pushkin. [translator's note]
[2] *King Lear*, Act 3, sc. 2

[*Impatiently*] Now, the part of the fool. [*Stamps his foot*] Come take the fool's part! Be quick, I can't wait!

IVANITCH. [*Takes the part of the fool*]

> "O, Nuncle, court holy-water in a dry house is better than this rain-water out o' door. Good Nuncle, in; ask thy daughter's blessing: here's a night pities neither wise men nor fools."[3]

SVIETLOVIDOFF.

> "Rumble thy bellyful! spit, fire! spout, rain!
> Nor rain, wind, thunder, fire, are my daughters;
> I tax not you, you elements, with unkindness;
> I never gave you kingdom, call'd you children."[4]

Ah! there is strength, there is talent for you! I'm a great artist! Now, then, here's something else of the same kind, to bring back my youth to me. For instance, take this, from Hamlet, I'll begin . . . Let me see, how does it go? Oh, yes, this is it. [*Takes the part of Hamlet*][5]

> "O! the recorders, let me see one.—To withdraw with you. Why do you go about to recover the wind of me, as if you would drive me into a toil?"

IVANITCH. "O, my lord, if my duty be too bold, my love is too unmannerly."

SVIETLOVIDOFF. "I do not well understand that. Will you play upon this pipe?"

IVANITCH. "My lord, I cannot."

SVIETLOVIDOFF. "I pray you."

IVANITCH. "Believe me, I cannot."

SVIETLOVIDOFF. "I do beseech you."

IVANITCH. "I know no touch of it, my lord."

SVIETLOVIDOFF. "'Tis as easy as lying: govern these vantages with your finger and thumb, give it breath with your mouth, and it will discourse most eloquent music. Look you, these are the stops."

IVANITCH. "But these I cannot command to any utterance of harmony: I have not the skill."

SVIETLOVIDOFF. "Why, look you, how unworthy a thing you make of me. You would play upon me; you would seem to know my stops; you would pluck out the heart of my mystery; you would sound me from my lowest note to the top of my compass; and there is much music, excellent voice, in this little organ, yet cannot you make it speak. S'blood! Do you think I am easier to be played on than a pipe? Call me what instrument you will, though you can fret me, you cannot play upon me!" [*laughs and clasps*] Bravo! Encore! Bravo! Where the devil is there any old age in that? I'm not old, that is all nonsense, a torrent of strength rushes over me; this is life, freshness, youth! Old age and genius can't exist together. You seem to be struck dumb, Nikitushka. Wait a second, let me come to my senses again. Oh! Good Lord! Now then, listen! Did you ever hear such tenderness, such music? Sh! Softly;

> "The moon had set. There was not any light,
> Save of the lonely legion'd watch-stars pale
> In outer air, and what by fits made bright
> Hot oleanders in a rosy vale
> Searched by the lamping fly, whose little spark
> Went in and out, like passion's bashful hope."[6]

[*The noise of opening doors is heard*] What's that?

IVANITCH. There are Petrushka and Yegorka coming back. Yes, you have genius, genius, my master.

SVIETLOVIDOFF. [*Calls, turning toward the noise*] Come here to me, boys! [*TO IVANITCH*] Let us go and get dressed. I'm not old! All that is foolishness, nonsense! [*laughs gaily*] what are you crying for? You poor old granny, you, what's the matter now? This won't do! There, there, this won't do at all! Come, come, old man, don't stare so! What makes you stare like that? There, there! [*Embraces him in tears*] Don't cry! Where there is art and genius there can never be such things as old age or loneliness or sickness . . . and death itself is half . . . [*Weeps*] No, no, Nikitushka! It is all over for us now! What sort of a genius am I? I'm like a squeezed lemon, a cracked bottle, and you— you are the old rat of the theatre . . . a prompter! Come on! [*They go*] I'm no genius, I'm only fit to be in the suite of Fortinbras, and even for that I am too old. . . . Yes. . . . Do you remember those lines from Othello, Nikitushka?

> "Farewell the tranquil mind! Farewell content!
> Farewell the plumed troops and the big wars

[3]*King Lear*, Act 3, sc. 2
[4]*King Lear*, Act 3, sc. 2
[5]The following dialogue is from *Hamlet*, Act 3, sc. 2.
[6]From Edward Bulwer Lytton's *A Night in Italy*

That make ambition virtue! O farewell!
Farewell the neighing steed and the shrill trump,
The spirit-stirring drum, the ear-piercing fife,
The royal banner, and all quality,
Pride, pomp and circumstance of glorious war!"[7]

IVANITCH. Oh! You're a genius, a genius

SVIETLOVIDOFF. And again this:

"Away! the moor is dark beneath the moon,
Rapid clouds have drunk the last pale beam of
 even:

Away! the gathering winds will call the darkness
 soon,
And profoundest midnight shroud the serene
 lights of heaven."[8]

They go out together, the curtain falls slowly.

[7]*Othello*, Act 3, sc. 3
[8]From Percy Bysshe Shelley, "Remorse"

EXPERIENCING Anton Chekhov's *The Swan Song*

1. Plot: What happens in this drama? Who changes in what way?
2. Ideas: What ideas are important in this drama? Could this be said to be a drama of ideas rather than a drama of action? How does the fact that all the speeches from Shakespeare come from the third act (of five) contribute to the main idea of the play?

The question of plot in this play is different from that in most plays. Instead of an action that takes place outside the characters, the action in this play takes place mostly inside the characters. It is their state of mind that changes in the process of the scene, not their physical or financial state that is altered. Things do not happen to Svietlovidoff and Ivanitch, they happen within them. What stands in for plot is interaction. In some dramas an action involving two characters of separate types is called an "agon," and the interaction causes both these men to understand that Svietlovidoff is a classically trained actor who was once great but who has suffered the ravages of age and of being forgotten.

If this is a drama of ideas, it is about the idea of theater. These characters enter the stage feeling defeated by life, but as the evening goes on, each of them relives moments of his youth, and each realizes that he has been in touch with greatness. Shakespeare's texts stimulate them to remember how magnificent are the dramas they once dominated. The fact that the texts they choose are from the third acts of plays points to the fact that they themselves are in the late stages of their own lives. But it also implies that the moments they remember are from the points in the drama when the arc of tension has grown highest and thus the level of drama is highest. Chekhov, in this first play, is paying tribute to the greatness of drama by taking these two beaten men and showing how they transform themselves into important dramatic figures.

3. Character: To what extent are Svietlovidoff and Ivanitch comic types? In what ways do they surprise us? In what ways do they surprise themselves?
4. Setting: Where is the action set? Why is the setting of critical importance to the ideas in the drama?
5. Genre: the main character is a comedian. Is this then a comedy? Svietlovidoff is reduced to preposterous roles in old age. Is this then a tragedy?

FIGURE 8-8
The Phanton of the Opera, the
longest running of all current
musical plays.

MUSICAL COMEDY

Most of the plays discussed so far do not emphasize music, but in *The Poet-ics,* Aristotle includes it as an essential part of the dramatic experience: "a very real factor in the pleasure of the drama." The great Greek tragedies were chanted to musical instruments, and the music had a significant effect on the audiences. Most of the great Elizabethan plays included music, some of which came at important moments in the action. Shakespeare's plays especially are noted for numerous beautiful and moving songs.

In modern times, the Broadway musical represents one of the most important contributions made by the United States to the stage. The musical comedies that have developed since the early part of the twentieth century have been produced around the globe, and today they are being written and performed in many nations abroad. The Broadway musical is now an international drama that is in most cases more popular than standard drama (Figure 8-8). In the twenty-first century, musical comedy attracts much greater audiences over longer runs than virtually any straight drama. *The Fantasticks,* for example—a simple love story featuring a block-ing character and two young lovers—ran for forty-two years with a piano

FIGURE 8-9
Faye Arthurs (as Maria) and
Benjamin Millepied (as Tony) in
the New York City Ballet's pro-
duction of the *West Side Story*
suite in the Colliseum, New
York City, 2008.

They pause at a critical moment
of the action, fully aware that
their attraction for one another
may cause a tragedy.

accompaniment and essentially one hit song, "Try to Remember that Night
in September."

Cats, based on T. S. Eliot's *Old Possum's Book of Practical Cats,* stayed
on Broadway for almost 7,500 performances, longer than Michael Ben-
nett's *A Chorus Line,* which lasted for 6,137 performances. Other contem-
porary long-running musicals are *The Phantom of the Opera* (8,700 on
Broadway, 9,500 in London), *Beauty and the Beast, Chicago,* and *The Lion
King.* On the one hand, these are extraordinary commercial successes.
In addition, the quality of some musicals in terms of drama has been
recognized many times; for example, the following are a few of the musi-
cal comedies that have won the Pulitzer Prize for Drama: *Of Thee I Sing*
(1932); *South Pacific* (1950); *A Chorus Line* (1976); *Sunday in the Park
with George* (1985); *Rent* (1996).

Many of the most popular musicals have been adaptations of novels,
short stories, or other plays. *Kiss Me! Kate* is an adaptation of Shakespeare's
comedy *The Taming of the Shrew. My Fair Lady* is an adaptation of George
Bernard Shaw's play *Pygmalion,* which itself draws upon the Greek myth
of the lovers Pygmalion and Galatea. *Les Miserables* is based on French
author Victor Hugo's popular novel, and *Rent* is based on Puccini's opera
La Bohème. West Side Story, by Leonard Bernstein with lyrics by Stephen
Sondheim, is an original musical, although it essentially rewrites *Romeo
and Juliet* for modern urban dwellers (Figure 8-9).

FIGURE 8-10
Celena Shafer and Jonathan
Hadary in the closing scene
of Jerome Kern and Oscar
Hammerstein II's *Show Boat*
production at Carnegie Hall in
New York City, 2008.

Of Thee I Sing, the longest-running drama of the 1930s, had an original
book by George S. Kaufman and Morrie Ryskind and lyrics by Ira Gershwin,
whose brother George wrote the music. It had a serious Depression-era
message that assailed incompetent politicians, including a bachelor presi-
dent running for office on a ticket that promised to return love to the White
House. Stephen Sondheim wrote the music for *Sunday in the Park with
George,* inspired by a famous painting by Georges Seurat (*Sunday Afternoon
on the Island of La Grande Jatte*), and *Into the Woods*, inspired by the most
famous characters from Grimms' fairy tales. James Lapine wrote the book
for each of those musicals. Obviously, the musical theater is one of the
most collaborationist of dramatic art forms. Most musicals include exten-
sive choreography, often by celebrated modern dancers, such as Agnes de
Mille in *Oklahoma!,* Jerome Robbins in *The King and I*, Gower Champion
in *42nd Street*, and Bob Fosse in *Chicago, Dancin'*, and *All That Jazz.*

The musical comedy can be especially rich in spectacle, with massed dance
scenes and popular songs that have a life outside the drama, as in the case of
musicals by Cole Porter, Jerome Kern, and Richard Rodgers. But some musi-
cals also treat serious subjects, as in Jerome Kern's and Oscar Hammerstein's
Show Boat (Figure 8-10), which comes closer to being a drama than a musi-
cal in part because of its treatment of slavery in the South. It was adapted

from Edna Ferber's novel, and partly through the powerful song "Ol' Man River," it has become one of the most moving of musicals. One interesting aspect of Broadway musicals is that they have often been successfully transformed into excellent films, bringing them to audiences around the world.

PERCEPTION KEY Musical Comedy

1. If you have the chance to see either a live or filmed version of one of the musical comedies mentioned above, explain what you feel has been added to the drama by the use of music and song.
2. If possible, compare a musical comedy with its source, such as Edna Ferber's novel *Show Boat*. You might also try *West Side Story* or *Romeo and Juliet* or *My Fair Lady* or Shaw's *Pygmalion*.
3. Given that people generally do not communicate with one another in song, is it possible to consider musical comedies as being realistic and true to life? If not, why are musicals so powerful and popular among audiences? Isn't realism a chief desirable quality in drama?
4. Try reading the book and lyrics of a major successful musical comedy. How effective do you think this work would be on the stage if there were no music with it? What is missing besides the music?
5. Musical comedy dominates the popular stage. Why is there no such thing as musical tragedy? How could a composer-writer produce a successful musical based on, say, *Oedipus Rex*, *Hamlet*, *Macbeth*, *Medea*, or *Othello*?

EXPERIMENTAL DRAMA

We have seen exceptional experimentation in modern drama in the Western world. Samuel Beckett wrote plays with no words at all, as with *Acts without Words*. One of his plays, *Not I*, has an oversized mouth talking with a darkened, hooded figure, thus reducing character to a minimum. In *Waiting for Godot*, plot is greatly reduced in importance. In *Endgame*, two of the characters are immobilized in garbage cans. Beckett's experiments have demonstrated that even when the traditional elements of drama are deemphasized or removed, it is still possible for drama to evoke intense participative experiences. Beckett has been the master of refining away.

Another important thrust of experimental drama has been to assault the audience. Antonin Artaud's "Theater of Cruelty" has regarded audiences as comfortable, pampered groups of privileged people. Peter Weiss's play—*The Persecution and Assassination of Marat as Performed by the Inmates of the Asylum at Charenton under the Direction of the Marquis de Sade* (or *Marat/Sade*)—obviously was influenced by Artaud's radical antiestablishment thinking. Through a depiction of insane inmates contemplating the audience at a very close range (Figure 8-11), it sought to break down the traditional security associated with the proscenium theater. *Marat/Sade* ideally was performed in a theater-in-the-round with the audience sitting on all sides of the actors and without the traditional fanfare of lights dimming for the beginning and lighting up for the ending. The audience is

FIGURE 8-11
Peter Weiss's experimental drama set in the round: *The Persecution and Assassination of Jean-Paul Marat as Performed by the Inmates of Charenton Asylum under the Direction of the Marquis de Sade,* 1965.

The characters interact with the audience, sometimes making them uncomfortable.

deliberately made to feel uneasy throughout the play. The depiction of intense cruelty within the drama is there because, according to Weiss, cruelty underlies all human events, and the play attempts a revelation of that all-pervasive cruelty. The audience's own discomfort is a natural function of this revelation.

Richard Schechner's *Dionysus in '69* also did away with spatial separation. The space of the theater was the stage space, with a design by Jerry Rojo that made players and audience indistinguishable. The play demanded that everyone become part of the action; in some performances—and in the

filmed performance—most of the players and audience ended the drama with a modern-day orgiastic rite. Such experimentation, indeed, seems extreme. But it is analogous to other dramatic events in other cultures, such as formal religious and celebratory rites.

> ## PERCEPTION KEY Experimental Drama
>
> Should you have the chance to experience a drama produced by any of the directors or groups mentioned above, try to distinguish its features from those of the more traditional forms of drama. What observations can you add to those made above? Consider the kinds of satisfaction you can get as a participant. Is experimental drama as satisfying as traditional drama? What are the differences? To what extent are the differences to be found in the details? The structure? Are experimental dramas likely to be episodic or organic? Why?

SUMMARY

The subject matter of drama is the human condition as represented by action. By emphasizing plot and character as the most important elements of drama, Aristotle helps us understand the priorities of all drama, especially with reference to its formal elements and their structuring. Aristotle's theory of tragedy focuses on the fatal flaw of the protagonist. Hegel's theory of tragedy focuses on the collision of good intentions. Tragedy and comedy both have archetypal patterns that help define them as genres. Some of the archetypes are related to the natural rhythms of the seasons and focus, in the case of tragedy, on the endings of things, such as death (winter) and, in the case of comedy, on the beginnings of things, such as romance (spring). The subject matter of tragedy is the tragic—sorrow and suffering. The subject matter of comedy is the comic—oddball behavior and joy.

Comedy has several distinct genres. Old Comedy revels in broad humor. New Comedy satirizes the manners of a society; its commentary often depends on type and stereotype characters. Tragicomedy combines both genres to create a third genre. The ambiguity implied by tragedy joined with comedy makes this a particularly flexible genre, suited to a modern world that lives in intense uncertainty. Musical drama usually adopts the comic mode and sometimes veers toward social commentary, or even social satire. The success of musical drama in modern times suggests that Aristotle was correct in assuming the importance of music in drama on an almost equal footing with its other elements. The experiments in modern drama have broken away from traditional drama, creating fascinating insights into our time. The human condition shifts from period to period in the history of drama, but somehow the constancy of human concerns makes all great dramatists our contemporaries.

Chapter 9

MUSIC

Music is one of the most powerful of the arts partly because sounds—more than any other sensory stimulus—create in us involuntary reactions, pleasant or unpleasant. Live concerts, whether of the Boston Symphony, Wynton Marsalis at Lincoln Center, or Bruce Springsteen and the E Street Band on tour, usually excite delight in their audiences. Yet, in all cases, the audiences rarely analyze the music. It may seem difficult to connect analysis with the experience of listening to music, but everyone's listening, including the performer's, benefits from a thorough understanding of some of the fundamentals of music.

HEARING AND LISTENING

Music can be experienced in two basic ways: "hearing" or "listening." *Hearers* do not attempt to perceive accurately either the structure or the details of the form. They hear a familiar melody such as the Beatles' "Strawberry Fields," which may trigger associations with John Lennon, early rock and roll, and perhaps even the garden in Central Park dedicated to his memory. But aside from the melody, little else—such as the details of chord progression, movement toward or away from tonic and dominant—is heard sensitively. The case is much the same with classical music. Most hearers prefer richly melodic music, such as Tchaikovsky's Fifth Symphony, whose second movement especially contains lush melodies that can trigger romantic associations. But when one asks hearers if the melody was repeated exactly

or varied, or whether the melody was moved from one instrumental family to another, they cannot say. They are concentrating on the associations evoked by the music rather than on the details and structure of the music. A hearer of hard rock is likely to attend as much to the performer as to the sonic effects. Powerful repetitive rhythms and blasting sounds trigger visceral responses so strong that dancing or motion—often wild—becomes imperative. Another kind of hearer is "suffused" or "permeated" by music, bathing in sensuous sounds, as many people will do with their earphones tuned to soft rock, new age, or easy-listening sounds. In this nonanalytic but attractive state of mind, the music spreads through the body rhythmically, soothingly. It feels great, and that is enough.

The *listeners,* conversely, concentrate their attention upon the form, details as well as structure. They could answer questions about the structure of Tchaikovsky's Fifth Symphony. And a listener, unlike a hearer, would be aware of the details and structure of works such as the Rolling Stones' "Sympathy for the Devil." Listeners focus upon the form that informs, that creates content. Listeners do not just listen: They listen for something—the content.

PERCEPTION KEY Hearing and Listening

1. Play one of your favorite pieces of music. Describe its overall organization or structure. Is there a clear melody? Is there more than one melody? If so, are they similar to one another or do they contrast with one another? Is the melody repeated? Is it varied or the same? Do different instruments play it? If there are lyrics, are they repeated?
2. Describe details such as what kind of rhythm is used. Is it varied? How? Is there harmony? What kind of instruments are played? How do these details fit into the structure?
3. Play the first movement of Beethoven's Third Symphony (the *Eroica*). Answer the same questions for this piece as were asked in questions 1 and 2. Later, we will analyze this movement. You may wish to compare your responses now with those you have after you have studied the work.
4. Do such questions annoy you? Would you rather just experience the music as physically stimulating? Or as a means to daydreaming? Or as sensuously suffusing?
5. Are you basically a hearer or a listener? Are you sometimes one and then the other? Which would you rather be most of the time? And at what times? Why?

If you find that you cannot answer the first three questions easily, or find them annoying, then indeed you are a hearer. Even the most avid listeners will be hearers under certain circumstances. No one is always up for concentrated attention. And although one can *hear* the Mozart in the background of a loud cocktail party, no one can *listen*. If you are usually a hearer even when the circumstances allow for listening, it is our hope that we can help you toward being a listener. And if you are a listener, we hope to make you and ourselves better ones. The content of music gives generous gifts, provided we are prepared to receive them.

Before we try to describe the subject matter of music, we will introduce some of the important terms and concepts essential to a clear discussion of music. We begin with some definitions and then analyze the basic musical elements of tone, consonance, dissonance, rhythm, tempo, melody, counterpoint, harmony, dynamics, and contrast. A common language about music is prerequisite to any intelligible analysis.

Tone

A sound that has one definite frequency or that is dominated by one definite frequency is a ***tone.*** Most music is composed of a succession of tones. Musical patterns are heard because of our ability to hear tones and remember them as they are played in succession. Tones on a musical instrument—except for pure tones—will have subordinate, related tones, or partials, sounding simultaneously, although not as loudly as the primary tone. Our ears are used to hearing a primary tone with fainter partials; therefore, when electronic instruments produce a pure tone—that is, with no partials—it may sound very odd to us. All instruments differ in the intensity or loudness of each of the partials. Consequently, a trumpet or a piano playing C will each have its distinctive timbre, or tone color, because of the variation in intensity of the simultaneously sounding partials that accompany the primary tone.

Consonance

When two or more tones are sounded simultaneously and the result is pleasing to the ear, the resultant sound is said to be consonant. The phenomenon of ***consonance*** may be qualified by several things. For example, what sounds dissonant or unpleasant often becomes more consonant after repeated hearings. Thus the sounds of the music of a different culture may seem dissonant at first but consonant after some familiarity develops. Also, there is the influence of context: A combination of notes or chords may seem dissonant in isolation or within one set of surrounding notes while consonant within another set. In the C major scale, the strongest consonances will be the eighth (C + C′) and the fifth (C + G), with the third (C + E), the fourth (C + F), and the sixth (C + A) being only slightly less consonant. Use Figure 9-1 if helpful, and sound the chords above on a piano.

FIGURE 9-1
Notes of the piano keyboard.

Dissonance

Just as some tones sounding together tend to be soothing and pleasant, other tones sounding together tend to be rough and unpleasant. This unpleasantness is a result of wave interference and a phenomenon called "beating," which accounts for the roughness we perceive in **dissonance.** The most powerful dissonance is achieved when notes close to one another in pitch are sounded simultaneously. The second (C + D) and the seventh (B + C) are both strongly dissonant. Dissonance is important in building musical tension, since the desire to resolve dissonance with consonance is strong in almost everyone. There is a story that Mozart's wife would retaliate against her husband during or after some quarrel by striking a dissonant chord on the piano. Wolfgang would be forced to come from wherever he was and play a resounding consonant chord to relieve the unbearable tension.

Rhythm

Rhythm refers to the temporal relationships of sounds. Our perception of rhythm is controlled by the accent or stress on given notes and their duration. In the waltz, the accent is heavy on the first note (of three) in each musical measure. In most jazz music, the stress falls on the second and fourth notes (of four) in each measure. Marching music, which usually has six notes in each measure, emphasizes the first and fourth notes.

Tempo

Tempo is the speed at which a composition is played. We perceive tempo in terms of beats, just as we perceive the tempo of our heartbeat as seventy-two pulses per minute, approximately. Many tempos have descriptive names indicating the general time value. *Presto* means "very fast"; *allegro* means "fast"; *andante* means "at a walking pace"; *moderato* means at a "moderate pace"; *lento* and *largo* mean "slow." Sometimes metronome markings are given in a score, but musicians rarely agree on any exact time figure. Tension, anticipation, and one's sense of musical security are strongly affected by tempo.

Melodic Material: Melody, Theme, and Motive

Melody is usually defined as a group of notes played one after another, having a perceivable shape or having a perceivable beginning, middle, and end. Usually a melody is easily recognizable when replayed. Vague as this definition is, we rarely find ourselves in doubt about what is or is not a melody. We not only recognize melodies easily but also can say a great deal about them. Some melodies are brief, others extensive; some slow, others fast; some bouncy, others somber. A **melodic line** is a vague melody, without

a quite clear beginning, middle, and end. A ***theme*** is a melody that undergoes significant modifications in later passages. Thus, in the first movement of the *Eroica*, the melodic material is more accurately described as themes than melodies. On the other hand, the melodic material of "Swing Low, Sweet Chariot" (see Figure 9-4) is clear and singable. A ***motive*** is the briefest intelligible and self-contained fragment or unit of a theme—for example, the famous first four notes of Beethoven's Symphony no. 5.

Counterpoint

In the Middle Ages, the monks composing and performing church music began to realize that powerful musical effects could be obtained by staggering the melodic lines. This is called ***counterpoint***—playing one or more themes or melodies or motives against each other, as in folk songs such as "Row, Row, Row Your Boat." Counterpoint implies an independence of simultaneous melodic lines, each of which can, at times, be most clearly audible. Their opposition creates tension by virtue of their competition for our attention.

Harmony

Harmony is the sounding of tones simultaneously. It is the vertical dimension, as with a chord (Figure 9-2), as opposed to the horizontal dimension, as with a melody. The harmony that most of us hear is basically chordal. A ***chord*** is a group of notes sounded together that has a specific relationship to a given key: The chord C-E-G, for example, is a major triad in the *key* of C major. At the end of a composition in the key of C, the major triad will emphasize the sense of finality—more than any other technique we know.

G or treble clef

F or bass clef

FIGURE 9-2
Harmony—the vertical element.

Chords are particularly useful for establishing ***cadences:*** progressions to resting points that release tensions. Cadences move from relatively unstable chords to stable ones. You can test this on a piano by first playing the notes C-F-A together, then playing C-E-G (consult Figure 9-1 for the position of these notes on the keyboard). The result will be obvious. The first chord establishes tension and uncertainty, making the chord unstable, while the second chord resolves the tension and uncertainty, bringing the sequence to a stable conclusion. You probably will recognize this progression as one you have heard in many compositions—for example, the "Amen" that closes most hymns. The progression exists in every key with the same sense of moving to stability.

EXPERIENCING "Battle Hymn of the Republic"

1. How do the chords and harmony of "The Battle Hymn of the Republic" affect our perception of the piece? How do they contribute to producing feelings in us as we listen?
2. To what extent might the association of "The Battle Hymn of the Republic" with historical events affect our response to the melody?

In this simplified version of the chorus "The Battle Hymn of the Republic" (Figure 9-3), the opening chords are very stable and establish themselves firmly, giving us a sense of a strong beginning and a powerful grounding. The first chord, the octave C interval in the bass clef and the third plus the fifth interval (E under G) in the treble clef, is the basic triad of the chord C major, and thus establishes itself in our ears with great definiteness. Thus at the outset of the piece the harmony establishes a strong equilibrium. Whatever else happens in the middle of the composition, we will expect the end to be just as stable. The treble part of the chord includes F and D, but is rooted by the C octave, producing a slight sense of instability, but quickly the initial chord returns to comfort us. In the first two measures the progression of the bass clef never changes—the C octave is a powerful root against which the treble changes only very slightly as it rises to its highest point, now with the E higher than the G, held for a little longer than the other chords, resolving into the final chord of the second measure, C above E. This very chord implies great stability and appears again at the end of the chorus. So the pattern is a beginning that establishes a powerful musical base in the key of C major, then a series of measures that include tones that differ only slightly from the basic chord of the key, thus establishing expectation and uncertainty in the next to last measure, then providing us with total musical satisfaction in the final measure. Whereas the opening includes two Cs, and E, and a G, the final harmony dispenses with the G and substitutes another C, adding an even stronger sense of closure to the ending.

Incidentally, this piece is closely connected to our historical memory because it was sung by Union soldiers during the Civil War from 1861–1865. For some listeners it is a hymn to the freeing of the slaves in 1862. For other listeners it is a reminder of the loss of the Ante-Bellum South. The point is that our responses to this piece, like many other pieces of music, will be affected by our understanding of its historical implications and connections. Our position in this book is that we must omit political considerations and listen rather to the music itself, responding when we can to the structure of the pieces that we feel reward us most.

3. Sing this piece to a friend or friends. Sing it with them if you can. Do they recognize the moments of stability and instability in the piece? Do they find its structure satisfying musically?
4. Are you aware of a deeply felt response to the chorus of "The Battle Hymn of the Republic"?

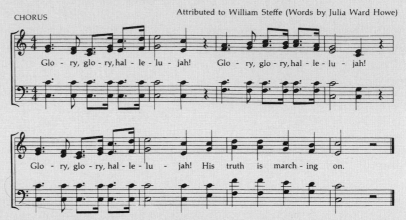

Battle Hymn of the Republic

Attributed to William Steffe (Words by Julia Ward Howe)

CHORUS

Glo - ry, glo - ry, hal - le - lu - jah! Glo - ry, glo - ry, hal - le - lu - jah!

Glo - ry, glo - ry, hal - le - lu - jah! His truth is march - ing on.

FIGURE 9-3
The words to the "Battle Hymn of the Republic" were written in 1861 by Julia Ward Howe on a visit to the Union troops during the Civil War. The music may have been composed by William Steffe. It is one of the most popular abolitionist songs of the period.

Harmony is based on apparently universal psychological responses. All humans seem to perceive the smoothness of consonance and the roughness of dissonance. The effects may be different due to cultural conditioning, but they are predictable within a limited range. One anthropologist, when told about a Samoan ritual in which he was assured he could hear original Samoan music—as it had existed from early times—hauled his tape recorder to the site of the ceremonies, waited until dawn, and when he heard the first stirrings turned on his machine and captured the entire group of Samoans singing "You are my sunshine, my only sunshine." The anthropologist was disappointed, but his experience underscores the universality of music.

Dynamics

One of the most easily perceived elements of music is **dynamics:** loudness and softness. Composers explore dynamics—as they explore keys, tone colors, melodies, rhythms, and harmonies—to achieve variety, to establish a pattern against which they can play, to build tension and release it, and to provide the surprise that can delight an audience. Two terms, **piano** ("soft") and **forte** ("loud"), with variations such as *pianissimo* ("very soft") and *fortissimo* ("very loud"), are used by composers to identify the desired dynamics at a given moment in the composition. A gradual buildup in loudness is called a **crescendo,** whereas a gradual reduction is called a *decrescendo.* Most compositions will have some of each, as well as passages that sustain a dynamic level.

Contrast

One thing that helps us value dynamics in a given composition is the composer's use of contrast. But contrast is of value in other ways. When more than one instrument is involved, the composer can contrast timbres. The brasses, for example, may be used to offer tonal contrast to a passage that may have been played by the strings. The percussion section, in turn, can contrast with both those sections, with high-pitched bells and low-pitched kettledrums covering a wide range of pitch and timbre. The woodwinds create very distinctive tone colors, and the composer writing for a large orchestra can use all of the families of instruments in ways designed to exploit the differences in the sounds of these instruments even when playing the same notes.

Composers may approach rhythm and tempo with the same attention to contrast. Most symphonies begin with a fast movement (usually labeled **allegro**) in the major key, followed by a slow movement (usually labeled **andante**) in a related or contrasting key, then a third movement with bright speed (usually labeled **presto**), and a final movement that resolves to some extent all that has gone before—again at a fast tempo *(molto allegro),* although sometimes with some contrasting slow sections within it, as in Beethoven's *Eroica.*

THE SUBJECT MATTER OF MUSIC

In music, as in other arts, content is achieved by the form's transformation of subject matter. The question of music's subject matter is dealt with in many ways by critics. Our approach is to identify two kinds of subject matter: feeling (emotions, passions, and moods) and sound.

Music cannot easily imitate nature, unless it does so the way bird songs and clocks sometimes appear in Haydn's symphonies or as Beethoven does in his *Pastoral* Symphony when he suggests a thunderstorm through his music. Other musicians sometimes use sirens or other recognizable sounds as part of their composition.

Program music attempts to provide a musical "interpretation" of a literary text, as in Tchaikovsky's *Overture: Romeo and Juliet,* in which the opening clarinet and oboe passages seem dark and forbidding, as if foreshadowing the tragedy to come. *La Mer,* by Claude Debussy, is an interpretation of the sea. His subtitles for sections of his work are "From Dawn to Noon at Sea," "Gambols of the Waves," and "Dialogue between the Wind and the Sea." For many listeners, the swelling of the music implies the swelling of the sea, just as the music's peacefulness suggests the pacific nature of the ocean.

However, our view is that while a listener who knows the program of *La Mer* may experience thoughts about the sea, listeners who do not know the program will still respond powerfully to the music on another level. It is not the sea, after all, that is represented in the music, but the feelings in Debussy that are evoked by his experience of the sea as mediated by his composition. Thus the swelling moments of the composition, along with the more lyrical and quiet moments, are perceived by the listener in terms of sound, but sound that evokes an emotional response that pleases both those who know the program and those who do not. This then means there is no strict relationship between the structures of our feelings and the structures of music, but there is clearly a general and worthwhile relationship that pleases us.

Feelings

Feelings are composed of sensations, emotions, passions, and moods. Any stimulus from any art produces a sensation. ***Emotions*** are strong sensations felt as related to a specific stimulus. ***Passions*** are emotions elevated to great intensity. ***Moods*** sometimes arise from no apparent stimulus, as when we feel melancholy for no apparent reason. In our experience, all these feelings mix together and can be evoked by music. No art reaches into our life of feeling more deeply than music.

In some important ways, music is congruent with our feelings and is thus capable of clarifying and revealing them to us. Nervous-sounding music can make us feel nervous, while calm, languorous music can relax us. A slow passage in a minor key, such as a funeral march, will produce a response quite different from that of a spritely dance. These extremes

are obvious, of course, but they only indicate the profound richness of the emotional resources of music in the hands of a great composer. Things get most interesting when music begins to clarify and produce emotional states that are not nameable. We name only a small number of the emotions we feel: joy, sorrow, guilt, horror, alarm, fear, calm, and many more. But those that can be named are only a scant few of those we feel. Music has an uncanny ability to give us insight into the vast world of emotions we cannot name.

The philosopher Susanne Langer has said that music has the capacity to educate our emotional life. She can say this because she believes, as we do, that music has feeling as part of its subject matter. She maintains that

> the tonal structures we call "music" bear a close logical similarity to the forms of human feelings—forms of growth and attenuation, flowing and stowing, conflict and resolution, speed, arrest, terrific excitement, calm, or subtle activation and dreamy lapses—not joy and sorrow perhaps, but the poignancy of either and both—the greatness and brevity and eternal passing of everything vitally felt. Such is the pattern, or logical form, of sentience, and the pattern of music is that same form worked out in pure, measured sound and silence. Music is a tonal analogue of emotive life.[1]

Roger Scruton, a contemporary philosopher who has considered this problem extensively, says this about emotion in music:

> The use of the term "expression" to describe the content of music reflects a widespread view that music has meaning because it connects in some way with our states of mind.[2]

These examples of the close similarity between the structures of music and feelings are fairly convincing because they are extreme. Most listeners agree that some music has become associated with gloomy moods, while other music has become associated with exhilaration. Much of this process of association undoubtedly is the result of cultural conventions that we unconsciously accept. But presumably there is something in the music that is the basis for these associations, and Langer has made a convincing case that the basis is in the similarity of structures. It is unlikely, indeed, that a bouncy, dynamic trumpet passage would ever be associated with peaceful feelings. Such a passage is more likely to be associated with warlike alarms and uncertainties. Soft vibrating string passages, on the other hand, are more likely to be associated with

[1]Susanne Langer, *Feeling and Form* (New York: Scribner's, 1953), p. 27.
[2]Roger Scruton, *The Aesthetics of Music* (Oxford: Oxford University Press, 1996), p. 346.

noises into a musical composition. Then, for once, we listen to rather than away from them, and then we may discover these noises to be intrinsically interesting, at least briefly.

PERCEPTION KEY The Subject Matter of Music

1. Select two brief musical compositions you enjoy. Choose one that you believe has recognizable emotions as its primary musical content. Choose another that you believe has sounds more than tones as its primary musical content. Listen to both with a group of people to see if they agree with you. What is the result of your experiment?

2. Choose one piece of popular music that evokes strong emotion in you. Listen to it with people older or younger than you and determine whether they have similar emotional reactions.

3. What piece of music convinces you that the content of music is related to the expression of feeling? What piece of music convinces you otherwise?

4. Find a piece of music that you and a friend disagree about in terms of its apparent emotional content. If you think it expresses one kind of emotion, passion, or mood, and your friend thinks it expresses a totally different kind of emotion, passion, or mood, would that then call into question the theory that the content of music is connected to feelings?

5. To what extent do you think the emotional content of a piece of popular music may result in great differences of opinion among listeners of different generations? Do you and your parents listen to the same music? Do your parents listen to the same kind of music their parents listened to?

TONAL CENTER

A composition written mainly in one scale is said to be in the key that bears the name of the tonic or tonal center of that scale. A piece in the key of F major uses the scale of F major, although in longer, more complex works, such as symphonies, the piece may use other related keys in order to achieve variety. The tonal center of a composition in the key of F major is the tone F. We can usually expect such a composition to begin on F, to end on it, and to return to it frequently to establish stability. Each return to F builds a sense of security in the listener, while each movement away usually builds a sense of insecurity or tension. The listener perceives the tonic as the basic tone because it establishes itself as the anchor, the point of reference for all the other tones.

After beginning with A in the familiar melody of "Swing Low, Sweet Chariot" (Figure 9-4), the melody immediately moves to F as a weighty rest point. The melody rises no higher than D and falls no lower than C. (For convenience, the notes are labeled above the notation in the figure.) Most listeners will sense a feeling of completeness in this brief composition as it comes to its end. But the movement in the first four bars, from A downward to C, then upward to C, passing through the tonal center F, does not suggest such completeness; rather, it prepares us to expect something

Swing Low, Sweet Chariot

Swing low, sweet char - i - ot,___ Com - ing for to car - ry me home!

Swing___ low, sweet char - i - ot,___ Com - ing for to car - ry me home!

1 I
2 If

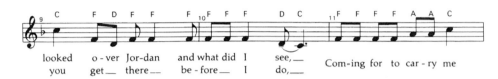

looked o - ver Jor - dan and what did I see,___ Com - ing for to car - ry me
you get___ there___ be - fore___ I do,___

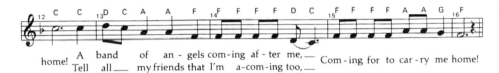

home! A band of an - gels com - ing af - ter me,___ Com - ing for to car - ry me home!
Tell all___ my friends that I'm a - com - ing too,___

FIGURE 9-4
"Swing Low, Sweet Chariot" is a Negro spiritual written by Wallace Willis some time before the emancipation of the slaves in America (1862). Willis was a freedman, a Choctaw, whose music was recorded by the Jubilee Singers, students at Fisk University, in 1909. Both Anton Dvořák and Eric Clapton are credited with incorporating the melody in their music.

more. If you sing or whistle the tune, you will see that the long tone, C, in bar 4 sets up an anticipation that the next four bars attempt to satisfy. In bars 5 through 8, the movement downward from D to C, then upward to A, and finally to the rest point at F suggests a temporary rest point. When the A sounds in bar 8, however, we are ready to move on again with a pattern that is similar to the opening passage: a movement from A to C and then downward through the tonal center, as in the opening four bars. Bar 13 is structurally repetitious of bar 5, moving from D downward, establishing firmly the tonal center F in the last note of bar 13 and the first four tones of bar 14. Again, the melody continues downward to C, but when it returns in measures 15 and 16 to the tonal center F, we have a sense of almost total stability. It is as if the melody has taken us on a metaphoric journey: showing us at the beginning where "home" is; the limits of our movement away from home; and then the pleasure and security of returning to home.

The tonal center F is home, and when the lyrics actually join the word "home" in bar 4 with the tone C, we are a bit unsettled. This is a moment of instability. We do not become settled until bar 8, and then again in bar 16, where the word "home" falls on the tonal center F, which we have already understood—simply by listening—as the real home of the composition. This composition is very simple, but also subtle, using the resources of tonality to excite our anticipations for instability and stability.

MUSICAL STRUCTURES

The most familiar musical structures are based on repetition—especially repetition of melody, harmony, rhythm, and dynamics. Even the refusal to repeat any of these may be effective mainly because the listener usually anticipates repetition. Repetition in music is of particular importance because of the serial nature of the medium. The ear cannot retain sound patterns for very long, and thus it needs repetition to help hear the musical relationships.

Theme and Variations

A theme and variations on that theme constitute a favorite structure for composers, especially since the seventeenth century. We are usually presented with a clear statement of the theme that is to be varied. The theme is sometimes repeated so that we have a full understanding, and then modifications of the theme follow. "A" being the original theme, the structure unfolds as A^1-A^2-A^3-A^4-A^5 . . . and so on to the end of the variations. Some marvelous examples of structures built on this principle are Bach's *Art of Fugue,* Beethoven's *Diabelli Variations,* Brahms's *Variations on a Theme by Joseph Haydn,* and Elgar's *Enigma Variations*.

If the theme is not carefully perceived when it is originally stated, the listener will have little chance of hearing how the variations relate to the theme. Furthermore, unless one knows the structure is theme and variations, much of the delight of the variations will be lost. Theme and variations is a structure that many arts can employ, especially the dance.

Rondo

The first section or refrain of a **rondo** will include a melody and perhaps a development of that melody. Then, after a contrasting section or episode

with a different melody, the refrain is repeated. Occasionally, early episodes are also repeated, but usually not so often as the refrain. The structure of the rondo is sometimes in the pattern A-B-A-C-A—either B or D—and so on, ending with the refrain A. Some rondos end on an episode instead of a refrain, although this is unusual. The rondo may be slow, as in Mozart's *Hafner Serenade,* or it may be played with blazing speed, as in Weber's *Rondo Brillante.* The rondo may suggest a question-answer pattern, as in the children's song "Where Is Thumbkin?" Sometimes the A-B organization is reversed, so that the refrain comes second each time. The first and third movements of Vivaldi's *Four Seasons,* Haydn's *Gypsy Rondo,* Pachelbel's *Dance Rondo,* and the second movement of Beethoven's Symphony no. 4 are all fine examples of the rondo.

Fugue

The *fugue,* a specialized structure of counterpoint, was developed in the seventeenth and eighteenth centuries and is closely connected with Bach and his *Art of Fugue.* Most fugues feature a melody—called the "statement"—which is set forth clearly at the beginning of the composition, usually with the first note the tonic of its key. Thus if the fugue is in C major, the first note of the statement is likely to be C. Then that same melody more or less—called the "answer"—appears again, usually beginning with the dominant note (the fifth note) of that same key. The melodic lines of the statements and answers rise to command our attention and then submerge into the background as episodes of somewhat contrasting material intervene. Study the diagram in Figure 9-5 as a suggestion of how the statement, answer, and episode at the beginning of a fugue might interact. As the diagram indicates, the melodic lines often overlap, as in the popular song "Row, Row, Row Your Boat."

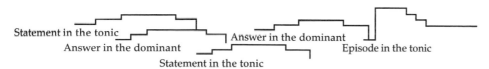

Statement in the tonic
Answer in the dominant
Statement in the tonic
Answer in the dominant
Episode in the tonic

FIGURE 9-5
The fugue.

The fugue, like theme and variations, is a repetitive structure, for the statements, answers, and episodes generally are very similar to one another. Sometimes they share the same pattern of ascending or descending tones. Often they have similar rhythms. In some cases, the answer appears like a mirror image of the statement, or sometimes the answer may be an upside-down image of the statement. Sometimes the statements and answers are jammed together in the stretto (narrow passage), a device usually used near the conclusion of the fugue. Sometimes fugues exist not as independent compositions but as part of a larger composition. Many symphonies, for example, have fugal passages as a means of development. Sometimes those fugal passages become the basis for independent fugues. Thus Beethoven's *Grosse Fuge* in B♭ was originally composed as a section within a string quartet.

Sonata Form

The eighteenth century brought the **sonata form** to full development, and many contemporary composers still find it very useful. Its overall structure basically is A-B-A, with these letters representing the main parts of the composition and not just melodies. The first A is the exposition, with a statement of the main theme in the tonic key of the composition and usually a secondary theme or themes in the dominant key (the key of G, for example, if the tonic key is C). A theme is a melody that is not merely repeated, as it usually is in the rondo, but is instead developed in an important way. In the A section, the themes are usually restated but not developed very far. This full development of the themes occurs in the B, or development, section, with the themes normally played in closely related keys. The development section explores contrasting dynamics, timbres, tempos, rhythms, and harmonic possibilities inherent in the material of the exposition. In the third section, or recapitulation, the basic material of the first section, or exposition, is more or less repeated, usually in the tonic key. After the contrasts of the development section, this repetition in the home key has the quality of return and closure.

The sonata form is ideal for revealing the resources of melodic material. For instance, when contrasted with a very different second theme, the principal theme of the exposition may take on a surprisingly new quality, as in the opening movement of Beethoven's *Eroica*. We sense that we did not fully grasp the principal theme the first time. This is one of the major sources of satisfaction for the careful listener. Statement, contrasting development, and restatement is a useful pattern for exploring the resources of almost any basic musical material, especially the melodic.

The symphony is usually a four-movement structure often employing the sonata form for its opening and closing movements. The middle movement or movements normally are contrasted with the first and last movements in dynamics, tempos, timbres, harmonies, and melodies. The listener's ability to perceive how the sonata form functions within most symphonies is essential if the total structure of the symphony is to be comprehended.

PERCEPTION KEY Sonata Form

1. Listen to and then examine closely the first movement of a symphony by Haydn or Mozart. That movement with few exceptions will be a sonata form. If a score is available, it can be helpful. (You do not have to be a musician to read a score.) Identify the exposition section—which will come first—and the beginning of the development section. Then identify the end of the development and the beginning of the recapitulation section. At these points, you should perceive some change in dynamics, tempo, and movements from home key or tonic to contrasting keys and back to the tonic. You need not know the names of those keys in order to be aware of the changes. They are usually easily perceptible.

2. Once you have developed the capacity to identify these sections, describe the characteristics that make each of them different. Note the different characteristics of melody, harmony, timbre, dynamics, rhythm, tempo, and contrapuntal usages.

3. When you have confidence in your ability to perceive the sonata form, do some comparative studies. Take the first movement of a Haydn symphony—Symphony no. 104 in D major, the *London*, for example—and compare its first movement with any of the first movements of Brahms's four symphonies. All these movements are sonata forms, but notice how differently they are structured and how much more difficult it is to know where you are with the Brahms. The sonata form allows for great variability. For example, most of Haydn's early symphonies, up to around Symphony no. 70, are monothematic; that is, only one theme appears in the exposition. Mozart's, Beethoven's, and Brahms's sonata forms, on the other hand, are very rarely monothematic.

Fantasia

Romantic composers, especially in the period from 1830 to 1900, began working with structures much looser than those of earlier periods. We find compositions with terms such as "rhapsodies," "nocturnes," "aubades," and "fantasias." The names are impressionistic and vague, suggesting perhaps that their subject matter may be moods. The **fantasia** may be the most helpful of these to examine, since it is to the sonata form what free verse is to the sonnet. The word "fantasia" implies fancy or imagination, which suggests, in turn, the fanciful and the unexpected. It is not a stable structure, and its sections cannot be described in such conventional terms as A-B-A. The fantasia usually offers some stability by means of a recognizable melody of a singable quality, but then it often shifts to material that is less identifiable, tonally certain, and harmonically secure. The succession of motives (brief musical units) is presented without regard for predetermined order. However, there are controls in terms of pacing, the relationship of motives, the harmonic coloring, dynamics, and rhythms. Sometimes the fantasia will explore a wide range of feelings by contrasting fast and slow, loud and soft, rich and spare harmonies, and singable melodies with those less singable.

Many of Robert Schumann's best works are piano pieces he called fantasias. Mozart's Fantasia in C minor is an excellent example of the mode, but probably most of us are more familiar with Moussorgsky's fantasia *A Night on Bald Mountain*, which was used in Walt Disney's *Fantasia*, a 1940 film.

Symphony

The symphony marks one of the highest developments in the history of Western instrumental music (Figure 9-6). The symphony has proved to be so flexible a structure that it has flourished in every musical era since the Baroque period in the early eighteenth century, especially with the works of Handel and C. P. E. Bach. The word "symphony" implies a "sounding together." From its beginnings, through its full and marvelous development in the works of Haydn, Mozart, Beethoven, and Brahms, the symphony was particularly noted for its development of harmonic structures. Harmony is

FIGURE 9-6
The BBC Symphony Orchestra.

the sounding together of tones that have an established relationship to one another. Because of its complexity, harmony is a subject most composers must study in great depth during their apprentice years.

The symphony as it existed in the Baroque period of the late seventeenth and early eighteenth centuries, the Classical period of the late eighteenth and early nineteenth centuries, and the Romantic period of the nineteenth and early twentieth centuries has undergone great changes. Many of these can be traced to developing concepts of harmony, most of which are extremely complex and not fully intelligible without considerable analysis. Triadic harmony (which means the sounding of three tones of a specific chord, such as the basic chord of the key C major, C-E-G, or the basic chord of the key F major, F-A-C) is common to most symphonies, especially before the twentieth century. Even in classical symphonies, however, such as Mozart's, the satisfaction that the listener has in triadic harmony is often withheld by the composer in order to develop musical ideas that will resolve their tensions only in a full, resounding chordal sequence of triads.

The symphony usually depends on thematic development. All the structures that we have discussed—theme and variations, rondo, fugue, and sonata form—develop melodic material, and some or all of them are often included in the symphony. Because it is a much larger structure with usually three or four movements, the symphony lends itself to expansive developments of musical material. In general, as the symphony evolved into its conventional structure in the time of Haydn and Mozart, the four movements were ordered as follows: first movement, sonata form; second movement, A-B-A or rondo; third movement, minuet; fourth movement, sonata form or rondo. There were exceptions to this order even in Haydn's and Mozart's symphonies, and in the Romantic and following periods the exceptions increased as the concern for conventions decreased.

The relationships between the movements of a symphony are flexible. On the one hand, the same melodic or key or harmonic or rhythmic approach may not prevail in all the movements. The sequence of movements may then seem arbitrary. On the other hand, some symphonies develop similar material through all movements, and then the sequence may seem less, if at all, arbitrary. This commonality of material is relatively unusual because its use for three or four movements can rapidly exhaust all but the most sustaining and profound material. One's ear can get tired of listening to the same material for an extended time. The preferred method, until the twentieth century, was to follow the conventional patterns of tempo throughout, using appropriate melodies and harmonies in each movement, which is to say material best suited for fast or slow tempos.

A comparison of the tempo markings of several symphonies by important composers usually shows several similarities: fast opening and closing movements with at least one slower middle movement. One of the most important connecting devices holding the movements of a symphony together is the convention of altering the tempo in patterns similar to those listed below. An alteration of tempo can express a profound change in the feeling of a movement. The predictable alteration of tempo is one of the things our ears depend upon for finding our way through the whole symphony. In such large structures, we need all the signposts we can get, since it is easy to lose one's way through a piece that may last an hour or more. The following tempo markings are translated loosely:

Haydn, Symphony in G major, no. 94, the *Surprise*
1. *Adagio, vivace* (slowly, lively)
2. *Andante* (moderately slow)
3. *Allegretto* (dancelike)
4. *Allegro molto* (very fast)

Mozart, Symphony in C major, no. 41, the *Jupiter*
1. *Allegro vivace* (fast and lively)
2. *Andante cantabile* (slow and songlike)
3. *Allegretto* (dancelike)
4. *Allegro molto* (very fast)

Beethoven, Symphony in C minor, no. 5
1. *Allegro con brio* (fast, breezy)
2. *Andante con moto* (slowly with motion)
3. *Allegro, scherzo* (fast, with dance rhythm)
4. *Allegro, presto* (fast, very quick)

Brahms, Symphony in E minor, no. 4
1. *Allegro non assai* (fast, but not very)
2. *Andante moderato* (moderately slow)
3. *Presto giocoso* (fast and jolly)
4. *Allegro energetico e patetico* (fast, with energy and feeling)

The tempo markings, such as *andante* and *allegro,* in these and other symphonies, including those of modern composers, such as Charles Ives and Igor Stravinsky, suggest that each movement is designed with other movements in mind. That is, each movement offers a contrast to those that come before or after it. Composers of symphonies have many means besides tempo at their disposal by which to achieve contrast, especially rhythm. The first movement is often written in 4/4 time, which means that there are four quarter notes in each measure, with the first especially and the third usually getting accents. The rhythms of the second movement are so varied that no general pattern is discernible. The third movement, especially in the early period of the symphony (Haydn and Mozart) usually is a dancelike minuet—3/4 time, three quarter notes to a measure, with the first note receiving the accent. Occasionally in the second and third movements, march time is used, either 6/8 time or 2/4 time. In 6/8 time, there are six eighth notes to a measure, with the first and fourth receiving the accent. In 2/4 time, the first of the two quarter notes receives the accent. Sometimes this produces the "oom-pah" sound we associate with marching bands. The fourth movement, usually a sonata form or a rondo, normally returns to 4/4 time.

Contrast is also achieved by varying the dynamics, with opposing loud and soft passages likely to be found in any movement. We might expect the middle movements, which are normally shorter than the first and last, to use less dynamic shifting. We usually expect the last movement to build to a climax that is smashing and loud. Variations in the length of movements add to contrast. And since the symphony is usually played by a large orchestra, the composer has a variety of instrumental families to depend on for adding contrast of tone colors. A theme, for instance, can be introduced by the violins, passed on to the woodwinds, then passed on to the horns, only to return to the violins. Secondary themes can be introduced by flutes or piccolos so as to contrast with the primary themes developed by other families of instruments. A secondary theme is often very different in length, pitch, and rhythmic character from a primary theme, thus achieving further contrast. Sometimes a theme or a developmental passage is played by a single instrument in a solo passage and then with all the instruments in that family playing together. Once the theme has been introduced by a single instrument or a small group, it may be played

by the entire orchestra. These contrasts should hold our attention—for otherwise we miss much of what is going on—helping us to grasp the melodic material by showing us how it sounds in different timbres and ranges of pitch (higher in the flutes, lower in the cellos). The exceptional possibilities for achieving contrast in the symphony account, in part, for its sustaining success over the centuries.

We readily perceive contrasts in tempo, time signature, dynamics, and instrumentation, even if we are not trained and do not have access to the score of the composition. But there are subtler means of achieving contrast. For one thing, even within a specific movement, a composer will probably use a number of different keys. Usually they are closely related keys, such as C major followed by G major, or F major followed by C major. The dominant tone is the fifth tone, and one of the most convenient ways of moving from key to key is to follow the cycle of fifths, confident that each new key will clearly relate to the key that precedes it. Distant keys, A major to, say, D minor, can produce a sense of incoherence or uncertainty. Such motions between keys often are used to achieve this effect.

The average listener cannot always tell just by listening that a passage is in a new key, although practiced musicians can tell immediately. The exploration of keys and their relationships is one of the more interesting aspects of the development portions of most symphonies. The very concept of development, which means the exploration of a given material, is sometimes best realized by playing the same or similar material in different keys, finding new relationships among them. Our awareness of an especially moving passage is often due to the subtle manipulation of keys that analysis with a score might help us better understand. For the moment, however, let us concentrate on what the average listener can detect in the symphony.

PERCEPTION KEY The Symphony

Listen to a symphony by Haydn or Mozart (they established the form). Then analyze as you listen intermittently, jotting down notes on each movement with the following questions in mind:

1. Is the tempo fast, medium, or slow? Is it the same throughout? How much contrast is there in tempo within the movement? Between movements?
2. Can you hear the differences in time signatures—such as the difference between waltz time and marching time?
3. How much difference in dynamics is there in a given movement? From one movement to the next? Are some movements more uniform in loudness than others?
4. Identify melodic material as treated by single instruments, groups of instruments, or the entire orchestra.
5. Are you aware of the melodic material establishing a tonal center, moving away from it, then returning? (Perhaps only practiced listeners will be able to answer this in the affirmative.)
6. As a movement is coming to an end, is your expectation of the finale carefully prepared for by the composer? Is the finale sensed as surprising or inevitable?

BEETHOVEN'S SYMPHONY IN E♭ MAJOR, NO. 3, *EROICA*

Beethoven's "heroic" symphony is universally acclaimed by musicians and critics as a symphonic masterpiece. It has some of the most daring innovations for its time, and it succeeds in powerfully unifying its movements by developing similar material throughout, especially the melodic and the rhythmic. The symphony was finished in 1804 and was intended to celebrate the greatness of Napoleon, whom Beethoven regarded as a champion of democracy and the common man. But when Napoleon declared himself emperor in May 1804, Beethoven, his faith in Napoleon betrayed, was close to destroying the manuscript. However, the surviving manuscript indicates that he simply tore off the dedication page and substituted the general title *Eroica*.

The four movements of the symphony follow the tempo markings we would expect of a classical symphony, but there are a number of important ways in which the *Eroica* is unique in the history of musical structures. The first movement, marked *allegro con brio* (fast, breezy), is a sonata form with the main theme of the exposition based on a triadic chord in the key of E♭ major that resoundingly opens the movement. The development section introduces a number of related keys, and the recapitulation ultimately returns to the home key of E♭ major. There is a **coda** (a section added to the end of the recapitulation) so extended that it is something of a second development section as well as a conclusion. After avoidance of the home key in the development, the E♭ major finally dominates in the recapitulation and the coda. The movement is at least twice as long as the usual first movements of earlier symphonies, and no composer before had used the coda in such a developmental way. Previously, the coda was quite short and repetitive. The size of the movement, along with the tight fusion of themes and their harmonic development into such a large structure, were very influential on later composers. The feelings that are evoked and revealed are profound and enigmatic.

The slow second movement is dominated by a funeral march in 2/4 time, with a very plaintive melody and a painfully slow tempo (in some performances), and an extremely tragic mood prevails. In contrast with the dramatic and vivid first movement, the second movement is sobering, diminishing the reaches of power explored in such depth in the first movement. The second movement uses a fugue in one of its later sections, even though the tempo of the passage is so slow as to seem to "stretch time." Despite its exceptional slowness, the fugue, with its competing voices and constant, roiling motion, seems appropriate for suggesting heroic, warlike feelings. The structure is a rondo: A-B-A'-C-A"-B'-D-A-‴, A being the theme of the funeral march, the following A's being variations. The other material, including the fugue in C, offers some contrast, but because of its close similarity to the march theme, it offers no resolution.

The relief comes in the third movement, marked **scherzo,** which is both lively (*scherzo* means "joke") and dancelike. The movement is derivative from the first movement, closely linking the two in an unprecedented way. The time signature is the same as a minuet, 3/4, and the melodic material is built on the same triadic chord as in the first movement. And there is the

same rapid distribution from one group of instruments to another. However, the third movement is much briefer than the first, while only a little briefer than the last.

The finale is marked *allegro molto* (very fast). A theme and variation movement, it is a catchall. It includes two short fugues, a dance using a melody similar to the main theme of the first movement, which is not introduced until after a rather decorative opening, and a brief march. Fast and slow passages are contrasted in such a fashion as to give us a sense of a recapitulation of the entire symphony. The movement brings us triumphantly to a conclusion that is profoundly stable. At this point, we can most fully appreciate the powerful potentialities of the apparently simple chord-based theme of the first movement. Every tonal pattern that follows is ultimately derivative, whether by approximation or by contrast, and at the end of the symphony the last triumphal chords are characterized by total inevitability and closure. The feelings evoked and revealed defy description, although there surely is a progression from yearning to sorrow to joy to triumph.

The following analysis will be of limited value without your listening carefully to the symphony more than once. If possible, use a score, even if you have no musical training. Ear and eye can coordinate with practice.

Listening Key: The Symphony

BEETHOVEN, SYMPHONY NO. 3, OPUS 55, *EROICA*
Performed by George Szell and the Cleveland Orchestra.

Listen to the symphony using the timings of this recording. Before reading the following discussion, listen to the symphony. Then, study the analysis and listen again, this time participatively. Your enjoyment will likely be much greater.

Movement I: *Allegro Con Brio.* **Fast, Breezy.**
Sonata form, 3/4 time, E♭ major: Timing: 14:46; Track 1.

Violino I

FIGURE 9-7
Opening chords in E♭ major (0:01).

The first two chords are powerful, staccato, isolated, and compressed (Figure 9-7). They are one of the basic chords of the home key of E♭ major: G-E♭-B♭-G. Then at the third measure (Figure 9-8), the main theme, generated from the opening chord of the symphony, is introduced. Because it is stated in the cellos, it is low in pitch and somewhat portentous, although not threatening. Its statement is not quite complete, for it unexpectedly ends on a C♯ (♯ is the sign for sharp). The horns and clarinets take the theme

at bar 15 (0:19), only to surrender it at bar 20 (0:23) to a group of ascending tones closely related to the main theme.

The second theme is in profound contrast to the first. It is a very brief and incomplete pattern (and thus could also be described as a motive) of three descending tones moved from one instrument to another in the woodwinds, beginning with the oboes at bar 45 (Figure 9-9). This theme is unstable, like

a gesture that needs something to complete its meaning. And the following motive of dotted eighth notes at bars 60 through 64 played by flutes and bassoons (Figure 9-10) is also unstable.

This is followed by a rugged rhythmic passage, primarily audible in the violins, preparing us for a further incomplete thematic statement at bar 83, a very tentative, delicate interlude. The violin passage that preceded it (Figure 9-11) functions here and elsewhere as a link in the movement between differing material. Getting this passage firmly in your memory will help you follow the score, for it returns dependably.

Many passages have unsettling fragments, such as the dark, brooding quality of the cello and contrabass motive shown in Figure 9-12, which sounds as a kind of warning, as if it were preparing us for something like the funeral march of the second movement. It repeats much later in variation at bar 498, acting again as an unsettling passage. Many other passages also appear to be developing into a finished statement, only to trail off. Some commentators have described these passages as digressions, but this is misleading, because they direct us to what is coming.

FIGURE 9-12
Cello and contrabass
motive (1:57).

The exposition starts to end at bar 148 (3:03), with a long passage in B♭, the measures from 148 to 152 hinting at the opening theme, but they actually prepare us for a dying-down action that joins with the development. In George Szell's rendition, as in most recordings, the repeat sign at 156 is ignored. Instead, the second ending (bars 152 to 159) is played, and this passage tends to stretch and slow down, only to pick up when the second theme is played again in descending patterns from the flutes through all the woodwinds (3:16).

The development section is colossal, from bars 156 to 394, beginning at 3:18. The main theme reoccurs first at 178 (3:48) in shifting keys in the cellos, then is played again in B♭ from 186 to 194 (3:55), very slow and drawn out. Contrasting passages mix in so strongly that we must be especially alert or we will fail to hear the main theme. The momentum speeds up around bar 200 (4:16), where the main theme is again played in an extended form in the cellos and the contrabasses. The fragmented motives contribute to a sense of incompleteness, and we do not have the fullness of the main theme to hold on to. The fragmentary character of the second theme is also emphasized, especially between bars 220 and 230 (4:39). When we reach the crashing discords at bar 275 (5:44), the following quieting down is a welcome relief. The subsequent passage is very peaceful and almost without direction until we hear again the main theme in B♭ at bar 300 (6:21), then again at 312 (6:37) in the cellos and contrabasses. The music builds in loudness, quiets down, and then the main theme is stated clearly in the bassoons, preparing for an extended passage that includes the main theme in the woodwinds building to a mild climax in the strings at bar 369 (Figure 9-13).

FIGURE 9-13
Strings at bar 369 (7:53).

The remainder of this passage is marvelously mysterious, with the strings maintaining a steady tremolo and the dynamics brought down almost to a whisper. The horn enters in bar 394 (8:24), playing the main theme in virtually a solo passage. Bars 394 and 395 are two of the most significant measures of the movement because of the way in which they boldly announce the beginning of the recapitulation. The horns pick up the main theme again at bar 408 (8:32), loud and clear, and begin the restatement of the exposition section. The recapitulation begins at bar 394 (8:24) and extends to bar 575 (12:05). It includes a brief development passage, treating the main theme in several unusual ways, such as the tremolo statement in the violins at bars 559 to 565 (Figure 9-14).

FIGURE 9-14
Violins at bars 559 to 565
(11:50).

267

The long, slow, quiet passages after bar 575 (12:05) prepare us for the incredible rush of power that is the coda—the "tail" or final section of the movement. The triumphal quality of the coda—which includes extended development, especially of the main theme—is most perceptible, perhaps, in the juxtaposition of a delightful running violin passage from bar 631 to bar 639 (13:31), with the main theme and a minimal variation played in the horns. It is as if Beethoven is telling us that he has perceived the musical problems that existed with his material, mastered them, and now is celebrating with a bit of simple, passionate, and joyous music.

PERCEPTION KEY Movement I of the *Eroica*

1. Describe the main theme and the second theme. What are their principal qualities of length, "tunefulness," range of pitch, rhythm, and completeness? Could either be accurately described as a melody? Which is easier to whistle or hum? Why could the second theme be plausibly described as a motive? Do the two themes contrast with each other in such a way that the musical quality of each is enhanced? If so, how?
2. What are the effects of hearing the main theme played in different keys, as in bars 3 to 7 (0:04), bars 184 to 194 (3:55), and bars 198 to 206 (4:16)? All these passages present the theme in the cellos and contrabasses. What are the effects of the appearance of the theme in other instrumental families, such as the bassoons at bar 338 (7:12) in the development section and the horns at bar 408 (8:32) in the recapitulation section? Does the second theme appear in a new family of instruments in the development section?
3. How clearly perceptible do you find the exposition, development, recapitulation, and coda sections? Can you describe, at least roughly, the feeling qualities of each of these sections?
4. Many symphonies lack a coda. Do you think Beethoven was right in adding a coda, especially such a long and involved one? If so, what does it add?
5. If possible, record the movement, but begin with the development section, then follow with the recapitulation, exposition, and coda sections. Does listening to this "reorganization" help clarify the function of each section? Does it offer a better understanding of the movement as it was originally structured? Does this "reorganization" produce significantly different feeling qualities in each section?

Before going on to the next Perception Key, give your ear a rest for a brief time. Then come back to the symphony and listen to it all the way through. Sit back and enjoy it. Then consider the following questions.

PERCEPTION KEY The *Eroica*

1. In what ways are the four movements tied together? Does a sense of relatedness develop for you?
2. Is the symphony properly named? What qualities do you perceive in it that seem "heroic"?
3. Comment on the use of dynamics throughout the whole work. Comment on variations in rhythms.

4. Is there a consistency in the thematic material used throughout the symphony? Are there any inconsistencies?
5. Do you find that fatigue affects your responses to the second movement or any other portion of the symphony? The act of creative listening can be very tiring. Could Beethoven have taken that into consideration?
6. Are you aware of a variety of feeling qualities in the music? Does there seem to be an overall plan to the changes in these qualities as the symphony unfolds?
7. What kind of feelings (emotion, passion, or mood) did the *Eroica* arouse in you? Did you make discoveries of your inner life of feeling because of your responses to the *Eroica*?

BLUES AND JAZZ: POPULAR AMERICAN MUSIC

So far, our emphasis is on classical music because its resources are virtually inexhaustible and its development, over many centuries and continuing today, has reached a pitch of refinement that matches that of painting, architecture, and literature. But other kinds of music in addition to opera, symphonies, and chamber music affect modern listeners. The blues, which developed in the African American communities in the southern United States, has given rise to a wide number of styles, among them jazz, which has become an international phenomenon, with players all over the world.

The term "blues" was used early to describe a form of music developed in the black communities in the South, and it seems to describe a range of feelings, although the blues was never a music implying depression or despair. Rather, it implied a soulful feeling as expressed in the blue notes of the scale and in the lyrics of the songs. The music that later developed from the blues is characterized by the enthusiasm of its audiences and the intense emotional involvement that it demands, especially in the great auditoriums and outdoor venues that mark the most memorable concerts seen by thousands of fans.

The blues evolved into a novel musical form by relying on a slightly different scale with blue notes: C E♭ F F♯ G B♭ C. Compare that with the standard C major scale: C D E F G A B C. The standard C scale has no sharps or flats, so the blues scale has a totally different feel. If you can play these scales, you will hear how different they are. The structure of the blues is twelve measures with a constant pattern of chord progressions that is then repeated for another twelve measures. Out of this original pattern, jazz developed in the early years of the twentieth century.

Jazz began in New Orleans around the turn of the twentieth century with the almost mythic figures of Buddy Bolden, the great trumpet player in Lincoln Park in the first years of 1900, and Jelly Roll Morton, who claimed to have single-handedly invented jazz. King Oliver's band in New Orleans was enormously influential, and when New Orleans was "cleaned up" by the U. S. Navy in 1917—drugs and prostitution were forced out of town—jazz moved up the Mississippi River to Chicago, where Louis Armstrong's powerful trumpet dominated jazz for more than a dozen

FIGURE 9-15
Louis Armstrong and the Hot Five, the dynamic mid-1920s band that made some legendary recordings in 1927–1929.

Armstrong is seated at the piano, although his wife, Lil Hardin, at the right, was the pianist. Johnny St. Cyr played banjo, Johnny Dodds clarinet, and Kid Ory played trombone.

years (Figure 9-15). The large, primarily white society bands, such as Paul Whiteman's Orchestra, introduced jazz to large radio audiences by employing great jazz stars such as Bix Beiderbecke, Jimmy and Tommy Dorsey, Hoagy Carmichael, and Jack Teagarden. Fortunately, all these orchestras recorded widely in the 1920s, and their music can be heard online at any of a number of sources.

The hot jazz of the time is marked by an extensive use of the blues scale, a powerful rhythm emphasizing the second and fourth beat of each measure, and a delight in counterpoint ensemble playing and dynamic solos that show off the talent of virtuoso players. The rhythm section was usually drums, piano, and guitar or bass. The horns, trumpet, clarinet, and trombone played most of the melodic material, supplying complex harmonic support while individuals were soloing. In general, all the players would begin with a rehearsed "head," including the primary tune that was being performed, and then they would improvise their solos and their support of the melodic lines. The daring improvisation of the musicians created an atmosphere of excitement and anticipation of something special at every performance.

Larger orchestras, such as Whiteman's and the swing bands of Benny Goodman, Count Basie, Jimmy Lunceford, and Duke Ellington, had to rely less on improvisation and counterpoint and more on ensemble playing. Their music was smoother, more harmonically secure, and less exciting except when a soloist stood for his improvised twelve or twenty-four measures. But even in the big bands, the emphasis on the weak beats (the

FIGURE 9-16
Miles Davis led a fusion group
in the late 1980s that brought
jazz to a younger audience.
His trumpet playing set the
standard in modern jazz for
three decades, and *The Quintet*
still stands as the best of jazz
throughout the 1960s.

second and fourth of each measure) and the use of syncopation and the
anticipation of the beats helped keep a sense of power and movement in the
music, even though it may have been played more or less the same way in
concert after concert. Big band music was originally designed for dancing,
and the best of the jazz groups kept to that concept.

Miles Davis has been compared with Picasso because of his various
stylistic periods, from the early bop of the late 1940s to the cool jazz of
the 1950s and 1960s and then the rock-fusion jazz of the *Bitches Brew*
album in 1970 that introduced electronic instruments (Figure 9-16). The
groups he formed were all crucial to innovations in jazz that other play-
ers followed. His early nonet introduced classical instruments, such as
the French horn, and his two great quintets are still regarded as akin to
classical chamber music. Charlie Parker, John Coltrane, Herbie Hancock,
Ron Carter, Bill Evans, Lee Konitz, Chick Corea, and many more giants of
jazz were among the members of Davis's groups, including the late sextet.
Sketches of Spain, 1960, arranged by his friend Gil Evans, is an example
of Davis's use of folk melodies to produce a classical jazz album.

Contemporary jazz musicians, such as Wynton Marsalis, Diana Krall,
Cyrus Chesnut, Marian McPartland, Geri Allen, Keith Jarrett, Joshua Red-
man, Christian McBride, Wayne Shorter, and Dave Brubeck, are all in the
tradition of the great improvisational players early in the twentieth century.
The essence of jazz is improvisation and, to an extent, competition. The
early jazz bands often competed with one another in "cutting contests" to
see which band was better. Players of the same instruments, such as the
saxophone, have sometimes performed onstage in intense competition to
help raise the excitement level of the music.

BLUES AND ROCK AND ROLL

Rock and roll has its roots in R&B—rhythm and blues—popular in the 1940s in the United States primarily among black radio audiences. Joe Turner, an early R&B man, composed "Shake, Rattle, and Roll," but it did not become a hit until Bill Haley recorded it in 1955. Louis Jordan's Tympany Five, Bo Diddley, and Muddy Waters were some of the major predecessors of rock and roll, and Ike Turner may have had the first true rock-and-roll record in 1951. However, the wide acceptance of rock and roll began only after white groups and singers began to adopt the black style. Elvis Presley was the first rock-and-roll star, with hit records beginning in the mid-1950s. Bill Haley's Comets, originally a country-western band, adopted the new style in "Rock Around the Clock," the first rock tune to be used in the popular 1955 film, *Blackboard Jungle,* in which rioting students destroy a high school teacher's collection of jazz records—obviously symbolic of a period of musical revolution.

Rock music and jazz are essentially countercultural art forms with codes for sexual behavior, and they usually went unobserved by general audiences. Rock groups were aided by the invention of the electric guitar in 1931. Les Paul popularized the Gibson solid-body electric guitar, and by the 1960s almost all rock-and-roll music was amplified, which made possible the great concerts of Led Zeppelin, the Who, Cream, Steve Miller Band, the Beatles, the Grateful Dead, and the Rolling Stones, all of whom began to tour internationally. The Beatles, a small group, was especially political during the 1960s and 1970s when they condemned the Vietnam war and popularized Indian mysticism (Figure 9-17). Some of these groups still appear, and all can be heard on the Internet and seen on YouTube and other sharing sites.

One of the most enduring of the classic age of rock groups is the Rolling Stones, whose tune, "(I Can't Get No) Satisfaction," 1965, is still a hit when performed by Mick Jagger and Keith Richards (Figure 9-18). Their band began in 1962, endures today, and is widely available on many recordings, both aural and visual, and is popular on Internet sharing sites. The Rolling Stones presented concerts marked by wild gyrations of Mick Jagger, running from one side of the stage to the other, jumping, hollering, and revving up the audience in any way he could, while the cool and cerebral Keith Richards stayed behind playing complex riffs inspiring the band. Both Jagger and Richards wrote most of their hits, and, unlike jazz groups, the Rolling Stones helped establish the pattern of great rock bands writing their own material rather than "covering" other people's music.

Styles in popular music evolve almost seamlessly from earlier styles and only become apparent as a distinct form of music when a major figure has a hit that catches the attention of a wide audience. Hip-hop and rap music have their roots in gospel, shout, and blues, just as do jazz and rock and roll. The use of amplified instruments, simple chord patterns—often the use of no more than three chords—and a heavy back beat (great stress on beats two and four) throughout a composition mark most of rock and later music. The lyrics are often personal, political, and usually countercultural—aimed at a youthful audience that sees itself as naturally rebellious.

FIGURE 9-17
The Beatles—George Harrison, Paul McCartney, Ringo Starr, and John Lennon—preparing for their 1969 *Abbey Road* recording date.

The Beatles, a British import, were often experimental in their music, producing a lyrical songbook that still is currently played throughout the world.

FIGURE 9-18
Mick Jagger and Keith Richards of the Rolling Stones in concert.

Mick Jagger and Keith Richards joined Ian Stewart and the original leader Brian Jones in 1962 with the Rolling Stones, adding the drummer Charlie Watts and bassist Bill Wyman. This band was part of the "British Invasion" that solidified the international credentials of rock and roll.

Today, popular music includes most styles derived from blues, and most of it is strictly commercial, designed to make money. But some of it derives from a serious artistic purpose that has little to do with making money. Serious lovers of popular music usually look for evidence of sincerity in the music they prefer. It is not always easy to detect. But all that aside, the elements of popular music are those of all music: tone, rhythm, tempo, consonance, dissonance, melody, counterpoint, harmony, dynamics, and contrast.

PERCEPTION KEY Popular Music

1. Choose a number of popular pieces, and identify their style (blues, jazz, punk, rock, rap, country, etc.). Decide whether this music seems to clarify a feeling state or states for you.
2. Select a piece of popular music that does not satisfy you. Listen to it several times and then explain what qualities the music has that you feel are insufficient for you to consider it a successful composition.
3. Listen to a composition by the Rolling Stones or another rock group that interests you. Comment on the band's respective use of rhythm, consonance and dissonance, melody, and harmony.
4. Select a popular composition and comment on its use of rhythm and tempo. Can you see connections with the use of rhythm and tempo in classical music?
5. Which of the elements of music is most imaginatively used in the popular composition that you currently listen to most?
6. Listen to George Gershwin's *Rhapsody in Blue.* It was written for piano and jazz band. Is Gershwin's composition classical in style, or is it jazz? What qualifies it as belonging to or not belonging to popular music?
7. Do you find structures in popular music like those of classical music—for example, theme and variations, rondos, fugues, sonatas, etc.? Which structure, if any, seems to dominate?
8. How closely related are popular music styles to those of classical music? How does understanding classical music help in appreciating popular music?

SUMMARY

We began this chapter by suggesting that feelings and sounds are the primary subject matters of music. This implies that the content of music is a revelation of feelings and sounds—that music gives us a more sensitive understanding of them. However, as we indicated in our opening statements, there is considerable disagreement about the subject matter of music, and, therefore, there is disagreement about the content of music. If music does reveal feelings and sounds, the way it does so is still one of the most baffling problems in the philosophy of art.

Even a brief survey of the theories about the content of music is beyond our scope here, but given the basic theory of art as revelation, as we have been presupposing in this book, a couple of examples of how that theory

might be applied to music are relevant. In the first place, some music apparently clarifies sounds as noises. For example, John Cage, at times, uses devices such as a brick crashing through glass. By putting such noises into a composition, Cage brackets out the everyday situation and helps us listen "to" rather than listen "through" such noises. In this way, he clarifies those noises. His musical form organizes sounds and sometimes silences before and after the noise of the breaking glass in such a way that our perception of the noise of breaking glass is made more sensitive. Similar analyses can be made of the sounds of musical instruments and their interrelationships in the structures in which they are placed.

Second, there seems to be some evidence that music gives us insight into our feelings. It is not ridiculous to claim, for example, that one is feeling joy like that of the last movement of Mozart's *Jupiter* Symphony, or sadness like the second movement—the funeral march—of Beethoven's *Eroica* Symphony. In fact, "joy" and "sadness" are general terms that only very crudely describe our feelings. We experience all kinds of different joys and different sadnesses, and the names language gives to these are often imprecise. Music, with its capacity to evoke feelings, and with a complexity of detail and structure that in many ways is greater than that of language, may be able to reveal or interpret feeling with much more precision than language. Perhaps the form of the last movement of the *Jupiter* Symphony—with its clear-cut rising melodies, bright harmonies and timbres, brisk strings, and rapid rhythms—is somehow analogous to the form of a certain kind of joy. Perhaps the last movement of the *Eroica* is somehow analogous to a different kind of joy. And if so, then perhaps we find revealed in those musical forms clarifications or insights about joy. Such explanations are highly speculative. However, they not only are theoretically interesting but also may intensify one's interest in music. There is mystery about music, unique among the arts; that is part of its fascination. In addition to classical music, modern popular styles such as blues, jazz, rock and roll, and rap all have capacity to evoke intense participation resulting from the use of standard musical elements such as rhythm, tone color, melody, and harmony. They produce feeling states that can be complex and subtle in proportion to the seriousness and commitment of the artists and composers.

Chapter 10

DANCE

Dance—moving bodies shaping space—shares common ground with kinetic sculpture. In abstract dance, the center of interest is upon visual patterns, and thus there is common ground with abstract painting. Dance, however, usually includes a narrative, performed on a stage with scenic effects, and thus has common ground with drama. Dance is rhythmic, unfolding in time, and thus has common ground with music. Most dance is accompanied by music, and dance is often incorporated in opera. According to Havelock Ellis: "Dancing is the loftiest, the most moving, the most beautiful of the arts, because it is no mere translation or abstraction from life; it is life itself."[1]

SUBJECT MATTER OF DANCE

At its most basic level, the subject matter of dance is abstract motion, but a much more pervasive subject matter of the dance is feeling. Our ability to identify with other human bodies is so strong that the perception of feelings exhibited by the dancer often evokes something of those feelings in ourselves. The choreographer, creator of the dance, interprets those feelings. And if we participate, we may understand those feelings and ourselves with greater insight. In Paul Sanasardo's *Pain*, for example, the portrayal of this feeling is so powerful that few in any audience can avoid some sense

[1]Havelock Ellis, *The Dance of Life* (Boston: Houghton Mifflin, 1923).

FIGURE 10-1
Judith Blackstone and Paul
Sanasardo in *Pain,* by the Paul
Sanasardo Dance Company.

One critic said, "Watching
the dance evokes an internal
screaming the way looking at
pictures of . . . war victims does."

of pain. Yet the interpretation of pain by means of the dancing bodies gives
us an objective correlative, a shaping "out there" that makes it possible for
us to understand something about pain rather than simply undergoing it.
Figure 10-1 shows Sanasardo's depiction of pain, but only with the moving
dance can its interpretation occur.

 States of mind are a further dimension that may be the subject matter of
dance. Feelings, such as pleasure and pain, are relatively transient, but states
of mind involve attitudes, tendencies that engender certain feelings on the
appropriate occasions. A state of mind is a disposition or habit that is not
easily superseded. For example, jealousy usually involves a feeling so strong
that it is best described as a passion. Yet jealousy is more than just a passion,
for it is an orientation of mind that is relatively enduring. Thus José Limón's
The Moor's Pavane explores the jealousy of Shakespeare's *Othello*. In Limón's
version, Iago and Othello dance around Desdemona and seem to be directly
vying for her affections. *The Moor's Pavane* represents an interpretation of the
states of mind Shakespeare dramatized, although it can stand independently
of the play and make its own contribution to our understanding of jealousy.

 Since states of mind are felt as enduring, the serial structure of the dance is
an appropriate vehicle for interpreting that endurance. The same can be said
of music, of course, and its serial structure, along with its rhythmic nature,
is the fundamental reason for the wedding of music with dance. Even si-
lence in some dances seems to suggest music, since the dancer exhibits visual
rhythms, something like the rhythms of music. But the showing of states of
mind is achieved only partly through the elements dance shares with music.
More basic is the body language of the dancing bodies. Perhaps nothing—not
even spoken language—exhibits states of mind more clearly or strongly.

EXPERIENCING Feeling and Dance

1. The claim that dance can interpret the inner life of feeling with exceptional power implies, perhaps, that no other art surpasses dance in this respect. Why would such a claim be made?

The fact that dance is usually considered the first art in the cultivation of culture among all civilizations may have something to do with the possibility that dance expresses and refines the emotional life of the dancer. Religious circle dances seem to be common in all

FIGURE 10-2
Social dance from Ingmar Bergman's film *The Seventh Seal.*

civilizations, just as spontaneous movement on the part of individuals in a social setting will, almost contagiously, attract participants who would otherwise just stand around. When one person starts dancing, usually a great many will follow suit.

Dances of celebration are associated with weddings around the world, often with precise movements and precise sections that seem to have an ancient pretext associated with fertility and the joy of love. Likewise, there are even some dances of death in certain cultures, such as the dance in Ingmar Bergman's film *The Seventh Seal,* which can be seen on the Internet (Figure 10-2).

Social dances not only interpret the inner life of feeling, but at times they can both produce an inner life of feeling in us, and also control that feeling. In ballroom dancing, for example, the prescribed movements are designed to channel our sense of our body's motion and thus to help constrain our feelings while we dance. Alternatively, rock and hip-hop dancing involve a high degree of improvisation and some of the movements will depend on the feeling-state of the dancer at the moment of the dance.

Other arts may equal dance in this respect, but most of us have had experiences in which we find ourselves dancing expressively with friends or even alone as a way of both producing and sustaining a feeling-state that we find desirable and occasionally overwhelming.

2. Compare dance and music in terms of their power to reveal the inner life of feeling.
3. Represent one of the following states of mind by bodily motion: love, jealousy, self-confidence, pride. Have others do the same. Do you find such representations difficult to perceive when others do them?
4. Try to move in such a way as to represent no state of mind at all. Is it possible? Discuss this with your group.
5. Representing or portraying a state of mind allows one to recognize that state. Interpreting a state of mind gives one insight into that state. In any of the experiments above, did you find any examples that went beyond representation and interpretation? If so, what made this possible? What does artistic form have to do with this?
6. Is it possible for you to recognize a state of mind such as jealousy being represented without having that state of mind being evoked in you? Is it possible for you not only to recognize but also to gain insight about a state of mind without that state of mind being evoked in you?

Narrative provides one obvious subject matter for many dances. Thus Robert Helpmann's ballet *Hamlet* uses Shakespeare's play as its subject matter. Viewers of the dance who know the play will see an interpretation of a drama, while others who do not know the play will see the interpretation of a tragic situation. In either case, feelings and states of mind relevant to the narrative are given vivid embodiment in the dancers' movements and gestures. Helpmann's *Hamlet* interprets the inner life of a tragic drama. Shakespeare's *Hamlet* provides the events that cause those reactions. In the dance, what is revealed is not so much why something happened but rather the inner-life reactions to the happening.

FORM

The subject matter of dance can be moving visual patterns, feelings, states of mind, narrative, or various combinations. The form of the dance—its details and structure—gives us insight into the subject matter. But in dance, the form is not as clearly perceptible as it usually is in painting, sculpture, and architecture. The visual arts normally "sit still" long enough for us to reexamine everything. But dance moves on relentlessly, like literature in recitation, drama, and music, preventing us from reexamining its details and organization. We can only hope to hold in memory a detail for comparison with an ensuing detail, and those details as they help create the structure.

Therefore, one prerequisite for thorough enjoyment of the dance is the development of a memory for dance movements. The dance will usually help us in this task by the use of repetitive movements and variations on them. It can do for us what we cannot do for ourselves: present once again details for our renewed consideration. Often the dance builds tension by withholding movements we want to have repeated. Sometimes it creates unusual tension by refusing to repeat any movement at all. Repetition or the lack of it—as in music or any serial art—becomes one of the most important structural features of the dance.

Most dance will make use of a number of basic compositional principles. Careful repetition of movements is often patterned on the repetition in the music to which the dancers perform. The musical structure of A-B-A is common to the dance: A melody is played (A), followed by a period of development (B), finally ending with a recapitulation of the melody (A). Movements performed at the beginning of a dance, the A section, are often developed, enlarged, and modified in the B section, and are repeated at the end of the dance during the second A section.

The dance, furthermore, achieves a number of kinds of balance. In terms of the entire stage, usually dancers in a company balance themselves across the space allotted to them, moving forward, backward, left, and right as well as in circles. Centrality of focus is important in most dances and helps us unify the shapes of the overall dance. The most important dancers are usually at the center of the stage, holding our attention while subordinate

groups of dancers balance them on the sides of the stage. Balance is also a structural consideration for both individual dancers (see Figure 10-5) and groups (see Figure 10-3).

The positions of the ballet dancer also imply basic movements for the dancer, movements that can be maneuvered, interwoven, set in counterpoint, and modified as the dance progresses. As we experience the dance, we can develop an eye for the ways in which these movements combine to create the dance. Modern dance develops a different vocabulary of dance, as one can see from the illustrations in Figures 10-1 and 10-7 through 10-13.

DANCE AND RITUAL

Since the only requirement for dance is a body in motion and since all cultures have this basic requirement, dance probably precedes all other arts. In this sense, dance comes first. And when it comes first, it is usually connected to a ritual that demands careful execution of movements in precise ways to achieve a precise goal. The dances of most cultures were originally connected with either religious or practical acts, both often involving magic. Early dance often religiously celebrates some tribal achievement. At other times, the dance is expected to have a specific practical effect. In this kind of dance— the Zuni rain dance, for instance—the movement is ritually ordered and expected to be practically effective as long as the dance is performed properly.

Some dance has sexual origins and often is a ritual of courtship. Since this phenomenon has a correlative in nature—the courtship dances of birds and many other animals—many cultures occasionally imitated animal dances. Certain movements in Mandan Indian dances, for instance, can be traced to the leaps and falls of western jays and mockingbirds who, in finding a place to rest, will stop, leap into the air while spreading their wings for balance, then fall suddenly, only to rise into the air again. Some modern dancers send their students to the zoo to observe leopards and other animals so that they can represent them onstage.

Dance of all kinds draws much of its inspiration from the movements and shapes of nature: the motion of a stalk of wheat in a gentle breeze, the scurrying of a rabbit, the curling of a contented cat, the soaring of a bird, the falling of leaves, the sway of waves. These kinds of events have supplied dancers with ideas and examples for their own movement. A favorite shape for the dance is that of the spiral nautilus, so often seen in shells, plants, and insects:

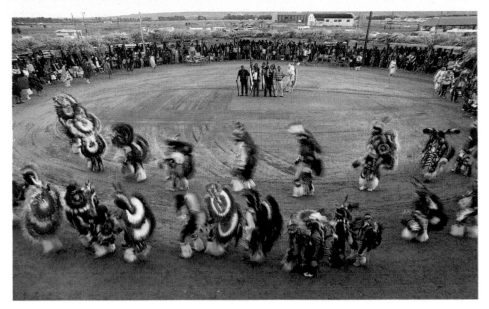

FIGURE 10-3
The ritual Sun Dance by Arapahoe and Shoshone dancers at the Windriver Reservation, Wyoming.

Performed every July, dancers pledge to the circle dance and perform for three days without eating as a way of committing themselves to the community in peace.

This shape is often apparent in the movement of groups of dancers whose floor pattern may follow the spiral pattern (Figure 10-3). The circle is another of the most pervasive shapes of nature. The movements of planets and stars suggest circular motion, and, more mundanely, so do the rings working out from a stone dropped in water. In a magical-religious way, circular dances sometimes have been thought to bring the dancers—and therefore humans in general—into a significant harmony with divine forces in the universe. The planets and stars are heavenly objects in circular motion, so it was reasonable for early dancers to feel that they could align themselves with these divine forces by means of dance.

Ritual Dance

Tourists can see rain dances in the American Southwest even today. The floor pattern of the dance is not circular but a modified spiral, as can be seen in Figure 10-3. The dancers, properly costumed, form a line and are led by a priest, who at specific moments spreads cornmeal on the ground, symbolizing his wish for the fertility of the ground. The ritual character of the dance is clearly observable in the pattern of motion, with dancers beginning by moving toward the north, then turning west, south, east, north, west, south, and ending toward the east. The gestures of the dancers, like the gestures in most rituals, have definite meanings and functions. For example, the dancers' loud screams are designed to awaken the gods and arrest their attention, the drumbeat suggests thunder, and the dancers' rattles suggest the sound of rain.

Social Dance

Social dance is not dominated by religious or practical purposes, although it may have secondary purposes such as meeting people or working off excess energy. More importantly, it is a form of recreation and social enjoyment. Country dance—for example, the English Playford dances—is a species of folk dance that has traces of ancient origins, because country people tended to perform dances in specific relationship to special periods in the agricultural year, such as planting and harvesting.

Folk dances are the dances of the people—whether ethnic or regional in origin—and they are often very carefully preserved, sometimes with contests designed to keep the dances alive. When they perform, the dancers often wear the peasant costumes of the region they represent. Virtually every nation has its folk dance tradition.

The Court Dance

The court dances of the Middle Ages and Renaissance developed into more stylized and less openly energetic modes than the folk dance, for the court dance was performed by a different sort of person and served a different purpose. Participating in court dances signified high social status. Some of the favorite older dances were the volta, a favorite at Queen Elizabeth's court in the sixteenth century, with the male dancer hoisting the female dancer in the air from time to time; the pavane, a stately dance popular in the seventeenth century; the minuet, popular in the eighteenth century, performed by groups of four dancers at a time; and the eighteenth-century German allemande—a dance performed by couples who held both hands, turning about one another without letting go. These dances and many others were favorites at courts primarily because they were enjoyable—not because they performed a religious or practical function. Because the dances were also pleasurable to look at, it very quickly became a commonplace at court to have a group of onlookers as large as or larger than the group of dancers. Soon professional dancers appeared at more significant court functions, such as the Elizabethan and Jacobean masques, which were mixed-media

entertainments in which the audience usually took some part—particularly in the dance sequences.

PERCEPTION KEY Social Dance

1. How would you evaluate rock dancing? Why does rock dancing demand loud music? Does the performing and watching of spontaneous and powerful muscular motions account for some of the popularity of rock dancing? If so, why? Why do you think the older generations generally dislike both rock music and rock dancing? Is rock dancing primarily a mode to be watched or danced? Or is it both? Explain what the viewer and the dancer, respectively, might derive from the experience of rock dancing. Substitute hip-hop for rock and answer the same questions.
2. Try to see an authentic folk dance. Describe the basic differences between folk dance and rock dance. Is the basic subject matter of the folk dance visual patterns, or feelings, or states of mind, or narrative? Or some combination of these? If so, what is the mix? Answer the same questions for rock dances and hip-hop.
3. Break and rock dancing for the young; square and ballroom dancing for the old. Why the divided generational appeal? Country dance seems to appeal to both young and old. Why?

BALLET

The origins of ballet usually are traced to the early seventeenth century, when dancers performed interludes between scenes of an opera. Eventually, the interludes grew more important, until finally ballets were performed independently. In the eighteenth century, the **en pointe** (on point) technique was developed, with female dancers elevated on their toes to emphasize airy, floating movements. This has remained a major technique to this day and is one of the important distinctions between ballet and modern dance, which avoids *en pointe* almost entirely.

Today there is a vocabulary of movements that all ballet dancers must learn, since these movements constitute the fundamental elements of every ballet. They are as important as the keys and scales in music, the vocabulary of tones constantly employed in most musical composition.

A considerable repertory of ballets has been built up in the last three centuries. Some of the ballets many of us are likely to see are Lully's *Giselle; Les Sylphides,* with music by Chopin; Tchaikovsky's *Nutcracker, Swan Lake,* and *Sleeping Beauty; Coppélia,* with music by Delibes; and *The Rite of Spring,* with music by Stravinsky. All these ballets—like most ballets—have a *pretext,* a narrative line or story around which the ballet is built (Figure 10-4). In this sense, the ballet has as its subject matter a story that is interpreted by means of stylized movements such as the **arabesque,** the bourrée, and the relévé, to name a few. Our understanding of the story is basically conditioned by our perception of the movements that present the story to us. It is astounding how, without having to be obvious and without having to resort very often to everyday gestures, ballet dancers can present a story to us in an intelligible fashion. Yet it is not the story or the movement that constitutes the ballet: It is the meld of story and movement.

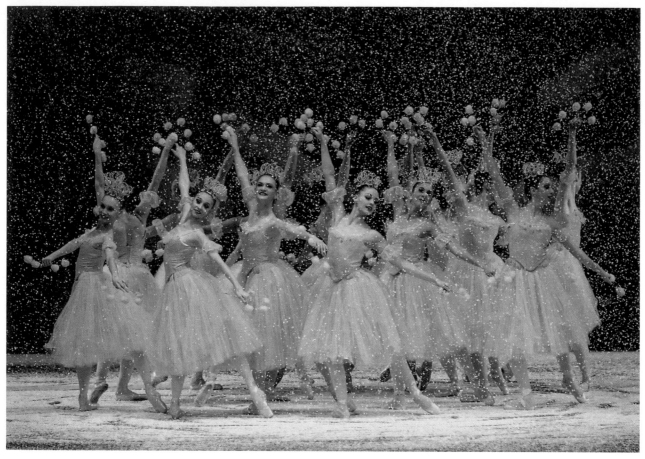

FIGURE 10-4
A scene from George Balanchine's *Nutcracker,* with music by Pyotr Ilych Tchaikovsky, based on E. T. A. Hoffmann's *The Nutcracker and the Mouse King.*

Here Clara has freed the Prince and journeyed with him to the world of the fairies as the Snowflakes gather in a blizzard in the last scene of Act I by the New York City Ballet in 2008.

PERCEPTION KEY Narrative and Bodily Movement

1. Without training, we cannot perform ballet movements, but all of us can perform some dance movements. By way of experiment and to increase our understanding of the meld of narrative and movement, try representing a narrative by bodily motion to a group of onlookers. Choose a narrative poem from our chapter on literature, or choose a scene from a play that may be familiar to you and your audience. Let your audience know the pretext you are using, since this is the normal method of most ballets. Avoid movements that rely exclusively on facial expressions or simple mime to communicate story elements. After your presentation, discuss with your audience their views about your success or failure in presenting the narrative. Discuss, too, your problems as a dancer, what you felt you wanted your movement to reveal about the narrative. Have others perform the experiment, and discuss the same points.
2. Even the most rudimentary movement attempting to reveal a narrative will bring in interpretations that go beyond the narrative alone. As a viewer, discuss what you believe the other dancers added to the narrative.

Swan Lake

One of the most popular ballets of all time is Tchaikovsky's *Swan Lake (Le Lac des Cygnes),* composed from 1871 to 1877 and first performed in 1894 (Act 2) and 1895 (complete). The choreographers were Leon Ivanov and Marius Petipa. Tchaikovsky originally composed the music for a ballet to be performed for children, but its fascination has not been restricted to young audiences. With Margot Fonteyn and Rudolf Nureyev, the reigning dancers in this ballet in modern times, *Swan Lake* has been a resounding favorite on television and film, not to mention repeated sellout performances in dance theaters the world over.

Act 1 opens with the principal male dancer, the young Prince Siegfried, attending a village celebration. His mother, the Queen, finding Siegfried sporting with the peasants, decides that it is time for him to marry someone of his own station and settle into the nobility. After she leaves, a ***pas de trois***—a dance with three dancers, in this instance, Siegfried and two maids—is interrupted by the Prince's slightly drunk tutor, who tries to take part in some of the dancing but is not quite able. When a flight of swans is seen overhead, the prince resolves to go hunting.

The opening scene of Act 2 is on a moonlit lake, with the arch magician Rothbart tending his swans. The swans, led by Odette, are maidens he has enchanted. They can return to human form only at night. Odette's movements are imitated by the entire group of swans, movements that are clearly influenced by the motions of the swan's long neck and by the movements we associate with birds—for example, an undulating motion executed by the dancers' arms and a fluttering executed by the legs. Siegfried comes upon the swans and restrains his hunters from shooting at them. He falls in love with Odette, now in her human form, all of whose motions are characterized by the softness and grace of a swan (Figure 10-5). Siegfried learns that Odette is enchanted and that she cannot come to the ball at which the Queen has planned to arrange his marriage. Siegfried also learns that if he vows his love to her and keeps his vow, he can free her from the enchantment. She warns him that Rothbart will do everything to trick him into breaking the vow, but Siegfried is determined to be steadfast. As dawn arrives, the lovers part and Rothbart retrieves his swans.

Act 3 commences with the ball the Queen has arranged for presenting to Siegfried a group of princesses from whom he may choose. Each princess, introduced in lavish native costume with a retinue of dancers and retainers, dances the folk dance of her country, such as the allemande, the czardas, the tarantella. But suddenly Rothbart enters in disguise with his own daughter, Odile, who looks exactly like Odette. Today, most performances require that Odette and Odile be the same dancer, although the parts were originally written for two dancers. Siegfried and Odile dance the famous Black Swan ***pas de deux,*** a dance notable for its virtuosity. It features almost superhuman leaps on the part of Siegfried, and it also involves thirty-two rapidly executed whipping turns (fouettés) on the part of Odile. Her movement is considerably different in character from that of Odette. Odile is more angular, less delicate, and in her black costume seems much less the picture of

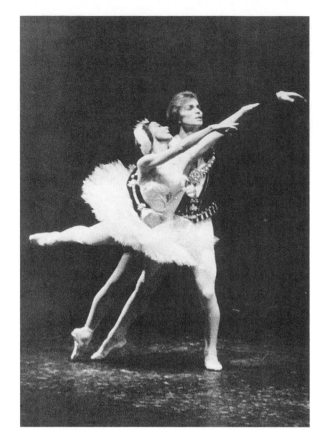

FIGURE 10-5
Margot Fonteyn and Rudolf
Nureyev in *Swan Lake*.

Siegfried has fallen in love with
Odette, in human form, only to
learn later she is enchanted by
the magician Rothbart. Fonteyn
and Nureyev, among the great-
est ballet dancers of their time,
were legendary in this 1964 pro-
duction. Sections of their dance
can be seen on YouTube.

innocence Odette had seemed in her soft white costume. Siegfried's move-
ments suggest great joy at being with Odette, for he does not realize that this
is really Odile, the magician's daughter.

When the time comes for Siegfried to choose among the princesses for
his wife, he rejects them all and presents Odile to the Queen as his choice.
Once Siegfried has committed himself to her, Rothbart exults and takes
Odile from him and makes her vanish. Siegfried, who has broken his vow
to Odette, realizes he has been duped and ends the act by rushing out to find
the real Odette.

Like a number of other sections of the ballet, Act 4 has a variety of ver-
sions that interpret what is essentially similar action (Figure 10-6). Siegfried,
in finding Odette by the lake at night, sacrifices himself for her and breaks
the spell. They are joined in death and are beyond the power of the magi-
cian. Some versions of the ballet aim for a happy ending and suggest that
though Siegfried sacrifices himself for Odette, he does not die. In this happy-
ending version, Odette, upon realizing that Siegfried had been tricked, for-
gives him. Rothbart raises a terrible storm in order to drown all the swans,
but Siegfried carries Odette to a hilltop, where he is willing to die with her
if necessary. This act of love and sacrifice breaks the spell, and the two of
them are together as dawn breaks.

FIGURE 10-6
The American Ballet Theater production of *Swan Lake*.

Here Rothbart's enchanted swans dance together in a classic pose.

Another version concentrates on spiritual victory and reward after death in a better life than that which was left behind. Odette and the swans dance slowly and sorrowfully together, with Odette rising in a stately fashion in their midst. When Siegfried comes, he begs her to forgive him, but nothing can break the magician's spell. Odette and he dance, they embrace, she bids him farewell and casts herself mournfully into the lake, where she perishes. Siegfried, unable to live without her, follows her into the lake. Then, once the lake vanishes, Odette and Siegfried are revealed in the distance, moving away together as evidence that the spell was broken in death.

The story of *Swan Lake* has archetypal overtones much in keeping with the Romantic age in which it was conceived. John Keats, who wrote fifty years before this ballet was created, was fascinated by the ancient stories of men who fell in love with supernatural spirits, which is what the swan-Odette is, once she has been transformed by magic. Likewise, the later Romantics were fascinated by the possibilities of magic and its implications for dealing with the forces of good and evil. In his *Blithedale Romance*, Nathaniel Hawthorne wrote about a hypnotist who wove a weird spell over a woman. The story of Svengali and his ward Trilby was popular everywhere, seemingly attesting to the fact that strange spells could be maintained over innocent people. This interest in magic and the supernatural is coupled with the Wagnerian interest in heroism and the implications of the sacrifice of the hero for the thing he loves. Much of the power of the idea of sacrifice derives from the sacrifice of Christ on the cross. But Tchaikovsky—like Wagner, whose hero in the *Ring of the Niebelungs* is also a Siegfried, whose end with Brünnhilde

is similar to the ending in *Swan Lake*—concentrates on the human valor of the prince and its implication for transforming evil into good.

> ## PERCEPTION KEY *Swan Lake*
>
> 1. If you can see a production or video of *Swan Lake*, focus on a specific act and comment in a discussion with others on the suitability of the bodily movements for the narrative subject matter of that act. Are feelings or states of mind interpreted as well as the narrative? If so, when and how?
> 2. If someone who has had training in ballet is available, you might try to get him or her to present a small portion of the ballet for your observation and discussion. What would be the most important kinds of questions to ask such a person?

MODERN DANCE

The origins of **modern dance** are usually traced to the American dancers Isadora Duncan and Ruth St. Denis. They rebelled against the stylization of ballet, with ballerinas dancing on their toes and executing the same basic movements in every performance. Duncan insisted on natural movement, often dancing in bare feet with gossamer drapery that revealed her body and legs in motion (Figure 10-7). She felt that the emphasis ballet places on the movement of the arms and legs was restrictive. Her insistence on placing the center of motion just below the breastbone was based on her feeling that the torso had been neglected in the development of ballet. She believed, too, that the early Greek dancers, whom she wished to emulate, had placed their center of energy at the solar plexus. Her intention was to return to natural movement in dance, and this was one effective method of doing so.

The developers of modern dance who followed Duncan (she died in 1927) built on her legacy. In her insistence on freedom with respect to clothes and conventions, she infused energy into the dance that no one had ever seen before. Although she was a native Californian, her successes and triumphs were primarily in foreign lands, particularly in France and Russia. Her performances differed greatly from the ballet. Instead of developing a dance built on a pretext of the sort that underlies *Swan Lake*, Duncan took more abstract subject matters—especially moods and states of mind—and expressed her understanding of them.

Duncan's dances were lyrical, personal, and occasionally extemporaneous. Since, she insisted, there were no angular shapes in nature, she would permit herself to use none. Her movements rarely came to a complete rest. An interesting example of her dance, one in which she does come to a full rest, is recounted by a friend. It was performed in a salon for close friends, and its subject matter seems to be human emergence on the planet:

> Isadora was completely covered by a long loose robe with high draped neck and long loose sleeves in a deep muted red. She crouched on the floor with her face resting on the carpet. In slow motion with ineffable effort she managed to get up on her knees. Gradually with titanic struggles she rose to her feet. She raised her

FIGURE 10-7
Isadora Duncan in *La Marseillaise*,
1915, one of her two most famous
dances.

During World War I, contem-
porary critics said it found the
"heart of Paris." In this dance and
in *Marche Slave*, 1915, Duncan
pointed the way to modern dance
as distinct from ballet and show
dance.

arms toward heaven in a gesture of praise and exultation. The mortal had emerged
from primeval ooze to achieve Man, upright, liberated, and triumphant.[2]

Martha Graham, Erick Hawkins, José Limón, Doris Humphrey, and other
innovators who followed Duncan developed modern dance in a variety of
directions. Graham, who was also interested in Greek origins, created some
dances on themes of Greek tragedies, such as her *Medea*. In addition to his
Moor's Pavane, Limón is well known for his interpretation of Eugene O'Neill's
play *The Emperor Jones*, in which a black slave escapes to an island only to
become a despised and hunted tyrant. These approaches are somewhat of a de-
parture from Duncan, as they tend to introduce the balletic pretext into modern
dance. Humphrey, who was a little older than Graham and Limón, was closer
to the original Duncan tradition in such dances as *Water Study*, *Life of the Bee*,
and *New Dance*, a 1930s piece that was very successfully revived in 1972.

[2]From Kathleen Cannell, "Isadorable Duncan," *Christian Science Monitor*, December 4,
1970. Reprinted by permission from The Christian Science Monitor. © 1970 The Christian
Science Publishing Society. All rights reserved.

FIGURE 10-8
The Alvin Ailey Dance Company in *Revelations,* a suite of dances to gospel music.

> ## PERCEPTION KEY Pretext and Movement
>
> 1. Devise a series of movements that will take about one minute to complete and that you are fairly sure do not tell a story. Then perform these movements for a group and question them on the apparent pretext of your movement. Do not tell them in advance that your dance has no story. As a result of this experiment, ask yourself and the group whether it is possible to create a sequence of movements that will not suggest a story line to some viewers. What would this mean for dances that try to avoid pretexts? Can there really be abstract dance?
> 2. Without explaining that you are not dancing, represent a familiar human situation to a group by using movements that you believe are not dance movements. Is the group able to understand what you represented? Do they think you were using dance movements? Do you believe it possible to have movements that cannot be included in a dance? Are there, in other words, nondance movements?

Alvin Ailey's Revelations

One of the classics of modern dance is Alvin Ailey's *Revelations* (Figure 10-8), based largely on African American spirituals and experience. It was first performed in January 1960, and hardly a year has gone by since without its having been performed to highly enthusiastic crowds. Ailey refined *Revelations* somewhat over the years, but its impact has brought audiences to their feet for standing ovations at almost every performance. Since Ailey's early death, the company has been directed by Judith Jamison, one of the great dancers in Ailey's company.

Some of the success of *Revelations* stems from Ailey's choice of the deeply felt music of the spirituals to which the dancers' movements are closely attuned. But, then, this is also one of the most noted qualities of a ballet like *Swan Lake,* which has one of the richest orchestral scores in the history of ballet. Music, unless it is program music, is not, strictly speaking, a pretext for a dance, but there is a perceptible connection between, say, the rhythmic characteristics of a given music and a dance composed in such a way as to take advantage of those characteristics. Thus in *Revelations* the energetic movements of the dancers often appear as visual, bodily transformations of the rhythmically charged music.

Try to see *Revelations*. We will point out details and structures an awareness of which may prove helpful for refining your experience not only of this dance but of modern dance in general. Beyond the general pretext of *Revelations*—that of African American experience as related by spirituals—each of its separate sections has its own pretext. But none of them is as tightly or specifically narrative as is usually the case in ballet. In *Revelations,* only generalized situations act as pretexts.

The first section of the dance is called "Pilgrim of Sorrow," with three parts: "I Been Buked," danced by the entire company (about twenty dancers, male and female); "Didn't My Lord Deliver Daniel," danced by only a few dancers; and "Fix Me Jesus," danced by one couple. The general pretext is the suffering of African Americans, who are, like the Israelites of the Old Testament, taking refuge in their faith in the Lord. The most dramatic moments in this section are in "Didn't My Lord Deliver Daniel," a statement of overwhelming faith characterized by close ensemble work. The in-line dancers parallel the rhythms of the last word of the hymn: "Dan´-i-el´," accenting the first and last syllables with powerful rhythmic movements.

The second section, titled "Take Me to the Water," is divided into "Processional," danced by eight dancers; "Wading in the Water," danced by six dancers; and "I Want to Be Ready," danced by a single male dancer. The whole idea of "Take Me to the Water" suggests baptism, a ritual that affirms faith in God—the source of energy of the spirituals. "Wading in the Water" is particularly exciting, with dancers holding a stage-long bolt of light-colored fabric to represent the water. The dancers shimmer the fabric to the rhythm of the music, and one dancer after another crosses over the fabric, symbolizing at least two things: the waters of baptism and the Mosaic waters of freedom. It is this episode that originally featured the charismatic Judith Jamison in a long white gown holding a huge parasol as she danced.

The third section is called "Move, Members, Move," with the subsections titled "Sinner Man," "The Day Is Past and Gone," "You May Run Home," and the finale "Rocka My Soul in the Bosom of Abraham." In this last episode, a sense of triumph over suffering is projected, suggesting the redemption of a people by using the same kind of Old Testament imagery and musical material that opened the dance. The entire section takes as its theme the lives of people after they have been received into the faith, with the possibilities of straying into sin. It ends with a powerful rocking spiritual that emphasizes forgiveness and

the reception of the people (the "members") into the bosom of Abraham, according to the prediction of the Bible. This ending features a large amount of ensemble work and is danced by the entire company, with rows of male dancers sliding forward on their outspread knees and then rising all in one sliding gesture, raising their hands high. "Rocka My Soul in the Bosom of Abraham" is powerfully sung again and again until the effect is almost hypnotic.

The subject matter of *Revelations* is in part that of feelings and states of mind. But it is also more obviously that of the struggle of a people as told—on one level—by their music. The dance has the advantage of a powerfully engaging subject matter even before we witness the interpretation of that subject matter. And the way in which the movements of the dance are closely attuned to the rhythms of the music tends to evoke intense participation, since the visual qualities of the dance are powerfully reinforced by the aural qualities of the music.

PERCEPTION KEY *Revelations*

1. A profitable way of understanding the resources of *Revelations* is to take a well-known African American spiritual such as "Swing Low, Sweet Chariot" (Figure 9-4) and supply the movements that it suggests to you. Once you have done so, ask yourself how difficult it was. Is it natural to move to such music?
2. Instead of spirituals, try the same experiment with popular music such as rock and rap. What characteristics does such music have that stimulate motion?
3. Is there anything archetypal in the subject matter of *Revelations*?

Martha Graham

Quite different from the Ailey approach is the "Graham technique," taught in Graham's own school in New York as well as in colleges and universities across the country. Like Ailey, Graham was a **virtuoso** dancer and organized her own company. After Isadora Duncan, no one has been more influential in modern dance. Graham's technique is reminiscent of ballet in its rigor and discipline. Dancers learn specific kinds of movements and exercises designed to be used as both preparation for and part of the dance. Graham's contraction, for example, is one of the most common movements one is likely to see. It is the sudden pulling in of the diaphragm with the resultant relaxation of the rest of the body. This builds on Duncan's emphasis on the solar plexus and adds to that emphasis the systolic and diastolic rhythms of heartbeat and pulse. The movement is very effective visually as well as being particularly flexible in depicting feelings and states of mind. It is a movement unknown in ballet, from which Graham always wished to remain distinct.

Graham's dances at times have been very literal, with narrative pretexts quite similar to those found in ballet. *Night Journey,* for instance, is an interpretation of *Oedipus Rex* by Sophocles. The lines of emotional force linking Jocasta and her son-husband Oedipus are strongly accentuated by the movements of the dance as well as by certain props onstage, such

FIGURE 10-9
Martha Graham in *Phaedra*, based on the Greek myth concerning the love of Phaedra for Hippolytus, the son of her husband Theseus.

Graham performed numerous dances based on Greek myths because she felt energized by their passion.

as ribbons that link the two together at times. In Graham's interpretation, Jocasta becomes much more important than she is in the original drama. This is partly because Graham saw the female figures in Greek drama—such as *Phaedra* (Figure 10-9)—as much more fully dimensional than we have normally understood them. By means of dancing their roles, she was able to reveal the complexities of their characters. In dances such as her *El Penitente*, Graham experimented with states of mind as the subject matter. Thus the featured male dancer in loose white trousers and tunic, moving in slow circles about the stage with a large wooden cross, is a powerful interpretation of penitence.

Pilobolus and Momix Dance Companies

The innovative modern dance companies, Pilobolus and Momix, perform around the world and throughout the United States. They originated in 1970 at Dartmouth College with four male dancers and choreographers Alison Chase and Martha Clarke. Their specialty involves placing moving bodies in almost acrobatic positions. Moses Pendleton, principal dancer in Pilobolus and director of the dance company Momix, choreographed *F.L.O.W. (For Love of Women)* and had it performed by Diana Vishneva, one of Russia's finest Maryinski ballerinas (Figure 10-10). Vishneva performs on a highly reflective floor producing a complex visual dynamic that complements other parts of the dance. Such intense moments characterize much of the style that Pendleton has developed with Momix and echoes some of the acrobatics of the Pilobolus company. *Suspended*, with dancers Renée Jaworski and

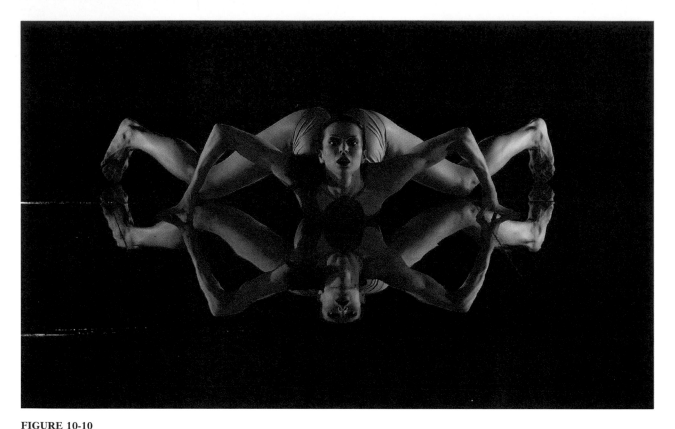

FIGURE 10-10
Diana Vishneva, from Russia's Maryinska Ballet, dancing in Moses Pendleton's *F.L.O.W. (For the Love of Women)* at the New York City Center in 2008.

Pendleton's emphasis on the body is intensified here by the reflective floor and the acrobatic position.

Jennifer Macavinta (Figure 10-11), shows the Pilobolus company's commitment to the principle that choreography is an art dependent on the body, not just on music, pretext, or lighting.

Mark Morris Dance Group

The Mark Morris Dance Group was created—"reluctantly," he has said—in 1980 because he found he could not do the dances he wanted with other existing companies. Morris and his company were a sensation from the first, performing to rave reviews in New York from 1981 to 1988. In 1988, the company shocked the dance world by accepting an invitation from Brussels to take up residence at Théâtre Royal de la Monnaie, where the famed and well-loved ballet company of Maurice Béjart had thrilled a very demanding audience.

Morris's first dance in Brussels was a theatrical piece with an intricate interpretation of Handel's music set to John Milton's lyric poems: *L'Allegro, il Penseroso, ed il Moderato*. The title refers to three moods: happiness, melancholy, and restfulness. The interpretation of the state of mind

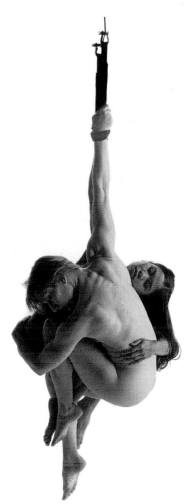

FIGURE 10-11
Renée Jaworski and Jennifer Macavinta in the Pilobolus
Dance Company's *Suspended*, emphasizing the body
in space.

The Pilobolus Company is known for its highly
experimental and daring dances sometimes involving
nudity.

associated with happiness is clearly evident in the movement patterns in
Figure 10-12. The dance was produced again in Edinburgh in 1994 and at
New York's Lincoln Center in 1995. David Dougill commented on the "ab-
solute rightness to moods and themes" with Milton's poems and Handel's
music. Morris left Brussels in 1991 and again centers his work in New
York.

Twyla Tharp

Tharp has developed a style pleasing to both serious critics and dance
amateurs. A thoughtful student of the philosophy of dance, she includes a
playful spontaneity that seems appropriately modern. She also has taken
advantage of the new opportunities for dance on television, particularly

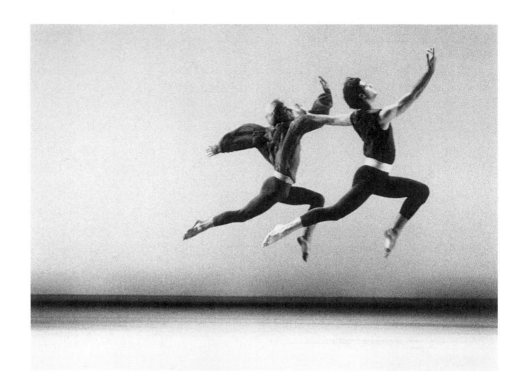

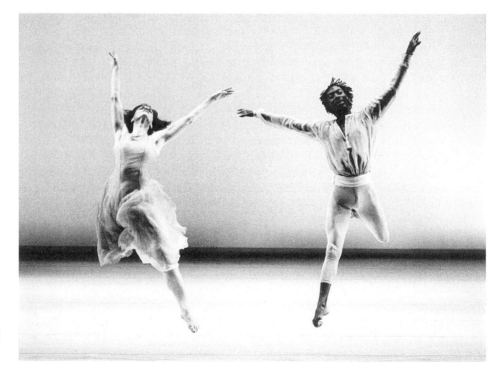

FIGURE 10-12
The Mark Morris Dance Company performs the joyous *L'Allegro, il Penseroso, ed il Moderato*.

With music by Handel, the dance is based on John Milton's youthful poems, *L'Allegro* and *Il Penseroso*.

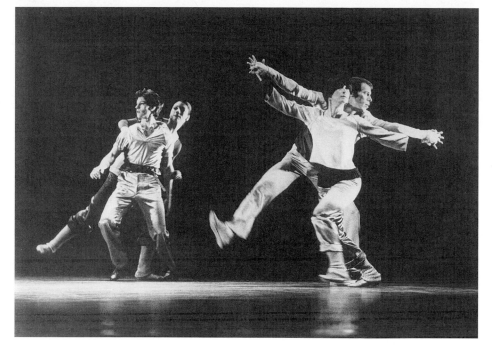

FIGURE 10-13

Sue's Leg. Choreography, Twyla Tharp; costumes, Santo Loquasto; lighting, Jennifer Tipton; dancers (l. to r.) Kenneth Rinker, Rose Marie Wright, Twyla Tharp, Tom Rawe.

Sue's Leg is set to the boogie-woogie music of Fats Waller. Tharp's dances begin from a powerful musical center, such as her very successful and frequently performed dance, *The Sinatra Suite.*

the Public Broadcasting Corporation's *Dance in America* series, which has been very popular and critically successful. For television productions, she often uses cuts from newsreel films along with her dancers' interpretations of 1930s dances. She has been particularly successful in adapting the jazz of the 1920s and 1930s to dance; for example, *Sue's Leg* features the music of "Fats" Waller (Figure 10-13). *Bix Pieces* was inspired by the cornetist Bix Beiderbecke, one of the first romantic, self-destructive young musicians of the twentieth century. *Eight Jelly Rolls,* premiered in 1971, and also televised, is a brilliant series of interpretations of eight songs written by the legendary Jelly Roll Morton, who claimed to have invented jazz. Tharp's interest in sequential dances—*Ocean's Motion,* a suite of dances to the music of Chuck Berry; *Raggedy Dances,* to ragtime tunes; and *Assorted Quarters,* to classical music—shows a virtuoso ability to explore feelings and states of mind as related to music.

Television has had a significant impact on dance performances since the early 1970s, making them much more available to the public. Tharp has been foremost among those experimenting with that medium, choreographing famous dancers, such as Rudolf Nureyev, the former star of the Russian Kirov ballet. Nureyev was interested in working with her partly because she had learned how to utilize the relatively restricted spaces available to the television camera and partly because her vocabulary of movements is very different from that of classical ballet. He welcomed a new dance challenge. Tharp choreographed *The Sinatra Suite,* a duet with Nureyev and Elaine Kudo, set to a group of songs sung by Frank Sinatra. The sultry style that

FIGURE 10-14
A scene from the film *You Got Served* (2004).

Street dancing can still be seen on the streets of many cities where young dancers put out the hat for tips. But it is also becoming a mainline form of dance seen on the stage and television. It is marked by sheer energy and virtuoso moves suggesting the one-time competitiveness of jazz music.

Nureyev brought to this American music and choreography was striking. Nureyev again showed his versatility by dancing in Tharp's *Push Comes to Shove,* set to ragtime music interwoven with selections from Haydn symphonies. These dances have no explicit pretext.

POPULAR DANCE

Popular styles in dance change rapidly from generation to generation. Early in the twentieth century, the Charleston was the exciting dance for young people; then in the 1930s and 1940s, it was swing dancing and jitterbugging. In the 1960s, rock dancing took over, then disco, and then in the 1980s break dancing led into the 1990s hip-hop (Figure 10-14). Recently, a resurgence in ballroom dancing has spawned not only competitions at a professional level but widespread competitions in urban middle schools across the United States.

In films, great dancers like Fred Astaire and Ginger Rogers as well as Donald O'Connor, Gene Kelly, Cyd Charisse, and many more, captivated wide audiences. The Nicholas Brothers (Figure 10-15) were among the most dazzling tap dancers on film. *Stormy Weather* (1943) was their favorite film, but one of their best dances was in *Orchestra Wives* (1942). Some of Fred Astaire's great films are *Flying Down to Rio* (1933), *Swing Time* (1936), *Shall We Dance?* (1937), and *Daddy Long Legs* (1955). Gene Kelly and Cyd Charisse are famous for *Singing in the Rain* (1952), one of the best loved of all dance films.

Fortunately, dance films are almost universally available on DVD and video, and as a result it is still possible for us to see the great work of our best dancers whatever their style.

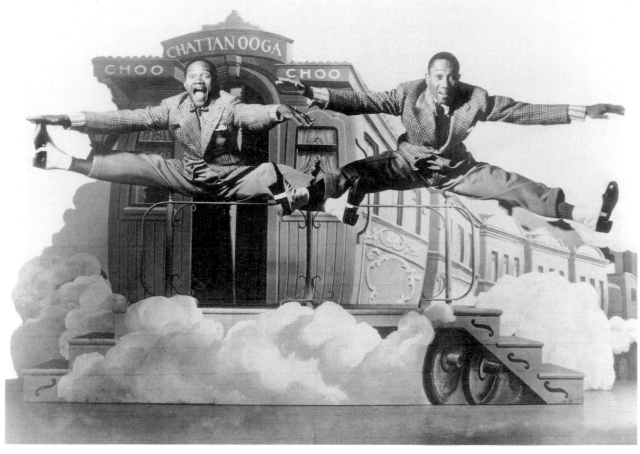

SUMMARY

Through the medium of the moving human body, the form of dance can reveal visual patterns or feelings or states of mind or narrative or, more probably, some combination. The first step in learning to participate with the dance is to learn the nature of its movements. The second is to be aware of its different kinds of subject matter. The content of dance gives us insights about our inner lives, especially states of mind, that supplement the insights of music. Dance has the capacity to transform a pretext, whether it be a story or a state of mind or a feeling. Our attention should be drawn into participation with this transformation. The insight we get from the dance experience depends on our awareness of this transformation.

Note: Many of the dance companies and their dances can be seen in full or in part in online video-sharing services such as YouTube, Hulu, Veoh, Metacafe, Google Videos, and others.

Chapter 11

FILM

Within a century, the film became the most popular art form around the world, mainly because of its realism. Film is never completely lifelike, of course, but it is more so than any other medium. From the beginning, film borrowed principles of visual organization from painting. Even today, as films are planned, a storyboard is often created with drawings of scenes that are realized on film very close to the way they were designed. But unlike the image of painting, the images of film move, projected on a screen at twenty-four frames per second, and the eye merges them as if they were continuous action. The indebtedness of film to drama and literature is also great, since virtually all films have a narrative structure. When films were young and silent, a pianist provided mood music to intensify visual scenes. After 1926, many films incorporated a soundtrack not only with the dialogue but also with background music that has now become virtually indispensable. Because the film is relatively inexpensive to see, it reaches millions, providing them with what may be their primary experience of art and, by extension, their primary experience of the arts that the film borrows from.

The Subject Matter of Film

Except in its most reductionist form, the subject matter of most great films is very difficult to isolate and restate in words. You could say that death is the subject matter of Bergman's *The Seventh Seal* (see Figure 11-3). But you would

also need to observe that the knight's sacrifice to save the lives of others—which he accomplishes by playing chess with Death—is also part of the subject matter of the film. As David Cook explains in *A History of Narrative Film,* there is a complexity of subject matter in film that is rivaled only by literature.

It may be that the very popularity of film and the ease with which we can access it lead us to ignore the form and the insights form offers into subject matter. For example, is it really possible to catch the subtleties of form of a great film in one viewing? Yet how many of us see a great film more than once? Audiences generally enjoy, but rarely analyze, films. Some of the analysis that follows may help your enjoyment as well as your analyses.

Except perhaps for opera, film more than any of the other arts involves collaborative effort. Most films are written by a scriptwriter, then planned by a director, who may make many changes. However, even if the director is also the scriptwriter, the film needs a producer, camera operators, an editor, designers, researchers, costumers, actors, and actresses. Auteur criticism regards the director as equivalent to the ***auteur,*** or author, of the film. For most moviegoers, the most important persons involved with the film will almost surely be not the director but the stars who appear in the film. George Clooney, Angelina Jolie, Julia Roberts, Brad Pitt, and Morgan Freeman are more famous than such directors of stature as Ingmar Bergman, Federico Fellini, Lina Wertmuller, Akira Kurosawa, Jane Campion, or Krzysztof Kieslowski.

DIRECTING AND EDITING

The two dominant figures in early films were directors who did their own ***editing:*** D. W. Griffith and Sergei Eisenstein, unquestionably the great early geniuses of filmmaking. They managed to gain control over the production of their works so that they could craft their films into a distinctive art. Some of their films are still considered among the finest ever made. *The Birth of a Nation* (1916) and *Intolerance* (1918) by Griffith, and *Battleship Potemkin* (1925) and *Ivan the Terrible* (1941–1946) by Eisenstein are still being shown and are still influencing contemporary filmmakers. These men were more than just directors. With many of their films, they were responsible for almost everything: writing, casting, choosing locations, handling the camera, directing, editing, and financing.

Directing and editing are probably the most crucial phases of filmmaking. Today most directors control the acting and supervise the photography, carried out by skilled technicians who work with such problems as lighting, camera angles, and focusing, as well as the motion of the camera itself (some sequences use a highly mobile camera, while others use a fixed camera). Among the resources available to directors making choices about the use of the camera are the kinds of shots that may eventually be edited together. A ***shot*** is a continuous length of film exposed

in the camera without a break. Some of the most important kinds of shots follow:

> *Establishing shot:* Usually a distant shot establishes important locations or figures in the action.
>
> *Close-up:* An important object, such as the face of a character, fills the screen.
>
> *Long shot:* The camera is far distant from the most important characters, objects, or scenes.
>
> *Medium shot:* What the camera focuses on is neither up close nor far distant. There can be medium close-ups and medium long shots, too.
>
> *Following shot:* The camera keeps a moving figure in the frame, usually keeping pace with the figure.
>
> *Point-of-view shot:* The camera records what the character must be seeing; when the camera moves, it implies that the character's gaze moves.
>
> *Tracking shot:* A shot in which the camera moves forward, backward, or sidewise.
>
> *Crane shot:* The camera is on a crane or movable platform and moves upward or downward.
>
> *Hand-held shot:* The camera is carried, sometimes on a special harness, by the camera operator.
>
> ***Recessional shot:*** The camera focuses on figures and objects moving away. A ***processional*** shot focuses on figures and objects moving toward the camera.

When you see films, you probably see all these shots many times. Add to these specific kinds of shots the variables of camera angles, types of camera lenses, variations in lighting, and variations in approach to sound, and you can see that the technical resources of the director are enormous. The addition of script and actors enriches the director's range of choices so that they become almost dizzying.

The editor, almost always under the control of the director, puts the shots in order after the filming is finished. This selective process is highly complex and of supreme importance, for the structuring of the shots forms the film. The alternatives are often vast, and if the film is to achieve an artistic goal—insight into its subject matter—the shot succession must be creatively accomplished. The editor trims the shots to an appropriate length, then joins them with other shots to create the final film. Edited sequences sometimes shot far apart in time and place are organized into a unity. Films are rarely shot sequentially, and only a part of the total footage is shown in a film. The old saying of the bit-part actor—"I was lost on the cutting-room floor"—attests to the fact that sometimes interesting footage is omitted. Some of the most bitter arguments in filmmaking are between the director and the editor, who frequently disagree on how to edit a film. Sometimes, especially in video stores, you will see the term "Director's Cut" on a film,

meaning that the director edited the film to please his or her vision—often adding sequences originally omitted to conform to the perceived needs of the exhibiting theaters.

It helps to know the resources of the editor, who cuts the film to create the relationships between takes. The way these cuts are related is at the core of the director's distinctive style. Some of the most familiar of the director's and editor's choices follow:

Continuity cut: shots edited to produce a sense of narrative continuity, following the action stage by stage. The editor can also use a discontinuity cut to break up the narrative continuity for effect.

Jump cut: sometimes just called a "cut"; moves abruptly from one shot to the next, with no preparation and often with a shock.

Cut-in: an immediate move from a wide shot to a very close shot of the same scene; the editor may "cut out," as well.

Cross-cutting: alternating shots of two or more distinct actions occurring in different places (but often at the same time).

Dissolve: one scene disappearing slowly while the next scene appears as if beneath it.

Fade: includes fade-in (a dark screen growing brighter to reveal the shot) and fade-out (the screen darkens, effectively ending the shot).

Wipe: transition between shots, with a line moving across or through the screen separating one shot from the next.

Graphic match: joining two shots that have similar composition, color, or scene.

Montage sequence: a sequence of images dramatically connected but physically disconnected.

Shot, reverse shot: a pair of shots in which the first shot shows a character looking at something; reverse shot shows what the character sees.

Our responses to film depend on the choices that directors and editors make regarding shots and editing almost as much as on the nature of the narrative and the appeal of the actors. In a relatively short time, film editing has become almost a kind of language—a language of imagery with close to universal significance.

When the editing is handled well, it can be profoundly effective, because it is impossible in real-life experience to achieve what the editor achieves. By eliminating the irrelevant, good editing accents the relevant. We cannot go instantly from the Los Angeles airport, where we are watching a hired assassin from Chicago land, to the office of the political candidate he has come to kill. Film can do this with ease. The ***montage***—dramatically connected but physically disconnected images—can be made without a word of dialogue. You undoubtedly can recall innumerable instances of this kind of editing. When done well, this tying together of images that could not possibly occur together in life enhances the meaning of the images we see.

THE PARTICIPATIVE EXPERIENCE AND FILM

Our participation with film is often virtually involuntary. For one thing, most of us know exactly what it means to lose our sense of place and time in a movie. This loss seems to be achieved rapidly in all but the most awkwardly conceived films. In a film like *Black Orpheus* (1958), shot in Rio, the intensity of tropical colors, Latin American music, and the dynamics of the carnival produce an imaginary or virtual reality so intense and vital that actual reality seems dull by comparison. But then there are other films that create the illusion of life itself. Aristotle analyzed the ways in which drama imitates life and the ways in which an audience identifies with some of the actors on the stage (Chapter 8). Yet the film seems to have these powers to an even greater degree than the stage.

Cinematic realism makes it easy for us to identify with actors who represent our values (a kind of participation). For instance, in *Forrest Gump* (1994), Tom Hanks plays what seems to be, on the surface, a mentally defective person. But Gump is not just dumb—he is good at heart and positive in his thinking. He is a character in whom cunning—not just intelligence—has been removed, and in him the viewers see their lost innocence. It would be very doubtful that anyone in the audience consciously identified with Gump, but it was clear from the reception of the film that something in him touched a nerve in the audience and was, in the final analysis, both appealing and cheering. Gump is an unlikely hero primarily because he is trusting, innocent, and good-hearted. When the audience participates with that film, it is in part because the audience sees in Gump something of what it would like to see in itself.

3. Compare your experience watching a play with actors on the stage and your experience of watching actors on the screen. Describe the differences in your sense of participation with the action of the drama in each case. What are the most important differences in the experiences?
4. Living drama still has many potentials for surprise and the unexpected. It also has the potential for a personal relationship between actor and audience. To what extent is the same true for a good film?
5. What are your standards for establishing excellence in a film? What are your critical principles? Which film could you defend on the grounds of its excellence?

It may be that we naturally identify with heroes in films, as we do in books. The characters played by extremely charismatic actors, like Julia Roberts or George Clooney, almost always appeal to some aspect of our personalities, even if sometimes that aspect is frightening. Such may be the source, for instance, of the appeal of Hannibal Lecter in *The Silence of the Lambs* (1992), in which Anthony Hopkins not only appears as a cannibal but actually gets away with it, identifying his former doctor as his next victim, whose liver he plans to eat with some "fava beans and a nice Chianti."

There are two kinds of participative experiences with film. One is not principally filmic in nature and is represented by a kind of self-indulgence that depends upon self-justifying fantasies. We imagine ourselves as James Bond, for example, and ignore the interrelationship of the major elements of the film. The other kind of participation evolves from an acute awareness of the details and their interrelationships. This second kind of participative experience means much more to us ultimately because it is significantly informative: We understand the content by means of the form.

Just a word more about the first kind of participation. It is usually referred to as "escapism." Escape films give us the chance to see ourselves complimented in a movie, thus satisfying our desire for self-importance. Unhappily, escape films often help us avoid doing anything about achieving something that would really make us more important to ourselves. In some ways, these films help rob people of the chance to be something in their own right.

THE FILM IMAGE

The starting point of film is the moving image. Just as still photographs and paintings can move us profoundly by their organization of visual elements, so can such images when they are set to motion. Indeed, many experts insist that no artistic medium ever created has the power to move us as deeply as the medium of moving images. They base their claim not just on the mass audiences who have been profoundly stirred, but also on the fact that the moving images of the film are similar to the moving images we perceive in life. We rarely perceive static images except when viewing such things as paintings or photographs. Watching a film closely can help us perceive much more intensely the visual worth of many of the images we experience outside film. We see, for example, someone walking in a jaunty, jumpy fashion with his

FIGURE 11-1
Charlie Chaplin in the silent film *The Champion* (1915).

Chaplin was the most famous comic film star of his age, the representative of the common man, usually abused by the rich and pretentious, but always the object of the viewers' sympathies.

feet turned out. Our visual interest is immediately enhanced if we remember Charlie Chaplin (Figure 11-1), and almost always we will remember if we have participated with a Chaplin film. There is a very long tracking shot in *Weekend,* by Jean-Luc Godard, of a road piled up with wrecked or stalled cars. The camera glides along nervelessly imaging the gridlock with fires and smoke and seemingly endless corpses scattered here and there along the roadsides—unattended. The stalled and living motorists are obsessed with getting to their vacation resorts. The horns honk and honk. The unbelievable elongation of the procession and the utter grotesqueness of the scenes evoke black humor at its extreme. If in reality we have to face anything even remotely similar, the intensity of our vision inevitably will be heightened if we have seen *Weekend*.

PERCEPTION KEY Godard's *Weekend*

Assuming that the analysis above is accurate, would you prefer to have seen *Weekend* if you someday are confronted with a bad car accident? If so, why? If not, why?

Many early filmmakers composed their films by adding single photographs to each other, frame by frame. Movement in motion pictures is caused by the physiological limitations of the eye. It cannot perceive the black line between frames when the film strip is moved rapidly. All it sees is the succession of frames minus the lines that divide them, for the eye cannot perceive separate images or frames that move faster than one-thirtieth of a second. Motion picture film is usually projected at a speed of twenty-four frames per second, and the persistence of vision merges the images. This is the "language" of the camera.

EXPERIENCING Still Frames and Photography

Study Figures 11-1, 11-2, 11-3, and 11-4. How would you evaluate these stills with reference to tightness of composition? For example, do the details and parts interrelate so that any change would disrupt the unity of the totality? Compare with Figure 2-2.

The still from *Casablanca* (Figure 11-2) is not only a tightly composed frame, but a revealing frame, typical of the powerful photography that characterizes the film and that contributes to its being one of the most highly regarded films ever made. We naturally read the still from left to right in part because Rick (Humphrey Bogart) is its star and the setting of the shot is in Rick's Place. The way the shadows fall on him, despite his wearing a white tuxedo coat, we are not sure if he is a thoroughly noble figure, or a possibly shady one. We know the film takes place in wartime, so it is no surprise to see Captain Renault (Claude Rains) in a uniform, but we are never sure where his interests lie. Up to this point in the film, his sympathies seem to be with the Allies, not the Germans who occupy his country. Yet, Renault is responsible for administering this territory and the city of Casablanca, which is in northern Africa. The brightest light falls on Victor Laszlo (Paul Henreid), the Czech patriot who has done important work in fighting the Nazi takeover of Europe. He is the tallest figure here, and the shadows are least evident on his portrayal. We are almost immediately made aware that there is no doubt about his goodness, his heroism, or his value to the cause. Ilsa (Ingrid Bergman), in the lower right, is Victor's wife, but she was also Rick's woman in Paris before the war. She is an ambiguous figure in this frame, and at this point in the film could either find herself in love with Rick again, or go off with her husband, who, while being a hero, is vastly less romantic and interesting than Rick. This still frame, with the central figures and the table highlighted, and all the rest of the room in shadow, is carefully structured to produce a controlled response from the viewer.

Not all films are made this carefully, but *Casablanca* and *Citizen Kane*, which we discuss later, are examples of the many great films that insist on making each frame tell its story.

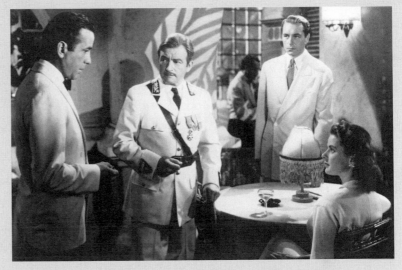

FIGURE 11-2
A still from *Casablanca* (1942) using strong light and dark shadow to intensify the dramatic meeting of Rick (Humphrey Bogart) with his former lover Ilsa (Ingrid Bergman) introduced by Captain Renault (Claude Rains) while Ilsa's husband Victor Laszlo (Paul Henreid) looks on. This chiaroscuro style distinguishes the entire film.

Because of this language, many filmmakers, both early and contemporary, attempt to design each individual frame as carefully as they might a photograph. (See "Photography and Painting: The Pictorialists" in Chapter 13.) Jean Renoir, the famous French filmmaker and son of painter Pierre-Auguste, sometimes composed frames like a tightly unified painting, as in *The Grand Illusion* (1936) and *The Rules of the Game* (1939). Sergei Eisenstein also framed many of his images especially carefully, notably in

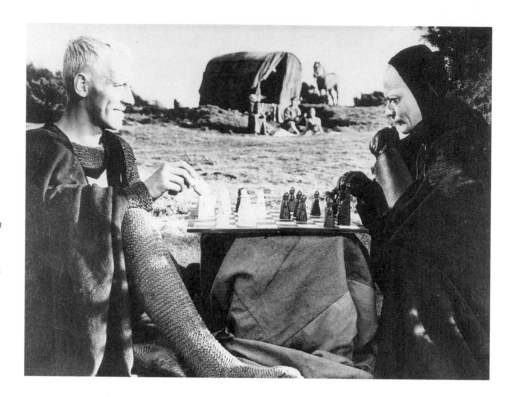

FIGURE 11-3
Ingmar Bergman's *The Seventh Seal* (1957).

The knight plays chess with death in order to save the lives of the traveling citizens in the distance. The close shot balances the knight and death in sharp focus, while the citizens are in soft focus. In chess, a knight sacrifice is often a ploy designed to achieve a stronger position, as in this film.

FIGURE 11-4
Gianni di Venanzo's extraordinary recessional shot for Federico Fellini's *8 ½* (1963), showing Guido (Marcello Mastroianni) meeting his mistress Carla (Sandra Milo) at the spa where he has gone to refresh his creative spirit.

Battleship Potemkin (1925). David Lean, who directed *Brief Encounter* (1945), *Bridge on the River Kwai* (1957), *Lawrence of Arabia* (1962, rereleased 1988), *Dr. Zhivago* (1965), and *Ryan's Daughter* (1970), also paid close attention to the composition of individual frames.

For some directors, the still frames of the film must be as exactly composed as a painting. The theory is that if the individual moments of the film are each as perfect as can be, the total film will be a cumulative perfection. This seems to be the case only for some films. In films that have long meditative sequences, such as Orson Welles' *Citizen Kane* (1941) or Bergman's *Cries and Whispers* (1972), or sequences in which characters or images are relatively unmoving for significant periods of time, such as Robert Redford's *A River Runs Through It* (1994), the carefully composed still image may be of real significance. Nevertheless, no matter how powerful, most stills from fine films will reveal very little of the significance of the entire film all by themselves: It is their sequential movement that brings out their effectiveness. However, the still frame and the individual shot are the building blocks of film. Controlling the techniques that produce and interrelate these blocks is the first job of the film artist.

CAMERA POINT OF VIEW

The motion in the motion picture can come from numerous sources. The actors can move toward, away from, or across the field of camera vision. When something moves toward the camera, it moves with astonishing speed, as we all know from watching the images of a moving locomotive (the favorite vehicle for this technique so far) rush at us and then "catapult over our heads." The effect of the catapult is noteworthy because it is a unique characteristic of the film medium.

People move before us the way they move before the camera, but the camera (or cameras) can achieve visual things that the unaided eye cannot: showing the same moving action from a number of points of view simultaneously, for instance, or showing it from a camera angle the eye cannot achieve. The realistic qualities of a film can be threatened, however, by being too sensational, with a profusion of shots that would be impossible in a real-life situation. Although such virtuoso effects can dazzle us at first, the feeling of being dazzled can degenerate into being dazed.

Another way the film portrays motion is by the movement or tracking of the camera. In a sequence in John Huston's *The Misfits* (1961), cowboys are rounding up wild mustangs to sell for dog food, and some amazing scenes were filmed with the camera mounted on a pickup truck chasing fast-running horses. The motion in these scenes is overwhelming because Huston combines two kinds of rapid motion—of trucks and of horses. Moreover, the motion is further increased because of the narrow focus of the camera and the limited boundary of the screen. The recorded action excludes vision that might tend to distract or to dilute the motion we are permitted to see. Much the same effect was achieved in the buffalo run in *Dances with Wolves* (1990) thirty years later. The screen in motion

pictures always constrains our vision, even when we imagine the space beyond the screen that we do not see, as when a character moves off the filmed space. Eliminating the space beyond the images recorded by the camera circumscribes and fixes our attention. And such attention is bound to enhance the rapidity and intensity of the moving images.

A final basic way film can achieve motion is by means of the camera lens. Even when the camera is fixed in place, a lens that affords a much wider, narrower, larger, or smaller field of vision than the eye normally supplies will give the illusion of motion, since we instinctively feel the urge to be in the physical position that would supply that field of vision. Zoom lenses, which change their focal length along a smooth range—thus moving images gradually closer or farther away—are even more effective for suggesting motion. One favorite shot is that of a figure walking or moving in some fashion, which looks, at first, as if it were a medium shot but which is actually revealed as a long shot when the zoom is reversed. Since our own eyes cannot imitate the action of the zoom lens, the effect can be quite dramatic when used creatively. It is something like the effect that slow motion or stop motion has on us. It interrupts our perceptions of something—something that had seemed perfectly natural—in a way that makes us aware of the film medium itself.

PERCEPTION KEY Camera Vision

1. Directors frequently examine a scene with a viewfinder that "frames" the scene before their eyes. Make or find a simple frame (or use your hands to create a "frame") and examine the visual world about you. To what extent can you frame it to make it more interesting?

2. Using the frame technique, move your eyes and the frame simultaneously to alter the field of vision. Can you make any movements that the camera cannot? Do you become aware of any movements the camera can make that you cannot?

3. If the camera is the principal tool of filmmaking, do directors give up artistic control when they have cinematographers operate the machines? Does your experimenting in the questions above suggest there may be a camera "language" that directors should be controlling themselves? Given your experience with film and cameras, how might camera language be described?

4. Using a video camera, experiment with shooting the same visual information with the lens wide-angled, and then at different stages of zoom until you reach the end of your lens's zoom range. Review the product and comment on the way the camera treats visual space.

Sometimes technique can take over a film by becoming the most interesting aspect of the cinematic experience. The Academy Award winner *2001: A Space Odyssey* (1968) (Figure 11-5), *Star Wars* (1977), *Close Encounters of the Third Kind* (1977), *ET* (1982), and the seven *Star Trek* films of the 1970s and 1980s have similar themes, concentrating on space, the future, and fantastic situations. All include shots of marvelous technical achievements, such as the images of the computer-guided cameras that follow the space vehicles of Luke Skywalker and Han Solo in the dramatic conclusion of *Star Wars* (Figure 11-6). But some critics have argued that these technical achievements were ends rather than means to artistic revelation.

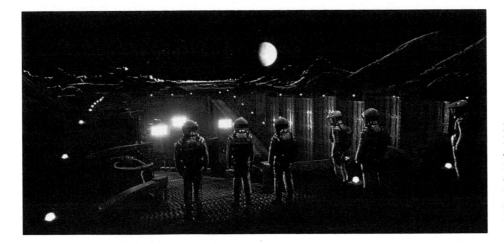

FIGURE 11-5
In Stanley Kubrick's *2001: A Space Odyssey* (1968), scientists from the Clavius moon base descend into the TMAi excavation to have a close look at the strange object that has been hidden beneath the lunar surface for millions of years.

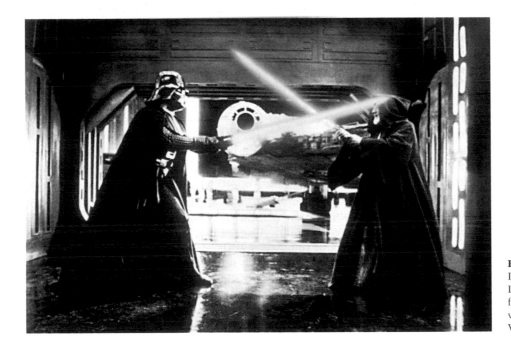

FIGURE 11-6
In *Star Wars* (1977), George Lucas used a number of powerful special effects, as in this duel with light sabers between Darth Vader and Obi-Wan Kenobi.

PERCEPTION KEY Technique and Film

1. Are the technical triumphs of films such as *Star Wars* used as means or ends? If they are the ends, then are they the subject matter? What kind of problem does such a possibility raise for our appreciation of the film?
2. In *Tom Jones* (1963), a technique called the "double take" was introduced. After searching for his wallet everywhere, Tom turns and looks at the audience and asks whether we have seen his wallet. Is this technique a gimmick or artistically justifiable? Could you make a defensible judgment about this without seeing the film?

(continued)

FIGURE 11-8
Religious services are held in the field while a tank flamethrower destroys crops in the background in Francis Ford Coppola's antiwar film *Apocalypse Now* (1979).

Surround sound may intensify our experience of film. Not only do we expect to hear dialogue, but we also expect to hear the sounds we associate with the action on screen, whether it is the quiet chirping of crickets in a country scene in *Sounder* (1972) or the dropping of bombs from a low-flying Japanese Zero in *Empire of the Sun* (1987). Subtle uses of sound sometimes prepare us for action that is yet to come, such as when in *Rain Man* (1989) we see Dustin Hoffman and Tom Cruise walking toward a convertible, but we hear the dialogue and road sounds from the next shot, when they are driving down the highway. That editing technique might have been very unsettling in the 1930s, but filmmakers have had eighty years to get our sensibilities accustomed to such disjunctions.

A very famous disjunction occurs in the beginning of *2001: A Space Odyssey* when, watching images of one tribe of apes warring with another tribe of apes in prehistoric times, we hear the rich modern harmonies of Richard Strauss's dramatic tone poem *Also Sprach Zarathustra*. The music suggests one very sophisticated mode of development inherent in the future of these primates—whom we see in the first phases of discovering how to use tools. They already show potential for creating high art. Eventually, the sound and imagery coincide when the scene changes to 2001, with scientists on the moon discovering a monolithic structure identical to one the apes had found on Earth.

1. In the next film you see, compare the power of the visuals with the power of the sound. Is there a reasonable balance between the two? Which one produces a more intense experience in you?
2. With Dolby sound systems in many movie houses, the use of sound is sometimes overwhelming. Which film of those you have recently seen has the most intense and powerful sound? Does it mesh well with the narrative line of the film? Why?
3. Play an important film on DVD and turn off its sound for a period of time. Study the images you see and comment on their ability to hold your attention. Then turn on the sound and comment on how your experience of the film is altered. Go beyond the simple addition of dialogue. Try the experiment with a foreign film that has English subtitles.
4. Play the same film on DVD and block the visual image by turning your back to it. Concentrate on the sound. To what extent is the experience of the film incomplete? How would you rate the relationship of sound to the visual images?

IMAGE AND ACTION

These experiments probably indicate that most contemporary film is a marriage of sight and sound. Yet we must not forget that film is a medium in which the moving image—the action—is preeminent, as in Federico Fellini's *8½* (1963). The title refers to Fellini's own career, ostensibly about himself and his making a new film after seven and a half previous films. *8½* is about the artistic process. Guido, played by Marcello Mastroianni, brings a group of people to a location to make a film (see Figure 11-4).

The film centers on Guido's loss of creative direction, his psychological problems related to religion, sex, and his need to dominate women. As he convalesces from his breakdown, he brings people together to make a film, but he has no clear sense of what he wants to do, no coherent story to tell. *8½* seems to mimic Fellini's situation so carefully that it is difficult to know whether Fellini planned out the film or not. He has said, "I appeared to have it all worked out in my head, but it was not like that. For three months I continued working on the basis of a complete production, in the hope that meanwhile my ideas would sort themselves out. Fifty times I nearly gave up."[1] And yet, most of the film is described in a single letter to Brunello Rondi (a writer of the screenplay), written long before the start of production.

The film is episodic, with memorable dream and nightmare sequences, some of which are almost hallucinatory. Such scenes focus on the inward quest of the film: Guido's search for the cause of his creative block so that he can resolve it. By putting himself in the center of an artistic tempest, he mirrors his own psychological confusion in order to bring it under control.

[1] John Kobal, *The Top 100 Movies* (New York: New American Library, 1988).

FIGURE 11-9
John Savage in a scene playing Russian roulette while a prisoner of the Vietnamese in Michael Cimino's *The Deer Hunter,* another antiwar film made in 1979.

Russian roulette was not actually played during this war, but its madness represented symbolically the situation of many American soldiers in the field.

Indeed, he seems intent on creating artistic tension by bringing both his wife and his mistress to the location of the film.

The film abandons continuous narrative structure in favor of episodic streams of consciousness in the sequences that reveal the inner workings of Guido's mind. In a way, they may also reveal the inner workings of the creative mind if we assume that Fellini projected his own anxieties into the film. *8½* is revelatory of the psychic turmoil of creativity.

FILM STRUCTURE

Michael Cimino's portrayal of three hometown men who fight together in Vietnam, *The Deer Hunter* (1979) (Figure 11-9), has serious structural problems because the film takes place in three radically different environments, and it is not always clear how they are related. Yet it won several Academy Awards and has been proclaimed one of the great antiwar films. Cimino took great risks by dividing the film into three large sections: sequences of life in Clairton, Pennsylvania, with a Russian Orthodox wedding and a last hunting expedition for deer; and sequences of war prisoners and fighting in Vietnam; and sequences afterward in Clairton, where only one of the three men, Mike, played by Robert DeNiro, is able to live effectively. Mike finally sets out to get Steven to return from the wheelchair ward of the VA hospital to his wife. Then he sets out to find his best friend, Nick, a heroin addict still in Saigon, playing Russian roulette for hardened Vietnamese gamblers. Russian roulette was not an actual part of the Vietnam experience, but Cimino made it a metaphor for the senselessness of war.

FIGURE 11-10
Susan Sarandon and Geena Davis in Ridley Scott's *Thelma and Louise* (1991), a road-style film with a reversal—the people driving the Thunderbird are women, not men, racing away from the law.

Cimino relied in part on the model of Dante's *Divine Comedy,* also divided into three sections—Hell, Purgatory, and Paradise. In *The Deer Hunter,* the rivers of molten metal in the steel mills and, more obviously, the war scenes suggest the ghastliness of Hell. The extensive and ecstatic scenes in the Russian Orthodox church suggest Paradise, while life in Clairton represents an in-between, a kind of Purgatory. In one of the most stirring episodes, when he is back in Saigon during the American evacuation looking for Nick, Mike is shown standing up in a small boat negotiating his way through the canals. The scene is a visual echo of Eugène Delacroix's *Dante and Virgil in Hell,* a famous nineteenth-century painting. For anyone who recognizes the allusion to Dante, Cimino's structural techniques become clearer, as do his views of war in general and of the Vietnam War in particular.

The function of photography in films such as *8½* and *The Deer Hunter* is sometimes difficult to assess. If we agree that the power of the moving image is central to the ultimate meaning of the motion picture, we can see that the most important structural qualities of any good film develop from the choices made in the editing stage. Sometimes different versions of a single action will be filmed, the director and the editor deciding which will be in the final mix after testing each version in relation to the overall structure.

The episodic structure of Ridley Scott's *Thelma & Louise* (1991) (Figure 11-10) lends itself to contrasting the interiors of a seamy Arkansas nightclub and a cheap motel with the magnificent open road and dramatic landscape of the Southwest. Louise, played by Susan Sarandon, and Thelma, played by Geena Davis, are on the run in Louise's 1956 Thunderbird convertible after Louise shoots and kills Harlan, who had attempted to rape Thelma. Knowing their story will not be believed, they head for Mexico and freedom but never get there. Callie Khouri wrote the script

for this feminist film and cast the women as deeply sympathetic outcasts and desperadoes—roles traditionally reserved for men. In one memorable scene, a truck driver hauling a gasoline rig harasses and makes lecherous faces at the women. The cross-cutting builds considerable tension, which is relieved, at first, when the women pull over as if they were interested in him. As the driver leaves his truck to walk toward them, they shoot his rig, and it explodes like an inferno. The editing in this film is quite conventional, but everyone who has seen it is very likely to remember this scene, the exceptional power of which depends on the use of cross-cutting.

The editor's work gives meaning to the film just as surely as the scriptwriter's and the photographer's. Observe, for instance, the final scenes in Eisenstein's *Battleship Potemkin*. The *Potemkin* is steaming to a confrontation with the Russian fleet. Eisenstein rapidly cuts from inside the ship to outside: showing a view of powerfully moving engine pistons, then the ship cutting deeply into the water, then rapidly back and forth, showing anxiety-ridden faces, all designed to raise the emotional pitch of anyone watching the movie. This kind of cutting or montage was used by Alfred Hitchcock in the shower murder scene of the 1960 horror thriller *Psycho*. He demonstrated that the technique could be used to increase tension and terror, even though no explicit murderous actions were shown on screen. Ironically, the scene was so powerful that its star, Janet Leigh, avoided showers as much as possible, always preferring the bath.

FILMIC MEANINGS

We cannot completely translate filmic meaning into language. We can only approximate a translation by describing the connections—emotional, narrative, symbolic, or whatever—implied by the sequence of images. When we watch the overturning coffin in Bergman's *Wild Strawberries* (1957), for example, we are surprised to find that the figure in the coffin has the same face as Professor Borg, the protagonist, who is himself a witness to what we see. Borg is face to face with his own death. That this scene has special meaning seems clear, yet we cannot completely articulate its significance. The meaning is embodied in the moving images. The scene has a strong tension and impact, and yet it is apparent that the full meaning depends on the context of the whole film in which it appears. The relation of detail to structure exists in every art, of course, but that relation in its nuances often may more easily be missed in our experiences of the film. For one thing, we are not accustomed to permitting images to build their own meanings apart from the meanings we already associate with them. Second, we do not always observe the way one movement or gesture will mean one thing in one context and an entirely different thing in another context. Third, moving images generally are more difficult to remember than still images, as in painting, and thus it is more difficult to become aware of their connections.

The filmmaker must control contexts, especially with reference to the gesture. In Eric Rohmer's film *Claire's Knee* (1970), a totally absurd gesture—

caressing the knee of an indifferent and relatively insensitive young woman—becomes the fundamental focus of the film. This gesture is loaded with meaning throughout the entire film, but loaded only for the main masculine character and us. The young woman is unaware that her knee holds such power over the man. Although the gesture is absurd, in a way it is plausible, for such fixations can occur in anyone. But this film is not concerned solely with plausibility; it is mainly concerned with the gesture in a context that reveals what is unclear in real-life experience—the complexities of some kinds of obsessions. And this is done primarily through skillful photography and editing rather than through spoken narrative.

> PERCEPTION KEY Gesture
>
> 1. Watch a silent film starring Charlie Chaplin or Buster Keaton. Enumerate the most important gestures. If a gesture is repeated, does it accumulate significance? If so, why? Does the absence of sound increase the importance of gesture? Suppose speech were inserted into this film. Would this decrease the importance of the gesture?
> 2. Examine a few recent films for their use of gesture. Are the gestures used in any way to tie the images together, making them more coherent? Be specific. Did you find any film in which gesture plays no significant role?
> 3. Compare the gestures in film with the gestures of sculpture. How do they differ? Do you see film sometimes borrowing familiar gestures, such as the posture of Michelangelo's *David* (Figure 5-8)?

THE CONTEXT OF FILM HISTORY

All meanings, linguistic or nonlinguistic, exist within some kind of context. Most first-rate films exist in many contexts simultaneously, and it is our job as sensitive viewers to be able to decide which are the most important. Film, like every art, has a history, and this history is one of the more significant contexts in which every film takes place. In order to make that historical context fruitful in our filmic experiences, we must do more than just read about that history. We must accumulate a historical sense of film by seeing films that have been important in the development of the medium. Most of us have a very rich personal backlog in film; we have seen a great many films, some of which are memorable and many of which have been influenced by landmark films.

Furthermore, film exists in a context that is meaningful for the life work of a director and, in turn, for us. When we talk about the films of Welles, Bergman, or Fellini, we are talking about the achievements of artists just as much as when we talk about the achievements of Rembrandt, Vermeer, or Van Gogh. Today we watch carefully for films by Steven Spielberg, Francis Ford Coppola, Woody Allen, Oliver Stone, Joel and Ethan Coen, Pedro Almodóvar, Martin Scorsese, Spike Lee, Jane Campion, Quentin Tarantino, and Lina Wertmuller—to name only a few of the most active current

directors—because their work has shown a steady development and because they, in relation to the history of the film, have shown themselves in possession of a vision that is transforming the medium. In other words, they are altering the history of film in significant ways. In turn, we should be interested in knowing what they are doing because they are providing new contexts for increasing our understanding of film.

Our concerns in this book have not been exclusively with one or another kind of context, although we have assumed that the internal context of a work of art is necessarily of first importance to begin with. But no work can be properly understood without resorting to some external contextual examination. To understand the content of a work of art, we must understand something about the subject matter, and the subject matter is always embedded in some external context. Even such a simple act as a gesture may need explanation. For example, in Greece, to put the palm of your hand in the face of someone is considered insulting. If we do not know that and are watching a film involving Greece that includes the gesture, we may be completely misled. A visual image, a contemporary gesture, even a colloquial expression will sometimes show up in a film and need explication in order to be fully understood. Just as we sometimes have to look up a word in a dictionary—which exists outside a poem, for instance—we sometimes have to look outside a film for explanations. Even Terence Young's James Bond thriller movies need such explication, although we rarely think about that. If we failed to understand the political assumptions underlying such films, we would not fully understand what was going on.

Francis Ford Coppola's *The Godfather*

Coppola's *The Godfather* (Figures 11-11 and 11-12), produced in 1972, is based on Mario Puzo's novel about an Italian immigrant fleeing from Sicilian Mafia violence. He eventually became a don of a huge crime family in New York City. The film details the gradual involvement of Michael Corleone, played by Al Pacino, in his father's criminal activities during the years from 1945 to 1959. His father Vito, played by Marlon Brando, suffers the loss of Sonny, an older son, and barely survives an assassination attempt. As Michael becomes more and more a central figure in his family's "business," he grows more frightening and more alienated from those around him until, as Godfather, he becomes, it seems, totally evil.

Although some critics complained that the film glorified the Mafia, almost all have praised its technical mastery. A sequel, *The Godfather: Part II,* was produced in 1974 and, while not as tightly constructed as the first film, fleshes out the experience of Michael as he slowly develops into a criminal. Both films center on the ambiguities involved in the conversion of the poverty-ridden Vito into a wealthy and successful gangster and Michael's conversion from innocence to heartless criminality.

The Godfather films both engage our sympathy with Michael and increasingly horrify us with many of his actions. We admire Michael's personal

FIGURE 11-11
Marlon Brando plays Don Vito Corleone, the Godfather, conferring with a wedding guest asking for an important favor at the beginning of Francis Ford Coppola's *The Godfather* (1972).

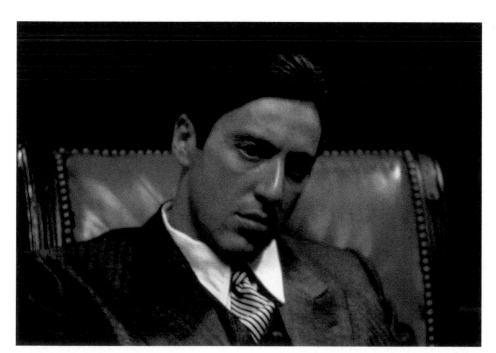

FIGURE 11-12
Late in the film *The Godfather*, Al Pacino reflects on his world now that he is the Godfather after his father's death. The responsibilities of the family have fallen on his shoulders.

valor and his respect for father, family, and friends. But we also see the corruption and violence that are the bases of his power. Inevitably, we have to work out for ourselves the ambiguities that Coppola sets out.

The Narrative Structure of the Godfather Films

The narrative structure of most films supplies the framework on which the filmmaker builds the artistry of the shots and sound. An overemphasis on the artistry, however, can distract a viewer from the narrative, whereas a great film avoids allowing technique to dominate a story. Such is the case with *The Godfather* and *The Godfather: Part II*, we believe, because the artistry produces a cinematic lushness that helps tell the story.

The first film begins with Michael Corleone, as a returning war hero in 1945, refusing to be part of his father's criminal empire. The immediate family enjoys the spoils of criminal life—big cars, a large house in a guarded compound, family celebrations, and lavish weddings. Although Michael's brothers are active members of the crime family, they respect his wishes to remain apart.

In a dispute over whether to add drug-running to the business of gambling, prostitution, extortion, and labor racketeering, Vito is gunned down, but not killed. Michael comes to the aid of his father and so begins his career in the Mafia. It takes him only a short time to rise to the position of Godfather when Vito is too infirm to continue. When he marries Kay, played by Diane Keaton, Michael explains that the family will be totally legitimate in five years. She believes him, but the audience already knows better. It is no surprise that seven years later, the family is more powerful and ruthless than ever.

In a disturbing and deeply ironic sequence, Michael acts as godfather in the church baptism of his nephew at the same time his lieutenants are murdering the men who head the five rival crime families. Coppola jump-cuts back and forth from shots of Michael in the church promising to renounce the work of the devil to shots of his men turning the streets of New York into a bloodbath. This perversion of the sacrament of baptism illustrates the depths to which Michael has sunk.

In the second film, as the family grows in power, Michael moves to Tahoe, gaining control of casino gambling in Nevada. He corrupts a senator, who even while demanding kickbacks expresses contempt for Italians. When the senator is compromised by killing a prostitute, however, he cooperates fully with the Corleones. The point is made again and again that without such corrupt officials, the Mafia would be significantly less powerful.

Michael survives an assassination attempt made possible by his brother Fredo's collusion with another gangster who is Michael's nemesis. At first, Michael does nothing but refuse to talk to Fredo, but when their mother dies, he has Fredo murdered. Meanwhile, Kay has left him, and those who were close to him, except his stepbrother Tom Hagen (Robert Duvall), have been driven away or murdered. The last images we have of Michael show

him alone in his compound staring into a darkened room. We see how far he has fallen since his early idealism.

Coppola's Images

Coppola chooses his frames with great care, and many would make an interesting still photograph. He balances his figures carefully, especially in the quieter scenes, subtly using asymmetry to accent movement. Sometimes he uses harsh lighting that radiates from the center of the shot, focusing attention and creating tension. He rarely cuts rapidly from one shot to another but depends on conventional establishing shots—such as showing a car arriving at a church, a hospital, a home—before showing us shots of their interiors. This conventionality intensifies our sense of the period of the 1940s and 1950s, since most films of that period relied on just such techniques.

Darkness dominates, and interiors often have a tunnel-like quality, suggesting passages to the underworld. Rooms in which Michael and others conduct their business usually have only one source of light, and the resulting high contrast is disorienting. Bright outdoor scenes are often marked by barren snow or winds driving fallen leaves. The seasons of fall and winter predominate, suggesting loneliness and death.

Coppola's Use of Sound

The music in *The Godfather* helps Coppola evoke the mood of the time the film covers. Coppola used his own father, Carmine Coppola, as a composer of some of the music. There are some snatches of Italian hill music from small villages near Amalfi, but sentimental dance music from the big band period of the 1940s and 1950s predominates.

An ingenious and effective use of sound occurs in the baptism/murder scene discussed earlier. Coppola keeps the sounds of the church scene—the priest reciting the Latin liturgy, the organ music, the baby crying—on the soundtrack even when he cuts to the murders being carried out. This accomplishes two important functions—it reinforces the idea that these two scenes are actually occurring simultaneously, and it underscores the hypocrisy of Michael's pious behavior in church. Because such techniques are used sparingly, this instance works with great power.

The Power of the Godfather

Those critics who felt the film glorified the Mafia seem not to have taken into account the fated quality of Michael. He begins like Oedipus—running away from his fate. He does not want to join the Mafia, but when his father is almost killed, his instincts push him toward assuming the role of Godfather. The process of self-destruction consumes him as if it were completely out of his control. Moreover, despite their power and wealth,

Michael and the Corleones seem to have a good time only at weddings, and even then the Godfather is doing business in the back room. Everyone in the family suffers. No one can come and go in freedom. Everyone lives in an armed camp. All the elements of the film reinforce that view. The houses are opulent, but vulnerable to machine guns. The cars are expensive, but they blow up. Surely such a life is not a glory.

In shaping the film in a way that helps us see Mafia life as neither glamorous nor desirable, Coppola forces us to examine our popular culture—one that seems often to venerate criminals like Bonnie and Clyde, Jesse James, Billy the Kid, and John Dillinger. At the same time, Coppola's refusal to treat his characters as simply loathsome, his acknowledgment that they are in some sense victims as well as victimizers, creates an ambiguity that makes his films an impressive achievement.

PERCEPTION KEY *The Godfather*

1. Watch *The Godfather* on DVD on a large screen if possible. Examine the ways in which the pleasing quality of the visuals alters depending on what is being filmed. Are the violent moments treated with any less visual care than the lyrical moments? What happens on screen when the images are unbalanced or skewed enough to make you feel uncomfortable?
2. *The Godfather* is sometimes ironic, as when church music is played while gangsters are murdered. How many such moments can you find in the film in which irony is achieved through the musical choices?
3. The name "Corleone" means lion-hearted, a term usually applied to England's King Richard the Lion-Hearted. Is it possible that the very name of the Godfather is an ironic application? Or do you feel that the Godfather's behavior is as noble as Richard the Lion-Hearted's? Why is there any confusion about this?
4. To what extent does *The Godfather* "lionize" the criminal enterprise of the Mafia? Does the film lure the viewer into accepting as positive the values of the mob? What does the film do to reveal the moral failures of the mob? Why is there so much reference to religion in the film?
5. *The Godfather* was produced almost forty years ago, when the Mafia was a serious power in the United States. If you take into account the social circumstances surrounding the film, would you say that today—with most organized crime bosses in prison—our reactions to this film would make it more or less difficult to romanticize the Mafia? Are you tempted to romanticize these criminals?
6. Is the structure of *The Godfather* episodic, tragic, or comic? Do we experience the feelings of fear and pity? What feelings are engendered by the film? What revelatory experience did you have from watching the film?

A CLASSIC FILM: *CITIZEN KANE*

When it was released in 1941 *Citizen Kane* was shown at first in only one theater. The aged William Randolph Hearst, head of a huge newspaper empire, did everything possible to stop the film, from trying to buy and burn the negative to bribing Hollywood officials. It was widely thought that the main character in the film, Charles Foster Kane, was modeled after him.

For twenty years the film was rarely seen except in 16 mm pirated versions. Despite the fact that in 1941 it was nominated for nine Oscars (it won only for best script), its reputation was made in European showings in the 1950s, and it was not until the mid-1970s that a Hearst newspaper finally "reviewed" the film. In 1998 the American Film Institute proclaimed it the number one film of all time.

The film is marked by an innovative nonlinear narrative, with a reporter piecing together information from an initial newsreel report of Kane's death. Kane's last word, and the first word in the film, is "Rosebud." A magazine reporter then sets out on a hunch that it is important to find out what that word means. In the process he reveals the story of a man who built a great newspaper business, married Emily, a president's niece, failed, because of his infidelity, at a run for governor of New York as a stepping stone to the presidency, then divorced his first wife and married Susan, a talentless woman for whom he built a Chicago opera house only to see her fail in a confected opera, *Salammbô*, and then attempt suicide. In the process, Kane builds an incredibly opulent home called Xanadu, collects an immense amount of art from Europe, loses Susan, and eventually lives and dies a lonely old man.

Since the story is told in terms of fragments and flashbacks, the viewer feels involved in a search for meaning and an act of discovery, a filmic technique that was, as many critics have said, at least fifty years ahead of its time. Even today the film will challenge the viewer. It is told from multiple points of view with numerous sudden flashbacks and interruptions, some of which challenged the audiences of 1941, but most of which are now taken for granted in modern films. The fact that the film technique looks modern to contemporary viewers is one reason *Citizen Kane* has been so highly praised.

The style of *Citizen Kane* is nominally film noir because the chiaroscuro effects of the film, from beginning to end, are similar to the early film noir mysteries that borrowed the stark black-and-white look from 1930s German films. Gregg Toland, the cinematographer, was given credit by Orson Welles, who produced, directed, wrote the script, and starred in the film, all when he was twenty-five years old. The film is notable for calling attention to its stylistic techniques rather than making them transparent. As a result, today we notice the painted mattes and scrims, the occasional animation, the double exposures, and especially the wide-angle lens shots. Toland experimented with lenses that permitted him to have the foreground in focus while the deep background was also in focus. These long shots are a signature of the film. In addition, the camera angles are completely unlike most of what had been done before. The camera often shoots up at the actors, making them appear colossal.

The Structure of Citizen Kane

The film begins with a prologue that resembles a loud series of announcements, then moves into a newsreel typical of the 1940s recapping the life of

Charles Foster Kane. Newspaper headlines underscore the key moments in his life, while still photos give us his image. The newsreel is being screened by magazine editors looking for a story. One reporter, Thompson, determines to follow through on the last word Kane says, "Rosebud." The rest of the film is a series of Thompson's interviews with the principal living witnesses.

Thompson begins with Susan, Kane's second wife, but she seems to be mourning Kane's death and refuses to talk with him. His first real "interview" is in a vast bank vault with pages 83–142 of a manuscript: *The Memoirs of Walter P. Thatcher*, the man who was given the care and raising of Charles Foster Kane. Kane's mother, made unexpectedly rich by a Colorado gold miner who gave her a deed to a mine in lieu of paying his board and keep, determined to protect Kane from his lout of a father. Thatcher, a wealthy banker, took the boy and was given control over his education. All this is told in a flashback in which we first see Kane sledding in the snow while his future is being decided for him. Later we see a mature Kane as a newspaperman planning war with Spain in order to control Cuba. He already reveals that he is two people, one good and one bad, something that informs much of the rest of the film. Thatcher's manuscript reveals their falling out and Thatcher's ultimate hatred of Kane.

The second interview is with Mr. Bernstein, Kane's long-time business manager, who reveals that from the start with the *Inquirer*, Kane was determined to use tricks and subterfuges to get news and gossip that would enliven the paper and make it attractive. The takeover of the newspaper is marked by trashing the high standards of the paper in order to get an audience. All this is done while Kane prints up his "Declaration of Principles," which are themselves a hymn to honesty—but his principles are never respected. This section of the film is marked by enormous high-energy scenes, with Kane posturing brilliantly when he returns from Europe, having married the niece of the president. When Bernstein, who still thinks Kane was a genius, is asked what Rosebud means, he simply says it may be something Kane lost. Kane, he tells Thompson, ultimately lost everything.

Jed Leland is the next interviewee, an old man in a sanitarium who has entirely lost his admiration for Kane. He was a schoolmate who eagerly joined Kane in creating the *Inquirer*, but watched as Kane undid his original values. He tells the story of Kane's first marriage, in a remarkable montage: a series of cuts back and forth between Kane and Emily having breakfast after a night of partying, indicating in each cut a passage of time by changing their clothes and styles. At the end of the montage they sit at a distance reading the paper at the breakfast table as a sign that they have drifted apart (Figure 11-13). Leland relates Kane's bid for governor of New York and then, in a series of flashbacks, tells the story of Susan, Kane's mistress, and being undone by Jim Gettys, the crooked politician Kane campaigned against (Figure 11-14). Competing papers printed headlines such as "Candidate Kane Caught in Love Nest with 'Singer.'" This ended his marriage and moved him to try to develop Susan as a great "singer." The quotation marks around the word galled him.

FIGURE 11-13
Kane and his first wife Emily
(Ruth Warrick) near the end
of their marriage in *Citizen
Kane* (1941) are seen in a shot
that emphasizes the distance
between them both physically
and emotionally. Placing the
camera so far below the table
produced an unsettling moment
in the film.

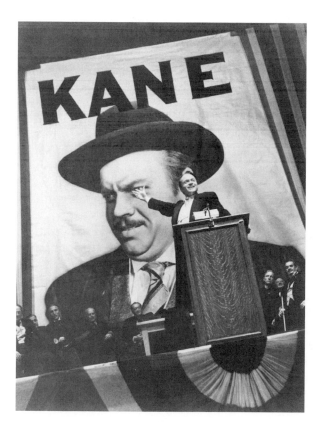

FIGURE 11-14
This scene from *Citizen Kane*
(1941) shows Kane giving his
stump speech in front of his
election banner while running
for governor of New York. The
low camera angle emphasizes
Kane's dynamism and his sense
of power. However, this scene is
followed by his political downfall
and the loss not only of his elec-
tion, but of his wife and family.

FIGURE 11-15
In a scene from *Citizen Kane*
(1941), Kane (Orson Welles),
with his second wife, Susan,
(Dorothy Commingore) works
on a jigsaw puzzle, a symbol
of the film itself, whose pieces
need to be assembled in order
to discover whatever truth can
be found about Charles Foster
Kane.

Leland lost faith in his friend at that time, realizing that Kane was only posturing as an honest liberal, and that he had essentially sold out his values. Leland, the drama critic of the paper, moved to the Chicago office. Another series of flashbacks tells the story of Kane building a Chicago opera house for Susan, having Leland write a bad review after a terrible production of *Salammbô*, modeled on the lush Victorian opera *Thaïs*, also set in Egypt and requiring an outstanding soprano. Susan is so bad in the opera that even she realizes she cannot go on tour, despite Kane's insistence. Kane finishes reading Leland's bad review, then fires him, and that ends their long friendship.

Thompson then returns to interview Susan, now a washed-up drunken singer in a club, and finds she is willing to talk. She tells the story in flashback of her failure in the opera, after which she reads Leland's review and rails against Kane because he let the *Inquirer* print it. When she goes on tour, however, the headlines of the Kane newspapers all praise Susan's performances. After the New York performance she tries to kill herself with poison, but Kane finds and saves her. He then builds the opulent and gigantic castle, Xanadu, in Florida for her. But she is miserable living in it and misses the excitement of New York. She does not want to be a hostess to people she hardly knows, but Kane is unmoved. It is here that she spends her time with jigsaw puzzles, comparing her hobby with Kane's collecting statues that he rarely even uncrates (Figure 11-15). She finally tells Kane

she is leaving him, and he sinks into a depression resembling the Great Depression, which is ruining his newspaper empire. In a startling scene, Kane wrecks Susan's bedroom before she takes her things and goes.

The last interview is brief, with Raymond, Kane's butler at Xanadu. He is an untrustworthy fellow who offers to tell Thompson the meaning of Rosebud for a thousand dollars. But he says only that Kane once used the term when he fingered a snowglobe paperweight, the one that he dropped when he died. Thompson looks over the assembled art treasures that fill the hall at Xanadu and sees they are both treasures and junk. Other reporters ask him questions, particularly whether he found out what Rosebud means. He has not. He tells a friend that it must be the missing piece of a jigsaw puzzle.

Meanwhile, the audience sees some of Kane's junk being thrown into a gigantic fire and with it his childhood sled, named "Rosebud." It is an emblem of a lost childhood innocence, something Kane could not hold on to.

In the final analysis, the film is about power and wealth and their effect on an innocent child. Unlike most films of the era, *Citizen Kane* is not a sentimental favorite, not a film that demands a sense of forgiveness from the audience. Instead, we see Kane for the complex man that he was, and in a sense we understand him no better than Thompson does.

PERCEPTION KEY *Citizen Kane*

1. This film is available on Warner Home Video DVD. Viewing *Citizen Kane* on a computer gives us the best chance to study each frame and each editing cut and montage with care. When you view *Citizen Kane*, consider some of the issues that constitute a good film. Begin with the skillful use of the tones of the black-and-white cinematography. Examine the scenes in which the faces of the primary actors move in and out of the light. Which moments imply a dark message when Kane's face moves into darkness? Which moments of strong chiaroscuro seem most effective to you? The editing, by Robert Wise, was nominated for an Academy Award—which edits did you find especially unsettling or especially powerful?

2. Comment on the visual organization of any specific still frames. Does the point of view of the camera make a clear value judgment among the characters and the forces they represent?

3. To what extent does the camera angle in Susan's scenes help to make her sympathetic in places and unsympathetic in other places? Why is Kane so often shot from below with a ceiling sometimes low over his head?

4. The music in the film, by Bernard Herrmann, was nominated for an Academy Award. Which passages did you feel had the most important supportive music? Why would the Academy nominate Herrmann's score?

5. Comment on the structure of the film. To what extent does the metaphor of the jigsaw puzzle help clarify the nature of the narrative? How effective is the use of flashback in the various interviews? Do you see similar techniques used today in modern films?

6. When this film was first made it was not always customary for people to see a film starting at the beginning, but to go anytime after it started and then stay until the place where they came in. Why would it be important to take the advice of the 1941 ads to see it from the beginning?

(continued)

7. *Citizen Kane* has had a profound appeal to the different generations that have seen it, probably in part because of apparent connections with abuse of power in contemporary life. What virtue does the film have for people in today's college-age generation? Is the critique of power and wealth in the film generic and abstract, or does it seem related to problems of power in your own immediate experience?

EXPERIMENTATION

In the early days of film, complex technical problems were at the forefront—lighting, zooming, montage, and the like. Most of these problems now have answers, thanks especially to early filmmakers such as Griffith and Eisenstein. Today the problems center on what to do with these answers. For example, Andy Warhol, primarily a painter and sculptor, did some interesting work in raising questions about film, especially about the limits of realism, for realism is often praised in films. But when Warhol put a figure in front of a camera to sleep for a full eight hours, we got the message: We want a transformation of reality that gives us insight into reality, not reality itself. The difference is important because it is the difference between reality and art. Except when unconscious or dreaming, we have reality in front of us all of the time. We have art much less frequently. Realistic art is a selection of elements that convey the illusion of reality. When we see Warhol's almost direct transcription of reality on film, we understand that selecting—through directing and editing—is crucial to film art. The power of most striking films is often their ability to condense experience, to take a year, for example, and portray it in ninety minutes. This condensation is what Marcel Proust, one of the greatest of novelists, expected from the novel:

> Every emotion is multiplied ten-fold, into which this book comes to disturb us as might a dream, but a dream more lucid, and of a more lasting impression, than those which come to us in sleep; why, then, for a space of an hour he sets free within us all the joys and sorrows in the world, a few of which, only, we should have to spend years of our actual life in getting to know, and the keenest, the most intense of which would never have been revealed to us because the slow course of their development stops our perception of them. It is the same in life; the heart changes . . . but we learn of it only from reading or by imagination; in reality its alteration . . . is so gradual that . . . we are spared the actual sensation of change.[2]

Some films address the question of the portrayal of reality. Antonioni's *Blow Up* (1966), for example, has the thread of a narrative holding it together: a possible murder and the efforts of a magazine photographer, through the medium of his own enlargements, to confirm the reality of that murder. But anyone who saw the film might assume that the continuity of the narrative was not necessarily the most important part of the film. Much of the meaning seems to come out of what were essentially disconnected moments: an odd party, some strange driving around London, and some extraordinary tennis

[2]Marcel Proust, *Swann's Way*, trans. C. K. Scott Moncrieff (New York: Modern Library, 1928), p. 119.

played without a ball. What seemed most important, perhaps, was the role of the film itself in suggesting certain realities. In a sense, the murder was a reality only after the film uncovered it. Is it possible that Antonioni is saying something similar about the reality that surrounds the very film he is creating? There is a reality, but where? Is *Blow Up* more concerned with the film images as reality than it is with reality outside the film? If you have a chance to see this fascinating film, be sure you ask that puzzling question.

Some more extreme experimenters remove the narrative entirely and simply present successions of images, almost in the manner of a nightmare or a drug experience. Sometimes the images are abstract, nothing more than visual patterns, as with abstract painting. Some use familiar images, but modify them with unexpected time-lapse photography and distortions of color and sound. Among the more successful films of this kind are *Koyaanisqatsi* (1983) and *Brooklyn Bridge* (1994). The fact that we have very little abstract film may have several explanations. Part of the power of abstract painting seems to depend on its "all-at-onceness" (see "Abstract Painting," Chapter 4), precisely what is missing from film. Another reason may be tied in, again, with the popular nature of the medium—the masses simply do not prefer abstraction.

The public generally is convinced that film, like literature and drama, must have plots and characters. Thus even filmic cartoons are rarely abstract, although they are not photographs but drawings. Such animated films as *Pinocchio* (1940), *Fantasia* (1940), and *Dumbo* (1941) have yielded to enormously successful later films such as *The Yellow Submarine* (1968), *Beauty and the Beast* (1993), *The Lion King* (1994), *Toy Story* (1995), *Pocahontas* (1995), and *Shrek* (2004). It may be unreasonable to consider animated films as experimental, and it is certainly unreasonable to think of them as children's films, since adult audiences have made them successful. What they seem to offer an audience is a realistic approach to fantasy that has all the elements of the traditional narrative film. This may also be true of animated films using clay figures and puppets for actors. These have had a narrower audience than cartoon and computer animations and have been restricted to film festivals, which is where most experimental films are presented.

PERCEPTION KEY Make a Film

The easy availability of video recorders makes it possible for you to make a film (actually a video). With a video camera, you may need to rerecord on a computer, reorganizing your visual material to take advantage of the various shot and editing techniques.

1. Develop a short narrative plan for your shots. After shooting, edit your shots into a meaningful sequence.
2. Instead of a narrative plan, choose a musical composition that is especially interesting to you and then fuse moving images with the music.
3. Short of making a film, try some editing by finding and clipping from twenty to thirty "stills" from magazines, brochures, newspapers, or other sources. Choose stills you believe may have some coherence and then arrange them in such a way as to make a meaningful sequence. How are your stills affected by rearrangement? This project might be more interesting if you use or make slides for viewing. Then add a soundtrack to heighten interest by clarifying the meaning of the sequence.

SUMMARY

The making of film is exceptionally complex because of the necessary and often difficult collaboration required among many people, especially the director, scriptwriter, actors, photographer, and editor. The range of possible subject matters is exceptionally extensive for film. The resources of the director in choosing shots and the imagination of the editor in joining shots provide the primary control over the material. Such choices translate into emotional responses evoked from the audience. The point of view that can be achieved with the camera is similar to that of the unaided human eye, but because of technical refinements, such as the wide-angle zoom lens and moving multiple cameras, the dramatic effect of vision can be greatly intensified. Because it is easy to block out everything irrelevant to the film in a dark theater, our participative experiences with film tend to be especially strong and much longer, of course, than with other visual arts. The temptation to identify with a given actor or situation in a film may distort the participative experience by blocking our perception of the form of the film, thus causing us to miss the content. The combination of sound, both dialogue and music (or sound effects), with the moving image helps engage our participation. The film is the most popular of our modern arts.

Chapter 12

TELEVISION AND VIDEO ART

THE EVOLUTION OF TELEVISION

Television, the most widely used artistic medium in contemporary culture, grew out of the radio broadcasts of the early decades of the twentieth century and developed in part from the traditions of drama and film. Because it was a product of a commercial culture, and because the Federal Communications Commission and governmental agencies that oversaw its early development insisted on its goals being devoted more to entertainment than to education, it has in large part been shaped by the needs of advertisers. This was not inevitable, but a decision made by politicians in the United States. Television developed differently in the United Kingdom and in other nations; but now, more than eighty years after the widespread introduction of television programming, the model established by the United States has become virtually the norm.

Consequently, much of what people around the world see on their television is dramatic entertainment similar to both the stage play and the cinematic experience. However, the commercial needs of television have created a formal structure that makes it distinct from both stage and screen. Instead of watching *CSI: Miami, Law and Order, NCIS,* or *Two and a Half Men* in a darkened room with a group of strangers, we watch them at home on a large or small screen in regular or high definition, in analog or digital images, with our families or alone. The needs of advertisers have dictated that hour-long episodes of standard shows be interrupted by commercials, thus necessitating that the drama itself have as many as six "crisis points" that

precede the advertising. Public broadcasting stations, on the other hand, do without commercials but often seem to have the same kind of structure, as if anticipating a subsequent broadcast on a commercial network. Home Box Office (HBO), a premium cable channel, charges a subscription fee, and thus its programs do not need to conform to network standards of decency or advertisers' needs. Television has evolved in such a way as to make it distinct from the earlier media from which it originated.

Television was originally ignored by filmmakers because the inherent limitations of the medium held them back. Standard-definition television images are projected at thirty frames per second, instead of twenty-four, in order to overcome limitations of the low-resolution image itself. The pixels in a video screen do not admit the range of contrast or the level of detail and resolution that are common to the continuous imagery of film. The interior of the cathode-ray tube has 525 vertical by 740 horizontal lines of pixels (a pixel is a group of green, red, and blue light-emitting phosphors), and because of technical limitations, the actual screen size is close to 480 by 740 pixels. The result is that long shots lose detail quickly and close-ups are preferred because they contain more emotional information. The viewing experience is always less "sharp" than it is for film. In addition, the back projection of the image made the early television screens extremely small.

Today the use of digital projection and digital cameras has made some of those limitations less significant. Current television screens are large enough to create home theaters. High-definition broadcast standards have closed the gap between television and film to a considerable extent. High-definition flat screens can contain 1,080 vertical by 1,920 horizontal pixels, permitting vastly improved details from both broadcast television and DVDs. However, despite recent technical improvements, and further improvements being planned, the ways in which television programs are viewed will probably always create a gap between television and film.

PERCEPTION KEY Television and Cinema

1. To what extent does watching a film on television make it more difficult to have a participatory experience as compared to watching the same film in a theater? Does the size of the moving image determine or limit your participatory experience?
2. What kinds of shots dominate television programming: close-ups, midrange shots, long shots? Are there any visual techniques used in television that are not used in film?
3. The video screen has less tonal range than film and less ability to represent detail. How do television programs try to accommodate these limitations? How pronounced are the differences in visual quality between television and film? To what extent does high-definition television alter the relationship of the video screen with the film screen?
4. Compare the sound of a television program with that of film. What effect does the experience of sound have on your sense of participation?

The moving image is as much the subject matter of television and video art as it is of film. The power of the image to excite a viewer, combined with music and sound, is more and more becoming an intense experience as the technology of the medium develops. Surround sound, large projection screens and LCDs, and the development of digital high definition have transformed the "small box" into an overwhelming and encompassing television experience that can produce almost the same kind of participation that we experience in a movie theater.

The subject matter of a given television program can range from the social interaction of characters on programs such as *Cheers* (NBC, 1982–1993), *Seinfeld* (1990–1998), and *Friends* (NBC, 1994–2004) all the way to the political and historical issues revealed in *Roots* (ABC, 1977) and *Holocaust* (NBC, 1978). Programming can be realistic or surrealistic, animated or with living actors, but in all cases the power of the moving image is as important in television as in film.

Video art is, however, the antithesis of commercial entertainment television. Because broadcast television centers on the needs of advertisers and depends on reaching specific demographics, it has become slick and to a large extent predictable. There is little room for experimentation in commercial television, but the opposite is true for video art. Artists such as Nam June Paik and Bill Viola are distinct in that their work has pioneered the use of video terminals, video imagery and sound, and video projection as fundamental to the purposes of the video artist.

Instead of a single image to arrest our attention, Nam June Paik often uses simultaneous multiple video monitors with different images whose intense movement is rarely linear and sequential, as in conventional broadcast television. His images appear and disappear rapidly, sometimes so rapidly that it is difficult to know exactly what they are. Paik has inspired numerous contemporary artists who work with and interact with monitors to achieve various effects. Bill Viola's work is often composed of multiple projected images using slow motion and low-volume sound. His work is hypnotic and so profoundly anticommercial that it forces us to look at the combination of visual and aural imagery in completely new ways. Video art surprises us and teaches us patience at the same time.

Just as some television programs can be experienced on the computer screen or on the portable iPod-style monitor, the same is true for some video art because it is an international movement. The Internet permits us to see the work of a great many leading artists from around the world at our convenience.

Commercial Television

Early black-and-white television began with its roots in radio and vaudeville. The first superstar of television was Milton Berle, whose variety show, *Texaco Star Theater* (ABC, 1948–1953), was part stand-up comedy and part baggy pants vaudeville and music. So many people bought television sets just to see Berle each Tuesday night that he was nicknamed "Mr. Television."

FIGURE 12-1
A typical scene from *The Honeymooners* with a smug Ralph Kramden (Jackie Gleason) seriously annoying his wife Alice (Audrey Meadows) while Ed Norton (Art Carney) and Trixie Norton (Jane Kean) stand by to see what will happen.

In 1951, NBC signed a contract to pay him $200,000 a year for thirty years as long as he did not appear on any other network. But the novelty of Berle and the variety format wore off rapidly, and competition caused Texaco to drop the show. The shows of Jack Benny, Fred Allen, Amos and Andy, and others moved from radio to television to help fill the schedules. Films were slow to arrive on the television screen, so hour-long dramas were produced for the *Hallmark Hall of Fame* and other shows. Eventually, the rise of cable television provided a wide range of films available almost all day and evening long—but that development was long in coming. The early days of television were essentially derivative of other forms of entertainment.

The Television Series

Eventually, the half-hour situation comedies and hour-long drama series began to dominate network television as they do today. Studying the content of early situation comedies reveals much about the social structure of the family and the larger community. Early comedies were often ethnic in content: *The Goldbergs* (CBS, 1949–1955) portrayed a caring Jewish family in New York City. The show ended when the family "moved" to the suburbs. *The Life of Riley* (NBC, 1953–1958) starred William Bendix as a riveter in a comedy about an Irish working-class family in Los Angeles. *Amos and Andy* (CBS, 1951–1953), which moved from radio, was set in Harlem, but because of complaints about black stereotypes, it was soon dropped by the network. Yet it had been a popular program even among some African Americans. These early shows, including *The Honeymooners* (NBC, 1952–1956, specials in 1970) (Figure 12-1), with Jackie Gleason, usually portrayed urban

working-class families facing some of the same everyday problems as did the audience.

PERCEPTION KEY Early Situation Comedies

Because early comedies are widely available on channels such as Nickelodeon, on DVD or VHS video, or from downloads, you may be able to view a sample episode from one of the series mentioned above, as well as from *Leave It to Beaver, Gilligan's Island, Father Knows Best, Happy Days, All in the Family, I Love Lucy,* or *M*A*S*H,* in order to respond to the following:

1. How does the structure of the situation comedy differ from that of a standard film?
2. Who are the characters in the comedy you have seen, and what is their social status? Is there any awareness of the political environment in which they live?
3. What are the ambitions of the families in any of these situation comedies? What are they trying to achieve in life? Do you find yourself sympathetic to the older characters? The younger characters?
4. Compare any one of these situation comedies with a current comedy seen on TV. What are the obvious differences? Based on your comparison, how has society changed since the earlier situation comedy? Do any of the changes you note imply that these comedies have a content that includes a commentary on the social life of their times?
5. What are the lasting values—if any—revealed in the early situation comedies? What values seem to have changed profoundly?

The Structure of the Self-Contained Episode

The early television series programs were self-contained half- or one-hour narratives that had a beginning, middle, and end. *Gunsmoke* (CBS, 1955–1975) was one of the longest-running and best-loved hour-long drama series on television. It can still be seen in syndication. The main character, Matt Dillon (James Arness), faced a difficult foe every episode, and in true western fashion, he never backed down and always did right. The episodes were broken by commercial interruption, so the writers made sure you wanted to see what happened next by creating cliff-hangers. But each episode was complete in itself. Because there was no background preparation needed, the viewer could see the episodes in any order and be fully satisfied. Until late in the 1980s, that was the standard for a series. As with another popular western series, *Bonanza* (NBC, 1959–1973), the characters generally remained the same, the situations were familiar and appropriate to the locale, and the sense of completion at the end of each episode was satisfying, as it is, for instance, in most films.

The pattern was constant in most genres of dramas. Current crime dramas, *Law and Order* (NBC, 1989), *CSI* (CBS, 2000), and each of their "branded" versions, follow the same pattern. Each of these successful series depends on a formula. *Law and Order,* the most successful show of its kind, has relied on interpreting versions of recent crimes ("ripped from the headlines"). There is a clear-cut division between the police, who investigate a crime, and the prosecutors, who take the case to court. *CSI* (Figure 12-2) in its several versions usually follows two separate killings and spends a great deal of time in the lab analyzing fingerprints and other forensic details. So

FIGURE 12-2
Gil Grissom (William Petersen), Catherine Willows (Marge Helgenberger), and Captain Jim Brass (Paul Guilfoyle) investigate a case of arson in *CSI: Crime Scene Investigation*, one of many long-running police procedural programs.

far, these have held the attention of mass audiences. But the structure of these shows is predictable, and each episode is, for the most part, complete so that no one who comes to any episode needs to be "brought up to speed" in order to appreciate the action.

The important thing about the usual series episode on television is that it is self-contained. It does not need preparation in advance, nor does it need explanation. Like a brief stage play, it is complete in itself. In this sense, the television series episode is a version of drama rather than an offshoot of drama. It is a "one-off" each time the program airs. What does not change—usually—are the characters, the locale, and the time when the program airs.

The Television Serial

One type of program with which commercial television has set itself apart from the standard production film is the serial. While the standard production film is about 120 minutes long, a television serial production can be open-ended. In the 1940s, children's films on Saturday mornings were made as serials, with cliff-hangers designed to make sure children tuned in the next week. Still, each episode was complete except for its ending. No child had to see earlier episodes in order to appreciate a current episode. Soap operas, daytime television's adaptation of radio's ongoing series, similar in structure, were broadcast at the same hour each weekday. Viewers could begin with any episode and be entertained, even though each episode had only a minor resolution. Early television soap operas such as *Another World* (NBC, 1964–1999), *The Secret Storm* (CBS, 1954–1974), and *Search for Tomorrow* (CBS, 1951–1986) were continuing stories focusing on personal problems involving money, sex, and questionable behavior

FIGURE 12-3
Kunta Kinte (LeVar Burton) in Alex Haley's
television drama *Roots,* the most widely
watched television drama of its time. Kunta
Kinte represents Haley's ancestor as he is
brought in chains from Africa.

in settings reflecting the current community. They usually did not have first-rate actors or well-funded production values. Yet they attracted a wide audience anxious about the fate of the characters whom they came to "know" well. In Spanish-language programming, *telenovelas* do the same.

In a sense, the structure of the soap opera contributed to television's development of the distinctive serial structure that remains one of the greatest strengths of the medium. Robert J. Thompson has said, "The series is, indeed, broadcasting's unique aesthetic contribution to Western art."[1] The British Broadcasting Corporation can be said to have begun the development of the serial show with historical epics such as the hugely popular open-ended *Upstairs, Downstairs* (BBC, 1971–1975) and twelve-part *I, Claudius* (BBC, 1976), both of which are now available in DVD format.

Roots: The Triumph of an American Family The first important serial program in the United States was *Rich Man, Poor Man* (ABC, 1976), a twelve-episode adaptation of a novel by Irwin Shaw. But the power of the serial was made most evident by the production of *Roots* (ABC, 1977), which was seen by 130 million viewers, the largest audience of any television series (Figure 12-3). More than 85 percent of all television households were tuned to one or more of the episodes.

The subtitle of the serial, *The Triumph of an American Family,* focused the public's attention on family and family values. Alex Haley's novel represented itself as a search for roots, for the ancestors who shaped himself and

[1]Quoted in Glen Creeber, *Serial Television* (London: British Film Institute, 2004), p. 6.

FIGURE 12-4
Tony Soprano (James Gandolfini), Carmela Soprano (Edie Falco), and Anthony Soprano, Jr. (Robert Iler) in a favorite diner having a difficult family conversation at the end of the sixth and final season of *The Sopranos*.

his family. African American slaves were ripped from their native soil, and the meager records of their travel to the West did not include information about their families. As a result, genealogy is not a hobby of most African Americans. But Haley showed how, by his persistence, he was able to press far enough to find his original progenitor, Kunta Kinte, in Africa.

Roots, which lasted twelve hours, explored the moral issues relative to slavery as well as racism and the damage it does. The network was uneasy about the production and feared it might not be popular, which is the primary reason why the eight episodes were shown on successive nights. The opening scenes of the program, not in Haley's novel, show white actor Ed Asner, then a popular television figure, as a conscience-stricken slave boat captain. This was intended to make the unpleasantness of the reality of slavery more tolerable to a white audience. The network executives were, as we know now, wrong to worry, because the series absolutely captured the attention of the mass of American television viewers. Never had so many people watched one program. Never had so many Americans faced questions related to the institution of slavery in America and what it meant to those who were enslaved. *Roots* changed the way many people thought about African Americans, and it also changed the way most Americans thought about television as merely entertainment.

Home Box Office: **The Sopranos** One of the most successful television series in recent years has been the result in large part of the expansion of cable television and the many channels that have ultimately weakened the traditional networks' hold on entertainment. Interestingly, ABC, Fox, and CBS all rejected the show before HBO stepped in to begin production. And from the first, television critics, cultural critics, and even cinema critics hailed *The Sopranos* as fresh, original, and intelligent (Figure 12-4).

HBO essentially transformed the popular gangster genre, which had enjoyed enormous popularity in films, from James Cagney's portrayal of a gangster in the 1930s in *The Public Enemy* (1931), through *The Godfather* (1974) and *Goodfellas* (1990), all the way to Quentin Tarantino's cartoonish *Pulp Fiction* (1994). These gangster movies constitute part of a stylistic category much as westerns do. However, the moral vision of the western has usually been high-minded, while the moral vision of the gangster film has usually been muddied and vague, partly because the audience is invited to thrill to what one critic calls "aesthetic violence." In some gangster films, the audience is invited to identify with the criminal, even though the criminal usually meets some form of justice.

Television's *The Sopranos* differs from any gangster film treatment by virtue of its having an extended space in which to work. Individual episodes do not usually end in cliff-hanger climaxes. In fact, the idea of climax is often neutralized by long, meditative sessions—usually wordless, with little more than incidental room noise and background music (or television sounds), which go on for as much as a full minute. It is this ability to stretch the action that makes it possible for the viewer to respond on several levels to the action.

The Sopranos differs from any network crime program in that the standards of acceptable language do not apply to premium cable television, which is financed entirely by subscription. In that one way alone, the program has considerable liberty in portraying the mobsters' use of foul language in what the viewer senses is an accurate approximation of reality. Further, the mobsters use the Bada-Bing, a strip club, as their headquarters. Nudity, also rare in network television and family shows, is common in *The Sopranos*, reflecting much of the reality of urban life today. Needless to say, the structure of the series makes the six crisis points of the standard hour show unnecessary; so a greater intensity is achieved because there are no interruptions in the progress of the scenes.

One problem with Francis Ford Coppola's *The Godfather* was that people saw the film as valorizing the Mafia, making it glamorous and appealing. That was not Coppola's intention, but it became an unavoidable result of the various "heroics" of Michael Corleone (Al Pacino) in the face of an attack by a rival family. *The Sopranos* has not had that effect on most viewers. For one thing, the mindless and conscienceless violence in the show is committed by people whose limitations we have already been made to understand. For example, we are not invited to admire *The Sopranos'* Paulie Walnuts, who maims and murders with virtually no sense that a person's life has any value at all. Yet he invites our contempt when he cowers at the thought of having a biopsy for possible prostate cancer, or when he goes "ballistic" over discovering that the woman who raised him was not his mother and that his real mother was the nun whom he thought was his aunt. He then calls his biological mother a "whore" while she lies on her deathbed. He is fascinating, but unredeemable.

The Sopranos offers a curious portrait of the mob that includes many moments of reprehensible actions as well as moments of derring-do. The small-time nature of the life that the Sopranos' mob lives is also an interesting clue to the limits of mob life. Except for men at the top like Tony Soprano

and his next in line, Silvio, the rest of the gangsters live almost meanly, usually worrying about how they will pay for things they need. They resemble a pyramid scheme, with those at the bottom doing the work and those at the top getting most of the benefits. All of the mobsters reflect their lack of education and the limits of their intelligence by getting their facts wrong, misusing language in a comic way, and arguing about trivia, often television or film trivia. These moments offer the viewer some comic relief.

From the first, *The Sopranos* established itself as a program designed to analyze mob life. The opening scene of the first episode involves Tony Soprano risking his reputation as a tough guy by going into analysis with a psychiatrist, Dr. Jennifer Melfi, because of panic attacks suffered through stress "on the job." These analytical sessions, like the show itself, are open-ended and do not resolve themselves into any specific "solutions" that bring the analysis to a close. The repetition of scenes in the analyst's office reinforces the fact that we are expected to conduct a constant analysis of the program on our own.

The following is a brief segment from a *Sopranos* script. It is Scene 55, the last scene of "The Knight in White Shining Armor," an episode from the second season. Just before this ending scene, Tony's sister, Janice, shot her fiancé to death while he threatened and belittled her. Tony helped her get rid of the body and get out of town. Scene 55 demonstrates the quiet complicity of a mobster's wife (Carmela Soprano) and contrasts Janice's relationship with the ordinary "family life" of Carmela and Tony.

THE SOPRANOS SCENE 55

[55 Int. Soprano House—Living Room—Day]

[CARMELA *is reading "Memoirs of a Geisha." Brochures and pamphlets on the coffee table next to her. She hears someone come in.*]

CARMELA. [*calling*] MEADOW, you have a UPS. It's up in your room.

[*But it's* TONY *who finds her.*]

TONY. What are you doing in here?

CARMELA. Oh, it's you. You've been gone all night, half the morning. What happened over there?

TONY. JANICE decided to go back to Seattle.

CARMELA. You're kidding. What about RICHIE? He must be devastated.

TONY. RICHIE's gone.

CARMELA. What do you mean, gone?

TONY. Gone.

CARMELA. Where?

TONY. CARMELA, after twenty years of marriage don't make me make you an accessory after the fact.

CARMELA. Accessory after the . . . ?

[*beat*]

Holy shit.

TONY. Stop asking.

CARMELA. Oh, my God. Oh, my God.

TONY. I took care of it.

[*What can she say? He did. Only he could—and would. She shakes the cobwebs out of her head.*]

CARMELA. That . . . that was not a marriage made in heaven.

[She stares off, grows quiet. TONY notices the travel brochures.]

TONY. What's this?

CARMELA. *[beat]* After meadow's graduation, me and ROSALIE APRILE are going to Rome. For three weeks.

TONY. Excuse me?

CARMELA. We're gonna stay at the Hassler. Shop. Try and see the Holy Father, maybe go on a tour of Tuscany.

TONY. What are people gonna say if you take off for three weeks?

CARMELA. You'll have to chauffeur AJ around to his dentist and whatnot. And you've gotta find a tennis clinic for MEADOW to join. Because if I have to do it, TONY, I just might commit suicide.

[She smirks. Then the smirk fades. Not smiling, she leaves the room. TONY sits there.]

THE END

PERCEPTION KEY *The Sopranos*

The Sopranos is available on DVD. The scene above is from "The Knight in White Shining Armor," the next to last episode of Season Two. A "sanitized" version of *The Sopranos* may be rerun on the Arts & Entertainment cable channel. If possible, view this episode (or another) to help you use this Perception Key.

1. In Scene 55, what are the "ordinary" family issues that occupy Carmela's attention? What occupies Tony's attention?
2. What distinguishes this scene from an ordinary family concern? Do you find the contrast between Tony's family and Janice's dramatically appropriate?
3. After viewing *The Sopranos*, do you find yourself admiring in any way the mobsters? Do you think most people would admire them? What is admirable about them, if anything?
4. What distinguishes *The Sopranos* from the gangster films you have seen?
5. What makes *The Sopranos* appropriate for television? Would it be just as effective on screen as a film? More effective? Examine individual scenes and shots to see what the producers have done to make *The Sopranos* effective on a television screen.
6. The final episode ends without anything resolved or anticipated. Many viewers thought something had gone wrong with their televisions or that there had been some kind of broadcasting cutoff. Many thought the ending was dramatically stupid. What do you think an Aristotelian critic would say? What do you say?

***Home Box Office:* The Wire** While *The Sopranos* portrayed the life of a Mafia family, another crime drama aimed at portraying the city of Baltimore as a way of demonstrating that all the segments of a community are interwoven. David Simon, formerly a reporter for a Baltimore newspaper, and Ed Burns, a former homicide detective, are responsible for creating the drama, drawing on their personal experience. *The Wire* is about the frustrations of a police unit that tries to use wiretapping to track the progress

FIGURE 12-7
Nam June Paik, *Video Flag z.*1986. Television sets, videodisc players, videodiscs, Plexiglass modular cabinet, 74½ ×138¾ × 18 inches (189.2 × 352.4 × 45.7 cm).

Paik's *Video Flag z* is on display at the Los Angeles County Museum of Art, where it blinks and changes images rapidly in prescribed patterns.

Flag z (Figure 12-7) is a large installation approximately six feet high by twelve feet wide, with eighty-four video monitors with two channels of information constantly changing, at a speed that makes it difficult to identify the specific images on each monitor. The effect is hypnotic and strange, but viewers are usually captured by the imagery and the dynamism of the several patterns that alternate in the monitors. Paik experimented widely with video monitors, combining them, in one case, to produce cello music, played by Charlotte Moorman, a musician and performance artist. In another installation, *Arc Double Face* (1985), he produced a large doorway composed of large monitors with three separate video channels showing simultaneously.

Peter Campus (b. 1937) has also been a seminal figure in video art. His *Three Transitions* (1973) at New York's Museum of Modern Art is a five-minute video of himself projected on a paper partition, his front on one side and his back on the other. Slowly, a hand reaches through from the front and pierces the back as if it were cutting through the paper. The image is that of an old-fashioned television monitor complete with a black frame. *Interface* (1972) (Figure 12-8) interacts with the viewer, whose image is projected from the back of a clear glass panel and whose reflection, in reverse, appears with it. The several images can merge depending on the movement of the viewer. The result is unsettling because it confounds our ideas about mirrors.

Gary Hill's (b. 1951) installation at the Museum of Modern Art in New York, *Inasmuch As It Is Always Already Taking Place* (1990) (Figure 12-9), is a collection of sixteen video monitors of varying sizes positioned in a horizontal recess in a wall. The monitors produce essentially a self-portrait, although a strange one. They show parts of Hill's body arranged haphazardly and projected in a seamless loop, each lasting from five to thirty seconds. The sixteen channels operate simultaneously with a low-volume soundtrack of rubbing skin, crinkling paper, and whispered sounds. The commentary

FIGURE 12-8
Peter Campus, prototype
for *Interface*. 1972. Video
installation. Dimensions
variable. Antiguo Colegio de San
Ildefonso, Mexico City, 2003.

Campus specializes in mysteri-
ous video experiences in which
his educational background,
experimental psychology, comes
into play.

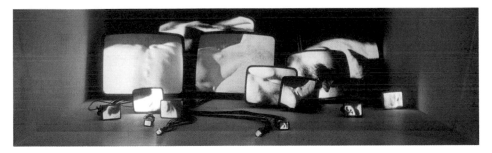

FIGURE 12-9
Gary Hill, *Inasmuch As It Is
Always Already Taking Place*.
1990. Sixteen-channel video/
sound installation: sixteen
modified ½-inch to 23-inch
black-and-white video moni-
tors, two speakers, multichan-
nel audio mixer with equalizer,
sixteen DVD players and sixteen
DVDs. Dimensions: horizontal
niche: 16 × 54 × 66 inches (41×
137 × 167 cm). Edition of two
and one artist's proof.

This installation in the New
York Museum of Modern Art
is hypnotic, with sixteen televi-
sion channels on various sizes
of monitors in which different
parts of Hill's body appear.

provided by the museum says that the unseen "core" linking all the moni-
tors mimics the unseen human soul.

Another active and constantly changing installation is Judith Barry's
(b. 1949) *Imagination, Dead Imagine* (1991) (Figure 12-10). It consists of
five video projectors with five DVD players. Each surface of the cube shows
a portion of a woman's face that remains static for a considerable time,
becomes slowly covered by a dark liquid until it is obliterated, and then
gradually returns to "normal." In a second room, an assemblage of plastic
on the floor reacts with the movement of the viewer while four projectors
flash a series of texts on the walls.

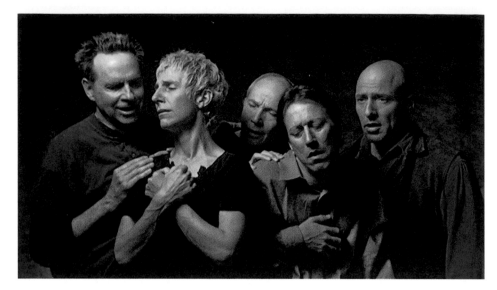

FIGURE 12-13
Bill Viola, *The Quintet of the Astonished*. 2000. Video/sound installation, rear projected on a screen mounted on a wall.

The work is a study in the expression of feelings.

Greeting, the wind blows softly, moving the women's draped clothing. Except for the wind, the projection is almost soundless, the action pointedly slow, but ultimately fascinating. The resources of slow-motion video are greater than we would have thought before seeing these images. Viola's techniques produce a totally new means of participation with the images, and our sense of time and space seems somehow altered in a manner that is revelatory of both the sensa of the work and the human content of greeting and joy.

Another remarkable installation that moved from the Getty Museum in Los Angeles to the National Gallery of Art in London is *The Passions* (2000–2002), a study of the uncontrollable human emotions that Viola sees as the passions that great artists of the past alluded to in their work. *The Quintet of the Astonished* (2000) (Figure 12-13), one of several video installations in the series *The Passions*, was projected on a flat-screen monitor, revealing the wide range of emotions that these figures were capable of. Figure 12-14, *Dolorosa*, also part of *The Passions*, shows the panels as they were exhibited. The original footage was shot at 300 frames per second but then exhibited at the standard television speed of 30 frames per second. At times, it looks as if the figures are not moving at all, but eventually the viewer sees that the expressions on the faces change slowly and the detail by which they alter is extremely observable, as it would not be at normal speed. *The Passions* consists of several different installations, all exploring varieties of emotional expression.

Bill Viola's work is informed by classical artists and by his own commitment to a religious sensibility. In his comments about his work, he often observes the religious impulse as it has been expressed by the artists of the Renaissance whom he admires, and as it has informed his awareness of spirituality in his own life.

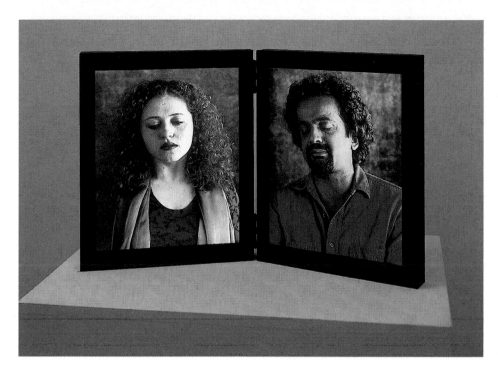

FIGURE 12-14
Bill Viola, *Dolarosa*. 2000.
Color video diptych on two
freestanding LCD panels.

The work portrays feelings
associated with the title, which
translates as "sadness."

PERCEPTION KEY Bill Viola and Other Video Artists

Most of us do not live near an installation by Bill Viola or other video artists, but there is a great deal of video art online, including some of Viola's. This Perception Key relies on your having the opportunity to see some of the important online sites.

1. The online site www.jamescohan.com/artists/bill-viola contains a good deal of information about Viola and his work. It includes video excerpts of him talking about what he does, and it includes video still samples of his work. Do you find the noncommercial approach he takes to art satisfying or unsatisfying? What do you feel Viola expects of his audience?

2. You can see a still from Viola's installation called *City of Man* (1989), composed of three projections, at the Guggenheim Museum in New York, at www.artnet .com/Magazine/reviews/moore/moore9-29-9.asp. In this installation, the images move with speed. The three images are very different and together form a triptych. Which can you interpret best? Which seems most threatening? What seems to be the visual message of this installation? How do you think the alternation of images on and off would affect your concentration on the imagery?

3. Sample video art by going online to the following websites: www.billviola.com, www.davidhallart.com, http://ukvideoart.tripod.com, www.tonkonow.com/ campus.html, www.kortermand.dk/overview.htm, or www.c3.hu/scca/butterfly/ Vasulkas/synopsis.html. Which work of art seems most interesting and most successful? What qualities do you find revealing in the piece you most admire? In which was the participative experience most intense?

(continued)

4. Video art is still in its infancy. If you have access to a video camera and a video monitor, try making a short piece of video art that avoids the techniques and clichés of commercial television. How do your friends react to it? Describe the techniques you relied upon to make your work distinct. If you wish, you can upload your work to videoart.net at www.videoart.net for others to view.

SUMMARY

Television is the most widely available artistic medium in our culture. The widespread accessibility of video cameras and video monitors has brought television to a new position as a medium available to numerous artists, both professional and amateur. Television's technical limitations, those of resolution and screen size, have made it distinct from film, but new technical developments are improving the quality of its imagery and its sound. Commercial television dramas have evolved their own structures, with episodic programs following a formulaic pattern of crisis points followed by commercial interruption. The British Broadcasting Corporation helped begin a novel development that distinguishes television from the commercial film: the open-ended serial, which avoids crisis-point interruption and permits the medium to explore richer resources of narrative. Video art is, by way of contrast, completely anticommercial. It avoids narrative structures and alters our sense of time and expectation. Because it is in its infancy, the possibilities of video art are unlike those of any other medium.

Chapter 13

PHOTOGRAPHY

Photography and Painting

The first demonstration of photography took place in Paris in 1839, when Louis J. M. Daguerre (1787–1851) astonished a group of French artists and scientists with the first Daguerreotypes. The process was almost instantaneous, producing a finely detailed monochrome image on a silver-coated copper plate. At that demonstration, the noted French painter Paul Delaroche declared, "From today painting is dead." An examination of his famous painting *Execution of Lady Jane Grey* (Figure 13-1) reveals the source of his anxiety. Delaroche's reputation was built on doing what the photograph does best—reproducing exact detail and exact perspective. However, the camera could not yet reproduce the colors that make Delaroche's painting powerful.

PERCEPTION KEY *Execution of Lady Jane Grey*

1. What aspects of Delaroche's style of painting would have made him think of photography as a threat? In what ways is this painting similar to a photograph?
2. Is it surprising to learn that this painting was exhibited five years before Delaroche saw a photograph—actually before the invention of photography?
3. Examine Delaroche's painting for attention to detail. This is a gigantic work, much larger than any photograph could be at mid-nineteenth century. Every figure is reproduced with the same sharpness, from foreground to background. To what extent is that approach to sharpness of focus like or unlike what might have been achieved by a photograph of this scene?
4. How does color focus our attention in Delaroche's painting?

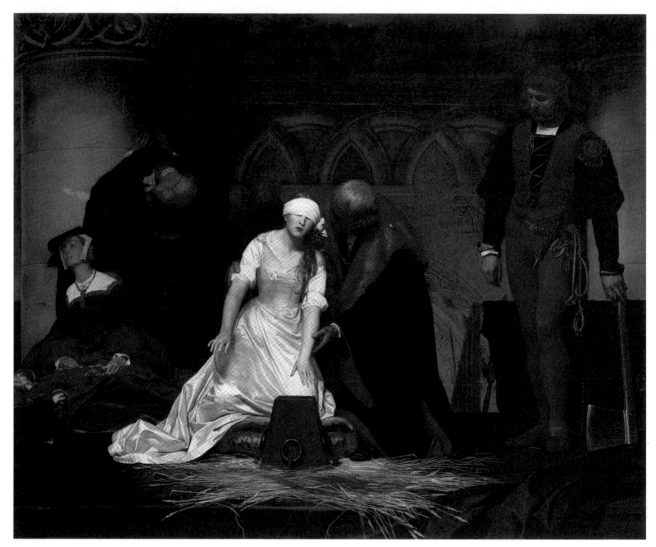

FIGURE 13-1

Paul Delaroche, *Execution of Lady Jane Grey*. 1843. Oil on canvas, 97 × 117 inches.

Delaroche witnessed the first demonstration of photography in 1839 and declared, "From today painting is dead." His enormous painting had great size and brilliant color, two ways, for the time being, in which photography could be superseded.

Some early critics of photography complained that the camera does not offer the control over the subject matter that painting does. But the camera does offer the capacity to crop and select the area of the final print, the capacity to alter the aperture of the lens and thus control the focus in selective areas, as well as the capacity to reveal movement in blurred scenes, all of which only suggest the ability of the instrument to transform visual experience into art.

Many early photographs exhibit the capacity of the camera to capture and control details in a manner that informs the viewer about the subject matter. For example, in his portrait of Isambard Kingdom Brunel (1857), a great builder of steamships (Figure 13-2), Robert Howlett exposed the negative for a shorter time and widened the aperture of his lens (letting in more light), thus controlling the depth of field (how much is in focus). Brunel's figure is in focus, but surrounding objects are in soft focus, rendering them

FIGURE 13-2
Robert Howlett, *Isambard Kingdom Brunel.* 1857.

This portrait of a great English engineer reveals its subject without flattery, without a sense of romance, and absolutely without a moment of sentimentality. Yet the photograph is a monument to power and industry.

less significant. The pile of anchor chains in the background is massive, but the soft focus makes them subservient to Brunel. The huge chains make this image haunting, but if they were in sharp focus, they would have distracted from Brunel. In *Execution of Lady Jane Grey*, almost everything is in sharp focus, while the white of Jane's dress and the red of the executioner's leggings focus our attention.

Brunel's posture is typical of photographs of the period. We have many examples of men lounging with hands in pockets and cigar in mouth, but few paintings portray men this way. Few photographs of any age show us a face quite like Brunel's. It is relaxed, as much as Brunel could relax, but it is also impatient, "bearing with" the photographer. And the eyes are sharp, businessman's eyes. The details of the rumpled clothing and jewelry do not compete with the sharply rendered face and the expression of control and power. Howlett has done, by simple devices such as varying the focus, what many portrait painters do by much more complex means—reveal something of the character of the model.

Julia Margaret Cameron's portrait of Sir John Herschel (1867) (Figure 13-3), and Étienne Carjat's portrait of the French poet Charles Baudelaire (1870) (Figure 13-4), unlike Howlett's portrait, ignore details in the background. But their approaches are also different from each other. Cameron, who reported being interested in the way her lens could soften detail, isolates Herschel's face and hair. She drapes his shoulders with a black velvet shawl so that his clothing will not tell us anything about him or distract

FIGURE 13-3 (*left*)
Julia Margaret Cameron, *Sir John Herschel*. 1867.

One of the first truly notable portrait photographers, Cameron was given a camera late in life and began photographing her friends, most of whom were prominent in England. After a few years she gave up the camera entirely, but she left an indelible mark on early photography.

FIGURE 13-4 (*right*)
Étienne Carjat, *Charles Baudelaire*. 1870.

The irony of this striking portrait lies in the fact that the famous French poet was totally opposed to photography as an art.

us from his face. Cameron catches the stubble on his chin and permits his hair to "burn out," so we perceive it as a luminous halo. The huge eyes, soft and bulbous with their deep curves of surrounding flesh, and the downward curve of the mouth are depicted fully in the harsh lighting. While we do not know what he was thinking, the form of this photograph reveals him as a thinker of deep ruminations. He was the chemist who first learned how to permanently fix a photograph.

The portrait of Baudelaire, on the other hand, includes simple, severe clothing, except for the poet's foulard, tied in a dashing bow. The studio backdrop is set far out of focus so it cannot compete with the face for our attention. Baudelaire's intensity creates the illusion that he is looking at us. Carjat's lens was set for a depth of field of only a few inches. Thus, Baudelaire's face is in focus, but not his shoulders. What Carjat could not control, except by waiting for the right moment to uncover the lens (at this time, there was no shutter because there was no "fast" film), was the exact expression he could catch.

One irony of the Carjat portrait is that Baudelaire, in 1859, had condemned the influence of photography on art, declaring it "art's most mortal enemy." He thought that photography was adequate for preserving visual records of perishing things, but that it could not reach into "anything whose value depends solely upon the addition of something of a man's soul." Baudelaire was a champion of imagination and an opponent of realistic art: "Each day art further diminishes its self-respect by bowing down before external reality; each day the painter becomes more and more given to painting not what he dreams but what he sees."[1] Some critics and philosophers

[1]Charles Baudelaire, *The Mirror of Art* (London: Phaidon, 1955), p. 230.

EXPERIENCING Photography and Art

1. Do you agree with Baudelaire that photography is "art's most mortal enemy"? What reasons might Baudelaire have had for expressing such a view?

For some time, photography was not considered an art. Indeed, some people today do not see it as an art because they assume the photograph is an exact replica of what is in front of the camera lens. On the other hand, realism in art had been an ideal since the earliest times, and sculptures such as *Aphrodite* (Figure 5-7) aimed at an exact replica of a human body, however idealized. Modern artists such as Duane Hanson, Andy Warhol, and others blur the line of art by creating exact replicas of objects such as Campbell's soup cans, so the question of replication is not the final question in art. Baudelaire saw that painters might be out of work—especially portrait painters—if photography were widespread. Yet, his own photographic portrait is of powerful artistic interest today.

For Baudelaire, photographs were usually Daguerreotypes, which means they were one of a kind. The "print" on silvered copper was the photograph. There was no negative and no way of altering the tones in the print. Shortly after, when the Daguerreotype process was superseded by inventions such as the glass plate negative, it became possible to subtly alter details within the photograph much as a painter might alter the highlights in a landscape or improve the facial details in a portrait. This is a matter of craft, but it became clear that in careful selection of what is in the photographic print, along with the attention to manipulating the print, in the fashion of Ansel Adams' great photographs of Yosemite, the best photographers became artists. Were Baudelaire alive to see how photography has evolved, he may well have changed his opinion. The work of Julia Margaret Cameron, Timothy O'Sullivan, Eugene Atget, Alfred Stieglitz, Edward Steichen, and Edward Weston changed the world's view of whether or not photography is an art.

2. Baudelaire's writings suggest that he believed art depended on imagination and that realistic art was the opponent of imagination. How valid do you feel this view is? Is it not possible for imagination to have a role in making a photograph?
3. Read a poem from Baudelaire's most celebrated volume, *The Flowers of Evil*. You might choose "Twilight: Evening" from a group he called "Parisian Scenes." In what ways is his poem unlike a photograph?
4. Considering his attitude toward photography, why would he have sat for a portrait such as Carjat's? Would you classify this portrait as a work of art?

of art argue that photography is not an art—or at least not a major art—on grounds different from Baudelaire's. Images can be selected and controlled, of course, but after their "taking," what can be done with them is very restricted. Therefore the photographer's ability to transform subject matter is also very restricted. Painters, on the other hand, create their images and in doing so have much greater flexibility in organizing their media—color, line, and texture. Perhaps this argument falters somewhat today because of the capacity of digital cameras and computers to alter, distort, and transform the image. But even without the magical powers of these tools, the photograph can be richly informative. It is not restricted only to recording slices of life.

FIGURE 13-5
Timothy O'Sullivan, *Canyon de Chelley, Arizona.* 1873.

The American West lured photographers with unwieldy equipment to remote locations such as this. Other photographers have visited the site, but none has outdone O'Sullivan, who permitted the rock to speak for itself.

Compare Carjat's and Cameron's portraits with Rembrandt's *Self Portrait* (Figure 4-13). Both photographers were familiar with Rembrandt's stylistic choices about lighting and background. Neither photograph has imitated Rembrandt's pose, but the use of a rich dark background in Cameron's photograph and the direct, frank stare of Carjat's subject demonstrate an awareness of style and a carefulness of expression that parallel Rembrandt's. Indeed, the photographs and the painting seem to have a similar purpose: to reveal the personality of the subject. They all share a sense of dramatic purpose, as if each subject were caught in an instant of time at a moment of meditation. And all of them exhibit superb lighting.

An impressive example of the capacity of the photographic representation is Timothy O'Sullivan's masterpiece, *Canyon de Chelley, Arizona,* made in 1873 (Figure 13-5). Many photographers have gone back to this scene, but none has treated it quite the way O'Sullivan did. O'Sullivan chose a moment of intense sidelighting, which falls on the rock wall but not on the nearest group of buildings. He waited for that moment when the great rock striations and planes would be most clearly etched by the sun. The closer group of buildings is marked by strong shadow. Comparing it to the more distant group shows a remarkable negative-positive relationship. The groups of buildings are purposely contrasted in this special photographic way. One question you might ask about this photograph is whether it reveals the

"stoniness" of this rock wall in a manner similar to the way Cézanne's *Mont Sainte-Victoire* (Figure 2-4) reveals the "mountainness" of the mountain.

The most detailed portions of the photograph are the striations of the rock face, whose tactile qualities are emphasized by the strong sidelighting. The stone buildings in the distance have smoother textures, particularly as they show up against the blackness of the cave. That the buildings are only twelve to fifteen feet high is indicated by comparison with the height of the barely visible men standing in the ruins. Thus nature dwarfs the work of humans. By framing the canyon wall, and by waiting for the right light, O'Sullivan has done more than create an ordinary "record" photograph. He has concentrated on the subject matter of the puniness and softness of humans, in contrast with the grandness and hardness of the canyon. The content centers on the extraordinary sense of stoniness—symbolic of permanence—as opposed to the transience of humanity, made possible by the capacity of the camera to transform realistic detail.

PHOTOGRAPHY AND PAINTING: THE PICTORIALISTS

Pictorialists are photographers who use the achievements of painting, particularly realistic painting, in their effort to realize the potential of photography as art. The early pictorialists tried to avoid the head-on directness of Howlett and Carjat, just as they tried to avoid the amateur's mistakes in composition, such as inclusion of distracting details and imbalance. The pictorialists controlled details by subordinating them to structure. They produced compositions that usually relied on the same underlying structures found in most nineteenth-century paintings until the dominance of the Impressionists in the 1880s. Normally, the most important part of the subject matter was centered in the frame. Pictorial lighting, also borrowed from painting, often was sharp and clearly directed, as in Alfred Stieglitz's *Paula* (Figure 13-6) and Edward Steichen's *The Pond—Moonlight* (Figure 13-7). The subject matter of pictorial photography is usually dramatic.

The pictorialist photograph was usually soft in focus, centrally weighted, and carefully balanced symmetrically. By relying on the formalist characteristics of early and mid-nineteenth-century paintings, pictorialist photographers often evoked emotions that bordered on the sentimental. Indeed, one of the complaints modern commentators have about the development of pictorialism is that it was emotionally shallow.

Rarely criticized for sentimentalism, Alfred Stieglitz was, in his early work, a master of the pictorial style. His *Paula,* done in 1889, places his subject at the center in the act of writing. The top and bottom of the scene are printed in deep black. The light, streaking through the venetian blind and creating lovely strip patterns, centers on Paula. Her profile is strong against the dark background partly because Stieglitz removed during the printing process one of the strips that would have fallen on her lower face. The strong vertical lines of the window frames reinforce the verticality of the candle and echo the back of the chair.

A specifically photographic touch is present in the illustrations on the wall: photographs arranged symmetrically in a triangle (use a magnifying

FIGURE 13-6
Alfred Stieglitz, *Paula*. 1889.

Stieglitz photographed Paula
in such a way as to suggest the
composition of a painting, fram-
ing her in darkness while bath-
ing her in window light.

FIGURE 13-7
Edward Steichen, *The Pond—
Moonlight*. 1904.

One of the early color photo-
graphs, this one is remarkable
for its rarity as an object. It was
sold in 2006 for almost three
million dollars.

glass). Two prints of the same lake-skyscape are on each side of a woman in a white dress and hat. The same photograph of this woman is on the writing table in an oval frame. Is it Paula? The light in the room echoes the light in the oval portrait. The three hearts in the arrangement of photographs are balanced; one heart touches the portrait of a young man. We wonder if Paula is writing to him. The cage on the wall has dominant vertical lines, crossing the light lines cast by the venetian blind. Stieglitz may be suggesting that Paula, despite the open window, may be in a cage of her own. Stieglitz has kept most of the photograph in sharp focus because most of the details have something to tell us. If this were a painting of the early nineteenth century, for example one by Delaroche, we would expect much the same style. We see Paula in a dramatic moment, with dramatic light, and with an implied narrative suggested by the artifacts surrounding her. It is up to the viewer to decide what, if anything, the drama implies.

One of pictorialism's early giants is Edward Steichen, whose soft-focus photographs of New York City landmarks are still hailed as among the most beautiful ever made. *The Pond—Moonlight,* while not one of his urban photographs, has become his most famous. This photograph is interesting first because it uses an old process called gum-bichromate, which permitted Steichen to realize a print with some color, while most other photographers made monochrome prints. The soft-focus scene of a pond in Mamaroneck, New York, taken in moonlight, establishes a meditative mood that may tend toward the sentimental. But what has made the photograph famous is that it sold to a collector in 2006 for $2,928,000. No photograph has ever come close to that price, and as a result, this one has a privileged position in the history of photography.

PERCEPTION KEY Pictorialism and Sentimentality

1. Pictorialists are often condemned for their sentimentality. What is sentimentality?
2. Are *Paula* and *The Pond—Moonlight* sentimental? Is their subject matter sentimental, or does their formal treatment make a neutral subject matter sentimental?
3. Does Steichen's use of color and his soft focus imply sentimentality in *The Pond—Moonlight*? Is a pond in moonlight sentimental all by itself, or would one need an artist to introduce sentimentality?
4. Is sentimentality desirable in paintings, photographs, or any art form?
5. How does the sale price of *The Pond—Moonlight* affect your view of it as a work of art?

Both paintings and photographs, of course, can be sentimental in subject matter. The severest critics of such works complain about their ***sentimentality:*** the falsifying of feelings by demanding responses that are cheap or easy to come by. Sentimentality is usually an oversimplification of complex emotional issues. It also tends to be mawkish and self-indulgent. The case of photography is special because we are accustomed to the harshness of the camera. Thus when the pictorialist finds tenderness, romance, and beauty in everyday occurrences, we become suspicious. We may be more tolerant of painting doing those things, but in fact we should be wary of any such emotional "coloration" in any medium if it is not restricted to the subject matter.

The pictorialist approach, when not guilty of sentimentalism, has great strengths. The use of lighting that selectively emphasizes the most important features of the subject matter often helps in creating meaning. Borrowing from the formal structures of painting also may help clarify subject matter. Structural harmony of the kind we generally look for in representational painting is possible in photography. Although it is by no means limited to the pictorialist approach, it is clearly fundamental to that approach.

STRAIGHT PHOTOGRAPHY

In his later work, beginning around 1905, Alfred Stieglitz pioneered the movement of *straight photography,* a reaction against pictorialism. The *f/64 Group,* working in the 1930s, and a second school, the *Documentarists,* continue the tradition. Straight photographers took the position that, as Aaron Siskind said later, "Pictorialism is a kind of dead end making everything look beautiful." The straight photographer wanted things to look essentially as they do, even if they are ugly.

Straight photography aimed toward excellence in photographic techniques, independent of painting. Susan Sontag summarizes: "For a brief time—say, from Stieglitz through the reign of Weston—it appeared that a solid point of view had been erected with which to evaluate photographs: impeccable lighting, skill of composition, clarity of subject, precision of focus, perfection of print quality."[2] Some of these qualities are shared by pictorialists, but new principles of composition—not derived from painting—and new attitudes toward subject matter helped straight photography reveal the world straight, as it really is.

Stieglitz: Pioneer of Straight Photography

One of the most famous straight photographs leading to the f/64 Group was Stieglitz's *The Steerage* of 1907 (Figure 13-8). It was taken under conditions that demanded quick action.

PERCEPTION KEY *The Steerage*

1. How many of the qualities Susan Sontag lists can be found in this photograph?
2. What compositional qualities make this photograph different from the pictorialist examples we have discussed? How does the structural organization control the details of the photograph?
3. What is the subject matter of the photograph? Is the subject matter made to seem beautiful? Should it be?
4. Does the framing cut off important figural elements of the photograph? If so, is this effective?
5. Does the photograph have content? If so, how does the form achieve it? And what is the content?

[2]Susan Sontag, *On Photography* (New York: Farrar, Straus, and Giroux, 1977), p. 136.

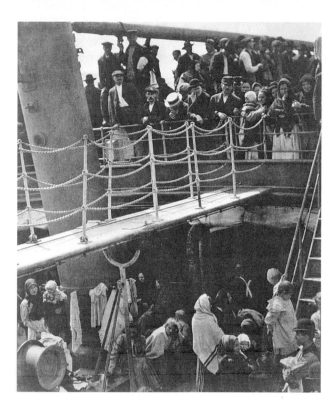

FIGURE 13-8
Alfred Stieglitz, *The Steerage.*
1907.

This is a portrait of emigres in the cheapest and most barren section of a ship, and it is used at Ellis Island to memorialize generations of immigrants to the United States. However, these immigrants are actually returning to Europe after failing to make a living in the United States.

The Steerage portrays poor travelers huddled in the "budget" quarters of the *Kaiser Wilhelm II,* which is taking this group of immigrants, disappointed because of economic hardship, back to their native lands. Ironically, the New York Public Library uses his photograph to celebrate the arrival of immigrants in America. Stieglitz wrote that while strolling on deck, he was struck by a

round straw hat, the funnel leaning left, the stairway leaning right, the white drawbridge with its railing made of circular chains, white suspenders crossing on the back of a man in the steerage below, round shapes of iron machinery, a mast cutting into the sky, making a triangular shape. . . . I saw a picture of shapes and underlying that the feeling I had about life.[3]

The Steerage shares much with the pictorialist approach: dramatic lighting and soft focus. But there is much that the pictorialist would probably avoid. For one thing, the *framing* omits important parts of the funnel, the drawbridge, and the nearest people in the lower-right quadrant. Moreover, the very clutter of people—part of the subject matter of the photograph—would be difficult for the pictorialist to tolerate. And the pictorialist certainly would

[3]Quoted in Beaumont Newhall, *The History of Photography* (New York: Museum of Modern Art, 1964), p. 111.

be unhappy with the failure to use the center of the photograph as the primary region of interest. Certain focal points have been used by Stieglitz to stabilize the composition: the straw hat attracts our eye, but so, too, does the white shawl of the woman below. The bold slicing of the composition by the drawbridge sharpens the idea of the separation between the well-to-do and the poor. On the other hand, the leaning funnel, the angled drawbridge and chains, the angled ladder on the right, and the horizontal boom at the top of the photograph are rhythmically interrelated. This rhythm is peculiarly mechanical and modern. The stark metal structures are in opposition to the softer, more random assortment of the people. Photographs like this can help teach us how to see and appreciate formal organizations.

The f/64 Group

The name of the group derives from the small aperture, f/64, which ensures that the foreground, middle ground, and background will all be in sharp focus. The group declared its principles through manifestos and shows by Edward Weston, Ansel Adams, Imogen Cunningham, and others. It continued the reaction against pictorialism, adding the kind of nonsentimental subject matter that interested the later Stieglitz. Edward Weston, whose early work was in the soft-focus school, developed a special interest in formal organizations. He is famous for his nudes and his portraits of vegetables, such as artichokes, eggplants, and green peppers. His nudes rarely show the face, not because of modesty, but because the question of the identity of the model can distract us from contemplating the formal relationships of the human body.

Weston's *Nude* (Figure 13-9) shows many characteristics of work by the f/64 Group. The figure is isolated and presented for its own sake, the sand being equivalent to a photographer's backdrop. The figure is presented not as a portrait of a given woman but rather as a formal study. Weston wanted us to see the relationship between legs and torso, to respond to the rhythms of line in the extended body, and to appreciate the counterpoint of the round, dark head against the long, light linearity of the body. Weston enjoys some notoriety for his studies of peppers, because his approach to vegetables was similar to his approach to nudes. We are to appreciate the sensual curve, the counterpoints of line, the reflectivity of skin, the harmonious proportions of parts.

Weston demanded objectivity in his photographs. "I do not wish to impose my personality upon nature (any of life's manifestations), but without prejudice or falsification to become identified with nature, to know things in their very essence, so that what I record is not an interpretation—my ideas of what nature should be—but a revelation."[4] One of Weston's ideals was to capitalize on the capacity of the camera to be objective and impersonal, an ideal that the pictorialists usually rejected.

[4]*The Daybooks of Edward Weston*, ed. Nancy Newhall, 2 vols. (New York: Aperture, 1966), vol. 2, p. 241.

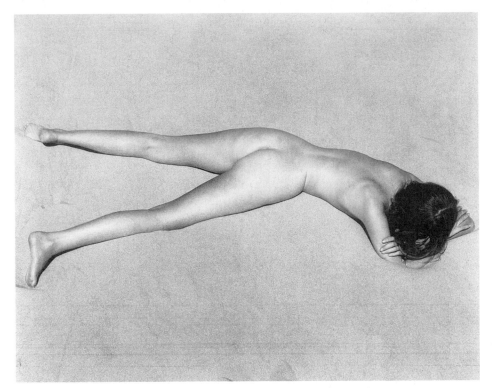

FIGURE 13-9
Edward Weston, *Nude.* 1936.

Weston's approach to photography was to make everything as sharp as possible and to make the finest print possible. He was aware he was making photographs as works of art.

The work of Ansel Adams establishes another ideal of the f/64 Group: the fine print. Even some of the best early photographers were relatively casual in the act of printing their negatives. Adams spent a great deal of energy and skill in producing the finest print the negative would permit, sometimes spending days to print one photograph. He developed a special system (the Zone System) to measure tonalities in specific regions of the negative so as to control the final print, keeping careful records so that he could duplicate the print at a later time. In even the best of reproductions, it is difficult to point to the qualities of tonal gradation that constitute the fine print. Only the original can yield the beauties that gradations of silver or platinum can produce. In his *Moonrise, Hernandez* (Figure 13-10), Adams aimed for a print of textural subtleties. He was returning near the end of the day when he saw the moon begin to rise dramatically beyond the hills of New Mexico. He placed his 8 × 10 camera on top of his van while the sun was dying on the church and cemetery in the foreground. In printing, he had the problem of keeping the clouds intensely white, with the sky uniformly dark, and the subtle gradations of vegetation and buildings in the foreground. A lesser artist could not have created this print, one of his most famous.

THE DOCUMENTARISTS

Time is critical to the Documentarist, who portrays a world that is disappearing so quickly we cannot see it go. Henri Cartier-Bresson used the phrase "the decisive moment" to define that crucial interaction of shapes

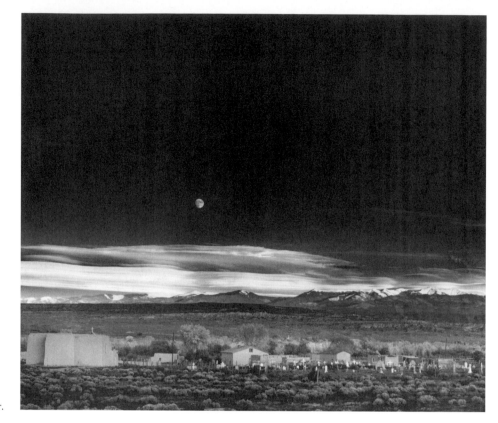

FIGURE 13-10
Ansel Adams, *Moonrise, Hernandez.* 1941.

Adams took this photograph in great haste, knowing the perfect moment might be lost. It has remained one of the most famous and respected photographs of his entire career.

and spaces, formed by people and things, that tells him when to snap his shutter. Not all his photographs are decisive; they do not all catch the action at its most intense point. But those that do are pure Cartier-Bresson.

Many Documentarists agree with Stieglitz's description of the effect of shapes on his own feelings, as when he took *The Steerage.* Few contemporary Documentarists, however, who are often journalists like Cartier-Bresson, can compose the way Stieglitz could. But the best develop an instinct—usually nurtured by years of visual education—for the powerful statement, as one can see in Eddie Adams' *Execution in Saigon* (Figure 2-2).

Eugène Atget spent much of his time photographing in Paris in the early morning, when no one would bother him. He must have been in love with Paris and its surroundings because he photographed for many years, starting in the late 1800s and continuing to his death in 1927. Generally there are no people in his views of Paris, although he did an early series on some street traders, such as organ grinders, peddlers, and even prostitutes. His photographs of important Parisian monuments, such as his view of the Petit Trianon (Figure 13-11), are distinctive for their subtle drama. Most commercial photographs of this building ignore the dramatic reflection in the pond, and none of them permit the intense saturation of dark tones in the surrounding trees and in the water reflection. The more one ponders this

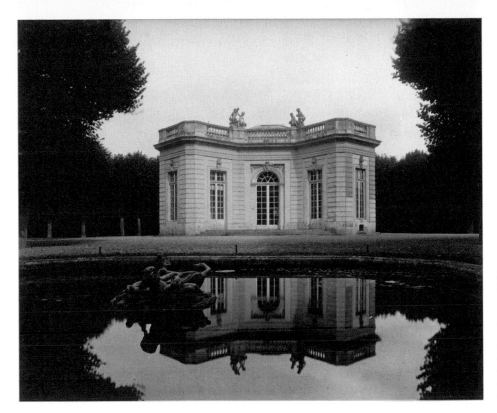

FIGURE 13-11
Eugène Atget, *Trianon, Paris.*
1923–1924.

Atget was rediscovered in the
1960s when it became clear he
was not just making record pho-
tographs, but finding ways of
intensifying the visual elements
to make a statement about how
we see.

photograph, the more one feels a sense of dramatic uncertainty and per-
haps even urgency. The many ways in which Atget balances and contrasts
the visual elements at the same time make the experience of the image in-
tense. Atget's work did not refer to painting: It created its own photographic
reference. We see a photograph, not just a thing photographed.

James Van Der Zee worked in a somewhat different tradition from
Atget. His studio in Harlem was so prominent that many important African
American citizens felt it essential that he take their portrait. Like Atget,
he was fascinated with his community, photographing public events and
activities from the turn of the century into the 1930s. *Couple in Raccoon
Coats* (Figure 13-12) is reminiscent of Howlett as well as of Atget. As
with Howlett's photographs, there is the contrast of soft focus for the
background and sharp focus for the foreground. Thus the couple and
their new car stand out brilliantly. Additionally, the interaction of for-
mal elements is so complex that it reminds us of Atget: There has been
no reduction of shapes to a simpler geometry. However, the car with its
strong, bright horizontals helps accent the verticals of the couple, ac-
cented further by the verticals of the buildings. The style and elegance of
the couple are what Van Der Zee was anxious to capture. Our familiar-
ity with the chief elements in the photograph—brownstones, car, and
furcoated people—helps make it possible for him to avoid the soothing

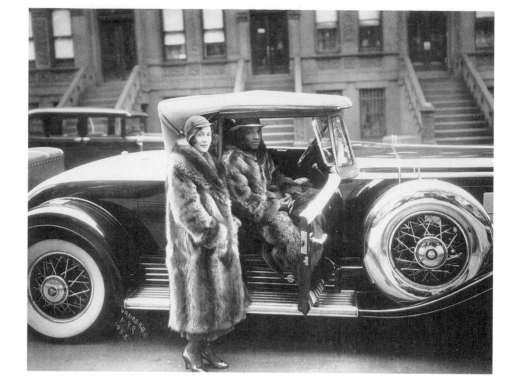

FIGURE 13-12
James Van Der Zee, *Couple in Raccoon Coats*. 1932.

Van Der Zee made a career photographing life in New York's Harlem in the first part of the twentieth century. This remains one of the most remarkable of urban photographs of the period.

formal order the pictorialist might have used. If anything, Van Der Zee is moving toward the snapshot aesthetic that was another generation in the making. His directness of approach puts him in the documentary tradition.

Unlike Atget and Van Der Zee, who used large cameras, Cartier-Bresson used the 35-mm Leica and specialized in photographing people. He preset his camera in order to work fast and instinctively. His *Behind the Gare St. Lazare* (Figure 13-13) is a perfect example of his aim to capture an image at the "decisive moment." The figure leaping from the wooden ladder has not quite touched the water, while his reflection awaits him. The entire image is a tissue of reflection, with the spikes of the fence reflecting the angles of the fallen ladder. The circles in the foreground are repeated in the wheelbarrow's reflection and the white circles in the poster. Moreover, the figure in the white poster appears to be a dancer leaping in imitation of the man to the right. The focus of the entire image is somewhat soft because Cartier-Bresson preset his camera so he could take the shot instantly without adjusting the aperture. The formal relationship of elements in a photograph such as this can produce various kinds of significance or apparent lack of significance. The best Documentarists search for the strongest coherency of elements while also searching for the decisive moment. That moment is the split-second peak of intensity, and it is defined especially with reference to light, spatial relationships, and expression.

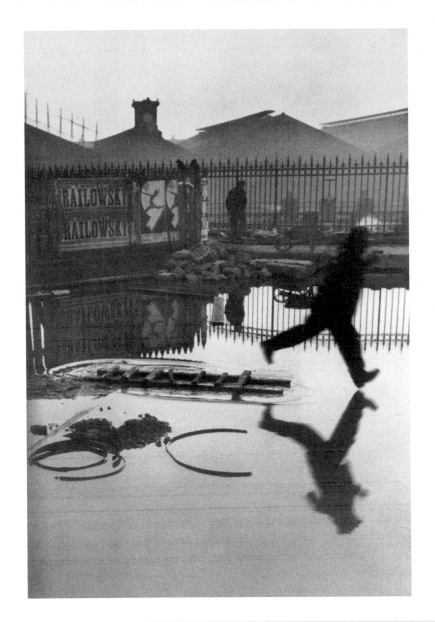

FIGURE 13-13
Henri Cartier-Bresson, *Behind the Gare St. Lazare.* 1932.

This photograph illustrates Bresson's theories of the "decisive moment." This photograph was made possible in part by the small, hand-held Leica camera that permitted Bresson to shoot instantly, without having to set up a large camera on a tripod.

PERCEPTION KEY The Documentary Photographers

1. Are any of these documentary photographs (Figures 13-11 through 13-15) sentimental?
2. Some critics assert that these photographers have made interesting social documents, but not works of art. What arguments might support their views? What arguments might contest their views?
3. Contemporary photographers and critics often highly value the work of Atget because it is "liberated" from the influence of painting. What does it mean to say that his work is more photographic than it is painterly?
4. What is the subject matter of each photograph? What is the content of each photograph? Is the "Railowsky" poster in Figure 13-13 a pun?

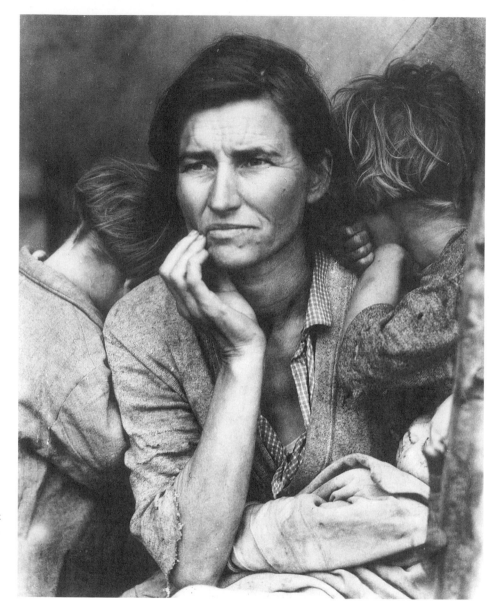

FIGURE 13-14
Dorothea Lange, *Migrant Mother.* 1936.

This is one of the most poignant records of the Great Depression in which millions moved across the nation looking for work. Lange did a number of photographs of this family in a very short time.

Dorothea Lange and Walker Evans were Documentarists who took part in a federal program to give work to photographers during the Depression of the 1930s. Both created careful formal organizations. Lange (Figure 13-14) stresses centrality and balance by placing the children's heads next to the mother's face, which is all the more compelling because the children's faces do not compete for our attention. The mother's arm leads upward to her face, emphasizing the other triangularities of the photograph. Within ten minutes, Lange took four other photographs of this woman and her children, but none could achieve the power of this photograph. Lange caught

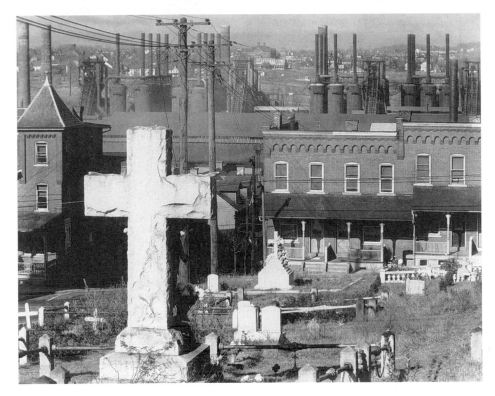

FIGURE 13-15
Walker Evans, *A Graveyard and Steel Mill in Bethlehem, Pennsylvania.* 1935.

Evans, like Lange, was part of the Works Progress Administration photographic project during the Great Depression. His subject was the nation itself.

the exact moment when the children's faces turned and the mother's anxiety comes forth with utter clarity, although the lens mercifully softens its focus on her face, while leaving her shabby clothes in sharp focus. This softness helps humanize our relationship with the woman. Lange gives us an unforgettable image that brutally and yet sympathetically imparts a deeper understanding of what the Depression was for many.

Evans' photograph (Figure 13-15) shows us a view of Bethlehem, Pennsylvania, and the off-center white cross reminds us of what has become of the message of Christ. The vertical lines are accentuated in the cemetery stones and repeated in the telephone lines, the porch posts, and, finally, the steel-mill smokestacks. The aspirations of the dominating verticals, however, are dampened by the strong horizontals, which, because of the low angle of the shot, tend to merge from the cross to the roofs. Evans equalizes focus, which helps compress the space so that we see the cemetery on top of the living space, which is immediately adjacent to the steel mills where some of the people who live in the tenements work and where some of those now in the cemetery died. This compression of space suggests the closeness of life, work, and death. We see a special kind of sadness in this steel town—and others like it—that we may never have seen before. Evans caught the right moment for the light, which intensifies the white cross, and he aligned the verticals and horizontals for their best effect.

THE MODERN EYE

Photography in recent years has gone in so many directions that classifications tend to be misleading. The snapshot style, however, has become somewhat identifiable, a kind of rebellion against the earlier movements, especially the pictorial. Janet Malcolm claims, "Photography went modernist not, as has been supposed, when it began to imitate modern abstract art but when it began to study snapshots."[5] John Szarkowski of the Museum of Modern Art in New York has praised the snapshot as one of the great resources of the medium. The snapshot appears to have low technical demands, allows for cluttered composition, and "snaps" reality presumably just as it is. No school of photography has established a snapshot canon. It seems to be a product of amateurs, a kind of folk photography. The snapshot appears primitive, spontaneous, and accidental. But the snapshot may not be unplanned and accidental, as is evidenced, for instance, in the powerful work of Garry Winogrand and Manuel Alvarez Bravo. The folk or amateur feel of their photographs is usually only a veneer. The basic difference between the snapshot and the documentary is that veneer.

Garry Winogrand respected Walker Evans and Henri Cartier-Bresson enough to concentrate on what he thought photography did best: describe the human scene faithfully. Like Cartier-Bresson, Winogrand often walked the streets with his 35-mm Leica, with a wide-angle lens preset at a specific f-stop at a specific shutter speed, allowing him to shoot quickly, without worrying about his equipment, just concentrating on what he saw. He was the photographer of American cities much as Atget was the photographer of Paris. His street scenes are filled with people, usually unaware of his presence, and with action that is sometimes enigmatic but always somehow significant. His aesthetic is the snapshot, quick, instinctive, unplanned. *Los Angeles 1969* (Figure 13-16) was taken at an iconic location: the corner of Hollywood and Vine, where countless starlets flocked in hope of being "discovered" by Hollywood filmmakers. We see three carefully coifed young women, possibly film hopefuls, in the center lighted as if on a stage by the sun and its reflections. But on the periphery of the scene is another story, a young boy sitting waiting for a bus on the right looks back to stare at an unfortunate young man slumped in a wheelchair in a posture of desperation. It is a snapshot filled with significance based on visual and sociological high contrast.

Manuel Alvarez Bravo, a Mexican photographer, was not precisely given to the snapshot, except when traveling with his small camera. *The Man from Papantla* (Figure 13-17) has many of the qualities of the snapshot. It appears unplanned, slightly off-center, as if Bravo had seen the man on the street and simply asked, "May I take your picture?" The difference is that the photograph reveals a man whose dignity is intact, despite his rudimentary clothes and his bare feet. The diagonal shadows suggest that it is late in the day and that the man has been walking for some time. Yet his face is impassive and his posture erect.

[5]Janet Malcolm, *Diana and Nikon: Essays on the Aesthetics of Photography* (Boston: David Godine, 1980), p. 113.

FIGURE 13-16
Garry Winogrand, *Los Angeles 1969*.

Winogrand has caught a moment filled with energy and dramatic potential. There is action, lighting, and implied drama—a tinge perhaps of both comedy and tragedy all in an instant snapshot.

Robert Mapplethorpe was arguably the best-known young photographer in America when he died of AIDS in 1989 at age forty-two. Six months after his death, he became even better known to the public because an exhibit of his work, supported by a grant from the National Endowment for the Arts, caused Senator Jesse Helms (R-NC) to add an amendment to an important appropriations bill that would make it almost impossible for the NEA to fund exhibitions of the work of artists like Mapplethorpe. The amendment reads as follows:

> None of the funds authorized to be appropriated pursuant to the Act may be used to promote, disseminate, or produce—(1) obscene or indecent materials, including but not limited to depictions of sadomasochism, homo-eroticism, the exploitation of children, or individuals engaged in sex acts; or (2) material which denigrates the objects or beliefs of the adherents of a particular religion or non-religion; or (3) material which denigrates, debases, or reviles a person, group, or class of citizens on the basis of race, creed, sex, handicap, age, or national origin.

The provisions of this bill—which was defeated—would essentially have applied to every federal granting or exhibition agency, including the National Gallery of Art. The exhibit that triggered this response included Mapplethorpe's photographs of the homosexual community of New York to which he belonged. Some of his work portrays bondage, sadomasochistic

373

FIGURE 13-17
Manuel Alvarez Bravo, *The Man from Papantla.* 1934.

Bravo permits the subject of his portrait to assume the simplest pose possible, while still making a statement.

accoutrements, and nudity. Such works apparently so angered Senator Helms that his proposed law would have made it difficult, if not impossible, for photographers such as Mapplethorpe to get the kind of government support that artists of all kinds have been given since World War II. The decision to withhold support would be made not by experts in the arts but by government functionaries.

Despite the defeat of the bill, federal support to public radio, public television, public institutions such as the most prominent museums in the United States, and all the public programs designed to support the arts has been curtailed so profoundly as to jeopardize the careers of dancers and composers as well as symphony orchestras and virtually all arts organizations. Interestingly, similar pressure was put on the arts by the governments of Franco, Stalin, Hitler, and Mao. The outcome of political control in the United States over the arts is very much in doubt.

Mapplethorpe's double portrait (Figure 13-18) might well be considered controversial in the light of Helms' amendment. Who is to say that this is not a homosexual portrait? Are there racial implications to this photograph? These are questions that may impinge on the photographic values of the portrait. Mapplethorpe has interpreted these heads almost as if they were sculptured busts. There is no hair. The surfaces are cool, almost stonelike. The tonal range of darks and lights is a marvel, and one of the most important challenges of this photograph was in making the print manifest the range of the paper from the brightest white to the darkest black. Mapplethorpe

FIGURE 13-18
Robert Mapplethorpe, *Ken Moody and Robert Sherman*. 1984.

Mapplethorpe produced a body of artistic work that explored the subtleties of the photographic medium. The range of tones in this photograph is part of his subject matter. He also had a very successful career as a commercial photographer.

portrayed the coolness and detachment of his subjects. Instead of revealing their personalities, Mapplethorpe seems to aim at revealing their physical qualities by inviting us to compare them not only with each other but also with the images we have in our minds of conventional portrait busts.

CONCEPTION KEY Art and Censorship

1. Should government support the arts as a means of improving the life of the public? The government supports education; is art a form of education?
2. Would you vote for the Helms amendment? Are there works in this book that you believe would fall under one of the three categories for which it restricts support? Is it right for the government of the United States to restrict support of art, however presumably obscene, sacrilegious, or immoral? If a work of art enlightens, then are not the obscene, the sacrilegious, and the immoral transformed? If so, then would you agree that these undesirables may be the subject matter of a work of art?

(continued)

3. Why would artists feel it appropriate to shock the public rather than to pander to its tastes? Is it possible that artists who pander to public taste ought to be censored on the basis that they are unoriginal, greedy, and socially destructive?
4. If the U.S. government has the right to reject art that offends, should it not also imprison the offending artist (as was done in the Soviet Union, Nazi Germany, and China)?
5. What are the alternatives to censorship of the arts?

COLOR PHOTOGRAPHY

Color photographers often choose apparently inconsequential subject matter in order to release the viewer from the tyranny of the scene, thereby permitting the viewer to concentrate on nuances of lighting, texture, color, and structure. These are expressly photographic values. In a sense, such photographers follow Atget's lead (Figure 13-11).

Joel Meyerowitz has been known as one of America's finest color photographers since his book *Cape Light* was published in 1977. He works with the large-format camera that he used for a massive project called *Aftermath* (2006), a study of the wreckage after the terrorist attack on the World Trade Center in New York on September 11, 2001. He is a fine-art photographer who rarely works in a journalistic tradition, so his study of Ground Zero is marked by a careful attention to color and light as he captures images that evoke deep emotional responses. Figure 13-19 is a night photo with a distant image of ruins standing like an ancient chapel. The cranes establish a strong vertical line, as do the remains of the buildings in the background. The rubble in the foreground seems almost fluid, as if it had been poured over the site. This image began on an eight by ten-inch sheet of film and was printed digitally. Meyerowitz has been a pioneer in fine-art digital photography.

Cindy Sherman is one of the few American photographers to have had a one-woman show at the prestigious Whitney Museum in New York City.

FIGURE 13-19
Joel Meyerowitz, *Assembled Panorama of the World Trade Center Looking East.* 2001.

Meyerowitz, famous as a color photographer, devoted months to recording the aftermath of the September 11, 2001, destruction of the World Trade Center in New York City.

FIGURE 13-20
Cindy Sherman, *Untitled*. 1987.
Color photograph, 86⅛ ×
61⅛ inches.

Famous as a photographer
who uses herself as her subject,
Sherman assembles the mate-
rial in her images. Here she
seems to portray her own ashes
in what may seem a dark self-
portrait.

Her work has annoyed, confounded, and alarmed many people both igno-
rant and well informed about photography as an art. For many years she
photographed herself in various costumes, with makeup and guises that
showed her almost limitless capacity to interpret her personality. Those
color photographs often had a snapshot quality and probably were most
interesting when seen as a group rather than individually.

Some of Sherman's work is condemned because it seems designed to
horrify the audience with images of garbage, offal, vomit, and body parts.
The crumpled suit and assorted garbage in *Untitled* (Figure 13-20) seem to
be the residue of a life. In the middle of the carpet is a small pile of ashes
that may suggest the remains of a cremated person (Cindy Sherman?). This
photograph should not be read only in terms of its objects. Color is also
part of the subject matter, as it is in Loretta Lux's *Isabella* (Figure 13-21),
and can be appreciated somewhat the way one appreciates the color of a
Rothko (Figure 4-11). The objects Sherman photographed have been pur-
posely simplified and relocated. This is not the kind of photograph about
which anyone would ask, "Where was this taken?"

Loretta Lux, a German photographer, uses a digital camera and digital
printing to achieve unusual effects through color management. She has

FIGURE 13-21
Loretta Lux, *Isabella*. 2001. Digital print, 9½ × 9½ inches.

Like Meyerowitz and many contemporary photographers, Lux uses the resources of digital imagery to construct photographs that cannot be simply "snapped" in nature. This image may have taken three months to produce.

been photographing children and presenting them in ways that are intentionally unsettling. Her pastel colors tend to make the photograph look unnatural and the figure in it look unreal. Figure and background are flattened by the limited tonal range, and the effect is similar to that which marks some fifteenth-century paintings in northern Europe. Diana Stoll says, "Lux describes her pictures of children as 'imaginary portraits.' She is dedicated, she says, to the 'creative will, to making a reality that differs from what I find in memory and imagination'."[6] Lux has also said she uses children in her photographs as a "metaphor for innocence and lost paradise." Each finished image takes three months or so of careful work with Adobe Photoshop, a computer program that permits her to elongate features, remove distracting details, and combine the child with a background of Lux's choosing. Her show in 2005 won her the International Center of Photography Prize for Photography, previously won by Cindy Sherman.

[6]Diana Stoll, "Loretta Lux's Changelings," *Aperture* 174 (Spring 2004): 70.

FIGURE 13-22
Gregory Crewdson, *Untitled.*
2001.

Like many contemporary art
photographers, Crewdson some-
times spends days or weeks
assembling the material for his
work. His use of multiple light
sources helps give his work an
unsettling quality.

Gregory Crewdson sets up his photographic subject matter in a manner
reminiscent of preparation for a feature film. At times, he needs cranes,
lights, and as many as thirty assistants to get the effect he wants. Like Lux,
he spends months on a single image. The photograph in Figure 13-22 al-
ludes to the drowning of Ophelia in *Hamlet.* Crewdson's Ophelia has left
her slippers on the stairs and has apparently entered the water on pur-
pose, as did Shakespeare's Ophelia. To get this effect, Crewdson appears to
have flooded an ordinary living room, positioned the artificial lights, and
captured the sunlight all at the same time. Ophelia's eyes are open, her ex-
pression calm, and the colors of the scene are carefully balanced. The level
of drama in the photograph is intense, yet the reclined, passive figure of
Ophelia lends an almost peaceful quality to the image.

PERCEPTION KEY The Modern Eye

1. Compare the photographic values of Robert Mapplethorpe's *Ken Moody and Robert
 Sherman* with those of Garry Winogrand's *Los Angeles.* In which are the gradations
 of tone from light to dark more carefully modulated? In which is the selectivity
 of the framing more consciously and apparently artistic? In which is the subject
 matter more obviously transformed by the photographic image? In which is the
 form more fully revealed?

(continued)

2. Which color photograph most transforms its subject matter by the use of color? What is the ultimate effect of that transformation on the viewer?

3. Cindy Sherman and Gregory Crewdson both build sets to make their photographs. Given that the sets are artificial, and to an extent their subject matter is artificial, can their work be said to be truly representational? What distinguishes their work from, say, the work of Ansel Adams or other Documentarists?

4. Photocopy any of the color photographs to produce a black-and-white image. What has been lost in the reproduction? Why is color important to those photographs?

5. We have suggested that both the Meyerowitz and the Sherman photographs could be described as abstracts, as we also suggested with Parmigianino's *The Madonna with the Long Neck* (Figure 4-4) and Frankenthaler's *The Bay* (Figure 4-7). These are complicated issues, especially with respect to photographs, for they seem to be inherently representational. What do you think?

SUMMARY

The capacity of photography to record reality faithfully is both a virtue and a fault. It makes many viewers of photographs concerned only with what is presented (the subject matter) and leaves them unaware of the way the subject matter has been represented (the form). Because of its fidelity of presentation, photography seems to some to have no transformation of subject matter. This did not bother early photographers, who were delighted at the ease with which they could present their subject matter. The pictorialists, on the other hand, relied on nineteenth-century representational painting to guide them in their approach to form. Their carefully composed images are still valued by many photographers. But the reaction of the straight photographers, who wished to shake off any dependence on painting and disdained sentimental subject matter, began a revolution that emphasized the special qualities of the medium: especially the tonal range of the silver or platinum print (and now color print), the impersonality of the sharply defined object (and consequent lack of sentimentality), spatial compression, and selective framing. The revolution has not stopped there but has pushed on into unexpected areas, such as the exploration of the snapshot and the rejection of the technical standards of the straight photographers. Many contemporary photographers are searching for new ways of photographic seeing based on the capacity of digital cameras and computers to transform and manipulate images. They are more intent on altering rather than recording reality. This is a very interesting prospect.

Chapter 14

IS IT ART OR SOMETHING LIKE IT?

ART AND ARTLIKE

In Chapter 2, we argued that a work of art is a form-content. The form of a work of art is more than just an organization of media. Artistic form clarifies, gives us insight into some subject matter (something important in our world). A work of art is revelatory of values. Conversely, an *artlike* work is not revelatory. It has form but lacks a form-content. But what is revelatory to one person might not be to another. What is revelatory to one culture might not be to another. As time passes, a work that was originally not understood as art may become art for both critics and the public—cave paintings, for example (Figure 1-1). It is highly unlikely that the cave painters and their society thought of their works as art. If one argues that art is entirely in the eye of the beholder, then it is useless to try to distinguish art from the artlike. But we do not agree that art is *entirely* in the eye of the beholder. And we think it is of paramount importance to be able to distinguish art from the artlike. To fail to do so leaves us in chaotic confusion, without any standards. Anything goes. Joyce Kilmer's poetry is just as valuable as Shakespeare's; Norman Rockwell's painting (see Figure 14-6) is just as valuable as Raphael's (see Figure 14-10).

It is surely important to keep the boundaries between art and the artlike flexible, and the artlike should not be blindly disparaged. Undoubtedly, there

General Guidelines for Types of "Artlike" Creations

Traditional Avant-Garde

I Illustration (Realism) Folk Popular Propaganda Kitsch **C**	II Decoration **R**	III Idea Art Dada Duchampism Conceptual Art **A**	IV Performance Art **F**	V Shock Art **T**	VI Virtual Art

Differences

Works closed	Works open
Establishment	Anti-establishment
Craft emphasized	Craft de-emphasized
Chance avoided	Chance invited
Makers separate from media	Makers may be part of media
Audience separate from work	Audience may be part of work

are many artlike works—much propaganda, ***pornography,*** and shock art, for example—that may deserve condemnation. But to denigrate the artlike in order to praise art is critical snobbery. For the most part, the artlike plays a very civilizing role, as does, for instance, the often marvelous beauty of crafts. To be unaware, however, of the differences between art and the artlike or to be confused about them weakens our perceptive abilities. This is especially true in our time, for we are inundated with myriad works that are labeled art, often on no better grounds than that the maker says so. Concepts (beliefs) govern percepts to some extent. Confused concepts lead to confused perceptions. The fundamental and common feature that is shared by art and the artlike is the crafting—the skilled structuring of some medium. The fundamental feature that separates art from the artlike is the revelatory power of that crafting, the form-content (pages 58–61), the clarification of some subject matter. But we may disagree about whether a particular work has revelatory power. The borderline between art and the artlike can be very tenuous. In any case, our judgments should always be understood as debatable.

We shall classify and briefly describe some of the basic types of the artlike. We will use examples mainly from the visual field, not only because that field usually cannot be shut out, but also because that field seems to be the most saturated with what appears to be art. Our classifications will not be exhaustive, for the various manifestations of the artlike, especially in recent years, appear endless. Nor will our classifications be exclusive, for many kinds of the artlike mix with others. For example, folk art may be decoration and usually is a popular art.

We shall briefly analyze six fundamental types of works that often are on or near the boundary of art: illustration, decoration, idea art, performance art, shock art, and virtual art (see the chart "General Guidelines for Types of 'Artlike' Creations"). This schema omits, especially with respect to the avant-garde, other types and many species. However, we hope that our

schema provides a reasonable semblance of organization to a very broad and confusing range of phenomena that rarely has been addressed. The schema, furthermore, should highlight the most important issues. The division between the traditional and the avant-garde points up the powerful shift in the "new art" trends beginning with Dada during World War I. The avant-garde seems to exist in every art tradition, but never has it been so radicalized as in our time. That is one reason why the art of our time is so extraordinarily interesting from a theoretical perspective. We flock to exhibitions and hear, "What is going on here? This is art? You've got to be kidding." In this chapter, we can only begin to do justice to the controversy and excitement the avant-garde continues to produce. Those who are conservative in approaching the avant-garde should remember this caution by the late Jean Dubuffet, the painter-sculptor: "The characteristic property of an inventive art is that it bears no resemblance to art as it is generally recognized and in consequence . . . does not seem like art at all."

The two types placed under "Traditional" on the chart belong fairly clearly to the artlike. Many centuries of professional criticism have made possible something of an objective perspective for such classification. On the other hand, with the four types placed under "Avant-Garde," there has been much less time to develop an objective perspective. Because of a natural instinct to shun the new, there is a tendency to place all or most of the works of the avant-garde automatically with the artlike. This is surely a mistake. Avant-garde works can be revelatory—they can be art, of course. But they do it in different ways from traditional art, as is indicated by the listing under "Differences" on the chart. The key: Does the work give us insight? This typology is one way of classifying works that are not revelatory, but that does not mean that they cannot have very useful and distinctive functions. The basic function of decoration, for example, is the enhancement of something else, making it more interesting and pleasing. The basic function of idea art is to make us think about art. Every work should be judged by its unique merits. We should be in a much better position now than before the study of this text to make distinctions, however tentative, between art and the artlike. It can be a fascinating and illuminating study.

CONCEPTION KEY Theories

Our theory of art as revelatory, as giving insight into values, may appear to be mired in a tradition that cannot account for the amazing developments of the avant-garde. Is the theory inadequate? As you proceed with this chapter, ask yourself whether the distinction between art and artlike is valid. How about useful? If not, what theory would you propose? Or would you be inclined to dismiss theories altogether?

The distinctions that we have listed in the chart are generalities, for exceptions (sometimes many) exist. And often the opposition between the traditional and the avant-garde is one of degree. For example, as indicated by the word "craft" stretched out across all six types, craft is a prerequisite of both the traditional and the avant-garde. But craft is usually less demanding

in idea art, performance art, and shock art. In virtual art, however, craft of the highest order is generally required. Note that a distinction is being made between **craft,** or crafting, and crafts, or **craftworks.** Craft, or crafting, is the skillful use of some medium (even if, as in some performance art and shock art, the medium includes the maker's body). On the other hand, crafts, or craftworks, are the products of the crafting.

ILLUSTRATION

Realism

An **illustration** is almost always realistic; that is, the images closely resemble some object or event. Because of this sharing of realistic features, the following are grouped under "Illustration" in the chart: folk art, popular art, propaganda, and kitsch.

The structure of an illustration portrays, presents, or depicts some object or event as the subject matter. Accordingly, a basically abstract painting or sculpture—for example, Mondrian's *Broadway Boogie Woogie* (Figure 4-10)—is never an illustration. Nor is Pollock's *Autumn Rhythm* (Figure 3-3) illustrative, for although there is a suggestion of an autumnal event, there is no close resemblance, and the suggestion probably would not be noticed without the title. On the other hand, we have no difficulty recognizing that wax figures in a museum are meant to represent famous people. But do realistic portrayals give us something more than presentation? Some significant interpretation? If we are correct in thinking not, then the forms of these wax figures only *present* their subject matter. They do not *interpret* their subject matter, which is to say they lack content or artistic meaning. Such forms—providing their portrayals are realistic—produce illustration. They are not artistic forms. They are not form-content (Chapter 2).

PERCEPTION KEY *Woman with a Purse*

Is Figure 14-1 a photograph of a real woman? An illustration? A work of art?

The following experience happened to one of the authors:

On entering a large room in the basement gallery of the Wallraf-Richartz Museum in Cologne, Germany, I noticed a woman standing by a large pillar staring at an abstract painting by Frank Stella. She seemed to be having an exceptionally intense participative experience with the Stella. After a few participative experiences of my own with the Stella and some other paintings in that room, I was amazed to find the lady still entranced. My curiosity was aroused. Summoning courage, I moved very close to find that the "woman" was in fact a sculpture— the *trompe l'oeil* was almost unbelievable, becoming recognizable only within a few feet. Very few visitors in that gallery made my amusing discovery. And when they did, they too were amazed and amused, but no one's attention was held on this lady very long. Any concentrated attention was given to the technical

FIGURE 14-1
Duane Hanson, *Woman with a Purse.*

This is one of a group of life-size, totally realistic fiberglass "counterfeits" of real people. They represent a sculptural trompe l'oeil that blurs the line between art and life.

Art © Estate of Duane Hanson/Licensed by VAGA, New York, NY.

details of the figure. Was the hair real? Were those real fingernails? We decided they were.

The form of the sculpture seemed to be less than artistic, apparently revealing nothing about women or anything else, except for exceptional craftsmanship. The late Duane Hanson's *Woman with a Purse* is so extraordinarily realistic that it is a "substitute," a duplicate of the real thing. Is *Woman with a Purse* an example of art or the artlike? We will return to this question (see Perception Key, page 389).

Folk Art

There is no universally accepted definition of **folk art.** Most experts agree, however, that folk art is outside fine art or what we simply have been calling art. Unfortunately, the experts offer little agreement about why.

Folk artists usually are both self-taught and trained to some extent in a nonprofessional tradition. Although not trained by "fine artists," folk artists sometimes are directly influenced by the fine-art tradition, as in the case of Henri Rousseau, who was entranced by the works of Picasso. Folk art is never aristocratic or dictated by the fashions of the artistic establishment, and it is rarely fostered by patrons. Folk art is an expression of the folkways of the "plain society," the average person, the values of the unsophisticated. Often quite provincial, folk art generally is commonsensical, direct, naive, and earthy. Almost everything that is carefully made and not mass-produced has a folk-art quality—dress, utensils, furniture, carpets, quilts, crockery, toys, ad infinitum. After a generation or two, such works often become antiques and, in turn, increasingly valuable. The craft or skill that produces these things is often of the highest order. The products of a high degree of skill can be described as craftwork, although, of course, not all craftwork is folk art. Crafts do not necessarily express folkways, and craftspersons usually are professionally trained.

CONCEPTION KEY Photography and Film

Every art seems to have its folk counterpart. Furthermore, every art—with the possible exceptions of photography and film—seems to have evolved from folk art, dance and music being the most obvious examples. The artlike often precedes art. Why is it apparently problematic whether photography and especially film as art evolved from folk predecessors?

The folk artist, lacking the training of the professional artist, usually exhibits greater technical limitations. Picasso's technical achievements far surpass those of Rousseau. Awkwardness in a Picasso painting—*Guernica,* for example (Figure 1-4)—always appears intentional. Nevertheless, Rousseau developed, through "dogged work," as he described it, some exceptional skills, especially with color, light, and composition. Very few folk

painters have been as skillful as Rousseau, although even his work shows lack of skill at times. Technical limitations are a clue to identifying folk art. Another clue is the more or less obvious attempt at realistic portrayals, especially in technologically developed societies. Because folk painters of these cultures tend to share the values of the common person, they usually paint with a commonsense directness things they see rather than ideas, and try to make these things look as they really are. Intentional distortion in this kind of folk art is usually frowned upon. Thus, when folk painting of technologically developed cultures is less than art but is artlike, it is almost always an example of illustration—the portrayal of easily identifiable objects and events. On the other hand, the folk art of technologically undeveloped societies, such as the works of the North American Indians—the totem pole, for example—tends more toward the nonrealistic. What explains these different tendencies? Perhaps in developed societies, unlike the undeveloped, realistic images are everywhere. That is not to claim, however, that in undeveloped societies realistic images are necessarily lacking; for example, on the totem pole, animals often are very realistically portrayed, as they are in the cave painting (Figure 1-1).

Both Grandma Moses (Anna Mary Robertson Moses), who started painting in her sixties and was still at it when she died in 1961 at age 101, and Henri Rousseau, who for a time was both an amateur painter and a street musician, are sometimes called "naive artists." The term implies that they have no training and that they are essentially outsiders in the world of art. Grandma Moses seems to be interested in recording details of farm life of the sort that existed when she was young. *The Quilting Bee* (Figure 14-2) shows an interest in creating perspective and distance, but all the figures seem to be on the same plane and are virtually the same size from top to bottom. The painting is crowded and busy, much like the quilt that is being made in the background. The static quality of the figures and the flatness of the colors imply a limitation of skill. Yet her paintings have been highly valued by some connoisseurs of American art.

Compare *The Quilting Bee* with Richard Estes' painting *Baby Doll Lounge* (Figure 14-3) in terms of the accuracy of perspective, the complexity of color, and the precision of representation. Clearly, Estes does not show the technical limitations of Grandma Moses. However, it is also clear that he has either copied a photograph or adapted a photograph in such detail as to replicate it in oils. Looking at both these works raises an interesting question: Is accurate representation a signal of art or of the artlike?

Henri Rousseau painted seriously from age forty-nine, when he retired on a small pension from the customs house to paint full time. He studied paintings in French museums and made every effort to paint in the most realistic style of the day. He was sometimes the butt of ironic comments that overpraised his work, but instead of taking offense, he seems to have accepted such comments as sincere. Picasso gave a dinner in his honor in 1908, two years before Rousseau died, and some commentators feel Picasso may have been mildly ironic in his praise. Rousseau painted animals he had seen only in zoos or in dioramas in natural history museums, and

FIGURE 14-2
Grandma Moses, *The Quilting Bee*. 1950. Oil on masonite, 20 × 24 inches.

Discovered at age seventy-eight, Anna Mary Robertson found herself a darling of the art world. Paintings she once sold for three dollars suddenly became worth thousands.

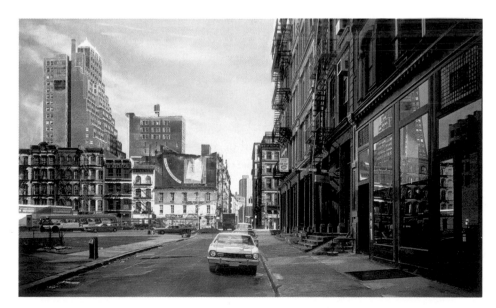

FIGURE 14-3
Richard Estes, *Baby Doll Lounge*. 1978. Oil on canvas, 3 × 5 feet.

Estes, who painted in oils, created a style that emulated photography, but tried to outdo it.

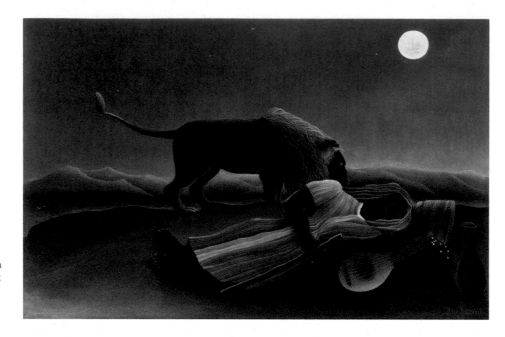

FIGURE 14-4
Henri Rousseau, *The Sleeping Gypsy*. 1897. Oil on canvas, 51 × 79 inches.

Rousseau was a customs agent during the day, but a painter in his free time. Although without training in art, he became one of the most original figures in modern art.

sometimes he painted animals together that could never have shared the same space. His sense of perspective was lacking throughout his career, and his approach to painting was marked by odd habits, such as painting all one color first, then bringing in the next color, and so on. However, his lack of skill came at a time in art history when Surrealism was under way, and his particular unrealities began to seem symbolic and significant in ways that a realistic painting, such as Estes' *Baby Doll Lounge*, could not. This is especially true of *The Sleeping Gypsy* (Figure 14-4), which improbably places a strange-looking lion next to a gypsy whose position is so uncertain as to suggest that he or she may roll out of the painting. Rousseau's intention was to make the painting totally realistic, but the result is, as with Grandma Moses's, more schematic and suggestive than realistic.

PERCEPTION KEY Grandma Moses, Richard Estes, Henri Rousseau

1. Which of these three paintings seems to reveal the greatest artistic skill?
2. When deciding on the distinction between art and the artlike, how essential is accuracy in representing reality?
3. Which of these three paintings is the most artistic in your opinion? Which is the least?
4. Which of these paintings is most likely folk art?
5. Which painting is closest to illustration?
6. In the case of each of these paintings, decide what the subject matter is. Then decide if the form transforms the subject matter and creates content. Which painting has the most interesting content? Which has the least interesting content? Are all of these paintings art, or are some artlike?

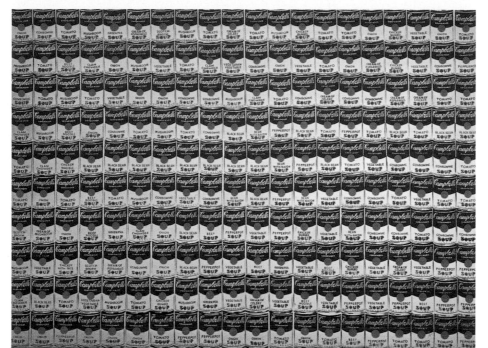

FIGURE 14-5
Andy Warhol, *200 Campbell's Soup Cans*. 1962. Acrylic on canvas, 72 × 100 inches.

The leader of the Pop Art movement, Warhol became famous for signing cans of Campbell's soup and fabricating individual cans of Campbell's soup. For a time, the soup can became an identifier of Pop Art.

Popular Art

Popular art—a very imprecise category—encompasses contemporary works enjoyed by the masses, who presumably lack artistic discrimination. The masses love Norman Rockwell, dismiss Mondrian, and are puzzled by Picasso. Popular art is looked down upon by the "highbrows." Fine art is looked down upon by the "lowbrows."

The term "Pop" derives from the term "popular." In the 1960s and 70s, ***Pop Art*** was at the edge of the avant-garde, startling to the masses. But as usually happens, time makes the avant-garde less controversial, and in this case the style quickly became popular. The realistic showings of mundane objects were easily comprehended. Here was an art people could understand without snobbish critics. We see the tomato soup cans in supermarkets. Andy Warhol helps us look at them as objects worthy of notice (Figure 14-5), especially their blatant repetitive colors, shapes, stacking, and simplicity. For the masses, we finally have an art that seemingly is revelatory.

PERCEPTION KEY Pop Art

1. Is Warhol's painting revelatory? If so, about what?
2. Go back to the discussion of Duane Hanson's work (Figure 14-1). If you decide that the Warhol work is art, then can you make a convincing argument that *Woman with a Purse* helps us really *see* ordinary people and thus also is a work of art? These are controversial questions.

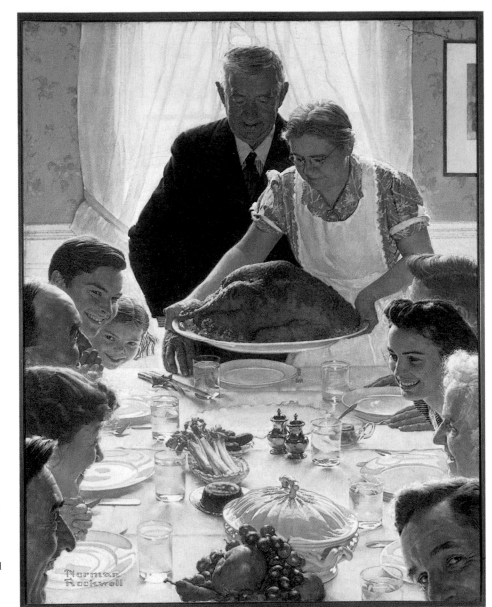

FIGURE 14-6
Norman Rockwell, *Freedom from Want*. 1943. Oil on canvas, 45¾ × 35½ inches.

An iconic representation of the American family during World War II, this image was parodied in the film *American Gangster,* with Denzel Washington at the head of the table.

PERCEPTION KEY Norman Rockwell's *Freedom from Want*

Next to Andrew Wyeth, Rockwell is probably the most popular and beloved American painter. A very modest man, Rockwell always insisted that he was only an illustrator. Does the folksy piety appear sentimental in *Freedom from Want* (Figure 14-6)? Is the scene superficial? Does the scene stir your imagination? Does the painting make any demand on you? Enhance your sensitivity to anything? Enlarge your experience? Is *Freedom from Want* art or illustration? Despite his popularity, Rockwell is almost universally described as an illustrator by the experts. They claim that his works are composed of pictorial clichés. Do you agree? Who anoints the experts?

Professional work can be much more realistic than folk art. Professional technical training usually is a prerequisite for achieving the goal of very accurate representation, as anyone who has tried pictorial imitation can attest. Professionals who are realists are better at representation than folk painters, as Richard Estes' *Baby Doll Lounge* (Figure 14-3) demonstrates. Realistic painting done by professionals is one of the most popular kinds of painting, for it requires little or no training or effort to enjoy. Usually, very realistic paintings are illustrations, examples of the artlike. Sometimes, however, realistic painters not only imitate objects and events but also interpret what they imitate, crossing the line from illustration to art.

PERCEPTION KEY Estes and Rockwell

1. Does the sharp-focus realism (known as "photo-realism" because it is based on photography) of *Baby Doll Lounge* make it an illustration?
2. Note the reflections in the store windows. Do we ever see reflections quite like that? If not, then can one reasonably argue that by means of such transformation Estes heightens our awareness of such "things as they are" in the cityscape?
3. Do you think that Norman Rockwell worked from a photograph to paint *Freedom from Want*? Is cutting off the heads on each side of the painting typical of photographs of scenes such as this? How impressive is Rockwell's artistic technique? Does his technique make this a work of art?
4. In terms of realism, how realistic is this portrait of a family sitting down to a happy Thanksgiving Day meal? Is it possible that this is more of a fantasy than a reality? Is it possible that this painting might serve as propaganda for family values? How would that affect its value as a work of art?
5. Compare Richard Estes' *Baby Doll Lounge* with Norman Rockwell's *Freedom from Want*. Which seems more representative of the world in which you live? Which transforms its subject matter more? Which has a richer content?

Baby Doll Lounge, in our opinion, is a work of art. Estes worked from a series of photographs, shifting them around in order to portray interesting relationships of abstract shapes as well as the illusion of realism. Thus the buildings in the left background are reflected in the glass in the right foreground, helping—along with the bright curving line on the dark roof of the building slightly left of center—to tie the innumerable rectangles together. A geometrical order has been subtly imposed on a very disorderly scene. Estes has retained so much realistic detail, totally unlike Mondrian in *Broadway Boogie Woogie* (Figure 4-10), that initially we might think we are looking at a photograph. Yet, with a second look, it becomes apparent that this cannot be a photograph of an actual scene, for such a complete underlying geometry does not occur in city scenes. Moreover, people are totally absent, a possible but unlikely condition. An anxious, pervasive silence emanates from this painting. Despite the realism, there is a dreamy unreality. Take an early Sunday morning stroll in a large city, with the dwellers still asleep, and see if you do not perceive more because of Estes.

The line between realistic painting that is illustration and realistic painting that is art is perhaps particularly difficult to draw with respect to the

paintings of Andrew Wyeth, hailed as the "people's painter" and arguably the most popular American painter of all time. His father, N. C. Wyeth, was a gifted professional illustrator, and he rigorously trained his son in the fundamentals of drawing and painting. Wyeth was also carefully trained in the use of tempera, his favorite medium, by the professional painter Peter Hurd, a brother-in-law. So although a nonacademic and although trained mainly "in the family," Wyeth's training was professional. Wyeth is not a folk painter.

Among the great majority of critics, Wyeth is not highly appreciated, although there are outstanding exceptions, such as Thomas Hoving, former director of the Metropolitan Museum of Art. Wyeth is not even mentioned, let alone discussed, in Mahonri Young's *American Realists*. Clement Greenberg, one of the most respected critics of recent times, asserted that realistic works such as Wyeth's are out of date and "result in second-hand, second-rate paintings." In 1987, an exhibition of Wyeth's work was held at the National Gallery of Art in Washington, D.C. Some critics demurred: Wyeth makes superficial pictures that look like "the world as it is," except tidied up and sentimentalized. They claim that Wyeth is a fine illustrator, like his father, but that the National Gallery of Art should be used for exhibitions of art, not illustrations. Notice again, incidentally, the relevance of the question: What is art?

Wyeth's most beloved and famous painting is *Christina's World* (Figure 14-7). He tells us that

When I painted it in 1948, *Christina's World* hung all summer in my house in Maine and nobody particularly reacted to it. I thought is this one ever a flat tire. Now I get at least a letter a week from all over the world, usually wanting to know what she's doing. Actually there isn't any definite story. The way this tempera

happened, I was in an upstairs room in the Olson house and saw Christina crawling in the field. Later, I went down on the road and made a pencil drawing of the house, but I never went down into the field. You see, my memory was more of a reality than the thing itself. I didn't put Christina in till the very end. I worked on the hill for months, that brown grass, and kept thinking about her in her pink dress like a faded lobster shell I might find on the beach, crumpled. Finally I got up enough courage to say to her, "Would you mind if I made a drawing of you sitting outside?" and drew her crippled arms and hands. Finally, I was so shy about posing her, I got my wife Betsy to pose for her figure. Then it came time to lay in Christina's figure against that planet I'd created for all those weeks. I put this pink tone on her shoulder—and it almost blew me cross the room.[1]

PERCEPTION KEY *Christina's World*

1. Does Wyeth's statement strike you as describing the crafting of an illustrator or the "crafting-creating" of an artist? But is such a question relevant to distinguishing illustration from art? Is not *what is made* the issue, not the *making* (Chapter 2)?
2. Would you describe the painting as sentimental (Chapter 13)? Could it be that sometimes critics tag works as sentimental because of snobbery?
3. Is this a pretty painting? If so, is such a description derogatory?
4. Try to imagine what the actual scene looked like. Is the painting very different from your image?
5. Is *Christina's World* illustration or art? Until you see the original in the museum, keep your judgment more tentative than usual.

Propaganda

No species of the artlike is likely to be as realistically illustrative as ***propaganda,*** for mass persuasion requires the easy access of realism. The title of Figure 14-8—*They Are Writing about Us in Pravda*—immediately suggests Soviet political propaganda, for *Pravda* was the chief propaganda organ of the Russian Communists. Superficially, the painting—with its apparent innocence and realism—might appear to be an example of folk art. And yet it is too well crafted (professionally executed) to be folk. Note, for example, the skillful use of perspective.

Once the historical context of the painting is understood, one confronts political propaganda of the most blatant kind. The five young harvesters lunch on a beautiful day amidst the golden cornfields of Moldova (eastern Romania). A gleaming green motorcycle is parked on the right side, and on the far left in the middle distance a combine is reaping. Alexei Vasilev produced a picture that, in Stalin's words, is "national in form and socialist in content." These happy peasants, blessed with modern machinery and the Soviet government, are even happier because of their notice in *Pravda*.

[1]Wanda M. Corn, *The Art of Andrew Wyeth* (Greenwich, Conn.: New York Graphic Society, 1964), p. 38.

FIGURE 14-8
Alexei Vasilev, *They Are Writing about Us in Pravda.* 1951. Oil on canvas, 39 × 61 inches.

Typical of Soviet propaganda art during the cold war, this painting idealizes the life of rural farmers, using the highly realistic style approved by the Communist Party.

EXPERIENCING Propaganda Art

1. If you were a communist, do you think you would describe *They Are Writing about Us in Pravda* as political propaganda?

 The likelihood that a dedicated communist would see Vasilev's painting as only propaganda may not necessarily be great. Someone who works in that system and believes as the system insists they believe may well think of this painting as a great work of art because it praises the work of the people in the fields—those who support the system. That person may also praise the work for its carefully drawn and composed realistic portrayal of farm workers reading *Pravda* during their lunch break. The motorbike implies that these workers have access to up-to-date transportation. The combine in the distance also implies that these farmers are up-to-date. For those reasons alone, that person may think this a fine work of art.

 For someone interested in other systems, however, certain issues may call the work into question. For one thing, all political systems produce art praising themselves, and virtually all of them insist on producing absolutely realistic art. Nazi Germany flooded Europe with posters of heroic SS men and saluting soldiers praising Hitler, all in absolutely realistic detail. The same was true in China during the rule of Mao Tse-Tung. Even today, huge posters of Mao stand in public places. Abstract art was condemned in Nazi Germany as decadent because it could not be turned into good propaganda for the system. The problem with propaganda art is not that it is realistic, but that it is limited. Its form does not inform because the message is primarily political, not primarily artistic. Vasilev's painting is overly sentimental and portrays workers who are obviously not really working. They are not sweaty, not tired, not truly realistic. They are puppets. This is art for people who are trained not to take art seriously.

2. Some propaganda artifacts are not so easily dismissed. Try to see either *Triumph of the Will* (1936) or *Olympia* (1938), by Leni Riefenstahl (1902–2003), a popular actress and film director who worked for Hitler. The camera work is extraordinarily imaginative. These films glorify Nazism. Can these films be considered art?

FIGURE 14-9
Salvador Dalí, *Love and Death*.

Dalí enjoyed shocking the art
world and prized his reputation
as a master surrealist.

Everything has been falsified: The Moldovan peasantry had been robbed
by the Soviet state of their land, culture, and even language. Most of them
were beaten, killed, or exiled. The painting is an artlike work with propa-
ganda as its subject matter.

Kitsch

Kitsch refers to works that realistically depict easily identifiable objects and
events in a pretentiously vulgar, awkward, sentimental, and often obscene
manner. Kitsch triggers disgust at worst and stock emotions at best, trivi-
alizing rather than enriching our understanding of the subject matter. The
crafting of kitsch is often minimal. Kitsch is the epitome of bad taste.

Study Salvador Dalí's *Love and Death* (Figure 14-9). The subject matter
is about Dalí, sex, and death. Craftsmanship is much more evident than in
Grandma Moses's *The Quilting Bee* (Figure 14-2), but what does the extraor-
dinary cleverness reveal about sex and death? It presents Dalí as an egoist,
hardly an earthshaking discovery. Dalí was associated with the surrealists in
the 1920s and 30s and did some paintings that generally are accepted as art.

Kitsch has been around for centuries, especially since the 1700s, but now it seems to be all pervasive. Bad taste greets us everywhere—tasteless advertisements, silly sitcoms, soap operas, vile music, superficial novels, pornographic images, and on and on. Where, except in virgin nature, is kitsch completely absent? According to Milan Kundera, "The brotherhood of man on earth will be possible only on the base of kitsch." Jacques Sternberg says, "It's long ago taken over the world. If Martians were to take a look at the world they might rename it kitsch." Are these overstatements? As you think about this, take a hard look at the world around you.

DECORATION

Decoration is something added to enhance something else, to make it more prominent or attractive or suitable. Decoration should be subordinate to what it decorates. Good decoration rarely calls attention to itself. If the decoration dominates a work of art, then as decoration it is inappropriate. Works of art usually control decoration, because the power of their content defies subordination. Sometimes something that often is decorated—such as the frame of a painting—may be an integral part of the painting. For example, Georges Seurat, the French impressionist of the late nineteenth century, sometimes painted tiny dots on his frames closely matching the dotting on his canvases. To describe the painting on the frames as decoration would be misleading. As you think about this, look at Raphael's *Madonna della Sedia* (Figure 14-10). The frame obviously is strikingly beautiful. But is it an integral part of the painting? Or is it decoration? Or is it unsuitable decoration, because its brilliance competes rather than harmonizes with the painting?

The Book of Kells was made in a monastery shortly after 800 on the island of Iona off the Irish coast, miraculously surviving ninth-century Viking raids of unprecedented destruction. Because Christians of the time believed that the Bible was divinely inspired, they regarded its letters, especially on the first page of one of the Gospels, as having miraculous religious potency. Thus the letters were painted with special care. On the first page of the Gospel of St. Matthew is a fantastic painting surrounding the Greek letter chi (Figure 14-11). Although the rest of the pages are beautifully printed, this first page is exceptional.

A letter functions as an element of language. The fabulous pattern of lines and colors around the chi enhances our interest in that letter. Therefore it would seem reasonable to assert that the pattern makes the chi more attractive and thus is decoration, is artlike.

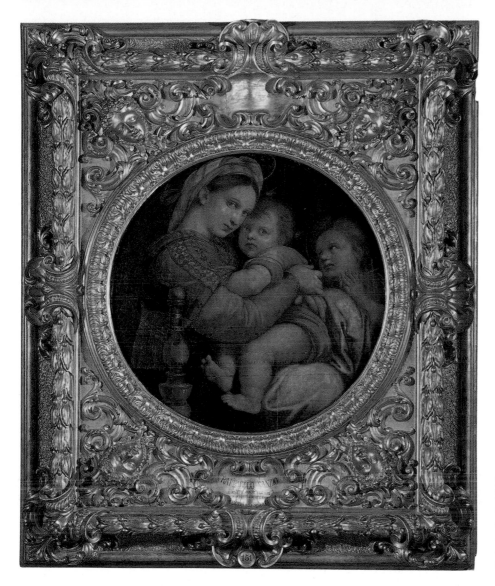

FIGURE 14-10
Raphael Sanzo, *Madonna della Sedia*. Circa 1516. Oil on panel.

The frame was added almost two hundred years later. By then the painting itself had become known worldwide.

PERCEPTION KEY Book of Kells

Because of the beautiful crafting of its letters, the Book of Kells is often described as "illuminated," suggesting "to light up," "to enlighten." Does this suggest that the *illumination* we have here, at least on this page, is more than decoration? But if so, what is the subject matter? What is the content?

Perhaps on one level, the subject matter of this page is abstract, the sensuous, the swirl of lines in endless patterns of exquisite color. So vast are the mazes of patterns, it is impossible to take them all in simultaneously as a

FIGURE 14-11
The chi rho monogram from the Book of Kells. Circa 800.

One of the few fully illustrated pages in the book, the Greek letters chi and rho are an abbreviation for Christ. The complexity of this page is sometimes the subject of study in courses in mathematics.

whole. Only by successive partial inspections, adding cumulatively, can we more or less comprehend the totality. Few if any works of art have more successfully revealed in such a small area (13 × 19½ inches) the dynamic linear rhythms and color patterns of certain kinds of intricate visual experience— for example, the walls of the Paris subway near the Louvre as one speeds by. Less obviously, there may be a deeper level of subject matter, undoubtedly

more evident to ninth-century contemporaries—the awesome complexity and incomprehensibility of the divine. The apparent infinity of line encompassed within such a finite space, it can be argued, reveals something of the majestic mystery of the sacred.

Good decoration is always modest. Only when what is decorated is especially powerful can the decoration also be powerful, providing it still remains secondary in attraction. Study again Raphael's *Madonna della Sedia* (Figure 14-10). The radiant patterns of the gold-gilt frame—made long after Raphael's death and one of the finest frames of all time—are well worth attention. Yet the painting is so overwhelming that the frame remains completely subordinate, and properly so. Its beauty enhances the beauty of the painting. Over the years, one of the authors has taken a large number of students to the Pitti Palace in Florence to see this work. Afterward, they were asked whether there were any portrayals of human faces in the frame. There are four. No student noticed.

For the most part, except when used with works of art of very high quality such as Raphael's *Madonna della Sedia,* decoration avoids realistic portrayals. Decoration and realism normally do not mix very well, because realism tends to distract our attention from what is being decorated. Decoration is rarely an illustration. Our survival depends upon recognizing objects and events, and so when we see them realistically portrayed, our attention automatically tends to focus upon them. Abstract decoration or highly stylized portrayals of things better suit the background, as with the Raphael.

Ideally we *attend* to works of art. Although we may not have time for the painting on the wall or the sculpture in the corner, we know they were meant to be participated with. Good decoration, on the other hand, makes no such demand. Its function is to provide a proper setting or background. Imparting no content, decoration requires no participation. We live comfortably with good decoration, find it fitting, and normally experience it with whatever fluctuating attention we can spare. Good decoration is restful, one of the most valuable amenities of civilized life.

IDEA ART

Idea art began with the Dadaists around 1916. Although never dominant, idea art has survived by spawning "isms"—***Duchampism,*** Conceptualism, Lettrism, New Dadaism, to name just a few—with little consensus about an umbrella name that indicates a common denominator. Idea art raises questions about the presuppositions of traditional art and the art establishment— that is, the traditional artists, critics, philosophers of art, historians, museum keepers, textbook writers, and everyone involved with the understanding, preservation, restoration, selling, and buying of traditional art. Sometimes this questioning is hostile, as with the Dadaists. Sometimes it is humorous, as with Marcel Duchamp. And sometimes it is more of an intellectual game, as with many of the conceptual artists. We will limit our discussion to these three species.

Dada

The infantile sound of "dada," chosen for its meaninglessness, became the battle cry of a group of disenchanted young artists who fled their countries during World War I and met, mainly by chance, in Zurich, Switzerland, in 1916. Led by the poet Hugo Ball, they assembled at the Cabaret Voltaire. In their view, humanity had forsaken reason—utterly. The mission of **Dadaism** was to shock a crazed world with expressions of outrageous nonsense, negating every traditional value.

Civilization was the subject of their violent attack, for it had produced maniacs murdering millions in World War I. The movement was joined by such outstanding artists as Jean Arp, Sophie Tauber, Hans Richter, Paul Klee, Francis Picabia, and Duchamp. Except for their talent and hatred of the bourgeoisie and the status quo, they had little in common. Yet the Dada movement held together for about seven years, spreading rapidly beyond Zurich, especially to Paris and New York City. During those years, the Dadaists for the most part tried to make works that were not art, at least in the traditional sense, for such art was part of civilization. They usually succeeded, but sometimes they made art in spite of themselves. The influence of the Dadaists on succeeding styles—such as surrealist, abstract, environmental, pop, performance, body, shock, outsider, and conceptual art—has been enormous. Picabia announced:

> Dada itself wants nothing, nothing, nothing, it's doing something so that the public can say: "We understand nothing, nothing, nothing." The Dadaists are nothing, nothing, nothing—certainly they will come to nothing, nothing, nothing.
> Francis Picabia
> Who knows nothing, nothing, nothing.

But there is a dilemma: To express nothing is something. Unless one remains silent (sometimes the Dadaists thought of their revolt as "nothing" but a state of mind), there has to be a crafted medium. Picabia's proclamation required the medium of language, and he obviously formed it to say something about "nothing," emphasized by its triadic repetition.

FIGURE 14-12
Francis Picabia, *The Blessed Virgin.* 1920. Ink.

Picabia, one of the Dadaist painters, pushed the concept of art in directions that few could follow. Like all Dadaists, he showed contempt for bourgeois society after World War I.

PERCEPTION KEY Picabia

1. Is *The Blessed Virgin* (Figure 14-12) about nothing? Is the title significant? Is the work anticivilization? Is it a work of art according to the theory of art proposed in this text? Compare this with Figure 3-7 by Chris Ofili.
2. If religious organizations protested Chris Ofili's painting, would they be likely to protest Picabia's? On what grounds would they do so? Would their protest be anti-art?

Picabia dropped ink on paper, and the resulting form is mainly one of chance, one of the earliest examples of a technique later to be exploited by artists such as Jackson Pollock (Figure 3-3). The height of the drop,

KEITH ARNATT IS AN ARTIST

FIGURE 14-13
Keith Arnatt, *Keith Arnatt Is an Artist*. 1972. Wall inscription exhibited in 1972 at the Tate Gallery in London.

Letters on a wall constitute the entire work of art, including the ideas behind the words.

the type of ink, and the color, texture, and dimensions of the paper were controlled, and the result is not entirely formless. Then there is the title. Is it entirely meaningless? If not, is the Virgin to be identified with the ink splash or the white paper? Is this blasphemy? An image of a bursting bomb? Splattered flesh and blood? Chance murder? Meanings gather. Given the sociopolitical context of 1920, this work is surely anticivilization. It defied both social and artistic conventions. Yet its very defiance obviously conveyed meanings. Unlike a traditional work of art, however, the meanings of *The Blessed Virgin* are suggested rather than embodied in the work. A glance or two suffices, and that triggers ideas. The form is too loose to hold attention. There is no invitation to participate with *The Blessed Virgin*. According to the theory of art proposed in this text, *The Blessed Virgin* is not a work of art but a work that makes us think about what is art. It is a clear example of idea art.

Idea art does not mix or embody its ideas in the medium. Rather, the medium is used to suggest ideas. Medium and ideas are experienced as separate. In turn, idea art tends increasingly to depend upon language for its communication. And in recent years, idea art has even generated a species called Lettrism, or word art—see, for example, *Keith Arnatt Is an Artist* (Figure 14-13).

PERCEPTION KEY Keith Arnatt

1. Is Figure 14-13 art? Is it artlike?
2. Is it well crafted? If so, would it be better classified as a craftwork?
3. Why would the curators of the highly respected Tate Gallery in London include such a work, especially one that requires such a large space?

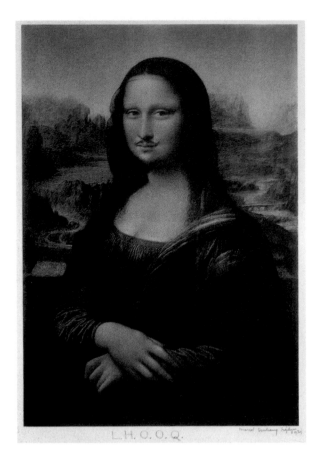

FIGURE 14-14
Marcel Duchamp, *L. H. O. O. Q.*
1919. Drawing, 7¾ × 4⅛ inches.

In several different ways,
Duchamp commits an act of
desecration of the *Mona Lisa*,
perhaps the most famous
painting in the West.

Duchamp and His Legacy

Dada, the earliest species of idea art, is characterized by its anger at our so-called civilization. Although Duchamp cooperated with the Dadaists, his work and the work of those who followed his style (a widespread influence) are more anti-art and anti-establishment than anticivilization. Duchamp's work is usually characterized by humor.

PERCEPTION KEY *L.H.O.O.Q.*

1. Is *L.H.O.O.Q.* (Figure 14-14) an example of idea art?
2. Is *L.H.O.O.Q.* a work of art?

L.H.O.O.Q. is hardly anticivilization, but it is surely anti-art and anti-establishment, funny rather than angry. It is a hilarious comment upon the tendency to glorify certain works beyond their artistic value. To desecrate one of the most famous paintings of the Western world was surely a great idea if you wanted to taunt the art establishment. And ideas gather. Sexual ambiguity, part of both Leonardo's and Duchamp's legends, is evident in

Leonardo's *Mona Lisa* (Figure 1-6). By penciling in a mustache and beard, Duchamp accents the masculine. By adding the title, he accents the feminine. *L.H.O.O.Q.* is an obscene pun, reading phonetically in French, "Elle a chaud au cul" ("She has a hot ass").

Perhaps the most famous (or infamous) example of Duchamp's idea art is the ready-made titled *Fountain*. In 1917, in New York City, a group of avant-garde artists, the Society of Independent Artists, put on an exhibition in which anyone could enter two works merely by paying six dollars. Duchamp submitted a porcelain urinal that he had bought, placed it on its back on a pedestal, and signed it "R. Mutt." Duchamp was claiming, with marvelous irony, that *any* object could be turned into a work of art merely by the artist labeling it as such. How amusing to nettle the jurors by challenging their libertarian principles! Predictably, the jury refused to display *Fountain*. Anti-art conquered even the avant-garde. And the ready-made—Duchamp selected and placed on pedestals such things as bottle racks and bicycle wheels—posed the ever-recurring question: What is a work of art? For the art establishment, the whole issue has been destabilizing ever since the rejection of *Fountain* in 1917. Many of Duchamp's ready-mades, including *Fountain*, are now ensconced in museums of art, the ultimate irony. They have great historical interest because of the originality of Duchamp's ideas, their humor, and the questions they raise; and for these reasons, their placement in museums seems to be justified. But are they works of art?

Conceptual Art

Conceptual art became a movement in the 1960s, led by Sol LeWitt, Jenny Holzer, Carl Andre, Christo, Robert Morris, Walter De Maria, Keith Arnatt, Terry Atkinson, Michael Baldwin, David Bainbridge, and Joseph Kosuth. There was a strategy behind the movement: Bring the audience into direct contact with the creative concepts of the artist. LeWitt claimed that "a work of art may be understood as a conductor from the artist's mind to the viewer's," and the less material used the better. The world is so overloaded with traditional art that most museums stash the bulk of their collections in storage bins. Now if we can get along without the material object, then the spaces of museums will not be jammed with this new art, and it will need no conservation, restoration, or any of the other expensive paraphernalia necessitated by the material work of art. Conceptual art floats free from material limitations, can occur anywhere, like a poem, and often costs practically nothing.

In recent years, LeWitt has modified his early Conceptualism. In an exhibition in 2001 involving a whole floor of the Whitney Museum in New York City, a vast array of color fields, mainly within large geometrical shapes, blazed out from the walls. LeWitt provided exact detailed blueprints to guide a dozen or so craftspeople. LeWitt did none of the work and very little supervising. He provided the ideas—the rest can be done by anyone with a little skill. The creativity is in the conceptual process that produced the blueprints. The crafting is completely secondary.

FIGURE 14-15
Walter De Maria, *The Broken Kilometer*. 1979. Solid brass bars, each rod two meters long. Long-term installation at Dia Center for the Arts, 393 West Broadway, New York City.

A clear break with traditional art, this piece encourages the viewer to consider the act of breaking a kilometer into pieces and then reflecting on their nature. This particular configuration of pieces is only one of many.

CONCEPTION KEY *The Broken Kilometer*

1. Is the work by Walter De Maria (Figure 14-15) an example of conceptual art?
2. Would its installation require the presence of the artist? The presence of a craftsperson?
3. Is there any way in which this work is a derivative from Dada? From Duchamp?

The idea of De Maria's example of conceptual art is to put into some kind of visible, total pattern a kilometer of 500 solid brass rods, each two meters long. They can be installed anywhere and in any way, as long as the concept of orderly visual recession is communicated. The artist's directions are all that is necessary for installation, which can be carried out by janitors. The brass rods have some material interest, and this interest no doubt compromises the conceptuality of *The Broken Kilometer*. The work is more a derivative from Duchamp than from Dada, for there is protest not against society, as in Dada, but against traditional art, as in Duchamp.

CONCEPTION KEY Conceptual Art

1. Some conceptual artists assert that their work raises for the first time truly basic questions about the nature of art. Do you agree?
2. Is idea art, in general, art or artlike? More specifically, in general, is Dada art or artlike? Duchampism? Conceptual art?

PERFORMANCE ART

Unlike conceptual art, ***performance art*** (as distinct from the traditional performing arts) brings back physicality, stressing material things as much as or more than it does concepts. There are innumerable kinds of performances,

but generally they tend to be site-specific, the site being either constructed or simply found. There rarely is a stage in the traditional style. But performances, as the name suggests, are related to drama. They clearly differ, however, especially from traditional drama, because usually there is no logical or sustained narrative, and perhaps no narrative at all. Sometimes there is an effort to allow for the expression of the subconscious, as in Surrealism. Sometimes provocative anti-establishment social and political views are expressed. Generally, however, performances are about the values of the disinherited, the outsiders.

Chance is an essential element of the form, which is to say the form is open. There usually is some control that makes possible the unforeseen, the happenings that are not planned. Many performances have instructions for the takeoff, but none for the landing. Repetition of a performance is rare, and close repetition even rarer. Thus photography may be essential for the record of the events. The factor of chance may weaken the crafting; for crafting is ordering, and chance is likely to be disordering in a performance situation. Both the artist and the audience may be an integral part of the performance. They can become part of the medium, an extraordinary departure from traditional art. Interaction between artist and audience is often encouraged. According to the performance artist Barbara Smith, "I turn to question the audience to see if their experiences might enlighten mine and break the isolation of my experience, to see if my Performance puts them into the same dilemma." There is a sense of digging for the common, unarticulated experience, especially of oppressed communities. The performance denies its independence, for it implicates the audience in its working. And there is no way of knowing exactly how all of this interaction is going to work out. The performance is an open event, full of suggestive potentialities rather than a self-contained whole, determined and final.

Visual effects are usually strongly emphasized in a performance, often involving expressive movements of the body, bringing performance close to dance. In early performances, language was generally limited. In recent performances, however, language has often come to the fore. Thus Taylor Woodrow, a British performer, and two collaborators covered themselves with spray paint, attached themselves to separate painted canvases by means of harnesses, stood there for about six hours, and talked with the curious.

Karen Finley became famous for a performance work called *We Keep Our Victims Ready,* a piece that anatomized aspects of American society in 1990, when the feminist movement was strong and when many efforts were being made to censor artists whose work was critical of American culture. Typical of many performance pieces, Finley used nudity, profanity, and an alarming attack on heterosexual white males, who, in her view, controlled society. In one section of her piece, she stripped to her panties and smeared chocolate over her body in an effort to represent what she felt was a woman's battered self-image resulting in a sense of disgust at her own body. It was no surprise that she was one of four performance artists whose work was denied support from the National Endowment for the Arts despite huge audiences and what became a national tour of her work. Ordinarily, performance art does not repeat itself, nor does it produce a tour.

FIGURE 14-16
Karen Finley, a performance
artist, uses her own body to
make statements, often covering
herself with various food prod-
ucts or other substances, such
as feathers.

But the resultant uproar from the powerful politicians in the community
essentially guaranteed a widespread audience for Ms. Finley and has led to
continued success (Figure 14-16). Like all performance art, *We Keep Our
Victims Ready* was designed to be memorable and sometimes shocking. Be-
cause there are no rules for performance art and usually no way to buy it,
the experience is what counts; and whether it is art may depend on whether
you agree with the performer, who says it is art. For us, ultimately, the
question is whether the experience informs through its form.

PERCEPTION KEY Performance Art

1. Does the fact that there are no rules to performance art affect our view of whether
 we can legitimately consider it art? One critic says that performance art is art
 because the performer says so. How valid is that argument?
2. If you were to strip down and cover yourself with chocolate, would you then be
 an artist?

3. William Pope.L chained himself for six hours to an ATM wearing only shorts and shoes in protest against capitalism, conversing with passersby all the while. Under what conditions might that constitute performance art?
4. Were you to attempt performance art, what would your strategies be? What would you do as a performer? Would it be obvious that your performance would be art?

We have been assuming that the participative experience (see Chapter 2) takes time. If a work fails to hold our attention, then presumably it is not a work of art, because there is insufficient time for anything to be revealed. There is surface recognition but no depth. But what is sufficient time? This may vary greatly from person to person. For some, perhaps a minute or so is enough. The ultimate test: Did the experience, however brief, make a significant difference in your understanding of values, of yourself and your world? Generally, for most of us, insight requires more than a few minutes of participation.

SHOCK ART

In recent years, works of a bewildering variety have been made that attract and then often astonish, scandalize, or repel. These works have been displayed—presumably as art—both inside and outside of museums. Many performances could also be classified as *shock art.*

The anti-establishment career of Paul McCarthy began with anti-Vietnam performances in the 1960s and 70s, and in recent years he has become one of the most well known of the "shockers." McCarthy's work has gradually expanded to include painting, sculpture, architecture (installations), drama, photography, film, and combined media, including his own body. He attacks the saccharine, Disneyfied view of the world with a vengeance, often with horrifying, stomach-churning repulsion. McCarthy probes the depths of the darkest side of the American psyche: fears, terrors, and obsessions. Since September 11, 2001, his work would seem to be increasingly relevant. Taboos, especially the erotic, and even excretion, incest, and bestiality, are portrayed with primal violence. In the carnage of his works—an ugliness that perhaps has never been surpassed—humor occasionally may glint with parody. But McCarthy's works nauseate most people. Try to see some of his work and experience it for yourself. However evaluated, his creations are so powerful that they cannot be dismissed as merely clever. And, surely, no one will be bored.

Much shock art seems to involve little more than clever gimmickry, grabbing but not holding our attention. We love to be shocked, as long as there is no danger. We look with curiosity and often bewilderment. For example, who would place on display a crucifix in a bottle of his urine? The answer is Andres Serrano. Why? And at a recent exhibition at the Guggenheim Museum in New York, someone neatly packaged a piece of his own excrement in a little box, carefully signed, dated, and authenticated. It was placed on a pedestal. Why? One answer might be that these makers lacked the craftsmanship and creativity to make anything better, and the making gains them

money and notice, as in a book such as this. But why would the museum directors display such objects? Perhaps because shock art draws crowds. Furthermore, much shock art challenges common assumptions about what is art and may serve an educational function. Shock art catches our attention, sometimes more strongly than traditional art. But usually, after the initial draw, we do not participate. After the first excited seizure, we turn away and perhaps think (or joke) about the possible meanings. Shock art often works as conversation pieces. Much shock art could also be classified as idea art.

CONCEPTION KEY Shock Art

In 2001, the Brooklyn Museum of Art presented an exhibition of photography that included the fifteen-foot panel *Yo Mama's Last Supper,* a color photograph of a nude black woman as Christ at the Last Supper. The woman shown is the artist herself, Renee Cox, and she is surrounded by twelve black apostles. The exhibition elicited a strong response from then Mayor Rudy Giuliani (remember his reaction to the museum's 1999 show *Sensation: Young British Artists,* Figures 3-6 and 3-7). Mayor Giuliani declared that he would appoint a commission to set decency standards—basically "Culture Cops." Do you agree or disagree with the mayor? Why? These kinds of incidents and issues are becoming more prevalent.

VIRTUAL ART

Virtual art is based on computer technology, often producing a mixture of the imaginary and the real. For example, imagine a world in which sculptures act in unpredictable ways: taking on different shapes and colors, stiffening or dancing, talking back or ignoring you, or maybe just dissolving. At a very sophisticated computer laboratory at Boston University, a team of artists and computer craftspeople have created a fascinating installation called *Spiritual Ruins*. One dons a pair of 3-D goggles and grabs a wand. On a large screen, a computer projects a vast three-dimensional space into which we appear to be plunged. Sensors pick up and react to the speed and angle of the wand. With this magical instrument, we swoop and soar like a bird over an imaginary, or virtual, park of sculpture. We are in the scene, part of the work. We have little idea of what the wand will discover next. We may feel anxiety and confrontation, recalling bumping into hostile strangers in the streets. Or the happenings may be peaceful, even pastoral. Embedded microchips may play sculptures like musical instruments. Or sometimes the space around a sculpture may resound with the sounds of nature. Exact repetition never seems to occur. Obviously we are in an imaginary world, and yet because of our activity it also seems real. Our participation is highly playful. If you are familiar with computer training simulators (golf, for instance) and computer games and videos— interactive and multisensory—you are well prepared for the complexities of virtual art.

CONCEPTION KEY Virtual Art

1. Do you think *Spiritual Ruins* as described above is art or artlike? Use your imagi-
 nation, for no descriptions or photographs can begin to capture the interactive
 scenario. Try to see some examples of virtual art. More and more exhibitions are
 being presented, especially at the larger museums.
2. You will find that *Spiritual Ruins* belongs to only one of many species of virtual art.
 It should be fascinating to watch the new developments. Ask yourself as it grows
 whether it is art or artlike.
3. Frank Gehry, along with many other architects, is using the computer to discover
 the possibilities inherent in his designs. Computer-created sounds have produced
 new kinds of music, as in the work of Milton Babbitt. Do you think the computer
 can be useful in any of the other arts? If so, which ones? And how?

Computer technology promises to have a powerful influence on the arts of
the twenty-first century. Perhaps "computer artists" will become the artists
of the future. It seems that technological advances inevitably generate new
art forms. For example, photography had a powerful impact on painting and
led to film.

CONCEPTION KEY Classification

1. Return to the chart (page 382). Can you think of a better way of classifying the
 artlike? Be as detailed as possible.
2. Does the study of the artlike clarify your understanding of what is art? Discuss.

SUMMARY

Artlike works share many basic features with art, unlike works of non-art.
But the artlike lacks a revealed subject matter, a content that brings fresh
meaning into our lives. The artlike can be attention-holding, as with illus-
tration; or fitting, as with decoration; or beautiful, as with craftwork; or
thought-provoking, as with idea art; or attention-grabbing, as with perfor-
mance art; or scandalizing, as with shock art; or fantasy-absorbing, as with
virtual art. Art may have these features also, but what "works" fundamen-
tally in a work of art is revelation. The artlike generally does not lend itself
to sustained participation (Chapter 2), and that is because it lacks revelatory
power. Yet what sustains participation varies from person to person. Dog-
matic judgments about what is art and what is artlike are counterproduc-
tive. We hope that our approach provides a stimulus for open-minded but
guided discussions.

Chapter 15

THE INTERRELATIONSHIPS OF THE ARTS

Close ties among the arts occur because artists share a special purpose: the revelation of values. Furthermore, every artist must use some medium, some kind of "stuff" that can be formed to communicate that revelation (content) about something (subject matter). All artists share some elements of media, and this sharing encourages their interaction. For example, painters, sculptors, and architects use color, line, and texture. Sculptors and architects work with the density of materials. Rhythm is basic to the composer, choreographer, and poet. Words are elemental for the poet, novelist, dramatist, and composer of songs and operas. Images are basic to the painter, filmmaker, and photographer. Artists constitute a commonwealth—they share the same end and similar means.

The interrelationships among the arts are enormously complex. We hope the following classification of *appropriation, synthesis,* and *interpretation* will clear some paths through the maze.

APPROPRIATION

Artistic **appropriation** occurs when (1) artists combine their basic medium with the medium of another art or arts but (2) keep their basic medium clearly dominant. For example, music is the basic medium for composers

of opera. The staging may include architecture, painting, and sculpture. The language of the drama may include poetry. The dance, so dependent on music, is often incorporated in opera, and sometimes in contemporary opera so are photography and even film. Yet music almost always dominates in opera. We may listen to Beethoven's *Fidelio* or Bizet's *Carmen* on a CD time after time. Yet it is hard to imagine anyone reading the **librettos** over and over again. Although essential to opera, the drama, along with the staging, rarely dominates the music. Often the librettos by themselves are downright silly. Nevertheless, drama and the other appropriated arts generally enhance the feelings interpreted by the music.

PERCEPTION KEY Opera

Attend an opera or watch a video of an opera by Puccini, perhaps *La Bohème*.

1. Compare your experience of seeing the opera with just listening. Is your enjoyment greatly diminished if you only listen? If so, why?
2. Watch a video of the opera for a short time without the sound. Your enjoyment presumably will be greatly diminished. Why?
3. Read the libretto. Is it interesting enough to achieve participation, as with a good poem or novel? Would you want to read it again?
4. Have you experienced any opera in which the drama dominates the music? Wagner claimed that in *The Ring* he wedded music and drama (and other arts as well) so closely that neither dominates the *Gesamtkunstwerk* (complete artwork). Read the libretto of one of the four operas that constitute *The Ring*, and then go to or listen to the opera. Do you agree with Wagner's claim?
5. Go to Verdi's *Otello*, one of his last operas, or use a video. Shakespeare's drama is of the highest order, although much of it is lost, not only in the very condensed libretto, but also in the translation into Italian. Does either the music or the drama dominate? Or is there a synthesis?

Except for opera, architecture is the art that appropriates the most. Its centering of space makes room for the placement of sculpture, painting, and photography; the reading of poetry; and the performance of drama, music, and dance. The sheer size of architecture tends to make it prevail over any of the incorporated arts, the container prevailing over the contents. The obvious exceptions occur when the architecture functions mainly as a place to show painting or sculpture.

The architecture of Gaudí's Sagrada Familia (Figures 6-19 through 6-21) is certainly not nondescript. Yet, despite its great size and powerful vertical stretches—surely a sky-oriented building—a good case can be made, perhaps, that the sculpture is just as compelling.

PERCEPTION KEY Architecture

1. Review the photographs of buildings in Chapter 6. Are there any in which the included arts appear to dominate the architecture?

(continued)

Thus there is a strong tendency toward appropriation by either art. Despite the use of the lovely white in Hepworth's *Pelagos* (Figure 5-13), it would be strange to describe the work as a painting. The grain and density of the wood and the push and pull of curved "real space" subordinate any suggestion of "imaginary space." And this would seem to remain true even if Hepworth had painted a beautiful landscape on the white.

The photographer's media—light, line, texture, shapes, and recently color—are close to the painter's. And the interaction between these two arts also is close. For example, the pictorial tradition in photography was directly influenced by painting, and painting was directly influenced by the realistic detail produced by photography (see Chapter 13). But the most useful and widespread interaction of photography with the other arts is its practical role as a recorder. Without photographs, this book, for better or worse, would be impossible. Photography, along with film, now provides us with a museum without walls. Photography can record the "still moments"—the painting, for instance. Film can record the "moving moments"—the dance, for instance. Both film and photography tend to be the arts best suited to using other arts as their subject matter. For example, a recent film of the life of Jackson Pollock may help us understand his paintings.

INTERPRETATION

When a work of art takes another work of art as its subject matter, the former is an ***interpretation*** of the latter. Thus Zeffirelli's film *Romeo and Juliet* takes Shakespeare's drama for its subject matter. The film interprets the play. It is fascinating to observe how the contents—the meanings—differ because of the different media. We will analyze a few interesting examples. Bring to mind other examples as you read the text.

Film Interprets Literature: Howards End

E. M. Forster's novel *Howards End* (1910) was made into a remarkable film in 1992 (Figures 15-1 and 15-2) by producer Ismail Merchant and director James Ivory. Ruth Prawer Jhabvala wrote the screenplay. The film stars Anthony Hopkins and Emma Thompson who, along with Jhabvala, won an Academy Award. The film itself was nominated as best picture, and its third Academy Award went to the design direction of Luciana Arrighi and Ian Whittaker.

The team of Merchant-Ivory, producer and director, has become distinguished for period films set in the late nineteenth century and early twentieth century. Part of the reputation won by Merchant-Ivory films is due to their detailed designs. Thus in a Merchant-Ivory film one expects to see Edwardian costumes meticulously reproduced, period interiors with prints and paintings, authentic architecture, both interior and exterior, and details sumptuously photographed so that the colors are rich and saturated and the atmosphere appropriately reflecting the era just before and after 1900.

FIGURE 15-1
Anthony Hopkins and Emma
Thompson in *Howards End.*

Henry Wilcox (Hopkins) and
Margaret Schlegel (Thompson),
now married, react to bad news.

FIGURE 15-2
Emma Thompson and Helena
Bonham Carter in *Howards End.*

Margaret Schlegel (Thompson)
tries to understand her
sister Helen's (Bonham
Carter) motives in helping
Leonard Bast.

All of that is true of the production of *Howards End.* But the subtlety of
the interplay of the arts in the film is intensified because of the subtlety of the
interplay of the arts in the novel. Forster wrote his novel in a way that em-
ulates contemporary drama, at least in part. His scenes are dramatically

conceived, with characters acting in carefully described settings, speaking in ways that suggest the stage. Moreover, Forster's special interest in music and the role culture in general plays in the lives of his characters makes the novel especially challenging for interpretation by moving images.

The film follows Forster's story faithfully. Three families at the center of the story stand in contrast: the Schlegel sisters, Margaret and Helen; a rich businessman, Henry Wilcox, his frail wife Ruth, and their superficial, conventional children; and a poor, young, unhappily married bank clerk, Leonard Bast, whom the Schlegel sisters befriend. Margaret and Helen are idealistic and cultured. The Wilcoxes, except for Ruth, are uncultured snobs. When Ruth dies, Henry proposes to and is accepted by Margaret. Her sister Helen, who detests Henry, is devastated by this marriage and turns to Leonard Bast. The story becomes a tangle of opposites and, because of the stupidity of Henry's son Charles, turns tragic. In the end, thanks to the moral strength of Margaret, reconciliation becomes possible.

Read the novel first, and then see the film. In one scene early in the novel, some of the protagonists are in Queen's Hall in London listening to Beethoven's Fifth Symphony. Here is Forster's wonderful description:

> It will be generally admitted that Beethoven's *Fifth Symphony* is the most sublime noise that has ever penetrated into the ear of man. All sorts and conditions are satisfied by it. Whether you are like Mrs. Munt, and tap surreptitiously when the tunes come—of course, not so as to disturb the others; or like Helen, who can see heroes and shipwrecks in the music's flood; or like Margaret, who can only see the music; or like Tibby, who is profoundly versed in counterpoint, and holds the full score open on his knee; or like their cousin, Fräulein Mosebach, who remembers all the time that Beethoven is "echt Deutsch" [pure German]; or like Fräulein Mosebach's young man, who can remember nothing but Fräulein Mosebach: in any case, the passion of your life becomes more vivid, and you are bound to admit that such a noise is cheap at two shillings.

Now that is a passage surely worth recording. But how could you get it into a film unless by a "voiceover," an awkward technique in this context. Observe how this scene is portrayed in the film. Also observe in the film the awkward drawn-out scenes of Leonard Bast pursuing Helen in the rain (she inadvertently had taken his umbrella when leaving the concert hall). One keeps wondering why the soaking Leonard does not simply run and catch up with Helen. In the novel, these events are much more smoothly handled. In such portrayals, written language has the advantage.

Conversely, the film captures something in 1992 that the novel could not have achieved in its own time—the sense of loss for an elegant way of life in the period before World War I. The moving images create nostalgia for a past totally unrecoverable. Nostalgia for that past is, of course, also created by Forster's fine prose, but not with the power of moving images. Coming back to the novel after its interpretation by the film surely makes our participation more complete.

> **PERCEPTION KEY** *Howards End*
>
> 1. Do the filmic presentations of Margaret Schlegel and Henry Wilcox "ring true" to Forster's characterizations? If not, what are the deficiencies?
> 2. Is the background music effective?
> 3. What kind or kinds of cuts are used in the film (page 303)? Are they effectively used? Explain.
> 4. In which work, the novel or the film, are the social issues of greater importance? Which puts more stress on the class distinctions between the Basts and both the Schlegels and the Wilcoxes? Which seems to have a stronger social message?
> 5. How does the film—by supplying the images your imagination can only invent in reading the novel—affect your understanding of the lives of the Schlegels, Wilcoxes, and Basts?
> 6. Can you return to the novel after seeing the film and read the novel with basically the same understanding?

Music Interprets Drama: The Marriage of Figaro

Perhaps in the age of Wolfgang Amadeus Mozart (1756–1791), the opera performed a function for literature somewhat equivalent to what the film does today. Opera—in combining music, drama, sets, and sometimes dance—was held in highest esteem in Europe in the eighteenth century. And despite the increasing competition from film and musical comedy, opera is still performed to large audiences in theaters and larger audiences on television. Among the world's greatest operas, few are more popular than Mozart's *The Marriage of Figaro* (1786), written when Mozart was only thirty.

Mozart's play interprets the French play *The Marriage of Figaro* (1784), by Pierre Augustin de Beaumarchais, a highly successful playwright friendly with Mme. Pompadour, mistress of Louis XVI at the time of the American Revolution. Beaumarchais began as an ordinary citizen, bought his way into the aristocracy, survived the French Revolution, went into exile, and later died in France. His plays were the product of, yet comically critical of, the aristocracy. *The Marriage of Figaro*, written in 1780, was held back by censors as an attack on the government. Eventually produced to great acclaim, it was seditious enough for later commentators to claim that it was an essential ingredient in fomenting the French Revolution of 1789.

Mozart, with Lorenzo Da Ponte, who wrote the libretto, remained generally faithful to the play, although changing some names and the occupations of some characters. They reduced the opera from Beaumarchais's five acts to four, although the entire opera is three hours long.

In brief, it is the story of Figaro, servant to Count Almaviva, and his intention of marrying the countess's maid Susanna. The count has given up the feudal tradition, which would have permitted him to sleep with Susanna first, before her husband. However, he regrets his decision because he has fallen in love with Susanna and now tries to seduce her. When his wife, the countess, young and still in love with him, discovers his plans, she throws in with Figaro and Susanna to thwart him. Cherubino, a very young man—sung by

FIGURE 15-3

An arpeggio from "Non più andrai" ("From now on, no more gallivanting"), from the end of Act 1 of *The Marriage of Figaro.*

Figaro sings a farewell aria to Cherubino, who has been sent to the army because of his skirt chasing. It can be heard on YouTube.

del - le bel - le tur-ban-do il ri - po - so,
Such di - ver - sions are done with and o - ver,

a female soprano—feels the first stirrings of love and desires both the countess and Susanna in turn. He is a page in the count's employ, and when his intentions are discovered, he is sent into the army. One of the greatest *arias* in the opera is "Non più andrai" ("From now on"), which Figaro sings to Cherubino, telling him that his amorous escapades are now over. The nine-page aria is derived from part of a single speech of Beaumarchais's Figaro:

> No more hanging around all day with the girls, no more cream buns and custard tarts, no more charades and blind-man's-bluff; just good soldiers, by God: weatherbeaten and ragged-assed, weighed down with their muskets, right face, left face, forward march.[1]

Mozart's treatment of the speech demonstrates one of the resources of opera as opposed to straight drama. In the drama, it would be very difficult to expand Figaro's speech to intensify its emotional content, but in the opera the speech or parts of it can be repeated frequently and with pleasure, since the music that underpins the words is delightful to hear and rehear. Mozart's opera changes the emotional content of the play because it intensifies feelings associated with key moments in the action.

The aria contains a very simple musical figure that has nonetheless great power in the listening. Just as Mozart is able to repeat parts of the dialogue, he is able to repeat notes, passages, and patterns. The pattern repeated most conspicuously is that of the arpeggio, a chord whose notes are played in quick succession instead of simultaneously. The passage of three chords in the key of C expresses a lifting feeling of exuberance (Figure 15-3). Mozart's genius was marked by a way of finding the simplest, yet most unexpected, solutions to musical problems. The arpeggio is practiced by almost every student of a musical instrument, yet it is thought of as something appropriate to practice rather than performance. Thus Mozart's usage comes as a surprise.

The very essence of the arpeggio in the eighteenth century was constant repetition, and in using that pattern, Mozart finds yet another way to repeat elements to intensify the emotional effects of the music. The listener hears the passage, is captured, yet hardly knows in any conscious way why it is as impressive and as memorable as it is. There are ways of doing similar things in drama—repeating gestures, for example—but there are very few ways of repeating elements in such close proximity as the arpeggio does without risking boredom.

The plot of the opera, like that of the play, is based on thwarting the plans of the count with the use of disguise and mix-ups. Characters are hidden in bedrooms, thus overhearing conversations they should not hear. They leap from bedroom windows, hide in closets, and generally create a comic

[1]Pierre Augustin de Beaumarchais, *The Marriage of Figaro,* tr. Bernard Sahlins. (Chicago: Ivan R. Dee, 1994), p. 29.

confusion. The much older Marcellina and her lawyer Bartolo introduce the complication of a breach of promise suit between her and Figaro just as Figaro is about to marry. The count uses it to his advantage while he can, but the difficulty is resolved in a marvelously comic way: Marcellina sees a birthmark on Figaro and realizes he is her son and the son of Bartolo, with whom she had an affair. That finally clears the way for Figaro and Susanna, who, once they have shamed the count into attending to the countess, can marry.

Mozart's musical resources include techniques that cannot easily be duplicated in straight drama. For example, his extended use of duets, quartets, and sextets, in which characters interact and sing together, would be impossible in the original drama. The libretto gave Mozart a chance to have one character sing a passage while another filled in with an aside. Thus there are moments when one character sings what he thinks others want him to say, while another character sings his or her inner thoughts, specifically designed for the audience to hear. Mozart reveals the duplicity of characters by having them sing one passage "publicly" while revealing their secret motives "privately."

The force of the quartets and the sextets in *The Marriage of Figaro* is enormous, adding wonderfully to the comic effect that this opera always achieves. Their musical force, in terms of sheer beauty and subtle complexity, is one of the hallmarks of the opera. In the play, it would be impossible to have six characters speaking simultaneously, but with the characters singing, such a situation becomes quite possible.

The resources that Mozart had in orchestration helped him achieve effects that the stage could not produce. The horns, for example, are sometimes used for the purpose of poking fun at the pretentious count, who is a hunter. The discords found in some of the early arias resolve themselves in later arias when the countess smooths them out, as in the opening aria in Act II: "Porgi Amor" ("Pour forth, O Love"). The capacity of the music to emulate the emotional condition of the characters is a further resource that permits Mozart to emphasize tension, as when, for example, dissonant chords seem to stab the air to reflect the anxiety of the count. Further, the capacity to bring the music quite low (pianissimo) and then contrast it with brilliant loud passages (fortissimo) adds a dimension of feeling that the play can barely even suggest.

Mozart's *The Marriage of Figaro* also has been successful because of its political message, which is essentially democratic. The opera presents us with a delightful character, Figaro, a barber become a servant, who is level-headed, somewhat innocent of the evil ways of the world, and a smart man when he needs to be. He loves Susanna, who is much more worldly-wise than he, but who is also a thoughtful, intelligent young woman. In contrast, the count is an unsympathetic man who resents the fact that his servant Figaro can have what he himself wants but cannot possess. The count is outwitted by his servant and his wife at almost every turn. The countess is a sympathetic character. She loves her husband, knows he wants to be unfaithful, but plays along with Susanna and Figaro in a scheme involving assignations and disguises in order to shame him into doing the right thing. The audiences of the age loved the play because they reveled in the amusing way that Figaro manipulates his aristocratic master. Beaumarchais's play was as clear about this as the opera. Mozart's interpretation of the play (his subject matter) reveals such a breadth and depth of feeling that now the opera is far more appreciated than the play.

Poetry Interprets Painting: The Starry Night

Poets often use paintings, especially famous ones, for their subject matters. Since paintings are wordless, they tend to invite commentary. Vincent van Gogh was a tormented man whose slide into insanity has been chronicled in letters, biographies, romantic novels, and films. His painting *The Starry Night* (Figure 15-4) is an eloquent, tortured image filled with dynamic swirls and rich colors, portraying a night that is intensely threatening. He wrote, "Exaggerate the essential and leave the obvious vague."

The first poem, by Robert Fagles (b. 1933), speaks from the point of view of Van Gogh, imagining a psychic pain that has somehow been relieved by the act of painting:

THE STARRY NIGHT

Long as I paint
I feel myself
less mad
the brush in my hand
a lightning rod to madness

But never ground that madness
execute it ride the lightning up
from these benighted streets and steeple up
with the cypress look its black is burning green

I am that I am it cries
it lifts me up the nightfall up
the cloudrack coiling like a dragon's flanks
a third of the stars of heaven wheeling in its wake
wheels in wheels around the moon that cradles round the sun

FIGURE 15-4
Vincent van Gogh, *The Starry Night*. 1889. Oil on canvas, 29 × 36¼ inches (73.7 × 92.1 cm). The Museum of Modern Art, New York. Acquired through the Lillie P. Bliss Bequest.

Van Gogh's most famous painting represents the view outside the window of his sanitarium room—painted in daylight as a night scene.

and if I can only trail these whirling eternal stars
with one sweep of the brush like Michael's sword if I can
cut the life out of the beast—safeguard the mother and the son
all heaven will hymn in conflagration blazing down
 the night the mountain ranges down
 the claustrophobic valleys of the mad

 Madness
is what I have instead of heaven
God deliver me—help me now deliver
all this frenzy back into your hands
our brushstrokes burning clearer into dawn

Anne Sexton (1928–1975) is one of America's most powerful poets, but her life was cut short by insanity and then suicide. She may have seen the painting as an emblem of madness from a perspective that most sane people cannot. In light of her personal journey, it is especially fascinating to see how she interprets the painting:

THE STARRY NIGHT
That does not keep me from having a terrible need of—shall I say the word—religion.
Then I go out at night to paint the stars.

 Vincent van Gogh in a letter to his brother Theo.

The town does not exist
except where one black-haired tree slips
up like a drowned woman into the hot sky.
The town is silent. The night boils with eleven stars
Oh starry starry night! This is how
I want to die.

It moves. They are all alive.
Even the moon bulges in its orange irons
to push children, like a god, from its eye.
The old unseen serpent swallows up the stars.
Oh starry starry night! This is how
I want to die:

into that rushing beast of the night,
sucked up by that great dragon, to split
from my life with no flag,
no belly,
no cry.

Both poets offer only the briefest description of the painting. A reader who had not seen it could not know quite what the painting looks like. Yet both poets move directly to the emotional core of the painting, its connection with madness and psychic pain. For Fagles, the effort was intensely imaginative. For Sexton, perhaps less so. Shortly before she wrote her poem, her father died and she had an illegal abortion because she feared the baby she was about to have was not fathered by her husband. Her personal life was terribly tormented for several months before she wrote the poem, but she continued to write all the time, producing her most widely read volume, *All My Pretty Ones*, which, for a book of modern poetry, had extraordinary sales and popularity. Interestingly, both poets see in the painting the form of a dragon, the biblical beast that hounded humanity to make a hell of life.

PERCEPTION KEY Fagles' and Sexton's "The Starry Night"

1. How relevant is the imagery of the beast in the poems to an understanding of the content of the painting?
2. Do the poems help you interpret the imagery of the painting in ways that are richer than before you read the poems? Or do the poems distract you from the painting?
3. How effective would the poems be if there were no painting for their subject matter? Could they stand on their own, or must they always be referenced to the painting?
4. Do you understand the painting better because of these poems?
5. Don McLean wrote music and lyrics for a song inspired by Van Gogh's painting. The lyrics and music for "Vincent (Starry Starry Night)" can be heard at YouTube: www.youtube.com/watch?v=dipFMJckZOM. What effect does the addition of music have on you? How does it help you interpret the painting better or more fully?
6. Try writing your own song or your own poem as an interpretation of Van Gogh's painting.

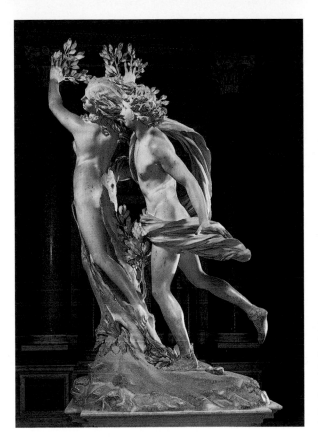

FIGURE 15-5
Gian Lorenzo Bernini, *Apollo and Daphne*. 1622–1625. Marble, 8 feet high. Galleria Borghese, Rome.

The sculpture portrays Ovid's story of Apollo's foiled attempt to rape the nymph Daphne.

Sculpture Interprets Poetry: **Apollo and Daphne**

The Roman poet Ovid (43 B.C.–A.D. 17) has inspired artists even into modern times. His masterpiece, *The Metamorphoses*, includes a large number of myths that were of interest to his own time and that have inspired readers of all ages. The title implies changes, virtually all kinds of changes imaginable in the natural and divine worlds. The sense that the world of Roman deities intersected with humankind had its Greek counterpart in Homer, whose heroes often had to deal with the interference of the gods in their lives. Ovid inspired Shakespeare in literature, Botticelli in painting, and, perhaps most impressively, the sculptor Gian Lorenzo Bernini (1598–1680).

Bernini's technique as a sculptor was without peer in his era. His purposes were quite different from those of most modern sculptors in that he was not particularly interested in "truth to materials" (pages 117–118). If anything, he was more interested in showing how he could defy his materials and make marble, for example, appear to be flesh in motion.

Apollo and Daphne (1622–1625) represents a section of *The Metamorphoses* in which the god Apollo falls in love with the nymph Daphne (Figure 15-5). Cupid had previously hit Apollo's heart with an arrow to inflame him, while he hit Daphne with an arrow designed to make her reject love

EXPERIENCING Bernini's *Apollo and Daphne* and Ovid's *The Metamorphoses*

1. If you had not read Ovid's *The Metamorphoses*, what would you believe to be the subject matter of Bernini's *Apollo and Daphne*? Do you believe it is a less interesting work if you do not know Ovid?

One obvious issue in looking at this sculpture and considering Ovid's treatment of Apollo and Daphne is that today very few people will have read Ovid before seeing the sculpture. In the era in which Bernini created the work, he expected it to be seen primarily by well-educated people, and in the seventeenth century, most educated people would have been steeped in Ovid from a young age. Consequently, Bernini worked in a classical tradition that he could easily rely on to inform his audience.

Today that classical tradition is essentially gone. Few people, comparatively, read Roman poets, yet the people who see this sculpture in the Borghese Gallery in Rome respond powerfully to it, even without knowing the story it portrays. Standing before this work, one is immediately struck by its size, eight feet high, with the figures fully life-size. The incredible skill of the sculptor is apparent in the ways in which the fingers of Daphne are becoming the leaves of the plant that now bears her name—she is metamorphosing before our eyes, even if we do not know the reference to Ovid's *The Metamorphoses*. The question aesthetically is how much difference does our knowledge of the source text for the sculpture make for our responses to and participation with the sculpture? The interesting thing about knowledge is that once one has it, one cannot "unhave" it. Is it possible to set apart enough of our knowledge of Ovid to look at the sculpture the way we might look at a sculpture by Henry Moore or David Smith? Without knowledge of Ovid one would see figures in action impressively represented in marble, mixed with important but perhaps baffling vegetation. Visitors to the sculpture seem obviously awed by its brilliance, and just being told that it portrays a moment in Ovid hardly alters their response to the work. Only when they read Ovid and reflect on the relationship of text to sculpture do they find their responses altered.

2. What does Bernini add to your responses to Ovid's poetry? What is the value of a sculptural representation of a poetic action? What are the benefits to your appreciation of either Bernini or Ovid?
3. Bernini's sculpture is famous for its virtuoso perfection of carving. Yet in this work, "truth to materials" is largely bypassed. (Compare Michelangelo's *Pietà*, Figure 5-5.) Does that fact diminish the effectiveness of the work?

entirely. Cupid did this in revenge for Apollo's having killed the python with a bow and arrow. Apollo woos Daphne fruitlessly, she resists, and he attempts to rape her. As she flees from him, she pleads with her father, the river god Peneius, to rescue her, and he turns her into a laurel tree just as Apollo reaches his prey. Here is the moment in Ovid:

> The god by grace of hope, the girl, despair,
> Still kept their increasing pace until his lips
> Breathed at her shoulder; and almost spent,
> The girl saw waves of a familiar river,
> Her father's home, and in a trembling voice
> Called, "Father, if your waters still hold charms

To save your daughter, cover with green earth
This body I wear too well," and as she spoke
A soaring drowsiness possessed her; growing
In earth she stood, white thighs embraced by climbing
Bark, her white arms branches, her fair head swaying
In a cloud of leaves; all that was Daphne bowed
In the stirring of the wind, the glittering green
Leaf twined within her hair and she was laurel.

Ovid portrays the moment of metamorphosis as a moment of drowsiness as Daphne becomes rooted and sprouts leaves. It is this instant that Bernini has chosen, an instant during which we can see the normal human form of Apollo, while Daphne's thighs are almost enclosed in bark, her hair and hands growing leaves. The details of this sculpture, whose figures are life-size, are extraordinary. In the Borghese Gallery in Rome, one can walk around the sculpture and examine it up close. The moment of change is so astonishingly wrought that one virtually forgets that it is a sculpture. Bernini has converted the poem into a moment of drama through the medium of sculpture.

Certainly, Bernini's sculpture is an "illustration" of a specific moment in *The Metamorphoses,* but it goes beyond illustration. Bernini has brought the moment into a three-dimensional space, with the illusion of the wind blowing Apollo's garments and with the pattern of swooping lines producing a sense of motion. From almost any angle, this is an arresting interpretation, even for those who do not recognize the reference to Ovid.

Painting Interprets Poetry: The Figure 5 in Gold

Charles Demuth's painting, *The Figure 5 in Gold* (Figure 15-6), was created in response to "The Great Figure," a poem by William Carlos Williams. The poem was written after Williams' vision of a fire engine roaring down Ninth Avenue in New York in 1928.

THE GREAT FIGURE

Among the rain
and lights
I saw the figure 5
in gold
on a red
fire truck
moving
tense
unheeded
to gong clangs
siren howls
and wheels rumbling
through the dark city

Demuth and Williams were close friends. The subject matter of Demuth's painting was the poem by Williams. Note the references to Williams in the painting: the "Bill" at the top left (Demuth's nickname for Williams), the

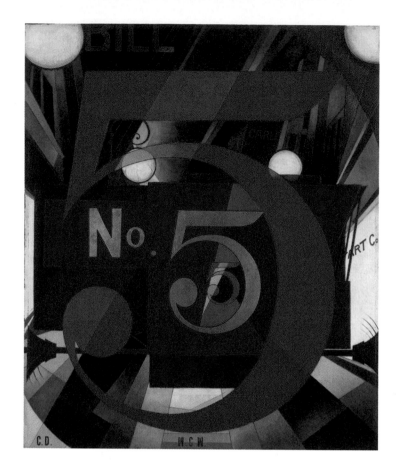

FIGURE 15-6
Charles Demuth, *The Figure 5 in Gold*. 1928. Oil on cardboard, 35½ × 30 inches. Alfred Stieglitz collection, Museum of Modern art.

The painting interprets a poem inspired by a sighting of a fire engine with the number 5 emblazoned on its side.

PERCEPTION KEY Charles Demuth and William Carlos Williams

1. How does Demuth's painting, *The Figure 5 in Gold* (Figure 15-6), intensify the experience of reading Williams' poem? What do Demuth's colors add to the sounds Williams attempts to reproduce?
2. What does Demuth choose to emphasize as he interprets Williams' poem? Do you think he makes the right choices?
3. Do you think that, after looking at Demuth's painting, a viewer would then value Williams' poem more highly or less? Does Demuth make it easier to participate with Williams' poem, or does it make no difference at all?
4. Demuth's painting came later, and thus is an interpretation of the poem. However, is it possible to see the poem as an interpretation of the painting?

Carlo(s) at the upper right, and the W. C. W. at the middle bottom. The truncated words help picture the passing velocity of the fire engine.

Williams related how, while walking down Ninth Avenue in New York City on a rainy night, he was assaulted by clanging bells and the roar of a charging fire engine. "I turned just in time to see a golden figure 5 on the

FIGURE 15-7 *(left)*
Frank Gehry, National
Nederlanden Building,
Prague. 1992–1996.

Widely known as "Ginger and
Fred," the building's design was
inspired by the dancers Ginger
Rogers and Fred Astaire, whose
filmed dance scenes are interna-
tionally respected.

FIGURE 15-8 *(right)*
Ginger Rogers and Fred Astaire
in one of their nine films to-
gether. Their configuration
closely resembles the form of
the building in Prague known as
"Ginger and Fred."

red background flash by. The impression was so sudden and forceful that I took a piece of paper out of my pocket and wrote a short poem about it."[2] The lines are mainly objective images, purely descriptive, with little suggestion of a narrative. There is, however, a powerful expression of the instantaneous.

The painting, surprisingly, is somewhat more sequential than the poem. Thus the three figures of 5 become progressively smaller, suggesting motion away, the closely stacked red planes diminish rapidly, the street lights and their lightings become progressively occluded, and the curbs and pavings of the street swirl away. Both the Demuth and the Williams are packed in a blurred present.

Architecture Interprets Dance: National Nederlanden Building

In what may be one of the most extraordinary interactions between the arts, the celebrated National Nederlanden Building in Prague, Czech Republic, by the modernist architect Frank Gehry, seems to have almost replicated a duet between Ginger Rogers and Fred Astaire. The building in Prague has been called "Ginger and Fred" since it was finished in 1996 (Figure 15-7). It has also been called "the dancing building," but everyone who has commented on the structure points to its rhythms, particularly the windows, which are on different levels throughout the exterior. The building

[2] William Carlos Williams, *Autobiography* (New York: New Directions, 1967), p. 172.

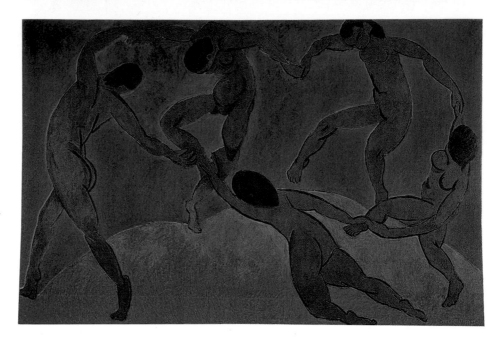

FIGURE 15-9
Henri Matisse, *The Dance*. 1910.
Decorative panel, oil on canvas,
102¼ × 125½ inches. The
Hermitage, St. Petersburg.

Painted for a Russian business-
man, this hymn to the idea of
dance has become an icono-
graphic symbol of the power of
dance.

definitely reflects the postures of Ginger Rogers and Fred Astaire as they ap-
peared in nine extraordinary films from 1933 to 1939 (Figure 15-8). Gehry
is known for taking considerable chances in design of buildings (such as
the Guggenheim Museum Bilbao, Figure 6-30). The result of his effort in
generally staid Prague has been a controversial success largely because of
its connection with Rogers' and Astaire's image as dancers.

Painting Interprets Dance and Music: The Dance *and* Music

Henri Matisse (1869–1954) was commissioned to paint *The Dance* and
Music (both 1910) by Sergey Shchukin, a wealthy Russian businessman
in Moscow who had been a longtime patron. The works were murals for a
monumental staircase and, since the Russian Revolution of 1917, have been
at the Hermitage in Saint Petersburg. In Matisse's time, Shchukin enter-
tained lavishly, and his guests were sophisticated, well-traveled, beautifully
clothed patrons of the arts who went regularly to the ballet, opera, and lav-
ish orchestral concerts. Matisse made his work stand in stark contrast to
the aristocratic world of his potential viewers.

According to Matisse, *The Dance* (Figure 15-9) derived originally from
observation of local men and women dancing on the beach in a fishing
village in southern France where Matisse lived for a short time. Their

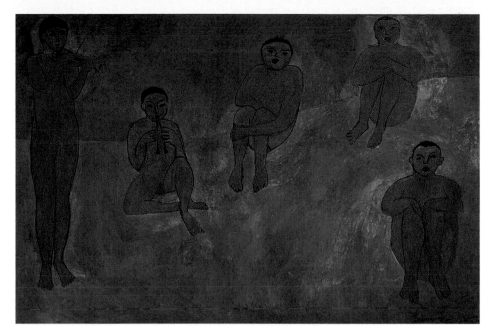

FIGURE 15-10
Henri Matisse, *Music*. 1910. Decorative panel, oil on canvas, 102¼ × 153 inches. The Hermitage, St. Petersburg.

This painting hangs near Matisse's *Dance* in the Hermitage. The five figures are placed as if they were notes on a music staff.

sardana was a stylized and staid traditional circle dance, but in the Matisse the energy and joy are wild. *The Dance* interprets the idea of dance rather than any particular dance. Moreover, it is clear that Matisse reaches into the earliest history of dance, portraying naked women and a man dancing with abandon on a green mound against a dark blue sky. Their sense of movement is implied in the gesture of each leg, the posture of each figure, and the instability of pose. The figures have been described as primitive, but their hairdos suggest that they might be contemporary dancers returning to nature and dancing in accord with an instinctual sense of motion.

Music is similarly primitive, with a fiddler and a pipes player (who look as if they were borrowed from a Picasso painting) and three singers sitting on a mound of earth against a dark blue sky (Figure 15-10). They are painted in the same flat reddish tones as the dancers, and it seems as if they are playing and singing the music that the dancers are themselves hearing. Again, the approach to the art of music is as basic as the approach to the art of dance, except that a violin, of course, would not exist in a primitive society. The violin represents the strings and the pipes the woodwinds of the modern orchestra, whereas the other musicians use the most basic of instruments, the human voice. The figures are placed linearly as if they were notes on a staff, a musical phrase with three rising tones and one falling tone (perhaps C A B C G). Music is interpreted as belonging to a later period than that of the dance.

The two panels, *The Dance* and *Music,* seem designed to work together to imply an ideal for each art. Instead of interpreting a specific artistic moment, Matisse appears to be striving to interpret the essential nature of both arts.

PERCEPTION KEY Painting and the Interpretation of *The Dance* and *Music*

1. Must these paintings (Figures 15-9 and 15-10)—which are close in size—be hung near each other for both to achieve their complete effect? If they are hung next to each other, would they need to have their titles evident for the viewer to respond fully to them?
2. What qualities of *The Dance* make you feel that kinetic motion is somehow present in the painting? What is dancelike here?
3. What does Matisse do to make *Music* somehow congruent with our ideas of music? Which shapes within the painting most suggest music?
4. Suppose the figures and the setting were painted more realistically. How would that stylistic change affect our perception of the essential nature of dance and music?
5. Does participating with these paintings and reflecting on their achievement help you understand and, in turn, enjoy dance and music?

It is fitting to close this chapter with questions arising from a film and an opera that take as their subject matter the same source: Thomas Mann's famous novella *Death in Venice,* published in 1911. Luchino Visconti's 1971 film interprets the story in one way; Benjamin Britten's 1973 opera interprets the story in a significantly different way. Both, however, are faithful to the story. The difference in media has much to do with why the two interpretations of Mann's story are so different despite their basically common subject matter.

EXPERIENCING *Death in Venice:* **Three Versions**

Read Mann's novella *Death in Venice.* This is a haunting tale—one of the greatest short stories of the twentieth century—of a very disciplined, famous writer who, in his fifties, is physically and mentally exhausted. Gustav von Aschenbach seeks rest by means of a vacation, eventually coming to Venice. On the beach there, he becomes obsessed with the beauty of a boy. Despite Aschenbach's knowledge of a spreading epidemic of cholera, he remains, and being afraid the boy will be taken away, withholds information about the epidemic from the boy's mother. Casting aside restraint and shame, Aschenbach even attempts, with the help of a barber, to appear youthful again. Yet Aschenbach, a master of language, never speaks to the boy, nor can he find words to articulate the origins of his obsession and love. Collapsing in his chair with a heart attack, he dies as he watches the boy walking off into the sea. Try to see Visconti's film, starring Dirk Bogarde. And listen to Britten's opera with the libretto by Myfanwy Piper, as recorded by London Records, New York City, and starring Peter Pears.

1. Which of these three versions do you find most interesting? Why?

2. Does the film reveal insights about Aschenbach (and ourselves) that are missed in the novella? Does the opera reveal insights that escape both the novella and the film? Be specific. What are the special powers and limitations of these three media?

3. In both the novella and the opera, the opening scene has Aschenbach walking by a cemetery in a suburb of Munich. The film opens, however, with shots of Aschenbach coming into Venice in a gondola. Why do you think Visconti did not use Mann's opening? Why, on the other hand, did Britten use Mann's opening?

4. In the film, Aschenbach is portrayed as a composer rather than a writer. Why?

5. In the opera, unlike the film, the dance plays a major role. Why?

6. The hold of a boy over a mature, sophisticated man such as Aschenbach may seem at first highly improbable and contrived. How does Mann make this improbability seem plausible? Visconti? Britten?

7. Is Britten able to articulate the hidden deeper feelings of Aschenbach more vividly than Mann or Visconti? If so, how? What can music do that these other two arts cannot do in this respect? Note Aschenbach's thought in the novella: "Language could but extol, not reproduce, the beauties of the sense." Note also that Visconti often uses the music of Gustav Mahler to help give us insight into the depths of Aschenbach's character. Does this music, as it meshes with the moving images, do so as effectively as Britten's music?

8. Do you think that seeing Britten's opera performed would add significantly to your participation? Note that some opera lovers prefer only to hear the music and shut their eyes most of the time in the opera house.

9. Do these three works complement one another? After seeing the film or listening to the opera, does the novella become richer for you? If so, how is this to be explained?

10. In the novella, Socrates tells Phaedrus, "For beauty, my Phaedrus, beauty alone, is lovely and visible at once. For, mark you, it is the sole aspect of the spiritual which we can perceive through our senses, or bear so to perceive." But in the opera, Socrates asks, "Does beauty lead to wisdom, Phaedrus?" Socrates answers his own question: "Yes, but through the senses . . . and senses lead to passion . . . and passion to the abyss." Why do you think Britten made such a drastic change in emphasis?

11. What insights into our lives are brought to us by these works? For example, do you have a better understanding of the tragedy of beauty and of the connection between beauty and death? Again, do we have an archetype?

SUMMARY

The arts closely interrelate because artists have the same purpose: the revelation of values. They also must use some medium that can be formed to communicate that revelation, and all artists use some elements of media. Furthermore, in the forming of their media, artists use the same principles of composition. Thus interaction among the arts is easily accomplished. The

arts mix in many ways. *Appropriation* occurs when an artist combines his or her medium with the medium of another art or arts but keeps the basic medium clearly dominant. *Synthesis* occurs when an artist combines his or her medium in more or less of a balance with the medium of another art or arts. *Interpretation* occurs when an artist uses another work of art as the subject matter. Artists constitute a commonwealth—sharing the same end and using similar means.

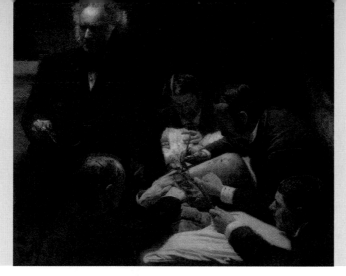

Chapter 16

THE INTERRELATIONSHIPS OF THE HUMANITIES

THE HUMANITIES AND THE SCIENCES

In the opening pages of Chapter 1 we defined the humanities as that broad range of creative activities and studies that are usually contrasted with mathematics and the advanced sciences, mainly because in the humanities strictly objective or scientific standards typically do not dominate.

Most college and university catalogs contain a grouping of courses called "the humanities." First, studies such as literature, the visual arts, music, history, *philosophy,* and *theology* are almost invariably included. Second, studies such as psychology, anthropology, sociology, political science, economics, business administration, and education may or may not be included. Third, studies such as physics, chemistry, biology, mathematics, and engineering are never included. The reason the last group is excluded is obvious—strict scientific or objective standards are clearly applicable. With the second group, these standards are not always so clearly applicable. There is uncertainty about whether they belong with the sciences or the humanities. For example, most psychologists who experiment with animals apply the scientific method as rigorously as any biologist. But there are also psychologists—C. G. Jung, for instance—who speculate about such phenomena as the "collective unconscious" and the role of myth (Chapter 8). To judge their work strictly by scientific methods is to miss much of their

contributions. Where then should psychology and the subjects in this group be placed? In the case of the first group, finally, the arts are invariably placed with the humanities. But then so are history, philosophy, and theology. Thus, as the title of this book implies, the humanities include subjects other than the arts. Then how are the arts distinguished from the other humanities? And what is the relationship between the arts and these other humanities?

These are broad and complex questions. Concerning the placement of the studies in group two, it is usually best to take each department case by case. If, for example, a department of psychology is dominated by experimentalists, as is most likely in the United States, it would seem most useful to place that department with the sciences. And the same approach can be taken for all the studies in group two. In most cases, probably, you will discover that clear-cut placements into the humanities or the sciences are misleading. Furthermore, even the subjects that are almost always grouped within either the humanities or the sciences cannot always be neatly cataloged. Rigorous objective standards may be applied in any of the humanities. Thus painting can be approached as a science—by the historian of medieval painting, for example, who measures, as precisely as any engineer, the evolving sizes of halos. On the other hand, the beauty of mathematics—its economy and elegance of proof—can excite the lover of mathematics as much as, if not more than, painting. Edna St. Vincent Millay proclaimed that "Euclid alone has looked on beauty bare." And so the separation of the humanities and the sciences should not be observed rigidly. The separation is useful mainly because it indicates the dominance or the subordinance of the strict scientific method in the various disciplines.

The Arts and the Other Humanities

Artists are humanists. But artists differ from the other humanists primarily because they create works that reveal values. Artists are sensitive to the important concerns of their societies. That is their subject matter in the broadest sense. They create artistic forms that clarify these values. The other humanists—such as historians, philosophers, and theologians—reflect upon, rather than reveal, values. They study values as given, as they find them. They try to describe and explain values—their causes and consequences. Furthermore, they may judge these values as good or bad. Thus, like artists, they try to clarify values, but they do this by means of analysis (see Chapter 3) rather than artistic revelation.

CONCEPTION KEY Artists and Other Humanists

1. Explain how the work of an artist might be of significance to the historian, philosopher, and theologian. Refer to specific examples.
2. Select works of art we have discussed in this book that you think might be of greatest significance to the other humanists. Ask others to do the same. Then compare and discuss your selections.
3. Can you find any works of art we have discussed that you think would have no significance whatsoever to any of the other humanists?

In their studies, the other humanists do not reveal values. However, they may take advantage of the revealing role of the arts. Their studies will be enhanced because, they will have a more penetrating understanding of the values they are studying. This is basically the help that the artists give to the other humanists. Suppose, for example, a historian is trying to understand the bombing of Guernica by the Fascists in the Spanish Civil War. Suppose he or she has explored all factual resources. Even then, something very important may be left out: a vivid awareness of the suffering of the non-combatants. To gain insight into that pain, Picasso's *Guernica* (Figure 1-4) may be very helpful.

CONCEPTION KEY Other Humanists and Artists

1. Is there anything that Picasso may have learned from historians that he used in painting *Guernica*?
2. Picasso painted a night bombing, but the actual bombing occurred in daylight. Why the change? As you think about this, remember that the artist transforms in order to inform.

Other humanists, such as critics and sociologists, may aid artists by their study of values. For example, we have concerned ourselves in some detail with criticism—the description, interpretation, and evaluation of works of art. Criticism is a humanistic discipline because it usually studies values—those revealed in works of art—without strictly applying scientific or objective standards. Good critics aid our understanding of works of art. We become more sensitively aware of the revealed values. This deeper understanding brings us into closer rapport with artists, and such rapport helps sustain their confidence in their work.

Artists reveal values; the other humanists study values. That does not mean, of course, that artists may not study values, but rather that such study, if any, is subordinated to revealing values in an artistic form that attracts our participation.

Perceiving and Thinking

Another basic difference between the arts and the other humanities is the way perceiving dominates in the arts, whereas thinking dominates in the other humanities. Of course, perceiving and thinking almost always go together. When we are aware of red striking our eyes, we are perceiving, but normally our brains are also conceiving, more or less explicitly, the idea "red." On the other hand, when we conceive the idea "red" with our eyes closed, we almost invariably remember some specific or generalized image of some perceptible, red. Probably the infant only perceives, although as we are sinking into unconsciousness from illness or a blow on the head, it may be that all ideas or concepts are wiped out. It may be, conversely, that conceiving sometimes occurs without any element of perceiving. Descartes,

EXPERIENCING The Humanities and Students of Medicine

Study the following report by Joann Loviglio for the Associated Press, published March 20, 2007.

Modern medicine provides doctors with an array of sophisticated machines that collect and present data about their patients, but the human eye is an invaluable yet often underappreciated diagnostic tool.

To address that, a new collaboration of Jefferson Medical College and the Pennsylvania Academy of the Fine Arts has been created to teach aspiring doctors to closely observe, describe and interpret the subtlest details with the eye of an artist.

The art-and-medicine program kicked off its first workshop Friday with a group of 18 white-coated medical students visiting the academy's museum and a dynamic representation of their chosen profession: Thomas Eakins' masterwork *The Gross Clinic,* which depicts an operation in progress.

The first- and second-year med students heard how to take a "visual inventory"—paying attention to overall elements of the painting, like texture and brightness, and specifics such as body language and facial expressions.

Besides the two-hour Visual Perception workshop, others slated for the 2007–2008 school year are Accuracy and Perception, Hand-Eye Coordination, Art in Healing, and Sculpture and Surgery. The courses are a mix of demonstrations, lectures and hands-on art lessons.

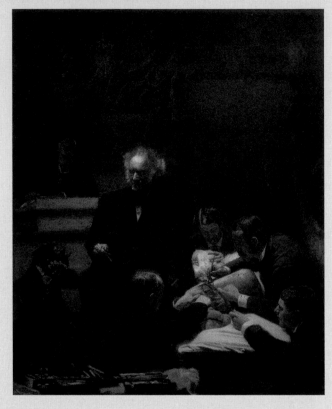

FIGURE 16-1
Thomas Eakins, *Portrait of Dr. Samuel D. Gross (The Gross Clinic).* 1875. Oil on canvas, 8 feet × 6 feet 6 inches. Philadelphia Museum of Art.

The Gross Clinic honors Samuel D. Gross, Philadelphia's most famous surgeon. He stands ready to comment on the surgery being performed on a nameless man's thigh. Eakins has caught Gross in a moment confident of great success. Many of the figures in the painting were known to his audience, and Eakins himself is portrayed in the upper right, in the shadows. Critics have claimed this is one of the greatest nineteenth-century American paintings.

A 2001 study in the *Journal of the American Medical Association* found that medical students in a similar Yale University program acquired more astute observational skills than their colleagues who didn't take the courses. In addition to assessing a patient's well-being during an office visit, finely honed visual abilities can also allow doctors to spot subtle changes in a patient's X-rays over time, for example.

Increasingly, medical schools nationwide are incorporating humanities courses to their curricula.

According to the Association of American Medical Colleges, 89 of the country's 125 medical schools have humanities as an educational element included in a required course, and 66 have it as an elective. (There's overlap because some schools have both.) The figures include all humanities, not just visual arts, spokeswoman Nicole Buckley said. Other humanities studies in medical schools include literature, performing arts, and music.[1]

1. Eakins' *The Gross Clinic* portrays Samuel D. Gross, a famous physician, supervising an operation on a man's left thigh (Figure 16-1). Judging from the expressions on the faces of those involved in the operation, what might a medical student learn about the values that most interested the painter? You can see this painting in greater detail at www.philamuseum.org/collections/permanent/299524.html.

[1]Joanne Loviglio, "Getting Medical Students to See," The Associated Press, March 20, 2007. Copyright 2007 by The Associated Press. All Rights Reserved.

2. It seems clear that painting can be important to the humanities education of medical students. However, it is also clear that other arts can contribute to the medical students' program. Which of the arts do you think would be most effective in revealing humanistic values for a medical doctor?
3. What values does Thomas Eakins' *The Gross Clinic* reveal that could have an impact on students of medicine?
4. How might historians of medicine interpret Eakins' *The Gross Clinic*?
5. What might a medical student learn from this painting that could make the student a better doctor?

the great seventeenth-century philosopher, thought so. Most philosophers and psychologists believe, however, that even the most abstract thinking of mathematicians, since it still must be done with perceptible signs such as numbers, necessarily includes residues of perception.

CONCEPTION KEY Perception and Conception

1. Think of examples in your experience in which percepts dominate concepts, and vice versa. Which kind of experience do you enjoy the most? Does your answer tell you anything about yourself?
2. Is it possible for you to shift gears easily from conceptually dominated thinking to perceptually dominated thinking? For example, if you are studying intensely some theoretical or practical problem—"thinking at"—do you find it difficult to begin to "think from" some work of art? Or, conversely, if you have been participating with a work of art, do you find it difficult to begin to "think at" some theoretical or practical problem? Do your answers tell you anything about yourself?
3. Select from the chapter on literature (Chapter 7) the poem that seems to demand the most from your perceptual faculties and the least from your conceptual faculties. Then select the poem that seems to demand the most from your conceptual faculties and the least from your perceptual faculties. Which poem do you like better? Does your answer tell you anything about yourself?
4. Which of the arts seems to demand the most from your perceptual faculties? Your conceptual faculties? Why? Which art do you like better? Does your answer tell you anything about yourself?

It seems evident that perceiving without some thinking is little more than a blooming buzzing confusion. Thus all our talk about art in the previous chapters has been a conceptualizing that we hope has clarified and intensified your perception of specific works of art. But that is not to suggest that conception ought to dominate perception in your participation with a work of art. In fact, if conception dominates, participation will be weakened or prevented—we will be thinking at rather than thinking from. If, as we listen to the sonata form, we concentrate only on identifying the exposition, development, and recapitulation sections, we inevitably would lower the

sensitivity of our listening. The harmonies, dissonances, rhythms, tone colors, contrast, and so on would not be clearly heard. Yet, if you were to ask trained music lovers after their listening, they probably could easily name the sections and tell you where such sections occurred, even though they had been thinking from the music. Perception holds us to the specificity of the work. In other words, to experience the arts most intensely and satisfactorily, conception is indispensable, but perception must remain in the foreground. When we come to the other humanities, conception comes to the foreground. The other humanities basically reflect about values rather than reveal values, as in the case of the arts. With the other humanities, therefore, concepts become more central than percepts.

VALUES

A value is something we care about, something that matters. A value is an object of an interest. The term "object," however, should be understood as including events or states of affairs. A pie is obviously an object and it may be a value, and the course of action involved in obtaining the pie may also be a value. If we are not interested in something, it is neutral in value or valueless to us. Positive values are those objects of interest that satisfy us or give us pleasure, such as good health. Negative values are those objects of interest that dissatisfy us or give us pain, such as bad health.

When the term "value" is used alone, it usually refers to positive values only, but it may also include negative values. In our value decisions, we generally seek to obtain positive values and avoid negative values. But except for the very young child, these decisions usually involve highly complex activities. To have a tooth pulled is painful, a negative value, but doing so leads to the possibility of better health, a positive value. *Intrinsic values* involve the feelings—such as pleasure and pain—we have of some value activity, such as enjoying good food or experiencing nausea from overeating. *Extrinsic values* are the means to intrinsic values, such as making the money that pays for the food. *Intrinsic-extrinsic values* not only evoke immediate feelings but also are means to further values, such as the enjoyable food that leads to future good health. For most people, intrinsic-extrinsic values of the positive kind are the basis of the good life. Heroin may have great positive intrinsic value, but then extrinsically it will have powerful negative value, leading to great suffering.

> ## CONCEPTION KEY Participation with Art and Values
>
> 1. Do you think the value of a participative experience with a work of art is basically intrinsic, extrinsic, or intrinsic–extrinsic? Explain.
> 2. Dr. Victor Frankl, a medical doctor and psychiatrist, writes in *The Doctor and the Soul,*
>
> The higher meaning of a given moment in human existence can be fulfilled by the mere intensity with which it is experienced, and independent of any action. If anyone doubts this, let him consider the following situation. Imagine a music lover sitting

in the concert hall while the most noble measures of his favorite symphony resound in his ears. He feels that shiver of emotion which we experience in the presence of the purest beauty. Suppose now that at such a moment we should ask this person whether his life has meaning. He would have to reply that it had been worthwhile living if only to experience this ecstatic moment.[2]

Do you agree with Frankl, or do you consider this an overstatement? Why?
3. It has been reported that some of the most sadistic guards and high-ranking officers in the Nazi concentration camps played classical music during or after torturings, and killings. Goering was a great lover of excellent paintings. Hitler loved architecture and the music of Wagner. What do you make of this?

Participation with a work of art not only is immediately satisfying but also is usually extrinsically valuable because it leads to deeper satisfactions in the future. To participate with one poem is likely to increase our sensitivity to the next poem. To participate in great moments in music is likely to strengthen our courage to face the tragic side of existence. To participate with the dance may help us be more graceful. To participate with the visual arts may enhance our seeing and touching.

The most important gift of the arts to our practical lives, however, is the understanding it gives us of others. This is especially the gift of literature, for it gives us a sounder orientation with others and deeper sympathy. Literature can teach us compassion, the profoundest of moral virtues. It is possible to compartmentalize one's feelings through acts of will. The insights of the arts can be separated from our moral lives, but that seems to occur only rarely. Our hope should be that compartmentalization is avoided.

CONCEPTION KEY The Origin of Value

1. Select the work of art examined in this book that is the most valuable to you. Why is it so valuable?
2. Which art do you like the most? Why?
3. Which art do you like the least? Why?
4. Do you believe that value is projected into things by us, that we discover values in things, or that in some way value originates in the relationship between us and things? Explain.

Values, we propose, involve a valuer and something that excites an interest in the valuer. *Subjectivist theories of value* claim, however, that it is the interest that projects the value on something. The painting, for example, is positively valuable only because it satisfies the interest of someone. Value is in the valuer. If no one is around to project interest, then there are no valuable objects. Value is entirely relative to the valuer. Beauty is in the eye

[2]Victor E. Frankl, *The Doctor and the Soul,* trans. Richard and Clara Winston (New York: Knopf, 1955), p. 49.

of the beholder. ***Objectivist theories of value*** claim, conversely, that it is the object that excites the interest. The painting is positively valuable even if no one has any interest in it. Value is in the object independently of any subject. Jane is beautiful even if no one is aware of her beauty.

The ***relational theory of value***—which is the one we have been presupposing throughout this book—claims that value emerges from the relation between an interest and an object. A good painting that is satisfying no one's interest at the moment nevertheless possesses potential value. A good painting possesses properties that under proper conditions are likely to stimulate the interest of a valuer. The subjectivist would say that this painting has no value whatsoever until someone projects value on it. The objectivist would say that this painting has actualized value inherent in it whether anyone enjoys it or not. The relationalist would say that this painting has potential value, that when it is experienced under proper conditions, a sensitive, informed participant will actualize the potential value. To describe a painting as "good" is the same as saying that the painting has positive potential value. For the relationalist, value is realized only when objects with potential value connect with the interests of someone.

Values are usually studied with reference to the interaction of various kinds of potential value with human interests. For example, criticism tends to focus on the intrinsic values of works of art; economics focuses on commodities as basically extrinsic values; and ***ethics*** focuses on intrinsic-extrinsic values as they are or ought to be chosen by moral agents.

Values that are described scientifically as they are found we shall call ***value facts.*** Values that are set forth as norms or ideals or what ought to be we shall call ***normative values.*** The smoking of marijuana, for instance, is a positive value for some. Much research is being undertaken to provide descriptions of the consequences of the use of marijuana, and rigorous scientific standards are applicable. We would place such research with the sciences. And the values that are described in such research are value facts. A scientific report may describe the relevant value facts connected with the use of marijuana, showing, for instance, that people who smoke marijuana generally have such-and-such pleasurable experiences but at the same time incur such-and-such risks. Such a report is describing what is the case, not what ought to be the case (that is, normative values). When someone argues that marijuana should be prohibited or someone else argues that marijuana should be legalized, we are in a realm beyond the strict application of scientific standards. Appeal is being made not to what "is," or factual value—this the sciences can handle—but to the "ought," or normative value.

CONCEPTION KEY Factual Value and Normative Value

1. Do you see any possible connection between factual and normative value? For example, will the scientific studies now being made on the use of marijuana have any relevance to your judgment as to whether you should or should not smoke marijuana?
2. Do you think that an artist can reveal anything relevant to your judgment about using marijuana?
3. Do you think humanists other than artists might produce anything relevant to your judgment about the use of marijuana?

There is a very close relationship between factual and normative value. If scientists were to discover that anyone who uses marijuana regularly cannot possibly live longer than ten more years, this obviously would influence the arguments about its legalization. Yet the basis for a well-grounded decision about such a complex issue—for it is hardly likely that such a clear-cut fact as death within ten years from using marijuana regularly will be discovered—surely involves more than scientific information. Novels such as Aldous Huxley's *Brave New World* reveal aspects and consequences of drug experiences that escape through the nets of scientific investigation. They clarify features of value phenomena that supplement the factual values as discovered by science. After exposure to such literature, we may be in a better position to make well-grounded decisions about such problems as the legalization of marijuana.

The arts and the other humanities often have normative relevance. They may clarify the possibilities for value decisions, thus clarifying what ought to be and what we ought to do. And this is an invaluable function, for we are beings who must constantly choose among various value possibilities. Paradoxically, even not choosing is often a choice. The humanities can help enlighten our choices. Artists help by revealing aspects and consequences of value phenomena that escape scientists. The other humanists help by clarifying aspects and consequences of value phenomena that escape both artists and scientists. For example, the historian or sociologist might trace the consequences of drug use in past societies. Moreover, the other humanists—especially philosophers—can take account of the whole value field, including the relationships between factual and normative values. This is something we are trying to do, however briefly and oversimply, right here.

CONCEPTION KEY Value Decisions

1. You may have made a judgment about whether or not to use marijuana. Was there any kind of evidence—other than the scientific—that was relevant to your decision? Explain.

2. Reflect about the works of art we have discussed in this book. Have any of them clarified value possibilities for you in a way that might helpfully influence your value decisions? How? Be as specific as possible. Do some arts seem more relevant than others in this respect? If so, why? Discuss with others. Do you find that people differ a great deal with respect to the arts that are most relevant to their value decisions? If so, how is this to be explained?

3. Do you think that in choosing its political leaders, a society is likely to be helped if the arts are flourishing? As you think about this, consider the state of the arts in societies that have chosen wise leaders, as well as the state of the arts in societies that have chosen unwise leaders.

4. Do you think that political leaders are more likely to make wise decisions if they are sensitive to the arts? Back up your answer with reference to specific leaders.

5. Do you think there is any correlation between a flourishing state of the arts and a democracy? A tyranny? Back up your answers with reference to specific leaders.

Factual values can be verified experimentally, put through the tests of the scientific method. Normative values are verified experientially, put through the tests of good or bad consequences. Satisfaction, for ourselves and the others involved, is an experiential test that the normative values we chose in a given instance were probably right. Suffering, for ourselves and the others involved, is an experiential test that the normative values we chose were probably wrong. Experiential testing of normative values involves not only the immediacy of experience but also the consequences that follow. If you choose to try heroin, you cannot escape the consequences. And, for-tunately, certain novels—Nelson Algren's *Man with the Golden Arm,* for instance—can make you vividly aware of those consequences before you have to suffer them. Science can also point out these consequences, of course, but science cannot make them so forcefully clear and present, thus so thoroughly understandable.

The arts are closely related to the other humanities, especially history, philosophy, and theology. In conclusion, we shall give only a brief sketch of these relationships, for they are enormously complex and require extensive analyses that we can only suggest.

THE ARTS AND HISTORY

Historians try to discover the what and the why of the past. They need as many relevant facts as possible in order to describe and explain the events that happened. Often they may be able to use the scientific method in their gathering and verification of facts. But in attempting to give as full an expla-nation as possible as to why some of the events they are tracing happened, they function as humanists, for here they need understanding of the nor-mative values or ideals of the society they are studying. Among their main resources are works of art. Often such works will reveal people's hopes and fears—their views of birth and death, blessing and disaster, victory and disgrace, endurance and decline, themselves and God, fate and what ought to be. Only with the understanding of such values can history become something more than a catalog of events.

CONCEPTION KEY The Arts and History

Suppose an ancient town were being excavated, but, aside from architecture, no works of art had been unearthed. And then some paintings, sculpture, and poems come to light—all from the local culture. Is it likely that the paintings would give information different from that provided by the architecture or the sculpture? Or what might the poems reveal that the other arts do not? As you reflect on these questions, reflect also on the following description by Martin Heidegger of a painting by Van Gogh of a pair of peasant shoes:

> From the dark opening of the worn insides of the shoes the toilsome tread of the worker stares forth. In the stiffly rugged heaviness of the shoes there is the accumu-lated tenacity of her slow trudge through the far-spreading and ever-uniform furrows of the field swept by a raw wind. On the leather lie the dampness and richness of the

soil. Under the soles slides the loneliness of the field-patch as evening falls. In the shoes vibrates the silent call of the earth, its quiet gift of the ripening grain and its unexplained self-refusal in the fallow desolation of the wintry field. This equipment is pervaded by uncomplaining anxiety as to the certainty of bread, the wordless joy of having once more withstood want, the trembling before the impending childbed and shivering at the surrounding menace of death. This equipment belongs to the earth, and it is protected in the world of the peasant woman.[3]

THE ARTS AND PHILOSOPHY

Philosophy is, among other things, an attempt to give reasoned answers to fundamental questions that, because of their generality, are not treated by any of the more specialized disciplines. Ethics, *aesthetics,* and metaphysics (or speculative philosophy), three of the main divisions of philosophy, are very closely related to the arts. Ethics is often the inquiry into the presuppositions or principles operative in our moral judgments and the study of norms or standards for value decisions. If we are correct, an ethic dealing with norms that fails to take advantage of the insights of the arts is inadequate. John Dewey even argued that

Art is more moral than moralities. For the latter either are, or tend to become, consecrations of the status quo, reflections of custom, reenforcements of the established order. The moral prophets of humanity have always been poets even though they spoke in free verse or by parable.[4]

CONCEPTION KEY Ethics and the Arts

1. In the quotation above, Dewey might seem to be thinking primarily of poets when he speaks of the contribution of artists to the ethicist. Or do you think he is using the term "poets" to include all artists? In any case, do you think that literature has more to contribute to the ethicist than do the other arts? If so, why?
2. Reflect on the works of art we have discussed in this book. Which ones do you think might have the most relevance to an ethicist? Why?

Throughout this book we have been elaborating an aesthetics, or philosophy of art. We have been attempting to account to some extent for the whole range of the phenomena of art—the creative process, the work of art, the experience of the work of art, criticism, and the role of art in society. On occasion we have avoided restricting our analysis to any single area within

[3]Martin Heidegger, "The Origin of the Work of Art," in *Poetry, Language, Thought,* trans. Albert Hofstadter (New York: Harper and Row, 1971), pp. 33ff.
[4]John Dewey, *Art as Experience* (New York: Minton, Balch, 1934), p. 348.

that group, considering the interrelationships of these areas. And on other occasions we have tried to make explicit the basic assumptions of some of the restricted studies. These are typical functions of the aesthetician, or philosopher of art. For example, much of our time has been spent doing criticism—analyzing and appraising particular works of art. But at other times, as in Chapter 3, we tried to make explicit the presuppositions or principles of criticism. Critics, of course, may do this themselves, but then they are functioning more as philosophers than as critics. Furthermore, we have also reflected on how criticism influences artists, participants, and society. This, too, is a function of the philosopher.

Finally, the aim of the metaphysicians, or speculative philosophers, roughly speaking, is to understand reality as a totality. Therefore they must take into account the artifacts of the artists as well as the conclusions and reflections of other humanists and scientists. Metaphysicians attempt to reflect on the whole in order to achieve some valid general conclusions concerning the nature of reality and our position and prospects in it. A metaphysician who ignores the arts will have left out some of the most useful insights about value phenomena, which are very much a fundamental part of our reality.

The Arts and Theology

The practice of religion, strictly speaking, is not a humanistic activity or study, for basically it neither reveals values in the way of the arts nor studies values in the way of the other humanities. A religion is an institution that brings people together for the purpose of worship. These people share beliefs about their religious experiences. Since the beliefs of various people differ, it is more accurate to refer to religions than to religion. Nevertheless, there is a commonsense basis, reflected in our ordinary language, for the term "religion." Despite the differences about their beliefs, religious people generally agree that their religious values—for example, achieving, in some sense, communion with the sacred—are ultimate, that is, more important than any other values. They have ultimate concern for these values. Moreover, religious people seem to share a common nucleus of experience: (1) uneasy awareness of the limitations of human moral and theoretical powers; (2) awe-full awareness of a further reality, a majestic mystery, beyond or behind or within the world of our sense experience; (3) conviction that communion with this further reality is of supreme importance.

Theology involves the study of religions. As indicated in Chapter 1, the humanities in the medieval period were studies about humans, whereas theology and related studies were studies about God. But in present times, theology, usually broadly conceived, is placed with the humanities. Moreover, for many religious people today, ultimate values or the values of the sacred are not necessarily ensconced in another world "up there." In any case, some works of art—the masterpieces—reveal ultimate values in ways that are relevant to the contemporary situation. Theologians who ignore these revelations cannot do justice to their study of religions.

CONCEPTION KEY Religious Values and the Arts

Reflect about the works of art you know best. Have any of them revealed ultimate values to you in a way that is relevant to your situation? How? Are they necessarily contemporary works?

Dietrich Bonhoeffer, in one of his last letters from the Nazi prison of Tegel, noted that "now that it has become of age, the world is more Godless, and perhaps it is for that very reason nearer to God than ever before." Our artists, secular as well as religious, not only reveal our despair but also, in the depths of that darkness, open paths back to the sacred.

At the end of the nineteenth century, Matthew Arnold intimated that the aesthetic or participative experience, especially of the arts, would become the religious experience. We do not think this transformation will happen, because the participative experience lacks the outward expressions, such as worship, that fulfill and in turn distinguish the religious experience. But Arnold was prophetic, we believe, in sensing that increasingly the arts would provide the most direct access to the sacred. Iris Murdoch, the late Anglo-Irish novelist, describes such an experience:

> Dora had been in the National Gallery a thousand times and the pictures were almost as familiar to her as her own face. Passing between them now, as through a well-loved grove, she felt a calm descending on her. She wandered a little, watching with compassion the poor visitors armed with guidebooks who were peering anxiously at the masterpieces. Dora did not need to peer. She could look, as one can at last when one knows a great thing very well, confronting it with a dignity which it has itself conferred. She felt that the pictures belonged to her. . . . Vaguely, consoled by the presence of something welcoming and responding in the place, her footsteps took her to various shrines at which she had worshipped so often before.[5]

Such experiences may be rare. Most of us still require the guidebooks. But one hopes the time will come when we no longer just peer but also participate. And when that time comes, a guide to the guidebooks like this one may have its justification.

SUMMARY

The arts and the other humanities are distinguished from the sciences because in the former, generally, strictly objective or scientific standards are irrelevant. In turn, the arts are distinguished from the other humanities because in the arts values are revealed, whereas in the other humanities

[5]*The Bell*, by Iris Murdoch, copyright © 1958 by Iris Murdoch. Reprinted by permission of The Viking Press, Inc., New York, and Chatto and Windus Ltd., London, p. 182.

values are studied. Furthermore, in the arts perception dominates, whereas in the other humanities conception dominates.

In our discussion about values, we distinguish between (1) intrinsic values—activities involving immediacy of feeling, positive or negative; (2) extrinsic values—activities that are means to intrinsic values; and (3) intrinsic-extrinsic values—activities that not only are means to intrinsic values but also involve significant immediacy of feeling. A value is something we care about, something that matters. The theory of value presupposed in this book has been relational; that is, value emerges from the relation between a human interest and an object or event. Value is not merely subjective—projected by human interest on some object or event—nor is value merely objective—valuable independently of any subject. Values that are described scientifically are value facts. Values set forth as norms or ideals or what ought to be are normative values. The arts and the other humanities often have normative relevance: by clarifying what ought to be and thus what we ought to do.

Finally, the arts are closely related to the other humanities, especially history, philosophy, and theology. The arts help reveal the normative values of past cultures to the historian. Philosophers attempt to answer questions about values, especially in the fields of ethics, aesthetics, and metaphysics. Some of the most useful insights about value phenomena for the philosopher come from artists. Theology involves the study of religions, and religions are grounded in ultimate concern for values. No human artifacts reveal ultimate values more powerfully to the theologian than works of art.

GLOSSARY

A

A-B-A In music, a three-part structure that consists of an opening section, a contrasting second section, and a return to the first section.

Abstract, or **nonrepresentational painting** Painting that has the sensuous as its subject matter. See *representational painting*.

Acrylic In painting, pigment bound by a synthetic plastic substance, allowing it to dry much faster than oils.

Adagio A musical term denoting a slow and graceful tempo.

Aerial perspective The portrayal of distance in painting by means of dimming light and atmosphere. See *perspective*.

Aesthetics Philosophy of art: the study of the creative process, the work of art, the aesthetic experience, principles of criticism, and the role of art in society.

Agnosticism Belief that one cannot know for sure whether God exists.

Aleatory Dependent on chance.

Allegory An expression by means of symbols, used to make a more effective generalization or moral commentary about human experience. See *Symbol*.

Allegretto A musical term denoting a lively tempo but one slower than allegro.

Allegro A musical term denoting a lively and brisk tempo.

Alliteration In literature, the repetition of consonant sounds in two or more neighboring words or syllables.

Ambiguity Uncertain meaning, a situation in which several meanings are implied. Sometimes implies contradictory meanings.

Anapest A poetic metrical foot of three syllables, the first two being short and the last being long.

Andante A musical term denoting a leisurely tempo.

Appropriation In the arts, the act of combining the artist's basic medium with the medium of another art or arts but keeping the basic medium clearly dominant. See *synthesis* and *interpretation*.

Arabesque A classical ballet pose in which the body is supported on one leg, and the other leg is extended behind with the knee straight.

Arcade In architecture, a series of arches side by side and supported by columns or piers.

Arch In architecture, a structural system in which space is spanned by a curved member supported by two legs.

Archetype An idea or behavioral pattern, often formed in prehistoric times, that becomes a part of the unconscious psyche of a people. The archetype is embedded in the "collective unconscious," a term from Jungian psychology that has been associated by Jung with myth. In the arts, the archetype is usually expressed as a narrative pattern, such as the quest for personal identity. See *myth*.

Architrave In post-and-lintel architecture, the lintel or lowermost part of an entablature, resting directly on the capitals of the columns.

Arena Theater A stage arrangement in which the stage is surrounded on all sides by seats.

Aria An elaborate solo song used primarily in operas, oratorios, and cantatas.

Art Deco In the visual arts, a style prevalent between 1915 and 1940.

Art Nouveau A style of architecture characterized by lively serpentine curves and organic growth.

Artistic form The organization of a medium that clarifies or reveals a subject matter. See *subject matter*, *content*, *decorative form*, and *work of art*.

Artlike Works that possess some characteristics of works of art but lack revelatory power.

Assemblage The technique of sculpture, such as welding, whereby preformed pieces are attached. See *modeling*.

Assonance A sound structure employing a similarity among vowels but not consonants.

Atonal Music without a dominant key.

Auteur The author or primary maker of the total film, usually the director.

Avant-garde The "advance guard"—innovators who break sharply with traditional conventions and styles.

Axis line An imaginary line—generated by a visible line or lines—that helps determine the direction of the eye in any of the visual arts.

Axis mundi A vertically placed pole used by some primitive peoples to center their world.

B

Baroque The style dominant in the visual arts in seventeenth-century Europe following the Renaissance, characterized by vivid colors, dramatic light, curvilinear heavy lines, elaborate ornamentation, bold scale, and strong expression of emotion. Music is the only other art of that time that can be accurately described as Baroque. See *Rococo*.

Beauty An arrangement that is pleasing.

Binder The adhering agent for the various media of painting.

Blank verse Poetry with rhythm but not rhyme.

Buttress In architecture, a structure built on a wall, vault, or an arch for reinforcing support.

C

Cadence In music, the harmonic sequence that closes a phrase.

Cantilever In architecture, a projecting beam or structure supported at only one end, which is anchored to a pier or wall.

Carving Shaping by cutting, chipping, hewing, etc.

Casting The process of making a sculpture or other object by pouring liquid material into a mold and allowing it to harden.

Catharsis The cleansing or purification of the emotions and, in turn, a spiritual release and renewal.

Centered space A site—natural or human-made—that organizes other places around it.

Character In drama, the agents and their purpose.

Chiaroscuro Technique in painting that combines and contrasts light and shade.

Chord Three or more notes played at the same time.

Cinematic motif In film, a visual image that is repeated either in identical form or in variation.

Cinematography The way the film camera tells a story.

Classical style In Greek art, the style of the fifth century B.C. More generally, the term "Classical" sometimes refers to the ancient art of Greece and Rome. Also, it sometimes refers to an art that is based on rational principles and deliberate composition. The lowercase term "classic" can mean excellence, whatever the period or style.

Closed line In painting, hard and sharp line. See *line*.

Coda Tonal passage or section that ends a musical composition.

Collage A work made by pasting bits of paper or other material onto a flat surface.

Collective unconscious Jung's phrase for the universality of myths among cultures, some of which had no contact.

Color The property of reflecting light of a particular wavelength.

Color value Shading, the degree of lightness or darkness of a hue.

Comedy A form of drama that is usually light in subject matter and ends happily but that is not necessarily void of seriousness.

Complementary colors Colors that lie opposite each other on the color wheel.

Composition The organization of the elements. See *design*.

Computer art Works using the computer as the medium.

Conception Thinking that focuses on concepts or ideas. See *perception*.

Conceptual art Works that bring the audience into direct contact with the creative concepts of the artist; a de-emphasis on the medium.

Conceptual metaphor A comparison that evokes ideas.

Configurational center A place of special value, a place to dwell.

Connotation Use of language to suggest ideas and/or emotional coloration in addition to the explicit or denoted meaning. "Brothers and sisters" denotes relatives, but the words may also connote people united in a common effort or struggle, as in the "International Brotherhood of Teamsters" or the expression "Sisterhood is powerful." See *denotation*.

Consonance When two or more tones sounded simultaneously are pleasing to the ear. See *dissonance*.

Content Subject matter detached by means of artistic form from its accidental or insignificant aspects and thus clarified and made more meaningful. See *subject matter*.

Cool color A color that is recessive, such as blue, green, and black.

Cornice The horizontal molding projecting along the top of a building.

Counterpoint In music, two or more melodies, themes, or motifs played in opposition to each other at the same time.

Craft Skilled making.

Craftwork The product of craft, usually utilitarian and beautiful.

Crescendo A gradual increase in loudness.

Criticism The analysis and evaluation of works of art.

Cross-referencing Memory of a similar work that enriches a participative experience.

Crosscutting In film, alternation between two separate actions that are occurring at the same time.

D

Dadaism A movement begun during World War I in Europe that was anti-everything. A precursor of shock art and Duchampism.

Decoration An artlike element added to enhance or adorn something else.

Decorative form The organization of a medium that pleases, distracts, or entertains but does not inform about values. See *artistic form*.

Denotation The direct, explicit meaning or reference of a word or words. See *connotation*.

Denouement The section of a drama in which events are brought to a conclusion.

Descriptive criticism The description of the subject matter and/or form of a work of art.

Design The overall plan of a work before implementation. See *composition*.

Detail Elements of structure; in painting, a small part. See *region*.

Detail relationships Significant relationships between or among details. See *structural relationships*.

Diction In literature, drama, and film, the choice of words with special care for their expressiveness.

Dissolve In film, the slow ending of a scene.

Dissonance When two or more tones sounded simultaneously are unpleasant to the ear. See *consonance*.

Documentarists Photographers who document the present to preserve a record of it as it disappears.

Duchampism School of art that produced works that are anti-art and anti-establishment but are funny rather than angry. See *Dadaism*.

Dynamics In music, the loudness and softness of the sound.

E

Earth sculpture Sculpture that makes the earth the medium, site, and subject matter.

Earth-dominating architecture Buildings that "rule over" the earth.

Earth-resting architecture Buildings that accent neither the earth nor the sky, using the earth as a platform with the sky as a background.

Earth-rooted architecture Buildings that bring out with special force the earth and its symbolism. See *sky-oriented architecture*.

Eclecticism A combination of several different styles in a work.

Editing In film, the process by which the footage is cut, the best version of each scene chosen, and these versions joined together for optimum effect. See *montage*.

Elements The basic components of a medium. See *media*.

Elements of drama (Aristotle's) Plot, character, thought, diction, spectacle, and music. See entries under individual elements.

Embodiment The meshing of medium and meaning in a work of art.

Emotion Strong sensations felt as related to a specific and apparent stimulus. See *passion* and *mood*.

En pointe (on point) In ballet, a specific technique using special shoes in which the dancer dances on the points of the toes.

Entasis The subtle convex swelling near the center of a column.

Epic A lengthy narrative poem, usually episodic, with heroic action and great cultural scope.

Epicureanism The belief that happiness is based on pleasure.

Episodic narrative A story composed of separate incidents (or episodes) tied loosely together. See *organic narrative*.

Ethics The inquiry into the presuppositions or principles operative in our moral judgments. Ethics is a branch of philosophy.

Evaluative criticism Judgment of the merits of a work of art.

Expressionism School of art in which the work emphasizes the artist's feelings or state of mind.

Extrinsic value The means to intrinsic values or to further, higher values. See *intrinsic value*s.

F

f/64 Group A group of photographers whose name derives from the small aperture, *f*/64, which ensures that the foreground, middle ground, and background will all be in sharp focus.

Fantasia A musical composition in which the "free flight of fancy" prevails over conventional structures such as the sonata form.

Flaw in character (hamartia) In drama, the prominent weakness of character that leads to a tragic end.

Figure of speech Language used to heighten effect, especially by comparison.

Flying buttress An arch that springs from below the roof of a Gothic cathedral carrying the thrust above and across a side aisle.

Folk art Work produced outside the professional tradition.

Form-content The embodiment of the meaning of a work of art in the form.

Forte A musical term denoting loud.

Framing The photographic technique whereby important parts of figures or objects in a scene are cut off by the edges of the photograph.

Fresco A wall painting. Wet fresco involves pigment applied to wet plaster. Dry fresco involves pigment applied to a dry wall. Wet fresco generally is much more enduring than dry fresco.

Frieze Low-relief sculpture running high and horizontally on a wall of a building.

Fugue A musical composition in which a theme, or motive, is announced and developed contrapuntally in strict order. See *counterpoint*.

▨ G ▨

Genre Kind or type.

Genre painting Subjects or scenes drawn from everyday life portrayed realistically.

Gouache A water color medium with gum added.

Greek cross A cross with equal vertical and horizontal arms. See *Latin cross*.

▨ H ▨

Happenings Very impromptu performances, often involving the audience. See *shock art*.

Harmony The sounding of notes simultaneously.

Hearer One who hears music without careful attention to details or structure. See *listener*.

High-relief sculpture Sculpture with a background plane from which the projections are relatively large.

Historical criticism The description, interpretation, or evaluation of works of art with reference to their historical precedents.

Hue The name of a color. See *saturation*.

Humanities Broad areas of human creativity and analysis essentially involved with values and generally not using strictly objective or scientific methods.

▨ I ▨

Iambic pentameter Type of poetic meter. An iamb is a metrical unit, or foot, of two syllables, the first unaccented and the second accented. Pentameter is a five-foot line. See *sonnet*.

Idea art Works in which ideas or concepts dominate the medium, challenging traditional presuppositions about art, especially embodiment. In an extreme phase, ideas are presented in diagram or description rather than in execution. See *embodiment*.

Illumination Hand-drawn decoration or illustration in a manuscript.

Illustration Images that closely resemble objects or events.

Imagery Use of language to represent objects and events with strong appeal to the senses, especially the visual.

Impasto The painting technique of heavily applying pigment so as to create a three-dimensional surface.

Impressionist school The famous school of art that flourished between 1870 and 1905, especially in France. Impressionists' approach to painting was dominated by a concentration on the impression light made on the surface of things.

Improvisation Music or other performance produced on the spur of the moment.

Inorganic color In painting, flat color, appears laid on the object depicted. See *organic color*.

Intaglio A printmaking process in which ink is transferred from the grooves of a metal plate to paper by extreme pressure.

Intentional fallacy In criticism, the assumption that what the artists say they intended to do outweighs what they in fact did.

Interpretation In the arts, the act of using another work of art as subject matter. See *appropriation* and *synthesis*.

Interpretive criticism Explication of the content of a work of art.

Intrinsic value The immediate given worth or value of an object or activity. See *extrinsic value*.

Irony A literary device that says one thing but means another. Dramatic irony plays on the audience's capacity to perceive the difference between what the characters expect and what they will get.

▨ K ▨

Key A system of tones based on and named after a given tone—the tonic.

Kitsch Works that realistically depict objects and events in a pretentious, vulgar manner.

▨ L ▨

Labanotation A system of writing down dance movements.

Largo A musical term denoting a broad, very slow, stately tempo (also called lento).

Latin cross A cross in which the vertical arm is longer than the horizontal arm, through whose midpoint it passes. Chartres and many other European cathedrals are based on a recumbent Latin cross. See *Greek cross*.

Legato A musical term indicating that a passage should be played smoothly and without a break between the tones.

Leitmotif In music, a leading theme.

Libretto The text of an opera.

Line A continuous marking made by a moving point on a surface. The basic building block of visual design.

Linear perspective The creation of the illusion of distance in a two-dimensional work by means of converging lines. In one-point linear perspective, developed in the fifteenth century, all parallel lines in a given visual field converge at a single vanishing point on the horizon. See *perspective*.

Listener One who listens to music with careful attention to details and structure. See *hearer*.

Living space The feeling of the comfortable positioning of things in the environment that promotes both liberty of movement and paths as directives.

Low-relief sculpture Sculpture with a background plane from which the projections are relatively small.

Lyric A poem, usually brief and personal, with an emphasis on feelings or states of mind as part of the subject matter. Lyric songs use lyric poems.

▓ M ▓

Machine sculpture Sculpture that reveals the machine and/or its powers.

Madrigal In music, a secular song usually for two or three unaccompanied voices.

Mass In sculpture, three-dimensional form suggesting bulk, weight, and density.

Media The materials out of which works of art are made. These elements either have an inherent order, such as colors, or permit an imposed order, such as words; these orders, in turn, are organizable by form. Singular, *medium*. See *elements*.

Melodic line A vague melody without a clear beginning, middle, and end.

Melodrama In theater, a genre characterized by stereotyped characters, implausible plots, and emphasis on spectacle.

Melody A group of notes having a perceivable beginning, middle, and end. See *theme*.

Metaphor An implied comparison between different things. See *simile*.

Middle Ages The centuries roughly between the dissolution of the Roman Empire (ca. 500) and the Renaissance (fifteenth century).

Mixed media The combination of two or more artistic media in the same work.

Mobile A constructed structure whose components have been connected at the joints to move by force of wind or motor.

Modeling The technique of building up a sculpture piece by piece with some malleable material. See *assemblage*.

Moderato A musical term instructing the player to be neither fast nor slow in tempo.

Modern art The bewildering variety of styles that developed after World War II, characterized by the tendency to reject traditionally accepted styles, emphasizing originality and experimentation, often with new technologies.

Modern dance A form of concert dancing relying on emotional use of the body, as opposed to formalized or conventional movement, and stressing emotion, passion, mood, and states of mind.

Montage The joining of physically different but usually psychologically related scenes. See *editing*.

Mood A feeling that arises from no specific or apparent stimulus.

Motive In music, a brief but intelligible and self-contained unit, usually a fragment of a melody or theme.

Myth Ancient stories rooted in primitive experience, usually of unknown authorship, ostensibly based on historical events of great consequence.

▓ N ▓

Narrative A story told to an audience.

Narrator The teller of a story.

Negative space In sculpture, any empty or open space.

Neo-classical A return in the late eighteenth and early nineteenth centuries, in reaction to the Baroque and the Rococo, to the Classical styles of ancient Greece and Rome, characterized by reserved emotions. See *Romanticism*.

New Comedy Subject matter centered on the foibles of social manners and mores. Usually quite polished in style, with bright wit and incisive humor.

Nocturne In music, a pensive, dreamy composition, usually for piano.

Normative values Values set forth as norms or ideals, what "ought to be."

▓ O ▓

Objective correlative An object, representation, or image that evokes in the audience the emotion the artist wishes to express.

Objectivist theory of value Value is in the object or event itself independently of any subject or interest. See *relational* and *subjectivist theory of value*.

Ode A ceremonious lyric poem.

Oil painting Artwork in which the medium is pigment mixed with linseed oil, varnish, and turpentine.

Old Comedy Subject matter centered on ridiculous and/or highly exaggerated situations. Usually raucous, earthy, and satirical.

On point See *en pointe*.

Onomatopoeia The use of words whose sounds suggest their meaning.

Open line In painting, soft and blurry line. See *closed line*.

Organic color In painting, color that appears deep, as if coming out of an object depicted. See *inorganic color*.

Organic narrative A story composed of separable incidents that relate to one another in tightly coherent ways, usually causally and chronologically. See *episodic narrative*.

▪ P ▪

Panning In film, the moving of the camera without pause.

Paradox An apparent contradiction that, upon reflection, may seem reasonable.

Participative experience Letting something initiate and control everything that comes into awareness—thinking from.

Pas de deux A dance for two dancers.

Pas de trois A dance for three dancers.

Passion Emotions elevated to great intensity.

Pediment The triangular space formed by roof jointure in a Greek temple or a building on the Greek model.

Perception Awareness of something stimulating our sense organs.

Perceptual metaphor A comparison that evokes images.

Performance art Generally site-specific events often performed with little detailed planning and leaving much to chance; audience participation may ensue. See *shock art*.

Perspective In painting, the illusion of depth.

Philosophy The discipline that attempts to give reasoned answers to questions that—because of their generality—are not treated by any of the more specialized disciplines. Philosophy is the systematic examination of our fundamental beliefs.

Piano A musical term instructing the player to be soft, or quiet, in volume.

Pictorial space The illusory space in a painting that seems to recede into depth from the picture plane (the "window effect").

Pictorialists Photographers who use realistic paintings as models for their photographs. See *straight photography*.

Picture plane The flat surface of a painting, comparable to the glass of a framed picture behind which the picture recedes in depth.

Pigment For painting, the coloring agent.

Plot The sequence of actions or events in literature and drama.

Polyphony In music, two or more melodic lines sounded together.

Pop Art Art that realistically depicts and sometimes incorporates mass-produced articles, especially the familiar objects of everyday life.

Popular art Contemporary works enjoyed by the masses.

Pornography Works made to sexually arouse.

Post-and-lintel In architecture, a structural system in which the horizontal pieces (lintels) are upheld by vertical columns (posts).

Presentational immediacy The awareness of something that is presented in its entirety with an "all-at-onceness."

Presto A musical term signifying a rapid tempo.

Pretext The underlying narrative of the dance.

Primary colors Red, yellow, and blue. See *secondary colors*.

Print An image created from a master wooden block, stone, plate, or screen, usually on paper. Many impressions can be made from the same surface.

Processional shot The camera focuses on figures and objects moving toward the camera.

Propaganda Political persuasion.

Proportion Size relationships between parts of a whole.

Proscenium The arch, or "picture frame," stage of traditional theater that sets apart the actors from the audience.

Protagonist The chief character in drama and literature.

▪ Q ▪

Quest narrative In literature, a story that revolves around the search by the hero for an object, prize, or person who is hidden or removed. This typically involves considerable travel and wandering on the part of the hero.

Quoins Large squared stones, often roughly cut, that accent the corners of a building.

R

Realism The portrayal of objects and events in a highly representational manner. An important style of painting around 1840–1860.

Recessional shot The camera focuses on distant figures while leaving foreground figures somewhat blurred, used typically when the distant figure is leaving.

Recitative Sung dialogue in opera, cantata, and oratorio.

Recognition In drama, the moment of truth, often the climax.

Region In painting, a large part. See *detail*.

Regional relationships Significant relationships between regions. See *structural relationships*.

Relational theory of value Value emerges from the relation between a human interest and an object or event. See *objectivist* and *subjectivist theory of value*.

Relief With sculpture, projection from a background.

Renaissance The period in Europe from the fifteenth through sixteenth centuries with a renewed interest in ancient Greek and Roman civilizations. See *Classical style*.

Representational Descriptive of portrayals that closely resemble objects and events.

Representational painting Painting that has specific objects or events as its primary subject matter. See *abstract painting*.

Requiem A mass for the dead.

Reversal In drama, when the protagonist's fortunes turn from good to bad.

Rhyme A sound structure coupling words that sound alike.

Rhythm The relationship, of either time or space, between recurring elements of a composition.

Ritardando In music, a decrease in tempo.

Rococo The style of the visual arts dominant in Europe during the first three-quarters of the eighteenth century, characterized by light curvilinear forms, pastel colors, ornate and small-scale decoration, the playful and lighthearted. Rococo music is lighter than Baroque. See *Baroque*.

Romanticism Style of the nineteenth century that in reaction to Neo-classicism denies that humanity is essentially rational and the measure of all things, characterized by intense colors, open line, strong expression of feeling, complex organizations, and often heroic subject matter.

Rondo A form of musical composition employing a return to an initial theme after the presentation of each new theme—for example, A B A C A D A.

Rubato A style of musical performance in which the performer takes liberties with the rhythm of the piece.

S

Satire Literature that ridicules people or institutions.

Saturation The purity, vividness, or intensity of a hue.

Scherzo A musical term implying playfulness or fun. The word literally means "joke."

Sciences Disciplines that for the most part use strictly objective methods and standards.

Sculpture in the round Sculpture freed from any background plane.

Secondary colors Green, orange, and violet. See *primary colors*.

Sensa The qualities of objects or events that stimulate our sense organs, especially the eyes. See *sensuous*.

Sensuous In painting, the color field as composed by sensa. See *abstract painting*.

Sentimentality Oversimplification and cheapening of emotional responses to complex subject matter.

Setting In literature, drama, opera, dance, and film, the time and place in which the work of art occurs. The setting is established mainly by means of description in literature and spectacle in drama, opera, dance, and film.

Shape The outlines and contours of an object.

Shock art Attention-grabbing works intended to shock or repel, which usually fail to hold attention.

Shot In film, a continuous length of film exposed in the camera without a break.

Simile An explicit comparison between different things, using comparative words such as "like."

Sky-oriented architecture Buildings that bring out with special emphasis the sky and its symbolism. See *earth-resting*, *earth-rooted*, and *earth-dominating architecture*.

Soliloquy An extended speech by a character alone with the audience.

Sonata form In music, a movement with three major sections—exposition, development, and recapitulation, often followed by a coda.

Sonnet A poem of fourteen lines, with fixed rhyming patterns, typically in iambic pentameter. See *iambic pentameter*.

Space A hollow volume available for occupation by shapes, and the effect of the positioned interrelationships of these shapes.

Space sculpture Sculpture that emphasizes spatial relationships and thus tends to de-emphasize the density of its materials.

Spectacle The visual setting of a drama.

Spectator experience Thinking at something. See *participative experience*.

Staccato In music, the technique of playing so that individual notes are short and separated from each other by sharp accents.

State of mind An attitude or orientation of mind that is relatively enduring.

Stereotype A very predictable character. See *type character*.

Stoicism The curbing of desire to cope with the inevitability of pain.

Straight photography Style that aims for excellence in photographic techniques independent of painting. See *pictorialists*.

Structural relationships Significant relationships between or among details or regions to the totality. See *regional relationships*.

Structure Overall organization of a work.

Style The identifying features—characteristics of form—of a work or group of works that identify it with an artist, group of artists, era, or culture.

Subject matter What the work of art "is about"; some value *before* artistic clarification. See *content*.

Subjectivist theory of value Value is projected by human interest on some object or event. See *objectivist* and *relational theory of value*.

Sunken-relief sculpture Sculpture made by carving grooves of various depths into the surface planes of the sculptural material, the surface plane remaining perceptually distinct.

Surface relief Sculpture with a flat surface plane as the basic organizing plane of the composition, but with no clear perceptual distinction perceivable between the depths behind the surface plane and the projections in front.

Surrealism A painting style of the 1920s and 1930s that emphasizes dreamlike and fantastic imagery.

Symbol Something perceptible that stands for something more abstract.

Symmetry A feature of design in which two halves of a composition on either side of a central vertical axis are more or less of the same size, shape, and placement.

Synthesis In the arts, the more or less equal combination of the media of two or more arts. See *appropriation* and *interpretation*.

■ T ■

Tactility Touch sensations, both inward and outward.

Tempera In painting, pigment bound by egg yolk.

Tempo The speed at which a composition is played.

Tertiary colors Colors produced by mixing the primary and secondary colors.

Texture The surface "feel" of a material, such as "smooth" bronze or "rough" concrete.

Theatricality Exaggeration and artificiality.

Theme In music, a melody or motive of considerable importance because of later repetition or development. In other arts, a theme is a main idea or general topic.

Theology The study of the sacred.

Thought The ideas expressed in works of art. Also, the thinking that explains the motivations and actions of the characters in a story.

Tone A sound that has a definite frequency.

Tragedy Drama that portrays a serious subject matter and ends unhappily.

Tragicomedy Drama that includes, more or less equally, characteristics of both tragedy and comedy.

Transept The crossing arm of a church structured like a Latin cross. See *Latin cross*.

Truth to materials Respect for the distinctive characteristics of an artistic medium.

Twelve-tone technique A twentieth-century atonal structuring of music—no tonic or most important tone—developed especially by Schoenberg.

Tympanum The space above an entranceway to a building, often containing sculpture.

Type character A predictable character. See *stereotype*.

■ V ■

Value facts Values described scientifically. See *normative values*.

Values Objects and events that we care about, that have great importance. Also, with regard to color, value refers to the lightness or darkness of a hue.

Vanishing point In linear perspective, the point on the horizon where parallel lines appear to converge.

Virtual art Computer-created, imaginary, three-dimensional scenes in which the participant is involved interactively.

Virtuoso The display of impressive technique or skill by an artist.

■ W ■

Warm color A color that is aggressive, such as red and yellow.

Watercolor For painting, pigment bound by a water-soluble adhesive, such as gum arabic.

Work of art An artifact that informs about values by means of artistic form. See *artistic form*.

CREDITS

Ghost Ranch Cliffs, 1940–1942, oil on canvas, 16 × 36 inches. Private Collection. Photograph courtesy of the Gerald Peters Gallery, Santa Fe, New Mexico. © 2010 Georgia O'Keeffe Museum/Artists Rights Society (ARS), New York; **Fig. 4-13,** Andrew W. Mellon Collection. National Gallery of Art, Washington, DC; **Fig. 4-14,** © Erich Lessing/ Art Resource, NY; **Fig. 4-15,** The Samuel Courtauld Trust, The Courtauld Gallery, London; **Fig. 4-16,** The Phillips Collection, Washington, DC; **Fig. 4-17,** Mary Cassatt, *The Boating Party*, Chester Dale Collection, Image © 2006 Board of Trustees, National Gallery of Art, Washington, DC; **Fig. 4-18,** Image © The Metropolitan Museum of Art/Art Resource, NY; **Fig. 4-19,** William S. and John T. Spaulding Collection, 1921. © Museum of Fine Arts. Boston; **Fig. 4-20,** Asher B. Durand, *Kindred Spirits,* 1849. Oil on canvas. 44 × 36 in. Courtesy Crystal Bridges Museum of American Art, Bentonville, Arkansas; **Fig. 4-21,** Collection of the Modern Art Museum of Fort Worth, Museum purchase, Sid W. Richardson Foundation Endowment Fund. Acquired in 1988. © Howard Hodgkin

Chapter 5 Chapter opener © The Tate Gallery, London/ Art Resource, NY. © Bowness, Hepworth Estate; **Fig. 5-1,** Philadelphia Museum of Art. Gift of Curt Valentin. © 2009 Artists Rights Society (ARS), New York/VG Bild-Kunst, Bonn; **Fig. 5-2,** Image © The Metropolitan Museum of Art/Art Resource, NY; **Fig. 5-3,** Collection, Walker Art Center, Minneapolis. Gift of the T. B. Walker Foundation, 1964; **Fig. 5-4,** Image © The Metropolitan Museum of Art/Art Resource, NY; **Fig. 5-5,** © Alinari/Art Resource, NY; **Fig. 5-6,** Gaston Lachaise, *Floating Figure*, 1927. Bronze. 135.0 h × 233.0 w × 57.0 d cm. National Gallery of Australia, Canberra. Purchased 1978; **Figs. 5-7, 5-8,** © Alinari/Art Resource, NY; **Fig. 5-9,** © Giraudon/Art Resource, NY; **Fig. 5-10,** Photo © Calder Foundation, New York/Art Resource, NY. © 2009 Calder Foundation, New York/Artists Rights Society (ARS), New York; **Fig. 5-11,** Photo © The Tate Gallery, London/ Art Resource, NY. Reproduced by permission of the Henry Moore Foundation; **Fig. 5-12,** The Horniman Museum & Gardens, London (31.42); **Fig. 5-13,** © The Tate Gallery, London/Art Resource, NY. © Bowness, Hepworth Estate; **Fig. 5-14,** Naum Gabo, American, 1890–1977, *Spiral Theme*, 1941. Construction in plastic. 5 1/2 × 13 1/4 × 9 3/8″ (14 × 33.6 × 23.7 cm), on base 24″ (61 cm) square. 5 1/2 × 13 1/4 × 9 3/8″ (14 × 33.6 × 23.7 cm). Advisory Committee Fund. The Museum of Modern Art, NY. Digital image © The Museum of Modern Art, NY/Licensed by Scala/Art Resource, NY. The works of Naum Gabo © Nina Williams; **Fig. 5-15,** © 2007 The Art Institute of Chicago. Gift of Mr. and Mrs. R. Howard Goldsmith; **Fig. 5-16,** Collection, Walker Art Center, Minneapolis. Gift of the T. B. Walker Foundation, 1965; **Fig. 5-17,** George Segal, American, 1924–2000, *The Bus Driver*, 1962. Figure of plaster with cheesecloth; bus parts, including coin box, steering wheel, driver's seat, railing, dashboard, etc. Figure: 53 1/2 × 26 7/8 × 45″ (136 × 68.2 × 114 cm); overall, 7′5″ × 51 5/8″

× 6′4 3/4″ (226 × 131 × 195 cm). Philip Johnson Fund. The Museum of Modern Art, NY. Digital image © The Museum of Modern Art, NY/Licensed by Scala/Art Resource, NY. Art © The George and Helen Segal Foundation/Licensed by VAGA, New York, NY; **Fig. 5-18,** Alberto Giacometti, Swiss, 1901–1966, *City Square*, 1948. Bronze. 8 1/2 × 25 3/8 × 17 1/4″ (21.6 × 64.5 × 43.8 cm). Purchase. The Museum of Modern Art, NY. Digital image © The Museum of Modern Art, NY/Licensed by Scala/Art Resource, NY. © 2009 Artists Rights Society (ARS), New York/ADAGP, Paris/FAAG, Paris; **Fig. 5-19,** David Smith, American, 1906–1965, *Cubi X*, 1963. Stainless steel. 10′1 3/8 × 6′6 3/4 × 24″ (308.3 × 199.9 × 61 cm), including steel base 2 7/8 × 25 × 23 (7.3 × 63.4 × 58.3 cm). Robert O. Lord Fund, The Museum of Modern Art, NY. Digital image © The Museum of Modern Art, NY/Licensed by Scala/Art Resource, NY. Art © Estate of David Smith/Licensed by VAGA, New York, NY; **Fig. 5-20,** George Rickey, American, born 1907. *TWO LINES—TEMPORAL I*, 1964. Two stainless steel mobile blades on stainless steel base. 35′ 4 5/8″ (10.79 m), overall height; blades a. 31′ 3/4″ h. (946.8 cm.), .b 31′ 1 1/4″ h. (948.5 cm.); base .c 8′ 11 1/4″ h. (247.0 cm) weight 498 lbs (not including extra weights). Mrs. Simon Guggenheim Fund. The Museum of Modern Art, NY. Digital image © The Museum of Modern Art, NY/Licensed by Scala/Art Resource, NY. Art © Estate of George Rickey/Licensed by VAGA, New York, NY; **Fig. 5-21,** Photo by David Gahr. © 2009 Artists Rights Society (ARS), New York/ADAGP, Paris; **Fig. 5-22,** Estate of Robert Smithson. Courtesy James Cohan Gallery, New York. Art © Estate of Robert Smithson/Licensed by VAGA, New York, NY; **Fig. 5-23,** © David Noble; **Fig. 5-24,** Judy Chicago, *The Dinner Party*. 1979. Elizabeth A. Sackler Center, Brooklyn Museum of Art. Photo by Donald Woodman. Courtesy Through the Flower. © 2009 Judy Chicago/Artists Rights Society (ARS), New York; **Fig. 5-25,** Photo © Frederick Charles. © 2009 Richard Serra/Artists Rights Society (ARS), New York

Chapter 6 Chapter opener, Photo © Scott Frances/Esto. © 2009 Frank Lloyd Wright Foundation, Scottsdale, AZ/ Artists Rights Society (ARS), NY; **Fig. 6-1,** © Anderson/Art Resource, NY; **Fig. 6-2,** © César Lucas Abreu; **Fig. 6-3,** © Scala/Art Resource, NY; **Fig. 6-4,** © Robert Fried/Alamy; **Fig. 6-5,** © Lee A. Jacobus; **Fig. 6-7,** © Ezra Stoller/Esto; **Fig. 6-8,** © David Heald/The Solomon R. Guggenheim Museum; **Fig. 6-9,** © Robert E. Mates/The Solomon R. Guggenheim Museum; **Fig. 6-10,** French Government Tourist Office; **Fig. 6-11,** Courtesy Rockefeller Center. © Rockefeller Center Management Corporation; **Fig. 6-12,** Photo © Scott Frances/Esto. © 2009 Frank Lloyd Wright Foundation, Scottsdale, AZ/Artists Rights Society (ARS), NY; **Fig. 6-13,** © Ingram Publishing/SuperStock; **Figs. 6-14, 6-15,** © Scala/Art Resource, NY; **Fig. 6-16,** National Gallery of Art, Washington, DC. Samuel H. Kress Collection; **Fig. 6-17,** © Canali Photobank, Italy; **Fig. 6-18,** Image supplied by Blom Aerofilms; **Fig. 6-19,** © Vanni/Art Resource, NY; **Figs. 6-20, 6-21,** © Lee A.

Fig. 13-1, © National Gallery, London/Art Resource, NY; **Figs. 13-2, 13-3, 13-4, 13-5, 13-6,** International Museum of Photography at the George Eastman House, Rochester; **Fig. 13-7,** Permission of Joanna T. Steichen. Image courtesy Sotheby's; **Fig. 13-8,** Alfred Stieglitz, 1864–1946, *The Steerage*, 1907. Photogravure, 12 5/8 × 10 3/16″. Provenance unknown. (436.1986). The Museum of Modern Art, New York. Digital Image © The Museum of Modern Art, NY/ Licensed by Scala/Art Resource, NY. © 2009 Artists Rights Society (ARS), New York; **Fig. 13-9,** Collection Center for Creative Photography, The University of Arizona, © 1981 Arizona Board of Regents; **Fig. 13-10,** © Ansel Adams Publishing Rights Trust/Corbis; **Fig. 13-11,** Digital Image © The Museum of Modern Art/Licensed by SCALA/Art Resource, NY; **Fig. 13-12,** © 1997 All rights reserved by Donna Van Der Zee; **Fig. 13-13,** © Henri Cartier-Bresson/Magnum Photos; **Fig. 13-14,** Library of Congress Prints and Photographs Division Washington, DC (LC-USZ62-95653); **Fig. 13-15,** Walker Evans, 1903–1975, *A Graveyard and Steel Mill in Bethlehem, Pennsylvania*, 1935. Gelatin-silver print, 7 7/8 × 9 5/8″. Gift of the Farm Security Administration. (569.1953). The Museum of Modern Art, NY. Digital image © The Museum of Modern Art, NY/Licensed by Scala/Art Resource, NY; **Fig. 13-16,** Garry Winogrand. *Los Angeles, California*, 1969. Gelatin-silver print. Width 31.7 cm × height 21.7. © The estate of Garry Winogrand, Courtesy Fraenkel Gallery, San Francisco; **Fig. 13-17,** Virginia Museum of Fine Arts, Richmond. Gift of Mr. and Mrs. Ivor Massey. © 2009 Artists Rights Society (ARS), New York/ ADAGP, Paris; **Fig. 13-18,** Ken Moody and Robert Sherman, 1984. © The Robert Mapplethorpe Foundation. Courtesy Art + Commerce Anthology; **Fig. 13-19,** © Joel Meyerowitz; **Fig. 13-20,** Cindy Sherman. *Untitled #168*, 1987. Color photograph(image) 85 × 60 inches. Courtesy of the Artist and Metro Pictures; **Fig. 13-21,** Loretta Lux, *Isabella*, 2001, Courtesy of the artist and Yossi Milo Gallery. © 2009 Artists Rights Society (ARS), New York/VG Bild-Kunst, Bonn; **Fig. 13-22,** Courtesy of the artist and Luhring Augustine

Chapter 14 Chapter opener, Photo © The Andy Warhol Foundation, Inc./Art Resource, NY. © 2010 The Andy Warhol Foundation for the Visual Arts, Inc./ARS, New York/Trademarks, Campbell Soup Company. All rights reserved; **Fig. 14-1,** Photo © AKG London. Art © Estate of Duane Hanson/Licensed by VAGA, New York, NY; **Fig. 14-2,** Grandma Moses: The Quilting Bee. Copyright 1950 (renewed 1978), Grandma Moses Properties Co., New York. Courtesy Galerie St. Etienne; **Fig. 14-3,** © Richard Estes, courtesy Marlborough Gallery, New York. Photo © Artothek; **Fig. 14-4,** Digital Image © The Museum of Modern Art/Licensed by Scala/Art Resource, NY; **Fig. 14-5,** Photo © The Andy Warhol Foundation, Inc./Art Resource, NY. © 2010 The Andy Warhol Foundation for the Visual Arts, Inc./ARS, New York/Trademarks, Campbell Soup Company. All rights reserved; **Fig. 14-6,** From the Collection of The Norman Rockwell Museum at Stockbridge, Norman Rockwell Art Collection Trust. Printed by permission of the Norman Rockwell Family Agency. © 1943 the Norman Rockwell Family Entities; **Fig. 14-7,** Andrew Wyeth, b. 1917, *Christina's World*, 1948. Tempera on gessoed panel. 32 1/4 × 47 3/4″. Purchase. (16.1949) The Museum of Modern Art, New York, NY. Digital image © The Museum of Modern Art/ Licensed by Scala/Art Resource, NY © Andrew Wyeth; **Fig. 14-8,** Courtesy Overland Gallery; **Fig. 14-9,** Reprinted from "Pornography and Pornokitsch," by Ugo Volli, from *Kitsch: The World of Bad Taste*, by Gillo Dorfles, New York: Universe Books. © 2009 Salvador Dali, Gala-Salvador Dali Foundation/Artists Rights Society (ARS), New York; **Fig. 14-10,** © Scala/Art Resource, NY; **Fig. 14-11,** Trinity College Library, Dublin, Eire/© The Bridgeman Art Library; **Fig. 14-12,** © 2009 Artists Rights Society (ARS), New York/ADAGP, Paris; **Fig. 14-13,** Courtesy Tate Archive; **Fig. 14-14,** Photo © Cameraphoto/Art Resource, NY. © 2009 Artists Rights Society (ARS), New York/ ADAGP, Paris/Succession Marcel Duchamp; **Fig. 14-15,** Walter De Maria, *The Broken Kilometer*, 1979. Long-term installation at Dia Center for the Arts, 393 West Broadway, New York City. Photo: Jon Abbott. © Dia Center for the Arts; **Fig. 14-16,** © Christopher Smith/Corbis

Chapter 15 Chapter opener, Vincent van Gogh, Dutch, 1853–1890, *The Starry Night*, 1889. Oil on canvas. 29 × 34 1/4″ (73.7 × 92.1 cm). Acquired through the Lillie P. Bliss Bequest. The Museum of Modern Art, NY. Digital image © The Museum of Modern Art, NY/Licensed by Scala/Art Resource, NY; **Figs. 15-1, 15-2,** Courtesy Everett Collection; **Fig. 15-4,** Vincent van Gogh, Dutch, 1853–1890, *The Starry Night*, 1889. Oil on canvas. 29 × 34 1/4″ (73.7 × 92.1 cm). Acquired through the Lillie P. Bliss Bequest. The Museum of Modern Art, NY. Digital image © The Museum of Modern Art, NY/Licensed by Scala/Art Resource, NY; **Fig. 15-5,** © Scala/Art Resource, NY; **Fig. 15-6,** Image copyright © The Metropolitan Museum of Art/Art Resource, NY; **Fig. 15-7,** © Don Klumpp/ The Image Bank/Getty Images; **Fig. 15-8,** © RKO Radio Pictures/Photofest; **Fig. 15-9,** Photo © Scala/Art Resource, NY. © 2009 Succession H. Matisse/Artists Rights Society (ARS), New York; **Fig. 15-10,** Photo: Hermitage, St. Petersburg, Russia/The Bridgeman Art Library. © 2009 Succession H. Matisse/Artists Rights Society (ARS), New York

Chapter 16 Chapter opener, Fig. 16-1, © The Philadelphia Museum of Art/Art Resource, NY

INDEX